Editions Alecto

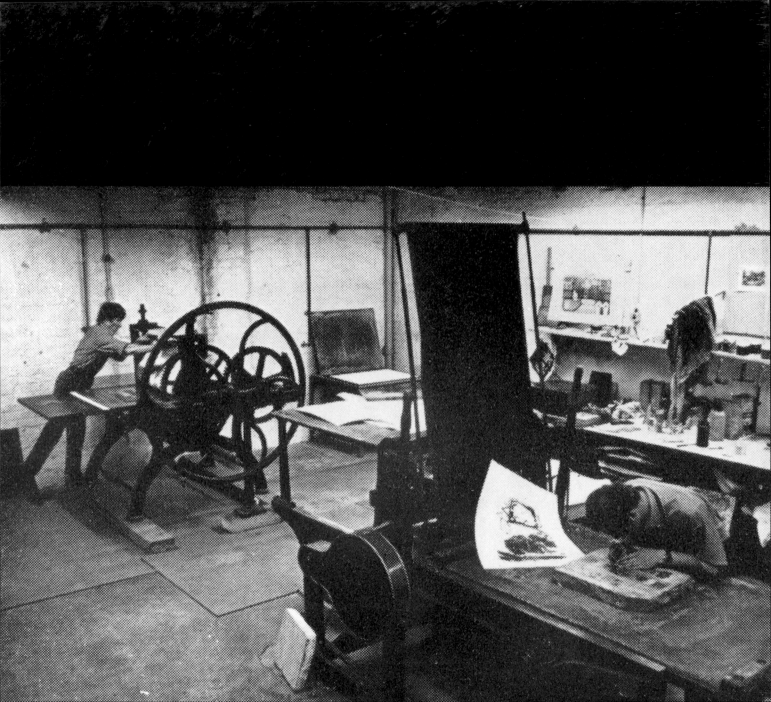

Editions Alecto

Original Graphics, Multiple Originals 1960–1981

Tessa Sidey

with foreword by David Alan Mellor

Lund Humphries

First published in 2003 by
Lund Humphries
Gower House
Croft Road
Aldershot
Hampshire GU11 3HR

and

Suite 420
101 Cherry Street
Burlington
VT 05401
USA

Lund Humphries is part of Ashgate Publishing

British Library Cataloguing-in-Publication Data
A catalogue record for this book is available from
the British Library

ISBN 0 85331 877 8

Library of Congress Control No: 2002115188

Designed by Sally Jeffery

Printed in China by Midas Printing International Ltd
on behalf of Compass Press

FRONT COVER
Glass façade of Alecto Studios, Kelso Place,
London, 1966. © Tony Evans

FRONTISPIECE
The newly opened etching studio at Kelso Place,
with Trevor Allen printing and Michael Rand
demonstrating on litho stone at right, 1965

For Ernest Sidey 1913–2002

Contents

Acknowledgements

This publication would not have been realised in its present form without Joe Studholme. He has financially realised and encouraged the idea of cataloguing Editions Alecto's achievements, from the very beginning when an initial meeting was arranged in 1997 through the initiative of Cathy Courtney. Paul Cornwall-Jones has provided acute insights into the world of post-war publishing, when visiting him in New York and on the phone.

The associated exhibition is very much a collaboration with the Whitworth Art Gallery, Manchester. I would like to thank David Morris, Curator of Prints, as well as the other curators and directors who are supporting the tour: Judy Dixey of Bankside Gallery, London and Ian O'Riordan of City Art Centre, Edinburgh. With all their commitments, Antony Griffiths has found time to read this manuscript and offer incisive comments and advice, and David Mellor has brought his expansive knowledge of the period to bear in a foreword that sets the scene for the wider context for ea.

I have had the privilege of interviewing and corresponding with a large number of artists, their families, printers and associates of ea. Without their participation, it would have been impossible to trace and record work, much of which was destroyed in the 1978 fire at Kelso Place. Sincere thanks are due to them all, and it is their work and skills that have continued to be absorbing. In particular I would like to mention: Brooke Alexander, Douglas Allsop, Nicholas Ardizzone, Guy Arnold, Duffy and the late Eric Ayers, Gillian Ayres, Marc Balakjian, George Ball, Tadek Beutlich, Geoffrey Bertram, Betty Bessant, Tina and Tony Bicât, Peter Carr, David Case, Kate and John Catleugh, the late Michael Chase, Mavis Cheek, Bernard and Chloë Cheese, Douglas Corker, Alan Cristea, James Collyer, Alan Cox, John Crossley, Bill Culbert, Robyn Denny, Alan Davie, Michael Deakin, Anthony Deigan, Jennifer Dickson, Jim Dine, Ernie Donagh, Carolyn Edwards, Joy Edwards, Robert Erskine, Zofia Everett, Nigel and Julia Frith, Liz Fraser, Martin Frishman, Richard Gault, Pat Gilmour, René Gimpel, Mark Glazebrook, Alan Green, Nigel Greenwood, Nigel Hall, Richard Hamilton, Kevin Harris, Anthony Harrison, John Henn, Lisebeth Heenk, Werner Hillman, Derek Hirst, Doreen Hosgood, Gordon House, the late Walter and Denise Hoyle, Peter Huber, Alice Hutchins, Bernard Jacobson, Patricia Jordan Evans, Allen Jones, Robert Jones, Stanley Jones, Annely Juda, Bernard Kay, Ron King, John Kasmin, Bert Kitchen, Michael Knigin, Radovan and Nina Kraguli, Tom La Dell, Mark Lancaster, Ian Lawson, Les Levine, Jorge Lewinsky, Christopher Logue, James Madge, Helena Markson, Anthony Mathews, Peter Matthews, James McFarlane, Deidre Morrow, Toddy Munson, Charles Newington, Prue O'Day, Peter Olley, Maurice Payne, Kevin Pearsh, Tom Piper, Steve Poleskie, Paul Pollak, George Ramsden, Michael and Julia Rand, Norman Redman, Tony Reichardt, Katherine Reid, Nicholas Ritchie, David Cleaton-Roberts, J. P. Rudman, Brian Rushton, Judith Russell, Gordon Samuel, Robert Scott, Peter Sedgley, Doris Seidler, Richard Selby, Bud Shark, Agathe Sorel, Charles Spencer, Jean Stevens, Yvonne Hagen Stubbing, Frank Tinsley, Ian Tyson, Eddie Smith, Marabeth and Kenneth Tyler, June Wayne, Gerald Woods, Dorothea Wight.

Museum colleagues have put up with persistent requests. Special thanks are due to Roger Golding and Robert Jones, for the numerous (and for me highly enjoyable) visits to the Government Art Collection; Diana Eccles of the British Council; Isabel Johnson and Jill Constantine at Arts Council of England; Janet Skidmore and Print Room, Victoria and Albert Museum; Sarah Taft and Christopher Webster of Tate; British Museum Print Room; Marguerite Nugent at Wolverhampton Art Gallery; James McGregor at Cecil Higgins Art Gallery, Bedford; Beth McIntyre of National Museum and Gallery, Cardiff; Roger Dodsworth of Dudley Museum and Art Gallery; Chris Jordan of South London Gallery; Craig Hartley of the Fitzwilliam Museum, Cambridge; Anne Chumbley formerly of Tate; Norma Watt of Castle Museum, Norwich; Jane Farrington and Jane Arthur at Birmingham Museums and Art Gallery for allowing me to realise this research.

Others have given their help and expertise in many ways: David Hockney for producing a new image for the exhibition poster; Miki Slingsby for undertaking much of the photography for this book; Daniel Peirsol of New Orleans Museum and Art Gallery; Research Centre, Tate; the National Arts Library; Birmingham Reference Library, Steve Hoskins, Jean Vaudeau, Terry Huguenin, Robin Spencer, Patrick Elliot, Fiona Pearson, Hugh Stevenson; Jo Beggs, Development Officer at the Whitworth Art Gallery; Barbara Yanni for her hospitality when visiting New York; Helen Bruce, David Bailey, Carla Yanni, Carol Selby, Henrietta Lockhart, Ian Harrison, Jane England, Stephen Bury, Robert Kennan of Bonhams; Sally Townsend of The Multiple Store; Lucy Clark and Alison Green respectively publishing and editorial manager at Lund Humphries; Sally Jeffery for designing this book with such insight; and my mother and father for their encouragement when it was most needed.

Tessa Sidey, Birmingham, August 2002

Foreword

In the spring of 1966, Edition Alecto's art-magazine advertisements, with their sampled displays of Allen Jones, Richard Smith, David Hockney and Jim Dine, fascinated like a range of intensely coloured exotic stamps. They were the bright, compacted talismans of a modernising culture in mid-1960s Britain. Formally, the tabular appearance of those advertisements was a tantalising promise of that typical aspect of many of the prints which were being marketed – especially those of Eduardo Paolozzi and Richard Hamilton. Here was a prospect of a playful decoding of framed registers of different styles and forms, of photo-generated images juxtaposed with full, saturated, abstract colours. The world, the advertisements seemed to say, had been newly divided and transformed into vivid cells of information which could be accessible – no longer socially rarified as in earlier moments of British Modernism – surpassing the abject rhetorics of the 1950s, optimistic in the sensuous unpacking of representation; all in a moment before the puritan visual regimes of the 1970s.

The histories which will, in future, be read from the pages of Tessa Sidey's essay and her catalogue, will stem from her first authoritative narrative of this important commercial project. Here is a text which will be an indispensable starting point for students and scholars of twentieth-century British art. It charts, among other things one crucial swerve: the switch which the founders of Editions Alecto – Paul Cornwall-Jones and Michael Deakin – made from selling Neo-Romantic topographic prints, to another kind of scenography altogether: that of an internationalised and renovated vista of fashion and wit and camp humour found in Hockney's *A Rake's Progress* series in 1963. They moved – like the band of early 1960s satirists – from Cambridge to a London whose culture they would help modify. There was something epic and something shared with other young cultural producers in this shift towards a modernised metropolitan scenography. This was foundationally exemplified by Hockney and the contours of a virtual culture was emphatically Atlanticised by him with his phalanx of T-shirted youths with transistor radio earpieces plugged into their skulls. What was being imaged in *A Rake's Progress* was a humorously inflected outline of an emergent media or communications landscape, a topic which would go on to constitute the grand theme of Paolozzi's suites of prints between 1967 and 1971, the prints which stand not only as the culminating point of Editions Alecto's project, but which can also claim to be the most ambitious and advanced position that British Pop attained.

The gravitational cultural and economic pull of the United States was as decisive for Hockney and Editions Alecto as it was for the rest of Britain and its high-culture and Pop institutions. Unlike the ill-starred Larry Parnes, but, in company with the genius of Brian Epstein, Editions Alecto broke into the American market. As well, this dynamic had a reciprocal aspect: the company's successful inveigling of American artists to come to work in London at a time of the unparalleled prestige of London's Pop culture, exemplified by *Time* magazine's 'Swinging London' issue. Jim Dine and Claes Oldenburg were riveted by this metropolitan pastoral: rather than the complex virtual image landscapes of his English counterparts, Oldenburg produced a monumental erotic scenography driven by fashion trends, a print contingent upon the miniskirt and the designs of Mary Quant. Brute economics as well as London's emergence as a renowned centre of cultural production dictated the situation: for American artists and dealers, just like the film-makers of United Artists, 'we were cheap' – as the doyen of English printmakers, Gordon House, has recently said. And although Editions Alecto was wedded to an exceptional 'idea of quality', by the direction of Paul Cornwall-Jones and the skills of Chris Prater, it was vulnerable, like all other commercial ventures, to recessional pressures. The economic wind which blew the modernising administration of Harold Wilson 'off course' in July 1966 also dealt a heavy blow to the finances of Editions Alecto, too. (Yet there was to be an extraordinary linkage between this and the following Labour Administration and the company: hundreds of their prints were purchased to decorate governmental offices, creating a new décor as part of the Wilsonian project of modernising the apparatus of the state.)

Their marketing effort to place low price pictures on the walls of an aspirant middle class echoed that of previous twentieth-century British attempts to market the avant-garde, particularly Sickert's Camden Town selling of 'small pictures to small patrons'. The modernisation of the middle-class interior, in the early and mid 1960s, was the vector across which Editions Alecto moved, as their prints projected into a redefined domestic landscape – literally, in the case of the screenprinted reliefs, such as Hamilton's *Guggenheim*, Allen Jones' *A New Perspective on Floors* and Dick Smith's *Sphinx Series*. The enlightened – and generally metropolitan – 1960s domestic interior had become an arena for the emulative display of objects of cool contemporaneity, as the *Sunday Times Colour Magazine*'s 'Lifestyle' features reiterated

each week. Smith's three-dimensional screenprint *Sphinx* was simultaneously an outgrowth of heroic Constructivism and an ambiguous Bacon-esque space frame which could stand like a TV pop music show prop. It was, Charles Spencer suggested in 1966, to be disposed around the interior in a free play of desire and in an aleatory manner: 'you place the shapes round a room, or a house, in any way you wish'.

In the permissive play of cultural counters and signs, Editions Alecto prints embodied not only the modernising ethos of the Wilson years, but also a certain calculated vulgarity of sanctioned art formats; they were, after all, 'cheaper and easier to handle, transport and display [than paintings]'. There was undoubtedly a populist moment after 1969 – instanced by the 'flikker books' – and this was associated with the opening up of multiple editions and new hybrids such as the poster-poem onto a yet further horizon, that of unlimited editions – a kind of democratic utopia of art production which the entrepreneur Jeremy Fry had already embarked on in 1966. It was, essentially, the photo-generated nature of many of the prints which could still provoke a cultural panic and scandal as late as 1967, as Pat Gilmour has traced. It was this connection to a technologically industrialised world of production which helped engage the energies and attentions of artists such as Hamilton and Paolozzi, who flourished in the labyrinths of this artisanal world and who were perceived by designers such as Gordon House as being 'technicians like us'. Hybrid processes in production developed, improvisationally, out of the skills encounters of Chris Prater and Eduardo Paolozzi and the gifted ex-RAF photographer, Dennis Francis. The chief instrument of these diverse methods was to be montage – that once and future form of twentieth-century Modernism – and in the Kelpra Studio, the process-led collaging of elements in an artwork onto Mylar plastic film. This embrace of a technologised montage world went alongside related developments in painting – especially in the hands of Rauschenberg, Warhol and Bacon. Prater and Paolozzi annexed new commercial devices such as Zippertone, the adhesive film manufactured by Letraset, to produce areas of mechanical tone and, by 1970, Francis Bacon was using Letraset transfers in his paintings.

Editions Alecto should have some claim to our attention because of its important place in consolidating Modernism in British visual culture. And, like other episodes in the saga of Modernism, there were liaisons with experimental writing. In London in the 1960s, the presence of William Burroughs and his dissident form of 'cut-up' texts was inspirational to writers such as J. G. Ballard who wrote an introduction to Paolozzi's suite, *General Dynamic F.U.N.* in 1970. Out of Paolozzi's well-established interests in earlier French Modernist writers – particularly Raymond Roussel – a new form of graphic textuality began to be invented in his prints from 1964 onwards, with IBM typewriter-generated blocks of text and purloined extracts of type from books, which were integral to the pictorial elements in the prints. When Ed Ruscha visited London to produce a set of prints, *News, Mews, Pews, Brews, Stews and Dues*, in 1970, the borders of writing, lettering and material signs expanded again, in an audacious project that may mark the moment of a certain Conceptualist development nurtured by Editions Alecto: 'Language', he said, 'gets into my work.' From the multiple intoxications of information technologies – Paolozzi's 'harried world' – to the exclamatory and absurd signs of Ruscha, Editions Alecto established new visual challenges, as well as consolidations, in the last hours of Modernism.

David Alan Mellor

Editions Alecto: A fury for artists' prints

Prints were not only given new life by British artists during the 1960s, they crystallised an era and its aspirations. This produced sequences of images and multiple objects that continued into the 1970s to be vital and exploratory. How an undergraduate venture was transformed into a name synonymous with original graphics, and the role this publisher played in London and the wider international art scene remains an achievement to be documented and written into the accounts of the period.

The immediate post-war period in Britain was largely determined by limited resources. Artists were dependent on their own printing skills and facilities or, if finances and contacts allowed, on access in London to the main colleges and their print technicians. Ernest and George Devenish, on the staff respectively of the Central School and The Royal College of Art (RCA), regularly printed for artists, but only when time and the availability of presses allowed. Established printers in Paris such as Desjoubert, or the commercial printer Thomas Griffits of the Baynard Press in London, were used on an individual basis, but generally London and printmaking functioned on a parochial and fragmented level.

Alliances between the few key outlets that did exist nevertheless began to signal an alternative. The Miller's Press in Sussex linked up with the Redfern Gallery in Cork Street in 1948 to exhibit contemporary British colour prints under the aegis of the Society of Painter-Printers. The Redfern Gallery on its own cornered the market in modern French prints as an adjunct to its selling of French painting, leaving the Zwemmer Gallery under Michael Chase as the only serious alternative venue. Chase notably supported the exhibitions of the New Editions Group, founded in 1956 by British painters and sculptors to 'raise the standard of print-making and, by this, increase the respect for the graphic arts'.[1]

In 1950 the Giles Bequest Fund, administered by the Victoria and Albert Museum, began to award what became for artists a much sought-after prize 'for the encouragement of relief-printing in colour'.[2] Only two years earlier, The Royal College of Art had appointed Edwin La Dell as Lithography Tutor in 1948, later to become Head of the then named Engraving School and a key promoter of colour lithography. The medium's revival and promotion of the large-scale led to such aspiring public schemes as the School Print and Lyons Series,[3] with La Dell himself initiating the first of a series of RCA publications in 1953.[4]

St George's Gallery and its legacy

In this context, the opening of the St George's Gallery in November 1955 at 7 Cork Street filled a vacuum.[5] Its founder, Robert Erskine, had started to organise print shows as a student at Cambridge. An introduction to the print studio system in Paris and belief in the power of dissemination helped shape his vision of a dedicated centre for retailing and publishing prints. From the earliest exhibitions, the gallery concentrated almost exclusively on showing prints of established and young British printmakers, alongside occasional international exhibitions. On the rare occasion when drawings were shown, such as Anthony Gross's drawings for *Le Boulvé Suite*, they were given space specifically for their relationship with prints.

Erskine selected artists who he saw as making some kind of impact with their chosen medium, 'I was an archaeologist after all and used to seeing artifacts that were foreign to my own culture. It did not faze me to find something that I did not quite understand, abstract or figurative, as long as it had some kind of impact and craft skill. I would not put up with people who couldn't be bothered to learn the media'[6] Gross and Merlyn Evans were two favoured artists, though regular visits to art colleges ensured a constant representation of student work. In 1961 this resulted in the discovery of David Hockney's etchings. The then student was awarded £100 for the etching of *Three Kings and a Queen*, which allowed him to travel to America for the first time.[7]

From a small gallery space, fronted by the St George's bookshop, Erskine set about professionalising the standards demanded of print publishing. This had as much to do with the choice of paper and printers, as to how a graphic image was presented and distributed through exhibitions at home and abroad, and supported by well-designed catalogues illustrating and documenting work, for example, with accompanying film strips and informative descriptions of techniques. The role of educator culminated in 1957 in the *Artist's Proof* film, showing six artists making prints in different media. This succeeded in being distributed to Academy and Everyman Cinemas, as well as to film societies, clubs and schools, with forty copies sold abroad.[8]

Erskine's financial resouces were limited, and essentially he ran the St George's Gallery over an eight-year period as a single-person operation. Typically, to find an appropriate way to realise a

new publication with an artist, he would buy the whole edition of one or two plates from a new suite of prints, and contribute towards the printing costs. His negotiating skills, in partnership with Timothy Simon of the Curwen Press, lead to the setting up of a dedicated studio to produce artists' lithographs. The pilot scheme, opened in St Ives in 1958, was run by the French-trained Stanley Jones, and the following year secured a permanent home as the Curwen Studio in Plaistow, East London. At the same time, public and critical attention was galvinised by *The Graven Image* exhibitions, at the Whitechapel Art Gallery in 1959, and then annually at the RWS Galleries, Conduit Street until 1963. Though Erskine himself had increasingly little in common with the rapidly changing London of the early 1960s, his vision of a committed centre for the contemporary British print was now in place for development by a younger generation.

From Cambridge to London

The beginnings of Editions Alecto, however, had nothing directly to do with Erskine and was little more than an idea that two Cambridge students floated in the hope of earning some extra money. Michael Deakin and Paul Cornwall-Jones approached Julian Trevelyan to produce, as and when he could, lithographs of Cambridge colleges, the key to the venture being to pay for the production by pre-selling to past members of the colleges. Initial sales proved successful enough for a private limited company to be registered in Cambridge.[9] The name of Alecto, one of the Greek Furies, prefixed by an essential graphic term, was felt to be in keeping with other publishing names of the time such as Ganymed Press.[10,11]

The concept of pre-selling to a captive audience was applied to another topographic theme, the Public Schools Project, launched by John Piper's lithographs of Westminster school, both editions of which sold out without difficulty.[12] In spite of failing to capture the imagination of most of the artists involved, the principle of working successfully with a leading artist (such as Piper) had been registered. The company established a base in London in 1962, working initially from the home of Mark Glazebrook, with the minimal management structure of Paul Cornwall-Jones as managing director, and supporting university contemporaries providing a small capital investment.[13] The fundamental vision of publishing artists' prints, however, proved strong enough to entice Joe Studholme, a National Service friend of Paul Cornwall-Jones, to give up his city job the following year and become a full-time executive.

Cornwall-Jones singles out the role that Mark Glazebrook, then working for the Arts Council, had in introducing him to the London

art world and, in particular, those RCA artists already attracting public and media attention. It would not have been difficult to recognise the London axis of Notting Hill Gate-Westbourne Grove-Kensington as the focus for many of the most interesting artists at this time.[14] The choice of 8 Holland Street in 1962 as an initial London base therefore appears significant. With the unambigious name of The Print Centre, this ground floor gallery, with stock room in the basement and offices on the first, second and third floors, was located close to the future Biba shops in Kensington as well as the RCA. It can be seen as the most tangible indication of Editions Alecto's aspiration to be part of a new generation of art and consumerism.

Though the college and public school commissions maintained the topographic theme into and beyond 1963, attention also turned to selling the range of work being produced by contemporary British printmakers. The mantle of the St George's Gallery was, quite literally, handed over with the transference of its stock to the new company in the summer of 1963. Artists who directly worked with their chosen medium, such as George Chapman, John Brunsdon, Agathe Sorel, Jennifer Dickson and Michael Rothenstein, formed the basis of the *Britische Graphische Scene* exhibition, the first major exhibition organised by ea for showing in the leading bookshop in Zürich.[15] The same artists began to provide the company with an income through their first significant sales to architects, designers and hoteliers.

What in retrospect marked a turning point for retailing on a substantial commercial scale came from a coincidental connection being made with the department store Sears Roebuck in Chicago.[16] On their first sales trip to America, Paul Cornwall-

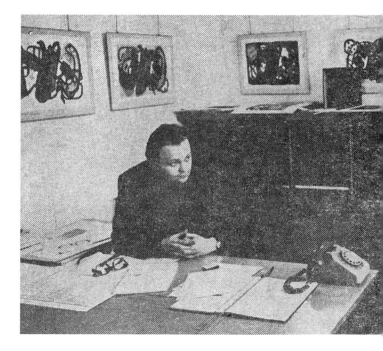

FROM LEFT TO RIGHT
Fig.1 Paul Cornwall-Jones at The Print Centre, Holland Street, 1965
Fig.2 Paul Cornwall-Jones and Michael Deakin at The Print Centre, Holland Street, 1965
Fig.3 Eric Ayers in Claes Oldenburg's studio, Kelso Place, 1966 ©Tony Evans

Jones and Joe Studholme, successfully negotiated with the actor Vincent Price, art consultant for Sears Roebuck, and secured a large order for artists' prints. The income was quickly re-invested in buying more stock for a possible re-order, that in the end never materialised.

The sophistication of the American market had been over-estimated in this instance, but a successful series of 'travelling salesman trips' with car and portfolio followed. 'There was no other English publisher going around America at this time.'[17] Similar success with bulk sales to hotels, that included the Merrion and Intercontinental chains, was no doubt helped by an increasing profile in lifestyle magazines as well as national newspapers. This typically highlighted the bargain-value in buying an original print by a living artist for a few pounds, increasing to 15–35 guineas by 1966. The introduction of a comprehensive film-strip catalogue of over 200 images was credited as 'one of the most effective art-sales systems yet devised',[18] appealing to new collectors as well as the more specialist demands of museums, galleries, libraries, and universities at home and abroad. The then named South London Art Gallery was one of the collections in Britain to promote an acquisition policy for contemporary prints under the St George's Gallery/Editions Alecto influence.

The publishing concept

The initial practice of pre-selling to a known audience had now been all but superseded by the riskier business of buying-in existing work. It was this principle that was applied to David Hockney's *A Rake's Progress*, which already existed in proof form when Paul Cornwall-Jones offered to publish sixteen plates in an edition of fifty. What above all registers as unprecedented in publishing terms, was the offer of the incredible sum of £5000 to secure the rights to publication. This allowed Hockney to go and live in California for a year. He also recalls being equally amazed when the complete set of etchings sold for £250 on its initial exhibition in December 1963.[19]

Unlike Erskine, Editions Alecto raised the financial stakes and expanded their operations and staff from the start. Ianthe Eley (later Mrs Cornwall-Jones) became their first employee in 1962, followed by a steady stream of young recruits that included Michael Rand and Danyon Black to oversee the stock room and, in 1963, Terence Benton to help administer projects. The company characteristically in these early years bought whole or part editions from their most saleable artists and, in the case of André Bicât, established the principle of working as an exclusive agent, with first option on his graphic work. Payment was spread out as a monthly retainer, beginning at £50 in 1963 and rising to £100 in 1967.[20]

A marketing identity had already begun to emerge by the summer of 1963. The graphic designer Eric Ayers designed the famous entwined insignia of *ea*, hand-drawn and probably derived from the typeface Adonis, which found its way into catalogues, press and letter headings, portfolios and posters, as well as on the published work itself as an initial embossed stamp and then a flat stamp with publication number.[21] The approach appeared fresh and progressive, combining spacious wording and layout with simple eye-catching devices such as Cobb Demise coloured paper inserts for catalogues.

The company continued into 1964 and 1965 to be involved in reactive publishing, the buying in of existing work by already

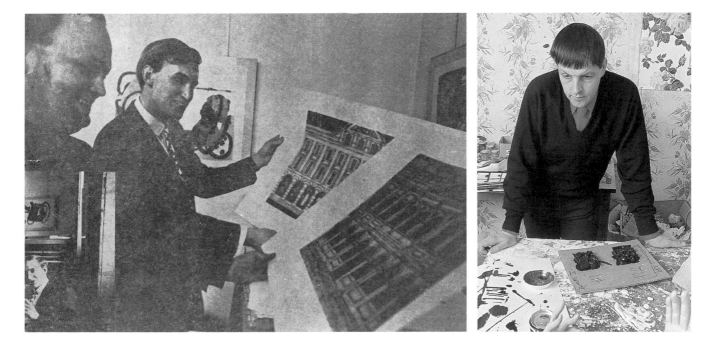

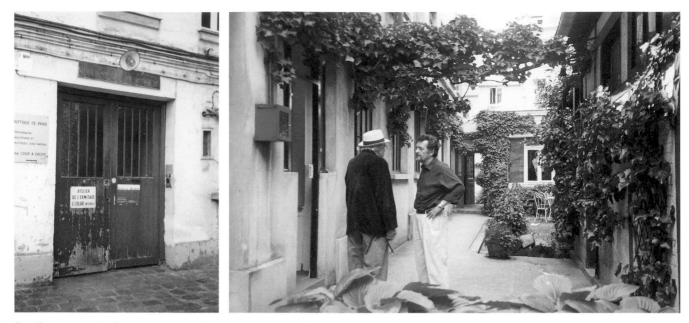

Fig.4 Entrance to Atelier Georges Leblanc from Rue San Jacques, Paris, with view of inner courtyard and studio buildings, George Ball and Pierre Lallier in foreground, 2001. © the author

established printmakers. At the same time, in the wake of the financial and critical success of *A Rake's Progress*, attention was inevitably drawn to a new generation of painters and sculptors, who were establishing a reputation on the London art scene. 'We began to work with artists who had galleries There was the benefit of getting the artist known throughout the world. No one else was doing it . . . providing the opportunity to work with print seriously and to produce a body of graphic images'[22]

The momentum that this proactive publishing concept generated had a lot to do with the newness and freshness of working on what for many of the artists turned out to be their first print portfolio. As described by Allen Jones, 'Paul Cornwall-Jones would have been aware of my work, and the fact that I won a prize in 1963 at the Paris Biennale. They (ea) paid for the whole production of the *Concerning Marriages* Portfolio. Paul asked me where I wanted to work. Trials at Curwen had not worked. Sam Francis had worked with Matthieu in Zürich, so I thought that will be fine for me'[23]

It was not simply a matter of the publisher locating good printers, relatively few as they were in England, but of skilfully matching the printing environment to each artist and particular project. Resident printers like Gabriel Sitkey and in-house Michael Rand, were used with some success,[24] but it was the European ateliers who provided the most extensive facilities. Raymond Haasen and Georges Le Blanc in Paris printed respectively for Lil Michaelis and Richard Beer and, in Zürich, Allen Jones, Bernard Cohen and Alan Davie all printed with Matthieu AG.

A commercial printing house, famous for its printing of historic maps of Zürich, Emil Matthieu and his workshop established a reputation from the later 1950s for printing artists' lithographs. The studio's adherence to traditional distinctions between artists and printer saw Davie confined to a small separated space from which he was expected to produce a drawing on stone or plate. It was rather the business-like working atmosphere that ultimately impressed publishers and artists. In the case of Matthieu, 'plate upon plate appeared, followed by Davie with his instructions to print in varying order and colour; there began to develop images with two, three or four printings and involved composition. For all their techniques, he wanted the medium used his way with his rhythm; quite slowly they warmed to his approach as various combinations were tried'[25] The excitement that ended up being generated produced the remarkable *Zurich Improvisations*, an improvised series of thirty-four colour lithographs.

Jones also benefited from a concentrated period of working in an environment that provided few distractions. He began with, 'little scribbles on a sheet of paper so that I can progress ideas like a story-board. I had most of the images in my head or on paper by the time I went to Matthieu, but the final image came out of the reality of working there. My wife was able to come along and do a lot of the tracing We needed a tracing for each of the colours or proofs as they were pulled. We were there for three weeks, which was not bad going The folio (*Concerning Marriages*) was not just an illustration of some pre-made thing but came out of

the process of making lithographs The lithos might contain images that 18 months/two years later would appear in paintings. They were very spontaneous, almost like sketchbook substitutes.'[26]

The phenomenon of screenprint

Above all, it was the emergence of screenprint as a fine-art medium for artists that provided the adrenalin of this early period. Gordon House and Eduardo Paolozzi had worked with Chris Prater at the Kelpra Studio as early as 1961 and 1962. It was to take another two years before the medium was publicly launched by the *ICA Screenprint Project*, initiated by Richard Hamilton and exhibited at the ICA in November 1964. Despite being a commercial failure – the works did not sell to any significant degree – the process of successfully convincing twenty-four artists to work with screenprint at Kelpra Studio opened the door to the creative possibilities of the medium. ea was quick to respond in publishing terms, setting the production of Paolozzi's *As is When* in progress as early as April 1964, to be published as a portfolio of twelve screenprints in spring the following year.

Kelpra Studio's Day Book reveals that it was working on both of these pioneering screen commissions during the same period. ea subsequently established itself as the studio's main publishing client, a position it held until early 1967 and which Chris Prater himself acknowledged.[27] This can only be compared to Marlborough's New London Gallery, run by Tony Reichardt, which began to publish screenprints by R. B. Kitaj and Joe Tilson as early as 1964.[28] Working independently of each other, both these publishers recognised the importance that a new medium was having for a generation of young artists. While Marlborough concentrated on the artists they were already exhibiting, ea began to work with a remarkable group of artists. Richard Hamilton, Peter Sedgley, Derek Boshier, Jim Dine, Bernard Cohen, Patrick Caulfield, Robyn Denny, Richard Smith, Gillian Ayres, and Eduardo Paolozzi in prodigious fashion, were all commissioned to produce screenprints at Kelpra Studio between 1964–6.

There was no recent precedent for the commitment invested by artist, publisher and printer in the *As is When* portfolio. It took the best part of a year, from the spring of 1964, to complete the project. Paolozzi had incorporated screenprinting into his collages as early as the 1950s, but in teaming up with the interpretative skills of Chris Prater and the printing skills of his assistants, he was able to work on an altogether different level of manipulation with existing material. The act of turning to printers and asking (as he frequently did), 'And what do you think?', actively embraced the collaborative process as a legitimate way of working. As Prater later described, 'the thing with Paolozzi was that he used to come to the studio once a week, and he would bring his artwork up, and if you hadn't done anything . . . then he would say, "Well, forget that one, we have got this one!" One learnt to work to that sort of time scale. Even if one hadn't got the edition finished in a week . . . one

would be far enough into it to be really excited again.'[29]

The hand-cutting of stencils combined with photographic stencilling in *As is When*, to present an astonishing assemblage of patterns and abstractions as equivalents for philosophical propositions. Extended texts from Wittgenstein, and the endless possibilities suggested by the printing of the same image in different colours, saw the medium's potential explored even further. Not suprisingly, the portfolio became a centrepiece of the then highly contentious debate that the screenprint had little to do with originality.[30] It has been well documented how Paolozzi cut up proofs to re-configure an image. The significance of this process was enough for him to say of the screenprints, *Tortured Life* and *Experience*, 'These are the ones I keep looking at.'[31]

Such early success for ea was supported by its alignment with the two most dynamic gallery dealers in London, John Kasmin and Robert Fraser. In December 1963 the former gave Hockney his first solo exhibition at the same time as *A Rake's Progress* was being shown at The Print Centre. The first showing of *The Cavafy Series* took place at Kasmin in New Bond Street three years later, before the etching plates were steel-faced and printed at the Alecto Studios. Bernard Cohen and Gillian Ayres have both described Kasmin exhibitions as stepping stones to working with Editions Alecto. Robert Fraser showed the work of Richard Hamilton, Derek Boshier, Patrick Caulfield and significantly, as it turned out, exhibited Jim Dine and Claes Oldenburg at the time they were working at the Alecto Studios in 1966. For a halcyon period, ea faced little competition in the choice of artists with whom they wanted to work.

Patrick Caulfield had only produced one screenprint, *Ruins*, for the *ICA Screenprint Project*, when Paul Cornwall-Jones proposed that he work on his first series of graphics at the Kelpra Studio. The flat anonymity of his painted surfaces suggested an obvious relationship with screenprinting. As described by Mel Gooding, for a painter who worked slowly and often on a large scale, the medium had the major advantage of reaching a wider audience. At the same time the translation process called for visual refinement. For this, Caulfield produced a sequence of smaller paintings on board as the basis for his screenprints, which have now entered museum and private collections.[32] Though the artist prefers to stress the functionalism of these smaller paintings, they appear to embody the sublime simplicity of content and form that constantly determines his large-scale painting and which points to the revealing connections that exist between Caulfield's painted and graphic world.

For Gillian Ayres, screenprinting was 'just another medium' that she took up for her own response to the 1960s. In collage drawings, she took to mapping out decorative shapes in clashing colours, derived from the famous 'headgear' of Niccolò da Tolentino in Uccello's *Battle of San Romano* in the National Gallery, and from an illustration of Crivelli's *Annunciation*. The

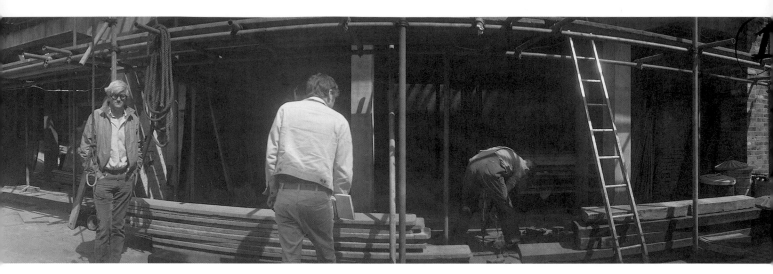

Fig.5 David Hockney visiting the construction site of Kelso Place, 1965, © Eric Ayers

related screenprints, produced at Kelpra Studio, allowed her to transform her 'hatred of perspective' into a wholehearted 'flattening out of things'. She asked Chris Prater for and duly achieved 'vulgar' as well as 'Sunday colour supplement colours'. However much a rare representational interlude within her career, the results were seen to be part of a creative process of working through ideas, when exhibited alongside initial *Untitled Drawings* at the Alecto Gallery in 1967.[33]

The reputation of The Print Centre in Holland Street was built on diversity. Figurative, architectural, abstract, pop and op graphics were all represented in one form or another, either by *ea*'s own publications or by the stock that it acquired. One aspect of print production that they put particular effort into realising was the portfolio box. This presentational device became one of the identifiable trade marks of an Editions Alecto production. Drawing upon the modern German and Swiss tradition of clean sharp edges and good materials, it was approached as an integral part of the overall production process, with the possibility (at best) of extending or encapsulating a thematic concept. Allen Jones designed an echoing bus shape covered in bright yellow cloth and bold lettering for *A Fleet of Buses*. A plain black box and red folder for *A Rake's Progress* referred quite simply to the colours that appeared in Hockney's etchings. Gordon House's familiarity with plastics, from his industrial work for ICA, lent itself to designing a clean-lined acrylic box for Robyn Denny's *Suite 66*. Modern materials were chosen, as and when appropriate, such as the soft-edged perspex and unmissable Day-Glo colours for Paolozzi's *Moonstrips Empire News*, triggered by the idea of a filing tray.[34]

Internationalism

By 1965 promotional material directed at museums listed over a hundred European and American artists. These were supported by

an exhibition programme at The Print Centre that regularly attracted commentary in the national press as the only dedicated centre for prints in London. New commissions, for example by Jennifer Dickson, Julian Trevelyan, Alistair Grant, Doris Seidler, Helena Markson and Allen Jones, were interspersed with shows of European graphics. *Joseph Albers*, *Artists from Atelier 17* and *1 Cent Life* were three memorable projects, while what can be considered Edition Alecto's most influential (though commercially unsuccessful) exhibition, *Graphics in the Sixties: An Improvisation* at the RWS Galleries in Conduit Street in May 1965, focused on new work by artists based in London and New York. Whenever possible, *ea* made a feature of showing graphics that had not been seen before in the capital.

In the succinct catalogue introduction to *Graphics in the Sixties*, Paul Cornwall-Jones provides a rare account, by a publisher at least, of the place of contemporary prints within the broader art world and its relationship to a new audience. It seems appropriate to quote this in full:

At the Tate Gallery and Whitechapel there have been shown in the last few months group exhibitions of sculpture, planned to articulate the situation now of the majority of those artists who made their reputation in the early fifties, in contrast to that younger generation of the sixties, a number of whom have already established a foothold on the international art scene. A similar exercise for painters in 1963 was equally rewarding, and formed an important platform for all those who showed at the Whitechapel.

Having inherited this booking at the RWS Gallery from Robert Erskine's annual 'Graven Image', sponsored in the past by Trust Houses, we decided very recently that it would be appropriate to show a cross section of the graphic work of artists based mainly in London and New York. We feel the range and quality assembled here has made the effort worthwhile, and demonstrates forcibly the possibilities of the mediums. To justify our temerity in selecting a well-worn title, we were happy to tack on 'an improvisation'

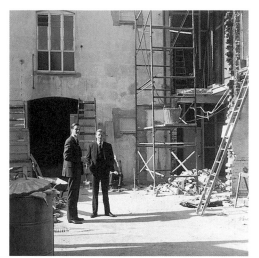

Fig.6 Joe Studholme (left) and Terence Benton visiting Kelso Place when under construction, 1965. © Eric Ayers

defined happily as 'Impulse, second thought, inspiration, flash, spurt'. This is not intended as a disclaimer as we run for cover, but to indicate we do not imply a definitive selection and to emphasise once more the inherent possibility of putting together top quality, manageable exhibitions at short notice.

The exhibition itself shows new work by Josef Albers, Bernard Cohen, Alan Davie, Sam Francis, Richard Hamilton, Eduardo Paolozzi and Victor Vasarely; and of Lee Bontecou, Jim Dine, Robert Rauschenberg and Larry Rivers that has not previously been seen in London. It is perhaps as well to stress that all these works are drawn from stock and that there are more like them. This is not a retrospective exhibition of unique and priceless examples set on a pinnacle only to admire; with a few exceptions all are for sale. To judge from the demands we have received from overseas for the work of those artists we have ourselves published, the mobility and low price of graphics has helped towards the growing international appreciation of London as a creative centre.

There is much talk currently of over-centralisation in the metropolitan cities: there have been warning shots fired in the direction of the dealer's merry-go-round and the publicity machine that can so ruinously force the pace; the international markets push prices of painting and sculpture way beyond the pockets of many would-be collectors, and although the majority now eschew the idea of 'Modern Art' the very size of the work often eliminates the possibility of a domestic setting. We have a Minister of Culture, and leisure time and affluence; in such a context can one dispute the significance of graphics in the sixties?

The Alecto Studios at Kelso Place

The need to coordinate and control its own productions precipitated a move from 8 Holland Street. As early as June 1964, the next phase of development focused on a new Kensington site. A former factory for non-alcoholic communion wine, 27 Kelso Place was located in an affluent residential area. Paul Cornwall-

Jones approached James Madge, a contemporary at Cambridge, to convert the courtyard into premises that combined production studios with office space. While there continued to be dispersed and under-represented printing facilities in London, Alecto's response was to create a highly professional alternative: an atelier system that catered for artists, printers and publisher working together on one site. Three specialist studios, rather than the traditional single workshop, were to lie at the centre of operations, with proper facilities for distribution on a worldwide basis and living accommodation for visiting artists from abroad earmarked for future development. In its international ambitions, this new facility represented a landmark in Britain that could only be recently compared with the newly created Tamarind Lithographic Workshop and Universal Limited Art Editions, on the west and east coast of America respectively.

As James Madge described at the time, the idea was to promote 'a refined industry atmosphere' with skylights providing as much light as possible into the first-floor etching and lithography studios, leaving screenprinting to be earmarked for the ground floor. Existing roof trusses allowed for a drawing gallery and, not least, a new façade captured the vision of the company. A single two-storey front of profilit glass channels, it stood for an unfussy mix of modern aesthetics and traditional functionalism as it diffused light into the prime working spaces.[35]

The move crystallised the decision to hand over retail sales to galleries in and outside London and, in Europe, most notably to Galerie der Spiegel in Cologne run by Eva and Hein Stünke. This left resources concentrated on production and publishing. Michael Rand, who had spent a year printing for Alecto in the old studio of Sir Herbert Herkomer in Bushey, moved to Kelso Place to set up the etching studio. He brought with him an 1880s Greig flywheel press owned by Jennifer Dickson,[36] which went alongside a starwheel Kimbers press purchased from George Chapman.[37] These traditional old presses were joined, as Rand recalls, by 'the very first Charles Bland etching press in the UK – very modern, all steel and lightweight with, I think, a 32-inch bed'. Demand was sufficient for Rand to train both Danyon Black and Maurice Payne as intaglio printers, before he left to join the staff of the RCA in early 1966.[38]

Payne first met David Hockney when working on the *Cavafy Series*, which he printed with Black in 1966 and 1967. Despite being elaborately produced in five editions, Hockney and Payne both refer to the relative ease of working on the thirteen etchings. The economy of fine etched line that was adopted throughout no doubt helped, setting up the paradox of a traditional technique being appropriated for a controversial homosexual subject. Hockney's association with Cavafy dated back to his student days in Bradford. Very much a personal project, it was in no small measure informed by the production process; initially the securing of a new translation of Cavafy's poems by Nikos Stangos and

Stephen Spender, and then the production of Hockney's etchings based on drawings done in Beirut. What amounted to a parallel rather than integrated interpretation of the poems continued to shape the final loose-leaf and book editions. The former are (still) regularly shown on museum walls without the related sheets of poetic text, leaving the book editions as the less public and only means of engaging with the common concerns that unite poet and author. Significantly *The Cavafy Series* was published in 1967, the year that saw homosexuality legalised in Britain, but only after Joe Studholme had persuaded commercial printers not to walk out on the production of the book edition.

The etching studio at Kelso Place established a national and international reputation that was maintained into the later 1970s. The same continuity of skills proved more difficult to achieve in lithography. There was an attempt to secure Marcel Durassier on the recommendation of June Wayne. She herself had tried to bring this great Mourlot-trained master printer to the Tamarind Workshop, but the cultural divide proved too great. 'Marcel was trained to paranoid secrecy about his [techniques] . . . I could not assure a permanent future complete with retirement benefits such as the French enjoy.'[39] Amidst considerable expectation and publicity, negotiations between Durassier and Alecto failed for similar reasons. What amounted to a major setback for the company was retrieved when Ian Lawson, who had already been approached to assist Durassier, was asked to set up the lithography studio. Joined by an old friend, Ernie Donagh, the studio began to operate towards the end of 1966. Among the early projects were proofs for Frank Stella, William Turnbull and editions for Howard Hodgkin.[40]

Editions Alecto was now actively seeing itself a player in an international market, which in effect represented the position of Paul Cornwall-Jones. He had by now completely moved away from the old idea of pre-selling or of buying-in large existing editions by British printmakers. Instead, the four-page promotional leaflet for 1966 announced *A New Look in Graphics*, with the intended opening of a New York office symbolising the expanding relationship between London and New York.[41] The reality appeared to back the vision. While Hockney worked with Ken Tyler in 1965 at Gemini Ltd in Los Angeles on *A Hollywood Collection*, Jim Dine the next year produced twelve screenprints for *A Tool Box* with Chris Prater and the Kelpra Studio in London. Established British printmakers like Richard Beer, Edward Bawden, Walter Hoyle, Helena Markson, Julian Trevelyan and Agathe Sorel[42] were still being published and represented, but the momentum had moved towards a twin-pronged approach of stocking international names such as Richard Anuskiewicz, James Rosenquist, Roy Lichtenstein, Josef Albers and Victor Vasarely, and promoting younger British artists to an American audience. Cohen, Davie, Hamilton, Paolozzi, Hockney and Jones were the names selected for promotion in the first ℮a advertisements taken out in the influential *Art in America* periodical from March 1966.

Technical innovation joined hands with the new internationalism when it secured Claes Oldenburg to work in a converted studio space in Kelso Place in the autumn of 1966. ℮a's ability to provide artists with exploratory time produced, in this case, experiments with a plaster light switch magnetically attached to sections of lithographic printed wallpaper, the principle being that, 'you could move your own switch around'.[43] But the project that went into

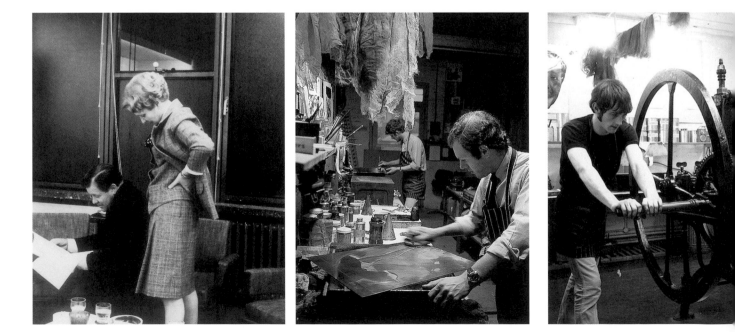

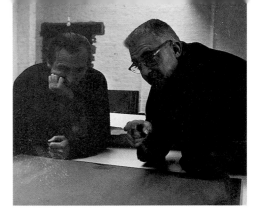

production was a contemporary tribute to London. The idea of *London Knees* grew from a pair of giant kilns seen from a plane when flying over London in 1966, while the chimneys of Battersea Power Station suggested placement on a vast public scale on Victoria Embankment. The actual life-size knees that ended up being fabricated paid homage to the miniskirt, or more accurately the section of the leg between the bottom of the miniskirt and the then fashionable jack boot, a look which Oldenburg's friend, Mary Quant, had been instrumental in promoting.[44]

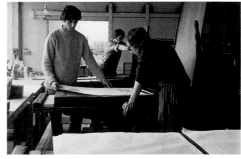

Photographs of beautiful legs were taken and finally absorbed into a mannequin version made (with considerable difficulty) out of slightly soft rubber Latex. Prototypes in various colours gave way to the Elgin 'museum white' of the final edition. In the end, Oldenburg realised a portable art object, a multiple edition of 120, that (quite literally) could travel anywhere, packed in soft felt bags, and accompanied by off-set litho sheets of documentary material and the final exterior layer of a travelling case. The production, overseen by Anthony Mathews, newly arrived as production manager at Kelso Place, only reached completion after two years, with the intervention of Hans Neuendorf as a co-publisher. This most celebrated of publications turned out to be a fortunate survivor of the financial problems now besetting ea.

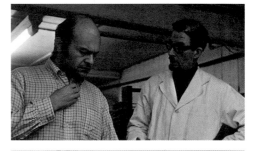

Financial crises, re-launch and new initiatives

For many artists the first indication of a serious situation came with the announcement in *The Times* on 14 April 1967 that the company's publishing activities would be forced to stop unless 'a capital sum of £150,000' was found to sustain the average nine months and £10,000 demanded in fees and production costs to

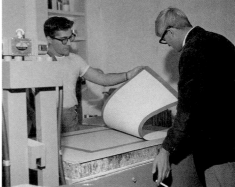

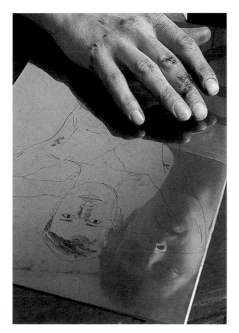

FROM LEFT TO RIGHT (LEFT)
Fig.7 Eva and Hein Stünke, owners of Galerie der Spiegel, c.1964, © Galerie der Spiegel
Fig.8 Michael Rand in etching studio, Kelso Place (foreground), 1965, © Tony Evans
Fig.9 Maurice Payne in etching studio, Kelso Place, c.1968, © Eric Ayers
Fig.10 Danyon Black working on *The Cavafy Series*, 1966 or 1967, © Tony Evans

FROM TOP TO BOTTOM (RIGHT)
Fig.11 Marcel Durassier (right) and William Turnbull talking in litho studio, Kelso Place, 1966, © Eric Ayers
Fig.12 Litho Studio, with Ian Lawson (wearing pullover), 1967, © Eric Ayers
Fig.13 Chris Prater and Jim Dine discussing *A Tool Box*, Kelpra Studio, 1966, © Eric Ayers
Fig.14 Ken Tyler and David Hockney during a proofing session for *A Hollywood Collection*, Gemini Ltd, Los Angeles, 1965, © Tyler Graphics Ltd
Fig.15 Claes Oldenburg working on *London Knees* and other experiments at Kelso Place, 1966 © Tony Evans

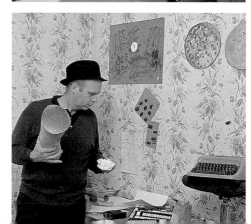

commission 'a portfolio from an artist of stature'. A closer reading however points to the situation being precipitated by the constant demand to sustain production at Kelso Place in order to maintain full-time salaries. With little room for manoeuvre, the company had also overtraded with stock it was no longer able to sell. In this context the failure of a board meeting in early 1967 to endorse expenditure on projects with Frank Stella and Roy Lichtenstein that Paul Cornwall-Jones had already begun to negotiate, becomes more understandable though regrettable. The longer-term repercussions proved to be immense. Cornwall-Jones flew to New York to return prototype work, and on return resigned as Managing Director.

Kelso Place immediately had to suspend its operations, albeit on a temporary basis, and a notable number of commissions in various stages of progress suffered the consequences. William Turnbull had to abandon working on a series of *Four Leaf Forms* in the lithography studio. Jennifer Dickson, Gordon House[45] and Ron King all reclaimed publications that were all but complete. In the case of the latter this involved the physical collection of 125 books and 600 prints of *The Prologue* individually stamped with ℮a publication numbers. Out of this disastrous situation, however, Ron King founded Circle Press, with *The Prologue* as its first publication.[46] A year later, in 1968, Paul Cornwall-Jones set up Petersburg Press, taking with him a number of the artists most identified with Editions Alecto.[47]

In this difficult situation Joe Studholme, now Managing Director, refined his commitments. He concentrated on completing *The Cavafy Series*, and in July went ahead with the opening of a West End gallery in Albemarle Street in order to provide ℮a with a retail outlet for their publications once again. Ian Lawson and Ernie Donagh were brought back to print in the litho studio and *London Knees* was completed. A specially chartered plane, taking artists

to a Milan exhibition of their graphics, captured media attention, as the symbol of a concerted launch into an European market.

What amounted to the second phase of Alecto's history achieved some of its most impressive publications and new directions in 1968. In the year of political protest, poster poems reflected the idealism of the times and the huge interest in the poster as an ultimate multiple statement. Posters were selling 'in a very pop way', and the sale of some 30,000 of Christopher Logue's *I Shall Vote Labour* in 1966 suggested that the visual poem could be part of the same phenomena. The imprint Ad Infinitum attempted to find a collaborative formula for poets and artists, that invariably ended up being conducted on a quite informal basis. That it ultimately proved short lived had a lot to do with a market that was obsessed with visuals rather than written content. Despite being unlimited, poster poems generally sold in modest numbers through alternative bookshops like Indica, or the Fulham Gallery in New Kings Road, frequently earning the artist £200 or £300, which left little margin for a publisher's involvement.[48] Only now perhaps can the Ad Infinitum publications that, for example, linked up Logue with Colin Self and Derek Boshier, Allen Ginsberg with Michael English, and Adrian Mitchell with Patrick Procktor, be recognised as a brave excursion into the graphic ideal.

Colin Self had already approached Joe Studholme to work on three *Out of Focus* etchings. Not content with traditional approaches to technique, Self incorporated screenprinting and photography into his hard-ground and aquatinted arrangements with flowers. 'I remember at the time there was Dusty Springfield on Top of The Pops. The lens would show her coming in and out of focus I wanted the sense of not being able to put your finger on what was happening in your life and what can cloud your vision.'[49]

Self became the first artist to work with Lyndon Haywood in the

newly equipped screenprint studio, the final workshop to open at Kelso Place in 1968.[50] In a career that has continually used the print medium thematically, *Power and Beauty* remains an impressive example of photographic manipulation with colour and scale, 'I cropped to bring out the real power of these images Things are not what they ought to be The stencilled eye of the *Cockerel* almost looks real, while the rest is unnatural in red. I was reading *Gulliver's Travels* at the time The *Cat* is almost like something formed in a cloud pattern. It also might come from a cinema screen'[51] Technique was certainly stretched when the only manufactured image in the series, a customised Joe Bullion car, was screened onto a plate to make the intended black and white etching. As described by John Crossley, now running the etching studio with James Collyer, 'The large piece of zinc proved particularly difficult to ink up, the (etched) holes were so large that they did not easily hold the ink to achieve the particular 1950s feeling that Colin wanted.'[52]

The screen workshop never developed the reputation, or indeed the facilities, for photographic work that was so closely identified with the Kelpra Studio. Under the direction of Lyndon Haywood, however, it produced its best work when meeting new technical challenges. For Robyn Denny, prints may have lacked 'the encompassing factor of a single painting', but the collaborative process was acknowledged to be the only means of working 'seriously' on a small scale. The *Colour Box Series* connected with his pictorial investigation into aerial perspective, extending the concept into a three-dimensional graphic form.

Each of the five perspex-framed boxes consists of four sheets of screened acrylic, interleaved into a symmetrical shape. 'When colour separates, it appears to darken or lighten in tone. In *Colour Boxes*, I explore the circular idea of five colours being repeated in different positions.'[53] The precision and evenness of screening that

was demanded for an edition run, had the additional problem of a box that easily attracted particles of dust and damage. Only when properly exhibited as a sequential group do the allusive colour relationships fully register as a subtle analogy for change and visual ambiguity.

ea had first ventured into 3-D objects in limited editions in 1966, when it published Richard Smith's *Sphinx Series*. These free-standing screenprints appear, quite intentionally, suited to open display in the home rather than the protective glass case of a museum, and, significantly, it was the domestic buyer rather than the museum who registered as its principal purchaser, the National Museum and Gallery, Cardiff being a notable exception. As an edition of fifty, the *Series* had the potential of introducing the artist to a larger, if familiar, audience. The demands in expenditure and on production time ensured that the traditional limited edition remained (at least for the publisher) the most viable means of calculating a feasible financial return. Further publications with the aforementioned Oldenburg and Denny, and George Segal in 1970, saw ea continue to tread a fairly secure and successful path as a 3-D publisher of well-established artists.

The multiple and Alecto International

Publishers, however, moved into unchartered territory when it came to the extended market of the so-called multiple. This broad term was connected with artists' prints in its concern for originality and multiplicity but, more precisely, promoted the concept of the unlimited and the three-dimensional, and the many ways of bringing art to a wider public. The multiple idea had been actively appropriated by the avant-garde in Europe and America during the 1960s, and arguably activity had already peaked by 1968–9.[54] In Britain, however, ground-breaking exhibitions at the Ikon Gallery, Birmingham and the Whitechapel Art Gallery, in 1969 and 1970

respectively, kept the multiple debate in the public arena. Editions Alecto's cautious but committed response was to set up Alecto International Ltd (AI) in 1971, initially as an independent company at 27 Kelso Place and then, two years later, at 14 West Central Street as part of the premises of the art journal *Studio International*. Jeremy Fry's *Unlimited*, based in Bath, and Gallery Group Four had pioneered the production of multiples, as had the Lisson and Axion Galleries in their London exhibition.[55] AI's aim was to combine production and distribution, but now working beyond the conventional gallery circuit.

The writer and critic Charles Spencer was appointed the editorial director of AI, with responsibility for selecting artists; and a phased strategy (written as early as 1969 or 1970) became the working premise for expanding into the publishing of multiples:

Stage 1. A logical continuation of previous publishing policy. Publication of three-dimensional objects by established artists, in limited editions. This will include a new publication – Peter Sedgley's 'Videorotors' [*Video Disques*], and a republication, in new format, of Richard Smith's 'Sphinxes'. An exhibition is being held at the Alecto Gallery during the months of June and July.

Stage 2. Promotion of Art Objects in unlimited editions. This unlimited aspect marks a radical departure for Alecto. These art objects will be by artists who are interested and conversant with the media of mass production. Before embarking on the second stage, a thorough survey will be made of marketing outlets on a world basis. It is envisaged that these will be on a far wider scale than the usual art channels.

Stage 3. Promotion of objects in unlimited editions, by artists, which have some utilitarian function, but are notable for their aesthetic value. This current interest by the artist in a useful object, is becoming increasingly evident. Again a full marketing survey will be made before this is undertaken.[56]

The commercial challenge that AI faced in funding the production process and in gauging audience demand cannot be underestimated. Their response was to work on a prototype or small-run basis before proceeding to full production stage. As a result, the AI catalogue ended up being more extensive than was actually realised. Derek Boshier's *Dome and Base*, Bill Culbert's *Galaxy* and *Cubic Projections*, Betty Thomson's *Equivocations* and Neils Young/David Pelham's *Loopee* were all notable projects that did not proceed beyond a few initial prototypes.[57] Pelham's *Minimum Chess Set* did however proceed to publication a year before the official founding of AI. Made out of highly polished acrylic, this transparent box is both a functional game and an aesthetic object, an idea already imaginatively subverted by Jean Dubuffet in his box of fifty-two playing cards *Banque de L'Hourloupe*, published by ea in 1967.

The concept of the unsigned, unlimited multiple was crucial to Alice Hutchins and her series of hand-size magnetic sculptures. Using ready made parts attached to a permanent industrial magnet (materials that could be easily duplicated), she created playful forms in flux. No longer a finite shape, *Nebula* and *Sound Piece* both invited the viewer to become involved in the creative process. The final outcome sold well, but not without its ironic qualifications: 'I like the look of the piece [*Sound Piece*] but deplore the uninteresting things people do with the discs, which can be made to do suprising things with a little patience: stand straight up for instance on top of the ball; extend into space; attach one to another as one leads the magnetic field from one disc to another. Sound of course accompanies all of this'[58]

America became the focus of AI, leaving marketing and distribution in the UK and Canada to be coordinated through Reeves and Sons, based in Middlesex. Museum shops and department stores were targeted as the main outlets for a general buying public, with a specially designed display unit as the vehicle for showing prints and multiples in shop settings.[59] This presentational device however failed to capture the imagination of the buying public or support a large enough retail market, and AI ceased as a production company after only two years.

The search for a wider print market nevertheless realised a series of flikker books in 1972, coordinated by Brian Rushton, head of production at AI. This ingeniously simple concept of bound drawings simulating movement had its roots in early cinematic history. It was familiar as a children's toy, but had not been explored as a vehicle for artists. AI published nine black and white hand-size books, based on sequential line drawings, photographic images and one collage silhouette, by Derek Boshier, Malcolm Carder, Francois Dallegret, Roy Grayson, Liliane Lijn, Eduardo Paolozzi, Patrick Procktor, Peter Schmidt and Chic Taylor. They retailed at 45p each, aimed at newsagents, stationers and gift shops, but sold more successsfully through art bookshops and museum shops. In retrospect, the idea can be seen to have been ahead of its time, involving artists in a genuinely popular product.[60]

The lack of competition that the early Editions Alecto had enjoyed had long since passed. Instead, their success helped to trigger two main London galleries, Marlborough and Waddington, to follow suit, in 1964 and 1967 respectively, only concentrating, however, on publishing painters and sculptors they were already selling. The Curwen Gallery, with its associated Curwen Studio, specialised in lithographs, and London Graphic Arts, founded by the Detroit-born Eugene Schuster, focused on selling 'young and unknown' British printmakers to America. Comparing the handful of print galleries and dealers that existed in London in 1963, and the thirty and sixty that are listed respectively by *Studio International* in 1966 and 1971 and in the latter case extended across the country, provides further evidence of the pace of expansion. While leading artists were increasingly tied up in established gallery associations, there was growing pressure on publishers and dealers to find inventive ways to bring new work and new names to public attention.

Accessible and cheap: The Collectors Club

The publishing spectrum in the early 1970s ran from Sunday supplements and Christies' Contemporary Prints to the high-profile internationalism of Petersburg Press. Editions Alecto pursued something of a middle ground, promoting new and less well-known artists at accessible prices. This approach formed the basis of its Collectors Club (EACC), launched in 1973. An annual subscription, initially set at £120, provided members with two limited edition prints and two newly commissioned multiples. In the same vein as AI, the selected artists were to be international, but not necessarily familiar to a British audience. An annual prize at the Bradford International Print Biennale provided young artists with access to the Alecto Studios to produce a new piece of work.

The problems that EACC ended up facing included the lengthy lead-in time demanded by a new production, particularly when also retailing in America. The preference of its subscribers for artists working in their own country and their desire to see work before making a final decision were further hurdles to negotiate. Largely in answer to the latter, the Richard Demarco Gallery in Edinburgh became the main distributor for ea and the Collectors Club in Scotland. The introduction of modest prices was directed at new collectors, but it nevertheless drew criticism, from no less than June Wayne, that the scheme could only undercut the American market. Selected artists also appeared to be 'almost exclusively male'.[61] Like AI, EACC only operated for some two years, but had some notable successes, which retain their place today in widely dispersed homes: Kenneth Armitage's *Daydream,* a playful combination of a cupped head and chair; Tom Phillips' modern interpretation of Renaissance principles in *After Raphael?* and Birgit Skiöld's disturbingly beautiful vision of the mushroom cloud of a hydrogen bomb in *Moruroa.*

Public patronage: collaborating with the Department of the Environment

The role of patronage in publishing had long interested Joe Studholme, and it took its most imaginative form in 1975 when he was working with the Government offices of the Property Services Agency of the Department of the Environment (PSA). As early as 1965, in response to Jennie Lee's white paper on 'A Policy for the Arts', the then named Ministry of Public Buildings and Works had become one of Editions Alecto's major clients. Under a public office programme, it secured an annual contract to supply government buildings with 'works by living artists in lithograph form'.[62] Concentrating on 'public offices . . . frequented by members of the public', the designated locations were to extend well beyond London to local and regional offices throughout the UK.[63] Scotland alone in 1965 acquired 211 lithographs, mostly representative of the British printmakers that ea was then buying-in and promoting.[64] The collection, which is now the Government

FROM TOP TO BOTTOM
Fig.20 a–b Two promotional photographs of a London flat with Alecto International and Editions Alecto Collectors Club publications, 1973; including top: Kenneth Armitage's *Daydream* with below Niel Young/ David Pelham's *Loopee* and on bottom shelf, Frosty Myer's *Loop* (left) and David Leverett's *Spaceometry II.* The lower photo shows Colin Self's *Willow,* © Tony Evans
Fig.21 The screen studio with Leslie Hosgood (left) and Robert Jones (back right), working with Derek Hirst on *Paradox Suite,* 1975, © Jorge Lewinsky

Art Collection, is one of the most extensive public collections of post-war British prints.

Though ℯ𝒶's exclusive relationship with the Government continued into the 1970s, it received a much-needed boost in 1975 with a fresh initiative. Joe Studholme set out a joint programme to commission new work in unlimited and limited editions. This would provide the PSA with the 'quantity' that it needed for its offices 'at the right price' while, as an example of patronage, benefiting 'artists, educationalists and the British art scene generally'. That the scheme survived a bureaucratic minefield, was in no small measure due to the efforts of one individual, Howell Leadbeater, at the PSA.

Multiple (unlimited) editions of 2500 were produced by Robyn Denny, Eduardo Paolozzi and William Scott, and limited editions by Nigel Hall, Bert Kitchen, Ben Johnson, Derek Hirst and Norman Stevens. The scheme delivered on both its criteria, though a shortfall in funds for proper framing and increased pressure for a government department to be seen to work to tender helped to ensure that the project was not renewed. It remains however one of the most enlightened and rare examples of post-war public print patronage in Britain.

New publications were always crucial to the full-time working of the Alecto Studios, but they became even harder to sustain in an economic climate that, after the oil crisis of 1973, experienced a cycle of rising inflation, high unemployment and regular wage claims. The decision to turn the printing workshops at Kelso Place into independent companies was a pragmatic response to the problem of sustaining the ℯ𝒶 imprint while relieving it of constant salary and production costs. In principle this was to leave the new companies free to bring in their own work. The first board meeting of Megara Screenprinting Ltd, held in June 1973, had Leslie Hosgood and Robert Jones as its director-printers and was followed, in 1976, by Tisiphone Etching Ltd run by Charles Newington and Frank Tinsley. What amounted to new companies and new printers, though still based at Kelso Place, signalled a revival in fortunes. ℯ𝒶's reputation for etching in particular was maintained with a series of new publications by Patrick Procktor,

that included *The Rime of the Ancient Mariner* in 1976, *The Venice Series* in 1978 and *A Chinese Journey* in 1980.

The watershed of 1978

In 1977, Tom Phillips used the screen, etching and lithograph studios to work on a book edition of Dante's *Inferno*. The original reason for having three workshops on one site appeared at last to being exploited. Though costly in production terms, the process continued over a year, and produced the first pre-publicity for the book. Tragically this was only months before most of the original artwork and photo-positives for the project were destroyed in a disastrous fire on 5 December 1978. The extent of the damage included large amounts of stock and archive on the ground floor (destroyed by water) and irreparable damage to printing equipment in the etching and screen studios on the first floor, where the fire had started.[65]

The aftermath of such a disastrous event was always going to be difficult, and it essentially drew a line under Editions Alecto as a contemporary print publisher. Kelso Place was rebuilt with insurance money from the fire, but Joe Studholme's own personal interest in reclaiming important historical material had already, before the fire, turned to the mammoth task of reprinting William Daniell's *A Voyage Round Great Britain* from original plates recently purchased by Ian Bain for the Tate Gallery. The original intention to produce a modern version of the *Voyage* by contemporary artists, had to be abandoned when it was realised that the next historic project, *Bank's Florilegium* required 'single-minded concentration'. This led to a dedicated Banks studio with some twenty printers, led by Edward Egerton-Williams, being set up in Appold Street in the City to print 743 plates. The project took ten years to complete. In marked contrast, only twenty artists' prints were commissioned and printed at the Alecto Studios in 1979 and 1980, before Derek Hirst, in July 1981, produced the screenprint *Sidlesham Sunrise*, the last contemporary print to be published by ℯ𝒶.[66]

Editions Alecto was part of the energy and idealism of the 1960s that saw prints as a dynamic format for artists and for the

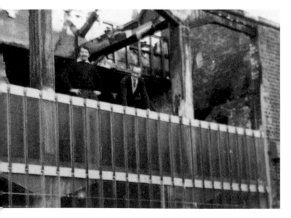
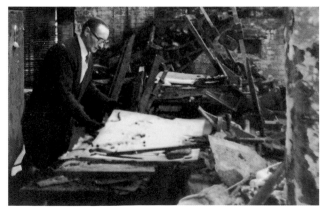

buying public. In 1963 they found themselves in the right place and at the right time in London to act as catalysts for the highest standards of production. At the most exciting time for British art in the twentieth century, their early print publications bear comparison with the best being produced in Europe and America. The different personalities and skills of Paul Cornwall-Jones and Joe Studholme shaped and sustained the company through two distinct phases in its history, as a key player in the revival of the artist's print in the 1960s and as a promoter into the 1970s of extended outlets for artists' prints and multiple objects. *ea* pioneered proactive print publishing in Britain, which took a degree of control away from the artist, but replaced it with what Chris Prater described as 'the real publishing art'.[67]

Notes

Quotations are drawn, unless otherwise stated, from taped interviews and correspondence assembled by the author while working on this project. Most of this material is to be deposited in The Research Centre, Tate.

1 Introductory Statement, *New Editions Group: Original Prints*, exh.leaflet, Auckland City Art Gallery, 1957
2 Leigh Ashton in 'Foreword', *International Colour Woodcuts*, exh.cat., Victoria and Albert Museum, 1954–5, which describes how after London, the exhibition was to be shown at 'City Art Galleries of Birmingham, Manchester and Glasgow during the spring of 1955, and will then visit a number of European capitals.'
3 For a full account of this period see Frances Carey and Antony Griffiths, *Avant-Garde British Printmaking 1914–1960*, London, British Museum, 1990
4 Tim Mara and Silvie Turner, *The Spirit of The Staircase: 100 Years of Print Publishing at the Royal College of Art 1896–1996*, London, Victoria and Albert Museum, 1997
5 See Bryan Robertson, 'Preface and Profile', *The Graven Image*, exh.cat., London, Whitechapel Art Gallery, April–May, 1959
6 Interview with Robert Erskine, 6/5/2000
7 *Three Kings and a Queen* was exhibited in the student section of *The Graven Image* exhibition, 1961, for which Hockney received a Guinness Award initiated by Robert Erskine. See David Hockney, *David Hockney My Early Years*, London, Thames and Hudson, 1988 (pbk), p.65
8 *Artist's Proof* demonstrated woodcutting, lithography, etching, aquatint, engraving and silkscreen by respectively: Roland Jarvis, Alistair Grant, Anthony Gross, Merlyn Evans, Anthony Harrison and John Coplans. See Bryan Robertson, op.cit.
9 Editions Alecto was trading from 5 Madingley Road, Cambridge in 1961–2, and on 20 July 1962 registered as a limited company at 68 Chesterfield Road, Cambridge
10 Interview with Paul Cornwall-Jones, 24/9/1998
11 Ganymed Press produced collotype reproductions of drawings and watercolours, before it used the same process for original graphics from 1951. See *Ganymed Printing, Publishing, Design*, exh.cat., London, Victoria and Albert Museum, 1981
12 See Appendix for Public Schools listing
13 The investor/directors were: John Guinness, Antony Longland and Mark Glazebrook, all Cambridge contemporaries of Paul Cornwall-Jones and Michael Deakin, and Joe Studholme who went to Oxford
14 David Alan Mellor, *The Sixties Art Scene in London*, exh.cat., London, Barbican Art Gallery, 1993, pp.46 & 59
15 *Britische Graphische Scene*, Zürich, Orell Fussli Buchhandlung, September, 1963
16 Michael Deakin was once again an unpremeditated instigator of events when he reputedly heard about Vincent Price's art collection for Sears Roebuck, the large department store in Chicago, while listening to the radio in the bath. 'I think we just called him (Price) there and then to ask why he had not been purchasing the best in contemporary British printmaking, and would he like to see some of our stock.' Rapid studio visits followed to acquire further work, which 'we duly sold to Sears Roebuck on what, unknown to Price, was our first selling trip to America'. Both Paul Cornwall-Jones and Joe Studholme recall seeing 'Kennedy and Mayor Daly campaigning from our hotel window in Chicago only months before the assassination.' (Joe Studholme and Paul Cornwall-Jones, 17/1/1998 and 27/5/2002)
17 Joe Studolme in interview with the author for National Life Story Collection, British Library, 19/1/1998
18 Edwin Mullins, 'Pictures of Low Prices', *Sunday Telegraph*, 17/4/1966
19 David Hockney, *David Hockney My Early Years*, London, Thames and Hudson, 1988, p.92 (pbk)
20 Letters: Terry Benton to André Bicât, 12/7/1965 and Waheed Joffrey to André Bicât, 6/3/1967
21 Eric Ayers worked with the idea of rollers and the printing press, which evolved into an abstracted hand-drawn version of two circles drawn together. He delighted in the accidental allusion that his design had to his own name.
22 op.cit., 10
23 Interview with Allen Jones, 16/3/2000
24 Gabriel Sitkey and his wife, the artist Agathe Sorel, both printed for André Bicât at their studio in 14 Irene Road, London SW6. Michael Rand became the first intaglio printer to work directly for Editions Alecto, initially from a studio in Bushey, Hertfordshire.
25 Paul Cornwall-Jones, *Alan Davie, Zurich Improvisations*, London, Gimpel Fils, London, 1965; repr., *A Decade of Printmaking*, ed. Charles Spencer, London, Academy Editions, 1973, p.29
26 op.cit., 23
27 Biographical notes from taped conversation between Pat Gilmour and Chris Prater, 9/11/1983 and 17/12/1985 (Pat Gilmour archive)
28 New London Gallery, at 17–18 Old Bond Street, was designed by Victor Pasmore as the contemporary gallery for Marlborough Fine Art. It began to publish prints in 1964, 'encouraging just about every artist attached to Marlborough to make prints'. (Tony Reichardt, 25/7/2002)
29 *Kelpra Studio: 25 Years*, exh.cat., Drumcroon, Wigan Education Art Centre, 1 Nov–17 Dec 1982, utilising a taped conversation between A. R. Taylor, Bryan Edmondson, Chris Prater and Douglas Corker
30 See Pat Gilmour, *Kelpra Studio: an exhibition to commemorate the Rose and Chris Prater Gift*, exh.cat., London, Tate Gallery, pp.17–18, which references M. G. McNay, 'Minting Prints', *Guardian*, 15/2/1967. During the same period, the Victoria and Albert Museum continued to refuse to recognise screenprinting as an original medium, based upon the principle of the process not being about the autograph mark. This resulted, tellingly, in Chris Prater offering his collection of Kelpra screenprints to the museum, and being turned down. The Tate Gallery,

through the offices of Pat Gilmour, subsequently entered into an agreement with Rose and Chris Prater in 1972 to receive an example of each of their prints. This laid the foundation for The Tate Gallery's Modern Print Collection.

31 Pat Gilmour, op.cit., p.32

32 Sheffield Galleries and Museums Trust own the painting of *The Hermit*, while *Coloured Still Life* and *Earthenware* are respectively in the collections of Sir Colin St. John Wilson and Joe Studholme

33 Mel Gooding, *Gillian Ayres*, Aldershot, Lund Humphries, 2001, pp.78–96

34 Anthony Mathews in conversation, 29/5/2002

35 *The Architectural Review*, August 1968, no.865, p.130

36 Jennifer Dickson bought her flywheel press with the £300 that she received from ℮a in 1964 for her etchings. It was formerly the press of Herbert Herkomer, purchased from Norman Cox who ran the Bushey Studio. His father, also a mezzotinter, had worked there as Herkomer's studio assistant. Dickson lent the press to Alecto, who transferred it to Kelso Place in the summer of 1965. The press returned to Dickson in Sussex sometime in 1966, before it was sold to Ravensbourne College of Art, Bromley, on her move to Canada.

37 Robert Meyrick, 'George Chapman 1908–93: painter and printmaker', *Printmaking Today*, vol.4/1, 1995, pp.11–12

38 Maurice Payne had produced lithographs, but had no etching experience before he was approached to join ℮a. There he quickly established himself as one of London's leading intaglio printers. Danyon Black was trained 'right up' by Rand, who has described him as learning 'very quickly' and becoming 'a very proficient printer'.

39 In correspondence with June Wayne, 23/1/2002

40 The lithography studio was initially located beside the etching studio, but as described by Bud Shark, who followed Ian Lawson as lithographic printer, was moved to the ground floor, 'The decision to move it had already been taken prior to my arrival. Part of my responsibility when I arrived was to set up the pieces into a functioning studio. It had been a few years since Ian Lawson had done any lithographs, and many of the necessary supplies and some of the equipment had to be replaced or refurbished' (BS, 17/6/2002)

41 Promotional four-page colour leaflet for 1966, in German and English, announcing the opening of ℮a's New York office at 165 East 61st Street

42 The following colour etchings by Agathe Sorel (*b.*Budapest, 1935) were prominently represented/distributed but not officially published by ℮a: *Aprés La Maison*, 1958; *Rochers*, 1959; *Vue sur La Montagne*, 1960; *Fumée*, 1961; *Troubled Square*, 1961; *Petra*, 1962

43 op.cit., 10

44 Mary Quant was one of the early purchasers of *London Knees*.

45 Gordon House produced twelve 'Vitrone' vacuum-formed vinyl sheets, as a boxed edition of seventy, finally published by Marlborough Fine Art.

46 Cathy Courtney, *The Looking Book, A Pocket History of Circle Press 1967–96*, London, Circle Press Publications, 1997, pp.41–4

47 Notably David Hockney and Jim Dine, as well as Patrick Caulfield and Richard Hamilton.

48 Marina Warner, 'The Men behind the Poster Boom', *Daily Telegraph Magazine*, 10/4/1968

49 Interview with Colin Self, 23/11/2001

50 Located on the first floor in the vacated lithography studio, which in 1971 reopened under Bud Shark on the ground floor. See note 40

51 op.cit., 49

52 Interview with John Crossley, 13/3/1998

53 Conversation with Robyn Denny, 28/5/2002

54 Hilary Lane, *Art Unlimited Multiples of the 1960s and 1990s*, exh.cat., National Touring Exhibition for South Bank Centre, 1994, p.13

55 Gallery Group Four, formed in 1962 by Brian Yale and Mauro Kunst, joined by John Berry, Barbara de Orfe and then Roy Grayson and Edward Alden. See Robert Thomas, 'Multiples in Britain', *Studio International*, Sept. 1971, pp.94–6

56 Information sheet headed: *Editions Alecto and Multiples*, undated

57 Brian Rushton describes MOMA wanting to buy '10,000 of Betty Thomson's cube games The tooling costs to make the object were high, and the trial pieces had to be made by hand. Start dividing by 10,000 MOMA got tired of waiting basically, and the piece was produced by someone else'. (in conversation, 12/10/2000)

58 Correspondence with Alice Hutchins, 30/9/2000

59 Alecto International Press Release, dated 1/9/1971

60 Press Release: *Alecto Flikker Books To Be Published, 11 May 1972*

61 Letter: June Wayne to Joe Studholme, 10/11/1972 (Centre for Southwest Research Collections, University of New Mexico)

62 Letter: T. L. Jones to Departments of Ministry of Public Buildings and Works, 31/9/1965 (Government Art Collection)

63 The vast number of participants in this scheme included the Ministry of Social Security, Ministry of Pensions and National Insurance, and HM Customs and Excise with offices in Hull, Liverpool, Preston, Chester, Southwark, Leeds, Glasgow, Bristol, Birmingham, Greenock, Newcastle-upon-Tyne, Belfast, Northampton, Salford and Harwich.

64 Artists purchased by The Ministry of Public Buildings and Works (now Government Art Collection) include: Elisabeth Aslin, Richard Beer, Lewin Bassingthwaighte, Anthony Currell, Jennifer Dickson, Alistair Grant, Margaret Kroch-Frishman, André Bicât and Edwin La Dell.

65 The fire began in the etching studio when, during the blackening of a plate with a taper, scrim hanging above accidentally caught alight. This minor fire was put out, but left a spark in the ceiling area which during the night/early morning of 5 December, surrounded by combustible material, quickly began to burn. Only when the sky lights were blown out was the fire service alerted by a boy living next door. (Joe Studholme, in conversation, 19/7/2002)

66 The remaining stock of Editions Alecto Ltd is with Joe Studholme.

67 From Chris Prater's own account of the setting up and development of Kelpra Studio, 1985 or 1986. (Pat Gilmour archive)

Catalogue

Catalogue note

The basis for this catalogue has been the ℮a Registry, a handwritten manuscript listing 992 Editions Alecto publications from December 1963 until July 1981. To this has been added the initial series of Cambridge lithographs by Julian Trevelyan commissioned between 1959–62, unlimited poster poem and 3-D editions published respectively by Ad Infinitum in 1968 and Alecto International, 1971–3, and exhibition posters based upon artists' designs that were sold and distributed by ℮a and became integral to their image and ethos. An Appendix lists the Public Schools Series.

A disastrous fire on 5 December 1978 destroyed large amounts of print stock and archive material. One of the main tasks of this project has been to physically locate the publications and, where this has proved more than difficult, to at least provide a useful listing of work from surviving records, interviews and archive correspondence. Any image or object not seen by the author is identified by an accompanying asterisk.

The catalogue entries are arranged alphabetically by artist, which can be cross-referenced with the ℮a Concordance. Publications have been traced across America and Europe to private and public collections, as well as through the artists themselves, their families and printers. Twenty years of international print publishing is clearly an immense subject for any one book. Hopefully, however, this publication will act as a reference point for further research and the fuller recognition of graphics in the annals of post-war British art.

Catalogue entries

Biographies
These have been kept to a succinct length, documenting print activities wherever possible, and including a bibliographical reference when considered relevant.

Series or Portfolios
Series or portfolios of prints are documented by a collective description, followed by individual titles and technical descriptions.

Numbering
A catalogue number is given for each printed image or object, whether it exists singularly or within a given portfolio or series. The scope of the project has limited the discussion and documentation of proofs to a brief mention in accompanying catalogue notes.

Title
Titles adhere to existing inscriptions on images and objects and, where there are discrepancies (eg with the ℮a Registry), they have been recorded.

Date
Refers to when a publication was printed, the date of publication being recorded separately. Proof dates are also referenced separately, when known and considered of importance.

Medium
Technique has been described as clearly and fully as possible within reasonable parameters of space. Accompanying notes consider the ideas that inform the choice of process.

Colours
Refer to the printed ink colours that identify an edition, but not necessarily in the order they were used, with brief mention of variations seen by the author.

Paper
Described where known. Barcham Green Crisbrook paper is here simply referred to as Crisbrook.

Dimensions
Two series of measurements are mostly given: the image or plate size, and the paper size; in millimetres and inches, height before width.

Inscriptions/Insc
Refers to titles, edition numbers, signatures and dates, which have been transcribed in italic. They are handwritten by the artist, unless stated otherwise. Other inscriptions on the paper or object surface are also recorded in italic, as well as printers' and publisher's chops.

Edition
Adhers to what is recorded on the image or object, but also cross-references with the ℮a Registry and catalogues/contemporary correspondence. Where there are discrepancies, they are noted in brackets. The number describes the declared edition, with any printing in batches recorded, when known.

Printer/Pr
The name of individual printers and print studios, and their locations, are documented, and also include a date reference if known to be different from the date of publication.

Publisher/pub
Editions Alecto Ltd, unless stated otherwise. The author has followed the format of the ℮a Registry which makes no distinction between pre-existing work selected and sold as a publication with an ℮a number, and newly commissioned work originated by the company and quite

clearly entitled to an ea number. Instead it has been left to the catalogue entries, and accompanying essay, to document and offer some analysis of the implications that surround this broad approach to publishing.

Exhibitions/Exh
Limitations of space have kept references to a minimum.

Notes
Quotations in the catalogue notes are drawn from the series of interviews, visits and correspondence that has been conducted by the author with artists, artists' families, printers and associates of ea over the last six years.

Illustrations
While it has not been possible to illustrate all the 1162 catalogued works, this publication contains 180 colour and black and white photographs, cross-referenced to the appropriate catalogue entry, and arranged left to right on any page. Where an image/object is not illustrated, there has been an attempt to include brief descriptions and/or references to known illustrated material.

Abbreviations

ACE	Arts Council of England, London
A Decade of Printing	Charles Spencer, *A Decade of Print Publishing*, London, Academy Editions in association with Editions Alecto Ltd, 1973
AI	Alecto International Ltd, London
Alecto Monographs 1–9	Charles Spencer, *Alecto Monographs 1–9*, London, Editions Alecto Ltd, 1973
ap	artist's proof
bat	*bon à tirer*; proof designated by the artist as the standard for the edition
BMAG	Birmingham Museums and Art Gallery
Brunsdon	John Brunsdon, *The Technique of Etching and Engraving*, London, Batsford, 1965
cp	cancellation proof
EACC	Editions Alecto Collectors Club

GAC	Government Art Collection, London
icp	Institute of Contemporary Prints run by the Tate Gallery, London during the 1970s
MOMA	Museum of Modern Art, New York
pp	printer's proof
Pr:	Printed by
Pub:	Published by
SNGMA	Scottish National Gallery of Modern Art, Edinburgh
RA	Royal Academy, London
RCA	Royal College of Art, London
Tamarind	*Catalogue Raisonné Tamarind Lithography Workshop, Inc, 1960–1970*, University of New Mexico Art Museum, 1989
V&A	Victoria and Albert Museum, London

Chops/stamps

Initial embossed chop used from the first numbered publication *A Rake's Progress* in December 1963, throughout 1964 and into 1965

The most familiar ea stamp, appearing in 1965 and continuing to be used until the last contemporary publication in 1981; for all media

Smaller, thinner version of initial embossed chop, used especially but not exclusively for etchings, 1973–81

Flat stamp used as early as 1964–6, particularly for screenprints

Large version of the above, used particularly for screenprints printed on card, 1969–70

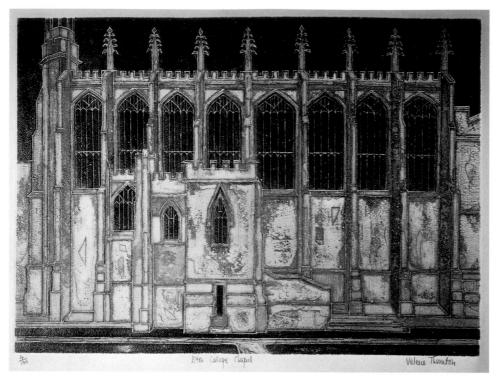

Plate 1 Valerie Thornton, *Eton College Chapel*, 1964 (1094)

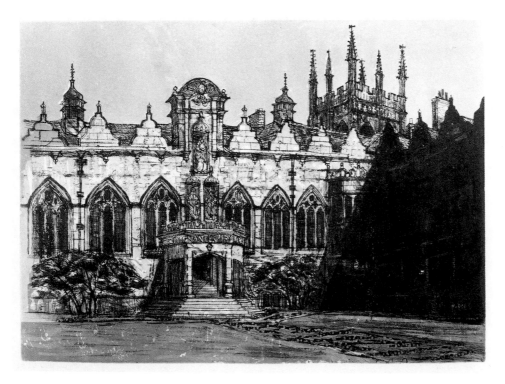

Plate 2 Richard Beer, *Oriel College, Oxford*, 1964–5 (46)

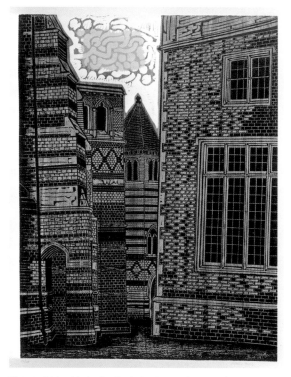

Plate 3 Walter Hoyle, *Rugby School*, 1964 (Appendix)

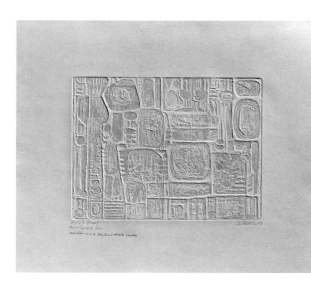

Plate 4 Doris Seidler, *Arkhaios XVI*, 1964 (1027)

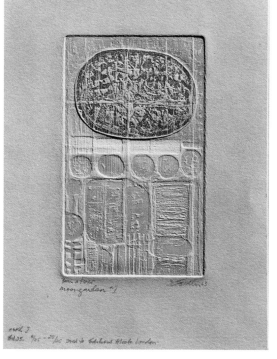

Plate 5 Doris Seidler, *Moongarden I*, 1963 (1030)

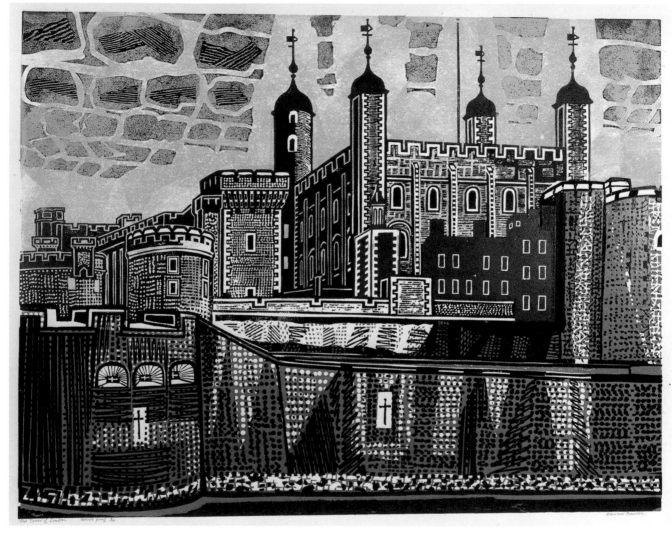

Plate 6 Edward Bawden, *The Tower of London*, 1966 (34)

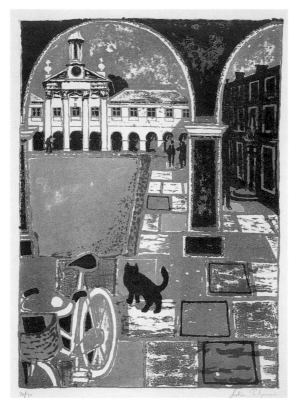

Plate 7 Julian Trevelyan, *Emmanuel College*, c.1960 (1110)

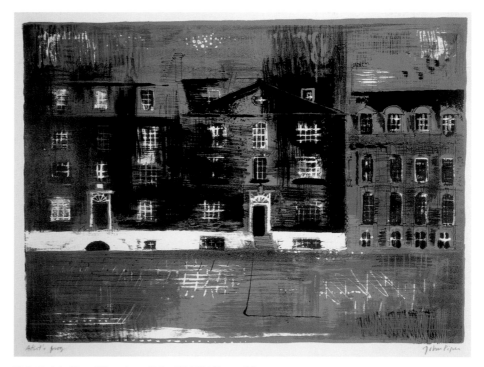

Plate 8 John Piper, *Westminster School II*, 1961 (Appendix)

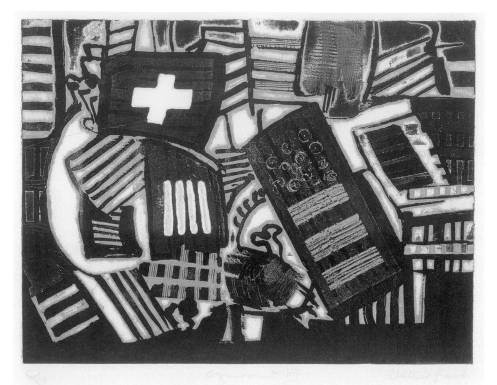

Plate 9 Alistair Grant, *Azincourt Suite IV*, 1964 (400)

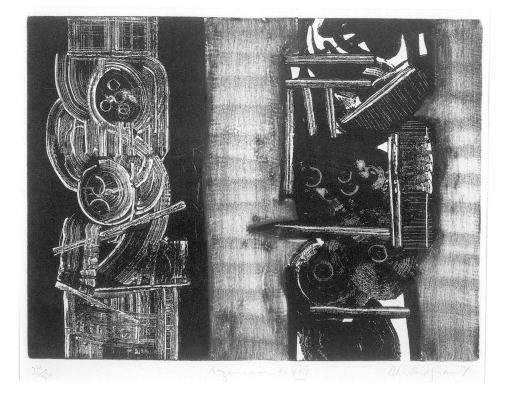

Plate 10 Alistair Grant, *Azincourt Suite VIII*, 1964 (404)

Plates 11–26 David Hockney, *A Rake's Progress*, 1963 (430–45) © David Hockney, 2002

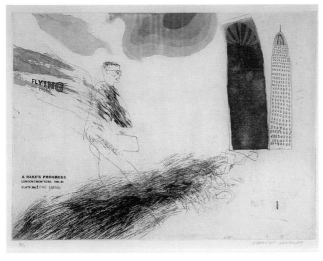

11

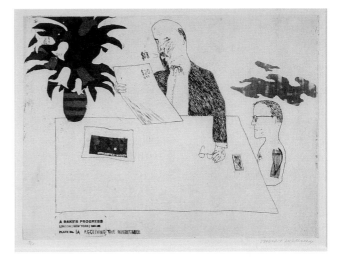

12

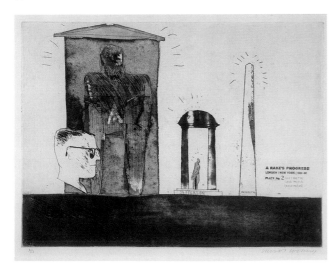

13

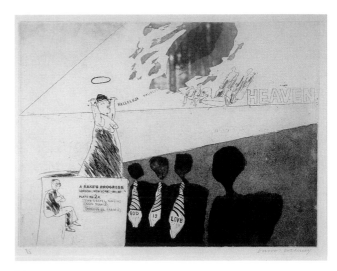

14

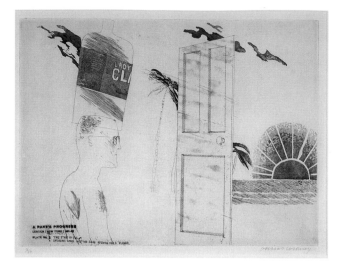

15

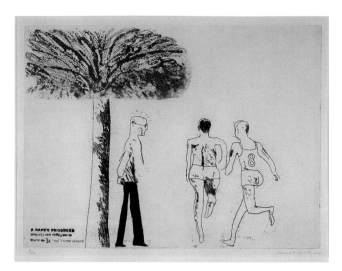

16

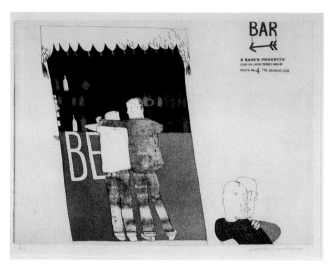

17

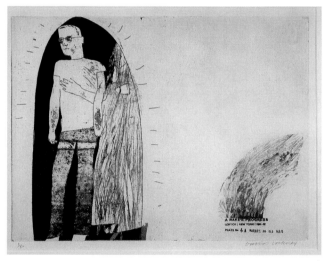

18

19

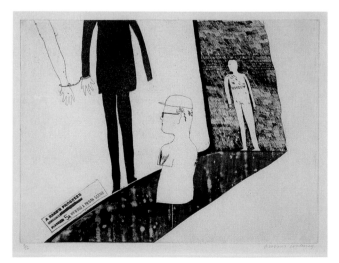

20

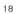

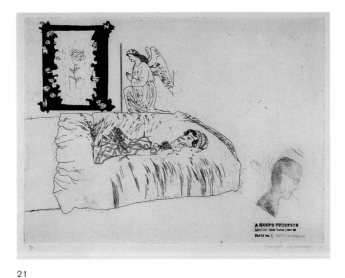

21

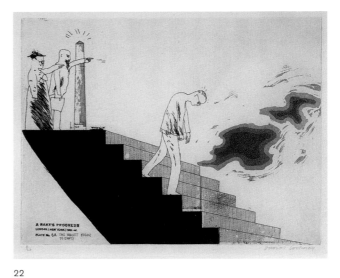

22

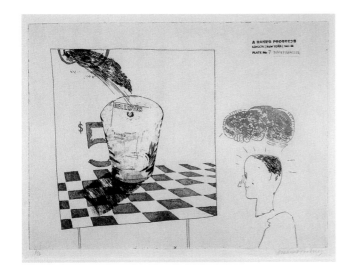

23

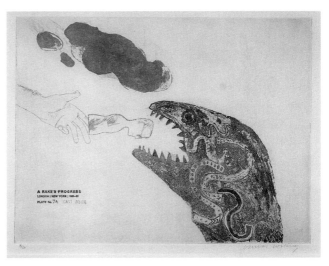

24

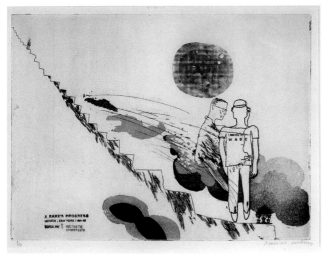

25

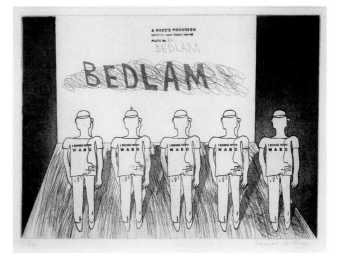

26

Plates **27–31** Eduardo
Paolozzi, *As is When:
Portfolio Box*; *Tortured Life*,
(698); *Wittgenstein in New
York*, (702); OPPOSITE
PAGE *Experience* (699);
1964–5

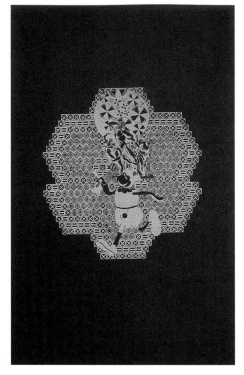

27

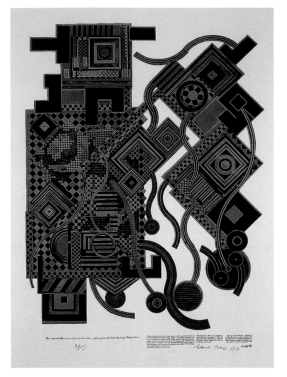

28

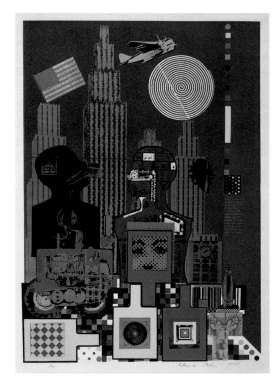

29

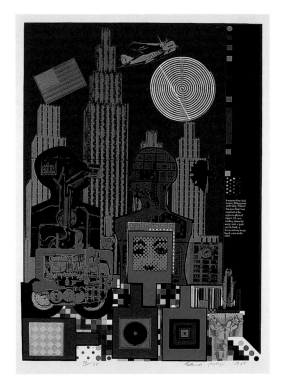

30

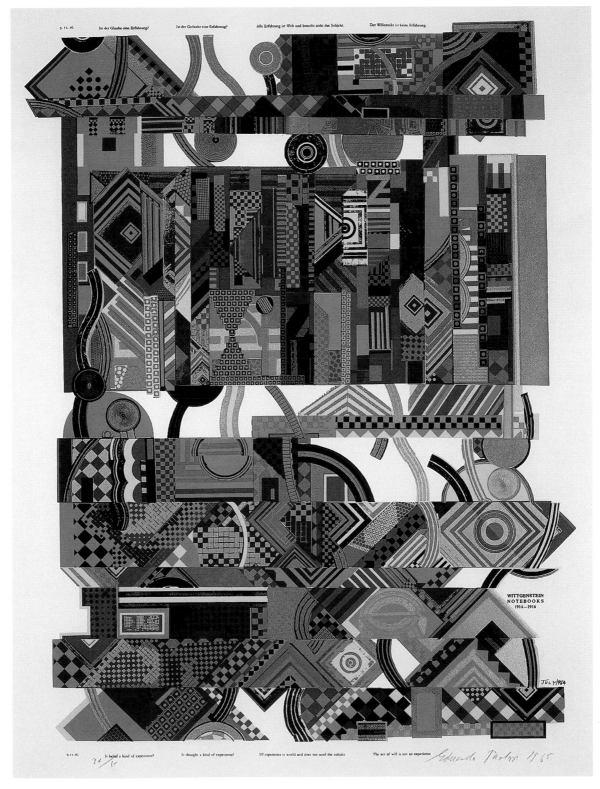

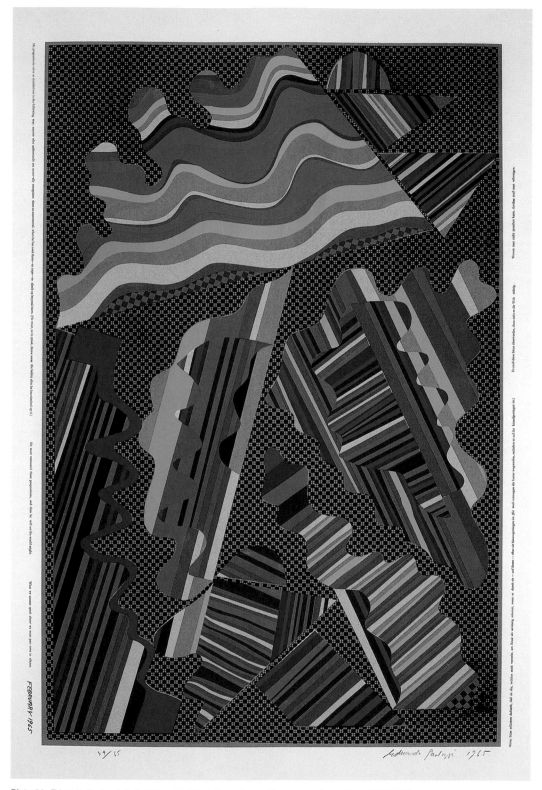

Plate 32 Eduardo Paolozzi, *As is When: He Must, So to Speak, Throw away the Ladder*, 1965 (707)

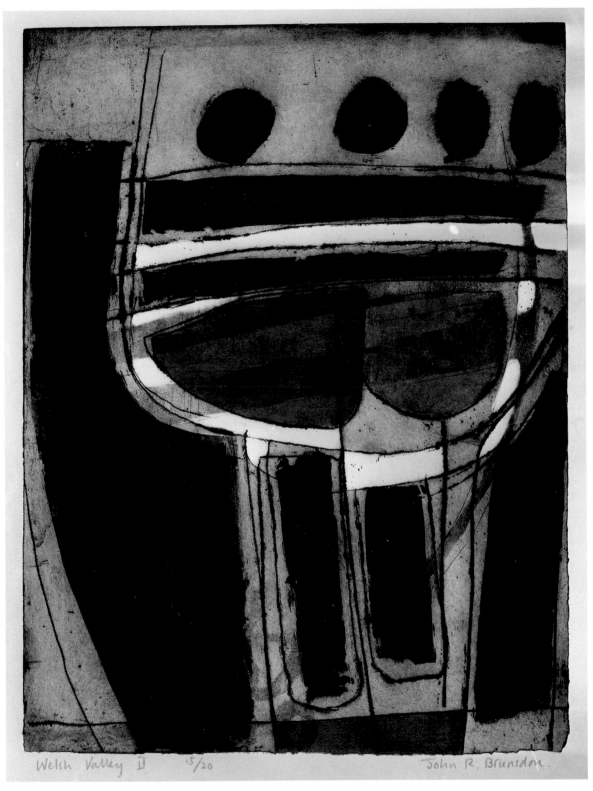

Welsh Valley II 15/20 John R. Brunsdon.

Plate 33 John Brunsdon, *Welsh Valley II*, 1964 (143)

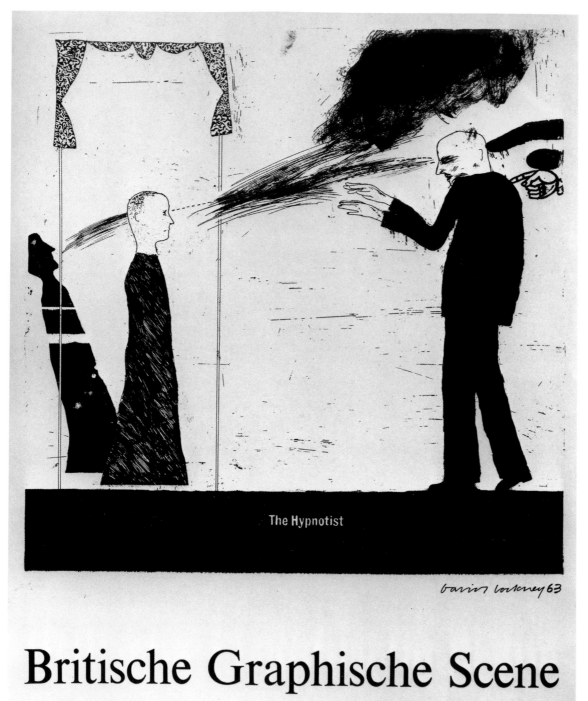

The Hypnotist

Britische Graphische Scene

2 bis 27 September 1963

Orell Füssli Buchhandlung Pelikanstrasse 10 Zürich 1

Plate 34 David Hockney, Poster for *Britische Graphische Scene*, 1963 (447) © David Hockney, 2002

Plate 35 David Hockney, *Portrait of Kasmin (Figure by a curtain)*, 1964 (450) © David Hockney, 2002

Plates 36, 37 Bernard Cohen, *Lithograph I* and *IV*, 1965 (204, 207)

"Laon"

Bernard Kay.

¹¹/100

Plate 38 Bernard Kay, *Laon*, 1965–6 (550)

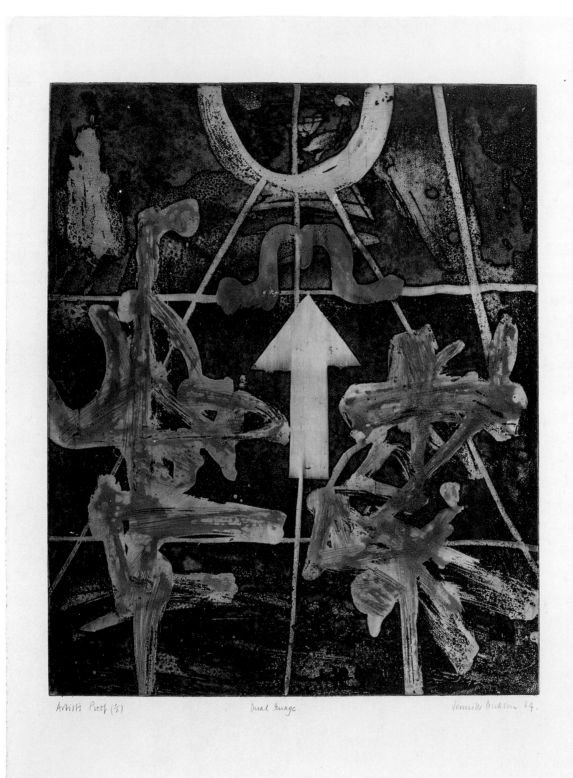

Artist Proof (½) Dual Image. Jennifer Dickson 64.

Plate 39 Jennifer Dickson, *Alecto Keys: Dual Image*, 1963–4 (331)

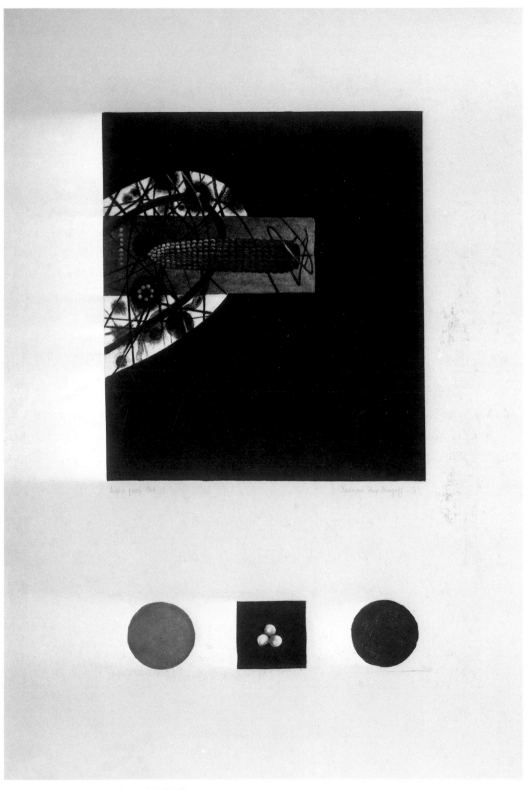

Plate 40 Radovan Kraguly, *Corn*, 1964 (592)

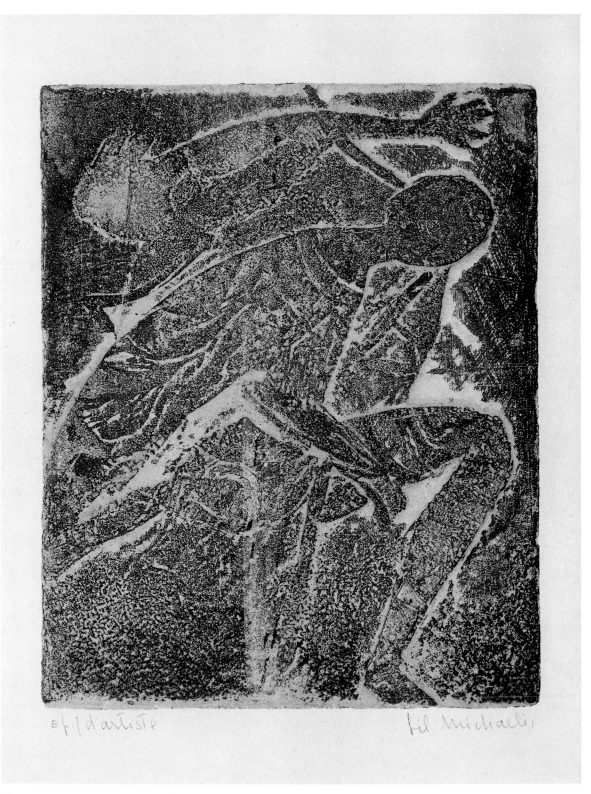

EP./ d'artiste Lil Michaelis

Plates 41, 42 Lil Michaelis, *Personnages (XI* and *XII)*, 1964–5 (670–1)

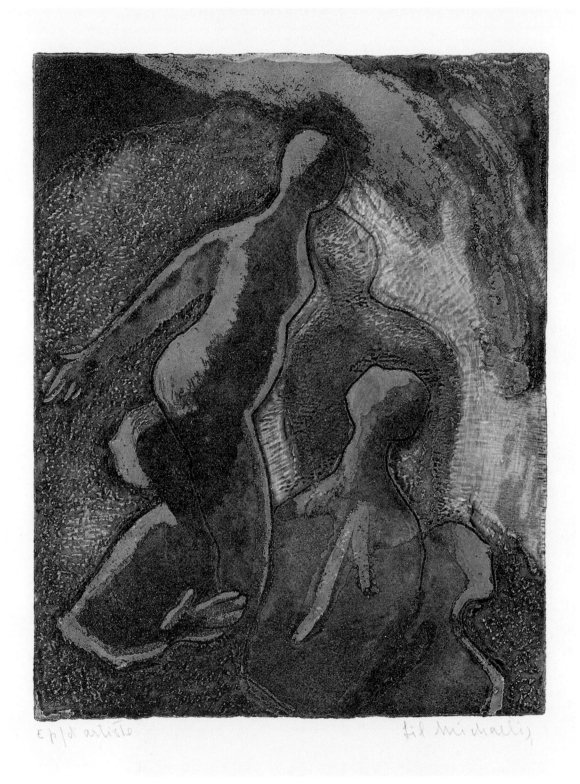

E p/d artiste til michaelis

Pauline Aitken (*b*.Bedford, 1943)

Slade School of Fine Art, 1962–4; Slade Etching Prize, 1965.
Exhibited: *Young Contemporaries*, RA, 1964; *Prints*, AIA Gallery,
London, 1964–8; and Bradford International Print Biennale, 1968–9.
First solo show at Curwen Gallery, London, 1966. More recent
exhibitions include: *Life Forces*, Bury St Edmunds, 1998.

1 'On no work of words', 1969
Etching, assembled set of eight copperplates, printed in red
(intaglio colour), pink (soft roller colour), purple (hard roller colour)
on J. Green 140 lb hot-pressed sized handmade rag paper
Plates assembled: 490 × 550 mm (19$\frac{5}{16}$ × 21$\frac{5}{8}$ in), paper:
584 × 760 mm (23 × 29$\frac{15}{16}$ in)
Insc bl: *71/75*, bc: *On no work of words*, br: *Pauline Aitken '69*
(pencil)
Edition: 75, 8 ap (4 – ℮ɑ, 4 – the artist)
Pr: The artist, Bournemouth and Poole College of Art with
assistance of Christopher Penny; pub: 1969 (℮ɑ 636)
Coll: GAC

'This is a quotation from Dylan Thomas. He writes about his
inability to write for a period of time The colour etching *On
no work of words* was literally that – the oil on canvas paintings
had explored handwritten script which then became simply an
undulating line. The prints explored this without identifiable
letters at all' (PA, 6/9/1999)

2 Skein, 1969
Etching, copperplate, deeply etched with stop-out varnish in
centre, lines drawn with etching needle through stop-out varnish,
printed in lilac greyish (intaglio inking), crimson blue red (hard
roller), yellow (soft roller) on J. Green 140 lb hot-pressed sized
handmade rag paper
Plate: 480 × 440 mm (18$\frac{7}{8}$ × 17$\frac{5}{16}$ in), paper: 750 × 595 mm
(29$\frac{17}{32}$ × 23$\frac{7}{16}$ in)
Insc bl: *65/75*, bc: *Skein*, br: *Pauline Aitken '69* (pencil)
Edition: 75, 8 ap (4 – ℮ɑ, 4 – the artist)
Pr: The artist, Bournemouth and Poole College of Art with
assistance of Christopher Penny; pub: 1969 (℮ɑ 637)
Coll: GAC

Another 'situation' image where moving lines have been pulled to
open up a 'cosmic hole . . . a mesh stretched to reveal
structures/forms that split apart, rejoin in "a floating space" and
pull themselves from what appears to be a structured plane in
front of a void.' (PA, 6/9/1999)

Edward Ardizzone (*b*.Haiphong, Indo-China, 1900–79)

3 Charterhouse: The Courtyard
(℮ɑ 851)

4 Charterhouse: The Mulberry Tree
(℮ɑ 848)

5 Downside Abbey: The Tower

6 Downside Abbey: The Courtyard
(℮ɑ 849)

7 St Paul's School, Hammersmith: The Front

8 St Paul's School, Hammersmith: The Nets
(℮ɑ 850)

See Appendix

Kenneth Armitage (*b*.Leeds, 1916–2002)

Leeds College of Art, 1934–7 and Slade School of Fine Art, 1937–9.
Head of Sculpture, Bath Academy of Art, Corsham, 1946–56.
Exhibited: *New Aspects of British Sculpture*, Venice Biennale, 1952;
the year of first solo show at Gimpel Fils, London. Preoccupied with
human figure, casting in bronze, but with growing interest in mixed
materials, methods and forms. Playful humour shown in transformations
of tables and chairs into women, or vice versa, from the late 1960s.

Lit: *Alecto Monographs 1*

9 Daydream, 1973 (Page 217)
Multiple, polyester resin with marble filling and screened eyes
295 mm (h), 121 mm (d), 99 mm (w) (11$\frac{5}{8}$ × 4$\frac{3}{4}$ × 3$\frac{29}{32}$ in)
Edition: unlimited (2000)
Prefabricated by Michael Maloney with screenprinting at Tanagra
Ltd; pub: EACC, 1973 (℮ɑ 834)

Early prototypes of *Daydream* date as early as 1967, when
Armitage was working as guest artist of the West German
Government in Berlin. This was the first sculpture multiple
published by EACC.

Elizabeth Aslin (*b*.Sheffield, 1923–89)

See Appendix

Gillian Ayres (*b*.London, 1930)

Camberwell School of Art, London, 1946–50. Took part in *Situation*
exhibition, RBA Galleries, London, painting in a free gestural manner.
Changed from acrylic to oil painting in 1977. First editioned lithograph
Tachiste 1,1956. ICA Screenprint Project, 1964. Continues to
produce print editions with Alan Cristea Gallery, London

Lit: Mel Gooding, *Gillian Ayres,* Aldershot and London, Lund
Humphries, 2001

10 Damask, 1967
Screenprint, printed in white on plastic sheet
Image: 482 × 644 mm (19 × 25$\frac{3}{8}$ in), perspex: 558 × 762 mm
(22 × 30 in)
Insc vo: with *K* stamp and number of Kelpra Studio

Edition: 75, 15 (16) ap
Pr: Kelpra Studio, London (invoiced 11/4/1967); pub: 1967
(*ea* 502)
Coll: Tate

'I did some lithography at Art College, but had published very little . . . Paul Cornwall-Jones initially saw my work on exhibition at the Kasmin Gallery and asked me to do some prints Though the title refers to a tablecloth, I intended this white on white image to be purely visual.' (GA, 5/10/1999)

11 Crivelli's Room I, 1967 (Page 122)
Photo-screenprint, printed in black, magenta, cyan, yellow, green, red, pale mauve on Saunders imperial special 140 lb paper
Image: 520 × 669 mm (20 ½ × 26 $\frac{11}{32}$ in), paper: 575 × 774 mm
(22 ⅝ × 30 ½ in)
Insc bl: *Gillian Ayres 67 PP 4/4* (pencil), vo: with *K* stamp and number of Kelpra Studio
Edition: 75, 5 ap, 4 (15) pp
Pr: Kelpra Studio, London; pub: 1967 (*ea* 503)
Coll: Tate; Financial Times; St Thomas's Hospital, London

12 Crivelli's Room II, 1967 (Page 122)
Photo-screenprint, printed in black, light grey, grey, green, greeny grey, dark red, purple on Saunders imperial special 140 lb paper (single deckle edge)
Image: 676 × 458 mm (26 ⅝ × 18 $\frac{1}{16}$ in), paper: 774 × 573 mm
(30 ½ × 22 $\frac{9}{16}$ in)
Insc bl: *Gillian Ayres 67/ A/P* (pencil), vo: with K and number of Kelpra Studio
Edition: 75, 11 ap, 4 pp
Pr: Kelpra Studio, London; pub: 1967 (*ea* 504)
Coll: Tate; ACE; BMAG; Hunterian Art Gallery, University of Glasgow

'I love the Crivelli in the National Gallery, it is such a rich and exotic painting. This is a rare time when I was figurative . . . my paintings at this time were tonally flattened out I told Chris Prater that I wanted the colour to be as vulgar as possible. He never dominated in the studio, though could get very excited' (GA, 5/10/1999)

13 Khuds, 1967
Screenprint, hand-cut stencils, printed in deep purple, red-black, blue-black with white masked edge on Arches mould-made paper
Image: 688 × 404 mm (27 ⅛ × 15 $\frac{15}{16}$ in), paper: 780 × 584 mm
(30 $\frac{11}{16}$ × 23 in, some variation)
Insc bl: *Gillian Ayres 67 23/75* (pencil), vo: *ea* 505 and *K* stamp and number of Kelpra Studio
Edition: 75, 11 ap
Pr: Kelpra Studio, London; pub: 1967 (*ea* 505)
Coll: Tate; GAC; ACE; Leeds City Art Gallery

In conversation the artist emphasises her liking for the sound of words, and this probably affected her choice of an Arabic-sounding title. The author however has been unable to find a precise translation for Khuds, while Ayres recalls the allusion to 'a kind of hillside, an undulating landscape'

14 Lorenzo the Magnificent and Niccolo the Gear, 1967
(Page 123)
Photo-screenprint, greeny grey, gold, green, ochre, light ochre, brown, black, blue, red, orange on printed graph lines printed on Saunders imperial special 140 lb paper
Image: 683 × 491 mm (26$\frac{8}{9}$ × 19$\frac{11}{32}$ in), paper: 773 × 575 mm
(30 $\frac{7}{16}$ × 22 ⅝ in)
Insc bl: *Gillian Ayres/ 67/ P/P* (pencil), vo: *K6761*
Edition: 75, 11 ap, 4 pp
Pr: Kelpra Studio, London; pub: 1967 (*ea* 506)
Coll: Tate; ACE; Museum of Fine Arts, Boston; Fitzwilliam Museum, Cambridge; St Thomas's Hospital, London

Sold for £18 in 1967, Ayres makes a humorous connection between the 'gear' of the Beatles/Stones era and the flamboyant pieces of clothing, notably hats, in Uccello's *Niccolò Maruzi da Tolentino at The Battle of San Romano* in the National Gallery, London. The reference to Lorenzo the Magnificent appears to be less about the politics of leaders than a homage to great art.

15 Aquatint I, 1969–70*
Embossed etching and aquatint, multicoloured with *à la poupée* colour, on Crisbrook waterleaf 140 lb paper
Edition: 30, proofs
Pr: Danyon Black and John Crossley, Alecto Studios; pub: 1970
(*ea* 651)

Gillian Ayres recalls that this edition was never fully printed. 'This is very embedded for those days. I had a show at Kasmin in 1969, which included some parallel-stripped paintings'
(GA, 14/2/2002)

16 Aquatint II, 1969–70
Embossed etching and aquatint, multicoloured with *à la poupée* colour, on Crisbrook waterleaf 140 lb paper
Plate: 505 × 380 mm (19 ⅞ × 15 in), paper: 745 × 540 mm
(29 $\frac{5}{16}$ × 21 ¼ in)
Insc bl: *2/30*, br: *Gillian Ayres 70* (paper)
Edition: 30, proofs
Pr: Danyon Black and John Crossley, Alecto Studios; pub: 1970
(*ea* 652)
Coll: GAC

'These two prints were probably very similar, with less colour in the first edition We used *à la poupée* like painting on the plate with tiny rolls of scrim or felt blanket dipped in ink We even used stumpy brushes to get the ink into the bitten mark, with careful wiping to leave the ink in the hole.' (John Crossley, 5/7/2001)

17–24 Variants, 1970 (Page 220)

Series of eight vitreous enamel steel tiles, white foundation with screenprinted glaze colours (including blues, yellow, purple, brown, red)

Size: 305 × 305 mm (12 × 12 in)

Insc vo: with artist's signature, date, edition number and series number *1 – 8* (ink)

Edition: 50

Pr: Lyndon Haywood and Michael O'Connor, Alecto Studios, London; fired at Royal College of Art by John Stevens, February 1970; pub: 1970 (ℯα 674–81)

Each tile contained in grey box printed: *Gillian Ayres/ Variants/ vitreous enamel/ screenprint on/ steel tile/* ℯα *1970 ©/ Editions Alecto Ltd./ London New York*

Coll: Manchester City Art Galleries (4/8)

'Like big bricks of metal . . . each was fitted with a boxed lid so the enamels could fit on top of each other They have something in common with the (Alecto) colour etchings, funny shapes that move across a surface, and can be put into different, changing relationships . . . I made stencils, which were then sprayed with glaze, sometimes using the same stencils in different colours.' (GA,14/2/2002)

Lewin Bassingthwaighte (*b.*Southminster, Essex, 1928–83)

Studied at RCA. Taught etching and woodblock printing at Chelsea College of Art, 1960–73. Freelance illustration work, before turning to painting full time and printmaking around 1959. Solo exhibitions at Piccadilly Gallery, London 1964–72; print exhibitions at Galleria Cavana, Venice, 1966 and Bear Lane Gallery, Oxford, 1968.

25 Untitled (Orange), 1964

Etching and aquatint, two zinc plates with textured surface using araldite and pieces of metal foil, printed in orange, black, brown on Crisbrook paper

Plate: 403 × 606 mm (15 $\frac{7}{8}$ × 23 $\frac{7}{8}$ in), paper: 558 × 763 mm (22 × 30 $\frac{1}{16}$ in)

Insc bl: *1/75*, br: *Lewin Bassingthwaighte 64* (pencil)

Edition: 75, approx. 5–7 ap

Pr: The artist, Chelsea College of Art, London; pub: 1964 (ℯα 126)

Coll: GAC

Entered in ℯα Registry as *Red*

26 Untitled (Blue), 1964

Etching and aquatint, two zinc plates with textured surface using araldite and pieces of metal foil, printed in blue, ochre, black on Japanese paper

Plate: 464 × 648 mm (18 $\frac{1}{4}$ × 25 $\frac{1}{2}$ in), paper: 588 × 789 mm (23 $\frac{3}{16}$ × 31 $\frac{1}{16}$ in)

Insc bl: *35/75*, br: *Lewin Bassingthwaighte 64* (pencil)

Edition: 75, proofs

Pr: The artist, Chelsea College of Art, London; pub: 1964 (ℯα 127)

Coll: GAC; Leeds City Art Gallery; Leicestershire Museums, Arts and Records Service

Proofs include impression with pink/red sky. The scene derived from Welsh trip to Ffestiniog in the summer of 1962, when Lewin Bassingthwaighte visited his friend Brian Perrin who had rented a cottage. This produced a series of drawings of an extraordinary lunar-type landscape.

27 Wall and Gate, 1964

Etching and aquatint, two zinc plates, printed in blue, black, yellow and brown, with blind embossing

Plate: 452 × 600 mm (17 $\frac{13}{16}$ × 23 $\frac{5}{8}$ in), paper: 524 × 667 mm (20 $\frac{5}{8}$ × 26 $\frac{1}{4}$ in)

Insc bl: *9/50*, br: *Lewin Bassingthwaighte 64* (pencil)

Edition: 50, proofs

Pr: The artist, Chelsea College of Art, London; pub: 1964 (ℯα 128)

Coll: GAC

28 Wall (Brick Structure), 1964

Etching and aquatint, two zinc plates with surface texture using araldite and pieces of metal foil and blind embossing, printed in black with white and ochre on Japanese paper

Insc bl: *23/50* and br: *Lewin Bassingthwaighte 64* (pencil)

Plate: 646 × 463 mm (25 $\frac{7}{16}$ × 18 $\frac{1}{4}$ in), paper: 789 × 592 mm (31 $\frac{1}{16}$ × 23 $\frac{5}{16}$ in)

Edition: 50, unsigned proofs (including brown ochre version)

Pr: The artist, Chelsea College of Art, London; pub: 1964 (ℯα 129)

Coll: Financial Times, London

'There was a wall at the bottom of our basement flat in St Mark's Crescent, Regent's Park Road. This became the subject of a number of paintings and prints by Lewin Glass balls and other bits of metal were glued onto the surface and bitten onto the plate.' (Inge Bassingthwaighte, 5/11/1999)

Edward Bawden (*b.*Braintree, Essex, 1903–89)

Cambridge School of Art from 1918–22, and Design School, RCA,1922–6. Worked for various publishers producing book illustrations and cover designs, posters, advertisements, leaflets and calendars. First solo show: Zwemmer Gallery, London, 1933. Linocut became his main graphic medium, often on a large scale, while also producing watercolours and murals for Festival of Britain (1950–1) and Expo '67, Montreal. Retrospective exhibition at V&A, 1989.

Lit: Justin Howes, *Edward Bawden: A Retrospective Survey*, Combined Arts, 1988

29 The Coal Exchange, 1963

Lithograph, crayon and tusche, printed in orange, grey green, cream, brown, dark blue on handmade Crisbrook paper

Image: 416 × 456 mm (16 $\frac{3}{8}$ × 17 $\frac{31}{32}$ in), paper: 570 × 801 mm (22 $\frac{7}{16}$ × 31 $\frac{9}{16}$ in)
Insc bl: *The Coal Exchange*, br: *Edward Bawden* (pencil)
Edition: 100, proofs
Pr: Richard Bawden, John Norris Wood's studio, Panfield, Essex; pub: 1963 (no ℮a publication number)
Coll: Cecil Higgins Art Gallery, Bedford; School of Art Collection, University of Wales, Aberystwyth

The Cecil Higgins Art Gallery has a watercolour study for this lithograph, which in contrast to *The Stock Exchange* is almost empty.

30 Lloyds, 1963
Lithograph, crayon and tusche, printed in pink, red, grey, green, purple, umber on handmade Crisbrook paper as well as J. Whatman *(1962)* paper
Image: 410 × 453 mm (16 $\frac{5}{32}$ × 17 $\frac{5}{8}$ in), paper: 587 × 799 mm (23 $\frac{1}{8}$ × 31 $\frac{15}{16}$ in)
Insc bl: *85/100 Lloyds*, br: *Edward Bawden* (pencil)
Edition: 100, proofs
Pr: Richard Bawden, John Norris Wood's studio, Panfield, Essex; pub: 1963 (no ℮a publication number)
Coll: Cecil Higgins Art Gallery, Bedford
Lit: *Combined Arts* (ill. as *The Corn Exchange*)

31 The Stock Exchange, 1963
Lithograph, tusche, printed in orange, dark and lighter brown, green, beige on J. Whatman *(1961)* paper
Image: 405 × 455 mm (15 $\frac{15}{16}$ × 17 $\frac{15}{16}$ in), paper: 580 × 723 mm (22 $\frac{27}{32}$ × 28 $\frac{1}{2}$ in)
Insc bl: *The Stock Exchange*, br: *Edward Bawden* and bl corner: *16 for Alecto* (pencil)
Pr: Richard Bawden, John Norris Wood's studio, Panfield, Essex; pub: 1963 (no ℮a publication number)
Coll: Cecil Higgins Art Gallery, Bedford

Suited black figures mingle under the domed structure of The Stock Exchange.

NINE LONDON MONUMENTS, 1966
Series of nine colour linocuts in four or five blocks on unsized filter paper
Insc bl: with title and edition number, br: signed by the artist *Edward Bawden* (pencil and occasionally ink)
Edition: 75, with 25 ap signed *out of series*
Pr: The artist on 1864 Albion Press at his studio, Brick House, Great Bardfield, Essex; pub: 1966 (℮a 278–86)
Coll: Cecil Higgins Art Gallery, Bedford; School of Art Collection, University of Wales, Aberystwyth (2/9)

32 St Paul's
Linocut, printed in paynes grey, black, blue-grey, grey, yellow ochre, brown and reducing medium
Image: 665 × 508 mm (26 $\frac{3}{16}$ × 20 in), paper: 867 × 683 mm

(34 $\frac{3}{16}$ × 26 $\frac{7}{8}$ in) (℮a 278)
Coll: Leeds City Art Gallery

Cecil Higgins Art Gallery also has an earlier lithograph of *St Paul's* on Royal College of Art paper.

33 The Mansion House
Linocut, printed in greeny cream grey, darker cream grey, blue, paynes grey, black
Image: 509 × 665 mm (20 $\frac{1}{16}$ × 26 $\frac{3}{16}$ in), paper: 692 × 870 mm (27 $\frac{1}{4}$ × 34 $\frac{1}{2}$ in) (℮a 279)

'A wire brush has been used for effect in the sky . . . and a knife to flick up texture for St Mary's Waldorf on the right As this is a flat design it needed variation.' (Richard Bawden, 25/3/1999 and for following quotes)

34 The Tower of London (Page 32)
Linocut, printed in opaque white, greys, ochre, black
Image: 514 × 669 mm (20 $\frac{1}{4}$ × 26 $\frac{3}{8}$ in), paper: 685 × 876 mm (27 × 34 $\frac{1}{2}$ in) (℮a 280)
Coll: Leicester City Museums

'Here my father is using the width of the roller like a paint brush in the sky area. The subtle colour arrangement includes what I call a dark umbery grey, pale grey with blue and white and a purple grey. The warm ochre appears to have been put on with a separate block.'

35 Westminster Abbey
Linocut, printed in paynes grey, black, brown, blue-grey, white and reducing medium
Image: 512 × 665 mm (20 $\frac{3}{16}$ × 26 $\frac{1}{4}$ in), paper: 684 × 876 mm (26 $\frac{15}{16}$ × 34 $\frac{1}{2}$ in) (℮a 281)

'The scratching over the Abbey entrance helps to break up the flat surface, while familiar forms like St Margaret's Church and the Abbey itself are compressed. Edward liked to take risks'

36 The Palace of Westminster
Linocut, five blocks and three separate small blocks, printed in raw umber, opaque white and raw sienna, lilac and white, charcoal grey, grey, paynes grey and blue, black
Image: 514 × 665 mm (20 $\frac{1}{4}$ × 26 $\frac{3}{16}$ in), paper: 687 × 878 mm (27 $\frac{1}{16}$ × 34 $\frac{9}{16}$ in) (℮a 282)

The Cecil Higgins Art Gallery impression is signed: *The Palace of Westminster Artists Proof 13/100* and *Edward Bawden*.

37 Guildhall
Linocut with paint remover and scratching, five blocks plus additional small blocks, printed in creamy grey, darker grey, paynes grey, blue-grey, black, red, purple grey, white
Image: 665 × 508 mm (26 $\frac{3}{16}$ × 20 in), paper: 882 × 685 mm (34 $\frac{3}{4}$ × 27 in) (℮a 283)

38 The Albert Bridge
Linocut, two main blocks plus smaller blocks for sky, printed in ochre, grey, white, purple, blue-grey with scratching
Image: 668 × 512 mm (26 5/16 × 20 3/16 in), paper: 887 × 683 mm (34 15/16 × 26 7/8 in) (ea 284)

The Cecil Higgins Art Gallery has five lino blocks for the *Albert Bridge*, as well as single blocks for *St Paul's* and *The Guildhall*.

39 The Horse Guards
Linocut with paint remover and wire brush, printed in paynes grey, black, blue-grey, creamy raw umber with white
Image: 510 × 669 mm (20 1/16 × 26 3/8 in), paper: 686 × 838 mm (27 1/4 × 33 in) (ea 285)
Coll: Leicester City Museums

40 St James's Palace
Linocut, printed in opaque grey, paynes grey, opaque pinkish and silvery grey, dirty green, deep purple, black, golden ochre
Image: 505 × 665 mm (19 7/8 × 26 3/16 in), paper: 619 × 772 mm (24 3/8 × 30 3/8 in) (ea 286)

Richard Bawden highlights the complexity behind what appears to be a simple method of printing: 'The order of printing the lino blocks: opaque grey for sky, paynes grey for the whole building, opaque pinkish and silvery grey pink printed over the paynes grey making the brickwork lighter, dirty green for base and some windows, opaque deep purple for entrance arches and sentries, black for window paines, arches and battlements; small block just for golden ochre on clock face and top of cupola.'

Richard Bawden (*b.*Black Notley, Near Braintree, 1936)

See Appendix

Harald Becker (*b.*Lingen, West Germany, 1940)

Studied painting, drawing and printmaking at Academy of Art, Berlin, 1961–6. Painting still lifes and interiors. Book on August Sander marked new interest in photographic images. Screenprint *Mann mit Geld* awarded Alecto prize at Bradford International Print Biennale, 1972. Series of paintings of men and dogs, partially based on newspapers and magazines, as well as on his studio interior in Dortmund and its landscape views.

Lit: *Alecto Monographs 6*

41 Man and German Dog, 1973
Photo-screenprint, printed in black, grey, dark brown, green brown, ochre, blue, dark and lighter pink on R. K. Burt handmade HP paper
Image: 628 × 500 mm (24 3/4 × 19 11/16 in), paper: 837 × 606 mm (32 15/16 × 23 7/8 in)
Insc bl: *40/150*, br: *H Becker 73* (pencil), br corner: ea embossed stamp
Edition: 150, 25 ap

Pr: Leslie Hosgood and Robert Jones of Megara Screenprinting Ltd, Alecto Studios, London; pub: EACC, 1973 (ea 830)
Coll: Tate; Cartwright Hall Art Gallery, Bradford

Richard Beer (*b.*London, 1928)

Slade School of Art, 1945–50. Studied at Atelier 17 and École des Beaux-Arts, Paris 1950–1. Taught etching at Regent School Polytechnic; Slade School of Art, 1958–61; and Chelsea College of Art from 1963 alongside Lewin Bassingthwaighte. Designed sets and costumes for ballet and opera. Solo shows at Arthur Jeffress Gallery, 1958–62; St George's Gallery, 1960 and Sally Hunter Fine Art, 1990–2 (all London).

OXFORD SERIES, 1964–5
Series of nine etchings of Oxford University Colleges mostly on Arches paper
Edition: 100, 10 ap
Insc bl: with title and edition number, br: signed by artist: *Richard Beer* (pencil), with ea embossed stamp (various)
Pr unless stated otherwise: Atelier Georges Leblanc, Paris. 1964–5; pub: 1964–5 (ea 80–8)
Coll: GAC

42 Worcester
Etching and aquatint, printed in green, ochre, purple, black
Plate: 423 × 580 mm (16 11/16 × 22 7/8 in) (ea 80)

43 St Johns
Etching and aquatint, printed in black, ochre and green
Plate: 578 × 423 mm (22 3/4 × 16 11/16 in), paper: 762 × 562 mm (30 × 22 1/4 in) (ea 81)

44 Brasenose
Etching and aquatint, printed in green, brown, blue-grey, black
Plate: 582 × 430 mm (22 15/16 × 16 15/16 in) (ea 82)
Coll: Arthur Andersen, London

45 Queens
Etching and aquatint, printed in black, green, yellow brown, brown
Plate: 449 × 578 mm (17 11/16 × 22 3/4 in), paper: 563 × 638 mm (22 3/16 × 25 1/4 in) (ea 83)

46 Oriel (Page 30)
Etching and aquatint, printed in cream, dark brown, green
Plate: 426 × 576 mm (16 3/8 × 22 11/16 in) (ea 84)
Coll: Leicestershire Museums, Arts and Records Service

47 Trinity
Etching and aquatint, printed in black, green, pink, ochre
Plate: 605 × 404 mm (23 13/16 × 15 15/16 in) (ea 85)

48 Magdalen*

Etching and aquatint

(ea 86)

49 Wadham*

Etching and aquatint

Pr: Douglas Allsop, Bushey Studio, Hertfordshire, 1964 (ea 87)

50 Merton

Etching and aquatint, printed in cream, green, dark and grey blue

Plate: 450 × 601 mm (17 $\frac{3}{4}$ × 23 $\frac{11}{16}$ in), paper: 580 × 725 mm

(22 $\frac{13}{16}$ × 28 $\frac{9}{16}$ in, approx.)

Pr: Alecto Studios, London, 1964 (ea 88)

View from within St Albans Quad, looking towards back of
Fellows Quad at Merton College.

51 Venetian Church, 1964

Etching and aquatint, printed in black, green, brown, cream on
Arches paper

Plate: 607 × 452 mm (23 $\frac{7}{8}$ × 17 $\frac{13}{16}$ in), paper: 723 × 533 mm

(28 $\frac{1}{2}$ × 21 in)

Insc bl: *Venetian Church 99/100*, br: *Richard Beer* (pencil)

Edition: 100, 10 ap

Pr: Atelier Georges Leblanc, Paris, 1964 (ea 89)

Coll: GAC

In conversation, Beer has described using combination of a main
copperplate and one or two steel plates for smaller colour areas
for many of the ea etchings.

52 Palazzo, 1964

Etching and aquatint, printed in pink, green, black, ochre brown
on Arches paper

Plate: 450 × 605 mm (17 $\frac{3}{4}$ × 23 $\frac{13}{16}$ in)

Insc bl: *Palazzo artists proof* and br: *Richard Beer* (pencil)

Edition: 100, 10 ap

Pr: Atelier Georges Leblanc, Paris, 1964 (ea 90)

Coll: Sheffield Galleries and Museums Trust

53 Spanish Hillside, 1964

Etching and aquatint with deep etching and burnishing, printed
in russet brown, yellow, black, green on Arches paper

Plate: 448 × 614 mm (17 $\frac{5}{8}$ × 24 $\frac{3}{16}$ in), paper: 562 × 712 mm

(22 $\frac{1}{4}$ × 28 $\frac{1}{16}$ in)

Insc bl: *Spanish Hillside 88/100*, br: *Richard Beer* (pencil)

Edition: 100, 10 ap

Pr: Atelier Georges Leblanc, Paris, 1964 (ea 91)

Lit: *Brunsdon*, ill.16

Coll: Leeds City Art Gallery

54 Red Valley, 1964

Etching and aquatint, printed in yellow brown, black, green on
Arches paper

Plate: 605 × 445 mm (23 $\frac{13}{16}$ × 17 $\frac{1}{2}$ in), paper: 760 × 560 mm

(29 $\frac{15}{16}$ × 22 $\frac{1}{16}$ in)

Insc bl: *Red Valley 73/100*, br: *Richard Beer* (pencil), br corner:
ea embossed

Edition: 100, 10 ap

Pr: Atelier Georges Leblanc, Paris; pub: 1964 (ea 92)

Coll: Leicestershire Museums, Arts and Records Service

55 Covent Garden, 1964

Etching and aquatint, printed in grey, yellow ochre and black

Plate: 600 × 450 mm (23 $\frac{5}{8}$ × 17 $\frac{3}{4}$ in), paper: 790 × 566 mm

(31 $\frac{1}{8}$ × 22 $\frac{5}{16}$ in)

Insc bl: *Covent Garden 17/100*, br: *Richard Beer* (pencil)

Edition: 100, 10 ap

Pr: Douglas Allsop, Digswell Arts Trust, Welwyn Garden City;
pub: 1964 (ea 93)

MEDITERRANEAN SUITE, 1966

Series of twelve colour etchings mostly on Arches paper

795 × 568 mm (31 $\frac{5}{16}$ × 22 $\frac{3}{8}$ in, with variation)

Edition: 100, 12 ap

Insc bl: with title and edition number, br: signed by artist: *Richard
Beer* (pencil), vo: ea stamped with publication number (various)

Pr: Atelier Georges Leblanc, Paris, unless stated otherwise; pub:
1966 (ea 254–65)

56 Noto I (Sicily)

Etching with aquatint, printed in pink and yellow brown

Image and plate: 602 × 425 mm (23 $\frac{11}{16}$ × 16 $\frac{3}{4}$ in) (ea 254)

Coll: GAC

57 Noto II (Sicily)

Etching with aquatint, printed in dark olive green and hot ochre

Image and plate: 602 × 470 mm (23 $\frac{11}{16}$ × 18 $\frac{1}{2}$ in) (ea 255)

Coll: GAC; Dudley Museum and Art Gallery

58 Noto III (Sicily)

Etching with aquatint, printed in greeny ochre, blue, green, black

Image and plate: 602 × 425 mm (23 $\frac{11}{16}$ × 16 $\frac{3}{4}$ in) (ea 256)

Coll: GAC

59 San Marco (Venice)

Etching and aquatint, printed in blue and silver

Plate: 602 × 446 mm (23 $\frac{11}{16}$ × 17 $\frac{9}{16}$ in) (ea 257)

Coll: GAC

60 Piazza Armerina I (Sicily)

Etching and aquatint, printed in yellow ochre, green and brown

Plate: 608 × 457 mm (23 $\frac{15}{16}$ × 18 in) (ea 258)

Coll: GAC

61 Piazza Armerina II (Sicily)

Etching and aquatint, printed in yellow ochre and brown

Plate: 605 × 454 mm (23 $\frac{13}{16}$ × 17 $\frac{7}{8}$ in) (ea 259)

Coll: GAC

62 Castel Sardo (Spain)*
Etching and aquatint
Plate: 610 × 393 mm (24 × 15 $\frac{1}{2}$ in)
Edition: 100, 12 ap (ℓα 260)

63 Ca D'Oro (Venice)*
Etching and aquatint
Plate: 610 × 457 mm (24 × 18 in) (ℓα 261)
Coll: GAC

64 Cadaqués (Spain)
Etching and aquatint, printed in blue and light brown
Plate: 605 × 446 mm (23 $\frac{13}{16}$ × 17 $\frac{9}{16}$ in)
Pr: Alecto Studios, London (ℓα 262)
Coll: GAC

65 Campanile
Etching and aquatint, printed in dark and light brown, yellow, green
Plate: 602 × 453 mm (23 $\frac{11}{16}$ × 17 $\frac{13}{16}$ in) (ℓα 263)
Coll: GAC

66 Quattro Canti (Palermo)
Etching and aquatint, printed in brown and yellow on B. F. K. Rives and Arches paper
Image and plate: 600 × 453 mm (23 $\frac{5}{8}$ × 17 $\frac{7}{8}$ in) (ℓα 264)
Coll: GAC

67 Siracusa (Sicily)
Etching and aquatint, printed in orange and brown
Image and paper: 603 × 403 mm (23 $\frac{3}{4}$ × 15 $\frac{7}{8}$ in) (ℓα 265)
Coll: GAC

68 All Souls, Oxford, 1966
Etching and aquatint, printed in black, grey, stone brown with touches of green on Crisbrook waterleaf 140 lb paper
Plate: 603 × 455 mm (23 $\frac{3}{4}$ × 17 $\frac{15}{16}$ in)
Insc bl: *All Souls 40/100*, br: *Richard Beer* (pencil)
Edition: 100, 12 ap
Pr: Alecto Studios, London; pub: 1966 (ℓα 375)
Coll: GAC

SECOND MEDITERRANEAN SUITE
Series of twelve colour etchings on Crisbrook waterleaf 140 lb paper
795 × 565 mm (31 $\frac{5}{16}$ × 22 $\frac{1}{4}$ in)
Insc bl: with title and edition number, br: signed *Richard Beer* (pencil), vo: variously stamped with ℓα and publication number
Edition: 100, 10 ap
Pr: Alecto Studios, London; pub 1967 (ℓα 464–75)

69 Village I (Tunisia), 1967
Etching and aquatint, printed in blue and blue-grey
Plate: 448 × 598 mm (17 $\frac{5}{8}$ × 23 $\frac{9}{16}$ in)

Pr: Harry Snook, Alecto Studios, London (ℓα 464)
Coll: GAC

70 Village II (Tunisia), 1967
Etching and aquatint, printed in orange and brown
Plate: 498 × 598 mm (19 $\frac{5}{8}$ × 23 $\frac{9}{16}$ in)
Pr: Michael Templar, Alecto Studios, London (ℓα 465)
Coll: GAC

71 Pitigliano (Southern Tuscany), 1967
Etching and aquatint, printed in blue, ochre, brown
Plate: 600 × 422 mm (23 $\frac{5}{8}$ × 16 $\frac{5}{8}$ in)
Pr: Harry Snook, Alecto Studios, London (ℓα 466)
Coll: GAC

72 Luxembourg Gardens (Paris), 1967
Etching and aquatint, printed in blue, green, grey, brown
Image and plate: 598 × 448 mm (23 $\frac{9}{16}$ × 17 $\frac{5}{8}$ in)
Pr: Michael Templar, Alecto Studios, London (ℓα 467)
Coll: GAC

73 Melk (Austria), 1967
Etching and aquatint, printed in green, ochre, dark blue
Plate: 600 × 450 mm (23 $\frac{5}{8}$ × 17 $\frac{3}{4}$ in)
Pr: Harry Snook, Alecto Studios, London (ℓα 468)
Coll: GAC

74 Vicenza, 1967*
Coloured etching and aquatint
Plate: 470 × 596 mm (18 $\frac{1}{2}$ × 23 $\frac{1}{2}$ in)
Pr: Harry Snook, Alecto Studios, London (ℓα 469)

75 Mosque I (Tunisia), 1967
Etching and aquatint, printed in brown and red
Plate: 600 × 414 mm (23 $\frac{5}{8}$ × 16 $\frac{5}{16}$ in)
Pr: Michael Templar, Alecto Studios, London (ℓα 470)
Coll: GAC; Dudley Museum and Art Gallery

76 Grand Canal (Venice), 1967
Etching and aquatint, printed in green, light pink, brown and orange
Plate: 440 × 559 mm (17 $\frac{5}{16}$ × 22 in)
Pr: Ian Lawson, Alecto Studios, London (ℓα 471)
Coll: GAC

77 Arsenale (Venice), 1967*
Colour etching and aquatint
Plate: 610 × 457 mm (24 × 18 in)
Pr: Harry Snook, Alecto Studios, London (ℓα 472)

78 Isola San Giorgio (Venice), 1967*
Colour etching and aquatint
Plate: 470 × 596 mm (18 $\frac{1}{2}$ × 23 $\frac{1}{2}$ in)
Pr: Michael Templar, Alecto Studios, London (ℓα 473)

79 Campo (Venice), 1967
Etching and aquatint, printed in green and brown
Plate: 598 × 450 mm (23 9/16 × 17 3/4 in)
Pr: Michael Templar, Alecto Studios, London (ea 474)
Coll: GAC

80 Santa Maria Della Salute (Venice), 1967*
Colour etching and aquatint
Plate: 610 × 444 mm (24 × 17 1/2 in)
Pr: Harry Snook and Michael Templar, Alecto Studios, London
(ea 475)
Coll: GAC

81 Gordes (France), 1968*
Colour etching and aquatint on Crisbrook waterleaf 140 lb paper
Plate: 560 × 430 mm (22 1/16 × 16 15/16 in, approx.)
Insc b: with title and edition number, and signed *Richard Beer*
(pencil)
Edition: 100, 10 ap
Pr: Maurice Payne and Danyon Black, Alecto Studios, London;
pub: 1968 (ea 520)

82 San Marco II, 1968*
Colour etching and aquatint on Crisbrook waterleaf 140 lb paper
Plate: 600 × 450 mm (23 5/8 × 17 3/4 in, approx.)
Insc bl: *San Marco 11 1/100* and *Richard Beer* (pencil)
Edition: 100, 10 ap
Pr: Maurice Payne and Danyon Black, Alecto Studios, London;
pub: 1968 (ea 521)
Coll: GAC

83 Santa Maria Della Formosa (Venice), 1968*
Colour etching and aquatint on Crisbrook waterleaf 140 lb paper
Plate: 600 × 450 mm (23 5/8 × 17 3/4 in, approx.)
Insc b: with title and edition number, and signed *Richard Beer*
(pencil)
Edition 100, 10 ap
Pr: Maurice Payne and Danyon Black, Alecto Studios, London;
pub: 1968 (ea 522)

84 Broadstairs, 1968*
Colour etching and aquatint on Crisbrook waterleaf 140 lb paper
Plate: 600 × 450 mm (23 5/8 × 17 3/4 in, approx.)
Insc bl: *Broadstairs 5/100* and *Richard Beer*
Edition: 100, 10 ap
Pr: Maurice Payne and Danyon Black, Alecto Studios, London;
pub: 1968 (ea 523)

85 Mercato, 1968*
Colour etching and aquatint on Crisbrook waterleaf 140 lb paper
Plate: 600 × 450 mm (23 5/8 × 17 3/4 in, approx.)
Insc bl: *Mercato 1/100* and *Richard Beer* (pencil)
Edition: 100, 10 ap

Pr: Maurice Payne and Danyon Black, Alecto Studios, London;
pub: 1968 (ea 524)

86 Port Lligat (Spain), 1968*
Etching and aquatint on Crisbrook waterleaf 140 lb paper
Plate: 600 × 450 mm (23 5/8 × 17 3/4 in, approx.)
Insc bl: *Port Liguat* (sic) *4/100* and *Richard Beer* (pencil)
Edition: 100, 10 ap
Pr: Maurice Payne and Danyon Black, Alecto Studios, London;
pub: 1968 (ea 525)
Coll: GAC

Series of six mostly Mediterranean subjects published in 1968.

TEN WREN CHURCHES, 1970
Portfolio of ten colour etchings, with screenprint, on Crisbrook
HP waterleaf 140 lb paper
Image: 605 × 405 mm (23 13/16 × 15 15/16 in), plate: 622 × 422
(24 1/2 × 16 5/8 in), paper: 767 × 545 mm (30 3/16 × 21 1/2 in), slight
variations
Accompanied by text by Sir John Betjeman
Pr: from single copperplates by James Collyer and John Crossley
and screenprinted by Lyndon Haywood, Alecto Studios, London;
presented in portfolio box made by Portfolio Multiservice Limited,
with typography by Eric Ayers
Edition: 75, 15 ap, and set of cancellation proofs
Each portfolio: numbered and signed by the author and artist on
the title sheet, with each etching titled, numbered and signed by
the artist in pencil, vo: printers' and publisher's chops; pub: 1970
(ea 664–73)
Coll: GAC; Arthur Andersen, London

87 St Dunstan in the East
Etching with aquatint, printed in black and screened in green,
light brown and cream
(ea 664)

88 St Mary le Bow
Etching with aquatint, printed in black, and screened in cream
and grey
(ea 665)

89 St Magnus the Martyr
Etching with aquatint and additional 'flak', printed in black, and
screened in cream and brown
(ea 666)

Flak and splat refer to two of the methods that Beer used to
break up aquatint texture.

90 St Lawrence, Jewry
Etching with aquatint and additional 'flak', printed in black, and
screened in grey green, pink, silver and purple
(ea 667)

91 St Bride's, Fleet Street
Etching with aquatint, printed in black, and screened in blue-grey, cream, light brown
(ea 668)

92 St Edmund the King and Martyr
Etching with aquatint, printed in black, and screened in cream, grey and blue
(ea 669)

93 St Benet, Paul's Wharf
Etching with aquatint and 'splat', printed in black and screened in cream, orange pink and blue-grey
(ea 670)

94 St Martin, Ludgate
Etching with aquatint and 'splat', printed in black and screened in cream, blue-grey, and orange pink
(ea 671)

95 St Augustine, Watling Street
Etching and aquatint, printed in black and screened in grey, purple and cream
(ea 672)

96 Christ Church, Newgate Street
Etching and aquatint, printed in black and screened in brown, cream and grey
(ea 673)

Tadek Beutlich (*b.*Lwowek, Poland, 1922)

Art student in Poznan, Poland, intending to become a painter. To England in 1947. Studied textiles at Camberwell School of Art. Second prize in Giles Bequest Competition for linocut *Fish* exhibited at V&A, 1956, encouraged focus on printmaking. Work sold through St George's Gallery, with Robert Erskine and Michael Rothenstein later making the connection with ea.. Solo shows: Grabowski Gallery, London 1963, 1967, 1968–9, the latter showing tapestries, hangings and prints; and more recently Hove Museum and Art Gallery, 1997. Author of: *The Technique of Woven Tapestry*, London, B. T. Batsford Ltd, 1967.

97 The Lake, 1963–4
Relief print (hardboard, lino, plywood, cross-cuts) printed in dirty yellow, green, brown and black on handmade Hosho no 150 paper
Image: 855 × 588 mm ($33\frac{11}{16} \times 23\frac{3}{16}$ in), paper: 990 × 680 mm ($39 \times 26\frac{3}{4}$ in)
Insc bl: *Artist Proof*, bc:"*Lake*", br: *Tadek Beutlich* (pencil)
Edition: 50, proofs
Hand-printed: The artist, Bromley studio, 1963–4; pub: 1964
(ea 175)

'I first began to exhibit with Robert Erskine. Later Editions Alecto commissioned some prints, and sold a lot. At the time, I was making more money out of prints than my textiles, and my printmaking was very much linked to ea' (TB, 27/3/1999)

98 The Earth, 1963–4
Relief print (hardboard, lino, plywood, cross-cuts), printed in orange, red, black and yellow on handmade Hosho no 150 paper
Image: 585 × 880 mm ($23\frac{1}{16} \times 34\frac{11}{16}$ in), paper: 680 × 980 mm ($26\frac{3}{4} \times 38\frac{9}{16}$ in)
Insc bl: *16/50*, bc: '*Earth'*/ *Tadek Beutlich* (pencil)
Edition: 50, proofs
Hand-printed: The artist, Bromley studio, 1963–4; pub: 1964
(ea 176)
Coll: Towner Art Gallery, Eastbourne

99 Burning Desert, 1964*
Colour relief print on handmade Hosho no 150 paper
Image: 634 × 876 mm ($24\frac{31}{32} \times 34\frac{1}{2}$ in)
Hand-printed: The artist, Bromley studio; pub: 1964 (ea 177)

100 Two Islands Meet, 1964
Relief print (lino and plywood) printed in dark purple, green, black, blue, white, purple on handmade Hosho no 150 paper
Image: 905 × 585 mm ($35\frac{5}{8} \times 23\frac{1}{16}$ in), paper: 972 × 674 mm ($38\frac{1}{4} \times 26\frac{9}{16}$ in)
Insc bl: *Artist Proof*, bc: "*Two Islands Meet*", br: *Tadek Beutlich* (pencil)
Edition: 50, proofs
Hand-printed: The artist, Bromley studio; pub: 1964 (ea 178)
Coll: Dudley Museum and Art Gallery

The related tapestry measures 6 × 6 feet, and is woven in orange, red and purple on deep green background. (*The Technique of Woven Tapestry*, ill.44)

101 River, 1964
Relief print (hardboard, weathered pieces of wood and lino) printed in blue, green, turquoise, brown and dark navy blue on handmade Hosho no 150 paper
Image: 727 × 598 mm ($28\frac{5}{8} \times 23\frac{9}{16}$ in), 983 × 673 mm ($38\frac{11}{16} \times 26\frac{1}{2}$ in)
Edition: 75, proofs
Hand-printed: The artist, Bromley studio; pub: 1964 (ea 179)
Coll: Financial Times, London

'I remember this print being sold to a number of doctors in America – for hanging in waiting rooms.' (TB)

102 Fritillary (Growth II), 1964
Relief print (hardboard, plywood and cross-cuts), printed in blue, brown, red, orange, green on handmade Hosho no 150 paper
Image: 877 × 648 mm ($34\frac{9}{16} \times 25\frac{1}{2}$ in), paper: 969 × 670 mm ($38\frac{3}{16} \times 26\frac{3}{8}$ in)

Insc bl: *Artist Proof*, bc:"*Growth 11*", br: *Tadek Beutlich* (pencil)
Edition: 50, proofs
Hand-printed: The artist, Bromley studio; pub: 1964 (℮a 180)
Lit: Michael Rothenstein, *Relief Printing*, Studio Vista, 1970
(ill.p.111)
Coll: Financial Times

'You will find in my prints two main ingredients: odd bits of wood
and cuts, two inch slices, across the grain from a tree trunk in the
garden in Bromley I couldn't afford an Albion Press, so I
rolled ink on bits of wood. Initially I printed with a spoon on the
back of the paper . . . and then I invented a little box, with stones
to weigh it down, and a roller which I worked up and down. An
unorthodox method, really a little press. I needed something to
press on the paper and the box was quite heavy and stable
Here there is the butterfly association.' (TB) The edition is
inscribed/ titled: *Fritillary*.

103 Red River, 1964
Relief print (hardboard, lino and weathered wood) printed in red,
orange, yellow, brown, black, darker red on handmade Hosho no
150 paper
Image: 780 × 588 mm (30 $\frac{3}{4}$ × 23 $\frac{3}{16}$ in), paper: 965 × 670 mm
(38 × 26 $\frac{3}{8}$ in)
Insc bl: *Artist Proof*, bc: "*Red River*", br: *Tadek Beutlich* (pencil)
Edition: 75, proofs
Hand-printed: The artist, Bromley studio; pub: 1964 (℮a 181)

104 Heatwave in Antarctic, 1964
Relief print (lino, weathered plankwood, plywood and cross-
cuts), printed in orange, yellow, red, black, brown and dark red
on handmade Hosho no 150 paper
Image: 823 × 597 mm (32 $\frac{7}{16}$ × 23 $\frac{1}{2}$ in), paper: 990 × 682 mm
(39 × 26 $\frac{7}{8}$ in)
Insc bl: *39/75*, bc:"*Heatwave in Antarctic*", br: *Tadek Beutlich*
(pencil)
Edition: 75, proofs
Hand-printed: The artist, Bromley studio; pub: 1964 (℮a 182)
Coll: Financial Times

105 Magic Pool, 1964 (Page 69)
Relief print (weathered plankwood and lino), printed in green,
blue, brown, purple on handmade Hosho no 150 paper
Image: 850 × 565 mm (33 $\frac{1}{2}$ × 22 $\frac{1}{4}$ in), paper: 876 × 610 mm
(34 $\frac{1}{2}$ × 24 in)
Insc b: *32/75 "Magic Pool" Tadek Beutlich* (pencil)
Edition: 75, proofs
Hand-printed: The artist, Bromley studio; pub: 1964 (℮a 183)
Coll: GAC; Dudley Museum and Art Gallery

106 Sunset II, 1964
Relief print (lino, plywood with multiple tool, and cross-cuts),
printed in red, black, russet brown and orange on handmade
Hosho no 150 paper
Image: 585 × 878 mm (23 $\frac{1}{16}$ × 34 $\frac{9}{16}$ in), paper: 678 × 993 mm

(26 $\frac{11}{16}$ × 39 $\frac{1}{8}$ in)
Insc bl: *30/75*, bc: *Sunset 11, Tadek Beutlich* (pencil)
Edition: 75, proofs
Hand-printed: The artist, Bromley studio; pub: 1964 (℮a 184)
Coll: New York Public Library; GAC

107 Dyad, 1967*
Colour relief print
Image: 625 × 770 mm (24 $\frac{5}{8}$ × 30 $\frac{5}{16}$ in, approx.)
Edition: 75, proofs
Exh: *Grabowski*, 1967 (12)
Hand-printed: The artist, Bromley studio; pub: 1967 (℮a 401)

108 Embryo, 1967*
Colour relief print
Image: 875 × 585 mm (34 $\frac{7}{16}$ × 23 $\frac{1}{16}$ in, approx.)
Edition: 75, proofs
Exh: *Grabowski*, 1967 (9)
Hand-printed: The artist, Bromley studio; pub: 1967 (℮a 402)

109 Eye, 1967
Relief print (hardboard, cross-cut, filler paste on plywood),
printed in turquoise, green, brown, orange and stronger orange
on handmade Hosho no 150 paper
Image: 607 × 904 mm (23 $\frac{15}{16}$ × 35 $\frac{5}{8}$ in), paper: 670 × 970 mm
(26 $\frac{3}{8}$ × 38 $\frac{3}{16}$ in)
Edition: 75, proofs
Hand-printed: The artist, Bromley studio; pub: 1967 (℮a 403)
Exh: *Grabowski*, 1967 (10)

110 Idol, 1967
Relief print (lino, cross-cuts and plywood), printed in black,
brown, orange, russet red, red and blue on handmade Hosho no
150 paper
Image: 780 × 610 mm (30 $\frac{3}{4}$ × 24 in), paper: 937 × 659 mm
(36 $\frac{7}{8}$ × 25 $\frac{15}{16}$ in)
Insc bl: *2/75*, bc: "*Idol*", *Tadek Beutlich* (pencil)
Edition: 75, proofs
Hand-printed: The artist, Bromley studio; pub: 1967 (℮a 404)
Exh: *Grabowski*, 1967 (11)
Coll: GAC

'Always have difficulty naming my things, I just do it. I come up
with a title when I exhibit, or when someone is buying
Sometimes I look up in the dictionary' (TB)

111 Purple Coral, 1967
Relief print (hardboard and filler) printed in red, purple, black on
handmade Hosho no 150 paper
Image: 823 × 597 mm (32 $\frac{7}{16}$ × 23 $\frac{1}{2}$ in), paper: 990 × 682 mm
(39 × 26 $\frac{7}{8}$ in)
Insc bl: *5/75*, bc: *Purple Coral*, br: *Tadek Beutlich* (pencil)
Edition: 75, proofs
Hand-printed: The artist, Bromley studio; pub: 1967 (℮a 405)
Exh: *Grabowski*, 1967 (8)

112 Landscape III, 1967*
Colour relief print
Image: 610 × 870 mm (24 × 34 $\frac{1}{4}$ in, approx.)
Edition: 75, proofs
Exh: *Grabowski*, 1967 (3)
Hand-printed: The artist, Bromley studio; pub: 1967 (℮ 406)

113 Meteors, 1967
Relief print (plankwood and hardboard), printed in dark brown, paler brown, dark red, red, yellow, black on handmade Hosho no 150 paper
Image: 884 × 623 mm (34 $\frac{13}{16}$ × 24 $\frac{17}{32}$ in), paper: 989 × 682 mm (38 $\frac{15}{16}$ × 26 $\frac{7}{8}$ in)
Insc bl: *48/75*, bc: *"Meteors"*, br: *Tadek Beutlich* (pencil)
Edition: 75, proofs
Hand-printed: The artist, Bromley studio; pub: 1967 (℮ 407)
Exh: *Grabowski*, 1967 (2)
Coll: GAC

114 Moth, 1967*
Colour relief print (woodcut and lino) on handmade Hosho no 150 paper
Image: 780 × 616 mm (30 $\frac{3}{4}$ × 24 $\frac{1}{4}$ in), paper: 994 × 685 mm (39 $\frac{1}{4}$ × 27 in, approx.)
Edition: 75, proofs
Hand-printed: The artist, Bromley studio; pub: 1967 (℮ 408)
Exh: *Grabowski*, 1967 (5)

Moth 2, printed in dark red, red and three browns, is closely related to this image.

115 River III, 1967
Relief print (woodcut and linocut), printed in brown, black, orange, russet red, blue and red on handmade Hosho no 150 paper
Image: 840 × 620 mm (33 $\frac{1}{16}$ × 24 $\frac{7}{16}$ in)
Insc bl: *4/75*, bc: *River 111*, br: *Tadek Beutlich* (pencil)
Edition: 75, proofs
Hand-printed: The artist, Bromley studio; pub: 1967 (℮ 409)
Exh: *Grabowski*, 1967 (7)
Coll: GAC

116 Seeds, 1967
Relief print (lino, hardboard, wood and filler), printed in black, two reds, orange, ochre on handmade Hosho no 150 paper
Image: 585 × 882 mm (23 $\frac{1}{16}$ × 34 $\frac{3}{4}$ in), paper: 682 × 990 mm (26 $\frac{7}{8}$ × 39 in)
Edition: 75, proofs
Hand-printed: The artist, Bromley studio; pub: 1967 (℮ 410)
Exh: *Grabowski*, 1967 (4)

117 Twin Constellation, 1967
Relief print (lino and plywood), printed in red, darker red, brown, black, yellow on handmade Hosho no 150 paper
Image: 880 × 590 mm (34 $\frac{21}{32}$ × 23 $\frac{1}{4}$ in), paper: 972 × 676 mm (38 $\frac{1}{4}$ × 26 $\frac{5}{8}$ in)

Insc bl: *40/75*, bc: *"Twin Constellation"*, br: *Tadek Beutlich* (pencil)
Edition: 75, proofs
Hand-printed: The artist, Bromley studio; pub: 1967 (℮ 411)
Exh: *Grabowski*, 1967 (6)

The related cotton warp rug of light and dark reds is illustrated in *The Technique of Woven Tapestry* (ill.83)

'A sheet of Japanese paper cost half a crown from T. N. Lawrence in London. The size of the paper in fact influenced my prints as I didn't want to lose the edges. I like to see the edge that surrounds a piece of paper.' (TB)

118 Sea Shore, 1967*
Colour relief print
Image: 820 × 520 mm (32 $\frac{5}{16}$ × 20 $\frac{1}{2}$ in, approx.)
Edition: 75, proofs
Exh: *Grabowski*, 1967 (1)
Hand-printed: The artist, Bromley studio; pub: 1967 (℮ 412)
Coll: GAC

119. Radiation II, 1970
Relief print (Lycra and lino) printed in chrome yellow, orange, red, dark red, black on handmade Hosho no 150 paper
Image: 900 × 608 mm (35 $\frac{7}{16}$ × 23 $\frac{15}{16}$ in), paper: 975 × 675 mm (38 $\frac{3}{8}$ × 26 $\frac{9}{16}$ in)
Insc bl: *Artist proof*, bc: *"Radiation 11"*, br: *Tadek Beutlich* (pencil)
Edition: 75, proofs
Hand-printed: The artist, Gospels studio, Ditchling, Sussex; pub: 1970 (℮ 692)

'After moving to Ditchling in late 1967, I began to work in a different material. Foam rubber was easier to print as it was softer. I also began to use Lycra for texture I approached printmaking by exploring different materials. This gives me the ideas. I couldn't work without materials.' (TB)

120 Waves II, 1970
Relief print (Lycra and lino) printed in layers of blue from pale to dark with black on top on handmade Hosho no 150 paper
Image: 795 × 542 mm (31 $\frac{5}{16}$ × 21 $\frac{3}{8}$ in), paper: 982 × 675 mm (38 $\frac{11}{16}$ × 26 $\frac{5}{8}$ in)
Insc bl: *Artist Proof*, bc: *"Waves 11"*, br: *Tadek Beutlich* (pencil)
Edition: 75, proofs
Hand-printed: The artist, Gospels studio, Ditchling; pub: 1970 (℮ 693)

121 Bios, 1973–4
Relief print (Lycra and lino), printed in layers of red and black with yellow on handmade Hosho no 150 paper
Image and paper: 979 × 682 mm (38 $\frac{9}{16}$ × 26 $\frac{7}{8}$ in)
Insc bl: *Artist Proof*, bc: *"Bios"*, br: *Tadek Beutlich* (pencil)
Edition: 75, proofs
Hand-printed: The artist, Gospels studio, Ditchling, 1973–4;

pub: EACC, 1974 (*ea* 852)
Coll: GAC

122 Pollination I, 1973–4
Relief print (Lycra and lino), printed in layers of green and black on handmade Hosho no 150 paper
Image: 958 × 585 mm (37 $\frac{3}{4}$ × 23 $\frac{1}{16}$ in), paper: 976 × 678 mm (38 $\frac{7}{16}$ × 26 $\frac{11}{16}$ in)
Insc bl: *4/75*, bc: *Pollination 1*, br: *Tadek Beutlich* (pencil)
Edition: 75, approx. 10 ap
Hand-printed: The artist, Gospels studio, Ditchling, 1973–4; pub: EACC, 1974 (*ea* 853)
Coll: GAC

123 Pollination II, 1973–4
Relief print (Lycra and lino), printed in layers of brown and black with red on handmade Hosho no 150 paper
Image: 795 × 585 mm (31 $\frac{5}{16}$ × 23 $\frac{1}{16}$ in), paper: 976 × 678 mm (38 $\frac{7}{16}$ × 26 $\frac{13}{16}$ in)
Insc bl: *Artist Proof*, bc: *"Pollination" 11*, br: *Tadek Beutlich* (pencil)
Edition: 75, proofs
Hand-printed: The artist, Gospels studio, Ditchling, 1973–4; pub: EACC, 1974 (*ea* 854)
Coll: GAC

André Bicât (*b.*Essex, 1909–96)

No formal art training. Designed textiles, theatre sets and costumes in 1930s, including Mercury Theatre, London productions. Solo exhibitions: Leicester Galleries, London 1949–70. Inspired to etch by close friend Gabriel White. Lecturer in etching at RCA, 1966–74. Retrospective exhibition: Reading Museum and Art Gallery, 1966 and also *André Bicât: Ten Years of Printmaking*, 1970. Lived at Crays Pond House, near Goring-on-Thames, where converted a barn as studio.

TUSCAN SUITE, 1965–6
Ten colour etchings of Tuscany on Crisbrook waterleaf 140 lb paper
Edition: 100, 10 ap, 2 pp
Proofed by the artist and variously printed by Michael Rand, Danyon Black and Trevor Allen at Alecto Studios, London, 1965; pub: 1966 (*ea* 194–203)

Based upon sketches made on annual visits to France and Italy. Bicât's favourite subjects included Dieppe and the area around Volterra in Tuscany.

124 Terraces, 1966
Etching and aquatint, printed in orange, white, green, black
Plate: 338 × 454 mm (13 $\frac{5}{16}$ × 17 $\frac{7}{8}$ in), paper: 482 × 572 mm (19 × 22 $\frac{17}{32}$ in, with variation)
Insc bl: *93/100*, br: *Bicât* (pencil) (*ea* 194)
Coll: GAC

Artist's proofs include a pink evening sky, printed on various

papers such as handmade Whatman, T. H. Saunders and Hayle Mill, but abandoned in the final edition.

125 Olives, 1966
Etching and aquatint, printed in green, ochre, dark brown
Plate: 339 × 452 mm (13 $\frac{3}{8}$ × 17 $\frac{13}{16}$ in), paper: 505 × 570 mm (19 $\frac{7}{8}$ × 22 $\frac{7}{16}$ in)
Insc bl: *A/P*, bc: *Olives* and br: *Bicât* (pencil) (*ea* 195)

A monochrome ap with the artist's estate is entitled *Olive Trees*.

126 Siena
Etching and aquatint, printed in red, black, brown, blue green
Plate: 339 × 450 mm (13 $\frac{3}{8}$ × 17 $\frac{3}{4}$ in), paper: 487 × 594 mm (19 $\frac{1}{4}$ × 23 $\frac{3}{8}$ in)
Insc bl: *Master*, br: *AP* (pencil) (*ea* 196)

An initial sketch for this scene appears in a sketchbook dated 1961 (artist's estate).

127 Tuscan Church, 1966
Etching and aquatint, printed in black, white, aquamarine
Plate: 336 × 450 mm (13 $\frac{1}{4}$ × 17 $\frac{3}{4}$ in), paper: 470 × 573 mm (18 $\frac{1}{2}$ × 22 $\frac{9}{16}$ in, cut edges)
Insc bl: *36/100*, br: *Bicât* (pencil) (*ea* 197)
Coll: GAC

128 Near Asciano, 1966
Etching and aquatint, printed in ochre brown, sea green, black, white
Plate: 338 × 450 mm (13 $\frac{3}{8}$ × 17 $\frac{3}{4}$ in), paper: 500 × 596 mm (19 $\frac{11}{16}$ × 23 $\frac{1}{2}$ in)
Insc bc: *Master/ Near Asciano*, br: *A/P* (pencil) (*ea* 198)

129 Tuscan Farm, 1966
Etching and aquatint, printed in lemon yellow and green
Plate: 340 × 455 mm (13 $\frac{3}{8}$ × 17 $\frac{15}{16}$ in), paper: 506 × 588 mm (19 $\frac{15}{16}$ × 23 $\frac{5}{32}$ in)
Insc bl: *Master/Bicât*, bc: *Tuscan Farm 111*, br: *A/P* (*ea* 199)

Bicât produced a series of views of the same Tuscan Farm.

130 Road to Asciano, 1966 (Page 74)
Etching and aquatint, printed in cream brown, dark brown, green
Plate: 340 × 453 mm (13 $\frac{3}{8}$ × 17 $\frac{27}{32}$ in), paper: 511 × 572 mm (20 $\frac{1}{4}$ × 22 $\frac{1}{2}$ in)
Insc bl: *A/P*, br: *Bicât* (pencil) (*ea* 200)

Also known as *Near Volterra II*.

131 Vineyards, 1966
Etching and aquatint, printed in dark and lighter brown
Plate: 335 × 452 mm (13 $\frac{3}{8}$ × 17 $\frac{13}{16}$ in), paper: 508 × 567 mm (20 × 22 $\frac{5}{16}$ in)
Insc bl: *34/100*, br: *Bicât* (pencil), vo: *ea No 201* stamped (*ea* 201)
Coll: GAC

132 Monticiano, 1966

Etching and aquatint, printed in olive green, pinkish brown, black
Plate: 338 × 448 mm (13$\frac{5}{16}$ × 17$\frac{5}{8}$ in), paper: 500 × 615 mm (19$\frac{11}{16}$ × 24$\frac{1}{4}$ in)
Insc br: *A/P Monticiano* (pencil) (*ea* 202)

133 Tuscan Landscape, 1966

Etching, printed in red and yellow green
Plate: 338 × 453 mm (13$\frac{5}{16}$ × 17$\frac{27}{32}$ in), paper: 501 × 562 mm (19$\frac{3}{4}$ × 22$\frac{1}{4}$ in)
Insc bl: *10/100*, br: *Bicât* and br corner: *Tuscan Landscape* (pencil) (*ea* 203)
Coll: GAC

A portfolio entitled *Rhythms* was realised in 1965, but never finally published by *ea*.. The project was nevertheless taken to edition stage: seven etchings and aquatints in monochrome; signed, titled and editioned in edition of twenty-five on handmade Crisbrook paper measuring 740 × 567 mm (29$\frac{1}{8}$ × 22$\frac{5}{16}$ in). A prototype black slipcase and red folder was produced, inscribed along the spine: *BICÂT RHYTHMS 1965*.
These impressive abstract images are entitled: *Percussion*, *Night Meeting*, *Orchestration*, *Armoured Head*, *Shadows*, *Head Form 2*, *Trio*. *Head Form 1* seems to have been abandoned from this series.
Coll: Tate

See Appendix

Derek Boshier (*b.*Portsmouth, 1937)

Yeovil School of Art 1954–7, specialising in painting and lithography; RCA, 1959–62. First solo exhibition *Image in Revolt*, Grabowski Gallery, 1962; also Robert Fraser Gallery, 1968 (both London). Turned to sculpture in 1966. Worked in various media including film and photography during 1970s. Lithographs published by Edizioni O, 1970. *Circle*, a film produced with Mathews, Miller and Dunbar, 1971. Returned to painting in 1979, and took up a teaching post at University of Houston, 1980.

134 Output, 1966 (Page 113)

Screenprint and stencil cut-outs, six printings, printed in pink, green, blue, purple, russet, red on two sheets of J. Green paper
Image: 465 × 817 mm (18$\frac{5}{16}$ × 32$\frac{3}{16}$ in), paper: 630 × 971 mm (24$\frac{13}{16}$ × 38$\frac{1}{4}$ in)
Insc br: *Artists Proof Derek Boshier 1966* (pencil), vo: *K6636*
Edition: 75, 20 ap
Pr: Kelpra Studio, London (invoice 30/7/1966); pub: 1966 (*ea* 374)
Coll: Tate; British Council; Manchester City Art Galleries; Art Gallery of Ontario, Toronto; New Orleans Museum of Art; Fitzwilliam Museum, Cambridge

'The prints I produced nearly always related to something I was doing at the time. *Output* was based around the shaped canvases I started in 1964 and which explored the idea of illusion. The title sounds like an industrial name . . . and I remember Chris Prater using a dye cutter to punch out the shapes.' (DB, 29/12/1999)

135 Plan I, 1972 (Page 228)

Off-set lithograph, printed in red, black, cream on commercial cartridge paper
Image and paper: 547 × 800 mm (21$\frac{9}{16}$ × 31$\frac{1}{2}$ in)
Insc bl: *AP Plan 1*, br: *Derek Boshier 1972* (pencil)
Edition: 100, 10 ap
Pr: RCA?; pub: AI, 1972 (*ea* 817)
Lit: *A Decade of Printmaking*, p.43 (ill.)
Coll: Tate; MOMA; Cartwright Hall Art Gallery, Bradford

136 Plan II, 1972 (Page 229)

Off-set lithograph, printed in red, black, cream on commercial cartridge paper
Image and paper: 546 × 800 mm (21$\frac{1}{2}$ × 31$\frac{1}{2}$ in)
Insc bl: *A P Plan 11*, br: *Derek Boshier 1972* (pencil)
Edition: 100, 10 ap
Pr: RCA?; pub: AI, 1972 (*ea* 818)
Coll: Tate; MOMA

These two prints draw upon Derek Boshier's interest in architecture and the idea of different representations of the same object or image. They were made at the same period as *Six Cities*, a series of postcards which experimented with the ground plan of six famous cities. Here the photographs derive from various trade and engineering magazines and divide into aerial views of urban and landscape sites paralleled by their abstracted shape.

137 Dome and Base, 1969

Black perspex stepped base, with transparent blue dome and tungsten light
Base: 335 × 335 cms, h: 150 mm (13$\frac{3}{16}$ × 13$\frac{3}{16}$ × 5$\frac{15}{16}$ in)
Edition: 75 declared, under 20 made
Pub: AI, 1969
Lit: *A Decade of Printmaking*, 1973, p.96 (ill.)

This multiple is related to the *Dome* sculptures that Derek Boshier exhibited at the Robert Fraser Gallery, 1968, and the film *Link* begun in the same year and containing a section on domes. It explores the essential forms that determine architecture, namely the pyramid, the circle and the square.

138 Poster Poem: Manifesto, 1969 (Page 161)

Collaboration with Christopher Logue
Colour off-set lithograph
Image and paper: 1012 × 640 mm (39$\frac{7}{8}$ × 25$\frac{3}{16}$ in)
Edition: 50
Pub: 1969; distributed by Stone's Posters (Bernard Stone, Turret Books) from August 1969
Lit: *Independent on Sunday* magazine, 4 May 1997; George Ramsden, *Christopher Logue A Bibliography 1952–97*, Stone Trough Books, 1997 (D22, ill. with full text)

The poem begins: ! Manifesto !/ Whereas in former times/ Poems were written for print/ We declare/ The book has exploded/ The ancient way is the new way./ The poet's shop is in his throat./ His factory his body./ His packaging department is his mind./ His customers all those who feel the cold./ A book is no more than a storage-unit for poems./ Poets give publishers their meaning./ . . .

139 Flikker Book No. 9, 1972 (Page 225)
Lithography, photo, off-set, printed in black
Image and paper: 75 × 93 mm (2 $\frac{31}{32}$ × 3 $\frac{11}{16}$ in, slanted edge)
Front text: *FLIKKER book/ Derek Boshier*
Pr: Hillingdon Press, Uxbridge; pub: AI, 1972

'Joe Studholme generated the idea of the flikker book. He was always interested in the technology that surrounded a project. I had used a similar image in the film *Circle.*. From being interested in architecture formally, I began to use architecture in a non-formal way . . . instead of moving from left to right it seems to move from the right edge into the interior of the building' (DB)

John Brunsdon (*b.*Cheltenham, 1933)

Cheltenham College of Art, 1949–53 and RCA, 1955–8. First solo show: *Mammoth Etchings*, New Vision Centre, London, 1962. *Britische Graphische Scene*, Zürich, 1963 organised by Editions Alecto, and various national and international print shows during the 1960s and 1970s. Author of: *The Technique of Etching and Engraving*, London, Batsford, 1965. Graphics pub: Christie's Contemporary Art, London.

140 Studio Panoramic, 1961–4
Etching and aquatint, steel plate, printed in cobalt and black (oil, wiped); vandyke brown, dark blue and crimson red; vandyke brown, red and yellow; and dark blue (all watercolour, rolled on) on Crisbrook waterleaf 140 lb paper
Plate: 452 × 600 mm (17 $\frac{13}{16}$ × 23 $\frac{5}{8}$ in), paper: 528 × 663 mm (20 $\frac{13}{16}$ × 26 $\frac{1}{8}$ in)
Insc bl: *Panoramic (Studio Interior)*, bc: *Artist Proof 4*, br: *John Brunsdon* (pencil)
Edition: 50, 5 ap
Etched by the artist, St Albans College, May 1961; pr: The artist on seven foot flat-bed etching press, Digswell Arts Trust, Welwyn Garden City, Hertfordshire 1963–4; pub: 1963 (ea 185)
Coll: GAC; Dudley Museum and Art Gallery

On Julian Trevelyan's advice, John Brunsdon joined the Digswell Arts Trust after finishing at RCA, 1958. This artists' colony was based in a Regency Mansion House in the village of Digswell, just outside Welwyn Garden City. There Brunsdon set up the first print studio with John Sturgess. He left in 1962, though returned to edition his prints, including those published by ea. This image is titled *Studio Panoramic* in the ea Register

141 Landscape II, 1962–4
Etching and aquatint, steel plate, oil-based colours in 'basically two colours' – prussian blue and black; and ultramarine, raw sienna and white (wiped and butted up to each other) on Crisbrook waterleaf 140 lb paper
Plate: 458 × 603 mm (18 $\frac{1}{16}$ × 23 $\frac{3}{4}$ in), paper: 571 × 795 mm (22 $\frac{1}{2}$ × 31 $\frac{5}{16}$ in)
Insc bl: *Landscape II 24/50*, br: *John R Brunsdon* (pencil)
Edition: 50, 5 ap
Proofed and pr: The artist, Digswell Arts Trust, 1963–4; pub: 1963 (ea 186)

'Abstracted view of St Albans from St Peter's Church, looking out and down onto the surrounding landscape with its big slabs of roads and black sky.' Brunsdon's entry book records that the composition dates initially from February 1962, with batches of printing taking place throughout 1963 into March 1964.

142 Studio Rhythms, 1962–4
Etching and aquatint with wiping, steel plate, printed in prussian blue and black (oil, wiped); red with yellow and umber white and dark blue (watercolour, rolled on) on Crisbrook waterleaf 140 lb paper
Plate: 458 × 683 mm (18 $\frac{1}{16}$ × 26 $\frac{7}{8}$ mm), paper: 555 × 754 mm (21 $\frac{7}{8}$ × 29 $\frac{11}{16}$ in)
Insc bl: *Studio Rhythms 37/50*, br: *John R Brunsdon* (pencil)
Edition: 50, 5 ap
Proofed and pr: The artist, Digswell Arts Trust, 1962–4; pub: 1963 (ea 187)
Lit: *Brunsdon* (ill.21)
Coll: Dudley Museum and Art Gallery

Arrangement of shapes based upon the press at Digswell, 'the arc is the end of the wheel, there's the press itself, the white bit is the sink The nice thing with steel is that you can use (wiped) white areas as a colour. The orange and blue watercolour was rolled on with a soft roller. I wanted these colours to sit up from the oil-based ink' (JB)

143 Welsh Valley II, 1964 (Page 41)
Etching and aquatint with stencil, steel plate, printed in veridian and black (oil, wiped); crimson, black and white; red, yellow, crimson and raw umber (watercolour, rolled on) on Crisbrook waterleaf 140 lb paper
Plate: 602 × 455 mm (23 $\frac{23}{32}$ × 17 $\frac{15}{16}$ in), paper: 758 × 570 mm (29 $\frac{7}{8}$ × 22 $\frac{7}{16}$ in)
Insc bl: *Welsh Valley II*, bc: *14/50*, br: *John R Brunsdon* (pencil)
Edition: 50, 5 ap
Proofed and pr: The artist, Digswell Arts Trust, 1964; pub: 1964 (ea 188)
Coll: GAC

The two *Welsh Valley* scenes are drawn from the memory of driving down a mountainside in Wales where 'the roads seemed to go into space'. (JB)

→ *p.85*

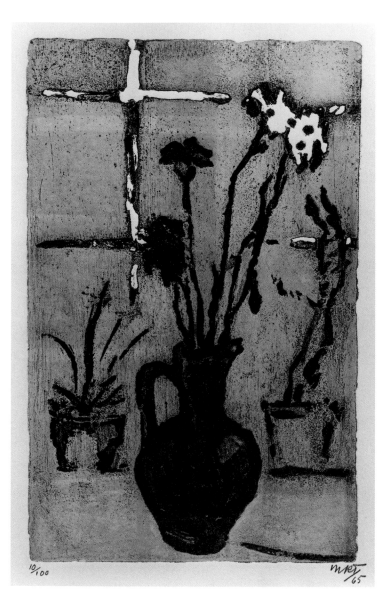

10/100 MKF
 65

Plate 43 Margaret Kroch-Frishman, *Orchid*, 1965 (379)

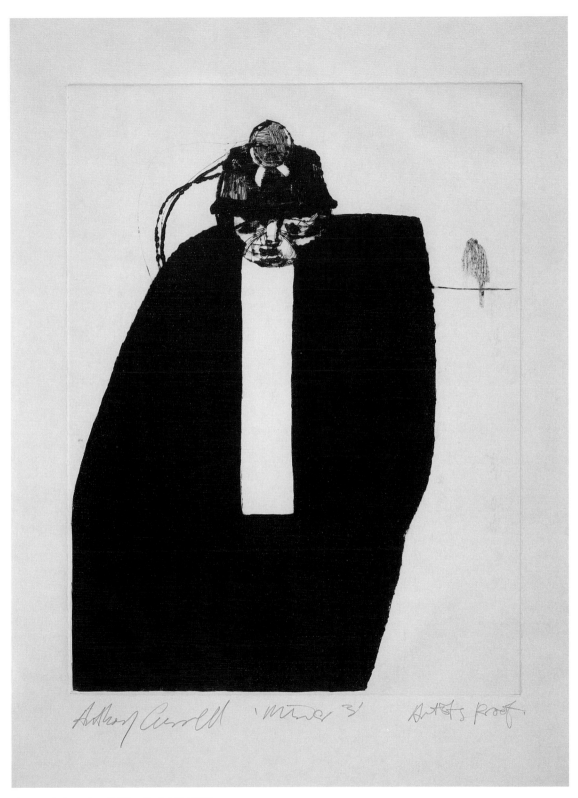

Plate 44 Anthony Currell, *Miner No 3*, 1964 (237)

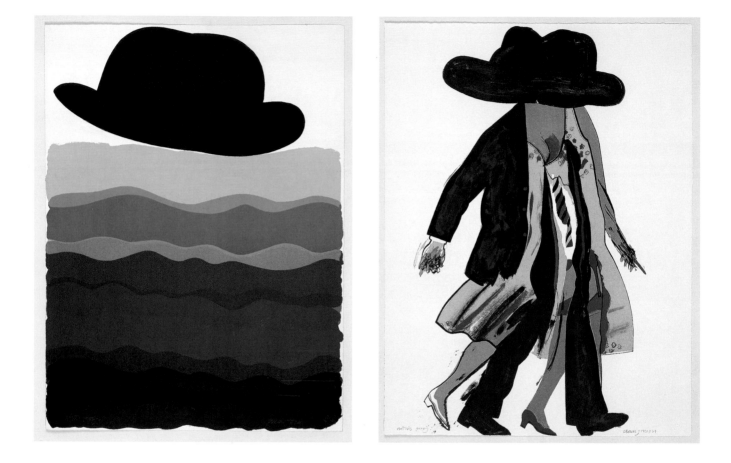

Plates 45, 46 Allen Jones, *Concerning Marriages* (*Bowler Hat* and *Walking*), 1964 (500, 504)

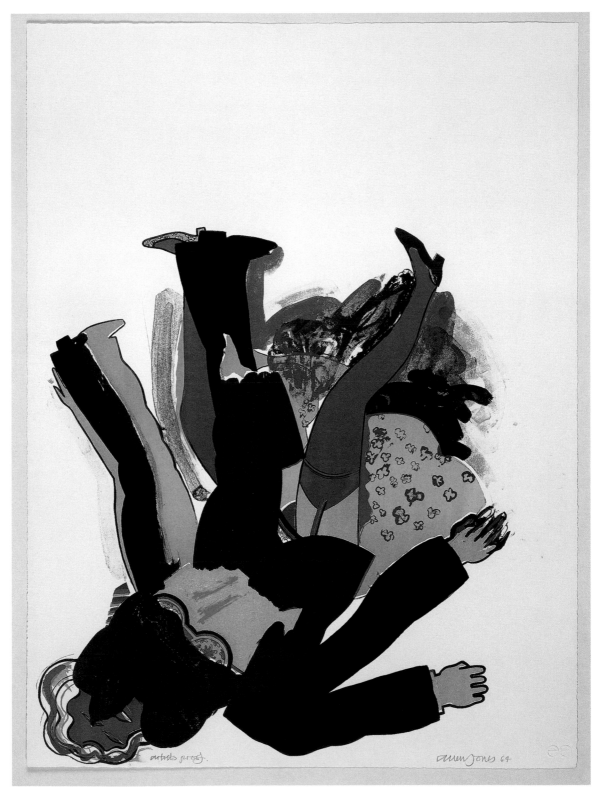

artist's proof. Allen Jones 64

Plate 47 Allen Jones, *Concerning Marriages* (*Falling*), 1964 (506)

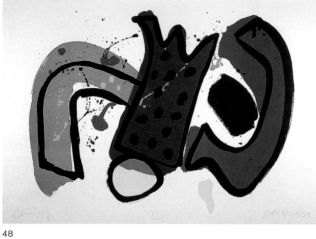

48

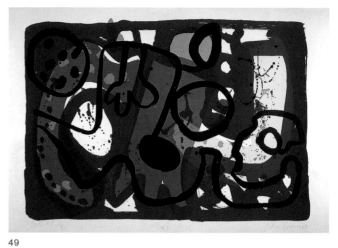

49

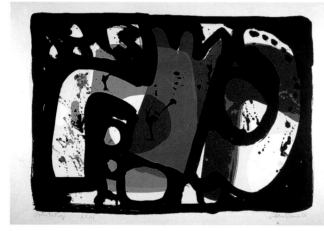

50

51

Plates 48–51 Alan Davie, *Zurich Improvisations I, XI, XXIII, XXXIV*, 1965 (243, 253, 265, 276)

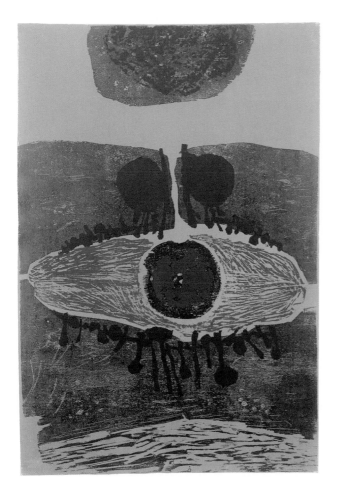

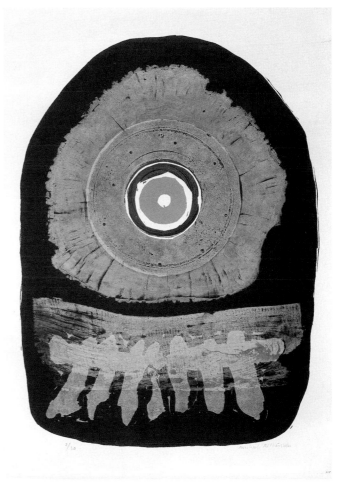

Plate 52 Tadek Beutlich, *Magic Pool*, 1964 (105)

Plate 53 Michael Rothenstein, *Black, Blue and White*, 1965–6 (980)

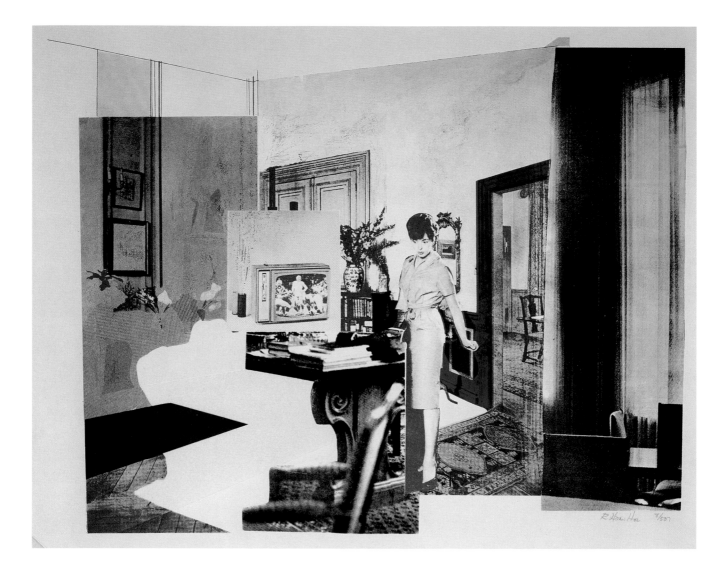

Plate 54 Richard Hamilton, *Interior*, 1965 (410)

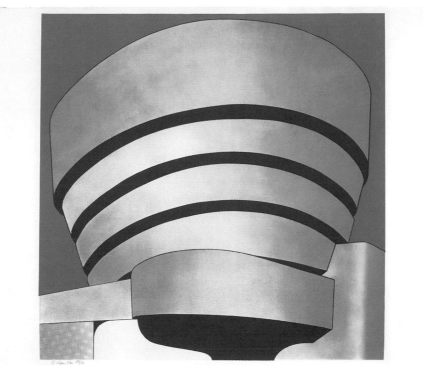

Plate 55 Richard Hamilton, *The Solomon R. Guggenheim*, 1965 (411)

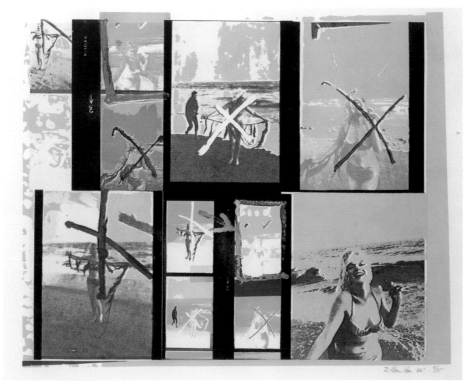

Plate 56 Richard Hamilton, *My Marilyn*, 1966 (412)

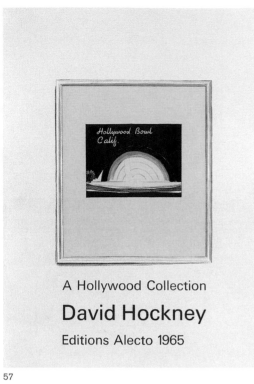

A Hollywood Collection

David Hockney

Editions Alecto 1965

57

58

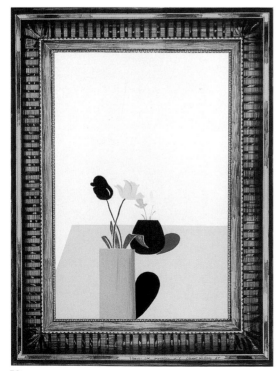

59

60

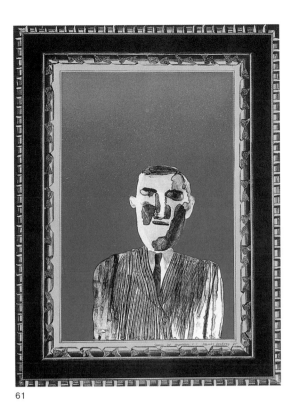

61

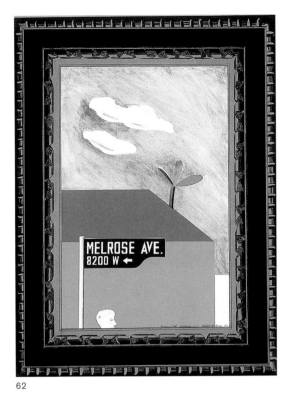

62

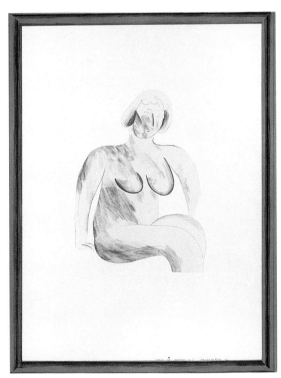

63

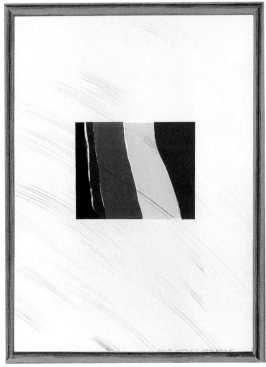

64

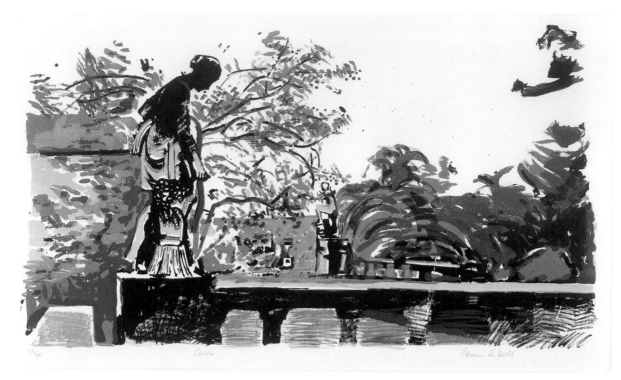

Plate 65 Edwin La Dell, *Ceres*, 1966–7 (604)

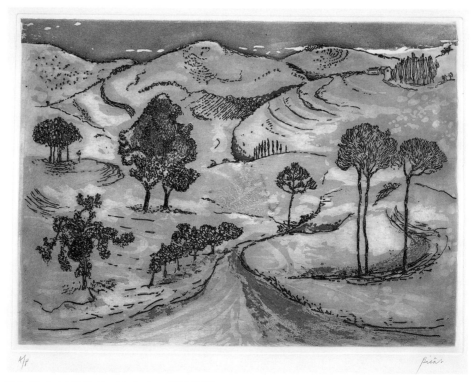

Plate 66 André Bicât, *Road to Asciano*, 1966 (130)

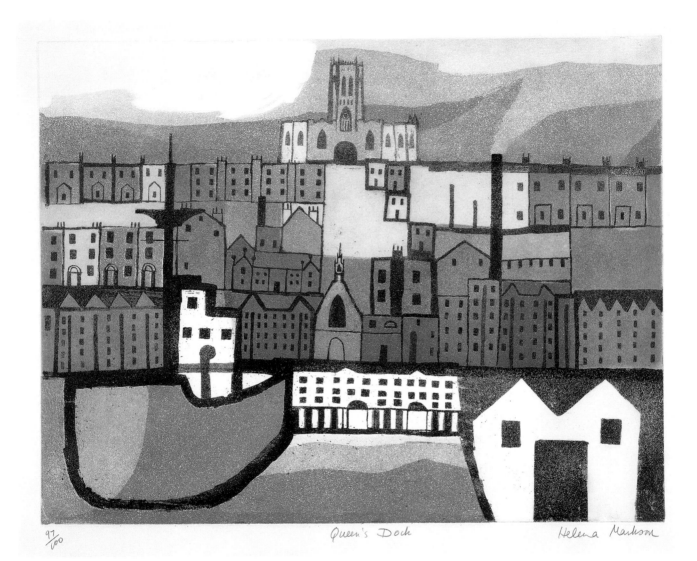

97/100 *Queen's Dock* *Helena Markson*

Plate 67 Helena Markson, *Queen's Dock*, 1964–5 (642)

68

69

Plates 68–71 Jim Dine, *A Tool Box 1, VIII, IX, X*, 1966 (357, 364–66)

70

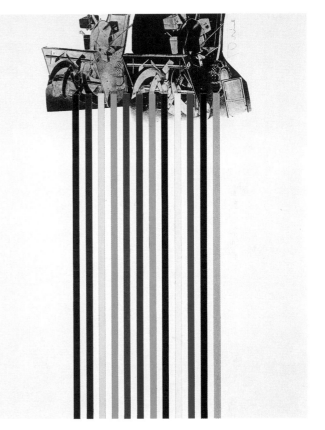

71

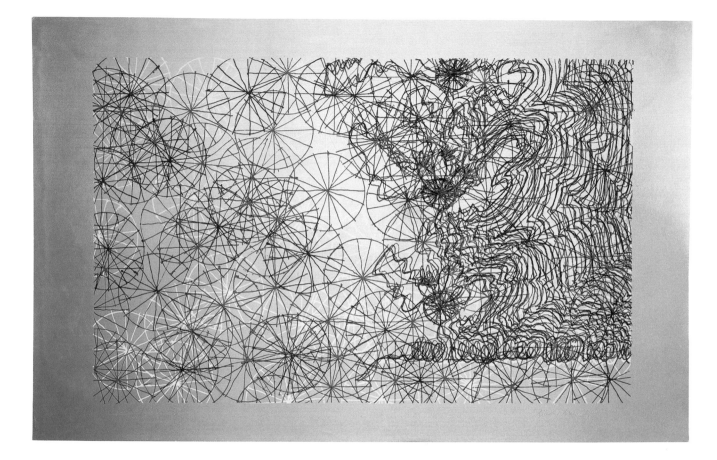

Plate 72 Bernard Cohen, *Silver*, 1964 (203)

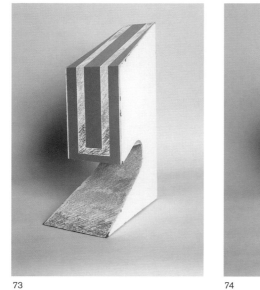

73

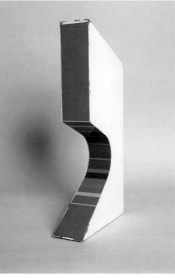

74

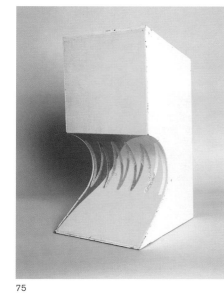

75

76

77

Plates 73–77 Richard Smith, *Sphinx Series*, 1966 (1063–7)

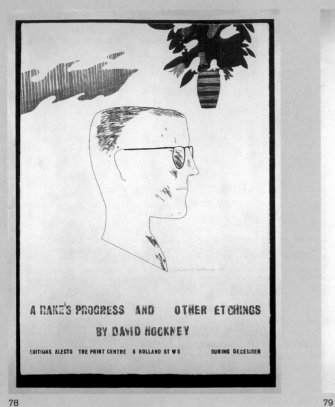

78

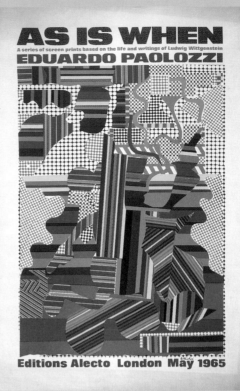

79

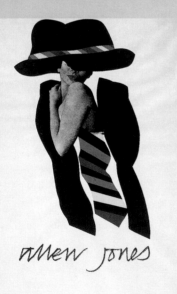

80

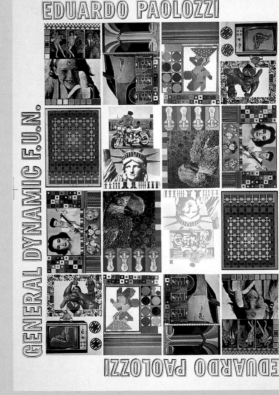

81

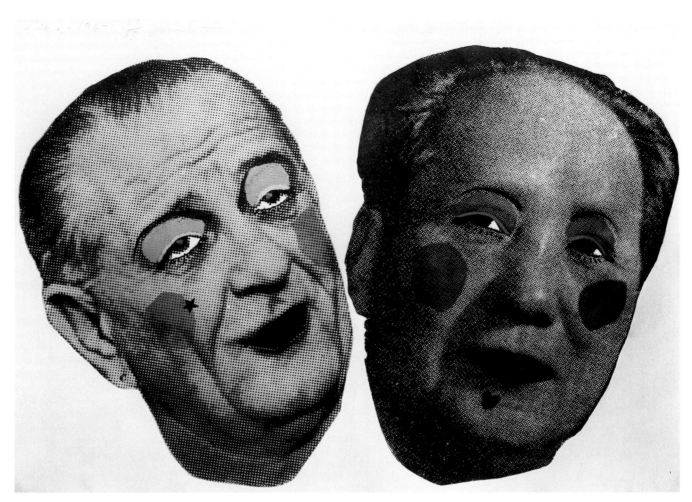

Plate 82 Jim Dine, *Drag: Johnson and Mao*, 1967 (367)

OPPOSITE **Plates 78–81** Editions Alecto Posters, 1963–70 (*A Rake's Progress, As is When, Concerning Marriages, General Dynamic F.U.N.*) (446, 508, 709, 863)

La Genèse
Jennifer Dickson 1965

ÉDITIONS ALECTO, LONDRES

Plates 83, 84 Jennifer Dickson, *Title Page* and *Que La Lumière Soit* from *La Genèse*, 1965 (343)

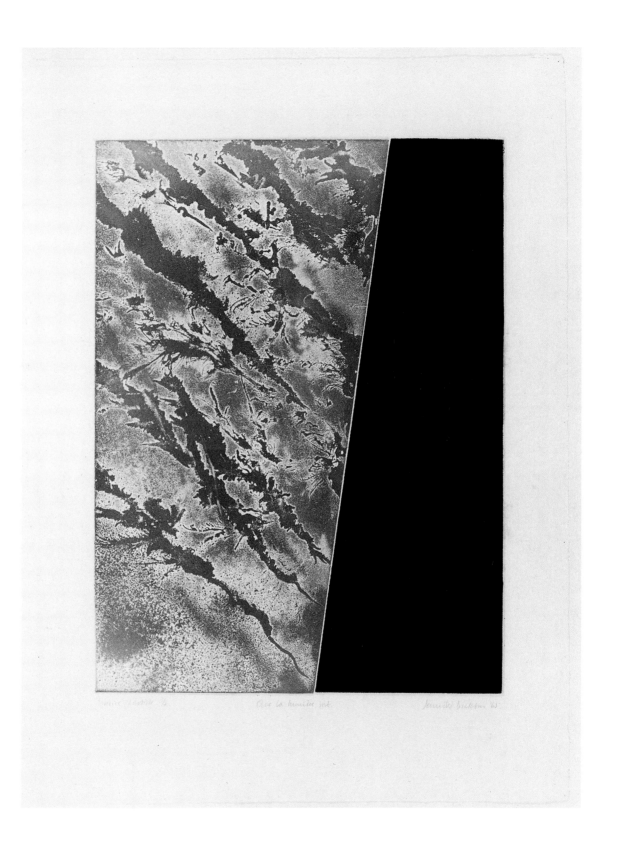

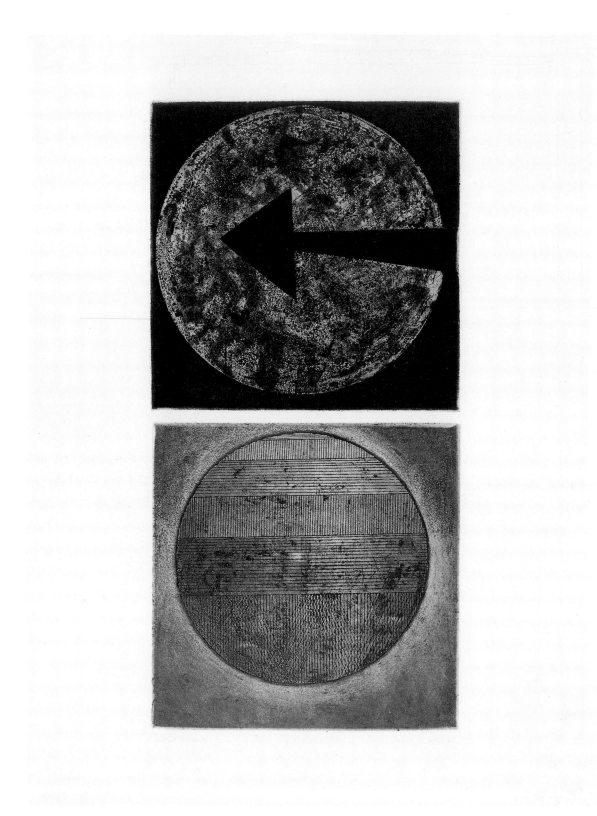

Plate 85 Jennifer Dickson, *Les Premiers Astres* from *La Genèse*, 1965 (339)

144 King and Queen, 1962–4

Etching and aquatint, steel plate, printed in prussian blue and black (oil, wiped); yellow; dark blue; crimson and dark blue (watercolour, rolled on) with white on Crisbrook waterleaf 140 lb paper

Plate: 601 × 453 mm (23$\frac{11}{16}$ × 17$\frac{27}{32}$ in), paper: 703 × 526 mm (27$\frac{11}{16}$ × 20$\frac{3}{4}$ in)

Insc bl: *King and Queen 10/50*, br: *John R Brunsdon 62* (pencil)

Edition: 50, 5 ap

Proofed and pr: The artist, Digswell Arts Trust, 1962–4; pub: 1964 (ea 189)

Petrol pumps were the starting point for this image.

145 Blue Water, 1963–4

Etching and aquatint, steel plate, printed in blue and black (oil, wiped); and ultramarine (watercolour, rolled on) on Crisbrook waterleaf 140 lb paper

Plate: 452 × 617 mm (17$\frac{13}{16}$ × 24$\frac{5}{16}$ in), paper: 544 × 727 mm (21$\frac{7}{16}$ × 28$\frac{1}{4}$ in)

Insc bl: *Blue Water Artist Proof 1/5*, br: *John R Brunsdon 1963* (pencil)

Edition: 50, 5 ap

Proofed and pr: The artist, Digswell Arts Trust, 1963–4; pub: 1964 (ea 190)

'The blobs are trees in a landscape. Digswell had a number of lakes . . . a design that just happened, the title came last.' (JB)

146 Dawn, 1964

Etching and aquatint, steel plate, printed in veridian with prussian blue and black (oil, wiped); dark blue, black and veridian; burnt umber, red, crimson and blue (watercolour, rolled on) on Crisbrook waterleaf 140 lb paper

Plate: 452 × 598 mm (17$\frac{13}{16}$ × 23$\frac{9}{16}$ in), paper: 551 × 694 mm (21$\frac{11}{16}$ × 27$\frac{5}{16}$ in)

Insc bl: *Dawn*, bc: *Artist Proof*, br: *John Brunsdon* (pencil)

Edition: 50, 5 ap

Proofed and pr: The artist, Digswell Arts Trust; pub: 1964 (ea 191)

'There are chalk pits on the hills around Digswell, though this is nowhere specific . . . I was crossed in love at the time.' (JB)

147 Blue Room (Woburn), 1964

Etching and aquatint, steel plate, printed in prussian blue and black (oil, wiped), prussian blue and white (oil, rolled on); crimson yellow, burnt umber and white (watercolour, rolled on) on Crisbrook waterleaf 140 lb paper

Plate: 453 × 604 mm (17$\frac{27}{32}$ × 23$\frac{25}{32}$ in), paper: 544 × 714 mm 21$\frac{7}{16}$ × 28$\frac{1}{8}$ in)

Insc bl: *Blue Room 5/25*, br: *John Brunsdon 64* (pencil)

Edition: 50 (extended from 25), 5 ap

Proofed and pr: The artist, Digswell Arts Trust; pub: 1964 (ea 192)

Brunsdon left Digswell in 1962 to live in the village of Woburn, about ten miles from Milton Keynes in Buckinghamshire. 'Here there is a blue wall, door handle, panelling on the door and the first introduction of chair backs . . . things are beginning to appear.' (JB)

148 Night Dreams, 1964

Etching and aquatint, steel plate, printed in prussian blue and black with veridian (oil, wiped); and crimson, burnt umber and white (watercolour, rolled on) on Crisbrook waterleaf 140 lb paper

Plate: 452 × 602 mm (17$\frac{13}{16}$ × 23$\frac{11}{16}$ in), paper: 540 × 713 mm (21$\frac{1}{4}$ × 28$\frac{1}{16}$ in)

Insc bl: *Night dreams 6/25*, br: *John R Brunsdon 64* (pencil)

Edition: 50 (extended from 25), 5 ap

Proofed and pr: The artist, Digswell Arts Trust; pub: 1964 (ea 193)

149 Breeze I, 1966–7

Etching and aquatint with muslin, steel plate, printed in sludge green and dark sludge green (oil, wiped) on Crisbrook waterleaf paper

Plate: 602 × 453 mm (23$\frac{11}{16}$ × 17$\frac{27}{32}$ in), paper: 702 × 525 mm (27$\frac{5}{8}$ × 20$\frac{11}{16}$ in., cut edges)

Insc bl: *Breeze 1*, bc: *13/50*, br: *John Brunsdon 67* (pencil)

Edition: 50, 5 ap

Pr: The artist, Woburn studio, 1966–7; pub: 1967 (ea 492)

Coll: GAC

'An interior at a time when I had back trouble and could not get out of bed. The curtains are blowing in the breeze' (JB) *Breeze II* also dates from Nov 1966.

150 The Twelfth Day, 1966–7

Etching and aquatint, steel plate, printed in warm grey (oil, wiped), brown and green (watercolour, brushed directly after printing) on Crisbrook waterleaf paper

Plate: 450 × 595 mm (17$\frac{3}{4}$ × 23$\frac{7}{16}$ in), paper: 557 × 780 mm (21$\frac{15}{16}$ × 30$\frac{23}{32}$ in)

Insc bl: *The Twelth* (sic) *Day 14/50*, br: *John Brunsdon* (pencil)

Edition: 50, 8 ap, 1 tp

Pr: The artist, Woburn studio, 1966–7; pub: 1967 (ea 493)

Coll: GAC; Dudley Museum and Art Gallery

'This is associated with the slightly drab colours of the twelfth day after Christmas . . . curtains are blowing in the breeze, There's the cracked table and the couch with stripey cover.' (JB)

151 Orbicular, 1969

Etching and aquatint, steel plate, printed in raw umber (oil, wiped), primrose yellow (oil, wiped) and yellow (watercolour, rolled on) on Crisbrook waterleaf paper

Plate: 601 × 453 mm (23$\frac{11}{16}$ × 17$\frac{27}{32}$ in), 725 × 522 mm (28$\frac{9}{16}$ × 20$\frac{1}{2}$ in)

Insc bl: *Orbicular*, bc: *Artists Proof 8/8*, br: *John Brunsdon 69* (pencil)
Edition: 75, 8 ap, 1 tp
Pr: The artist, Woburn studio; pub: 1969 (ea 643)

'An interior, still to do with tables and an interest in shapes and surfaces.' (JB)

152 Mud Flats, 1969
Etching and aquatint, steel plate, printed in dark green and raw sienna (oil, wiped); sky blue and white (oil, wiped) and deep crimson (watercolour, rolled on) on Crisbrook waterleaf paper
Plate: 452 × 599 mm (17$\frac{13}{16}$ × 23$\frac{5}{8}$ in), paper: 556 × 767 mm (21$\frac{8}{8}$ × 30$\frac{7}{32}$ in)
Insc bl: *"Mud Flats"*, bc: *62/75*, br: *John Brunsdon 69* (pencil)
Edition: 75, 8 ap
Pr: The artist, Woburn Studio; pub: 1969 (ea 644)
Coll: GAC

153 Pembroke I, 1969
Etching and aquatint, steel plate, printed in wiped orange; golden yellow sky (both oil) with yellow (watercolour brushed on after printing) on Crisbrook waterleaf paper
Plate: 300 × 415 mm (11$\frac{13}{16}$ × 16$\frac{11}{32}$ in), paper: 385 × 518 mm (15$\frac{3}{16}$ × 20$\frac{3}{8}$ in)
Insc bl: *Pembroke I*, bc: *AP*, br: *John Brunsdon* (pencil)
Edition: 45, 5 ap
Pr: The artist, Woburn studio, 1969; pub: 1969 (ea 645)

'A friend allowed us to park our caravan on his farm in Rhosson Isaf, Pembrokeshire. His cottage – a positive house – is seen on the right.' (JB)

This is the first of four etchings entitled *Pembroke*, each editioned to forty-five.

Malcolm Carder (*b.*1936)

Kingston College of Art, 1955–9. Freelance graphic designer, 1959–61. Taught constructional sculpture at Farnham School of Art 1964–6. Exhibited with Nigel Greenwood, London. Solo exhibition with Axiom, London 1968. To India in 1974, becoming Swami Anand Yatri.

154 Flikker Book No. 5, 1972 (Page 225)
Lithograpth, off-set, printed in black
75 × 93 mm (2$\frac{31}{32}$ × 3$\frac{11}{16}$ in)
Printed front: *Flikker/ book/ Malcolm Carder*, end page: *M Carder*
Pr: Hillingdon Press, Uxbridge; pub: AI, 1972

Balls fly and jostle against a grid construction.

Peter Carr (*b.*London, 1933) and
Terence Millington (*b.*Birmingham, 1942)

Peter Carr studied English at Christ College, Cambridge, 1952–5. Amateur pianist as well as painter and potter. Set up a pottery studio in Staithes, North Yorkshire, 1964. In 1968 he crossed the Sahara twice, making tracings of the Tassili Rock Paintings. Returned in 1972 to make more tracings.

Terence Millington studied painting and printmaking at Birmingham College of Art, 1958–63, where he became part-time lecturer. Postgraduate studies in lithography and etching at Manchester College of Art and Design, 1965–6, setting up an etching studio in Staithes, Yorkshire in 1968. Now lives and works in Devon, his etchings published and exhibited in Britain and in USA.

THE TASSILI PRINTS, 1969
Series of ten colour etchings, all but one printed on two steel plates, based upon tracings, master copy-line drawings and notes made by Peter Carr. Proofed and etched: Terence Millington on a 'converted mangle' at his studio in Staithes, Yorkshire before his editioning at Alecto Studios, London. The scale of each etching is identical to the original rock painting, the exception being no 10, reduced by a third.
Edition: 75, 10 ap (only 48 impressions printed)
Pub: 1969 (ea 586–95)
Exh: *Galerie Octave Landverlin*, Strasbourg, April 1970

In 1968 Peter Carr joined the first commercially organised expedition (by landrover) to cross the Sahara twice, and returned to England with tracings of prehistoric rock paintings made on the Tassili n'Ajjer plateau near Djanet (south eastern Algeria). Shortly afterwards he met the artist Terence Millington, and together they produced fourteen etched steel plates featuring the Tassili designs. Joe Studholme persuaded fellow directors at ea to produce a low-cost limited edition. Ten of the fourteen plates were chosen for an edition of seventy-five. These were mainly sold to American universities.

155 Group of Oxen
Etching and aquatint, single steel plate, printed in burnt sienna
Plate: 250 × 475 mm (9$\frac{17}{32}$ × 18$\frac{11}{16}$ in), paper: 450 × 677 mm (17$\frac{8}{8}$ × 26$\frac{5}{8}$ in)
Insc bl: *35/75*, bc: *Peinture rupestre c 2500 BC Tassili n'Ajjer Algerie*, br: *Millington/ Peter Carr '70* (pencil) (ea 586)

156 Buffalo
Etching and aquatint, printed in Indian red with black/brown overprint
Plate: 300 × 400 mm (11$\frac{13}{16}$ × 15$\frac{3}{4}$ in), paper: 500 × 590 mm (19$\frac{11}{16}$ × 23$\frac{1}{4}$ in)
Insc bl: *35/75*, bc: *Rock painting c4000 BC Tassili n'Ajjer Algeria*, br: *Millington/ Peter Carr '70* (pencil) (ea 587)

157 Giraffe
Etching and aquatint, printed in ochre with black/brown overprint
Plate: 450 × 400 mm (17 $\frac{3}{4}$ × 15 $\frac{3}{4}$ in), paper: 635 × 570 mm
(25 × 22 $\frac{7}{16}$ in)
Insc br: *Millington* (pencil) (ea 588)

158 Single Large Upright Antelope
Etching and aquatint, printed in Indian red with black/brown
overprint
Plate: 400 × 300 mm (15 $\frac{3}{4}$ × 11 $\frac{13}{16}$ in), paper: 605 × 500 mm
(23 $\frac{13}{16}$ × 19 $\frac{11}{16}$ in)
Insc bl: *Artists proof*, bc: *Antelope 3500BC/ Tassili n'Ajjer*, br:
Terence Millington/ Peter Carr '70 (pencil) (ea 589)

159 Single Running Gazelle
Etching and aquatint, printed in Indian red with black/brown
overprint
Plate: 267 × 400 mm (10 $\frac{1}{2}$ × 15 $\frac{3}{4}$ in), paper: 480 × 478 mm
(18 $\frac{7}{8}$ × 18 $\frac{13}{16}$ in)
Insc bl: *B.A.T.*, bc: *Rock painting – Tassili n 'Ajjer, Algeria*, br:
Peter Carr '70 (pencil) (ea 590)

160 Two Cattle, Mouflon and Hunter
Etching and aquatint, printed in Indian red with black/brown
overprint
Plate: 450 × 400 mm (17 $\frac{3}{4}$ × 15 $\frac{3}{4}$ in), paper: 687 × 560 mm
(27 $\frac{1}{16}$ × 22 $\frac{1}{16}$ in)
Insc bl: *Artists proof*, bc: *Peinture rupestre c4000 + 3000BC
Tassili n'Ajjer, Algerie*, br: *Millington/ Peter Carr '70* (pencil)
(ea 591)

161 Striding Man and Goat (Horizontal)
Etching and aquatint, printed in Indian red with black/brown
overprint
Plate: 302 × 398 mm (11 $\frac{7}{8}$ × 15 $\frac{11}{16}$ in), paper: 510 × 595 mm
(20 $\frac{1}{16}$ × 23 $\frac{7}{16}$ in)
Insc bl: *Artists proof*, bc: *Rock painting – Tassili n'Ajjer Algeria*,
br: *Terence Millington/ Peter Carr '70* (pencil) (ea 592)

162 Hunter with Arrows and Elephant
Etching and aquatint, printed in Indian red with black/brown
overprint
Plate: 300 × 395 mm (11 $\frac{13}{16}$ × 15 $\frac{9}{16}$ in), paper: 500 × 595 mm
(19 $\frac{11}{16}$ × 23 $\frac{7}{16}$ in)
Insc bl: *35/75*, bc: *Peinture rupestre c4000BC Tassili n'Ajjer*,
br: *Algerie Millington/ Peter Carr '70* (pencil) (ea 593)

The paper size differs throughout this series as the edges were
torn rather than cut to the same size. (PC, 1/9/1999)

163 Negroid Man (Vertical)
Etching and aquatint, printed in pale ochre with black/brown
overprint
Plate: 405 × 303 mm (15 $\frac{15}{16}$ × 11 $\frac{15}{16}$ in), paper: 630 × 497 mm
(24 $\frac{13}{16}$ × 19 $\frac{9}{16}$ in)

Insc bl: *32/75*, bc: *Rock painting c2000BC Tassili n Ajjer,
Algeria*, br: *Millington/ Peter Carr 70* (ea 594)
Coll: BMAG

164 Striding Man and Mouflon (Vertical)
Etching and aquatint, printed in pale ochre with black/brown
overprint
Plate: 398 × 300 mm (15 $\frac{11}{16}$ × 11 $\frac{13}{16}$ in), paper: 663 × 519 mm
(26 $\frac{1}{4}$ × 20 $\frac{7}{16}$ in)
Insc bl: *28/75*, bc: *Rock Painting c 4000BC/ Tassili n Ajjer,
Algeria*; br: *Terence Millington/ Peter Carr' 69* (pencil) (ea 595)
Coll: BMAG

The two-plate process involved, 'a base-colour plate with flat
colour rolled onto the steel plate. The second plate contained
the drawing and imagery which was "stopped out" through a
bituamastic marbled background. This was achieved by floating
dilute bitumen onto the surface of a water-bath and dipping the
surface of the printing plate thereby making a transfer to the
steel. This was then submerged in the acid to produce a marbled
texture intaglio plate.' (TM, 8/7/2002)

Patrick Caulfield (*b.*London, 1936)

Chelsea School of Art, and RCA, 1960–3. *Ruins* for ICA Screenprint
Project, 1964, which won *Prix des Jeunes Artistes* at 4th Biennale de
Paris, 1965. First print series published by ea, 1967. Six years later,
Some Poems of Jules Laforgue, a book in three editions of twenty-two
screenprints, published by Petersburg Press with Waddington
Galleries, London. Screenprints continued to be printed by Kelpra
Studio until 1987, and by Advanced Graphics (both London).

Lit: *Patrick Caulfield: The Complete Prints 1964–1999*, London, Alan
Cristea Gallery, 1999

UNTITLED SERIES, 1966–7
Six independent screenprints on still-life theme, printed on British
fluorescent cartridge 90 lb imperial paper
Insc br: with edition number and signed *Patrick Caulfield* (pencil)
with vo: *K* and number of Kelpra Studio; and ea stamp and
publication number (mostly)
Edition: 75, 10 ap, 5 pp
Pr: Kelpra Studio, London, 1966 (invoiced 20/12/1966); pub:
1967 (ea 413–18)
Coll: Tate; National Gallery of Australia, Canberra

165 The Hermit (I), 1966–7
Screenprint, printed in red, yellow, blue, black
Image and paper: 557 × 838 mm (21 $\frac{15}{16}$ × 33 in) (ea 413)
Coll: ACE

166 Earthenware (II), 1966–7
Screenprint, printed in green, black, brown
Image and paper: 559 × 914 mm (22 × 36 in) (ea 414)

167 Coloured Still Life (III), 1967
Screenprint, printed in two reds, blue, black, grey, yellow and green
Image and paper: 557 × 914 mm (21$\frac{15}{16}$ × 36 in) (ea 415)

168 The Letter (IV), 1967 (Page 124)
Screenprint, printed in grey, yellow, green, blue, black, white
Image and paper: 480 × 760 mm (18$\frac{7}{8}$ × 29$\frac{15}{16}$ in) (ea 416)
Coll: ACE

169 Sweet Bowl (V), 1967 (Page 124)
Screenprint, printed in three blues with orange, purple, yellow, red, black
Image and paper: 556 × 912 mm (21$\frac{7}{8}$ × 35$\frac{15}{16}$ in) (ea 417)
Coll: Manchester City Art Galleries; ACE

169a Reproduced as unlimited screen edition, on British Cartridge 200 gsm paper
Image and Paper: 557 × 880 mm (21$\frac{15}{16}$ × 34$\frac{5}{8}$ in)
Insc br: *Redesigned for PSA Supplies Division 1975*
Pr: Leslie Hosgood and Robert Jones of Megara Screenprinting Ltd, London for PSA, Department of The Environment, 1975 (ea 914).

170 Weekend Cabin (VI), 1967
Screenprint, printed in green, black, dark green, grey
Image and paper: 558 × 914 mm (21$\frac{31}{32}$ × 36 in) (ea 418)
Coll: ACE

George Chapman (*b.*East Ham, London, 1908–93)

See Appendix

Jacques Charoux (*b.*Mauritius, 1940)

Studied painting and etching at Central School of Art, London, 1961–4, and École National Supérieur des Arts, Brussels, 1964–5. Solo exhibitions: Théâtre National, Brussels, 1965; Mercury Theatre, 1968 and Hampstead Theatre Club, 1973 (both London); Hogarth Galleries, Sydney, 1987; Wollongong City Gallery, 2000. Group Shows: AIA Gallery, 1962; The Print Centre, 1964 (both London); Ljubljana International Graphic Exhibition, 1964; *English Graphics Today*, Midsommargarden, Stockholm, 1974.

171 Message III, 1964*
Colour etching on RWS handmade 140 lb imperial paper
Plate: 575 × 490 mm (22$\frac{5}{8}$ × 19$\frac{5}{16}$ in, approx.)
Edition: 70, proofs; pub: *c.*1964 (ea 350)

172 Message IV, 1964
Etching, two zinc plates, open bite, printed in ochre and brown, on RWS handmade 140 lb imperial paper
Plate: 523 × 490 mm (20$\frac{5}{8}$ × 19$\frac{5}{16}$ in), paper: 802 × 566 mm (31$\frac{5}{8}$ × 22$\frac{5}{16}$ in)

Insc bl: *Message IV 58/70*, br: *Jac Charoux 64* (pencil), vo: ea *No 351* stamped
Edition: 70, proofs
Pr: The artist, Central School of Art and Crafts, London, 1964; pub: *c.*1964 (ea 351)
Coll: GAC, South London Gallery

The GAC also has *Message I* and *Message Organique* from the same series. 'While at Central, I was a frequent visitor to the British Museum, drawing archaeological stones or pieces of parchment from a variety of different ancient cultures. I did not copy the inscriptions, rather used what I saw as basis for my own inventions' (JC, 4/7/2000)

173 Diptych II, 1964
Etching, zinc plate, open bite, printed in black with red rolled over surface on RWS handmade 140 lb imperial paper
Image and paper: 762 × 570 mm (30 × 22$\frac{7}{16}$ in)
Insc bl: *Diptych 11 1/20*, br: *Jac Charoux 64* (pencil)
Pr: The artist, Central School of Art and Crafts, London, 1964; pub: *c.*1964 (ea 352)
Coll: Dudley Museum and Art Gallery

ea successfully sold the first in the *Diptych* series, while also publishing this second edition.

Bernard Cheese (*b.*Sydenham, London, 1925)

Studied graphic design at RCA, 1947–50, where taught lithography by Edwin La Dell and George Devenish. Taught printmaking at St Martin's, Goldsmiths' College and Central School of Art and Design. Secretary of The Senefelder Club and member of New Editions Group, exhibiting with St George's Gallery and Zwemmer Gallery, London, late 1950s–early 1960s. With wife, Sheila Robinson, associated with artists living in and around Great Bardfield, Essex, when living at nearby Thaxted from 1953. Shared an etching press with George Chapman. Moved to Stisted, Essex, 1957.

174 Movement in a Hedgerow, 1969
Lithograph, zinc plates, printed in orange, brown, transparent grey, ochre grey on J. Green waterleaf paper
Image: 560 × 755 mm (22$\frac{1}{16}$ × 29$\frac{3}{4}$ in), paper: 595 × 793 mm (23$\frac{7}{16}$ × 31$\frac{1}{4}$ in)
Insc bl: *Movement in a Hedgerow 67/75*, br: *Bernard Cheese* (pencil), br corner: *Bernard Cheese Hand Print c* embossed stamp (variously)
Edition: 75, 5 ap
Pr: The artist, Stisted Studio, Essex; pub: 1969 (ea 639)
Coll: GAC

'I am writing to confirm that we wish to publish *Movement in a Hedgerow* in an edition of 75 – the price £2 per print We would be grateful if you would let us know how soon you can pull the edition and make the delivery.

 I also confirm that we are also interested in coming to an arrangement with you for an exclusive distribution of your

graphics in North America in return for publishing an additional 6 to 8 images. The edition size in this case would be 60 and the buying price £10' (Joe Studholme to BC, 8/8/1969)

See Appendix

Graham Clarke (b.Chipping Norton, Oxfordshire, 1941)

Beckenham School of Art, and RCA from 1961, where under the influence of Edward Bawden began to make lino and block prints. Taught at Canterbury and Maidstone Colleges of Art. Established Ebenezer Press in 1966 with the help of small monthly income from Editions Alecto that resulted in two print editions. Illustrated books include: *Balyn and Balan* and *Vision of Wat Tyler*. Moved to Boughton Monchelsea, Kent in 1968, from where continues to work.
Lit: Clare Sydney, *Graham Clarke*, Oxford, Phaidon, 1985

KENT SERIES, 1966–7

Twelve colour linocuts, 5–7 blocks, on handmade waterleaf Hosho no 150 paper, 650 × 867 mm (25 ⅝ × 34 ⅛ in, slightly irregular)
Insc bl with title, edition number; br signed by artist: *Graham Clarke* (pencil)
All the scenes are identified or associated with Shoreham area in Kent
Edition: 100, 10–12 ap, plus proofs
Proofed and pr: The artist on 1825 Cogger Press, with assistance of David Birtwhistle, Ebenezer Press, 77 Palace Road, Bromley, 1966–7; pub: 1967 (ℯℯ 376–87)
Coll: Arthur Andersen, London (incomplete)

175 Timberden (I)
Linocut, printed in light grey, black, dark grey, green and two browns
Image: 454 × 659 mm (17 ⅞ × 25 15⁄16 in) (ℯℯ 376)

176 Behind Shoreham (II)
Linocut, printed in brown, black, green, yellow, golden brown, purple grey
Image: 455 × 660 mm (17 15⁄16 × 26 in) (ℯℯ 377)

177 Sepham Oast Houses (III)
Linocut, printed in brown, cream, green, purple, dark green and black
Image: 456 × 655 mm (17 31⁄32 × 25 25⁄32 in) (ℯℯ 378)

178 Cottage in a Valley (IV)
Linocut, printed in dark green, dust pink, pink, black, light green, purple, brown
Image: 460 × 656 mm (18 ⅛ × 25 13⁄16 in) (ℯℯ 379)

First print in this Shoreham, Kent series, closely associated with Samuel Palmer's 'Valley of Vision'; 'I liked the spiritual notion of him (Palmer) finding a kind of heavenly feeling in the Kent countryside; that appealed to me as it still does.' (GC) Most of

the scenes are located two or three miles outside Shoreham. This is Timberden.

179 Chalk Hills (V), 1967
Linocut, printed in beige, pale yellow, brown, khaki, pink and black
Image: 455 × 659 mm (17 15⁄16 × 25 15⁄16 in) (ℯℯ 380)

180 Harvest Moon (VI)
Linocut, printed in black, brown, yellow ochre, green, blue, purple
Image: 455 × 659 mm (17 15⁄16 × 25 15⁄16 in) (ℯℯ 381)

181 Big Field (VII)
Linocut and plywood (with deep cutting for the large field), printed in orange, pale green, brown, purple, pale pink, black
Image: 455 × 659 mm (17 15⁄16 × 25 15⁄16 in) (ℯℯ 382)

182 Farm at Badgers Mount (VIII), 1967
Linocut, printed in green grey, grey, brown, black, pale orange
Image: 455 × 658 mm (17 15⁄16 × 25 29⁄32 in) (ℯℯ 383)
Coll: Arthur Andersen, London

183 Hill at Woodlands (IX), 1967
Linocut and plywood, printed in two browns, green, black and orange
Image: 456 × 660 mm (17 31⁄32 × 26 in) (ℯℯ 384)

184. Highfield Winter (X), 1967
Linocut, printed in purple, black, bright green, light green, light orange, sage green and khaki
Image: 456 × 658 mm (17 31⁄32 × 25 29⁄32 in) (ℯℯ 385)

185 Lane to Filston (XI), 1967
Linocut, printed in dark blue, brown, pale green, pink and black
Image: 456 × 658 mm (17 31⁄32 × 25 29⁄32 in) (ℯℯ 386)

186. Hayfield, Timberden (XII), 1967
Linocut, printed in dark grey, khaki, orange, pale green, bright yellow and black
Image: 454 × 658 mm (17 ⅞ × 25 29⁄32 in) (ℯℯ 387)

FISHING BOATS AT RYE AND HASTINGS (1 & 2), 1967–9

Two sets of eight colour linocuts on fishing boats at Rye and Hastings in Sussex, 5–7 blocks
Insc bl: title and edition number, br: artist's signature: *Graham Clarke* (pencil)
Proofed and pr: The artist, Ebenezer Press, Bromley on J. Green mould-made waterleaf paper, 646 × 866 mm (25 7⁄16 × 34 ⅛ in, slight variation).
Edition: 75, 15 ap
Pub: 1967 and 1969 (ℯℯ 510–17 and 616–23)

187 RX 21, 61, 73; 1967
Linocut with caustic, printed in gold, claret, orange, black, blue, white
Image: 481 × 630 mm (18⅝ × 24¹³⁄₁₆ in) (ea 510)

188 Stages at Rye, 1967
Linocut, printed in coral, brown, silver, orange, blue, black
Image: 480 × 641 mm (18⅞ × 25¼ in) (ea 511)

189 Valiant of Hastings, 1967
Linocut with netting, printed in light grey, black, dark grey, brown, blue, orange
Image: 482 × 636 mm (19 × 25¹⁄₁₆ in) (ea 512)

190 Low Tide, 1967
Linocut and caustic, printed in blue, grey, gold, orange, dark blue, white
Image: 480 × 633 mm (18⅞ × 24¹⁵⁄₁₆ in) (ea 513)

191 Sterns, 1967
Linocut with scraped plywood, printed in grey, pale blue, pink, black, ochre, dark blue
Image: 481 × 633 mm (18¹⁵⁄₁₆ × 24¹⁵⁄₁₆ in) (ea 514)

192 Two Brothers, 1967
Linocut with caustic, printed in lilac, black, khaki, silver, blue, cream
Image: 484 × 635 mm (19¹⁄₁₆ × 25 in) (ea 515)

193 Beach at Hastings, 1967
Linocut with curtain netting and caustic, printed in plum, brown, grey green, blue, black, coral
Image: 481 × 633 mm (18¹⁵⁄₁₆ × 24¹⁵⁄₁₆ in) (ea 516)

194 Rye Fishmarket, 1967
Linocut with plywood, netting and multiple tool; printed in brown, ochre, orange, black, blue
Image: 481 × 636 mm (18¹⁵⁄₁₆ × 25¹⁄₁₆ in) (ea 517)

195 Winch Shed, 1969
Linocut and caustic, printed in pale brown, green, red brown, black, silver, blue
Image: 485 × 634 mm (19¼ × 24³¹⁄₃₂ in) (ea 616)

196 Daybreak, 1969
Linocut with caustic, printed in dark blue, pale blue, silver, coral, brown
Image: 482 × 634 mm (19 × 24³¹⁄₃₂ in) (ea 617)

197 Rye Harbour, 1969
Linocut with caustic, printed in grey blue, khaki, sand, silver mauve, ochre, black, blue
Image: 480 × 633 mm (18¹⁵⁄₁₆ × 24¹⁵⁄₁₆ in) (ea 618)

198 To Crusty Crampton, 1969
Linocut, printed in pale blue, pink, black, mid blue, ochre, black, orange
Image: 482 × 685 mm (19 × 26³¹⁄₃₂ in) (ea 619)

'A tribute to a fisherman, a legendary character, who I knew through another fisherman, Johnny Doughty.' (GC)

199 Dungeness, 1969
Linocut, printed in dark brown, grey blue, pale yellow, ochre, black and caustic
Image: 481 × 633 mm (18¹⁵⁄₁₆ × 24¹⁵⁄₁₆ in) (ea 620)

'There are a couple of winches on the beach, alongside shingle and salt-air plants.' (GC)

200 Two Brothers Unloading, 1969
Linocut with caustic, printed in brown, dark grey, coral, black, blue, silver
Image: 482 × 633 mm (19 × 24¹⁵⁄₁₆ in) (ea 621)

201 Luggers Low Tide, 1969
Linocut with caustic, printed in grey, gold, plum, cherry, brown
Image: 481 × 633 mm (18¹⁵⁄₁₆ × 24¹⁵⁄₁₆ in) (ea 622)
Coll: Towner Art Gallery, Eastbourne

202 RX 134, 126, 1969
Linocut with caustic, printed in khaki, green grey, black, silver mauve, coral, white
Image: 483 × 633 mm (19¹⁄₃₂ × 24¹⁵⁄₁₆ in) (ea 623)

Bernard Cohen (b.London, 1933)

Studied lithography at St Martin's School of Art, and etching under John Buckland Wright at Slade School of Fine Art, 1951–4. First solo shows: Midland Group Gallery, Nottingham and Gimpel Fils, London, 1958. *Situation*, RBA Galleries, London, 1960. *Untitled (Yellow)* for ICA Screenprint Project, 1964. Kasmin Gallery, London, 1963–7 and later. *Prints* at Editions Alecto, Kelso Place, 1966. Published by Waddington Graphics, 1970–80s; including *Six Images for J.*, 1976. Printed with Bud Shark since 1969, producing *Colorado 1* and *11*, 1999. Retrospective at Hayward Gallery, London, 1972. *Paintings of The 90s*, Flowers East, London and tour, 1998.

203 Silver, 1964 (Page 78)
Screenprint, printed in magenta, cyan, yellow, green on Samuel Jones Bright Aluminium card
Image: 480 × 747 mm (18¹⁵⁄₁₆ × 29⁷⁄₁₆ in), card: 582 × 913 mm (22¹⁵⁄₁₆ × 35¹⁵⁄₁₆ in)
Insc bl: *29/40*, br: *Bernard Cohen 1964* (incised)
Edition: 40, 10 ap
Pr: Kelpra Studio, London, 1964; pub: 1965 (ea 32)
Coll: Tate; South London Gallery; Financial Times

Based upon a ballpoint drawing, and developed during proofing by the artist working closely with the printer. This is a metallic version of *Untitled (Yellow)*, 1964.

Lithographs (I–IX), 1965
Portfolio of nine off-set lithographs, tusche, on B. F. K. Rives paper
Insc bl: with edition number and title in Roman numerals, br: signed and dated: *Bernard Cohen 1965* (pencil) with ea embossed stamp
Edition: 75, 15 ap
Pr: Matthieu AG, Zürich, 1965; pub: 1965 (ea 33–41)
Coll: British Council (incomplete)

204 I (Page 44)
Lithograph, printed in black
Image: 490 × 695 mm (19 $\frac{5}{16}$ × 27 $\frac{3}{8}$ in), paper: 562 × 756 mm (22 $\frac{1}{4}$ × 29 $\frac{3}{4}$ in) (ea 33)
Coll: V&A

205 II
Lithograph, printed in gold and black
Image and paper: 558 × 760 mm (22 × 29 $\frac{15}{16}$ in) (ea 34)
Coll: Brooklyn Museum of Art

206 III
Lithograph, printed in green, purple, orange
Image and paper: 564 × 760 mm (22 $\frac{3}{16}$ × 29 $\frac{15}{16}$ in) (ea 35)
Coll: GAC

207 IV (Page 44)
Lithograph, printed in black and brown
Image: 440 × 691 mm (17 $\frac{5}{16}$ × 27 $\frac{7}{32}$ in), paper: 570 × 762 mm (22 $\frac{7}{16}$ × 30 in) (ea 36)
Coll: Financial Times

208. V
Lithograph, printed in black
Image and paper: 560 × 761 mm (22 $\frac{1}{16}$ × 30 in) (ea 37)
Coll: GAC

209 VI
Lithograph, printed in brown and black
Image and paper: 559 × 762 mm (22 × 30 in) (ea 38)

210 VII
Lithograph, printed in black
Image and paper: 562 × 760 mm (22 $\frac{1}{8}$ × 29 $\frac{15}{16}$ in) (ea 39)

211 VIII
Lithograph, printed in brown and black
Image: 532 × 692 mm, paper: 560 × 757 mm (20 $\frac{15}{16}$ × 29 $\frac{13}{16}$ in) (ea 40)
Coll: GAC; Fitzwilliam Museum, Cambridge

212 IX
Lithograph, printed in brown and black
Image and paper: 559 × 762 mm (22 × 30 in) (ea 41)

Bernard Cohen recalls being approached by Paul Cornwall-Jones through his dealer Kasmin, 'having seen my show of seventy-five drawings at Kasmin in December 1964'. Printing in the Germanic atmosphere of Matthieu turned out not to be a particularly happy experience, though the *Lithographs* series bears interesting comparison with Cohen's recent painting.

213 Poster: Graphics in the Sixties, 1965
Photo-lithograph, typography by Eric Ayers
Image and paper: 500 × 744 mm (19 $\frac{11}{16}$ × 29 $\frac{5}{16}$ in)
Printed: ea/ *Graphics in the Sixties/ Editions Alecto at the RWS Galleries/ 26 Conduit Street London W1/ 5–29 May 1965 Opening Tuesday 4 May 3–7pm*

The ink and acrylic drawing for this poster design is owned by Duffy Ayers, and relates to drawings for the painting *White Plant*.

214 Taper, 1966
Screenprint, printed in purple and orange on Crisbrook paper
Image: 494 × 682 mm (19 $\frac{1}{2}$ × 26 $\frac{7}{8}$ in), paper: 567 × 756 mm (22 $\frac{5}{16}$ × 29 $\frac{3}{4}$ in)
Insc bl: 35/40, br: *Bernard Cohen 1966* (pencil), vo: ea *No 298* stamped
Pr: Kelpra Studio, London; pub: 1966 (ea 298)

Jack Coutu (b.Farnham, Surrey, 1924)

Studied at Farnham School of Art, 1947–51; RCA, 1951–4 and Central School of Art, 1954–5 where Merlyn Evans was a notable influence. Lecturer in printmaking at Central School of Art, 1957–65; and West Surrey College of Art and Design, Farnham, 1965–85. Joint show with Michael Rothenstein, The Print Centre, London, 1965. Career as a carver of netsuke began in 1968.

215 Ichthyology, 1962–4
Etching, two copperplates, open bite and soft-ground with pieces cut out and soldered onto plate, printed in brown, red-orange and white on J. Whatman handmade and Crisbrook 140 lb papers
Plate: 430 × 597 mm (16 $\frac{15}{16}$ × 23 $\frac{1}{2}$ in), paper: 503 × 672 mm (19 $\frac{13}{16}$ × 26 $\frac{1}{2}$ in)
Insc bl: *Artists Proof Folio Copy*, bc: *Ichthyology*, br: *Coutu 62/ Edition 50 All Printed*
Edition: 50, 5 ap, 1 artist's folio copy
Pr: The artist, Farnham studio, 1962–4; pub: 1964 (ea 121)

Based upon earlier engraving, *Marine Parade*, 1960 and retitled to suggest the connection with fossils and the study of ancient fish.

216 Dancer, 1963–4

Etching, copperplate, soldered metallic pieces, stop-out varnish, fixative spray and sugar-lift solution, printed in yellow brown, black and pastel pink with red and yellow painted in afterwards on J. Whatman handmade and Crisbrook 140 lb papers

Plate: 545 × 420 mm (21 $\frac{7}{16}$ × 16 $\frac{9}{16}$ in), paper: 705 × 543 mm (27 $\frac{3}{4}$ × 21 $\frac{3}{8}$ in)

Insc bl: *Dancer 5th State (Folio Copy)*, br: *Jack Coutu 63/ Edition 50. All sold to Alecto*

Edition: 50, 5 ap, 1 artist's folio copy

Pr: The artist, Farnham studio, 1963–4; pub: 1964 (ℯℯ 122)

'I was building up series of shapes in a sculptural way. Odd bits of metal were laid onto the plate and sprayed with stop-out varnish, then removed. Those areas that were left were deep-etched I used pieces of string covered in sugar solution to hit the plate. This left ragged speckly lines' (JC, 7/11/1999)

217 Witches' Moon, 1964

Etching, copperplate, deep etched and fret-sawed, printed in blue-grey, black, pastel pink on Crisbrook 140 lb paper

Plate irregular: 395 × 600 mm (15 $\frac{9}{16}$ × 23 $\frac{5}{8}$ in), paper: 523 × 705 mm (20 $\frac{5}{8}$ × 27 $\frac{3}{4}$ in)

Insc bl: *33/50*, bc: *Witches Moon*, br: *Coutu 64* (pencil)

Edition: 50, 5 ap, 1 artist's folio copy

Pr: The artist, Farnham studio; pub: 1964 (ℯℯ 123)

Coll: GAC

'There was the idea of dancing shapes and the moon on the left . . . but little attempt at being intellectual. I liked the technical means of producing an image.' (JC, 7/11/1999)

218 Jungle, 1964–5

Line engraving, copperplate, printed in black on Crisbrook 140 lb paper

Plate: 390 × 600 mm (15 $\frac{3}{8}$ × 23 $\frac{5}{8}$ in), paper: 527 × 707 mm (20 $\frac{3}{4}$ × 27 $\frac{7}{8}$ in)

Insc bl: *42/50*, bc: *Jungle*, br: *Coutu 65* (pencil)

Edition: 50, 1 artist's folio copy (5 ap entered in ℯℯ Register)

Pr: The artist, Farnham studio, 1964–5; pub: 1964 (ℯℯ 124)

Coll: GAC

'My best print, it took six months to engrave. I wanted to work on all the different things you could do with an engraving tool The image was based on Rousseau's *Snake Charmer* with jungle on the right and a form coming out of the sea. It's about the interplay between two shapes.' (JC, 7/11/1999)

Titled *Jungle II* in final state proof to distinguish it from the first interpretation of this subject printed in 1954.

219 Red Monolith, 1964

Etching, copperplate, deeply bitten with metal pieces attached, printed in red, green black, pastel pink on Crisbrook 140 lb paper

Plate: 603 × 410 mm (23 $\frac{3}{4}$ × 16 $\frac{1}{8}$ in, irregular), paper: 785 × 528 mm (30 $\frac{27}{32}$ × 20 $\frac{13}{16}$ in)

Insc bl: *45/50 Red Monolith*, br: *Coutu 64* (pencil), br corner: ℯℯ embossed stamp

Edition: 50, 5 ap, folio copy

Pr: The artist, Farnham studio, 1964; pub: 1964 (ℯℯ 125)

Coll: New York Public Library; South London Gallery

'I used my favourite pieces of eylet holes and at the top a piece of old sculpture which I flattened out and soldered on. I was thinking in a sculptural and less restrictive way with open edges A standing form with a simple power This edition sold immediately. ℯℯ said it was their best edition yet.' (JC)

Bill Culbert (*b.*Port Chalmers, New Zealand, 1935)

Canterbury University School of Art, New Zealand, 1953–6; studied painting at RCA, 1957–60. First solo shows: Commonwealth Institute Gallery, London and Edinburgh Festival, 1961. Won Open Painting Competition, Arts Council for Northern Ireland, 1964. Began to work with light, 1968. Large version of *Cubic Projections* light sculpture for Fredrick Ashton's ballet *Lament of the Waves*, Royal Ballet, Covent Garden, 1970. Based in London and France, continues to work conceptually and perceptually with light.

220–9 WINDOW 84490 (I–X), 1977* (Page 257)

Series of ten matt monochromatic photographs, taken by the artist and printed on photo-documentary paper

Image and paper: 762 × 762 mm (30 × 30 in)

Edition: 25, 5 ap (only partly printed)

Pub: 1977 (ℯℯ 949–58)

Exh: Editions Alecto Gallery, Kelso Place, London, 20 Jan– 25 Feb 1977

The number title refers to the postcode of Bill Culbert's home in Provence. These ten photographs follow an alternating sequence of interior and exterior views of one particular window between sunrise and moonshine on one day in the winter of 1975. While the medium of photography has remained an important part of Culbert's work since the 1960s, this commission represents a rare publication of a sequence of photo images. The initial presentation series, printed on document paper and measuring 385 × 388 mm (15 $\frac{3}{16}$ × 15 $\frac{1}{4}$ in), is in the artist's posession, and inscribed *Croagnes*, the name of the Culberts's house. Unfortunately the negatives for *Window* were destroyed in the Kelso Place fire of 1978.

Culbert had contact with Joe Studholme and AI as early as 1971, when he discussed proposals for producing multiples of three camera obscura works. The famous *Cubic Projections*, already published by the Lisson Gallery, projected light from the perforated surface of a black fibreglass globe. AI negotiated with the Lisson to republish the work as a smaller unlimited edition. *Celeste*, also known as *Galaxy* and *Nebula*, was made of acrylic plastic, sheet metal, and again perforated holes with a single light bulb source of light. Prototype boxes of 14, 12 and finally 10 in were made in an effort to reduce size and production costs, the project having transferred to the more tightly budgeted

resources of the EACC in 1973. Another projected light box *Outline* was also considered by AI. All three projects were finally unrealised.

Anthony Currell (*b*.London, 1942)

Bideford School of Art, and Central School of Arts and Crafts, 1960–3, specialising in painting and printmaking. Selected by Robert Erskine for Student Section of *The Graven Image* exhibition, 1963. Attended Atelier 17, Paris, 1963–4. Subsequently taught at Preston College of Art, 1964–5; Plymouth College of Art, 1966–80, and Chesterfield College of Art as Head of Printmaking from 1980. Recent exhibitions: Rotherham Art Gallery, 2000; and Derby Museum and Art Gallery, 2002.

WALES SERIES, 1962–4

Series of twelve drypoints on single sheets of duralumin
Insc bl: signed *Anthony Currell*, br: with edition number (pencil)
Presented in a black folder and slipcase inscribed *Anthony Currell/ Wales/* ea
Etched by the artist at Central School of Art from 1962 with some proofing for final degree show, 1963
Editioned: Douglas Allsop, Digswell Arts Trust, Welwyn Garden City, mostly in 1964 with later printing by the artist continuing into 1967
Edition: 20, up to 5 ap; with additional related editions unpublished by ea; pub: 1964 (ea 145–56)
Lit: *The Poetry Makers*, The Bodley Head Series for Secondary Schools, London, Sydney and Toronto, 1968

230 Memories of the Levant, No 1
Drypoint and plate tone, printed in black, on 140 lb Whatman paper
Plate 622 × 468 mm (24$\frac{1}{2}$ × 18$\frac{7}{16}$ in), paper 798 × 565 mm (31$\frac{7}{16}$ × 22$\frac{1}{4}$ in, with variation) (ea 145)
Coll: V&A; GAC

231 Memories of the Levant, No 2
Drypoint and plate tone, printed in black, on 140 lb Whatman paper
Plate: 622 × 482 mm (24$\frac{1}{2}$ × 19 in), paper: 753 × 555 mm (29$\frac{11}{16}$ × 21$\frac{7}{8}$ in, with variation) (ea 146)

The steep cliff of the quarry is here seen as a heavy unrelenting black mass.

232 Memories of the Levant, No 3
Drypoint and plate tone, printed in black, on 140 lb Whatman paper
Plate: 622 × 468 mm (24$\frac{1}{4}$ × 18$\frac{7}{16}$ in), paper: 793 × 582 mm (31$\frac{1}{4}$ × 22$\frac{15}{16}$ in, slight variation) (ea 147)

The mining quarry is here obscured and dominated by solid blocks of black ink. '. . . *Memories of the Levant* was inspired by a thin little book, of the same title I think, written by a St Just

miner and recounting the collapse of a man-made engine that killed most of the men The dominant steep cliff face in each of the three images eventually went under the sea.' (AC, 31/12/1999)

ea purchased the twelve plates cut by Currell when a student at Central to edition them in 1964, though printing continued into 1967 as 'Douglas Allsop stopped printing before he had finished'. (Terry Benton to AC 13/9/1967)

233 Townscape
Drypoint with plate tone, printed in black on handmade paper
Plate: 499 × 400 mm (19$\frac{5}{8}$ × 15$\frac{3}{4}$ in), paper: 717 × 570 mm (28$\frac{1}{4}$ × 22$\frac{7}{16}$ in, edge folded back) (ea 148)
Coll: South London Gallery

'This is my first serious body of work, the way I did them was forced on me by circumstances. The scenes were based on drawings done in Wales, in the Rhonda Valley, which I regularly visited as a child. I would see miners coming back from the pit My father worked in a factory and duralumin were off-cuts I picked up' (AC 31/12/1999)

Currell considers this his first 'acceptable' print, shown at *The Graven Image* exhibition, 1962. Telegraph poles as much as the structure of the land fill this scene. It relates to another linear composition, also entitled *Townscape*, and owned by the artist.

234. Williamstown*
Drypoint, printed in black
Plate: 445 × 300 mm (17$\frac{1}{2}$ × 11$\frac{13}{16}$ in) (ea 149)
Lit: *A Decade of Printmaking*, p.13 (ill.)

235 Miner
Drypoint, printed in black on handmade Crisbrook paper
Plate: 622 × 468 mm (24$\frac{1}{2}$ × 18$\frac{7}{16}$ in), paper: 793 × 582 mm (31$\frac{1}{4}$ × 22$\frac{15}{16}$ in) (ea 150)

Single figure with wide white scarf-front and centred light.

236 Miner, No 2
Drypoint, printed in black
Plate: 579 × 403 mm (22$\frac{13}{16}$ × 15$\frac{7}{8}$ in), paper: 763 × 559 mm (30$\frac{1}{16}$ × 22 in) (ea 151)

Obscured face of single miner with open white scarf-front running the length of his clothes, two telegraph posts behind on the left.

237 Miner, No 3 (Page 65)
Drypoint with wiped tone, printed in black on handmade Crisbrook paper
Plate: 605 × 452 mm (23$\frac{13}{16}$ × 17$\frac{13}{16}$ in), paper: 790 × 570 mm (31$\frac{1}{8}$ × 22$\frac{7}{16}$ in)
Insc bl: *Anthony Currell*, bc: '*Miner 3*', br: *Artists proof* (pencil) (ea 152)
Coll: ACE

238 Miner, No 4*
Drypoint, printed in black
Plate: 355 × 280 mm (14 × 11$\frac{11}{32}$ in, approx.) (ea 153)

Diagonal hunched figure of a miner, with back view of a small figure in the left background. The Walker Art Gallery (National Galleries on Merseyside) owns a closely related *Two Miners* print from an edition of fifteen, which was sold but not published by ea.

239 Two Miners, No 1*
Drypoint, printed in black
Plate: 610 × 455 mm (24 × 17$\frac{15}{16}$ in) (ea 154)

Three-quarter-length figure directly confronting the viewer, with silhouette of figure in left background.

240 Two Miners, No 2*
Drypoint, printed in black
Plate: 510 × 455 mm (20$\frac{1}{16}$ × 17$\frac{15}{16}$ in) (ea 155)

Blocked figure of miner on left with partly sectioned second figure on right.

241 Two Miners, No 3*
Drypoint, printed in black
Plate: 610 × 455 mm (24 × 17$\frac{15}{16}$ in) (ea 156)

Two miners blocked together on a diagonal. MOMA own a related *Two Miners* with heavily obscured faces, from an edition of fifteen.

'The shirt fronts of the miners appear like big white strips that also operate in the landscape. It is a visual device The white shirt front in fact comes from the white scarfs that the miners used to wear . . . I needed the weight of the paper to take the ink . . . really a balance between black and the lines, or the question of shape; colour did not come into it . . . I cut as hard, as close and as deeply as possible. To achieve the whites, I wiped the plates with french chalk and rag, being careful around the lines as I did not want to mix the chalk with the ink to create a grey. I just wanted black and white.' (AC, 31/12/1999)

François Dallegret (b.Port Lyautey, Morocco, 1937)

Exhibiting with Galerie Iris Clert, Paris since 1962, alongside exhibitions in Quebec, USA and Europe.

242 Flikker Book, No. 1, 1972 (Page 225)
Off-set lithograph, printed in black; 75 × 93 mm (2$\frac{15}{16}$ × 3$\frac{11}{16}$ in)
Printed front: *Flikker book/ François Dallegret*, end page: *Dallegret*
Pr: Hillingdon Press, Uxbridge; pub: AI, 1972

Silhouetted kiss.

Alan Davie (b.Grangemouth, 1920)

Scholarship to Edinburgh College of Art, 1938. Travelling after the war, encountered Peggy Guggenheim's collection of Surrealist and contemporary art in Venice. Settled in London. Started teaching basic design in Jewellery Department, Central School of Art, 1953. First exhibitions: Gimpel Fils, London, 1950 and 1952. Produced monotypes, 1948–50, and in 1956 first colour screenprint. Began to produce colour lithographs with Stanley Jones at Curwen Studio, 1962. Relationship between his art and jazz playing became increasingly important.

Lit: Patrick Elliott, *Alan Davie: Work in the Scottish National Gallery of Modern Art*, exh.cat., Scottish National Gallery of Modern Art, 2000

ZURICH IMPROVISATIONS, 1964–5
Portfolio of thirty-four colour lithographs, tusche, zinc plates, on B. F. K. Rives paper, measuring 630 × 900 mm (24$\frac{13}{16}$ × 35$\frac{7}{16}$ in, with variation)
Presented in black folio within green cloth-covered slipcase, inscribed along spine: *ALAN DAVIE ZURICH IMPROVISATIONS* ea
Insc b: with edition number, title as Roman numeral and signed br: *Alan Davie 65* (pencil) with ea embossed chop
Edition: 75, 15 ap (nos I, IX–XI); 25, 5 ap (nos II–VIII, XII–XXXIV)
Proofed and pr: Matthieu AG, Zürich, 1964–5; pub: 1965
(ea 42–75)
Exh: *Alan Davie Zurich Improvisations*, Gimpel Fils, London, 25 May–19 June 1965
Coll: SNGMA; British Council (incomplete)

On arriving at the Matthieu Studio, Davie began working on the series *Ghost of a Chance*. This was subsequently sold (but not published) by ea as a sequence of four lithographs, alongside *Ducky, lets be friends*, also printed at Matthieu. As described by Paul Cornwall-Jones, the plates for *Zurich Improvisations* were started shortly afterwards, 'They were initially intended as three images from five plates each, but as the proofing continued and accelerated over an intense period of some five days, ended up as an edition of thirty-four prints, each made up from up to ten different plates, some printed upside down.' Davie himself remarks that 'I think the six old master printers there found the whole process an enlightening experience as they all actively collaborated in the production in an instructive and creative way.' (AD, 11/8/1997)

243 I (Page 68)
Lithograph, printed in blue, pink, purple, black, yellow
Image: 530 × 715 mm (20$\frac{7}{8}$ × 28$\frac{3}{16}$ in) (ea 42)
Coll: Fitzwilliam Museum, Cambridge

244 II
Lithograph, printed in yellow, purple, blue, pink, black
Image: 535 × 715 mm (21$\frac{1}{16}$ × 28$\frac{3}{16}$ in) (ea 43)

245 III
Lithograph, printed in green, black, orange, green, wine red
Image: 520 × 730 mm (20 $\frac{1}{2}$ × 28 $\frac{3}{4}$ in) (ea 44)

246 IV
Lithograph, printed in blue, yellow, black, blue, purple
Image: 550 × 725 mm (21 $\frac{21}{32}$ × 28 $\frac{9}{16}$ in) (ea 45)

247 V
Lithograph, printed in purple, black, yellow, dark pink
Image: 510 × 765 mm (20 $\frac{1}{8}$ × 30 $\frac{1}{8}$ in) (ea 46)

248 VI
Lithograph, printed in red, yellow, pink, purple, black
Image: 537 × 775 mm (21 $\frac{5}{32}$ × 30 $\frac{1}{2}$ in) (ea 47)

249 VII
Lithograph, printed in red, blue, pink, black, purple
Image: 548 × 780 mm (21 $\frac{9}{16}$ × 30 $\frac{3}{4}$ in) (ea 48)

250 VIII
Lithograph, printed in yellow, green, red, purple, dusty pink, black, grey
Image: 525 × 750 mm (20 $\frac{11}{16}$ × 29 $\frac{17}{32}$ in) (ea 49)

251 IX
Lithograph, printed in yellow, pink, purple, black, blue
Image: 550 × 750 mm (21 $\frac{11}{16}$ × 29 $\frac{9}{16}$ in) (ea 50)
Coll: Art Gallery of Ontario, Toronto

252 X
Lithograph, printed in red, purple, yellow, blue, black, pink
Image: 540 × 780 mm (21 $\frac{1}{4}$ × 30 $\frac{23}{32}$ in) (ea 51)

253 XI (Page 68)
Lithograph, printed in red, yellow, purple, black, blue
Image: 552 × 780 mm (21 $\frac{3}{4}$ × 30 $\frac{3}{4}$ in) (ea 52)
Coll: Whitworth Art Gallery, University of Manchester

254 XII
Lithograph, printed in red, pink, blue, yellow, black
Image: 543 × 778 mm (21 $\frac{3}{8}$ × 30 $\frac{5}{8}$ in) (ea 53)

255 XIII
Lithograph, printed in red, purple, yellow, pink, black
Image: 534 × 777 mm (21 $\frac{1}{32}$ × 30 $\frac{5}{8}$ in) (ea 54)

256 XIV
Lithograph, printed in red, blue, yellow, purple, black
Image: 548 × 780 mm (21 $\frac{19}{32}$ × 30 $\frac{23}{32}$ in) (ea 55)

257 XV
Lithograph, printed in red, pink, purple, yellow, black
Image: 547 × 775 mm (21 $\frac{9}{16}$ × 30 $\frac{1}{2}$ in) (ea 56)

258 XVI
Lithograph, printed in red, blue, black, pink, purple
Image: 554 × 780 mm (21 $\frac{13}{16}$ × 30 $\frac{23}{32}$ in) (ea 57)

259 XVII
Lithograph, printed in red, blue, black, yellow, purple, green
Image: 549 × 780 mm (21 $\frac{5}{8}$ × 30 $\frac{3}{4}$ in) (ea 58)

260 XVIII
Lithograph, printed in red, blue, yellow, purple, olive green
Image: 557 × 779 mm (21 $\frac{15}{16}$ × 30 $\frac{11}{16}$ in) (ea 59)

261 XIX
Lithograph, printed in yellow, pink, red, black, purple
Image: 546 × 780 mm (21 $\frac{1}{2}$ × 30 $\frac{3}{4}$ in) (ea 60)
Coll: Southampton City Art Gallery

262 XX
Lithograph, printed in red, purple, yellow, black, pink
Image: 535 × 780 mm (21 $\frac{1}{16}$ × 30 $\frac{23}{32}$ in) (ea 61)

263 XXI
Lithograph, printed in yellow, red, purple, black, orange
Image: 540 × 784 mm (21 $\frac{1}{4}$ × 30 $\frac{7}{8}$ in) (ea 62)

264 XXII
Lithograph, printed in orange, black, green, red
Image: 549 × 780 mm (21 $\frac{5}{8}$ × 30 $\frac{23}{32}$ in) (ea 63)
Coll: National Museum and Gallery, Cardiff

265 XXIII (Page 68)
Lithograph, printed in yellow, black, orange, red, purple
Image: 550 × 780 mm (21 $\frac{21}{32}$ × 30 $\frac{23}{32}$ in) (ea 64)

266 XXIV
Lithograph, printed in black, red, green, orange, purple
Image: 535 × 775 mm (21 $\frac{1}{16}$ × 30 $\frac{1}{2}$ in) (ea 65)
Coll: Glasgow Museums

267 XXV
Lithograph, printed in black, orange, red, purple, ochre
Image: 535 × 774 mm (21 $\frac{1}{16}$ × 30 $\frac{1}{2}$ in) (ea 66)

268 XXVI
Lithograph, printed in black, red, pink, yellow, purple, orange
Image: 533 × 772 mm (21 × 30 $\frac{13}{32}$ in) (ea 67)

269 XXVII
Lithograph, printed in yellow, green, red, purple, pink, black
Image: 557 × 780 mm (21 $\frac{15}{16}$ × 30 $\frac{23}{32}$ in) (ea 68)

270 XXVIII
Lithograph, printed in yellow, purple, pink, black, red, green
Image: 537 × 775 mm (21 $\frac{3}{16}$ × 30 $\frac{1}{2}$ in) (ea 69)

271 XXIX
Lithograph, printed in black, blue, yellow, red, orange ochre
Image: 537 × 775 mm (21$\frac{3}{16}$ × 30$\frac{1}{2}$ in) (ea 70)

272 XXX
Lithograph, printed in black, blue, red, pink, orange, purple
Image: 554 × 777 mm (21$\frac{13}{16}$ × 30$\frac{5}{8}$ in) (ea 71)

273 XXXI
Lithograph, printed in orange, red, black, blue, pink
Image: 535 × 775 mm (21$\frac{1}{16}$ × 30$\frac{1}{2}$ in) (ea 72)

274 XXXII
Lithograph, printed in pink, blue, purple, red, yellow, orange
Image: 542 × 775 mm (21$\frac{3}{8}$ × 30$\frac{1}{2}$ in) (ea 73)
Coll: Financial Times

275 XXXIII
Lithograph, printed in black, yellow, red, blue, purple, orange
Image: 541 × 780 mm (21$\frac{5}{16}$ × 30$\frac{23}{32}$ in) (ea 74)

276 XXXIV (Page 68)
Lithograph, printed in yellow, black, purple, red, green, blue, orange ochre
Image: 542 × 780 mm (21$\frac{3}{8}$ × 30$\frac{23}{32}$ in) (ea 75)

Anthony Deigan (b.Ireland, 1945)

Walthamstow College of Art, and Maidstone College of Art, 1964–8 studying graphic design. Anglo-French Scholarship to study printmaking in Paris, 1968. Following year worked as print technician in etching department at St Martin's School of Art, London, while living in Saffron Walden, Essex. From 1981, annual visits to Australia; migrated in 1991. Teaches etching at Berrima District Art Society, Bowral, while working as an artist.

Lit: *A Decade of Printmaking*, 1973

277 Somebodies Old Pot, 1968*
Series of nineteen etchings, individual zinc plates, with aquatint and stencils, various colours, and accompanying letterpress poem, printed on handmade Crisbrook 140 lb paper
Plate: 135 × 185 mm (5$\frac{5}{16}$ × 7$\frac{5}{16}$ in), paper: 215 × 267 mm (8$\frac{15}{32}$ × 10$\frac{1}{2}$ in)
Insc bl: with title in Roman numeral and edition number;
br: signed *A Deigan* and dated *'68* (pencil)
Edition: 25, 1 ap and proofs
Pr: The artist, Maidstone College of Art, summer 1968; pub: 1968 (ea 581)

The prints were already editioned when seen by Anthony Mathews at ea, 'He organised a box for presentation to be made. I wanted something in ceramic to be in keeping with the pottery idea, but we settled for white perspex slipcase box with screenprinted title I was interested in bits/shards of

household china scattered in the garden beds of country houses, along pathways and amongst bushes surrounding houses; the people who may have used the original object, the person who broke it and its maker. The fragments, mostly cups, plates, dishes etc., were the pride of some household but when broken were just discarded in the corner of the garden I loosely wrote the poem around that thought'

Somebodies old pot

along the back path
watching from the bushes was a peeping Tom
whom we noticed and whom we watched in turn
eluded and followed the path along beside the pond
coming too soon on your favourite girl

with green leaves over my head I lay down under the sycamore tree
what a strange sun that day

Toni showed and gave me some shards of china found in her garden
those were the days when pots were pots
and when flowers grew close to the ground
when the word spread of that afternoon
it was decided that our hero would not be going to heaven

but as our hero walked along the path unperturbed
pointing and saying look at that
among the gooseberry bushes somethings shining brightly
thats no rose cottage
wash off the dirt its all hand drawn
and quite beautiful a jewel in the darkness

ah I never like anything

I Did, 1969
Series of eight colour etchings, single oval shaped chrome-faced zinc plates, on handmade Crisbrook 140 lb paper, with folded sheet printed with poem by Anthony Deigan and colophon details
Plate: 196 × 255 mm (7$\frac{23}{32}$ × 10$\frac{1}{16}$ in, oval), paper: 288 × 400 mm (11$\frac{3}{8}$ × 15$\frac{3}{4}$ in, slight variation)
Insc bm: with edition number, title as roman numeral, signed and dated: *Deigan '69* (pencil)
Edition 75, 15 ap
Pr: The artist, Saint Martin's School of Art; box design by Haarlem Picture Framers and typography by Collis Clements; pub: October 1969 (ea 608–15)

'*I Did* was seen in proof form . . . a set of twelve but edited down to eight by Anthony Mathews. He required me to edition at seventy-five with fifteen proofs, so the zinc plates needed to be chrome-faced by Thomas Ross. There was also a box made for presentation and a wrap-around sheet with the poem and the colophon I thought at the time it would be fun to have my typography lecturer (Collis Clements), from Maidstone College of Art, to design the layout of the poem etc The poem was written in 1968 recalling my childhood in Ireland, and the edition

printed during the summer holidays at St Martin's School of Art on a Dickerson Combination Press in 1969.' (AD, 20/11/2000)

278 I
Etching, open bite and stencil, printed in brown, green, grey, blue
(ea 608)

279 II
Etching and aquatint, open bite and stencils, printed in brown, green, grey green, with red, yellow, mauve and blue
(ea 609)

280 III
Etching, open bite and stencils, printed in brown, blue, black, green with yellow, green, red
(ea 610)

281 IV
Etching, open bite, soft-ground and stencils, printed in blue, ochre, with green, red
(ea 611)

282 V
Etching and aquatint, open bite, soft-ground, and stencil, printed in green, brown, blue with red
(ea 612)

283 VI
Etching and aquatint, with soft-ground and stencil, printed in brown, red, grey with yellow
(ea 613)

284 VII (Page 169)
Etching and aquatint, with soft-ground and stencils, printed in black, green with green, red
(ea 614)

285 VIII
Etching and aquatint, with soft-ground, open bite and stencil, printed in olive green, blue, red, grey with yellow
(ea 615)

I DID

I did you ever go for long walks/ ride in a donkey cart/ or on the back of a pig

II did you ever visit a sandpit and see the sandmartins homes/ play in a sandpit among hills covered in yellow gorse/ or try to catch butterflies on clumps of thistles

III did you ever pick wild strawberries at the edge of a wood/ fall off a bicycle after playing in a farmyard/ or see a freshly ploughed field through drizzle

IV did you ever swim in a sandy bottomed river/ catch pinkeens and eels/ or eat hawberries and play in ripe corn

V did you ever play hurling in a field surrounded by hedges/ see where the tinkers had camped/ or go rabbit shooting with your father

VI did you ever dance across the kitchen floor/ or see a farmer play an accordian/ or have a bath in front of the kitchen fire/

VII did you ever think your father dead and cut his hair to wake him up/ see a dead man/ or go to a wake

VIII did you ever draw with coloured chalks on the stone kitchen floor/ get chased by a donkey/ or stand chest high in a field full of dog-daisies

I DID/ Anthony Deigan

FOUR THOUGHTS IN A ROOM, 1969
Series of four colour etchings, zinc plate, on handmade Crisbrook 140 lb paper
Plate: 232 × 335 mm (9 $\frac{1}{8}$ × 13 $\frac{3}{16}$ in), paper: 394 × 565 mm (15 $\frac{1}{2}$ × 22 $\frac{1}{4}$ in, slight variation)
Insc bl: with edition number and title, br: signed *Deigan* and date *'69* (pencil)
Edition: 30, 3 ap
Pr: The artist, St Martin's School of Art, London; pub: November 1969 (ea 624–7)

286 I could make love to that right now
Etching, aquatint with stencil, printed in grey and red
(ea 624)

287 Have you seen? He's just left the room
Etching, aquatint with stencil, printed in grey and red
(ea 625)
Coll: British Council

288 Coming in the window I
Etching, aquatint with stencil, printed in ochre and red
(ea 626)
Coll: British Council

289 Coming in the window II
Etching, aquatint with stencil, printed in ochre, red, pale green
(ea 627)
Coll: British Council

290 Sing to the mirror, 1969
Etching, open bite, printed in green, black, blue, red on Crisbrook 140 lb paper
Insc on image: *there once was an ugly/ duckling/ with feathers all stuffy*; bl: *Artists Proof*, bc: *Sing to the mirror*, br: *Deigan '69* (pencil)
Plate: 231 × 337 mm (9 $\frac{3}{32}$ × 13 $\frac{1}{4}$ in), paper: 392 × 459 mm (15 $\frac{7}{16}$ × 18 $\frac{1}{16}$ in)
Edition: 30, 5 ap
Pr: The artist, St Martin's School of Art, London; pub: 1969
(ea 634)

291 Blowing bubbles, 1969*
Colour etching
Plate: 235 × 335 mm (9 $\frac{1}{4}$ × 13 $\frac{3}{16}$ in, approx.)
Edition: 30, 5 ap
Pr: The artist, St Martin's School of Art, London; pub: 1969
(ea 635)

Richard Demarco (b.Edinburgh, 1930)

Edinburgh College of Art, 1949–53. Mounted his first exhibitions of contemporary art in Edinburgh at Jim Haynes's Paperback Bookshop, and then at Traverse Gallery. Founder member of Traverse Theatre, 1963. Launched Richard Demarco Gallery at 8 Melville Crescent, 1966, which moved to various locations in Edinburgh, before becoming The Demarco European Foundation,1993. Long associations with Malta and with promotion of Eastern European Arts in Britain. Elected to Royal Scottish Society of Painters in Watercolours and Society of Scottish Artists.

MALTA SUITE, 1969–70

Five hard-ground etchings, single copperplates, on Crisbrook J. Green waterleaf 140 lb paper, measuring 470 × 380 mm (18 $\frac{1}{2}$ × 14 $\frac{31}{32}$ in, slight variation)
Insc bl: with title and edition/proof number, signed br: *Richard Demarco* (pencil), vo: ea stamp and number
Edition: 75, 15 ap
Pr: James Collyer, Alecto Studios, 1969–70; pub: 1970
(ea 653–7).
Exh: Alecto Gallery, Albemarle Street, London, 1970; *Malta Now*, St George's Park (Administration Building), Spinola, Malta, 3–18 July 1970

292 Senglea, Malta
Etching, printed in black
Plate: 380 × 277 mm (14 $\frac{31}{32}$ × 10 $\frac{29}{32}$ in) (ea 653)

293 Scots Street, Valletta
Etching, printed in black
Plate: 379 × 280 mm (14 $\frac{15}{16}$ × 11 $\frac{1}{32}$ in) (ea 654)

294 St Julian's, Malta
Etching, printed in black
Plate: 282 × 380 mm (11 $\frac{1}{8}$ × 14 $\frac{31}{32}$ in) (ea 655)

295 Victoria, Gozo
Etching, printed in black
Plate: 278 × 379 mm (10 $\frac{15}{16}$ × 14 $\frac{15}{16}$ in) (ea 656)

296 Dingli, Malta
Etching, printed in black
Plate: 278 × 382 mm (10 $\frac{15}{16}$ × 15 $\frac{1}{16}$ in) (ea 657)

In 1968 Richard Demarco produced a series of line drawings of the streets and tall, closely packed houses typical of the harbour towns of Valletta and Senglea in Malta. He showed these to his friend Michael Spens who, as Director of Alecto International, approached Joe Studholme. The result was Demarco's first suite of etchings. 'I don't draw great buildings but the domestic spaces in between: a narrow street which invites you to enter the city and represents a human space When drawing I am not automatically thinking of aesthetics but defending a truth about what is going on in architecture' (RD, 30/8/1999)

LONDON SCENES, 1974

Series of six screenprints printed on cartridge paper
Image and paper: 455 × 658 mm (17 $\frac{15}{16}$ × 25 $\frac{15}{16}$ in)
Insc bl: with title and edition number, br signed and dated: *Richard Demarco 1974* (pencil)
Edition: 250, 100 printed, with at least 10 ap
Pr: Megara Screenprinting Ltd, Alecto Studios, London: pub: 1974 (ea 870–5)

297 St Paul's, Covent Garden
Screenprint, printed in black, green and lilac grey
(ea 870)

298 Shepherd Market, Mayfair
Screenprint, printed in black, pink and lilac grey
(ea 871)

299 Canning Place, Kensington
Screenprint, printed in black, lilac grey and green
(ea 872)

300 Kynance Mews, Kensington
Screenprint, printed in black, blue and pink
(ea 873)

301 St James' Palace
Screenprint, printed in black, grey and pink
(ea 874)

302 Kensington Gardens
Screenprint, printed in black, olive green and bright green
(ea 875)

Robyn Denny (b.Abinger, Surrey, 1930)

St Martin's School of Art, 1951–4, and RCA,1954–7. Various teaching jobs, including Slade School of Fine Art from 1965. First solo exhibition at Gallery One, 1957, subsequently showing at Gimpel Fils and Kasmin Ltd (all London). *ICA Screenprint Project*, 1964. Prize winner at John Moores, Liverpool, 1965 and 1978. Retrospective at Tate Gallery, 1973. Continued to produce screenprints in series, notably with Kelpra Studio, during 1960s and 1970s. *Robyn Denny* at Hirschl Contemporary Art, London, 2002.

SUITE 66 (1–10), 1966
Series of ten screenprints on British fluorescent cartridge paper 94 lb imperial paper, measuring 758 × 495 mm (29 $\frac{7}{8}$ × 19 $\frac{1}{2}$ in)
Presented in white perspex box designed by Gordon House and insc: *Robyn Denny Suite 66/ A series of 10 screenprints each 30 × 20 in/ 76.2 × 50.8 cms/ printed at Kelpra Studio, London/ on Fluorescent Cartridge Paper/ Published by Editions Alecto, London 1966/ in editions limited to 75 with 15 sets of artist's proofs*; box size: 797 × 535 mm (31 $\frac{3}{8}$ × 21 $\frac{1}{16}$ in)
Insc br: with edition number, signature and date *Denny 66* (pencil), vo: ℮a stamp and number, *K* stamp and number of Kelpra Studio
Edition: 75, 1–25 printed, 15 ap
Pr: Kelpra Studio, London (invoiced 25/5/1966); pub: 1966 (℮a 318–27)
Coll: V&A; Tate; ACE and British Council (both incomplete)

303 I
Screenprint, printed in brown, blue and green grey
Image: 466 × 363 mm (18 $\frac{3}{8}$ × 14 $\frac{5}{16}$ in) (℮a 318)

304 II
Screenprint, printed in dark blue, dark purple, dark green
Image: 467 × 364 mm (18 $\frac{3}{8}$ × 14 $\frac{5}{16}$ in) (℮a 319)
Coll: Sheffield Galleries and Museums Trust

305 III (Page 114)
Screenprint, printed in blue-grey, red maroon, brown
Image: 614 × 383 mm (24 $\frac{3}{16}$ × 15 $\frac{1}{16}$ in) (℮a 320)

306 IV
Screenprint, printed in maroon brown, lilac blue, olive green
Image and paper: 758 × 495 mm (29 $\frac{7}{8}$ × 19 $\frac{1}{2}$ in) (℮a 321)
Coll: Aberdeen Art Gallery; Arthur Andersen, London; MOMA

307 V
Screenprint, printed in dark blue, brown, grey blue
Image: 613 × 380 mm (24 $\frac{1}{8}$ × 15 in) (℮a 322)

308 VI
Screenprint, printed in blue, maroon brown, purple brown
Image and paper: 758 × 495 mm (29 $\frac{7}{8}$ × 19 $\frac{1}{2}$ in) (℮a 323)

309 VII
Screenprint, printed in brown and blue-grey
Image: 410 × 356 mm (16 $\frac{1}{8}$ × 14 $\frac{1}{32}$ in) (℮a 324)

310 VIII
Screenprint, printed in maroon and dark green
Image: 400 × 332 mm (15 $\frac{3}{4}$ × 13 $\frac{1}{16}$ in) (℮a 325)

311 IX
Screenprint, printed in dark blue, dark green, brown
Image: 414 × 358 mm (16 $\frac{5}{16}$ × 14 $\frac{1}{8}$ in) (℮a 326)
Coll: Fitzwilliam Museum, Cambridge

312 X
Screenprint, printed in dark green, grey, blue
Image: 357 × 488 mm (14 $\frac{1}{16}$ × 19 $\frac{1}{4}$ in) (℮a 327)
Coll: Arthur Andersen, London

COLOUR BOX SERIES, 1968–9 (Pages 172–3)
Series of five screenprints, using five colours, individually printed onto four separate sheets of acrylic
Boxed in a perspex lid box with aluminium frame and backing 620 × 519 × 32 mm (24 $\frac{7}{16}$ × 20 $\frac{7}{16}$ × 1 $\frac{17}{32}$ in)
Insc br: signed and dated *Denny '69* with edition number (engraved), vo printed: *Colour Box Series 1969 Number 1-V/ Produced and published by Editions Alecto London/* ℮a *572-576*
Edition: 75, two series; with 47 sets produced initially (one ap set to Robyn Denny). A shipment of 140 boxes to America was so badly damaged in transit that they had to be withdrawn from the market.
Pr: Lyndon Haywood, Alecto Studios, London, 1968–9; pub: 1969 (℮a 572–6)
Coll: Tate

Working with a manufacturer in Pontefract, twenty-five sets and twelve proofs were produced as a second edition, and signed by Denny in 1973. They are identified by a board backing, signed: *Denny V/ X11 Artists Proof/ Colour Box (2nd Series) 1969/ 73* (ink).

313 Colour Box I (Scarlet)
Screenprint, printed in scarlet and violet
(℮a 572)

314 Colour Box II (Violet)
Screenprint, printed in violet and turquoise
(℮a 573)
Coll: Leicestershire Museums, Arts and Records Service

315 Colour Box III (Turquoise)
Screenprint, printed in turquoise and lime green
(℮a 574)

316 Colour Box IV (Lime Green)
Screenprint, printed in lime green and orange
(℮a 575)
Coll: ACE

317 Colour Box V (Orange)
Screenprint, printed in orange and scarlet
(℮a 576)

SIX MINIATURES, 1975
Unlimited edition of six colour screenprints printed on Huntsman
Cartridge 200 gms paper
Image: 680 × 945 mm (26$\frac{7}{8}$ × 37$\frac{3}{16}$ in); paper: 718 × 972 mm
(28$\frac{1}{4}$ × 38$\frac{1}{4}$ in)
Insc br: *Denny '75* (pencil)/ *Six miniatures by Robyn Denny
Published for PSA Supplies Division by Editions Alecto Ltd.
© 1975 Screenprinted in London, England* (pen)

Pr: Leslie Hosgood and Robert Jones of Megara Screenprinting
Ltd, Alecto Studios, London, 1975. Part of the programme of
unlimited edition prints commissioned and published by Editions
Alecto Ltd for PSA, Department of the Environment, 1975
(ℯℊ 905–10)
In a letter dated 24 April 1975, Joe Studholme writes to Robyn
Denny to confirm that the PSA 'will pay a fee of £1000 . . .
probably by buying a study related to the print, for the run of
2000–2500. It is our intention that over and above the
Government run, your print will be sold to educational outlets,
museums and wholesalers throughout the world. On these sales
we will pay a royalty of 10 % of the net trade price. We hope to
establish a retail price of £5.00 per print, with a trade price of
£2.50. This would imply a royalty to you of £0.25 a sheet.'
Coll: Aberdeen Art Gallery; Cartwright Hall Art Gallery, Bradford

318 Red
Printed in red, yellow, green, black, blue, darker blue with white
varnish contours
(ℯℊ 905)

319 Yellow
Printed in yellow, green, red, black, blue, darker blue with white
varnish contours
(ℯℊ 906)

320 Green
Printed in green, yellow, red, black, two blues and white varnish
contours
(ℯℊ 907)

321 Dark Blue
Printed in dark blue, lighter blue, yellow, green, red, black and
white varnish contours
(ℯℊ 908)

322 Light Blue
Printed in light blue, dark blue, yellow, green, red, black and
white varnish contours
(ℯℊ 909)

323 Black
Printed in black, yellow, green, two blues, red and white varnish
contours
(ℯℊ 910)

Jennifer Dickson (b.Piet Retief, South Africa, 1936)

Goldsmiths' College of Art, 1954–9, before joining Atelier 17 in Paris,
to work under S. W. Hayter, 1960 and intermittently until 1965. *The
Graven Image* exhibition, 1962. Awarded Prix des Jeunes Artistes
Gravure, at Biennale de Paris, 1963. This resulted in an invitation to
exhibit at the next Paris Biennale, for which the portfolio *La Genèse*
was made. Developed and directed Printmaking Department, Brighton
College of Art, 1962–8, later teaching at Faculty of Fine Arts,
Concordia University, Montreal. Elected RA,1976. Prints and exhibits
internationally.

Coll: Agnes Etherington Art Centre, Queen's University, Ontario; BMAG

ALECTO KEYS, 1961–4
Term chosen by the artist to identify thirteen intaglio prints
published by ℯℊ, 1964
Printed by the artist in etching studio at Brighton College of Art,
unless stated otherwise
Exh: *Jennifer Dickson Graphics 1963–1964*, The Print Centre,
8 Holland Street, London, 1964 (ill.cat.)

324 Moon Forest, 1961
Colour etching, zinc plate, deeply etched, simultaneous printing
in blues and yellow ochre
Plate: 390 × 392 mm (15$\frac{3}{8}$ × 15$\frac{7}{16}$ in), paper: 518 × 510 mm
(20$\frac{3}{8}$ × 20$\frac{1}{8}$ in)
Insc bl: *15/25*, bc: *Moon Forest*, br: *Jennifer Dickson '61*
(pencil)
Edition: 25, proofs (ℯℊ 132)
Coll: GAC

325 Moon over Water II, 1963*
Colour etching and aquatint, steel plate, simultaneous printing in
violet and blue
Plate: 546 × 451 mm (21$\frac{1}{2}$ × 17$\frac{3}{4}$ in), paper: 800 × 585 mm
(31$\frac{1}{2}$ × 23$\frac{1}{16}$ in)
Insc br: *Jennifer Dickson '61*
Edition: 20–30, proofs (ℯℊ 133)

326 Moon in Equilibrium, 1963
Etching and aquatint, zinc plate, printed in black
Plate: 352 × 356 mm (13$\frac{7}{8}$ × 14 in), paper: 655 × 580 mm
(25$\frac{13}{16}$ × 22$\frac{27}{32}$ in)
Insc br: *Jennifer Dickson '63* (pencil)
Edition: 15, proofs (ℯℊ 134)

327 Sombre Victory, 1963
Etching and aquatint, steel plate, simultaneous printing in brown
and blue on J. Green pasteless 200 lb board
Plate: 349 × 351 mm (13$\frac{7}{8}$ × 13$\frac{13}{16}$ in), paper: 788 × 564 mm
(31$\frac{1}{32}$ × 22$\frac{3}{16}$ in)
Insc bl: *Artist's Proof*, bc: *Sombre Victory*, br: *Jennifer Dickson
'63* (pencil)
Edition: 20, proofs (ℯℊ 135)

'This image followed one called *Strange Fruit* – for Billie Holliday, the jazz singer. *Strange Fruit* dealt with the lynching of blacks in the Southern States by the Klu Klux Klan . . . a resurrection image – the triumph of Afro-Americans over white repression. It was particularly hopeful to a South African who happened to be born the wrong colour, *ie* white.' (JD, 17/7/1998 and following quotations, unless stated otherwise)

328 Vibrant Sun, 1963

Etching and aquatint, zinc plate, deeply etched, simultaneous printing in blue and green on Crisbrook paper
Plate: 397 × 391 mm (15 $\frac{5}{8}$ × 15 $\frac{13}{16}$ in), paper: 801 × 571 mm (31 $\frac{17}{32}$ × 22 $\frac{1}{2}$ in)
Insc bl: *Artist's Proof,* bc: *Vibrant Sun,* br: *Jennifer Dickson '63* (pencil)
Edition: 20, proofs
Pr: The artist, Brighton College of Art, with assistance of Eugenio Tellez (ea 136)

'A simple mandala image, where meditation leads to equilibrium (of a rather precarious kind).'

329 Time within Time, 1963

Etching and aquatint, zinc plate, simultaneous printing in blue, brown, pink on J. Green pasteless 200 lb board
Plate: 393 × 393 mm (15 $\frac{1}{2}$ × 15 $\frac{1}{2}$ in), paper: 789 × 570 mm (31 $\frac{1}{16}$ × 22 $\frac{7}{16}$ in)
Insc bl: *Artist's Proof,* bc: *Time within Time,* br: *Jennifer Dickson '63* (pencil)
Edition: 20, proofs
Pr: The artist, Atelier 17, Paris (ea 137)

'Linked closely to my 4 × 4 [feet] paintings of this period, dark symbolic landscapes of an interior world. The cross in this instance is both sacred, and a basis of equilibrium.'

330 Low Moon, 1963/4

Etching and aquatint, zinc plate, simultaneous printing in green and brown with rolled on filter of gold pigment on J. Green pasteless 200 lb board
Plate: 607 × 408 mm (23 $\frac{29}{32}$ × 16 $\frac{1}{16}$ in), paper: 790 × 575 mm (31 $\frac{1}{8}$ × 22 $\frac{21}{32}$ in)
Insc: *Artist's Proof,* bc: *Low Moon,* br: *Jennifer Dickson '64* (pencil)
Edition: 20, proofs (ea 140)

'First in the Jazz Trilogy . . . Ronald (my husband) and I spent many evenings sitting, often on stage, at the Royal Festival Hall (behind the band) hearing not only Ellington, but also John Coltrane, Eric Dolphy, and Jerry Mulligan. *Moon* in this case is a trumpet, and the gestural strokes are music. This print has a filter of gold pigment, I believe inspired by the shimmer of stage lights on brass instruments.'

331 Dual Image, 1963–4 (Page 46)

Etching and aquatint, zinc plate, simultaneous printing in brown and black on J. Green pasteless 200 lb board
Plate: 603 × 485 mm (23 $\frac{3}{4}$ × 19 $\frac{1}{8}$ in), paper: 788 × 570 mm (31 $\frac{1}{32}$ × 19 $\frac{1}{8}$ in)
Insc bl: *Artist's Proof (1/2),* bc: *Dual Image,* br: *Jennifer Dickson '64* (pencil)
Edition: 20, 2 ap (ea 138)
Coll: GAC

'. . . the centre of the Jazz Trilogy. Made . . . very fast and spontaneously *ie* improvised, like jazz. About the arrow: I was driving daily between Lewisham and Brighton at reckless speed and as I rounded curves at night the arrow rose up at me. It became a symbol of reckless power, the male side of my persona.'

332 Such Sweet Thunder, 1963–4

Etching and aquatint, zinc plate, simultaneous printing in brown and green with black on J. Green pasteless 200 lb board
Plate: 595 × 515 mm (23 $\frac{7}{16}$ × 20 $\frac{5}{16}$ in), paper: 790 × 571 mm (31 $\frac{1}{8}$ × 22 $\frac{1}{2}$ in)
Insc bl: *Artist's Proof 2/2,* bc: *Such Sweet Thunder,* br: *Jennifer Dickson '64* (pencil)
Edition: 20, 2 ap (ea 139)
Coll: Manchester City Art Galleries

'. . . response to the Ellington composition, *Such Sweet Thunder,* a very mellow composition. Moon trumpets and improvised notes – a very full and earthy image. The acid was painted on in gestures in the aquatinted areas – a very sensual activity as I watched in naïve fascination the orange fumes rise from the plate!'

333 Mourir à Madrid, 1963–4

Etching and aquatint, deep biting, steel plate, printed in black on J. Green pasteless board 200 lb, imperial size, watermarked
Plate: 552 × 453 mm (21 $\frac{3}{4}$ × 17 $\frac{7}{8}$ in), paper: 785 × 564 mm (30 $\frac{15}{16}$ × 22 $\frac{3}{16}$ in)
Insc bl: *Epreuve d'artiste,* bc: *Mourir à Madrid,* br: *Jennifer Dickson '64* (pencil)
Edition: 30, proofs (ea 141)
Coll: National Museum of American History; Metropolitan Museum, New York

'Ronald and I were members of the London Committee of the International Brigade. In 1963 General Franco garrotted (by slow strangulation) two students in public in Madrid, who opposed his fascist regime. I was sickened by this barbaric violence and made this plate as a protest and memorial to the young men.'

334 Écritures à venir, 1964

Etching and aquatint, deep biting, copperplate, simultaneous printing in green, yellow, black on J. Green pasteless 200 lb board

Plate: 600 × 450 mm (23 $\frac{5}{8}$ × 17 $\frac{3}{4}$ in), paper: 793 × 570 mm (31 $\frac{1}{4}$ × 22 $\frac{7}{16}$ in)
Insc bl: *Epreuve d'artiste*, bc: *Écritures à venir*, br: *Jennifer Dickson '64* (pencil)
Pr: The artist, Atelier 17, Paris
Edition: 30, proofs (*ea* 142)
Coll: GAC

'Usually when I worked on copper the plate was made in Paris . . . bought at Port de Vanves from the metal merchant adjacent to the Slaughter House. We walked past the porters carrying flayed horses over their backs, like mythological beasts The symbols of both *Genesis* and *Alchemic Images* are latent in this image.'

335 Hoochie-Coochie Man (For Cyril Davis), 1963–4
Etching and aquatint, steel plate, simultaneous printing in blue and green on J. Green pasteless 200 lb board
Plate: 471 × 558 mm (18 $\frac{9}{16}$ × 22 in), paper: 575 × 787 mm (22 $\frac{5}{8}$ × 31 in)
Insc bl: *Artist's Proof*, bc: *Hoochie-Coochie Man*, br: *Jennifer Dickson '64* (pencil)
Edition: 30, proofs (*ea* 143)
Coll: GAC; South London Gallery; Leeds City Art Gallery
Lit: *Brunsdon* (ill.18)

'Made in memory of my husband's friend, the blues-man Cyril Davis who died in his mid thirties. We often heard him at the Marquee (off Oxford Street). He was the harmonica player and vocalist with Alexis Korner's group *Rhythm and Blues Incorporated* . . . well known for his rendition of *Hoochie Coochie Man*, which starts: "I've got my Mo Jo working". The wild sound of his voice, interspersed with the banshee-wail of the harmonica, reminded me of African witch doctors. Cyril on stage, with Death just behind him.'

336 Lune Sous La Mer, 1963
Etching and aquatint, steel-faced copperplate, simultaneous printing in black, pink, green on J. Green pasteless 200 lb board
Plate: 499 × 376 mm (19 $\frac{21}{32}$ × 14 $\frac{13}{16}$ in), paper: 788 × 569 mm (31 $\frac{1}{32}$ × 22 $\frac{13}{32}$ in)
Insc bl: *25/30*, bc: *Lune sous La Mer*, br: *Jennifer Dickson '63* (pencil)
Edition: 30, proofs
Pr: The artist, Atelier 17, Paris
Awarded La Prix des Jeunes Artistes Pour Gravure, Biennale de Paris, 1963 (*ea* 144)
Coll: MOMA; South London Gallery

'This print combined my obsession with water (currents, surfaces and flow) and the dominant moon image. The idea of looking simultaneously at the movement of tides as indicated by currents seen on top of the water, and being under the water, looking up. Hayter's paintings in the 1960s were dominated by water fields.'

337 Poster – Jennifer Dickson / Editions Alecto London, 1964
Off-set lithograph, two zinc plates, printed in black and brown, on J. Green Crisbrook waterleaf 140 lb HP paper
Image and paper: 800 × 570 mm (31 $\frac{1}{2}$ × 22 $\frac{7}{16}$ in)
Insc on plate: *Jennifer Dickson/ June 1964/ Editions Alecto London*, br: *Dickson '64* (pencil)
Edition: 150
Pr: Curwen Studio, London, under supervision of Stanley Jones, April 1964
Commissioned by Editions Alecto Ltd
Coll: BMAG

'I drew my two dominant symbols of that time: the moon circle (female) and arrow (male).'

LA GENÈSE (GENESIS), 1964–5
Set of ten etchings on J. Green 200 lb HP Pasteless Board Paper, with title page, list of plates and colophon sheet on three sheets
Presented in red cloth folder inside black slipcase inscribed along spine: *Jennifer Dickson La Genèse* *ea*. Overall size of portfolio: 806 × 584 mm (31 $\frac{3}{4}$ × 23 in)
Each print numbered, signed and dated *Jennifer Dickson 65* and inscribed with title in French
Edition: 50, 7 ap inscribed *Epreuve d'artiste*
Pr: The artist on her press at Steyning, near Brighton with assistance of Jack Sherriff; pub: 1965 (*ea* 205–14)
Exh: Prizewinners Section, Biennale de Paris, 1965; Zwemmer Gallery, London, 1966
Coll: V&A; BMAG; GAC (various impressions)

Ten etchings executed during Jennifer Dickson's pregnancy in 1964–5. 'The symbolic language evolved as William David grew in my womb.' (JC, 10/6/1997)

Title Page (Page 82)
Etching, zinc plate, deeply bitten, printed in relief with handset type, in black and red
Image: 300 × 352 mm (11 $\frac{13}{16}$ × 13 $\frac{7}{8}$ in), paper: 790 × 569 mm (31 $\frac{1}{8}$ × 22 $\frac{7}{16}$ in)
Insc t: *La Genèse/ Jennifer Dickson 1965*, b: *Editions Alecto, Londres*

List of Plates
Ten prints listed with French titles, date, measurements and medium, also in French
Paper: 785 × 565 mm (30 $\frac{15}{16}$ × 22 $\frac{1}{4}$ in)

Colophon
Insc: *La Genèse/ Justification de Tirage/ Gravures Imprimerie L'Artiste/ Papier J Green/ 200lbs HP Pasteless Board/ Cartons Etui Zaehnsdorf Limited, Londres/ Caractères Monotype Garamond 156/ Dessin Don Warner/ Leon Roberts/ Éditeur Éditions Alecto, Londres/ Cartons de dix gravures, éditions signées et numérotées, tirées à cinquante exemplaires,/ plus sept séries d'épreuves d'artiste*

Paper: 790 × 565 mm (31 $\frac{1}{8}$ × 22 $\frac{1}{4}$ in); insc: edition number in pencil

Don Warner and Leon Roberts both worked in the Department of Typography at Brighton College of Art.

338 L'Origine, 1964–5
Etching, zinc plate, with soft-ground and aquatint, deeply etched, printed in dark brown and green
Image: 346 × 317 mm (13 $\frac{5}{8}$ × 12 $\frac{1}{2}$ in), paper: 791 × 571 mm (31 $\frac{1}{8}$ × 22 $\frac{1}{2}$ in) (ea 205)

'All of the lunar imagery (in *La Genèse*) coincided with space exploration and the first trips to the moon . . . imagined journeys to and from other worlds; in and out of time.' (JD, 10/7/2002)

339 Les Premiers Astres, 1965 (Page 84)
Etching, two zinc plates, with soft-ground and aquatint, deeply etched, printed in orange, purple, blue, black, brown
Image: 346 × 317 mm (13 $\frac{5}{8}$ × 12 $\frac{1}{2}$ in), paper: 778 × 561 mm (30 $\frac{5}{8}$ × 22 $\frac{1}{16}$ in) (ea 206)

340 Genèse, 1964–5
Etching, steel plate, with stop-out and deep etch, printed in dark and rust brown
Image: 600 × 447 mm (23 $\frac{5}{8}$ × 17 $\frac{5}{8}$ in), paper: 789 × 570 mm (31 $\frac{1}{16}$ × 22 $\frac{7}{16}$ in) (ea 207)

'The concept of matter begining to coagulate, and solidify. The idea borne out by what was actually happening physically to the plate.' (JD, 10/7/2002, and for the following quotations)

341 Le Silence, 1965
Etching, steel plate, with soft-ground and stop-out, deeply bitten in successive layers, final delicate sanding, printed in green and blue
Image: 583 × 432 mm (22 $\frac{31}{32}$ × 17 in), paper: 785 × 569 mm (30 $\frac{15}{16}$ × 22 $\frac{7}{16}$ in) (ea 208)

'The influence of Bergman films and the Book of Revelation 8, verse 1: Now when the Lamb broke the Seventh Seal, there was silence in heaven for what seemed half an hour.'

342 Rite Cabalistique, 1964–5
Etching, steel plate, deeply bitten with stop-out and sanding with electric drill to obtain middle tones, printed in green and darker green
Image: 600 × 450 mm (23 $\frac{5}{8}$ × 17 $\frac{3}{4}$ in), paper: 792 × 578 mm (31 $\frac{3}{16}$ × 22 $\frac{3}{4}$ in) (ea 209)

'At the time I was studying alchemy – a search for the transmutation of matter.'

343 Que La Lumière Soit, 1965 (Page 83)
Etching, two zinc plates, soft-ground and aquatint with flowmaster ink resist, printed in black and grey

Image: 590 × 440 mm (23 $\frac{1}{4}$ × 17 $\frac{5}{16}$ in), paper: 791 × 573 mm (31 $\frac{1}{8}$ × 22 $\frac{9}{16}$ in) (ea 210)

'From the Book of Genesis: And God said let there be light.'

344 Souffle Sur Éden, 1965
Etching on 'much abused' copperplate, soft-ground, deeply bitten, with electric drill, aquatint on top, printed in black and grey
Image: 498 × 495 mm (19 $\frac{5}{8}$ × 19 $\frac{1}{2}$ in), paper: 789 × 570 mm (31 $\frac{1}{16}$ × 22 $\frac{7}{16}$ in) (ea 211)
Coll: South London Gallery

'The rippling lines symbolise the wind of life (conception), *ie* consciousness emerging out of darkness. I went to great trouble to create absolute impenetrable *black*.'

345 Et Dieu Créa La Femme, 1965
Etching, steel plate, deeply bitten, with stop-out and sanded, printed in red, dark blue and green
Image: 372 × 595 mm (14 $\frac{21}{32}$ × 23 $\frac{7}{16}$ in), paper: 570 × 788 mm (22 $\frac{7}{16}$ × 31 in) (ea 212)

'Nude female figure giving birth through blood.'

346 Ève, 1965
Etching, copperplate, with flowmaster resist, stop-out, deep etch, printed in red, blue and green
Image: 493 × 497 mm (19 $\frac{7}{16}$ × 19 $\frac{9}{16}$ in), paper: 787 × 565 mm (31 × 22 $\frac{1}{4}$ in) (ea 213)

'Energy and sensuality and power of female sexuality (strong influence of Bridget Riley and Op Art . . .).'

347 Le Septième Jour, 1965
Etching on zinc plate, with soft-ground, stop-out and deep etch, printed in deep green, brown, blue and yellow
Image: 332 × 475 mm (13 $\frac{1}{16}$ × 18 $\frac{11}{16}$ in), paper: 570 × 787 mm (22 $\frac{7}{16}$ × 31 in) (ea 214)
Coll: Towner Art Gallery, Eastbourne

'The world as Paradise: birth (pregnant form) and anticipation of death (crucifixion shape). Vivid greens/yellows symbolic of the Garden of Eden.'

ALCHEMIC IMAGES, 1965–6
Set of ten etchings on J. Green 200 lb Pasteless Board paper measuring 790 × 580 mm (31 $\frac{1}{8}$ × 22 $\frac{27}{32}$ in); with title page, list of plates and colophon on three sheets in yellow cloth-bound portfolio box inscribed: *Jennifer Dickson Alchemic Images* ea; overall size of box: 840 × 611 mm (33 $\frac{1}{16}$ × 24 $\frac{1}{16}$ in); Insc b with title and mostly signed and dated: *Jennifer Dickson '66*
Edition: 30, 3 ap, 2 pp
Pr: The artist, studio in Steyning, Sussex, with assistance of Jack Shirreff
Commissioned but not finally published or distributed by ea because of financial crises in 1967
Coll: V&A

Title Page

Etching and aquatint on two steel plates, printed in black with ochre border

entitled: *Alchemic Images/ The Nearer we come the Further we Ar(e Apart)*

Inscribed on l plate: *To Enter a/ Wilderness and Find a/ Temple*, bl: *Key Print*, and signed with date *'66*

Plate: 423 × 591 mm (16$\frac{11}{16}$ × 23$\frac{1}{4}$ in), paper: 575 × 793 mm (22$\frac{5}{8}$ × 31$\frac{1}{4}$ in)

Colophon

Etching and aquatint on two steel plates; printed in ochre and black wiped ink

Insc: *A suite of 10 etchings/ etched and printed by the artist on J Green 200 lb Pasteless Board/ measuring 79 cm × 58 cm/ Printed in editions of 30/ signed and numbered by the artist/ with 3 artist's proofs/ and 2 publisher's proofs/ Editions Alecto Ltd. London 1967*

bl: *Key Print*, and signed with published date *'67*

Plate: 466 × 384 mm (18$\frac{11}{32}$ × 15$\frac{1}{8}$ in), paper: 789 × 570 mm (31$\frac{1}{16}$ × 22$\frac{7}{16}$ in)

List of Plates

Etching and aquatint, two side plates, printed in ochre, listing each print with technical description, date and measurements

Insc bl: *Key Print*, and signed with date *1966*

Plates: 298 × 201 mm (11$\frac{3}{4}$ × 7$\frac{15}{16}$ in), paper: 570 × 786 mm (22$\frac{7}{16}$ × 30$\frac{15}{16}$ in)

Centre plate, steel, printed in black, showing figure measuring distance; plate 212 × 182 mm (8$\frac{3}{8}$ × 7$\frac{3}{16}$ in)

348 Paradox

Etching and aquatint, two zinc plates, printed in blue and purple brown

Plate: 293 × 484 mm (11$\frac{9}{16}$ × 19$\frac{1}{16}$ in), paper: 568 × 790 mm (22$\frac{3}{8}$ × 31$\frac{1}{8}$ in)

Same plates and text as used for Title Page

349 Nemesis

Etching with screenprint and aquatint, copperplate and two zinc plates, printed in red, ochre and green

Right plate: 210 × 180 mm (8$\frac{1}{4}$ × 7$\frac{3}{32}$ in), left plates (circle and quadrant): 450 × 464 mm (17$\frac{3}{4}$ × 18$\frac{1}{4}$ in), paper: 571 × 788 mm (22$\frac{1}{2}$ × 31$\frac{1}{32}$ in)

'Line plate of Nemesis (sight, vision) taken from *Scientific American*; screened on plate and deep etched.' (JD, 10/7/2002, and for following quotations)

350 Alchemic Landscape

Etching and aquatint, steel plate, printed in brown

Plate 590 × 491 mm (23$\frac{1}{4}$ × 19$\frac{5}{16}$ in), paper: 789 × 565 mm (31$\frac{1}{16}$ × 22$\frac{1}{4}$ in)

Coll: Towner Art Gallery, Eastbourne

'Symbol of flower (centre) and serpent eating his tail (from Alchemy).'

351 Chiromantic Imprint

Etching and aquatint with soft-ground, zinc plate, printed in ochre, green and blue

Plate 467 × 476 mm (18$\frac{3}{8}$ × 18$\frac{3}{4}$ in), paper: 791 × 568 mm (31$\frac{5}{16}$ × 22$\frac{3}{8}$ in)

'The imprint of my hand in soft-ground, to ward off evil . . . blue handprint on side of doors in Egypt, warding off evil.'

352 Kiss

Etching, aquatint and soft-ground in black

Insc on image in roundel: *To Ent/ er A Tem/ ple & Find/ A Wilder/ ness*

Plate: 431 × 558 mm (16$\frac{31}{32}$ × 22 in), paper: 568 × 786 mm (22$\frac{3}{8}$ × 30$\frac{15}{16}$ in)

'The emptiness and solitude of love between two people. Physical proximity and spiritual solitude, hence the paradox.'

353 Mask of the Dreamer

Etching and aquatint, copperplate, with blind embossing, printed in purple, blue, brown and green

Insc on image: *Wha(t is the)/ Ans(wer/ ?/ There is no answer*

Plate: 497 × 670 mm (19$\frac{9}{16}$ × 26$\frac{3}{8}$ in), paper: 568 × 793 mm (22$\frac{3}{8}$ × 31$\frac{1}{4}$ in)

Coll: Sheffield Galleries and Museums Trust

'Dreams and delusions: the masked dreamer is a self portrait/ refers to the delusional aspect of love. The arrow = male symbol.'

354 Apocalypse I

Etching, aquatint and soft-ground, four zinc plates, with blind embossing, printed in green and blue

Plate 537 × 393 mm (21$\frac{1}{8}$ × 15$\frac{1}{2}$ in), paper: 793 × 572 mm (31$\frac{1}{4}$ × 22$\frac{9}{16}$ in)

'The concept of the sun and moon being darkened (Book of Revelation: The stars in the sky fell to earth).'

355 Apocalypse II

Etching and aquatint, copperplate, printed in green and pink

Plate: 667 × 499 mm (26$\frac{1}{4}$ × 19$\frac{5}{8}$ in), paper: 791 × 570 mm (31$\frac{1}{8}$ × 22$\frac{7}{16}$ in)

'The corruption/decay of matter, hence the verdigris colour (mortality).'

356a Apocalypse III: Poem for Bel-Ami

Etching with soft-ground and aquatint, two zinc plates, printed in black and red

Plate: 572 × 737 mm (22$\frac{17}{32}$ × 29$\frac{1}{2}$ in), paper: 572 × 787 mm (22$\frac{17}{32}$ × 31 in)

One half of the circular plate is printed on this sheet, the matching print being *Ritual Procession*
Coll: Sheffield Galleries and Museums Trust

356b Apocalypse III: Ritual Procession
Photo-screenprinted etching and aquatint, three zinc plates, printed in black and red
Paper: 578 × 795 mm (22 $\frac{3}{4}$ × 31 $\frac{5}{16}$ in)
An extension of *Poem for Bel-Ami*
Coll: Sheffield Galleries and Museums Trust

The Agnes Etherington Art Centre has a number of ink, wash and white gouache studies for *Alchemic Images*.

Also known as *The Great Apocalypse*, this large two-sheet etching includes Dickson's first experiments with photo-etching. The top image of a woman stride 'The Sun-turned-to-blood' derived from a freehand drawing traced and redrawn in soft-ground on the zinc plate, then deeply etched and aquatinted. The circular central plate was a copper matrix from one of The Rolling Stones's LPs, given by the group's drummer Charlie Watts. The collaged image below was made up of xeroxing various eighteenth-century engravings picked up in Brighton flea market, photographed as a Kodalith positive, and exposed onto silkscreen for transfer onto an etched plate with bitumen varnish.

Jim Dine (*b.*Cincinnati, Ohio, 1935)

Cincinnati Arts Academy, 1951–3 moving to New York, 1958. *Happenings* of 1959–60, followed by early paintings, drawings, prints and sculptures of common objects. First painting show in London: Robert Fraser Gallery, 1965. Large part of *London 1966* exhibition at the same gallery – with drawings, watercolours and collage-collaborations with Eduardo Paolozzi – seized by police under Obscene Publications Act. Lived and worked in London, 1967–71. Prints continue to be of importance, as Dine pursues themes in various media.

Lit: *Jim Dine Complete Graphics*, Galerie Mikro, Berlin, Kestner-Gesellschaft Hanover and Petersburg Press, London, 1970

A TOOL BOX, 1966
Ten screenprints on various papers, presented in red perspex box insc: *A Tool Box/ by Jim Dine*
Image and paper: 600 × 480 mm (23 $\frac{5}{8}$ × 18 $\frac{7}{8}$ in, slight variation)
Insc: collaged strips of paper with artist's signature *Jim Dine* (pencil), vo: variously stamped with *K* and number of Kelpra Studio
Edition: 150, 30 ap
Pr: Kelpra Studio, London, April–June 1966; pub: 1966
(℮a 328–37)
Coll: V&A; ACE; National Museum of American Art, Washington; BMAG; SNGMA; New Orleans Museum of Art; National Gallery of Canada, Ottawa; MOMA

Prater charged £300 to prepare and proof ten prints in April 1966 and £3000 to edition the whole set.

Title Page
Screenprint on British fluorescent cartridge 94 lb imperial paper, with collaged photo of Jim Dine and Chris Prater at work and text: *A Tool Box/ by Jim Dine/ screenprinted and assembled by/ Christopher Prater at Kelpra Studio Ltd./ in April 1966 London, on various/ materials and papers chosen by the artist/ and the printer. Each print is 19"x24"./ Published by Editions Alecto as/ Portfolios of ten images in numbered and signed editions limited to 150/ with 30 sets of artists proofs/ Jim Dine, London 1966.*
Coll: Bibliothèque Nationale, Paris

357 Tool Box I (Black) (Page 76)
Photo-screenprint with collage of silver card strip, printed in black and white on J. Green 90 lb imperial paper
(℮a 328)

358 Tool Box II (Secateurs)
Screenprint with photographic element and half-tone collage, printed in orange, white pink, grey, black on British cartridge 94 lb imperial paper
(℮a 329)
Coll: Bibliothèque Nationale, Paris; National Gallery of Australia, Canberra

359 Tool Box III (Blue Tracing)
Screenprint with photographic element, printed in black with red horizontal strip for signature on natural tracing MS Royal paper
(℮a 330)

360 Tool Box IV (Silver)
Screenprint with photographic element printed in black with torn pieces of pink collage on Samuel Jones Silver Foil Card
(℮a 331)
Coll: National Galley of Australia, Canberra

The hammers are inscribed: *craftsman*

361 Tool Box V (Child Drawing)
Screenprint with photographic element and collaged drawing, printed in black on ivorette 6 sheet board
(℮a 332)

362 Tool Box VI (Donald Duck)
Photo-screenprint with photo-collage (artist's two small children printed in sepia), printed in black with cyan, yellow, magenta on British cartridge fluorescent 94 lb imperial paper
(℮a 333)
Coll: Brooklyn Museum of Art

363 Tool Box VII (Graph Paper)
Screenprint with photographic element and collage of safety pin, printed in black on graph paper
(℮a 334)

364 Tool Box VIII (Polka Dot) (Page 76)
Screenprint with photographic element and collage of red piece of card, printed in black and metallic silver on J. Green 90 lb imperial paper
(ꞓꞓ 335)

365 Tool Box IX (Shiny Acetate) (Page 77)
Screenprint with photo-collage, printed in black and dark grey on matt polished acetate
(ꞓꞓ 336)
Coll: Art Gallery of Ontario, Toronto

366 Tool Box X (12 Colour Strip) (Page 77)
Screenprint with photographic element and collage colour strips, printed in black on pasteless board 200 lb imperial
(ꞓꞓ 337)

The colour strips run from: dark blue, brown, yellow, green, red orange, blue, pink, red, yellow, turquoise blue, purple, green.

367 Drag: Johnson and Mao, 1967 (Page 81)
Photo-etching, two shaped plates, with stencilled colour, printed in pink, red, yellow, blue, white, green, black on Saunders mould-made paper
Plate l: 800 × 540 mm (31 ½ × 21 ¼ in), r: 755 × 580 mm (29 ½ × 22 $\frac{13}{16}$ in), paper: 867 × 1216 mm (34 ⅛ × 47 $\frac{13}{16}$ in)
Insc tl: *Drag 1967 28/53 Jim Dine* (pencil), vo: ꞓꞓ *507* stamped
Edition: 53, 9 ap, 3 pp
Pr: Danyon Black and Maurice Payne, Alecto Studios, London; pub: November 1967 (ꞓꞓ 507)
Coll: ACE; Manchester City Art Galleries; British Museum; Museum of Fine Arts, Boston; Art Gallery of Ontario, Toronto; MOMA

'Dine did not know how to etch on a large scale so I gave him a demonstration and ordered a photograph from a newspaper where the dot formation was enlarged. This could then be transferred to an intaglio plate. You did not have to draw it This was the principle in *Johnson and Mao* – using photography for what you might have done in drawing' (Anthony Mathews, 29/11/1999)

368 Wall, 1967
Etching and rubber stamp, printed in green, red orange, blue, orange yellow, black on Crisbrook handmade paper
Image and paper: 785 × 586 mm (31 × 23 $\frac{1}{16}$ in)
Insc bl: *70/120 Jim Dine 1967* (pencil)
Edition: 120, 16 ap, 2 pp
Pr: Maurice Payne, Alecto Studios, London; pub: 1967 (ꞓꞓ 509)
Coll: Wolverhampton Museum and Art Gallery; MOMA

Achilles Droungas (b.Piraeus, Greece, 1940)

Studied Graphic Arts and Stage Design at Athens School of Fine Art, 1958–65. On state scholarship studied at Slade School of Fine Art, London, 1970. Graphics published by Christie's Contemporary Art; International Graphic Arts Society, New York; Redfern Gallery, London; Zoumboulakis Gallery, Athens as well as Editions Alecto. Started painting in 1974, with first show at Zoumboulakis Gallery, 1978.

Lit: *Alecto Monographs 4*

369 A fig, a plum, a quince, an apple, a pear, 1973
Etching and aquatint, two steel-faced copperplates, multicoloured with *à la poupée* colour on J. Green waterleaf HP 310 gsm paper
Plate: 520 × 695 mm (20 $\frac{15}{32}$ × 27 ⅜ in), paper: 693 × 853 mm (27 $\frac{9}{32}$ × 33 $\frac{9}{16}$ in)
Insc bl: *9/150*, bc: *"a fig, a plum, a quince, an apple, a pear"*, br: *A Droungas 1973* (pencil), br corner: James Collyer and John Crossley embossed stamps and ꞓꞓ embossed
Edition: 150, 25 ap
Pr: James Collyer and John Crossley of J. C. Editions at Alecto Studios, London and pub: EACC, August 1973 (ꞓꞓ 826)
Coll: Tate

Droungas studied under Bartolomew Dos Santos at Slade School of Fine Art. His initial contact with ꞓꞓ came through Charles Spencer who suggested he produce a new print for EACC. The intention behind the finalised image was a still-life composition 'without any pretence'. Still life became a central theme of Droungas's paintings. (AD, 15/2/2000)

370 City under Siege, 1973
Etching and aquatint with photo-etching, two steel-faced copperplates, printed in green, brown, blue green (sky) on J. Green waterleaf HP 310 gsm paper
Plate: 530 × 691 mm (20 ⅞ × 27 $\frac{3}{16}$ in), paper: 686 × 845 mm (27 × 33 ¼ in)
Insc bl: *9/63*, bc: *"City under Siege"*, br: *A Droungas 1973* (pencil), br corner: James Collyer and John Crossley embossed stamps and ꞓꞓ embossed stamp
Edition: 63, 10 ap
Pr: James Collyer and John Crossley of J. C. Editions at Alecto Studios, London; pub: EACC, 1973 (ꞓꞓ 837)
Coll: Tate

Political image done at a time when Greece was still under military dictatorship. Against a barracade of boxes in khaki uniform, a single finger is raised in defiant triumph.

Jean Dubuffet (b.Le Havre, France, 1901–85)

Attended classes at Le Havre Art School from 1916. Continued to take up and abandon art until the early 1940s. First solo show: Galerie René Drouin, Paris, 1944. First London exhibition at ICA in 1955. Extensive lithographic activity in Vence, 1958, and in graphic studio at Rue de Rennes, Paris. Start of the *Hourloupe* series, 1962. Retrospective exhibition at Tate Gallery; Stedelijk Museum, Amsterdam and Guggenheim Museum, New York, 1966.

371 Banque de L'Hourloupe, 1966–7 (Page 117)

Boxed set of 52 numbered and titled playing cards with title page, screenprinted, in combinations of red, white, black, blue on card with reverse side printed in white, violet, black with number and title

Full size: 250 × 163 mm (9 $\frac{7}{8}$ × 6 $\frac{7}{16}$ in), box size: 265 × 180 × 100 mm (10 $\frac{7}{16}$ × 7 $\frac{1}{16}$ × 3 $\frac{15}{16}$ in)

Box screenprinted with handwritten title: *Dubuffet/ L'Hourloupe/ Cartes/ à jouer/ et à tirer*, along side: *L'Hourloupe ea*; made in Cologne through Galerie der Spiegel.

Title page: *Jean Dubuffet/ Banque de L'Hourloupe/ cartes à jouer et à tirer/ 52 playing cards with a title card/ in an original edition of 350 numbered sets/ with 30 hors commerce/ each card numbered 25 × 16 cms/ Screenprinted by Kelpra Studio, London/ Editions Alecto, London 1967/ ea*

Insc inside box: *May the best/ man win! Our words – mirages of solid/ things, repositories of temporary/ combinations of thought which/ give us the illusion of carving/ up an incarvable world . . . we/ are now going to translate them/ into playing cards, muddle them/ up, and then rearrange them in/ a different order; we will shuffle/ them and deal them back on the/ table of the spirit to make it/ fresh and green again./ J Dubuffet*

Initial idea and edition pr: Kelpra Studio, London, 1966; pub: 1967 (ea 508)

Edition: 350, 30 proofs (to artist)

Coll: Bibliothèque Nationale, Paris

After initial proofing in 1966, the original run of 400 was stopped for a change of colour and a reduced edition run that was completed after April 1967. The subjects include: *L'Arbre, L'Hoche, La Mouche, La Valise, Le Gitan, Le Cancrelat, La Plante Grasse, Le Convive, Le Cruchon, La Route, Le Démarcheur, La Cafetière, La Condensateur, L'Assassin, La Flamme, Le Meuble, La Vache, Le Farceur, La Brioche, Le Prolétaire, Le Fauteuil, Le Gommeux, L'Escalier, La Fumée, Le Sémaphone, L'Ivrogne, Le Pot de Confiture, La Cantatrice, La Salière, Le Jardin, Le Soulier, L'Apothecaire, Le Lit, Le Légume, Le Mage, La Fenêtre, Le Flibustier, La Clef, Le Capitaliste, La Chope, L'Écrivain, La Vague, La Tasse de Thé, Le Magot, Le Main, Le Soufflet, La Rose, Le Soldat, La Stèle, La Villa, La Pendule, La Ballerine.*

Geoffrey Paul Eagleton (b.1935)

See Appendix

Michael English (b.Bicester, Oxfordshire, 1941)

Ealing School of Art, where a student of the Ground Course. Painted shop fronts, including the boutique *Granny Takes a Trip* in King's Road. Formed *Hapshash and the Coloured Coat* with Nigel Waymouth. The company produced posters for 'Underground' club UFO, and helped revive art of poster design with psychedelic posters, published by Osiris Visions Ltd, 1966–8. Screen editions of super-real brand products produced with Motif Editions from 1969. Later concentrated on painting and theme of transport machinery.

372 Message 2, 1968

Poster Poem with Allen Ginsberg

Coloured off-set lithograph, printed in black, red to pink, blue, orange

Image and text: 960 × 553 mm (37 $\frac{13}{16}$ × 21 $\frac{3}{4}$ in)

Edition: unlimited

Poem printed b: Message 2/ Long since the years/ letters songs Mantras/ eyes apartments bellies/ kissed and grey bridges/ walked across in mist/ Now your brother's Welfare's/ paid by State now Lafcadio's home with Mama, now you're/ in NY beds with big poetic/ girls & go picket on the street/ I clang my finger-cymbals in Havana, Ilie/ with teenage boys afraid of the red police,/ I jack off in Cuban modern bathrooms, I ascend/ ever blue oceans in a jet plane, the mist hides/ the black synagogue, I will look for the Golem,/ I hide under the clock near my hotel, it's intermission/ for the Tale of Hoffman, nostalgia for the 19th century/ rides through my heart like the music of Die Moldau,/ I'm still alone with long black bland and shining eyes/ walking down black smokey tramcar streets at night/ past royal muscular statues on an old stone bridge,/ Over the river again today in Breughel's wintery city,/ the snow is white on all the rooftops of Prague,/ Salute beloved comrade I'll send you my tears from Moscow./ Allen Ginsberg March 1965; br: *Poster Poem by Michael English + Allen Ginsberg/ published by Ad Infinitum Limited, London © 1968 102*

Pub: Ad Infinitum Ltd, London, 1968

Coll: V&A

English considers his rendering of the sinking Statue of Liberty not particularly successful: 'I don't think I fully appreciated Ginsberg's poem.'

373 Apollinaire Said, 1968

Poster Poem with Christopher Logue

Colour off-set lithograph

Image and paper: 760 × 560 mm (29 $\frac{15}{16}$ × 22 $\frac{1}{16}$ in)

Edition: unlimited, 12 signed

Insc b: *Designed by Michael English from a poem in New Numbers by C Logue . . . © Institute of Contemporary Arts 12 Carlton House Terrace London SW1*

Pub: Ad Infinitum Ltd, London for ICA exhibition *Tout Terriblement . . . Guillaume Apollinaire 1880–1918 a celebration*, 1–27 November 1968, and distributed by Bernard Stone

Lit: George Ramsden, *Christopher Logue A Bibliography 1953–1997*, Stone Trough Books, 1997 (D21, ill, where dated March 1969)

Border text reads: *Apollinaire Said come to the edge. we must fall come to the edge it's too high. Come to the edge so they came and he pushed and they flew.*

'Michael Kustow was running the exhibition side of the ICA at the time. He suggested I write a poem for a poster to accompany the exhibition I asked Michael English to design it' (Christopher Logue, 5/3/2002)

374 Yellow No I, 1979 (Page 183)
Screenprint, fourteen colours with hand spraying, on B. F. K. Rives 300 gsm paper
Image: 585 × 915 mm (23 $\frac{1}{32}$ × 36 in), paper: 766 × 1096 mm (30 $\frac{3}{16}$ × 43 $\frac{1}{8}$ in)
Insc bl: (with variation) *BR Type 4 Diesel Electric Loco 45.140 ME 49/85* (pencil) and br: ℮a embossed, vo: ℮a *973* stamp
Edition: 85, 20 ap
Pr: Leslie Hosgood and Robert Jones, Megara Screenprinting Ltd, Alecto Studios, London; pub: 1979 (℮a 973)

' . . . to continue the illusion each one of the 85 screenprints in the edition has been hand-sprayed by the artist to record the chance effects of weather and travel on the locomotive. Each print is unique.' (℮a information sheet, July 1979)

Margaret Kroch-Frishman (*b.*Saxony, 1897–1972)

Academy for Graphic Art in Leipzig, and Staatliche Kunstschule in Berlin, where she came into contact with Kokoschka. Established reputation as a painter-sculptor and graphic illustrator. Lived in Brussels, 1934–9, before emigrating to Australia, 1939. Settled in London, 1951, producing etchings and lithographs editioned at Charlotte Street Studio as well as RCA (Peter Matthews). Exhibited widely: Andre Weil, Paris; Kozminiski Gallery, Melbourne; Gallery One, London; Galleria Santa Stefano, Venice; Painter Etchers, Conduit Street, London and The Tib Lane Gallery, Manchester, April 1967.

The following nine etchings with sugar-lift aquatint, drawn directly on copperplates, were proofed by the artist and editioned on Arches paper at Atelier Lacourière, Paris, unless otherwise stated
Edition: 100, 12 ap
Insc bl: with edition number, br: signed by artist *MKF* and dated *65* (in pencil), vo: stamped ℮a with publication number
Pub: 1965–6 (℮a 287–96)

375 Belgravia, 1965
Etching and aquatint, deeply etched, printed in black with orange and yellow
Plate: 652 × 500 mm (25 $\frac{11}{16}$ × 19 $\frac{11}{16}$ in), paper: 762 × 567 mm (30 × 22 $\frac{5}{16}$ in) (℮a 287)
Coll: GAC

View from roof of MK-F's etching studio at 17 Gerald Road, London where she lived *c.*1962–72.

376 Gondola I, 1964–5
Etching and aquatint, printed in black, yellow ochre, blue, brick red
Plate: 390 × 403 mm (15 $\frac{3}{8}$ × 15 $\frac{7}{8}$ in), paper: 759 × 570 mm (29 $\frac{7}{8}$ × 22 $\frac{7}{16}$ in) (℮a 288)

377 Gondola II, 1964–5
Etching and aquatint, printed in black, pink, ochre brown, blue-grey on Crisbrook paper

Plate: 403 × 452 mm (15 $\frac{7}{8}$ × 17 $\frac{13}{16}$ in), paper: 570 × 800 mm (22 $\frac{7}{16}$ × 31 $\frac{1}{2}$ in)
Pr: David Zaig, ? London (℮a 289)

View of Terrazza Regina near San Marco, Venice.

378 Gondola III, 1965
Etching and aquatint, printed in black, pink, ochre brown, blue
Plate: 403 × 455 mm (15 $\frac{7}{8}$ × 17 $\frac{15}{16}$ in), paper: 570 × 800 mm (22 $\frac{7}{16}$ × 31 $\frac{1}{2}$ in) (℮a 290)
Coll: GAC

An early black proof of this image is dated as early as 1962, and a version in two colours 1966.

379 Orchid, 1965 (Page 64)
Etching and aquatint, printed in red, black, green
Plate: 457 × 400 mm (18 × 15 $\frac{3}{4}$ in), paper: 759 × 567 mm (29 $\frac{7}{8}$ × 22 $\frac{5}{16}$ in) (℮a 291)
Coll: GAC

Orchid was a favourite subject of MK-F, other versions including *Orchid (Red and Yellow)* in edition of thirty and *Yellow Orchid*, distributed by ℮a in edition of twenty.

380 Flowers, 1965
Etching and aquatint, deeply bitten, printed in stone grey, brown pink, white, black, blue
Plate: 451 × 399 mm (17 $\frac{3}{4}$ × 15 $\frac{23}{32}$ in), paper: 596 × 532 mm (23 $\frac{15}{32}$ × 20 $\frac{31}{32}$ in) (℮a 292)
Coll: GAC

381 Tulips, 1965–6
Etching and aquatint, deeply etched, printed in red, dark blue, yellow ochre
Plate: 402 × 275 mm (15 $\frac{13}{16}$ × 10 $\frac{13}{16}$ in) (℮a 293)
Coll: GAC

Initial proofs are dated 1964.

382 Venice, 1965
Etching and aquatint, printed in black, blue, yellow brown, pink
Plate: 393 × 295 mm (15 $\frac{1}{2}$ × 11 $\frac{5}{8}$ in), paper: 545 × 419 mm (21 $\frac{7}{16}$ × 16 $\frac{1}{2}$ in, edges cut)
Pub: 1965 (℮a 294)
Coll: GAC

383 Carnations, 1965
Etching and aquatint, deeply bitten, printed in brown, stone grey, red
Plate 391 × 255 mm (15 $\frac{3}{8}$ × 10 $\frac{1}{16}$ in), paper: 760 × 565 mm (29 $\frac{15}{16}$ × 22 $\frac{1}{4}$ in)
Pub: 1965 (℮a 295)
Coll: GAC

℮a also distributed *Vultures* in an edition of twenty-five.

Robert Gordy (*b.*Jefferson Island, Louisiana, 1933–87)

Southwestern Louisiana Institute, Lafayette; and Louisiana State University, 1956. Lived in Mexico City, San Francisco and New Iberia, before moving to New York, 1961. Settled in New Orleans, 1964. Solo exhibitions in New Orleans and San Francisco. Work purchased by Whitney Museum, 1968. Exhibition of *Recent Paintings and Drawings*, Tampa Bay Art Center, Florida, 1969. Trip to London to produce suite of prints for ea, summer 1969.

GOLDEN DAYS, 1969–70

Portfolio of six colour screenprints on Oram & Robinson 070 board, measuring 837 × 634 mm (32$\frac{15}{16}$ × 25 in)
Insc bl: edition number, br: signed by the artist (pencil), vo: stamped with ea and publication number
Edition: 100, 20 ap
Pr: Lyndon Haywood and Michael O'Connor, Alecto Studios, London, 1969; with yellow cloth-bound portfolio box produced by Multiservice Bookbinding Ltd and insc along edge: ea *Golden Days/ Robert Gordy* (in gold); overall size: 853 × 644 mm (33$\frac{9}{16}$ × 25$\frac{3}{8}$ in)
Pub: January 1970 (ea 628–33)
Exh: Alecto Gallery, London and Gimpel & Weitzenhoffer, New York, 1970
Coll: New Orleans Museum of Art

384 Golden Days
Screenprint, printed in two shades of pink, purple, black, two greys, two yellows, two greens
Image: 712 × 510 mm (28$\frac{1}{32}$ × 20$\frac{1}{16}$ in) (ea 628)

385 Hesperides
Screenprint, printed in two blues, two greys, black, two greens, light and darker pink, yellow
Image 509 × 720 mm (20$\frac{1}{16}$ × 28$\frac{3}{8}$ in) (ea 629)

386 Water Babes (Page 182)
Screenprint, printed in blue, black, two greens, dark and lighter pink
Image and paper: 838 × 633 mm (33 × 24$\frac{15}{16}$ in) (ea 630)
Coll: Financial Times

387 Green Nile
Screenprint, printed in brown, black, two greys, green
Image: 510 × 714 mm (20$\frac{1}{16}$ × 28$\frac{1}{8}$ in) (ea 631)

388 Women and Boxes
Screenprint, printed in black and light and darker greys
Image: 514 × 736 mm (20$\frac{1}{4}$ × 29 in) (ea 632)

389 Folly
Screenprint, printed in black, two greys, two yellows, pink, brown, cream, blue
Image and paper: 634 × 837 mm (24$\frac{15}{16}$ × 32$\frac{15}{16}$ in) (ea 633)
Coll: Financial Times

Robert Graham (*b.*Mexico City, 1938)

Studied at San Jose State College and San Francisco Institute of Art in the early 1960s. 1963 etching of three girls and two men became the source for a 3-D scene. Began to sculpt small female figures grouped inside architectural settings. Living in London. Introduced to Hans Neuendorf, who subsequently published his graphics. Whitechapel Art Gallery exhibition, 1970, included series of miniature boxed environments without figures. Prints and multiples in 1970s and 1980s made with Gemini GEL.

390 Top View, 1968
Etching, deeply bitten, printed in sandy yellow and red on Crisbrook waterleaf paper
Plate: 498 × 499 mm (19$\frac{5}{8}$ × 19$\frac{21}{32}$ in), paper: 597 × 568 mm (23$\frac{1}{2}$ × 22$\frac{3}{8}$ in)
Insc bl: *BAT*, bc: *top view*, br: *Robert Graham 1968* (pencil)
Edition: 65, 10 ap, 1 bat
Pr: Danyon Black and Maurice Payne, Alecto Studios, London; pub: Editions Alecto Ltd with Neuendorf Verlag, Germany, 1968 (ea 556)

ROOM SERIES I–VI, 1968

Six colour etchings, deeply bitten, printed on Crisbrook waterleaf paper
Plate: 350 × 548 mm (13$\frac{3}{4}$ × 21$\frac{9}{16}$ in), paper: 455 × 640 mm (17$\frac{15}{16}$ × 25$\frac{3}{16}$ in)
Insc bl: edition number and title with Roman numeral, br: signed and dated: *Robert Graham 1968*, vo: stamped ea with publication number
Edition: 65, 10 ap
Pr: Danyon Black and Maurice Payne, Alecto Studios, London; pub: Editions Alecto Ltd with Neuendorf Verlag, Germany, 1968 (ea 557–62)

391 Room I
Etching, deeply bitten, printed in brown, pink, black (ea 557)
Coll: British Museum

392 Room II
Etching, deeply bitten, printed in red rust, blue, yellow, black (ea 558)

393 Room III
Etching, deeply bitten, printed in yellow ochre and russet pink (ea 559)

394 Room IV
Etching, deeply bitten, printed in pink, rust brown, black (ea 560)
Coll: British Museum

→ *p.129*

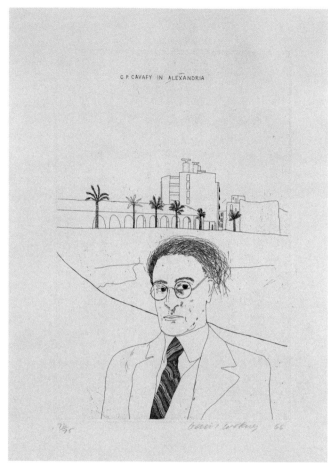

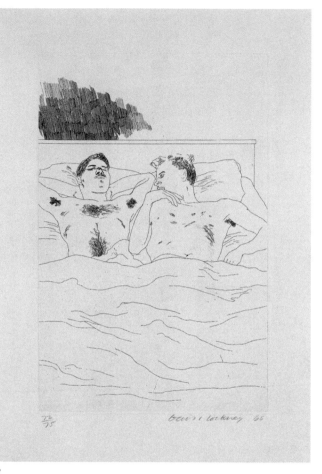

86

87

Plates 86–8 David Hockney, *Portrait of Cavafy in Alexandria*, *In the dull village* and *he enquired after the quality* from *The Cavafy Series*, 1966–7 (458, 465, 460)
© David Hockney, 2002

He enquired after the quality

He came out of the office where he worked
in a position that was insignificant and under-paid
(about eight pounds a month, including tips).
When he had finished with the odious chores
over which he had stooped all the afternoon,
he went outside, at seven, walking slowly,
idling away his time in the street. Handsome
and interesting; the way he seemed to have achieved
his full potential sensuality.
His twenty-ninth birthday was last month.

He idled away his time in the street and
in the poor alleys leading to his home.

Passing in front of a small shop
which sold some fake, cheap goods
for working people,
he saw within a face, a figure,
and this urged him to enter, as if to ask about
some coloured handkerchiefs.

He enquired after the quality of the handkerchiefs
and what they cost, in a low voice
almost stifled by desire.
And the answers that came followed suit
abstracted, in a choking voice
implying willingness.

They kept on murmuring things about the goods – but
their sole intent: to touch each other's hands
across the handkerchiefs; to bring their faces
and their lips close together, as if by chance;
a momentary contact of their limbs.
Quickly and stealthily so that the owner of the shop
sitting at the far end should not notice.

88

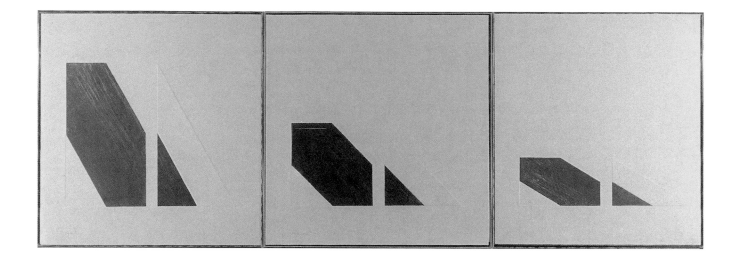

Plate 89 Richard Smith, *Triptych* (*Sixty, Forty-five, Thirty Degrees*, assembled), 1966 (1068–70)

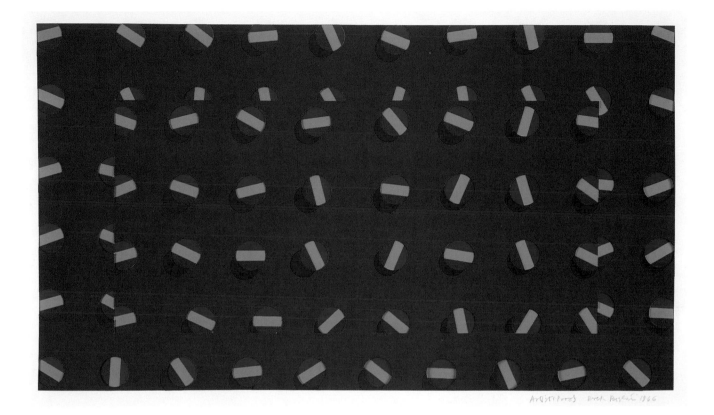

Plate 90 Derek Boshier, *Output*, 1966 (134)

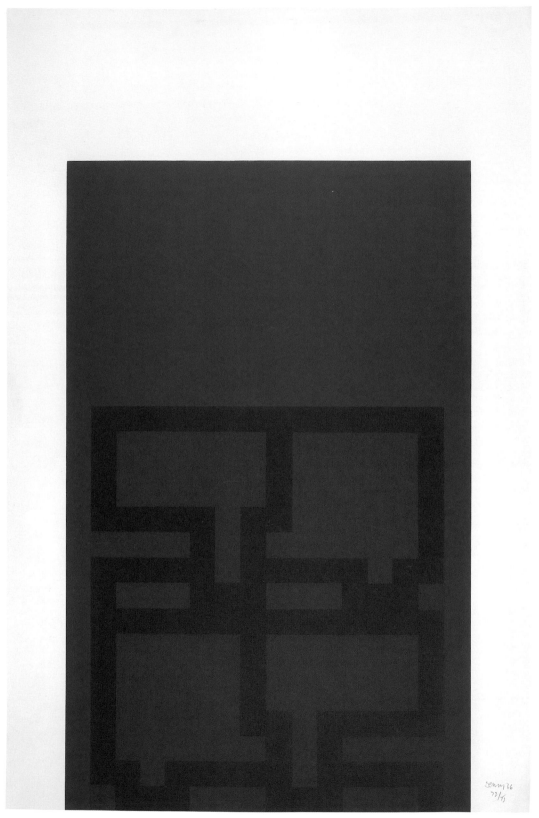

Plate 91 Robyn Denny, *Suite 66* (*III*), 1966 (305)

Plates 92, 93 Peter Sedgley, *Looking Glass Suite IV* and *II*, 1967 (1005, 1003)

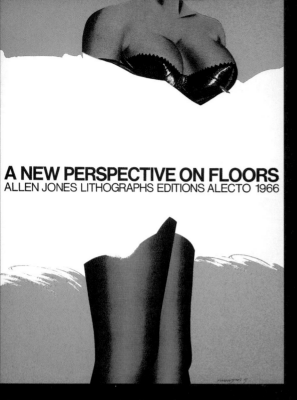

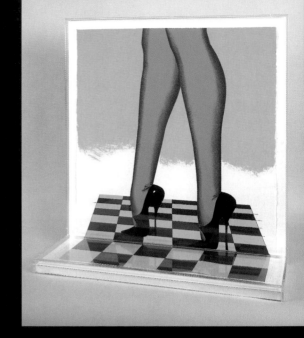

Plates 94, 95 Allen Jones, *A New Perspective on Floors*; poster and accompanying perspex box with 2, 1966 (526, 521)

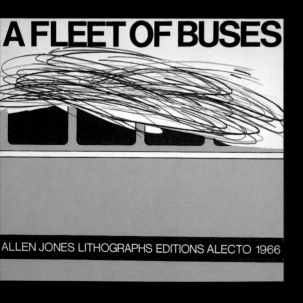

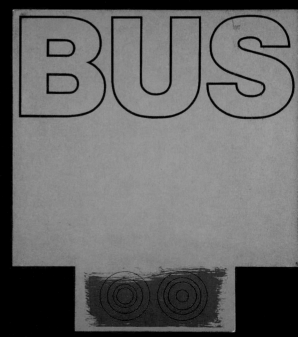

Plates 96, 97 Allen Jones, *A Fleet of Buses*; poster and portfolio box, 1966–7 (519)

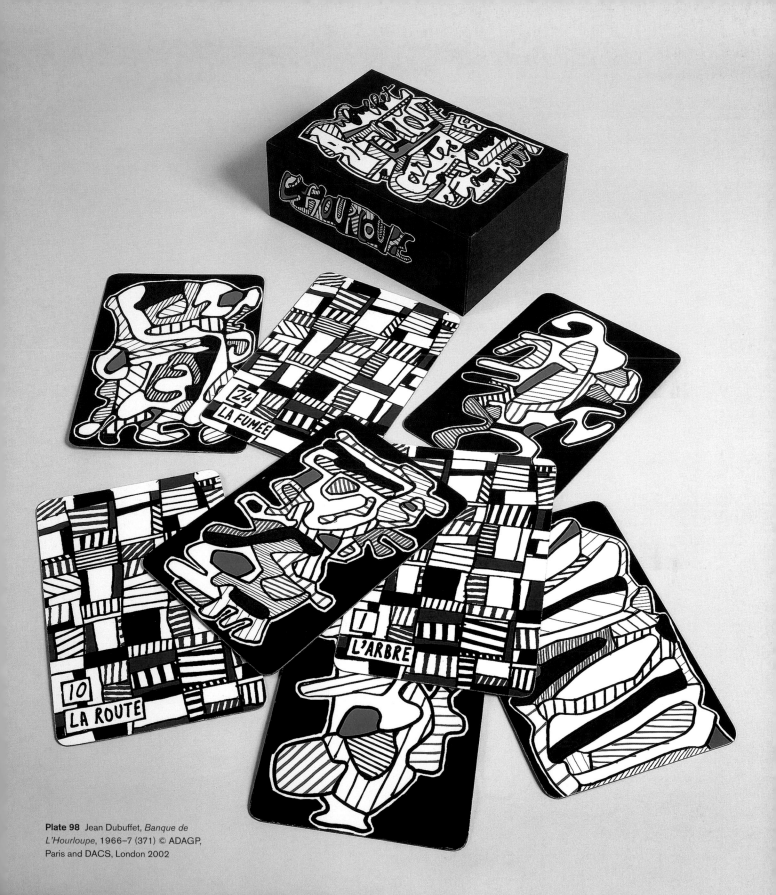

Plate 98 Jean Dubuffet, *Banque de L'Hourloupe*, 1966–7 (371) © ADAGP, Paris and DACS, London 2002

Plates 99, 100 Ron King, *Sea Anemone III* and *IV*, 1966 (574–5)

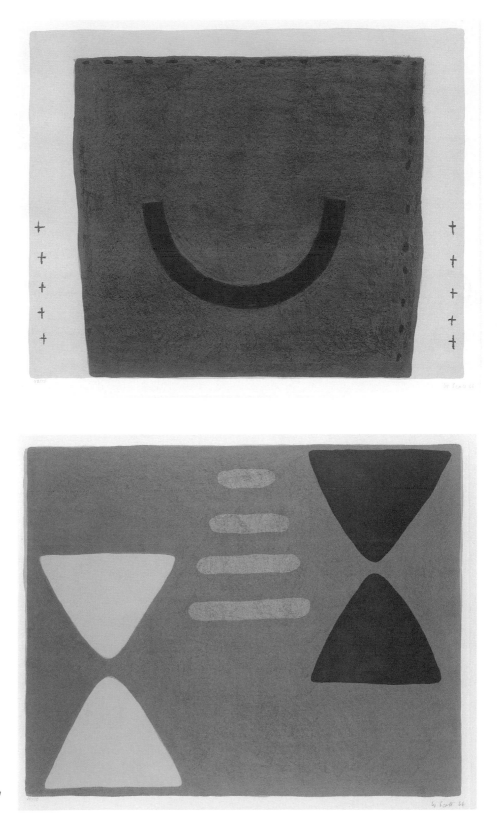

Plates 101, 102 William Scott, *Odeon Suite*, *I* and *VI*, 1966 (991, 996)

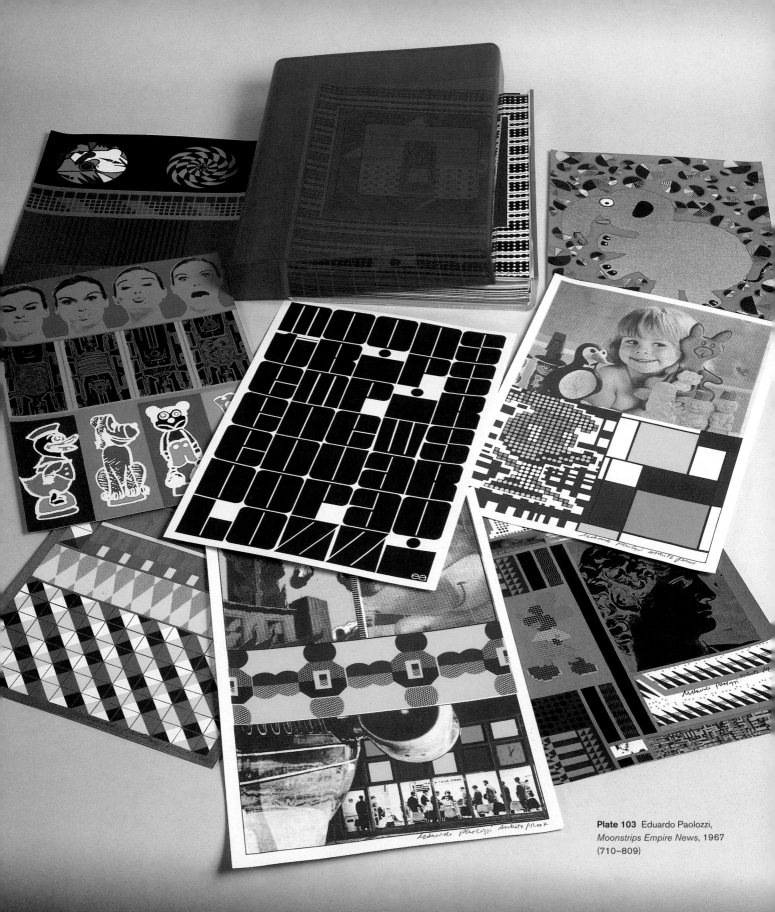

Plate 103 Eduardo Paolozzi,
Moonstrips Empire News, 1967
(710–809)

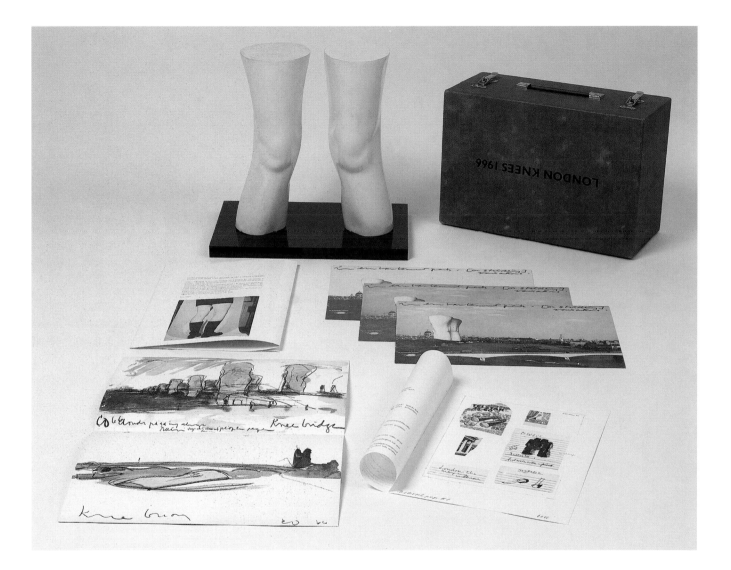

Plate 104 Claes Oldenburg, *London Knees*, 1966–8 (677)

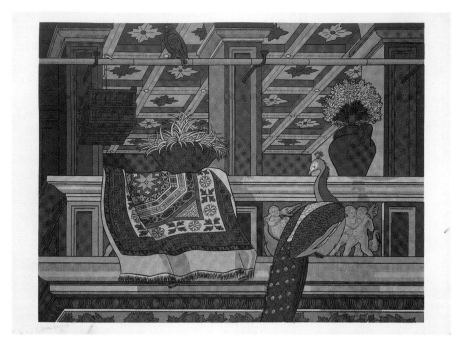

Plates 105, 106 Gillian Ayres, *Crivelli's Room I* and *II*, 1967 (11, 12)

Plate 107 Gillian Ayres, *Lorenzo the Magnificent and Niccolo the Gear*, 1967 (14)

Plate 108 Patrick Caulfield, *The Letter*, 1967 (168)

Plate 109 Patrick Caulfield, *Sweet Bowl*, 1967 (169)

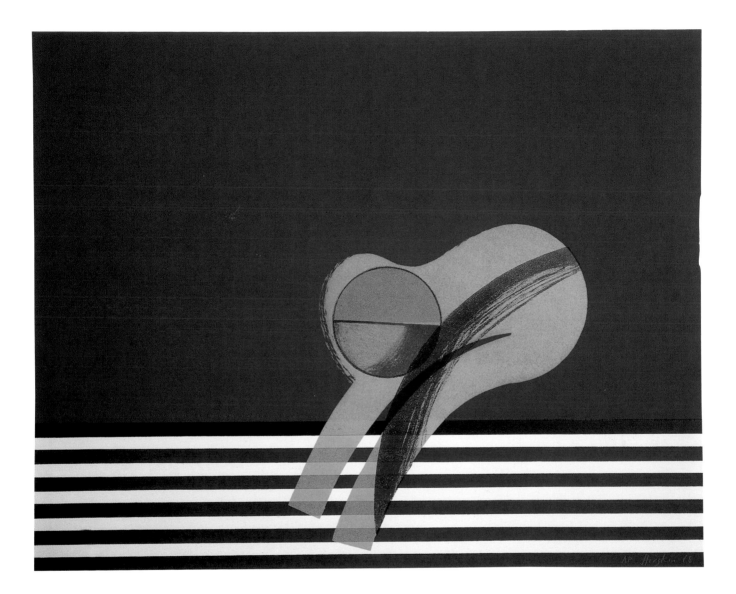

Plate 110 Howard Hodgkin, *Girl on a Sofa*, 1968 (480)

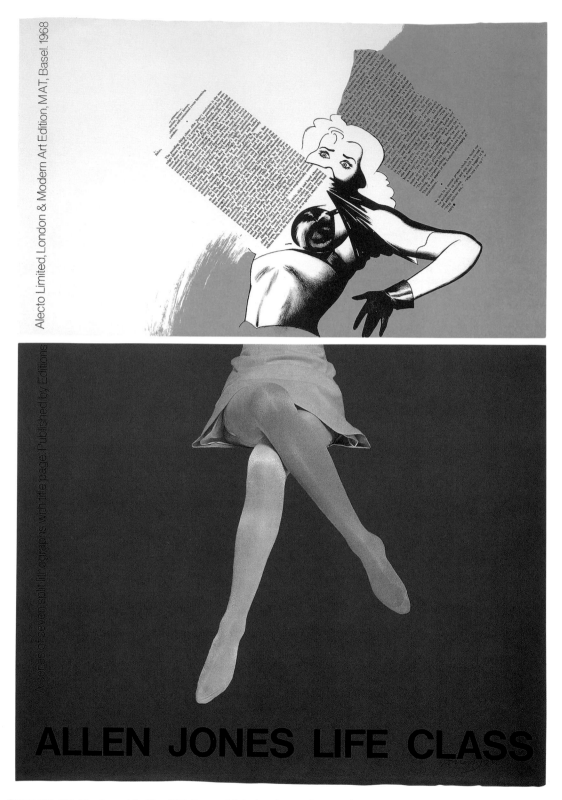

Alecto Limited, London & Modern Art Edition, MAT, Basel. 1968

A series of seven split lithographs with title page. Published by Editions

Plates 111, 112 Allen Jones, *Life Class* (*Title Page* and *Suit, Green*), 1968 (533, 536)

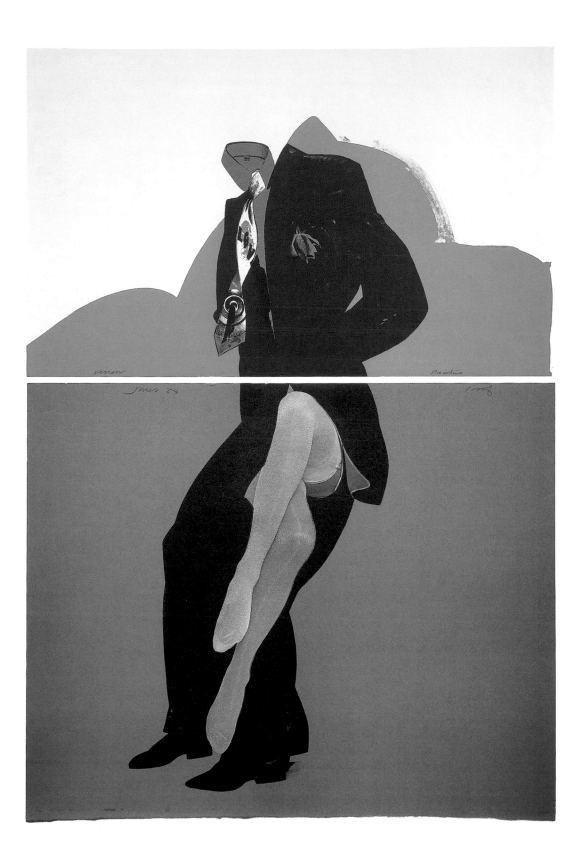

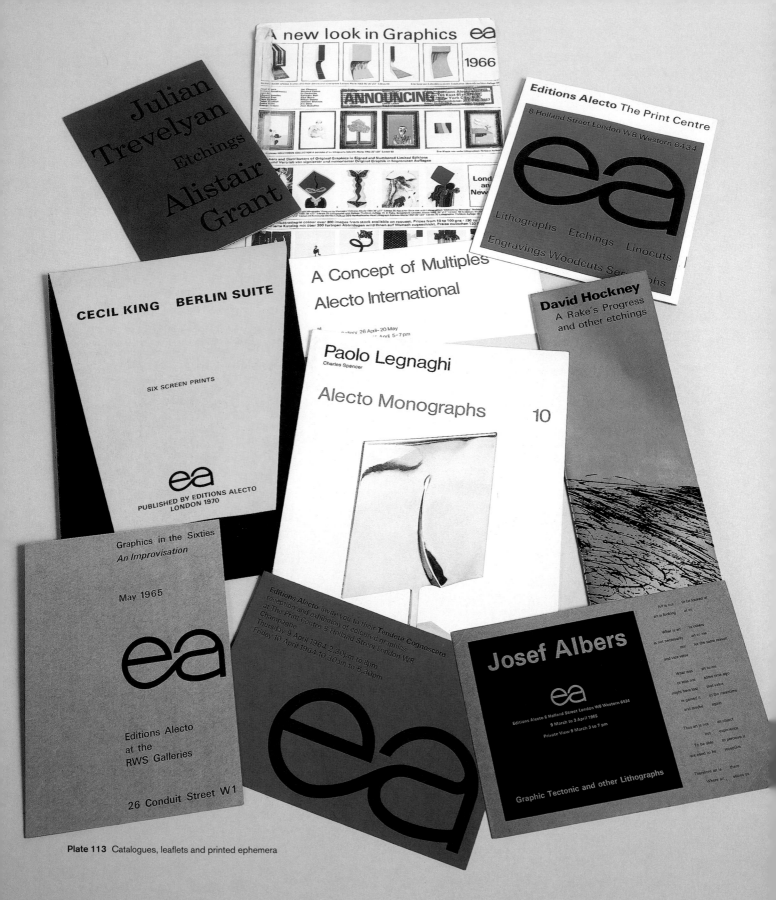

Plate 113 Catalogues, leaflets and printed ephemera

395 Room V
Etching, deeply bitten with blind embossing, printed in black and yellow
(ea 561)
Coll: British Museum

396 Room VI
Etching with blind embossing, printed in black
(ea 562)

Alistair Grant (b.London, 1925–97)

Birmingham School of Art, 1941–3; and RCA, 1947–50. Taught printmaking at RCA from 1955, becoming Head of Department, 1970–90. Solo shows include: Zwemmer Gallery, 1954; as well as Piccadilly and AIA Galleries (all London). Prizewinner at Cracow International Print Biennale, 1972. Produced drawings and paintings for films *Moulin Rouge* and *The Rebel*. Established Printmaking Department Appeal Fund at RCA in early 1980s, and continued to promote the College through a number of print portfolios.

Azincourt Suite (I–VIII), 1964
Series of eight colour etchings, deeply bitten on single zinc plates, printed on Crisbrook 140 lb paper
Plate: 250 × 327 mm ($9\frac{27}{32}$ × $12\frac{5}{8}$ in), paper: 396 × 460 mm ($15\frac{9}{16}$ × $18\frac{1}{8}$ in, with variation)
Insc bl: with edition number, bc: with title *Azincourt* and Roman numeral, and br: signed by artist: *Alistair Grant* (in pencil), with ea embossed (in GAC series has been mostly cut)
Edition: 50, 5 ap
Pr: Peter Matthews, RCA, London; pub: 1964 (ea 113–20)
Exh: *Julian Trevelyan Alistair Grant*, The Print Centre, London, 1964
Coll: GAC

Grant was commissioned to produce a series of battle drawings for a BBC Television production *The Picardy Affair* which examined Henry V's journey between Honfleur and Azincourt. 'The search for the most telling forms to do this resulted in this suite of etchings, which therefore speak of banners, and iron and leather-clad men, and arrow-showers, and moving masses of warriors, and the glitter, the sweat, the labour, the danger of cannon-less war. The aim is not to be literal, but to generalise: the relatively small scale of the plates conveys the sense of small incidents in the battle rather than a picture of the whole' (Robert Erskine, The Print Centre, 1964)

397 I
Etching, soft-ground, printed in black and ochre with material overlay and additional silver paper overlay in central panel
(ea 113)

398 II
Etching, soft-ground, impressed with pieces of string, printed in green, red rolled through a stencil mask, and black

(ea 115)
Coll: Leeds City Art Gallery

399 III
Etching, soft-ground, impressed with coins, printed in black, dull ochre, two blues
(ea 114)
Coll: Leeds City Art Gallery

400 IV (Page 34)
Etching, soft-ground and aquatint, with cross and four lines etched through the whole plate, printed in blue, black with yellow, pink
(ea 116)

401 V
Etching, soft-ground, deep etch, printed in prussian blue, power tool marks in ochre, surface rolled in black and orange
(ea 117)

402 VI
Etching, soft-ground, stencil for central shape, printed in pale blue, crimson, black
(ea 118)

403 VII
Etching, soft-ground, cross-hatching, printed in black, warm ochrey grey with blue and pink
(ea 119)

404 VIII (Page 34)
Etching, soft-ground, deep etch printed in blue, orange and lime yellow with surface rolled in black
(ea 120)

'Awful to print because the plates were not well made. Up to four colours and even a metallic paper overlay, were all printed at the same time. To compound it, Alistair was going through a busy period and was hardly ever there. In the morning a plate would be thrust into my hand and with a broad grin he would say, "Can you do this? You know the colours I like!" And off he would go' (Peter Matthews, 17/5/2000)

Roy Grayson (b.Sheffield, 1936)

Sheffield College of Art, 1952–4; RCA, 1958–61; Group One Four, 1966–9. Foundation of Jam Press, 1973. Professor of School of Art, University of Brighton. Represented by Galerie Fortlaan 17, Ghent.

405 Flikker Book No. 8 (Page 225)
Lithograph, off-set, printed in black; 75 × 92 mm ($2\frac{31}{32}$ × $3\frac{5}{8}$ in)
Printed front: *Flikker/ book/ Roy Grayson*, back page: *Roy Grayson*
Pr and pub: AI, 1972

Balloon is blown up across the paper surface.

Alan Green (*b.*London, 1932)

Beckenham School of Art, 1949–53; and RCA, 1955–8 obtaining travelling scholarship, 1958–9 (France and Italy). *Young Contemporaries*, RBA Galleries, London, 1957. Solo London exhibitions: AIA Gallery, 1963; and Annely Juda Fine Art, 1970 who continues to represent his work. Graphic work shown in *Printed Art: A View of Two Decades*, MOMA, 1980; and *Out of Print: British Printmaking 1946–76*, British Council European Touring Exhibition, 1994.

THREE VARIATIONS, 1974 (Page 250)

Series of three colour etchings, two copperplates, multi-intaglio processes with *à la poupée*, printed on J. Green waterleaf 296 gsm paper
Plate: 547 × 693 mm (21 $\frac{9}{16}$ × 27 $\frac{5}{16}$ in), paper: 680 × 849 mm (26 $\frac{3}{4}$ × 33 $\frac{7}{16}$ in)
Insc bl: edition number, bc: titled *Three Variations A–C*, br: signed and dated *Alan Green 74* (pencil) with embossed ꬲ and embossed chops of James Collyer and John Crossley of J. C. Editions
Edition: 42, 6 ap
Pr: James Collyer and John Crossley of J. C. Editions and David Green, Alecto Studios, London, 1974; pub: 1974 (ꬲ 861–3)
Coll: Leicestershire Museums, Arts and Records Service

406 A
Etching, printed in black, green, white with touch of red oxide
(ꬲ 861)

407 B
Etching, printed in black, grey, red oxide
(ꬲ 862)
Coll: Whitworth Art Gallery, University of Manchester

408 C
Etching, printed in turquoise, black, white grey
(ꬲ 863)

'I made eight editions at ꬲ between 1973–4. All the prints were made from the same plates and were sequential. The first suite *Five out of Five* consisted of five editions of coloured etchings, the plates being reworked after the printing of each edition. James Collyer and John Crossley, the printers, were skilled at masking areas of a plate and introducing local colour. This, plus the nature of the image (a loose grid of squares), allowed for considerable reworking and colour changes from one edition to the next.

I was, at that time, interested in the progression aspect of intaglio prints. That the image could be retained on copper and altered with ease seems unique to the copperplate Although made and printed at Alecto, the prints were finally published by Annely Juda in London.

When Joe Studholme realised the prints had been successful both critically and commercially, he suggested I attempt a sixth version of the plates, which were by now quite heavily worked.

This I made in 1974 – a suite of three editions entitled *Three Variations* which was a sixth state of *Five out of Five*. The *Variations* were more to do with colour changes than image. But with such complex plates, it was possible to make a considerable difference between the character of each print.' (AG, 31/8/1997)

Nigel Hall (*b.*Bristol, 1943)

West of England College of Art, Bristol, 1960–4; RCA, 1964–7. Harkness Fellowship, 1967–9; and Tutor at RCA, 1971–4. Solo exhibitions: Galerie Givaudan, Paris, 1967 and Galerie Neuendorf, Hamburg and Frankfurt, 1970. First print, a miniature photo-etching, printed at Charlotte Street Workshop for Bernard Jacobson. Exhibitions with Annely Juda Fine Art, London began in 1978. Alecto Commission Prize, Bradford Internatonal Print Biennale, 1974. *Drawings in Black and White*, MOMA, 1993 and *Prints of Darkness*, Fogg Art Museum, Harvard University, 1994.

409 Dialogue, 1975 (Page 252)

Aquatint, burnished, copperplate, printed in black on J. Green waterleaf paper
Edition: 125, 15 ap, 4 pp, 2 icp
Insc bl: *2/125*, br: *Nigel Hall/ 75* (pencil), br corner: ꬲ embossed, with embossed stamps of James Collyer and John Crossley of J. C. Editions
Image (outer measurements): 486 × 683 mm (19 $\frac{1}{8}$ × 26 $\frac{7}{8}$ in), paper: 694 × 887 mm (27 $\frac{5}{16}$ × 34 $\frac{15}{16}$ in)
Edition: 125, 15 ap, 4 pp and 2 icp
Pr: James Collyer and John Crossley of J. C. Editions, Alecto Studios, London, July 1975; pub: 1975 (ꬲ 886)
Coll: GAC, British Museum

Nigel Hall first worked at the Alecto Studios in 1974, with Don Bessant, on a two-colour stone lithograph, which he himself published. The following year, with the ending of the *Lithographs for Public Offices Programme*, Editions Alecto collaborated with the Department of the Environment on the commissioning of five new editions. Having won the Alecto Prize at the Bradford Biennale, Nigel Hall was invited to work again at the Alecto Studios, producing *Dialogue*, which became one of the editions supported by the Ministry. They purchased seventy-five impressions and four aps out of an edition of 125.

This image of interrelated horizontals is closely associated with charcoal drawings of this time where, 'I was developing a really dense black in the charcoal The different number of coats of charcoal would be recorded in the depth and tone of each band . . . after the first layer I'd fix and mask out the original band, say, that one, and then re-coat it and allow the next band to take up two coats of dust, fix it and then mask that one out' (NH in discussion with Pat Gilmour, Australian National Gallery, 1982)

The graphic process, in contrast, involved printing the aquatint with 'jet black ink' and then 'working back from that with the aid of burnishing . . . a difficult process.' (J. C. Editions)

Richard Hamilton (*b.*London, 1922)

Earliest etchings printed at Central School of Art, 1939. Member of The Independent Group, 1952. His poster collage *Just what is it that makes today's homes so different* is one of the earliest Pop images. Explored various print techniques, notably photo-screenprint with Chris Prater at Kelpa Studio. Organised *The ICA Screenprint Project*, 1964, the same year combining oil and screenprint for the interior entitled *Patricia Knight*.. The dissemination of printed images has continued to be a central concern, most recently embracing digital technology.

Col: Kunstmuseum Winterthur
Lit: *Richard Hamilton Prints 1939–83*, Edition Hansjörg Mayer with Waddington Graphics, 1984; Etienne Lullin, *Richard Hamilton Druckgraphik und Multiples*, Kunstmuseum Winterthur and Düsseldorf, Richterverlag, 2002

410 Interior, 1964–5 (Page 70)

Screenprint, photo, eight stencils, printed in three blacks, cyan, magenta, two yellows, green on 140 lb Crisbrook HP imperial paper
Image: 500 × 608 mm ($19\frac{11}{16} \times 23\frac{15}{16}$ in), paper: 567 × 782 mm ($22\frac{5}{16} \times 30\frac{2}{8}$ in)
Insc br: *R Hamilton 8/50* (pencil, also signed: *Richard Hamilton*) with embossed ℮ℴ
Edition: 50, 10 ap
Pr: initial state printed as four proofs at Kelpra Studio, editioned: Kelpra Studio, London (invoiced 29/4/1965); pub: 1965 (℮ℴ 31)
Coll: ACE; Staatliche Museen zu Berlin; Tate; SNGMA, National Gallery of Canada, Ottawa; Sheffield Galleries and Museums Trust

The woman seen here originally appeared in an advertisement for washing machines, while the historically tasteful interior came from an illustration in the magazine *House and Garden*. This vision of the modern interior is most closely based upon a collage study in Swindon Museum and Art Gallery, though initially the theme was inspired from a 1940s film still.

The screenprint process allowed for further modification with screens of flat colour. This final edition eliminated the old master paintings and floral arrangements of the initial state of *Interior*, creating a more spacious treatment of disparate objects.

Impressions of this state are held by MOMA and Whitworth Art Gallery, Manchester (*Richard Hamilton Prints*, p.56).

411 The Solomon R. Guggenheim, 1965 (Page 71)

Screenprint, photo, five stencils, printed in lemon green, pink, black, mauve, blue on 90 lb J. Green HP imperial paper
Image: 558 × 555 mm ($21\frac{31}{32} \times 21\frac{27}{32}$ in), paper: 583 × 764 mm ($22\frac{15}{16} \times 30\frac{1}{16}$ in, some variation)
Insc bl: *R Hamilton 46/50* (pencil), br: ℮ℴ stamp, vo: *K6523*
Edition: 50, 10 ap
Pr: Kelpra Studio, London (invoiced 29/4/1965); pub: 1965 (℮ℴ 30)
Coll: V&A; ACE; Tate; Metropolitan Museum of Art; Art Gallery of Ontario, Toronto; MOMA; National Gallery of Canada, Ottawa

Hamilton here distils the spiralling form of Frank Lloyd Wright's building into 'a total, coherent and unambigious image'. The colour separation process that was integral to screenprinting appears to have had a direct influence on the subsequent series of fibreglass and cellulose reliefs completed in 1966 and distinguished by distinctive colours.

412 My Marilyn, 1965–6 (Page 71)

Screenprint, photo, nine stencils, printed in apricot, pink, transparent purple, purple, blue, two oranges, two blacks on T. H. Saunders HP 133 lb DE paper
Image: 520 × 630 mm ($20\frac{7}{16} \times 24\frac{13}{16}$ in), paper: 691 × 840 mm ($27\frac{3}{16} \times 33\frac{1}{16}$ in)
Insc br: *R Hamilton 66 27/75* (pencil), vo: ℮ℴ *No 296*
Edition: 75, 9 ap, 5 pp
Proofed: The artist, University of Newcastle-upon-Tyne; pr: Kelpra Studio, London, 1965 (invoiced 20/1/1966); pub: 1966 (℮ℴ 296)
Coll: V&A; ACE; British Council; Tate; Art Gallery of Ontario, Toronto; National Gallery of Canada, Ottawa; National Gallery of Australia, Canberra; MOMA

The source for *My Marilyn* is a group of contact prints of Marilyn Monroe by George Barris, with the subject's own rejection marks. Hamilton began to manipulate these photographic images with oil in 1964 (Museum Ludwig, Cologne), before adding collage to a larger version of the same subject the following year (Stadt Aachen, Ludwig Forum für Internationale Kunst). This final screened edition was preceded by a 'test run' printed with basic equipment by Hamilton at the University of Newcastle-upon-Tyne, and published as varied proofs by Robert Fraser, 1965 (Kunstmuseum Winterthur).

Anthony Harrison (*b.*Truro, Cornwall, 1931)

Architectural student before studying under Merlyn Evans and Keith Vaughan at Central School of Arts and Crafts, London, 1949–55. St George's Gallery, 1956–62, exhibiting *The Formenterra Series*, 1959. Lecturer in printmaking at Central School, 1959–64. Exhibition of drawings and prints, San Francisco Museum of Art, 1964. USA residency. Taught at Pratt Graphic Art Center, and New York University, 1965–71. Full-time teaching in Visual Arts Department, Columbia University, 1970–93. Moved to New Jersey, 1983, converting small factory as studio-living space.

413 Engraving I, 1963

Engraving, copperplate, printed in black with tone around edge on J. Whatman 200 lb paper
Plate: 453 × 597 mm ($17\frac{13}{16} \times 23\frac{1}{2}$ in), paper: 585 × 795 mm $23\frac{1}{32} \times 31\frac{5}{16}$ in)
Insc bl: *Engraving 1 Artist Proof 1963*, br: *Harrison* (pencil)
Edition: 50, 5 ap
Pr: The artist, Blackheath studio, London, 1963; pub: 1964 (℮ℴ 166)

414 Engraving II, I963

Engraving, copperplate, printed in black with tone around edge on J. Whatman 200 lb paper

Plate: 500 × 642 mm (19$\frac{11}{16}$ × 25$\frac{1}{4}$ in), paper: 583 × 794 mm (22$\frac{15}{16}$ × 31$\frac{1}{4}$ in)

Insc bl: *Engraving 11 Artist proof. 1963*, br: *Harrison* (pencil)

Edition: 50, 5 ap

Pr: The artist, Blackheath studio, London, 1963; pub: 1964

(ea 167)

415 Engraving III, 1963

Engraving, two copperplates, printed in black with tone around edge on J. Whatman 200 lb paper

Plate: 500 × 591 mm (19$\frac{11}{16}$ × 23$\frac{1}{4}$ in), paper: 574 × 791 mm (22$\frac{5}{8}$ × 31$\frac{1}{8}$ in)

Insc bl: *Engraving 111 Artist Proof. 1963*, br: *Harrison* (pencil)

Edition: 50, 5 ap, proofs

Pr: The artist, Blackheath studio, London, 1963; pub: 1964

(ea 168)

416 Red and Black I, 1963

Etching, coarse sugar-lift, zinc plate, printed in red and black on J. Whatman 200 lb paper

Plate: 696 × 500 mm (27$\frac{3}{8}$ × 19$\frac{11}{16}$ in), paper: 795 × 584 mm (31$\frac{5}{16}$ × 23 in)

Insc bl: *Red + Black 1 Artists Proof. 1963*, br: *Harrison* (pencil)

Edition: 50, 5 ap, proofs

Pr: The artist, Blackheath studio, London, 1963; pub: 1964

(ea 169)

417 Red and Black II, 1963

Etching, coarse sugar-lift, zinc plate, printed in red and black on J. Whatman 200 lb paper

Plate: 693 × 500 mm (27$\frac{1}{4}$ × 19$\frac{11}{16}$ in), paper: 795 × 584 mm (31$\frac{5}{16}$ × 23 in)

Insc bl: *Red + Black 11 Artists Proof. 1963*, br: *Harrison* (pencil)

Edition: 50, 5 ap, proofs

Pr: The artist, Blackheath studio, London, 1963; pub: 1964

(ea 170)

Coll: Brooklyn Museum of Art

418 Red and Black III, 1963

Etching, coarse sugar-lift, zinc plate, printed in black and red on J. Whatman 200 lb paper

Plate: 687 × 497 mm (27$\frac{1}{16}$ × 19$\frac{9}{16}$ in), paper: 780 × 570 mm (30$\frac{11}{16}$ × 22$\frac{7}{16}$ in)

Insc bl: *Red + Black 111 Artist Proof 1963*, br: *Harrison* (pencil)

Edition: 50, 5 ap, proofs

Pr: The artist, Blackheath studio, London, 1963; pub: 1964

(ea 171)

419 Requiem I, 1963

Etching, sugar-lift aquatint, two zinc plates, printed in black on J. Whatman 200 lb paper

Overall plate size: 653 × 448 mm (25$\frac{11}{16}$ × 17$\frac{5}{8}$ in), paper: 750 × 545 mm (29$\frac{1}{2}$ × 21$\frac{7}{16}$ in, cut)

Insc bl: *Requiem 1 9/50 1963*, br: *Harrison* (pencil)

Edition: 50, 5 ap, proofs

Pr: The artist, Blackheath studio, London, 1963; pub: 1964

(ea 172)

Coll: GAC

420 Requiem II, 1963

Etching, sugar-lift aquatint, three zinc plates, printed in black on J. Whatman 200 lb paper

Overall plate size: 635 × 485 mm (25 × 19$\frac{1}{8}$ in), paper: 750 × 545 mm (29$\frac{1}{2}$ × 21$\frac{7}{16}$ in, cut)

Insc bl: *Requiem 11 7/50 1963*, br: *Harrison* (paper)

Edition: 50, 5 ap, proofs

Pr: The artist, Blackheath studio, London, 1963; pub: 1964

(ea 173)

Coll: GAC

421 Requiem III, 1963

Etching, sugar-lift aquatint, two zinc plates, printed in black on J. Whatman 200 lb paper

Overall plate size: 690 × 392 mm (27$\frac{3}{16}$ × 15$\frac{7}{16}$ in), paper: 750 × 545 mm (29$\frac{1}{2}$ × 21$\frac{7}{16}$ in, cut)

Insc bl: *Requiem 111 8/50 1963*, br: *Harrison* (paper)

Edition: 50, 5 ap, proofs

Pr: The artist, Blackheath studio, London, 1963; pub: 1964

(ea 174)

Coll: GAC

'The Alecto connection must have been via Robert Erskine, the first dealer to handle my work in London As a student at Central School I was very fortunate to have as my teacher in etching and engraving Merlyn Evans, also my mentor and later friend and a very fine artist. Bill Collins was the professional intaglio printer – one of the finest in the country. When he retired from printing, he gave me his press on which all the above prints were printed (and which had been formerly owned by Muirhead Bone)' (AH, 19/6/2000)

Stanley William Hayter (*b.*Hackney, London, 1901–88)

Worked as chemist/geologist in Abadan, Iran. First drypoints, woodcuts, and soft-ground etchings produced in Paris, 1926. Established printmaking workshop in Paris studio, 1927, which moved to 17 rue Campagne-Première, 1933. Atelier 17 artists included: Ernst, Masson, Miró, Hecht, Giacometti, Buckland Wright. Opened New York branch of Atelier 17, 1940. Produced *Cinq Personnages* in 1946, combining intaglio and screened colours printed simultaneously from one plate. Reopened Atelier 17 in Paris, 1950.

Lit: Peter Black and Désirée Moorhead, *The Prints of Stanley William Hayter*, London, Phaidon, 1992

422 Onde Verte, 1965
Etching, zinc plate, soft-ground etching and scorper, printed in green, orange, yellow on Barcham Green paper
Plate: 590 × 500 mm (23 $\frac{1}{4}$ × 19 $\frac{11}{16}$ in), paper: 812 × 686 mm (32 × 27 in)
Edition: 50, 5 ap and proofs I–VIII on B. F. K. Rives paper
Pr: The artist and Eugenio Tellez (plate begun 10 August); pub: 1965 (ea 299)
Coll: Whitworth Art Gallery, University of Manchester; GAC

Editions Alecto distributed other work by Hayter, sometimes stamping impressions with their embossed chop, *eg: Pelagic Forms* 1963 and *Dérive* 1964 (GAC impressions). The *Atelier 17* exhibition at The Print Centre, London, 14 April–30 May 1964 was accompanied by a lithographic poster designed by Hayter and printed by Atelier Pons, Paris.

Gertrude Hermes (*b.*Bromley, Kent, 1901–83)

See Appendix

Derek Hirst (*b.*Doncaster, 1930)

Doncaster School of Art, 1946–8; RCA, 1948–51. First exhibitions: Tooth's Gallery, 1962 and Angela Flowers Gallery (both London), 1970. Iconography at this time became more abstract and subject to 'greater schematisation and meticulous control', using the formal devices of the armchair and then the arch with increasing 'simple, almost banal bands and areas of colour "setting up" all manner of perceptual paradoxes.' (Peter Fuller) Continues to be represented by Angela Flowers Gallery.

PARADOX SUITE (I–V), 1975
Set of five colour screenprints printed on heavyweight board paper
Image: 530 × 530 mm (20 $\frac{7}{8}$ × 29 $\frac{7}{8}$), paper: 668 × 615 mm (26 $\frac{5}{16}$ × 24 $\frac{3}{16}$ in)
Insc bl: with edition number, title and date, br: signed by artist: *Derek Hirst* (pencil) and ea embossed, vo: stamped ea and publication number
Edition: 35, 6 ap, 2 pp, icp and ep proofs
Pr: Leslie Hosgood and Robert Jones, Megara Screenprinting Ltd, Alecto Studios, London, 1975; pub: Editions Alecto Ltd in collaboration with PSA, Department of the Environment, 1975, who acquired fifteen impressions plus one ap from each of the five editions by Hirst (ea 889–93)
Coll: GAC

423 I (Silver to Pink)
Screenprint, printed in silver, black, pink, light and darker blue and red
(ea 889)
Coll: ACE

424 II (Red to Yellow)
Screenprint, printed in red, black, orange, yellow, light and darker mauve
(ea 890)

425 III (Brown to Orange)
Screenprint, printed in brown, black, orange, red, yellow and light purple
(ea 891)

426 IV (Red to Blue)
Screenprint, printed in red, three blues, orange, cream yellow
(ea 892)
Coll: Leicestershire Museums, Arts and Records Service

427 V (Gold to Red)
Screenprint, printed in red, white, purple, orange, gold
(ea 893)

'This was my first screenprint series . . . about the illusion of space, something that looks 3-D but is actually flat. I worked off the hoof with the printers Bob and Les; it was a most amazing experience. A proposal for a single print turned into a sequence of five variations. They would produce three or four tones of each of the colours from which I would select one and we would build the *bon à tirer* that way.' (DH, 17/1/2000)

428 Sidlesham Sunrise, 1981 (Page 256)
Screenprint, eighteen printings, printed on Arches 88 paper
Image: 595 × 483 mm (23 $\frac{7}{16}$ × 19 in), paper: 725 × 570 mm (28 $\frac{9}{16}$ × 22 $\frac{7}{16}$ in)
Insc bl: printer's chop and *31/50*, bc: '*Sidlesham Sunrise*', br: *Derek Hirst 1981* (pencil) and embossed ea
Edition: 50, 12 ap plus 2 variation states
Pr: Leslie Hosgood and Robert Jones, Megara Screenprinting Ltd, Alecto Studios, London; pub: 1981 (ea 992)
Coll: St Thomas's Hospital, London

This was the final contemporary print to be published by ea, and 'the first new piece' for Hirst after a serious illness. 'What was extraordinary was that we editioned it as we *created* it (so there are no *bon à tirer* prints). Bob and Les separated out screens from the original collage, and we printed one colour at a time There was an edition of fifty or so plus artists proofs and two variations. It was these *latter* variations, which have a texture across the central image, that the Head of Dance at the Julliard School in New York and one of Martha Graham's original dancers, associated with the Hopi Indians' image for healing.' (DH 30/1/2000)

David Hockney (*b*.Bradford, 1937)

Bradford School of Art, 1953–7 where proofed a few lithographs; and RCA, 1959–62. Began to etch in 1961, receiving Guinness Award established by Robert Erskine for student section of *The Graven Image* exhibition. This paid for visit to New York, which inspired first print series *A Rake's Progress*. Through ℮a, met intaglio printer Maurice Payne who continues to print etchings. Graphics published by Petersburg Press from 1968 and throughout the 1970s. Produced lithographs with Kenneth Tyler at Gemini GEL, Los Angeles; and from 1980s produced small print editions with photocopier.

Exh and Lit: *Whitechapel Art Gallery*, 1970; *David Hockney Prints 1954–77*, The Midland Group, Scottish Arts Council and Petersburg Press, 1979

429 Gretchen and the Snurl, 1961–3

Etching, hard-ground and aquatint, five zinc plates, printed in black on Crisbrook 140 lb paper
Plate 1: 79 × 104 mm (3 $\frac{1}{8}$ × 4 $\frac{3}{32}$ in), insc: *Gretchen/ Aunt Jemima/ Coffee/ Cake Mix/ with/ Cinnamon/ topping . . .* ; Plate 2: 119 × 99 mm (4 $\frac{11}{16}$ × 3 $\frac{31}{32}$ in), insc: *io/ t'amo/ bambino/ snurl*; Plate 3: 78 × 98 mm (3 $\frac{1}{16}$ × 3 $\frac{7}{8}$ in), insc: *to the big wide world*; Plate 4: 78 × 99 mm (3 $\frac{1}{16}$ × 3 $\frac{31}{32}$ in), insc: *Snatch (nasty)*; Plate 5: 89 × 117 mm (3 $\frac{1}{2}$ × 4 $\frac{5}{8}$ in), insc: *Snurl/ Gretchen/ and they/ lived hap(pily)/ ever aft(er)*; paper: 225 × 791 mm (8 $\frac{7}{8}$ × 31 $\frac{1}{8}$ in)
Insc b: *artists proof Gretchen + the Snurl – a modern fairy story written by my friend Mark B*, br: *David Hockney '61* (pencil) with ℮a embossed (in edition)
Edition: 50, 10 (16) ap
Proofed: The artist, 1961; pr: Peter Matthews, RCA, 1963; pub: 1963 (℮a 2)
Lit: *David Hockney Prints 1954–77* (9, where edition is described as 75, 16 proofs)
Coll: Manchester City Art Galleries; Cartwright Hall Art Gallery, Bradford; V&A

An illustration to unpublished story by Mark Berger, with at least one proof showing the five plates in a different sequence to the published edition.

A RAKE'S PROGRESS, 1961–3 (Pages 35–7)

Portfolio of sixteen etchings with sugar-lift aquatint on 44 lb Crisbrook Royal Hotpress paper, single zinc plates, printed in red and black, with title sheet, colophon and artist's statement sheet. Letterpress by Curwen Press, London, in Times New Roman type
Plate: 300 × 400 mm (11 $\frac{13}{16}$ × 15 $\frac{3}{4}$ in), paper: 500 × 625 mm (19 $\frac{11}{16}$ × 24 $\frac{5}{8}$ in, slight variation)
Insc bl: edition number, br: *David Hockney* (pencil) with ℮a embossed
Presented in red cloth folio and black portfolio box, designed by Eric Ayers (638 × 506 mm, 25 $\frac{1}{4}$ × 19 $\frac{15}{16}$ in)
Edition: 50, 10 ap
Proofed: The artist at RCA, 1961–3 (no. 7 and 7a at The Pratt

Graphic Workshop, New York, May 1963); pr: C. H. Welch, London studio; pub: 1963 (℮a 1)
Exh: *A Rake's Progress*, The Print Centre, London, Dec 1963
Coll: V&A; Tate; National Gallery of Australia, Canberra; MOMA; British Council; Yale Center for British Art, New Haven

The cancelled plates for *A Rake's Progress* were presented by ℮a to V&A. The sixteen etchings were subsequently reproduced by half-tone letterpress blocks, reduced in size and with an accompanying poem by David Posner, for the book of the same title, published by The Lion and Unicorn Press, London, 1967.

430 1. The Arrival

Etching, hard-ground and aquatint
Insc on plate: *A Rake's Progress/ London/ New York 1961–62/ Plate No 1 The Arrival*

431 1a. Receiving the Inheritance

Etching, hard-ground and aquatint
Insc on plate: *A Rake's Progress/ London/ New York/ 1961–62/ Plate No 1A Receiving The Inheritance* and *$ 18/$20/000/ myself and my heroes*

432 2. Meeting the Good People (Washington)

Etching, hard-ground and aquatint
Insc on plate: *A Rake's Progress/ London/ New York/ 1961–62/ Plate No 2 Meeting The/ Good People/ (Washington)* and *Jefferson/ Washington*

433 2a. The Gospel Singing (Good People) (Madison Square Garden)

Etching, hard-ground and aquatint
Insc on plate: *A Rake's Progress/ London/ New York/ 1961–62/ Plate No 2A/ The Gospel Singing/ (Good People)/ (Madison Sq Garden)* and *Halleluja Halleluja/ Heaven/ God is Love*

434 3. The Start of the Spending Spree and the Door Opening for a Blonde

Etching, hard-ground and aquatint
Insc on plate: *A Rake's Progress/ London/ New York/ 1961–62/ Plate 3 The Start of The/ Spending Spree And The Door Opening For A Blonde* and *Lady CL* on bottle

435 3a. The Seven Stone Weakling

Etching, hard-ground and aquatint
Insc on plate: *A Rake's Progress/ London/ New York/ 1961–62/ Plate 3A The 7 Stone Weakling*

436 4. The Drinking Scene

Etching, hard-ground and aquatint
Insc on plate: *A Rake's Progress/ London/ New York/ 1961–62/ Plate 4 The Drinking Scene* and *BAR/BE*

437 4a. Marries an Old Maid
Etching, hard-ground and aquatint
Insc on plate: *A Rake's Progress/ London/ New York/ 1961–62/ Plate 4A Marries An Old Maid*

438 5. The Election Campaign (with Dark Message)
Etching, hard-ground and aquatint
Insc on plate: *A Rake's Progress/ London/ New York/ 1961–62/ Plate No 5 The Election Campaign/ (With Dark Message)*

439 5a. Viewing a Prison Scene
Etching, hard-ground and aquatint
Insc on plate: *A Rake's Progress/ London/ New York/ 1961–62/ Plate No 5A Viewing A Prison Scene* and *12345678*

440 6. Death in Harlem
Etching, hard-ground and aquatint
Insc on plate: *A Rake's Progress/ London/ New York/ 1961–62/ Plate No 6 Death In Harlem*

441 6a. The Wallet begins to empty
Etching, hard-ground and aquatint
Insc on plate: *A Rake's Progress/ London/ New York/ 1961–62/ Plate 6A The Wallet Begins To Empty* and *Admission 50$*

442 7. Disintegration
Etching, hard-ground and aquatint
Insc on plate: *A Rake's Progress/ London/ New York/ 1961–62 Plate 7 Disintegration* and *B E L L O W S / Blended/ Whiskey/ $5*

443 7a. Cast Aside
Etching, hard-ground and aquatint
Insc on plate: *A Rake's Progress/ London/ New York/ 1961–62 Plate 7A Cast Aside*

444 8. Meeting the Other People
Etching, hard-ground and aquatint
Insc on plate: *A Rake's Progress/ London/ New York 1961–62 Plate 8 Meeting The Other People*

445 8a. Bedlam
Etching, hard-ground and aquatint
Insc on plate: *A Rake's Progress/ London/ New York 1961–62 Bedlam BEDLAM/ I swing with W A B C*

446 A Rake's Progress: Poster, 1963 (Page 80)
Lithograph, off-set, tusche and crayon, zinc, red and black on Crisbrook paper
Image and paper: 797 × 573 mm (31 $\frac{3}{8}$ × 22 $\frac{9}{16}$ in)
Insc b: *A Rake's Progress and other etchings/ By David Hockney/ Editions Alecto The Print Centre 8 Holland St W8 During December*, br: *David Hockney 63* (pencil)
Designed: Eric Ayers; pr: Curwen Studio, London under the supervision of Stanley Jones, November 1963

Edition: 110 signed in pencil
Coll: British Council; MOMA; Research Centre, Tate

'These etchings were begun in London in September 1961 after a visit to the United States. My intention was to make eight plates, keeping the original titles but moving the setting to New York. The Royal College, on seeing me start work, were anxious to extend the series with the idea of incorporating the plates in a book of reproductions to be printed by the Lion and Unicorn Press; accordingly I set out to to make twenty-four plates, but later reduced the total to sixteen, retaining the numbering from one to eight and most of the titles in the original tale.

Altogether I made about thirty-five plates of which nineteen were abandoned, so leaving these sixteen in the published set. No 7 and 7a were etched at Pratt Graphic workshop in New York City in May of this year, the others at the Royal College of Art from 1961 to 1963.' (David Hockney, *A Rake's Progress and other etchings*, The Print Centre, Dec 1963)

447 Poster: Britische Graphische Scene, 1963 (Page 42)
Photo-litho reproduction, printed in black and red
Designed by Eric Ayers, printed by Shenval Press, London
Image and paper: 460 × 340 mm (18 $\frac{1}{8}$ × 13 $\frac{3}{8}$ in)
Insc b: *Britische Graphische Scene/ 2 bis 27 September 1963/ Orell Füssli Buchhandlung Pelikanstrasse 10 Zürich 1* (printed)
Edition: 50 (for sale)

Printed from the etching *The Hypnotist*, 1963, and in turn the (reversed) painting of the same title and year. Eric Ayers also designed the catalogue for *Britische Graphische Scene* exhibition, using the same image for the front cover.

448 Pacific Mutual Life, 1964
Lithograph, stone, crayon and tusche with pencil and scraping, printed in black on B. F. K. Rives paper
Image and paper: 514 × 635 mm (20 $\frac{1}{4}$ × 25 in)
Insc with title across top and along bottom: *Pershing Square*, bl: Tamarind monogram and below *Ak* monogram, br: *Tam imp David Hockney 64* (crayon, red)
Proofed: Irwin Hollander, Tamarind Lithography Workshop; pr: Aris Koutroulis, Tamarind Lithography Workshop, Los Angeles, 12–13 March 1964; pub: 1964 (ea 14)
Edition: 20, 9 Tamarind impressions, 3 ap, 1 tp, 2 pp, 1 cp
Coll: University of New Mexico Art Museum, Albuquerque; Cecil Higgins Art Gallery, Bedford; MOMA; Tate

449 Water pouring into swimming pool, Santa Monica, 1964
Lithograph, tusche and crayon, stone and three zinc plates, printed in blue, pink, grey, black on Japanese handmade paper
Image: 468 × 620 mm (18 $\frac{7}{16}$ × 24 $\frac{3}{8}$ in), paper: 507 × 655 mm (19 $\frac{15}{16}$ × 25 $\frac{13}{16}$ in)
Insc bl: *23/75* (pencil) and on plate: *water pouring into swimming pool, Santa Monica*, br: *David Hockney '64* (pencil) with ea embossed
Edition: 75, 15 ap

Pr: Matthieu AG, Zürich; pub: 1964 (ℰ𝒶 15)
Coll: Tate

This image relates to the acrylic painting *Different Kinds of water pouring into a swimming pool, Santa Monica*, 1965.

450 Portrait of Kasmin, 1964 (Page 43)
Lithograph, tusche and crayon, stone and zinc, printed in black and grey, with screenprint addition in white on B. F. K. Rives mould-made paper
Image: 499 × 657 mm (19 $\frac{5}{8}$ × 25 $\frac{7}{8}$ in)
Insc bl: *40/75*, br: *David Hockney '64* (pencil) with ℰ𝒶 embossed
Edition: 75, 15 (16) ap
Pr: Matthieu AG, Zürich; pub: 1964 (ℰ𝒶 16)
Coll: GAC

Also known as *Figure by a curtain*, this image relates to the painting *Play within a Play*, depicting Hockney's dealer John Kasmin. The immediate sources are the mural *Apollo killing Cyclops* by Domenichino in the National Gallery, London and a photograph of Kasmin with his face squashed against glass.

A HOLLYWOOD COLLECTION 1965 (Pages 72–3)
Series of six, colour lithography, crayon and tusche on stone and aluminium plates, plus offset-lithography for title and contents pages, on B. F. K. Rives mould-made paper
Insc br: signed *David Hockney 65* with edition number (pencil), vo: Gemimi circular stamp and ℰ𝒶 stamp with publication number
Edition: 85, 12 ap, 4 tp
Pr: Kenneth Tyler, Gemini Ltd, Los Angeles, 1965; pub: 1965 (ℰ𝒶 13)
Coll: Staatliche Museen zu Berlin; MOMA; Metropolitan Museum of Art; Art Gallery of Ontario, Toronto; Brooklyn Museum of Art; Financial Times; British Council (incomplete); National Gallery of Australia, Canberra; MOMA

These prints were Hockney's idea of an instant art collection, pre-packaged in appropriate frames, but also refering to the Gemini studio which was behind a frame-maker's shop (*David Hockney By David Hockney; My Early Years*, Thames and Hudson, 1976, p.101). ℰ𝒶 in turn sold the series in their own specially designed white perspex frame.

Table of Contents
Offset-lithograph printed in black, with photo of David Hockney and text: 'Drawn on stones and aluminium plates 1965/ Printed by Gemini Ltd, Hollywood, California/ B. F. K. Rives paper 30 in × 20 in/ 76.2 cm × 50.8 cm/
Lithograph 1 Picture of a still life which has an elaborate silver frame/ Seven colours/
Lithograph 2 Picture of a landscape in an elaborate gold frame/ Six colours/
Lithograph 3 Picture of a portrait in a silver frame/ Five colours/
Lithograph 4 Picture of Melrose Avenue with an ornate gold frame/ Six colours/
Lithograph 5 Picture of a simple framed traditional nude drawing/ Four colours/
Lithograph 6 Picture of a pointless abstraction framed under glass/ Six colours/
Published by Editions Alecto Ltd as portfolios of six original lithographs in/ numbered and signed editions limited to eighty-five and twelve artists proofs, with four trial proofs.

451 Picture of a still life which has an elaborate silver frame (1)
Lithograph, two stones and five aluminium plates, printed in red, two greens, grey, three blues, black
Image and paper: 768 × 563 mm (30 $\frac{1}{4}$ × 22 $\frac{3}{16}$ in) (ℰ𝒶 13)

Also printed as a reproductive edition for PSA, 1975 (see below)

452 Picture of a landscape in an elaborate gold frame (2)
Lithograph, two stones and four aluminium plates, printed in two yellows, brown, blue, two greens
Image and paper: 766 × 562 mm (30 $\frac{3}{16}$ × 22 $\frac{1}{8}$ in) (ℰ𝒶 13)

453 Picture of a portrait in a silver frame (3)
Lithograph, two stones and three aluminium plates, printed in blue, black, grey, silver, pink
Image and paper: 767 × 564 mm (30 $\frac{3}{16}$ × 22 $\frac{3}{16}$ in) (ℰ𝒶 13)

The ℰ𝒶 Register mistakenly lists *Picture of Melrose Avenue . . .* as number three in this Series and *Poster – American Bowl* as number six.

454 Picture of Melrose Avenue in an ornate gold frame (4)
Lithograph, two stones and four aluminium plates, printed in black, blue, two yellows, grey, pink maroon
Image and paper: 764 × 562 mm (30 $\frac{1}{16}$ × 22 $\frac{1}{8}$ in) (ℰ𝒶 13)

455 Picture of a simple framed traditional nude drawing (5)
Lithograph, two stones and two aluminium plates, printed in brown, buff, green, black
Image and paper: 766 × 562 mm (30 $\frac{3}{16}$ × 22 $\frac{1}{8}$ in) (ℰ𝒶 13)

456 Picture of a pointless abstraction framed under glass (6)
Lithograph, two stones and four aluminium plates, printed in green, black, grey, blue, yellow, red
Image and paper: 768 × 562 mm (30 $\frac{1}{4}$ × 22 $\frac{1}{8}$ in) (ℰ𝒶 13)

457 Poster: A Hollywood Collection, 1965
Lithograph, photo and offset, from drawing, printed in black, red, orange and yellow
Image: 392 × 335 mm (15 $\frac{7}{16}$ × 13 $\frac{3}{16}$ in), paper: 768 × 566 mm (30 $\frac{1}{4}$ × 22 $\frac{9}{32}$ in)
Insc on picture frame: *Hollywood Bowl/ Calif/* below: *A Hollywood Collection/ David Hockney/ Editions Alecto 1965* (red and black)

Pr: Mansell Litho, London with varnish printing screened by Kelpra Studio, London
Edition: 300 signed in pencil
Coll: Wednesbury Art Gallery; Art Gallery of Ontario, Toronto

THE CAVAFY SERIES, 1966–7

Series of twelve etchings, steel-faced copperplate, printed in black on handmade Crisbrook waterleaf 140 lb imperial paper (except vellum edition). Pr: Maurice Payne and Danyon Black, Alecto Studios, London, 1966–7; with reprinting by James Collyer and John Crossley, 1968. Accompanied by fourteen poems translated from C. P. Cavafy by Nikos Stangos and Stephen Spender. Portfolio editions have text and poems printed on separate folded sleeves containing the appropriate etchings. Produced in five editions, with book editions entitled: *Fourteen Poems by C P Cavafy*; typography and book design by Gordon House; magenta cotton silk bookcases, black slipcases and black cloth/leather portfolio boxes produced by Galerie der Spiegel, Cologne; pub: 1967 (ea 362–73)
Plate: 350 × 225 mm (13$\frac{5}{8}$ × 8$\frac{7}{8}$ in)
Coll: National Gallery of Australia, Canberra

The author has seen two cancellation editions, unsigned and with printers' and publishers' stamps. The images are titled after the accompanying poems unless stated otherwise.

458 Portrait of Cavafy in Alexandria (Page 110)
Etching, hard-ground and aquatint
Insc along top on plate: *C P Cafavy in Alexandria*
Accompanies the poem: *The mirror at the entrance* (ea 362)
Coll: National Gallery of Canada, Ottawa; Brooklyn Museum of Art

459 Two boys aged 23 or 24
Etching, hard-ground and aquatint
(ea 363)

460 He enquired after the quality (Page 111)
Etching, hard-ground and aquatint
(ea 364)

461 To remain
Etching, hard-ground and aquatint
(ea 365)

462 According to prescriptions of ancient magicians
Etching, hard-ground
(ea 366)

463 In an old book
Etching, hard-ground
(ea 367)

464 The shop window of a tobacco store
Etching, hard-ground and aquatint
(ea 368)

465 In the dull village (Page 110)
Etching, hard-ground
(ea 369)

466 The beginning
Etching, hard-ground and aquatint
(ea 370)
Coll: SNGMA

467 One night
Etching, hard-ground and aquatint
(ea 371)

468 In despair
Etching, hard-ground
(ea 372)

469 Beautiful and white flowers
Etching, hard-ground and aquatint
(ea 373)

470 Edition A:
250 books, each with twelve etchings and text, bound in cotton silk bookcase and slipcase; numbered *1–250/ 500* with fifty proofs inscribed *artist's proof* and signed by the artist on the final page; additional signed loose etching *Portrait of Cavafy 11*; vo: stamped *Edition A* with ea and publication number
Paper: 467 × 328 mm (18$\frac{3}{8}$ × 12$\frac{15}{16}$ in); overall bound size: 475 × 338 mm (18$\frac{11}{16}$ × 13$\frac{5}{16}$ in)
Coll: Glasgow Museums; Fitzwilliam Museum, Cambridge

471 Edition B:
250 books, each with twelve etchings and text, bound in cotton silk bookcase and slipcase; numbered *251–500* and signed by the artist on the final page; vo: stamped *Edition B* with ea and publication number
Paper: 467 × 328 mm (18$\frac{3}{8}$ × 12$\frac{15}{16}$ in); overall bound size: 475 × 338 mm (18$\frac{11}{16}$ × 13$\frac{5}{16}$ in)
Coll: Whitworth Art Gallery, University of Manchester; MOMA; British Museum, V&A

Edition C:
Fifty sets of twelve etchings, loose, each numbered *1–50/ 75* and signed by the artist, each etching stamped vo: ea and publication number
Paper: 580 × 410 mm (22$\frac{13}{16}$ × 16$\frac{1}{8}$ in)
Coll: ACE

Edition D:
Twenty-five sets of twelve etchings, loose with text, boxed in cloth lined portfolio, each etching numbered individually *51–75/ 75* and signed by the artist; vo: stamped *ea* and publication number, fifteen additional sets signed *artist's proof*
Paper: 580 × 410 mm (22$\frac{13}{16}$ × 16$\frac{1}{8}$ in)
Coll: New Orleans Museum of Art; British Council

Edition E:
Twenty-five sets of thirteen etchings, loose with text, on handmade vellum wove 72 lb Royal paper by J. Barcham Green Ltd, and including *Portrait of Cavafy 11*, in boxed leather portfolio. Numbered individually: *1–XXV/ XXV*, signed by the artist and dated *66*; vo: stamped *ea* and publication number, further five sets signed *artist's proof*
Paper: 635 × 506 mm (25 × 19$\frac{15}{16}$ in), Box: 660 × 528 mm (26 × 20$\frac{13}{16}$ in)

472 Portrait of Cavafy II, 1967
Etching, hard-ground and aquatint, steel-faced copperplate on Crisbrook handmade 140 lb paper
Plate: 360 × 230 mm (14$\frac{3}{16}$ × 9$\frac{1}{16}$ in), paper: 570 × 395 mm (22$\frac{7}{16}$ × 15$\frac{9}{16}$ in) (vellum 635 × 505 mm, 25 × 19$\frac{7}{8}$ in)
Edition: 300 (Crisbrook); 25 in Roman numerals, 5 proofs (vellum edition) (*ea* 431)

472a Reprinted as a photo-litho reproduction, 1975
Image: 254 × 165 mm (10 × 6$\frac{1}{2}$ in)

473 Cushions, 1968
Etching with aquatint, copperplate, printed in black on Crisbrook handmade 140 lb paper
Plate: 386 × 351 mm (15$\frac{3}{16}$ × 13$\frac{13}{16}$ in), paper: 562 × 530 mm (22$\frac{1}{8}$ × 20$\frac{7}{8}$ in)
Insc: *70/75* and br: *David Hockney 68* (pencil)
Edition: 75, 15 (17) ap
Proofed and pr: Maurice Payne, Alecto Studios, London; pub: 1968 (*ea* 518)

Also known as *Cushions on a Sofa*, this etching relates to the painting *Some Neat Cushions*, 1967

474 An Etching and a Lithograph for Editions Alecto, 1973
Etching, hard-ground and aquatint, copperplate, printed in red, black, brown, and lithograph, two stones and zinc plate, worked in crayon and printed in grey, black, orange, yellow, red, green, blue on J. Green waterleaf HP 310 gsm paper
Image: 760 × 492 mm (29$\frac{15}{16}$ × 19$\frac{3}{8}$ in), paper: 927 × 655 mm (36$\frac{1}{2}$ × 25$\frac{13}{16}$ in)
Insc across plate: *AN ETCHING/ and a lithograph for/ Editions Alecto/ 1973*, b: signed, dated and numbered by the artist in pencil
Edition: 100, 20 ap, 5 cp (without litho dated *9 May 1973*)
Pr: James Collyer, John Crossley and Bud Shark, Alecto Studios, London; pub: EACC, 1973 (*ea* 829)

Coll: Cleveland Museum of Art; New Orleans Museum of Art; Brooklyn Museum of Art

To mark the tenth anniversary of *ea*, a collotype reproduction was produced on cartridge paper; insc: *rep proof*, signed, dated and numbered by the artist; printed by Cotswold Collotype in an edition of 2000; and distributed through EACC, 1973.

475 Picture of a Still Life that has an elaborate Silver Frame, 1975
Coloured lithograph, off-set, printed on cartridge paper
Image: 763 × 565 mm (30$\frac{1}{16}$ × 22$\frac{1}{4}$ in), paper: 1000 × 717 mm (39$\frac{3}{8}$ × 28$\frac{1}{4}$ in)
Insc b. printed: *'Picture of a Still Life that has an elaborate Silver Frame' by David Hockney © Published for PSA Supplies Division by Editions Alecto Ltd. Printed offset litho in London, England*
Edition: unlimited
Pr: Curwen Studio, London; pub: PSA, Department of the Environment through Editions Alecto Ltd, 1975 (*ea* 915)

Howard Hodgkin (*b.*London, 1932)

Camberwell School of Art, 1949–50; Bath Academy of Art, Corsham, 1950–4. First visit to India, 1964. Worked in most print media, most recently producing hand-painted carborundum etchings, printed by Jack Shirreff. *Howard Hodgkin Complete Prints* at MOMA, Oxford, 1977 and *Howard Hodgkin: Prints 1977–83* at Tate Gallery, 1984. International exhibitions include: *Howard Hodgkin at Dulwich Picture Gallery*, London, 2001. Liesbeth Heenk's catalogue raisonné of prints to be published by Thames and Hudson, 2003.

5 ROOMS SERIES, 1966–8
Five colour lithographs, produced as editions of seventy-five
Image and paper: 510 × 650 mm (20$\frac{1}{16}$ × 25$\frac{9}{16}$ in, slight variation)
Insc bl and br: with edition number and signed *Hodgkin* with date (pencil), vo: stamped with *ea* and publication number
Pub: 1966 and 1968 (*ea* 300–1, 519, 541–2)

476 Interior with Figure, 1966
Lithograph, zinc, tusche and crayon, printed in orange, three blues, black on B. F. K. Rives paper
Edition of 75, 15 ap and couple of pp
Pr: Matthieu AG, Zürich, 1966; pub: 1966 (*ea* 300)
Coll: V&A; Tate; Art Gallery of Ontario, Toronto

477 Girl at Night, 1966
Lithograph, zinc, tusche and crayon, printed in orange, two pinks, black on B. F. K. Rives paper
Edition: 75, 15 ap and couple of pp
Pr: Matthieu AG, Zürich, 1966; pub: 1966 (*ea* 301)
Coll: V&A; Tate

478 Indian Room, 1967–8
Lithograph, zinc, tusche, printed in lemon yellow, warm yellow
(*pou de crapou*), blue green, dark green, creamy white and red
on B. F. K. Rives paper
Edition: 75, 14 ap, 1 tp, up to 2 pp, 1 bat, and 1 incomplete
proof
Proofed: Ian Lawson, Bath Academy of Art, Corsham; pr: Ian
Lawson, Alecto Studios, London, 1967; pub: 1968 (ℯⓐ 519)
Coll: V&A; Tate; ACE

'Howard Hodgkin was teaching at Corsham, so the first print
was proofed there, and then editioned at Alecto One colour
a day . . . for an edition of seventy-five this meant a long day.' (Ian
Lawson, 14/8/1999)

479 Bedroom, 1968
Lithograph, zinc, tusche and crayon with splatter, printed in red,
orange, green, black, pink on J. Green paper
Edition: 75, 15 ap, 2 pp
Pr: Ian Lawson and Ernest Donagh, Alecto Studios, London;
pub: 1968 (ℯⓐ 541)
Coll: V&A; ACE; Tate; Fitzwilliam Museum, Cambridge

480 Girl on a Sofa, 1968 (Page 125)
Lithograph, zinc, tusche and crayon, printed in dark blue, two
blacks, orange, pink, green, brown on J. Green paper
Edition: 75, 15 ap, 2 pp
Pr: Ian Lawson and Ernest Donagh, Alecto Studios, London;
pub: 1968 (ℯⓐ 542)
Coll: Tate; ACE

Liesbeth Heenk has written in correspondence that these five
prints were independent of any kind of drawing or gouache, and
were not originally intended to form a series. 'He (Howard) was
simply asked by Paul Cornwall-Jones to make some prints. In
hindsight he wasn't too pleased with them and thought that
perhaps there should have been four rather than five rooms'
(29/3/2002)

Walter Hoyle (*b.*Rushton, Lancashire, 1922–2000)

Beckenham School of Art, before attending RCA, 1940–2 and
1947–8. Contributed linocut wall of animals to House and Gardens
section of Festival of Britain. Lived near Great Bardfield for some
twenty-two years, exhibiting in Great Bardfield exhibitions during
1950s. Taught at Cambridge School of Art, 1964–85, where set up
the workshop Cambridge Print Editions, and helped launch the
accompanying magazine *Private View*. After retirement, a studio in
Dieppe was combined for many years with living in Hastings.

481 Administrative Staff College, Henley on Thames, 1964
Linocut, printed in brown, black, blue, green on handmade
Japanese paper
Image: 404 × 535 mm (15$\frac{29}{32}$ × 21$\frac{1}{16}$ in), paper: 509 × 643 mm
(20$\frac{1}{16}$ × 25$\frac{5}{16}$ in)

Insc bl: *AP*, bc: *Henley Business College*, br: *Walter Hoyle*
(pencil)
Edition: 75, 10 ap
Pr: The artist on Harrild Albion (1885) Press, Rosemary House,
Great Saling; pub: 1964 (no publication number)

Founded in 1945 outside Henley-on-Thames, The Administrative
Staff College was retitled The Henley Management College in
1991. The connection for the commission came through Paul
Cornwall-Jones, his father, A. T. Cornwall-Jones (known as C-J),
being a celebrated Director of Studies at the College.

CAMBRIDGE SERIES, 1965–6
Ten linoleum prints, two blocks unless stated otherwise, with title
page/poster and contents sheet ('red and black lettering cut-out
of cork and stuck onto board for inking up and printing'). Cut,
proofed and printed by the artist on handmade Japanese Hosho
no 150 paper on a Harrild Albion Press (1885) at studio,
Rosemary House, Great Saling, Essex, 1965–6
Paper: 967 × 678 mm (38$\frac{1}{16}$ × 26$\frac{11}{16}$ in)
Insc bl: with edition number, bc: with title and br: signed by the
artist: *Walter Hoyle* (pencil), vo: stamped with ℯⓐ and
publication number (mostly).
Pub: 1966 (ℯⓐ 266–75)
Edition: 75, 10 ap, the complete set presented as a boxed
portfolio (also sold individually)
Coll: Arthur Andersen, London; GAC (both incomplete)
Exh: *Zodiac Paintings and Cambridge Prints*, The Savage
Gallery, Old Brompton Road, London, 20 Oct–5 Nov 1966

482 King's College Chapel
Linocut, three blocks, printed in two browns, black, white,
bronze, blue
Image: 710 × 410 mm (27$\frac{15}{16}$ × 16$\frac{1}{8}$ in) (ℯⓐ 266)

483 Sundial, Queens College
Linocut, printed in Naples yellow, brown, blue, black
Image: 764 × 573 mm (30$\frac{1}{16}$ × 22$\frac{9}{16}$ in) (ℯⓐ 267)

484 Jesus College
Linocut, printed in Naples yellow (and with reducer), cerise,
sepia, vermilion, turpentine dropped on lino along top
Image: 765 × 487 mm (30$\frac{1}{8}$ × 19$\frac{3}{16}$ in) (ℯⓐ 268)

485 Gate of Honour, Caius College
Linocut, printed in Naples yellow, blue and blue diluted, blue
green, black, with turpentine dropped on lino
Image: 560 × 432 mm (22$\frac{1}{32}$ × 17 in) (ℯⓐ 269)

486 Wren Chapel, Emmanuel College
Linocut, printed in black, blue, Naples yellow, white
Image: 431 × 556 mm (16$\frac{31}{32}$ × 21$\frac{7}{8}$ in) (ℯⓐ 270)

Hoyle's inclusion of *edition/ proof* on some of his prints was a
practice also used by Edward Bawden.

487 King's College Chapel Porch
Linocut, printed in grey, brown, orange, black
Image: 712 × 495 mm ($28\frac{1}{32}$ × $19\frac{1}{2}$ in) (*ea* 271)

488 King's College
Linocut, printed in silver, grey, brown, two blacks
Image: 562 × 759 mm ($22\frac{1}{8}$ × $29\frac{7}{8}$ in) (*ea* 272)

489 Senate House
Linocut, printed in silver, green, blue, brown, black
Image: 460 × 692 mm ($18\frac{1}{8}$ × $27\frac{1}{4}$ in) (*ea* 273)

'There is quite a complicated build up of texture in this print, with roulette and knife marks across the various sky areas.' (WH, 26/3/1999)

490 St John's College
Linocut, one block, printed in metallic silver, two blacks, ochre, brown
Image: 560 × 560 mm ($22\frac{1}{16}$ × $22\frac{1}{16}$ in) (*ea* 274)
Coll: South London Gallery

'Although I used two blocks for most of the relief prints, I sometimes used a block (same block) twice, inking different areas from the first printing.' (WH, 16/4/1999)

491 Poster/Title Page – Cambridge
Linocut, printed in bronze, blue, black, yellow
Image: 560 × 436 mm ($22\frac{1}{16}$ × $17\frac{3}{16}$ in), paper: 965 × 676 mm (38 × $26\frac{5}{8}$ in)
Insc tc: *Cambridge*, bc: *Walter Hoyle/ Editions Alecto 1966* (printed), bl: *Artists proof*, bc: *Cambridge*, br: *Walter Hoyle* (pencil) (*ea* 275)

'A view of King's College . . . I dropped turps on it.' (WH, 16/4/1999)

492 Planets, 1969
Etching and aquatint, two copperplates, printed in brown and orange red
Plates: 667 × 500 mm ($26\frac{1}{4}$ × $19\frac{11}{16}$ in, overall size), paper: 788 × 585 mm ($31\frac{1}{32}$ × $23\frac{1}{32}$ in, various cut edges)
Insc bl: *artists proof*, bc: *Planets*, br: *Walter Hoyle* (pencil)
Edition: 75, 10 ap
Pr: The artist on his Hunter Penrose Press, Rosemary House, Great Saling; pub: 1969 (*ea* 646)
Coll: GAC

Series on the planets of the zodiac and their related signs: 'I remember buying a book on the signs of the zodiac. I first worked on a series of paintings and then made a number of prints.' This allowed *ea* to have a choice, but 'usually I agreed with Joe Studholme.' (WH, 16/4/1999) Other related prints include *Jupiter* published by the artist in edition of twenty-five.

493 Saturn, 1969
Etching and aquatint, two copperplates, printed in black and orange on Arches paper
Plate: 305 × 619 mm (12 × $24\frac{3}{8}$ in, undulating edges), paper: 495 × 784 mm ($19\frac{1}{2}$ × $30\frac{7}{8}$ in)
Insc bl: *Artists proof*, bc: *"Saturn"*, br: *Walter Hoyle* (pencil)
Edition: 75, 10 ap
Pr: The artist on starwheel press, Rosemary House, Great Saling; pub: 1969 (*ea* 647)

'I used aquatint and drill for the figure on the left . . . early in the series and printed with a starwheeel which had no gears; it was hard work!' (WH, 16/4/1999)

494 Mars, 1969
Etching and aquatint, two copperplates, printed in brown and red on Arches paper
Plate: 637 × 500 mm ($25\frac{1}{16}$ × $19\frac{11}{16}$ in), paper: 713 × 575 mm ($28\frac{1}{16}$ × $22\frac{5}{8}$ in)
Insc bl: *Artists proof*, bc: 'Mars', br: *Walter Hoyle* (pencil)
Edition: 75, 10 ap
Pr: The artist on Hunter Penrose Press, Rosemary House, Great Saling; pub: 1969 (*ea* 648)
Coll: Bibliothèque Nationale, Paris; Towner Art Gallery, Eastbourne

The figure of Mars, with symbols of ram and crab on the shield he is carrying, and staff to one side. 'I didn't overwipe it, so left bloom of colour on the surface.' (WH, 26/3/1999)

495 Sun, 1969
Etching and aquatint, two copperplates, printed in red and brown on Arches paper
Plate: 495 × 500 mm ($19\frac{1}{2}$ × $19\frac{11}{16}$ in), paper: 792 × 585 mm ($31\frac{3}{16}$ × $23\frac{1}{32}$ in)
Insc bl: *Artists proof*, bc: 'the Sun', br: *Walter Hoyle* (pencil)
Edition: 75, 10 ap
Pr: The artist on Hunter Penrose Press, Rosemary House, Great Saling; pub: 1969 (*ea* 649)

'A number of *Moons* in this series were rejected and never published I usually received a cheque for £200 a month when working for *ea*.' (WH, 26/3/1999)

496 Hammersmith House of BOC, 1977
Etching and aquatint, two steel-faced copperplates, printed in grey, black, orange yellow, on Arches 88 paper
Plate: 272 × 694 mm ($10\frac{11}{16}$ × $27\frac{5}{16}$ in), paper: 543 × 762 mm ($21\frac{3}{8}$ × 30 in)
Insc bl: *3/15 A/P*, bc: 'Hammersmith – Home of BOC', br: *Walter Hoyle* (pencil) and *ea* embossed
Edition: 150, 15 ap
Pr: Alecto Studios, London; pub: 1977 (no publication number)

Based upon a gouache of the British Oxygen Company building in Hammersmith. Hoyle was not particularly interested in modern

architecture and ended up showing this new building on a small scale in the background, alongside a sweeping view of the Thames looking upstream; 'the early state proofs are crisp in comparison to the edition'. BOC moved in 1985, and the building was taken over by United Distillers.

See Appendix

Alice Hutchins (b.Van Nuys, California, 1916)

University of California, Berkeley, moving to Paris in 1950. Studied with Robert Lapoujade, painter and film-maker, 1956–7. Painting full-time from 1962. Five years later began to create assemblages with magnets and found objects, described as 'optional art works'. Exhibited widely in USA, New York and Paris. Exhibiting with Contemporary Arts Forum in Santa Barbara, California *Women Beyond Borders*, 1995–2000. Represented in *Fluxus*, shown as part of the opening display, Tate Modern, 2000.

Lit: *Improvisation Magnetic Sculpture by Alice Hutchins*, Redding Museum and Art Center, USA

497 Nebula, 1971
Dark blue magnet and forty-nine polished chrome steel ball bearings
Height : 75 mm ($2\frac{15}{16}$ in), width: 50 mm ($1\frac{31}{32}$ in); with varying ball bearings; foam box: 150 × 150 × 76 mm ($5\frac{29}{32} × 5\frac{29}{32} × 3$ in)
Edition: unlimited
Pub: AI, London, 1971
Lit: *A Decade of Printmaking*, p.96 (ill.)

'*Nebula* is a painted version of *Petit Jeu*, which was sold as a multiple, unsigned, unlimited through the Gallery Lacloche in Paris, 1970 From my studio I later sold versions of this basic piece. Pieces were easy to duplicate as they were made up of ready mades held together in a magnetic field provided by the permanent industrial magnet which as in this case was also a visible component of the piece. The parts were on hand as I always bought in quantity when I found materials that appealed to me
 Nebula at first was called *Aluben*. I had nothing to do with the name which I left up to Alecto to confer The magnet, a bit smaller in diameter from mine, was painted blue. Unfortunately the paint chipped and the ball bearings in some cases rusted' (AH, 30/9/2000)

498 Sound Piece, 1971 (Page 217)
Magnetic sculpture; anodised matt black metal column with polished chrome steel movable ball plus six polished discs
Height of column: 104 mm ($4\frac{3}{16}$ in), ball: 64 mm ($2\frac{1}{2}$ in), discs: 50 mm ($1\frac{15}{16}$ in), foam box: 235 × 90 × 100 mm ($9\frac{1}{4} × 3\frac{17}{32} × 3\frac{15}{16}$ in)
Edition: unlimited
Pub: AI, 1971
Lit: Carol Cutler, *Art in America*, Sept/Oct 1969
Coll: Research Centre, Tate (Fluxus Collection)

Based upon the magnet piece *Bio* shown at Galerie Lacloche, Hutchins describes this as 'a magnet encased in a larger metal sheath to give it the proper proportions and for this reason is not as magnetic as the original which is one huge Alnico Magnet' (30/9/2000). The title is derived from the percussion effect of attaching discs to the central form to create endlessly variable structures.

Ben Johnson (b.Llandudno, Wales, 1946)

Studied painting at RCA, 1965–9. First solo show at Wickesham Gallery, New York. Exhibited with Fischer Fine Art, London in 1970s and 1980s. Painting and prints inspired by the architecture of Norman Foster, Richard Rogers, Arup Associates and James Stirling amongst others. Honorary Fellow of the Royal Institute of British Architects for contribution 'to public understanding of architecture', 1995. *Hong Kong Panorama* completed in 1997 for Hongkong Telecom, as part of personal project to paint the world's major cities.

499 Escalator, 1975
Screenprint, photo-stencils and air spray, printed in yellow, two greens, orange, two blues on R. K. Burt paper
Image: 560 × 841 mm ($22\frac{1}{32} × 33\frac{1}{8}$ in), paper: 660 × 946 mm ($26 × 37\frac{1}{4}$ in)
Insc bc: *25/125 BJ*, br: *Ben Johnson '75* (pencil), vo: ℮a *888* stamped
Edition: 125, 15 ap, 2 icp, 2 pp
Pr: Leslie Hosgood and Robert Jones, Megara Screenprinting Ltd, Alecto Studios, London; pub: 1975 (℮a 888)
Coll: Arthur Andersen, London; GAC

One of the five editions commissioned by ℮a between October 1975 and February 1976 as a joint venture with PSA, Department of the Environment. From the edition of one hundred and twenty-five, the Department purchased seventy-five impressions, plus three ap. Johnson's interest in contemporary architecture and architectural space was already established by the time of his ICA and Fischer Fine Art exhibitions in 1973 and 1975 respectively. This image from the Norman Foster *Willis Faber and Dumas* head offices in Ipswich is related to three acrylic paintings and based upon photographs taken by the artist. Working with screen separations and a spray gun, the final effect is of a granular surface of optically mixed colours.

Allen Jones (b.Southampton, 1937)

Painting and lithography at Hornsey College of Art, London, 1955–9; RCA, 1959–60. Taught lithography at Croydon College of Art, 1961–3. First lithographs at Matthieu AG, Zürich in 1964, who continue to print work into the 1970s. New York, 1964–5. Tamarind Lithography Fellowship, Los Angeles, 1966. Later prints, predominantly lithographs but also screenprints, printed by Landfall Press, Chicago; Kelpra Studio, London and Angeles Press, Los Angeles.

Lit: Marco Livingstone and Richard Lloyd, *Allen Jones Prints*, Munich and New York, Prestel-Verlag, 1995

CONCERNING MARRIAGES, 1964

Suite of eight colour lithographs, zinc plate, mainly tusche, plus title, colophon and artist pages, on B. F. K. Rives paper, published in oatmeal box insc: *Allen Jones Concerning Marriages ℮a* and containing orange folio, conceived by Allen Jones and realised by Eric Ayers
Image and paper: 762 × 563 mm (30 × 22 $\frac{3}{16}$ in)
Insc bl: with edition number, br: *Allen Jones 64* (pencil) and ℮a embossed
Pr: Matthieu AG, Zürich; pub: 1964 (℮a 3–10)
Edition of 75, 15 ap
Lit: *Allen Jones Prints*, 24 a–h
Coll: New Orleans Museum of Art; British Council; Financial Times; Staatliche Museen zu Berlin and MOMA (both incomplete)

Records show that Curwen Studio did some initial proofing for *Concerning Marriages* on three dates in Feb and March 1964. Failing to materialise, Paul Cornwall-Jones then asked Allen Jones where he would like to work, 'I said Matthieu because I knew Sam Francis printed there; and his print was one of the finest pieces of art I had acquired.' (AJ, 16/3/2000 and following quotations)

Title Sheet
Insc: *Concerning Marriages/ A Portfolio of Eight Lithographs/ Allen Jones/ Editions Alecto, 8 Holland Street, London W8*, insc bl: *2/75*, br: *Allen Jones 64* (pencil) with ℮a embossed

Artist Sheet
Never yet found I woman by whom I
Would have children, save by this
Woman that I love,
For I have thee O Eternity!
For I love thee O Eternity!

 Nietzsche

Any continuity in this folio comes from the attitude/ in which it was created and the natural progression/ of one thought leading to another. These images tell/ no literary tale, thus they remain individually untitled./ They are eight attempts at marriage.
Allen Jones

Colophon Sheet
Concerning Marriages/ Printed by Emil Matthieu, Zurich, Switzerland/ Paper BFK Rives, France/ Letterpress Shenval Press, London, England/ Type Standard Medium/ Portfolio design Eric Ayers/ Portfolio Zaehnsdorf Limited, London/ Publishers Editions Alecto, London, as folios of eight original lithographs in/ numbered and signed editions,/ limited to seventy five, with fifteen/ further sets of artist's proofs

500 1 (Bowler Hat) (Page 66)
Printed in black, yellow, orange, red, purple
(℮a 3)
Coll: Sheffield Galleries and Museums Trust

'Bowler hat – a male sign, a celebration of my first visit to New York. The colour bands can be interpreted as the cloud-bank below as I (the hat) flew the Atlantic.'

501 2 (Headless Couple)
Printed in red, green, blue, yellow, orange
(℮a 4)
Coll: Whitworth Art Gallery, University of Manchester

502 3 (Grass)
Printed in dark and lighter blue, ochre brown, yellow, green
(℮a 5)

503 4 (Swimming)
Printed in yellow, dark and lighter blue, black, flesh pink, turquoise
(℮a 6)
Coll: Cartwright Hall Art Gallery, Bradford

504 5 (Walking) (Page 66)
Printed in black, flesh pink, orange, yellow, green
(℮a 7)

505 6 (Clouds)
Printed in blue, yellow, flesh pink, pink red, black
(℮a 8)
Coll: Bibliothèque Nationale, Paris

506 7 (Falling) (Page 67)
Printed in green, yellow, flesh pink, dark blue, black
(℮a 9)

'By placing the image to one side of the sheet it forced the viewer to accept the whole sheet as an object – like a canvas – rather than allow a "window mount" to be used, which favoured the old idea of the image being a window onto an illusionary world.'

507 8 (Open centre)
Printed in yellow, orange, green, black
(℮a 10)

'On my first New York visit I went to Coney Island with Dick Smith. In a side show one could paint an abstract picture by putting colour randomly onto a card lying on a turntable. I noticed that all the results were centrifugally fused, like a Paul Jenkins. By only placing the colour at the edges, the colour was thrown outwards and produced an "original" effect, like a Sam Francis. I still have the picture, thirty years before Damien Hirst – and cheaper!'

508. Poster for 'Concerning Marriages', 1964 (Page 80)
Screenprint, with photo-lithography, printed in black, pink, yellow and ochre brown
With printed: *Allen Jones* under image and along b: *Lithographs Editions Alecto London November 1964*
Image and paper: 1020 × 635 mm (40$\frac{3}{16}$ × 25 in)
Edition: 50, proofs, signed and unsigned
Pr: Matthieu AG, Zürich; pub: 1964
Coll: MOMA

509 Hermaphrodite Head, 1964
Lithograph, zinc plate, tusche, printed in yellow ochre, brown, red, black and pink, on B. F. K. Rives paper
Image and paper: 764 × 567 mm (30$\frac{3}{32}$ × 22$\frac{5}{16}$ in)
Insc bl: *35/75*, br: *Allen Jones 64* (pencil), vo: *ea* embossed
Edition: 75, 15 ap
Pr: Matthieu AG, Zürich; pub: 1964 (ea 11)
Coll: ACE

510 Woman, 1965
Lithograph, hand-drawn and photographic, zinc plate, printed in black, yellow, red, flesh tint, with collaged paper patches on B. F. K. Rives paper
Image and paper: 700 × 560 mm (27$\frac{9}{16}$ × 22$\frac{1}{16}$ in)
Edition: 75, 10 ap
Pr: Irwin Hollander, Hollander Workshop, New York; pub: 1965 (ea 76)
Coll: British Council; Art Gallery of Ontario, Toronto

Based on photograph of Elizabeth Taylor taken by Bert Stern. Irwin Hollander recalls there being two to three trial proofs before the final state. 'We began by making a plate from a photo brought into the studio by Allen Jones, and then added the colour and finally the green collaged pieces of paper, printed black for the eyes.' (10/10/2000) Jones comments further: 'However well a print is registered, there is the problem of the edge. By collaging the green patches this problem was removed, allowing any frisson between the two colours to be produced directly onto the retina.'

511 Polka, 1965
Screenprint, hand-cut laquer stencil, printed in red, blue, flesh pink, yellow, black on Beckett Hi-White (commercial) paper
Image and paper: 611 × 458 mm (24$\frac{1}{16}$ × 18$\frac{1}{32}$ in)
Insc bl: *artists proof* (pencil) and *Chiron Press/ New York* (stamped), br: *Allen Jones 65* (pencil)
Edition: 50, 5 ap
Pr: Chiron Press, New York; pub: 1965 (ea 77)
Coll: British Council

'The ink used [for *Polka*] was oil based, the Nar Dar 5500 series, made in Chicago. It was chosen because it seemed to contain the most actual pigment when compared to other brands I tested. Also, it had the widest range of colours, its colour chart matching almost exactly the colours of Liquatex, the popular

acrylic artists' colours of the time' (Steven Poleskie, Chiron Press, 27/11/2000)

512 Daisy Daisy, 1965
Lithograph, tusche, aluminium, printed in black on buff Arches paper
Image and paper: 483 × 622 mm (19 × 24$\frac{1}{4}$ in)
Insc bl: *artists proof* with two chops of Tamarind and printer, br: *Allen Jones 65* (pencil)
Edition: 20, 9 for Tamarind, bat, 3 ap, 2 tp, 1 cp, 2 presentation proofs
Pr: Clifford Smith, Tamarind Lithography Workshop, 24–6 July 1965; pub (ea 79)
Lit: *Tamarind*, p.110; *Allen Jones Prints*, p.34 where described as published by the artist
Coll: British Council; University of New Mexico Art Museum, Albuquerque

The lettering on the image reads: *Padded Hip* and *Daisy Daisy*. One of the two guest prints made by Allen Jones on his first visit to the Tamarind Workshop, and a rare time when he 'cribbed' an image directly from a magazine. 'The title is a play on the repeated image, and the English song (a reference to the fact that I was a visitor)'

513 Man Woman, 1965
Lithograph, ink and crayon on stone, printed in black on B. F. K. Rives paper
Image and paper: 762 × 568 mm (30 × 22$\frac{3}{8}$ in)
Edition: 20, 9 for Tamarind, bat, 2 ap, 2 pp, 1 tp, 1 cp
Insc bl: *Tamarind Imp*, br: *Allen Jones 65* (pencil), br corner: Tamarind and Ken Tyler chops
Pr: Kenneth Tyler, Tamarind Workshop, Los Angeles 2–3 March 1965; pub: 1965 (ea 78)
Lit: *Tamarind*, p.110; *Allen Jones Prints*, p.35 where described as published by the artist
Coll: University of New Mexico Art Museum, Albuquerque; MOMA

Initially registered by Editions Alecto under the title of *Tamarind 1* and by Tamarind as *Untitled*.

A FLEET OF BUSES, 1966
Suite of five colour lithographs, various combinations of zinc and stone, with screenprinted title page insc: *A Fleet of Buses/ Allen Jones Lithographs Editions Alecto 1966*
Image and paper: 635 × 559 mm (25 × 22 in)
Presented in bus-shaped yellow rexine-covered portfolio box with two circle-wheels overpainted in red and titled: *Bus*, measuring: 664 × 583 mm (26$\frac{5}{32}$ × 22$\frac{15}{16}$ in)
Inside colophon page: *A Fleet of Buses/ Allen Jones/ A suite of five shaped colour lithographs, 65 cm × 57 cm/ Printed in Los Angeles at the Tamarind Workshops on Arches paper./ signed and numbered by the artist in an edition limited to 20 with 10 sets of artist's proofs and various printer's proofs./ Editions Alecto, London 1966*

Edition: 20 printed on white Arches paper, plus 9 impressions reserved for Tamarind, 3 ap, 2–5 tp, 1 bat, 1 cp (The colophon sheet refers to 10 ap)
Pr: Tamarind Lithography Workshop, Los Angeles, May–June 1966; with title-page screenprinted by Kelpra Studio, London; pub: 1966 (*ea* 388–92)
Lit: *Tamarind*, p.110; *Allen Jones Prints*, p.37 a–e
Coll: University of New Mexico Art Museum, Albuquerque; MOMA

'My work at Tamarind should be seen in the context of my previous years as a student and teacher of lithography – as the Fellowship allowed for work to be produced without a commercial consideration. I treated the experience as a chance to question the notion of the fine art print, and to stretch the boundaries of the medium, *eg* tearing the precious hand-made paper, folding etc.'

514 1
Lithograph, printed in yellow, red, medium and transparent blue, black
Insc br: Tamarind Workshop and Donn Steward chops, *Allen Jones 66* (pencil); bl: *Tam imp* (pencil)
Pr: Donn Steward, Tamarind Workshop, 3 May–1 June 1966 (*ea* 388)

A poster version of this image was produced by Galerie Mikro, Berlin for the *Allen Jones Complete Graphics* exhibition, 1969.

515 2
Lithograph, printed in light grey, medium grey, dark grey, light blue and black
Insc br: Tamarind Workshop and Ernest de Soto chops, *Allen Jones 66* (pencil); bl: *Tam imp* (pencil)
Pr: Ernest de Soto, Tamarind Workshop, 4–18 May 1966 (*ea* 389)
Coll: Brooklyn Museum of Art

Only 2 ap are recorded for this edition.

516 3
Lithograph, printed in red, green, yellow, blue
Insc br: Tamarind Workshop and Kinji Akagawa chops, *Allen Jones 66* (pencil); bl: *Tam imp* (pencil)
Pr: Kinji Akagawa, Tamarind Workshop, 4–26 May 1966 (*ea* 390)
Coll: British Museum

517 4
Lithograph, printed in red, green, yellow
Insc br: Tamarind Workshop and Clifford Smith chops, *Allen Jones 66* (pencil); bl: *Tam imp* (pencil)
Pr: Clifford Smith, Tamarind Workshop, 27 May–20 June 1966 (*ea* 391)

518 5
Lithograph, printed in red, light pink, silver, black
Insc br: Tamarind Workshop and John Dowell chops, *Allen Jones 66* (pencil); bl: *Tam imp* (pencil)
Pr: John Dowell, Tamarind Workshop, 16 May–10 June 1966 (*ea* 392)

Only 2 ap are recorded in this edition.

519 Poster: A Fleet of Buses, 1966–7 (Page 116)
Screenprint, five printings, printed on Saunders 140 lb imperial plain mould-made paper
Image and paper: 516 × 560 mm (20 $\frac{5}{16}$ × 22 $\frac{1}{16}$ in)
Insc on image: *A Fleet of Buses/ Allen Jones Lithographs Editions Alecto 1966*
Edition: 305 unnumbered (at least 20 signed initially)
Pr: Kelpra Studio, London, 1967 (invoiced 16/3/1967); pub: 1967, based upon title page to *A Fleet of Buses*, 1966 (*ea* 477)
Coll: National Museum and Gallery, Cardiff

A NEW PERSPECTIVE ON FLOORS, 1966
Suite of six hand-drawn colour lithographs, various combinations of zinc and stone, on white Arches paper, with screenprinted title page of flesh-pink torso, published in green cloth-covered portfolio box designed by Allen Jones and insc: *Five Floors/ Allen Jones Lithographs/ Editions Alecto London 1966*
Image and paper: 765 × 559 mm (30 $\frac{1}{8}$ × 22 in)
Insc ll: with edition number, br: signed and dated: *Allen Jones 66* with printer's and Tamarind chops
Edition: 20, 9 for Tamarind, 2–3 ap, 4–5 tp, bat (The colophon sheet refers to 10 ap)
Pr: Tamarind Lithography Workshop, Los Angeles, May–June 1966; pub: 1966 (*ea* 393–8)
Lit: *Tamarind*, pp.110–11; *Allen Jones Prints* 36 a–f
Coll: University of New Mexico Art Museum, Albuquerque; MOMA

Specially designed perspex frame accompanies this series, but was not a compulsory addition. It angles the lower 150 mm (5 $\frac{29}{32}$ in) of five of the images towards the viewer (665 × 631 × 218 mm, 26 $\frac{3}{16}$ × 24 $\frac{13}{16}$ × 8 $\frac{9}{16}$ in). The first in the series was not intended to be folded, acting as instruction sheet for the remaining five prints.

Inside Sheet: *A NEW PERSPECTIVE ON FLOORS/ Allen Jones/ A Suite of colour lithographs, folding into perspective, 78 cm × 57 cm/ Printed in Los Angeles at the Tamarind Workshops on Arches paper/ signed and numbered by the artist in an edition limited to 20 with 10 sets of/ artist's proofs and various printer's proofs/ Editions Alecto, London 1966*

Back Sheet: *It is intended by the artist that these lithographs be viewed with/ the floor portion at a right angle to the upright portion, at a/ level enabling the viewer to co-ordinate the perspective of the two/ sections. Special frames have been constructed for the mounting of/ the lithographs in this way, and*

the points at which the prints should be folded are designated on each sheet.

520 1
Lithograph, printed in chrome yellow, grey, black
Pr: John Dowell, Tamarind Workshop, 17–30 June 1966
(ℯⁿ 393)

Only 1 tp is recorded in this edition. Screened as a vignette on the front of the portfolio box, a poster version of this image was also produced by Galerie der Spiegel to accompany the exhibition *Allen Jones A New Perspective On Floors*, 1967.

521 2 (Page 116)
Lithograph, printed in red, flesh pink, blue, green
Pr: Ernest de Soto, Tamarind Workshop, 26 May–8 June 1966
(ℯⁿ 394)

522 3
Lithograph, printed in yellow, light green, dark green, black
Pr: Jack Lemon, Tamarind Workshop, 26 May–8 June 1966
(ℯⁿ 395)

523 4
Lithograph, printed in green, pink, red brown, dark green, black
Pr: Jack Lemon, Tamarind Workshop, 8–29 June 1966 (ℯⁿ 396)

524 5
Lithograph, printed in yellow, light blue, red, black on white Arches paper
Pr: Donn Stewart, Tamarind Workshop, 2–20 June 1966
(ℯⁿ 397)
Coll: Art Gallery of Ontario, Toronto

525 6
Lithograph, printed in red, grey, blue, black on white Arches paper
Image and paper: 762 × 559 mm (30 × 22 in)
Pr: Robert Evermon, Tamarind Workshop, 3–24 June 1966
(ℯⁿ 398)

526 Poster: A New Perspective on Floors, 1966–7 (Page 116)
Screenprint, six printings, on Saunders 230 lb D.E. plain mould-made paper
Image and paper: 758 × 565 mm (29 $\frac{13}{16}$ × 22 $\frac{1}{4}$ in)
Insc m: *A New Perspective on Floors/ Allen Jones Lithographs Editions Alecto 1966*
Pr: Kelpra Studio, London 1967 (invoiced 16/3/1967); pub: 1967 (ℯⁿ 476)
Edition: 305 unnumbered (20 initially signed)
Coll: National Museum and Gallery, Cardiff

This poster edition of the title page to the portfolio *A New Perspective on Floors* was made on Allen Jones's return from his Tamarind Fellowship.

527 Large Bus, 1966
Lithograph, printed on two sheets; on four stones in yellow, dark red, red orange, blue (top) and on three zinc plates in orange, red, blue (bottom), on Copperplate Delux paper
Image and paper, top: 723 × 1086 mm (28 $\frac{1}{2}$ × 42 $\frac{3}{4}$ in); bottom: 297 × 515 mm (11 $\frac{11}{16}$ × 20 $\frac{1}{4}$ in); overall size: 1025 × 1075 mm (40 $\frac{3}{8}$ × 42 $\frac{5}{16}$ in); Box: 756 × 105 × 103 mm (29 $\frac{3}{4}$ × 4 $\frac{1}{8}$ × 4 $\frac{1}{16}$ in)
Insc b: *Large Bus 20/20* and br: *Allen Jones 66* (pencil) with embossed chops of Tamarind Workshop and Clifford Smith
Edition: 20, 9 for Tamarind, 3 ap, bat, 3 tp, cp (colophon text refers to 10 ap)
Pr: Clifford Smith, Tamarind Lithography Workshop, 3 May–1 June 1966 (ℯⁿ 399)
Lit: *Tamarind*, p.110
Coll: British Council; University of New Mexico Art Museum, Albuquerque; Glasgow Museums; MOMA

The accompanying box titled: *Large Bus/ Allen Jones* (white) with ℯⁿ (black); underside of lid printed: *Allen Jones/ Large Bus/ a combination of two colour lithographs 83 × 108 cm and 30 × 52 cm/ Printed in Los Angeles at the Tamarind Workshops on Arches paper, signed and numbered by the artist in an edition limited to 20 with 10 sets of artist's proofs and various printer's proofs. Editions Alecto, London 1966.* A piece of loose paper inside box insc: *The smaller lithograph has been attached to the large lithograph with hinges, in the position indicated by the artist.*

Allen Jones refers to this being 'an essay in what a fine print could be. Two prints were required to make up one image.'

528 Subtle Siren, 1966
Lithograph, stone, printed in black ink on Copperplate Delux paper
Image and paper 572 × 765 mm (22 $\frac{1}{2}$ × 30 $\frac{1}{8}$ in)
Insc bl: *Trial Proof*, br: *Allen Jones 66* (pencil), br on image: *Subtle Siren*
Edition: 20, 9 Tamarnd impressions, bat, 1 ap, 1 cp
Pr: Robert Evermon, Tamarind Workshop, 27–9 June 1966; pub: 1966 (ℯⁿ 400)
Lit: *Tamarind*, p.111
Coll: MOMA

529 Miss, 1966
Etching with aquatint, zinc, printed in black on Crisbrook waterleaf 140 lb paper
Plate: 501 × 403 mm (19 $\frac{3}{4}$ × 15 $\frac{7}{8}$ in), paper: 615 × 567 mm (24 $\frac{3}{16}$ × 22 $\frac{5}{16}$ in, folded bottom paper edge in some impressions)
Insc bl: *20/30 Miss* and *Allen Jones 66* (pencil), vo: ℯⁿ *308* stamped
Edition: 30, 3 ap
Pr: Maurice Payne and Danyon Black, Alecto Studios, London; pub: 1966 (ℯⁿ 308)
Coll: National Gallery of Canada, Ottawa; Brooklyn Museum of Art

530 Head, 1967
Lithograph, tusche and crayon, printed in red, blue, black, yellow, green on B. F. K. Rives paper
Image and paper: 755 × 561 mm (29$\frac{3}{4}$ × 22$\frac{1}{16}$ in)
Insc: *48/75*, br: *Allen Jones 67* (pencil), vo: ℮a *478* stamped
Edition: 75, 15 ap
Pr: Matthieu AG, Zürich, 1967; pub: 1967 (℮a 478)
Coll: British Council

Titled *Face* in ℮a Register.

531 Lesson, 1967
Lithograph, tusche and crayon, printed in yellow, green, pink, purple blue, black
Image and paper: 630 × 897 mm (24$\frac{13}{16}$ × 35$\frac{5}{16}$ in)
Insc bl: *AP*, br: *Allen Jones 67* (pencil), vo: ℮a *479* stamped
Edition: 50, 14 ap
Pr: Mathieu AG, Zürich, 1967; pub: 1967 (℮a 479)

Text on image: *Realism is simply the immediate/ comprehension of a set of pictorial/ conventions that, through perpetual/ use, have become familiar to everyone./ This over-experience, has blunted our/ sensativity* (sic)*, and in order to keep/ alert the lady in my illustration is doing her exercises,/ Repeat after me 'this surface is flat'*

532 Icarus, 1968
Lithograph, with photo-lithography, tusche and crayon, printed in citrus yellow, black, ochre yellow, blue, red on B. F. K. Rives paper
Image and paper: 702 × 1000 mm (27$\frac{5}{8}$ × 39$\frac{3}{8}$ in)
Insc bl: *46/75*, br: *Allen Jones 68* (pencil), vo: ℮a *538* stamped
Edition: 75, approx. 10 ap
Pr: Matthieu AG, Zürich; pub: 1968 (℮a 538; nos 1–23 are numbered 555)
Coll: British Council; ACE; Glasgow Museums

LIFE CLASS, 1968
Suite of fourteen lithographs, off-set, photo and hand drawn, forming seven images, each of two abutting sheets with similarly divided title page, on J. Green Imperial 140 lb waterleaf paper
Each of the fourteen sections contained in separate plastic sleeves, hinged into a red portfolio box, with a red cloth-covered slipcase insc: *Allen Jones Life Class*. Direct lithography: Matthieu AG, Zürich; offset photo-lithography: Beck & Partridge Ltd, Leeds
Pub: Editions Alecto Ltd and Modern Art Edition, MAT, Basle, 1968 (℮a 526–33)
Portfolio produced by Galerie der Spiegel Workshop, Cologne (508 × 594 mm, 20 × 23$\frac{3}{8}$ in)
Each plate signed and dated in pencil, with signature split between the two sheets
Image and paper-top: 347 × 564 mm (13$\frac{21}{32}$ × 22$\frac{3}{16}$ in), bottom: 474 × 564 mm (18$\frac{11}{16}$ × 22$\frac{3}{16}$ in), overall size with gap: 828 × 564 mm (32$\frac{5}{8}$ × 22$\frac{3}{16}$ in)

Edition: 75, 15 ap
Lit: *Allen Jones Prints* 48 a–g
Coll: V&A; British Council and Art Gallery of Ontario, Toronto (both incomplete sets); National Gallery of Australia, Canberra

The separation of the upper and lower sections of these seven prints allows the viewer to create various combinations, top and bottom.

533 Title page (Page 126)
Lithograph, printed in pink, green, two shades of blue, orange and black
Insc b: *Allen Jones Life Class/ A Series of Seven Split Lithographs with Title Page. Published by Editions/ Alecto Limited, London & Modern Art Edition, MAT, Basle 1968* (℮a 533)
Two pieces of text including Norbert Lynton's critique in *Art International*: '. . . a copy of *Esquire* and what must have been a Vargas girl, and found myself swept into a vertiginous world of total longing and desire It may be that Vargas's highly sophisticated sexual ikons have contributed stirringly to his maturing too; otherwise there would seem to be an arbitrary and rather defensive-looking stylistic device here for parading intensely sexual imagery without accepting responsibility for it He also alludes to the kind of world Vargas's illustrations imply, of babes and molls, johns and gangsters. Here the physical extension of some of the recent paintings by means of tiled steps leading out of the picture on to the gallery floor, provide not only a frisson but also a specific shock to one's sense of real and unreal. They are real but it is an emphatically unreal world they are making more real'
A poster version of the title page was produced on cartridge paper for the ℮a exhibition: *Allen Jones Life Class/ The Alecto Gallery 38 Albemarle Street London W1 27 March–27April 1968*.

Coll: Walker Art Gallery, Liverpool (National Museums and Galleries on Merseyside)

534 1 (Swivel Chair, Yellow)
Lithograph, printed in yellow, blue, pink, green, brown, black (℮a 526)

535 2 (Touching Shoe, Pink)
Lithograph, printed in pink, dark blue, aquamarine, green yellow, black, brown (℮a 527)

536 3 (Suit, Green) (Page 127)
Lithograph, printed in green, pink, black, orange, flesh cream, blue (℮a 528)

537 4 (Surreal Portrait, Black)
Lithograph, printed in black, green, blue, orange, flesh pink
(ea 529)
Coll: Bibliothèque Nationale, Paris

538 5 (Surprised, Green)
Lithograph, printed in green, orange, flesh pink, red brown, pink, blue
(ea 530)

'Moira Swan was the *Vogue* model, Peter Rand the *Vogue* photographer. Coloured stockings, 42nd Street Boutique, entrance to the "shuttle" metro line.'

539 6 (Touch on Ankle, Orange)
Lithograph, printed in pink, blue, black, orange, green
(ea 531)

'There was a huge technical problem to print a mechanical dot onto handmade paper. We first printed a clear varnish underneath the area where the photo image would be.'

540 7 (Cross Legged, Oatmeal)
Lithograph, printed in yellow cream, red, blue, grey, black
(ea 532)

541 Thrill me, 1969
Lithograph, off-set with photo, printed in green, orange, brown, flesh pink
Image and paper: 708 × 1037 mm (27 $\frac{7}{8}$ × 40 $\frac{13}{16}$ in)
Insc ml: *James Wedge*, br: *artists proof*, mr: *Allen Jones 69* (pencil)
Edition: 120, proofs
Pr: Matthieu AG, Zürich; pub: 1969 (ea 585)
Coll: Art Gallery of Ontario, Toronto

Countersigned by James Wedge, whose photograph is incorprated in the left-hand image. Right figure appears again in the lithograph *Haxli*, 1971. 'One of the last prints consciously to question the medium – artists' appropriation of photo-images – Rauschenberg et al. I decided to "order" an image for this print and split my earnings with the photographer as a gesture to the contribution made by the photographer.'

542 Kneeling Figure I, 1970
Lithograph, off-set with photo, zinc, printed in yellow, red, green, flesh, black
Image and paper: 574 × 763 mm (22 $\frac{19}{32}$ × 30 $\frac{1}{16}$ in)
Insc bl: *artists proof*, br: *Allen Jones 70* (pencil)
Edition: 75, proofs
Pr: Curwen Press, London; pub: 1970 (no publication number)

Kneeling Figure No 2 was published by Petersburg Press, London in the same year.

543 Haxli, 1971
Lithograph, tusche, printed in black, on B. F. K. Rives paper
Image and paper: 450 × 560 mm (17 $\frac{23}{32}$ × 22 in)
Insc bl: *artists proof*, mr: *Allen Jones 71* (pencil)
Edition: several unnumbered proofs
Pr: Matthieu AG, Zürich; pub: 1971 (no publication number)

Also incorrectly titled *Latex Lady*. Proofed in 1968, but not printed until 1971.

Stanley Jones (*b.*Wigan, 1933)

See biographies.

544 Lunar Sound, 1969 (Page 170)
Lithograph, off-set, stone, five colours, printed in red, blue, dark brown, pink, turquoise on J. Green 140 lb trimmed paper
Image and paper: 700 × 553 mm (27 $\frac{9}{16}$ × 21 $\frac{3}{4}$ in)
Insc bl: *Artists Proof*, br: *Stanley Jones* (white), vo: *Title 'Lunar Sound'* (pencil)
Edition: 75, approx. 7 ap
Pr: The artist, Curwen Studio, Midford Place, London, 1969; pub: 1969 (ea 642)
Coll: GAC

ea sold Stanley Jones's lithograph *Essex Landscape* 1962–4, before they published *Lunar Sound*; 'Not just flat colours, this is a visual game that plays with your perceptions.' (SJ, 16/3/2000)

Bernard Kay (*b.*Southport, Lancashire, 1927)

Liverpool College of Art, and Royal Academy Schools. French Government Scholarship, studying at Atelier Friedlaender, Paris, 1954–5. Etching continued to be a main concern alongside painting. Awarded Print Club of Philadelphia's International Purchase Prize for *Notre Dame*, 1959, proofed at Atelier Georges Leblanc,1955, and later editioned by C. H. Welch. Exhibiting with St George's Gallery, London, 1956–63. Solo exhibitions of painting at Rowland, Browse and Delbanco, London, 1959 and 1962.

CATHEDRAL SUITE, 1965–6
Nine soft-ground and sugar aquatint etchings on theme of French medieval cathedrals and churches. Based upon initial sketches, worked up on the plate by the artist.
Insc bl: edition number, bc: title, br: signed *Bernard Kay* (pencil)
Plate: 487 × 345 mm (19 $\frac{3}{16}$ × 13 $\frac{9}{16}$ in), paper: 648 × 512 mm (25 $\frac{1}{2}$ × 20 $\frac{1}{8}$ in, with variation)
Pr: C. H. Welch, London on Barcham Green handmade paper, 1965
Edition: 100, 12 ap, a few proofs
Pub: 1966 (ea 224–32)

545 Tours
Etching and aquatint, two copperplates, printed in brown and black with wiped tone
(ea 224)

546 Rouen
Etching and aquatint, copperplate, printed in black, blue, sienna with wiped tone
(ea 225)
Coll: South London Gallery

547 Bourges
Etching and aquatint, copperplate, printed in black, raw sienna, Indian red and blue with wiped tone
(ea 226)
Coll: GAC

548 Chartres – West
Etching and aquatint, copperplate, printed in black, brown and blue with wiped tone
(ea 227)
Coll: GAC

549 Chartres – East
Etching and aquatint, copperplate, printed in black, brown, blue with wiped tone
(ea 228)
Coll: GAC

550 Laon (Page 45)
Etching and aquatint, copperplate, printed in black, burnt sienna and 'small amount of blue', with wiped tone
(ea 229)

551 Beauvais
Etching and aquatint, copperplate, printed in brown and Indian red, with wiped tone
(ea 230)

552 Buttress – Chartres
Etching and aquatint, copperplate, printed in black
(ea 231)
Coll: GAC, South London Gallery

'A sort of pair with *Interior Poitiers*.'

553 Interior – Poitiers
Etching and aquatint, copperplate, printed in black and Indian red, with wiped tone
(ea 232)

'After closure of St George's Gallery, ea continued to sell my work. I was subsequently asked by Joe Studholme to produce three suites, of which only one was completed. The idea for the *Cathedral Series* was completely my own. From initial sketches

and other sources like photographs, I made full-size drawings which were transferred to plate with soft-ground and then built upon with sugar aquatint' **(BK, 31/1/1999)**

See Appendix

Cecil King (*b.*Rathdrum, Co. Wicklow, 1921–86)

Businessman before began to paint, 1954. Mainly self-taught. Semi-abstract pictures gave way to more strident form of abstraction. Involved with 'hard-edge school' in late 1960s, which influenced first major *Berlin Suite* of prints. Paintings from this series are with Irish Management Institute, Dublin and Arts Council Collection, Dublin. Widely exhibited in UK and in Europe. Retrospective exhibition at the Hugh Lane Municipal Gallery of Modern Art, Dublin, 1981.

Berlin Suite, 1970
Six screenprints printed on J. Green waterleaf 140 lb paper
Image: 340 × 248 mm (13 $\frac{3}{8}$ × 9 $\frac{3}{4}$ in), paper: 528 × 390 mm (20 $\frac{7}{8}$ × 15 $\frac{3}{8}$ in)
Insc bl: with title and date, br: signed *Cecil King* (pencil), vo: stamped ea and publication number, and *KH*
Edition: 75, 15 ap
Pr: Kevin Harris, Alecto Studios, London, 1970; typography Lyndon Haywood; pub: 1970 (ea 694–9)
Lit: Eithne Waldron, *Cecil King Berlin Suite, Introduction to Six screenprints published by Editions Alecto, London, 1970*

554 1
Screenprint, printed in black, khaki, white, blue
(ea 694)

555 2
Screenprint, printed in two greens, grey, terracotta
(ea 695)

556 3
Screenprint, printed in black, slate grey, sienna
(ea 696)

557 4
Screenprint, printed in black, blue, khaki
(ea 697)

558 5
Screenprint, printed in black, grey-blue, yellow, rose-pink
(ea 698)

559 6
Screenprint, printed in black, red, magenta, tan
(ea 699)

'A recent visit to Berlin made a deep and lasting impression on the artist. Man living under tensions and the claustrophobic pressures of a divided city are reflected in the window-onto-life

effects of this new set of six prints. The colour variations introduce the city's subtle changes of mood and emphasis while their basic tensions remain taut and keyed-up to fever pitch . . . any change no matter how slight would cause the collapse and disintegration of the whole composition; a nervous break-down as it were, of the pent up energy and discipline of the artist's conception' (Eithne Waldron, *op. cit.*)

560 Threshold (Black), 1974
Screenprint, printed in black, brown, orange, white on Bockingford paper
Image: 514 × 743 mm (20 $\frac{1}{4}$ × 29 $\frac{1}{4}$ in), paper: 560 × 764 mm (22 × 30 $\frac{1}{16}$ in)
Insc bl: *A/P 2/10*, br: *Cecil King* (pencil)
Edition: 100 (50 printed), 10 ap
Pr: Leslie Hosgood and Robert Jones, Megara Screenprinting Ltd, Alecto Studios, London; pub: 1974 (ꂆ 876)
Coll: Tate; Leicestershire Museums, Arts and Records Service

561 Threshold (Orange), 1974
Screenprint, printed in orange, brown, red, white on Bockingford paper
Image: 514 × 743 mm (20 $\frac{1}{4}$ × 29 $\frac{1}{4}$ in), paper: 561 × 764 mm (22 $\frac{1}{16}$ × 30 $\frac{1}{16}$ in)
Insc bl on image: *A/P 4/10*, br: *Cecil King* (pencil)
Edition: 100 (50 printed), 10 ap
Pr: Leslie Hosgood and Robert Jones, Megara Screenprinting Ltd, Alecto Studios, London; pub: 1974 (ꂆ 877)
Coll: Tate

562 Intrusion (Green), 1974
Screenprint, printed in green, grey, white grey blend on Bockingford paper
Image: 514 × 745 mm (20 $\frac{1}{4}$ × 29 $\frac{5}{16}$ in), paper: 563 × 765 mm (22 $\frac{3}{16}$ × 30 $\frac{1}{8}$ in)
Insc bl: *A/P 2/10*, br: *Cecil King* (pencil)
Edition: 100 (50 printed), 10 ap
Pr: Leslie Hosgood and Robert Jones, Megara Screenprinting Ltd, Alecto Studios, London; pub: 1974 (ꂆ 878)
Coll: Tate

563 Intrusion (Red), 1974
Screenprint, printed in red, brown, white brown blend on Bockingford paper
Image: 514 × 745 mm (20 $\frac{1}{4}$ × 29 $\frac{5}{16}$ in), paper: 560 × 762 mm (22 $\frac{1}{16}$ × 30 in)
Insc bl: *A/P 2/10*, br: *Cecil King* (pencil)
Edition: 100 (50 printed), 10 ap
Pr: Leslie Hosgood and Robert Jones, Megara Screenprinting Ltd, Alecto Studios, London; pub: 1974 (ꂆ 879)
Coll: Tate; Leicestershire Museums, Arts and Records Service

The Dubai Suite, 1975
Three screenprints on handmade R. K. Burt paper (torn edges)
Image: 424 × 748 mm (16 $\frac{11}{16}$ × 29 $\frac{7}{16}$ in), paper: 601 × 897 mm (23 $\frac{21}{32}$ × 35 $\frac{5}{16}$ in)
Insc bl: edition number, br: signed *Cecil King* (pencil)
Edition: 30 (even nos for ꂆ), 5 ap and 2 icp
Pr: Leslie Hosgood and Robert Jones, Megara Screenprinting Ltd, Alecto Studios, London; pub: 1975 (ꂆ 880–2)
Coll: Tate

564 Red
Screenprint, printed in red, brown, blue, white (ꂆ 880)

565 Blue
Screenprint, printed in brown, blue-black, white, blue (ꂆ 881)

566 Orange
Screenprint, printed in orange, brown, white, turquoise (ꂆ 882)

'Cecil King used to optically squeeze colours. This meant that a vibrant orange surrounded by a band of mauve would optically bleach out the warmth in the mauve so that you'd get an almost electric blue' (Kevin Harris 12/6/2000)

Ronald King (*b.*Sao Paulo, Brazil, 1932)

Chelsea School of Art, 1951–5 specialising in painting. Assistant Art Director for magazine publisher Mclean Hunter in Canada, 1957–60. Lecturer in Graphics, Farnham School of Art, 1961–5. Set up workshop in Guildford home, where made monoprints and explored hand-cut stencils. Following ꂆ's abandonment of *The Prologue* project, founded Circle Press, 1967, specialising in limited editions of fine books and prints. Collaborations with Ian Tyson, John Christie, Birgit Skiöld, Roy Fisher amongst others. *Cooking The Books: Ron King and Circle Press*, Yale Center for British Art, New Haven, 2002.

567 Slate Lichen I, 1966
Screenprint from hand-cut paper stencil, printed in black, blue, yellow (stripped back) on J. Green waterleaf 133 lb paper
Image: 864 × 572 mm (34 × 22 $\frac{1}{2}$ in), paper: 1046 × 699 mm (41 $\frac{3}{16}$ × 27 $\frac{1}{2}$ in)
Insc bl: *Artists proof Slate Lichen*, br: *Ronald King* (pencil)
Edition: 50, 7 ap
Pr: The artist, Guildford studio; pub: 1966 (ꂆ 215)
Coll: GAC

568 Slate Lichen II, 1966
Screenprint, from hand-cut paper stencil, printed in ochre, cobalt blue, cerulian blue, black on J. Green waterleaf 133 lb paper
Image: 873 × 576 mm (34 $\frac{3}{8}$ × 22 $\frac{11}{16}$ in), paper: 1045 × 691 mm (41 $\frac{1}{8}$ × 27 $\frac{3}{16}$ in)
Insc bl: *2/50 Slate Lichen II*, br: *Ronald King* (pencil)

Edition: 50, 7 ap
Pr: The artist, Guildford studio; pub: 1966 (*ea* 216)
Coll: GAC

569 Lichen I, 1966

Screenprint, from hand-cut paper stencil, printed in ochre, black, green, metallic silver on J. Green waterleaf 133 lb paper
Image: 870 × 573 mm (34 $\frac{1}{4}$ × 22 $\frac{9}{16}$ in), paper: 975 × 673 mm (38 $\frac{3}{8}$ × 26 $\frac{1}{2}$ in, slightly cropped)
Insc bl: *4/50 Lichen I*, br: *Ronald King* (pencil)
Edition: 50, 7 ap
Pr: The artist, Guildford studio; pub: 1966 (*ea* 217)
Coll: GAC

570 Lichen II, 1966

Screenprint, from hand-cut paper stencil, printed in pink red, green ochre, metallic silver
Image: 575 × 875 mm (22 $\frac{5}{8}$ × 34 $\frac{7}{16}$ in), paper: 685 × 974 mm (27 × 38 $\frac{11}{16}$ in)
Insc bl: *17/50 Lichen II*, br: *Ronald King* (pencil)
Edition: 50, 7 ap
Pr: The artist, Guildford studio; pub: 1966 (*ea* 218)
Coll: GAC

571 Moonstream, 1966

Screenprint from hand-cut paper stencil, printed in black, silver metallic, yellow (stripped back) on J. Green waterleaf 133 lb paper
Image: 575 × 869 mm (22 $\frac{5}{8}$ × 34 $\frac{7}{16}$ in), paper: 694 × 1050 mm (27 $\frac{5}{16}$ × 41 $\frac{5}{16}$ in)
Insc bl: *Artists proof. Moonstream – Edit 50*, br: *Ronald King* (pencil)
Edition: 50, 7 ap
Pr: The artist, Guildford studio; pub: 1966 (*ea* 219)
Coll: GAC

572 Sea Anemone I, 1966

Screenprint from hand-cut paper stencil, printed in yellow, blue, red on J. Green waterleaf 133 lb paper
Image: 577 × 868 mm (22 $\frac{11}{16}$ × 34 $\frac{3}{16}$ in), paper: 697 × 1050 mm (27 $\frac{7}{16}$ × 41 $\frac{5}{16}$ in)
Insc bl: *Artists proof (edit 50) Sea Anemone I*, br: *Ronald King* (pencil)
Edition: 50, 7 ap
Pr: The artist, Guildford studio; pub: 1966 (*ea* 220)
Coll: GAC

573 Sea Anemone II, 1966

Screenprint, from hand-cut paper stencil, printed in blue, silver (stripped back), ochre, darker blue on J. Green waterleaf 133 lb paper
Image: 580 × 867 mm (22 $\frac{13}{16}$ × 34 $\frac{1}{8}$ in), paper: 634 × 917 mm (24 $\frac{15}{16}$ × 36 $\frac{1}{8}$ in)
Insc bl: *Artists proof (edit 50) Sea Anemone II*, br: *Ronald King* (pencil)
Edition: 50, 7 ap
Pr: The artist, Guildford studio; pub: 1966 (*ea* 221)
Coll: GAC

574 Sea Anemone III, 1966 (Page 118)

Screenprint, from hand-cut paper stencil, printed in ochre, green, blue, silver (stripped back) on J. Green waterleaf 133 lb paper
Image: 867 × 573 mm (34 $\frac{1}{8}$ × 22 $\frac{9}{16}$ in), paper: 953 × 633 mm (37 $\frac{1}{2}$ × 24 $\frac{15}{16}$ in)
Insc bl: *Artists proof Sea Anemone III edit 50*, br: *Ronald King* (pencil)
Edition: 50, 7 ap
Pr: The artist, Guildford studio; pub: 1966 (*ea* 222)

575 Sea Anemone IV, 1966 (Page 118)

Screenprint, from hand-cut paper stencil, printed in ochre, red, silver, transparent blue, dark blue on J. Green waterleaf 133 lb paper
Image: 869 × 574 mm (34 $\frac{3}{16}$ × 22 $\frac{5}{8}$ in), paper: 1028 × 697 mm (40 $\frac{7}{16}$ × 27 $\frac{7}{16}$ in)
Insc bl: *8/50 Sea Anemone IV*, br: *Ronald King* (pencil)
Edition: 50, 7 ap
Pr: The artist, Guildford studio; pub: 1966 (*ea* 223)
Coll: GAC

576 THE PROLOGUE – CHAUCER, 1966–7

Book, fourteen hand-cut paper stencils, with text on facing page, made up of sixteen folded sections, printed on Barcham Green Double Elephant 246 lb paper. Fifty-seven numbered pages. Edition: 125, 15 ap. Images printed by the artist at his Guildford studio, with text designed by the artist and printed in 24 pt Monotype Plantin at Severn Corners Press, Guildford. Presented in cloth-covered folder enclosed in blue canvas slipcase, insc: *The Prologue Chaucer* and designed by Anthony Caines.
Title page insc: *Geoffrey Chaucer/ The Prologue/ From The Canterbury Tales/ Text based mainly on the Ellesmere MS/ original screen images printed by/ Ronald King/ Published by Editions Alecto Limited/ 1967*; editioned and signed inside front page: *Ronald King* (pencil)
Image and page: 522 × 360 mm (20 $\frac{9}{16}$ × 14 $\frac{3}{16}$ in); overall bound size: 535 × 370 mm (21 $\frac{1}{16}$ × 14 $\frac{9}{16}$ in)
Insc bl: with title, br: *RK* (pencil), vo: stamped *ea* and publication number (*ea* 444–57)
Coll: V&A; ACE

Separate single-sheet edition of twelve of the book designs, without text, on Barcham Green imperial 140 lb mould-made HP sized paper, each in edition of 50, 5 (2) ap
Image and paper: 586 × 392 mm (23 $\frac{1}{16}$ × 15 $\frac{7}{16}$ in)
Insc: with edition number, titled and signed br: *Ronald King* (pencil), vo: stamped *ea* and publication number (*ea* 444–57)
Coll: West Riding of Yorkshire Education Committee; Arthur Andersen, London

Lit: Cathy Courtney, *The Looking Book: A pocket history of Circle Press 1967–96*, Circle Press, 1997

577 Knight
Screenprint, printed in black, yellow, silver, blue
(ℯɑ 444)

578 Squire
Screenprint, printed in red and green
(ℯɑ 445)

579 Nun
Screenprint, printed in black and silver
(ℯɑ 446)

580 Monk
Screenprint, printed in silver metallic, red and purple
(ℯɑ 447)

581 Friar
Screenprint, printed in two silvers, blue, red
(ℯɑ 448)
Not included in the single-sheet set

582 Franklin
Screenprint, printed in silver metallic, red, black, green, green (stripped back), silver
(ℯɑ 449)
Not included in the single-sheet set

583 Shipman
Screenprint, printed in blue, yellow, green
(ℯɑ 450)

584 Wife of Bath
Screenprint, printed in blue, green, red
(ℯɑ 451)

585 Parson
Screenprint, printed in black, pink, blue
(ℯɑ 452)

586 Miller
Screenprint, printed in orange and blue
(ℯɑ 453)

587 Summoner
Screenprint, printed in black, blue, red
(ℯɑ 454)

588 Pardoner
Screenprint, printed in metallic silver, mauve, black
(ℯɑ 455)

589 The Host
Screenprint, printed in red, orange, green, black
(ℯɑ 456)

590 Chaucer
Screenprint, printed in blue, green, magenta
(ℯɑ 457)

The book edition and single prints of *The Prologue* were all stamped and given publication numbers by ℯɑ in 1967, only to be retrieved by Ron King on hearing that the company was facing a financial crisis. The material subsequently became the first edition of *The Prologue*, published by Circle Press Publications, 1967.

Bert Kitchen (*b.*Liverpool, 1940)

Rochdale School of Art, and Central School of Arts and Crafts becoming a lecturer 1961–4, and City of London Polytechnic, 1964–92. Work ranged from designs for textiles, animation films and book illustrations to illustrations for *Private Eye*. Surrealist exhibitions in 1970s, and various solo exhibitions including Smith's Gallery, Covent Garden, London, 1991.

591 Cobalt Towers, 1975
Etching and aquatint, scraped and burnished, two copperplates, printed in yellow, blue, umber
Plate: 600 × 445 mm (23 $\frac{5}{8}$ × 17 $\frac{1}{2}$ in), paper: 775 × 595 mm (30 $\frac{1}{2}$ × 23 $\frac{7}{16}$ in)
Insc bl: *42/125*, bc:'*Cobalt Towers*', br: *Bert Kitchen '75*, br corner: James Collyer and John Crossley of J. C. Editions embossed stamps and ℯɑ embossed, vo: stamped ℯɑ *887*
Edition: 125, 15 ap, 2 icp, 2 pp, 1 cp
Pr: James Collyer and John Crossley of J. C. Editions, Alecto Studios, London; pub: 1975 (ℯɑ 887)
Coll: GAC

One of the five images commissioned and produced in 1975 and early 1976 in a collaborative venture with PSA, Department of the Environment. The Department acquired seventy-five impressions and three ap from the edition.

'The image evolved in the same way that the images in my paintings evolve, that is beginning with random [?] marks which are worked into progressively until forms evolve. These are then simplified and clarified. In the case of *Cobalt Towers* the first marks were made directly onto the master plate with aquatint. Then by burnishing etc. the two towers evolved.' **(**BK, 14/12/1999)

Radovan Dragoja Kraguly (*b.*Prijedor, Bosnia, 1934)

First solo exhibition at Galerija Doma JNA, Belgrade, 1954. Graduated from Academy of Fine Art, Belgrade, 1962. Various prizes for drawing and graphics. Awarded British Council grant to study at Central School of Art, London, 1962–3. *Radovan Kraguli exh of Drawings and Etchings*

at the ICA, London, 16 Sept–14 Oct 1965. Exhibits internationally including, more recently, dance and video works. First exhibition with Angela Flowers Gallery, London, 1977; and *Radovan Kraguly Identification: New Prints and Drawings*, Flowers East, London, 2001.

592 Corn, 1964–5 (Page 47)
Mezzotint and dry-point, two zinc plates, printed in black, red, dark blue
Plate: 475 × 298 mm (18$\frac{11}{16}$ × 11$\frac{3}{4}$ in), paper: 783 × 571 mm (30$\frac{13}{16}$ × 22$\frac{1}{2}$ in)
Insc bl: *5/40 64*, br: *Radovan Kraguly* with triangle (pencil), br corner: ea embossed
Edition: 40, proofs
Pr: The artist, Central School of Art, London, 1964; pub: 1964 (ea 130)
Coll: GAC

'These three prints are not a series but they complement each other A corn is a very symmetrical form, even the configuration of the grain is regular.' (RG 18/12/1999) Proofs include colour variations and the reversal of the bottom section of two circles and square.

593 Leaf and Coral, 1964
Etching, deeply bitten, with mezzotint, seven copperplates, rolled up ink, printed in deep blue, orange ochre, black on handmade paper including Crisbrook
Plates overall size: 597 × 504 mm (23$\frac{1}{2}$ × 19$\frac{7}{8}$ in), paper: 790 × 575 mm (31$\frac{1}{8}$ × 22$\frac{5}{8}$ in)
Insc bl: *38/40 65 Arap Radovan D Kraguly* (with triangle, in pencil)
Edition: 40, proofs
Pr: The artist, Central College of Art, London; pub: 1964 (ea 131)
Coll: South London Gallery

'In nature there is so much free form as well as geometry and symmetry. Take a leaf, it is very symmetrical. My early work was very inspired by plants and vegetation, fruits and flowers. Here there is symmetry, the coral is like a ghost shape The interplay between square and circle continues with the open square of the paper.' (RK, 18/12/1999)

594 Leaf in Space (Seeds and Leaves), 1964
Drypoint and mezzotint, printed in deep magenta red, black, green red on J. Whatman paper
Plate: 455 × 280 mm (17$\frac{29}{32}$ × 11 in), paper: 680 × 525 mm (26$\frac{3}{4}$ × 20$\frac{11}{16}$ in)
Insc b: *Artist proof 65* (triangle symbol) *"Seeds and Leaves" Radovan D Kraguly* (pencil)
Edition: 40, proofs
Pr: The artist, Central College of Art, London; pub: 1964

Another rectangular arrangement, centred by floating leaf and two circles.

Edwin La Dell (*b.*Coventry, 1914–70)

Sheffield College of Art, and RCA where taught lithography from 1948 becoming Head of School of Engraving in 1950. Leading promoter of colour lithography, forging links with Paris and initiating print commissions, notably the *Coronation Series*, 1953; *Wapping to Windsor* with Robert Erskine, 1960; and *Shakespeare Lithographs* with ea in 1964. Lithographs printed by George Devenish, Lithographic Printer at RCA. From 1960, lived at Stocks House, Grafty Green, Kent, the source of much of his work.

GARDEN SERIES, 1966–7
Series of twelve black etchings and colour lithographs, drawn from La Dell's own garden and conservatory in Grafty Green, as well as the surrounding area
Insc bl: with edition number, bc: title, br: signed by artist *Edwin La Dell* (in pencil)
Edition: 50, proofs
Pr: RCA, London on handmade Crisbrook and T. H. Saunders papers; pub: 1967 (ea 432–43)

595 Chilston Chestnuts
Etching, printed in black
Plate: 379 × 629 mm (14$\frac{15}{16}$ × 24$\frac{3}{4}$ in), paper: 580 × 800 mm (22$\frac{13}{16}$ × 31$\frac{1}{2}$ in) (ea 432)

Scene from Chilston Park, at Boughton Malherbe, near to where La Dell lived in Kent.

596 Centaurea
Etching and aquatint, printed in black
Plate: 353 × 551 mm (13$\frac{7}{8}$ × 21$\frac{11}{16}$ in); paper: 571 × 795 mm (22$\frac{1}{2}$ × 31$\frac{5}{16}$ in) (ea 433)

Also titled *Conservatory 11* at proof stage, with statue and bowl of fruit in centre.

597 Iris Pseudacorus
Etching and aquatint, printed in sepia
Plate: 365 × 541 mm (14$\frac{3}{8}$ × 21$\frac{5}{16}$ in), paper: 553 × 785 mm (21$\frac{3}{4}$ × 30$\frac{15}{16}$ in) (ea 434)
Coll: GAC; V&A

A classical statue is seen behind the outspanning leaves of an Iris plant. The impression in the V&A is titled *Conservatory*.

598 Conservatory
Etching, printed in black
Plate: 401 × 551 mm (15$\frac{13}{16}$ × 21$\frac{11}{16}$ in), paper: 570 × 800 mm (22$\frac{7}{16}$ × 31$\frac{1}{2}$ in) (ea 435)
Coll: GAC

The Conservatory at Stocks House was a constant source of inspiration to La Dell. Other versions of the same subject include a lithograph of 1970. Here cat and plant leaves dominate the left foreground.

599 Centaurea Americana, 1966/7
Etching, with aquatint, printed in black
Plate: 500 × 352 mm ($19\frac{11}{16}$ × $13\frac{7}{8}$ in), paper: 796 × 567 mm
($31\frac{3}{8}$ × $22\frac{5}{16}$ in) (ea 436)
Coll: GAC

The artist's proof in the family collection is inscribed with printing instructions to Michael Rand at RCA: *Mich/ this area/ kept light/ please/ Eddy* and *tone full here.*

600 Goldfish
Lithograph, tusche, printed in grey blue, brown, orange, green, blue crayon
Image: 564 × 387 mm ($22\frac{3}{16}$ × $15\frac{1}{4}$ in), paper: 775 × 538 mm
($30\frac{1}{2}$ × $21\frac{3}{16}$ in) (ea 437)
Coll: GAC

This image also exists as a green edition of twenty-five, reproduced as a poster for the *Edwin La Dell Memorial Exhibition of Prints*, RCA, 4–26 Feb 1971.

601 Fatsia Japonica
Etching, proofs printed in blue, brown, brown sepia
Plate: 500 × 400 mm ($19\frac{11}{16}$ × $15\frac{3}{4}$ in), paper: 793 × 565 mm
($31\frac{7}{16}$ × $22\frac{1}{4}$ in) (ea 438)

La Dell inscribed proofs for this etching *Fatsia*, which is not to be confused with the lithograph of this title. Here the elegant Fatsia and a classical statue jut against a bird in a box.

602 Fatsia
Lithograph, tusche, printed in orange, brown, lemon yellow, orange brown, two greens, blue, green blue
Plate: 545 × 380 mm ($21\frac{7}{16}$ × $14\frac{15}{16}$ in) (ea 439)
Coll: GAC

603 Woburn
Lithograph, tusche, printed in dark and lighter green, purple, brown, grey
Image: 393 × 557 mm ($15\frac{15}{16}$ × $21\frac{15}{16}$ in), paper: 543 × 795 mm
($21\frac{3}{8}$ × $31\frac{5}{16}$ in) (ea 440)
Coll: GAC

View across the lake at Woburn, proof impressions are also inscribed *Woburn Abbey.*

604 Ceres (Page 74)
Lithograph, tusche, printed in green and olive green, grey, buff, yellow green, brick orange, black crayon
Image: 366 × 650 mm ($14\frac{7}{16}$ × $25\frac{5}{8}$ in), paper: 563 × 800 mm
($22\frac{3}{16}$ × $31\frac{1}{2}$ in) (ea 441)
Coll: GAC

605 The Terrace
Lithograph, tusche and crayon, printed in brown, grey, turquoise, black, dark green, green

Image: 440 × 687 mm ($17\frac{5}{16}$ × $27\frac{1}{16}$ in), paper: 762 × 801 mm
(30 × $31\frac{17}{32}$ in) (ea 442)
Coll: GAC

606 Passiflora*
Lithograph, tusche, printed in shades of green, deep red, black, dark blue
Image: 365 × 615 mm ($14\frac{3}{4}$ × $24\frac{3}{16}$ in)
Insc bl: *23/50*, bc: *Passiflora*, br: *Edwin La Dell* (pencil)
Edition: 50, proofs (ea 443)
Coll: GAC

Correspondence from Terence Benton to ELD indicates that proofs were in existence when ea agreed, 'to buy the 12 editions of 50 of your "Garden Series". We will pay a fee of £12–12–6d per image for the seven editions of the coloured prints and a fee of £2–2–0d per image for the five editions of black and white prints' (artist's estate, dated 30/3/1967)

See Appendix

Mark Lancaster (b.Holmforth, Yorkshire, 1938)

University of Newcastle-upon-Tyne, 1961–5. Solo exhibitions at Rowan Gallery, London from 1965. Teaching at Newcastle-upon-Tyne and Bath Academy of Art. Prizewinner at 1st International Bradford Print Biennale, 1968. Artist-in-Residence, King's College, Cambridge, 1968–70. Met Andy Warhol and Jasper Johns in New York, while working at The Factory, and appeared in films. Moved to New York, 1972. Designed sets, lighting and costumes for Merce Cunningham Dance Company, 1973–98. Private secretary to Jasper Johns, 1974–85.

HENRY VI (MONOCHROME), 1971 (Page 223)
Series of three colour lithographs, tusche, four zinc plates, on J. Green waterleaf paper
Image and paper: 596 × 793 mm ($23\frac{15}{32}$ × $31\frac{1}{4}$ in, slight variation)
Insc br: edition number, signed and dated *Mark Lancaster '71*, with embossed chop of Bud Shark, vo: stamped ea and publication number
Edition: 40, 9 (5) ap
Pr: Bud Shark, Alecto Studios, London; pub: 1971 (ea 785–7)
Coll: Cartwright Hall Art Gallery, Bradford; Fitzwilliam Museum, Cambridge

607 I
Lithograph, printed in brown, four zinc plates, each plate printed once
(ea 785)

608 II
Lithograph, printed in brown, four zinc plates, each plate printed twice (rotated 180 degrees)
(ea 786)

609 III

Lithograph, printed in brown, four zinc plates, each plate printed twice (rotated 180 degrees)
(℮ 787)

HENRY VI (EIGHT COLOURS), 1971

Series of three lithographs, tusche, four zinc plates, printed in four to eight colours on J. Green waterleaf paper
Image and paper: 595 × 793 mm (23$\frac{7}{16}$ × 31$\frac{1}{4}$ in)
Insc br: title as roman numeral, edition number, signed and dated: *Mark Lancaster 71*, with embossed chop of Bud Shark, vo: stamped ℮ and publication number
Edition: 30, 7 ap, pp and trial proofs
Pr: Bud Shark, Alecto Studios, London; pub: 1971
(℮ 788–90)
Lit: *A Decade of Printmaking* (p.43, ill.)

'About the "Henry VI" lithographs: these are related to one of a series of paintings made at Cambridge in 1969 and 70, which refer to, and are named after, the architects of various buildings in King's College When I made a painting that was a response to King's College Chapel, whose architect was not known, I gave it the title of the founder, Henry VI who, according to historians, was instrumental in its design The lithographs are not so much like the painting as they are a kind of analysis of its parts and procedures, in which the elements are pulled apart and put back together in varying sequences. The monochrome series relates in colour to the sandstone of the chapel. The coloured series was an attempt, which I had used in other works of the period, to use an eight-colour spectrum in various progressive orders. I think of the grey and red print as a kind of spontaneous response to the preceding prints. Whatever their merits, these prints owe their existence to the patience and skill of Bud Shark.' (ML, 2/12/2000)

610 I

Lithograph, four zinc plates, each plate printed once (blue, yellow, green, red)
(℮ 788)

611 II

Lithograph, four zinc plates, each plate printed twice (rotated 180 degrees) and printed in red, orange, yellow orange, yellow, purple, blue, turquoise, green
(℮ 789)

612 III

Lithograph, four zinc plates, each plate printed twice (rotated 180 degrees) and printed opposite corners in red, orange, yellow orange, yellow, purple, blue, turquoise, green
(℮ 790)

'The zinc plates for this series were made using lithographic tusche applied to the plate with a squeegee in positions based upon a predetermined grid Trial proofs from various test plates were made to determine the process, colours and printing sequences for the final editions.' (Bud Shark, 1/17/2001)

613 Henry VI Series (Grey and Red), 1971

Lithograph, tusche, four zinc plates, each plate printed once (three in grey plus red) on J. Green waterleaf paper
Image and paper: 593 × 791 mm (23$\frac{3}{8}$ × 31$\frac{1}{8}$ in)
Insc br: *artists proof 10/12 Mark Lancaster 71* (pencil), br corner: Bud Shark embossed chop, vo: stamped ℮ *809*
Edition: 75, 12 ap
Pr: Bud Shark, Alecto Studios, London; pub: 1971 (℮ 809)

Colin Lanceley (*b.*Dunedin, New Zealand, 1938)

Family moves to Sydney, Australia, 1939. Apprenticed to colour photo-engraver, 1954. Graduate of East Sydney Technical College, 1960. Travelling scholarship to Italy and UK, 1964–5. Joined Marlborough Fine Art, London, 1966. Initial contact with ℮ when making suite of prints for Marlborough at Kelpra Studio, 1965–6. Continued to live in London until returned to Australia, 1981. Monograph by Robert Hughes and William Wright (Craftsman House, 1987).

614 Morning and Melancholia, 1973

Lithograph, tusche and crayon, three zinc and one aluminium plate, printed in black, red, yellow, purple-brown, blue, brown on J. Green waterleaf HP 310 gsm paper
Image and paper: 715 × 914 mm (28$\frac{1}{8}$ × 36 in)
Insc bl: *'Morning and Melancholia' 29/150*, br: *Lanceley 73* with ℮ embossed
Edition: 150, 25 ap, pp
Pr: Bud Shark, Alecto Studios, London; pub: EACC, 1973
(℮ 827)
Lit: *Alecto Monographs 3*
Coll: Cartwright Hall Art Gallery, Bradford; Tate

'The title of my print is a pun on Freud's paper "Mourning and Melancholia". Associated with the funereal images is an airy crispness that suggests morning A major preoccupation in my work is with visual language, so that the print should be literate, without being literary.' (CL, *Alecto Monographs*)
 Morning and Melancholia looks spare in relation to my more recent prints, but I always like the paper to do a lot of the work – the paper becomes a landscape and a horizon is implied. The placement of things has always been crucial.' (CL, 27/11/2000)

Ian Lawson (*b.*Leek, North Staffordshire, 1942)

See biographies

615 LA 1, 1966-7

Lithograph, stone and tusche, printed in four colours, light and dark blue, orange, red orange on J. Green paper
Image and paper: 586 × 795 mm (23$\frac{1}{16}$ × 31$\frac{5}{16}$ in)
Insc bl: *Trial Proof*, bc: *LA 1*, br: *Ian S Lawson* (pencil) with Tamarind and Ian Lawson chops

Edition: 15, 9 Tamarind impressions, bat, 1 ap, 4 tp
Pr: The artist, Tamarind Lithography Workshop, Los Angeles,
11 Aug–1 Sept 1966; pub: 1967 (ea 501)
Lit: *Tamarind*, p.134
Coll: University of New Mexico Art Museum, Albuquerque;
MOMA

'I spent six months at Tamarind, having worked for Irwin
Hollander in New York. This is the only print I produced in Los
Angeles. It is purely visual and self-contained Anything other
than a circle has edges. I wanted to put space into a sheet of
paper, so one is involved in the image and with notions that work
in space.' (IL, 18/12/1999)

Igino Legnaghi (*b.*Verona, 1936)

Igino Legnaghi has lived and worked in Verona throughout his
life. Studied sculpture at Accademia di Belli Arti de Brera, Milan.
Worked in father's stone workshop, which specialised in
religious appurtenances and copies of great works of art. Began
making own sculpture, 1964. First solo exhibition: Galleria
Ferrari, Verona, 1967; Galleria del Cavallino, Venice, 1970; and
Camden Arts Centre, London, 1973. Regular exhibitor in Italy,
Japan, and *Les tables de Igino Legnaghi 1970–1976*, Grand
Palais, Paris, 1987.

616 Sculptural Image, 1973
Screenprint, printed in cream, yellow, red, black, dark grey,
orange, brown, brown grey, blue-grey on R. K. Burt handmade
HP paper
Image: 817 × 615 mm ($32\frac{3}{16}$ × $24\frac{3}{16}$ in), paper: 900 × 680 mm
($35\frac{7}{16}$ × $26\frac{3}{4}$ in)
Edition: 150, 25 ap
Insc bl: *61/150*, br: *I Legnaghi* (pencil), br corner: ea embossed
Pr: Leslie Hosgood and Robert Jones, Megara Screenprinting
Ltd, Alecto Studios, London; pub: EACC, November 1973
(ea 831)
Lit: *Alecto Monographs 7*
Coll: Tate

'The relationship between printing and my sculpture has not
changed. In both I attempt to concentrate a maximum intensity in
a minimum, precise form. From the mid-1960s, I had been
making coloured sculptures, and this is reflected in the print, as
in the smooth reflective surface I was also aiming for at the time
. . . . I have (however) never considered my screenprints as
anything other than independent, autonomous works. They are
not projects or preparatory sketches for sculptures. The
colouring, the forms of the two activities, may go hand in hand
but my sculpture is three-dimensional and usually large scale,
while my prints are flat and related to the reach of my arms and
hands' (IL, 10/4/2000)

Paolo Legnaghi (*b.*Verona, 1939)

From a family of artists associated with Verona and brother of Igino.
Worked as a boy in father's stone workshop. Studied design at the
Scuola Statale d'Arte, Napoleone Nani, Verona. Started to paint on
USA visit, 1963–4. Returned to work in family workshop, producing
first sculpture, *Absolute Truth*, 1968. Simplified and pure forms
embraced the notion of the cut or divided image, 1970–3. Now living
in India.

617 Perception 1, 1973
Bronze, cast with brass base
Overall size: 160 × 115 mm ($6\frac{5}{16}$ × $4\frac{1}{2}$ in)
Insc vo: *P Legnaghi 3/50* (incised)
Edition: 50
Pub: EACC, 1973 (ea 835)
Lit: *Alecto Monographs 10*

Based on 1970 wall sculpture, one of a series entitled
Perception: 'The original was in wood, covered with white
Cementite. It inspired a series of standing panels, in silver and in
bronze, adding a support so that the relief became free-standing
. . . . The reason for these variations was that the original work
seemed to be the synthesis of a long period of research'
(PL, *Alecto Monographs*)

David Leverett (*b.*Nottingham, 1938)

Nottingham College of Art, 1957–61 and Royal Academy Schools,
1962–5. First exhibition at Redfern Gallery, London, 1965. Graphics at
Annely Juda, London, 1969; and Alecto Gallery/Redfern Gallery and
Editions Alecto, New York, 1970. Visiting artist, Slade School of Fine
Art from 1971. Experiments with translucent qualities of Tortulite
cellulose at Braas & Co. in Germany and Megara Screenprinting Ltd,
London, 1974. More recently exhibited landscapes internationally and
with Jill George Gallery, London.

Diagonal Inclinations, 1970
Series of six screenprints, printed on Oram & Robinson 060
white art board
Image: 510 × 708 mm ($20\frac{1}{16}$ × $27\frac{7}{8}$ in), paper: 648 × 839 mm
($25\frac{1}{2}$ × $33\frac{1}{32}$ in, slight variation)
Insc bl: with edition number, br: signed by artist: *David Leverett*
(pencil), vo: stamped ea and publication number
Edition: 100, 20 ap
Pr: 1–2 (plus folder) Lyndon Haywood and Michael O'Connor,
Alecto Studios; and 3–6 Leslie Hosgood and Robert Jones,
Tanagra Ltd, London; pub: 1970 (ea 658–63)

A black and red plastic zipped folder was produced for the
complete edition, insc: *David Leverett Diagonal Inclinations/
Editions Alecto 1970 London & New York* (670 × 855 mm,
$26\frac{3}{8}$ × $33\frac{11}{16}$ in). Leverett designed a *Diagonal Inclinations* poster
for simultaneous Redfern Gallery and Alecto Gallery exhibitions,
7 April–1 May 1970 (National Museum and Gallery, Cardiff).

618 1

Screenprint, printed in orange, pink, green, blue
(ea 658)
Coll: GAC

619 2

Screenprint, printed in blue, green, purple, red pink
(ea 659)
Coll: British Council

620 3

Screenprint, printed in yellow, pink, grey, blue
(ea 660)

621 4

Screenprint printed in orange, olive green, pink, blue
(ea 661)
Coll: GAC; British Council

622 5

Screenprint, printed in orange, purple, green, red pink
(ea 662)
Coll: GAC

623 6

Screenprint, printed in green, sky blue, orange, magenta
(ea 663)
Coll: The artist

624 Retained Image, 1970

Screenprint, printed in orange, blue, violet, pink
Image: 508 × 712 mm (20 × 28$\frac{1}{16}$ in), paper: 585 × 787 mm
(23 × 31 in)
Insc bl: *15/75*, br: *David Leverett* (pencil), vo: stamped ea *752*
Edition: 75, 15 ap
Pr: Kevin Harris, RCA; pub: 1970 (ea 752)
Exh: *David Leverett*, Alecto Gallery, London, 7 April–1 May 1970

EQUINOX, I–IV, 1972

Four colour lithographs, four zinc plates in various combinations,
tusche
Image: 662 × 663 mm (26$\frac{1}{16}$ × 26$\frac{1}{8}$ in), paper: 710 × 705 mm
(27$\frac{15}{16}$ × 27$\frac{3}{4}$ in)
Insc bl: edition number and title, br: signed *David Leverett*
(pencil) and embossed chop of Bud Shark, vo: stamped ea with
publication number
Edition: 25, 5 ap
Pr: Bud Shark, Alecto Studios, London; pub: AI, 1972
(ea 813–16)
Coll: Tate (trial proofs)

This series explores the idea of accumulative colour with
selected combinations of four colours.

625 I

Lithograph, printed in yellow, lemon yellow, light and dark pink
(ea 813)
Coll: Cartwright Hall Art Gallery, Bradford

626 II

Lithograph, printed in two yellows, pink
(ea 814)

627 III

Lithograph, printed in yellow, lavender, dark pink
(ea 815)

628 IV

Lithograph, printed in turquoise, yellow, lavender
(ea 816)

629 State of Change, 1973 (Page 221)

Lithograph, tusche with splatter, printed in yellow, pink, orange,
purple blue, green on J. Green waterleaf paper
Image and paper: 716 × 910 mm (28$\frac{3}{16}$ × 35$\frac{13}{16}$ in)
Insc bl: *9/75*, br: *David Leverett*, br corner: ea embossed
Edition: 75, 15 ap
Pr: Don Bessant, Alecto Studios, London; pub: EACC, 1973
(ea 838)
Coll: Tate; Leicestershire Museums, Arts and Records Service

3 × 3 SHIFT, 1973

Three screenprints exploring changing colour sequences on
Hollingworth Kent cartridge paper
Image: 600 × 907 mm (23$\frac{5}{8}$ × 35$\frac{11}{16}$ in), paper: 763 × 1018 mm
(30$\frac{1}{16}$ × 40$\frac{1}{16}$ in)
Insc bl: edition number in roman numbers, title and date, br:
signed *David Leverett* (pencil)
Edition: 30, 5 ap, 1 icp (even nos only with ea)
Pr: Lyndon Haywood and Kevin Harris, Alecto Studios, London;
pub: 1975 (ea 883–5)
Coll: Tate

630 Cerise

Screenprint, printed in cerise, blue, grey
(ea 883)

631 Orange

Screenprint, printed in orange, green, grey
(ea 884)

632 Blue

Screenprint, printed in blue, grey, rose-madder
(ea 885)

Huty

Prototype shown at *Play Orbit* exhibition, ICA, London, 1969
was a multiple idea for a piece of brightly coloured foam furniture

made of polystyrene which could be fitted together into a cube and also function as a children's toy. 'It was about a meter square, and when boxed in cubic form could form a Wendy house Joe Studholme liked the idea and it was even taken up by Edward Marcus in Dallas but finally adandoned when someone appeared who held the patent on the U shape in 3-D form. His demands proved far too high' (DL, 15/1/2000)

Spaceometry II
Thirty-six lengths of half-inch square section aluminium of different lengths, with injected moulded corner connections, forming three basic shapes – cube, pyramid and asymmetrical triangles. When clipped together created a variety of spatial sculptures.
Prototype produced by Al, c.1972.

Les Levine (b.Dublin, 1935)

First solo exhibitions in Canada at University of Toronto, 1964; Blue Barn Gallery, Ottawa; and David Mirvish Gallery, Toronto. Exhibited in New York from 1966, at the Fischbach Gallery. Worked in drawing, installation, video, multiples, photography, billboards and mixed media. Represented in Europe since 1985 by Brigitte March Galerie, Stuttgart. *Les Levine's Video: A Selection From Two Decades*, International Center of Photography, New York, 1989. Worked in the Alternative Museum, New York.

633 Masterprint, 1970 (Page 216)
Lithograph, photo, off-set, five to six *rainbow rolled* colours on 100 % rag paper
Edition: 1000
Pr: Del-mar Printing, Lafayette, New York in newspaper format of 28 pages; photographs by Les Levine and others; pub: Editions Alecto of America Ltd, 1970 (no publication number)
Overall size: 597 × 460 mm (23 $\frac{1}{2}$ × 18 $\frac{1}{8}$ in)
Coll: Bibliothèque Nationale, Paris; Fogg Museum of Art, Harvard University

Based on *Cultural Hero* – a cult newspaper produced by Les Levine in New York, 1967–70 – and the special issue dedicated to the dance critic of *Village Voice*, Jill Johnston.

Front Cover
Montage of spoof reviews and photo-repro of *Cultural Hero*
Insc b: ea *Editions Alecto of America Limited 276 Park Avenue South New York NY.*

Inside Front Page
Printed with rainbow rolling: purple to pink to blue
Image and paper: 575 × 440 mm (22 $\frac{5}{8}$ × 17 $\frac{5}{16}$ in)
Insc br: *Les Levine 70* (pencil) and headed with text: *Cultural/ Hero/ Jill Johnston Exposed: special issue/ A life dominated by Strange Arts/ Consuming Desires, and Ego-Eroticism . . ./ Cover by Les Levine*

List of numbered pages with contributions from: Lucas Samaras, Gregory Battcock, David Boundon, Yvonne Rainer, Jasper Johns, Andy Warhol, John Gruen, Marjorie Strider, John Giorno, Lil Picard, Willoughby Sharp, George Segal, Barbara Forest and others.

'A number one topic for gossip and discussion for many years, *Cultural Hero* decided to find out if any of the assorted gossipers and discussers had anything to say about her (Jill Johnston) for the record.' (*Masterprint*)

Liliane Lijn (b.New York City, 1939)

Studied archaeology and art history in Paris, also teaching herself how to draw. New York 1961–2, producing first work with reflection, motion and light and later kinetic poems. Settled in London, 1966. Exhibited at Indica Gallery, 1967 and *Sculpture, Drawings and Collages* at Hanover Gallery, 1970. Awarded Editions Alecto Commission Prize for *Quantum 1* at Bradford Print Biennale, 1976. This resulted in commission to work with Charles Newington at Alecto Studios on *Biting Through* Series.

BITING THROUGH, 1976–7 (Page 253)
Set of six sugar-lift aquatints on B. F. K. Rives Velin Cuve 240 gsm paper, each image pulled from two copperplates
Insc bl: with edition number, bc: titled with Greek alphabet letter, br: signed by artist and dated: *Liliane Lijn 1977* (pencil) with ea embossed
Image: 223 × 225 mm (8 $\frac{3}{4}$ × 8 $\frac{7}{8}$ in), paper: 350 × 350 mm (13 $\frac{3}{4}$ × 13 $\frac{3}{4}$ in)
Edition: 25, 5 ap
Pr: Charles Newington and Loraine Smith, Tisiphone Etching Limited, Alecto Studios, London; pub: 1977 (ea 959–64)
Coll: GAC

First exhibited at Serpentine Gallery, London and at Editions Alecto, 27 Kelso Place, London, 17 December–27 January 1977 with the following script on publicity leaflet:

'When there is something that can be contemplated, there is something that creates union. Hence there follows the hexagram of BITING THROUGH.
Biting Through means union.
Biting Through means consuming.'

I Ching

634 Alpha
Aquatint, sugar-lift, printed in metallic silver and dark blue, printed in close parallel
(ea 959)

635 Beta
Aquatint, sugar-lift, printed in light grey and green, printed in parallel
(ea 960)

636 Gamma

Aquatint, sugar-lift, printed in red blended through to brown and black
(ea 961)

637 Delta

Aquatint, sugar-lift, printed in blue blended through to purple
(ea 962)

638 Epsilon

Aquatint, sugar-lift, printed in turquoise and metallic silver
(ea 963)

639 Zeta

Aquatint, sugar-lift, printed in red orange and metallic light green, printed in parallel
(ea 964)

640 Flikker Book No. 6, 1972 (Page 225)

Lithograph, off-set, printed in black
Overall size: 75 × 92 mm ($2\frac{31}{32}$ × $3\frac{5}{8}$ in)
Printed front: *Flikker/ book/ Liliane Lijn*, back page: *Liliane Lijn*; back cover: *© 1972/ Alecto International/ Limited. Flikker book is a/ registered trade mark of/ Alecto International Ltd/ who printed/ and published this/ book from/ 27 Kelso Place/ London W8 5QG/ England/ Distributed in UK & Canada by Reeves & Sons Ltd, Enfield, Middlesex*
Pr: Hillingdon Press, Uxbridge; pub: AI, 1972

Flying form over the contours of a landscape, from series of nine flikker books.

Helena Markson (b.London, 1934)

Salisbury School of Art, and Central School of Art, London, 1952–6, studying etching under Merlyn Evans. Associated with St George's Gallery, London, and *The Graven Image* exhibitions, 1959, 1962 and 1963. Member of Senefelder Group and Printmakers' Council of Great Britain. Set up etching studio at Byam Shaw School of Painting, London, 1965–70. To Israel in 1970, teaching in Jerusalem and Tel Aviv. Established new Printmaking Studios, University of Haifa. *Helena Markson–Aquatints 1993–1994*, Israel Museum, Jerusalem, 1994.

641 Beaumont School

(ea 99)

Haileybury School

See Appendix

LIVERPOOL SUITE, 1964–5

Six colour etchings on Crisbrook 140 lb paper. Edition: 100, 10 ap, with small number presented in blue folder in hard slipcase inscribed: ea *Liverpool Suite Helena Markson* Insc bl: edition number, bc: titled, br: signed *Helena Markson* (pencil)

Proofed by the artist on starwheel press, Stoke Newington studio and pr: Michael Rand, The Studio, Bushey, 1964; pub: 1965 (ea 100–5)
Coll: GAC, South London Gallery (two from the series)
Exh: *Doris Seidler Helena Markson*, The Print Centre, London, 6–31 October 1964

Graeme Shankland, Town Planner for Liverpool, saw Helena Markson's work at a Senefelder Group exhibition. At his suggestion, and at a time when Liverpool was entering a new planning programme with old buildings coming down, Markson began to visit the city. The period of sketching and familiarising herself with buildings, both in the city centre and in the suburbs, lasted over a year. Paul Cornwall-Jones, who had himself studied architecture, commissioned a suite of prints. Additional Liverpool prints were then published by London Graphic Arts, before ea initiated a *New Suite* of London and Liverpool scenes, 1968.

642 Queen's Dock (Page 75)

Etching, sugar-lift aquatint, four copperplates, printed in blue, black, purple, brick red
Plate: 425 × 550 mm ($16\frac{3}{4}$ × $21\frac{5}{8}$ in), paper: 566 × 797 mm ($22\frac{5}{16}$ × $31\frac{3}{8}$ in) (ea 100)
Coll: Leeds City Art Gallery; Israel Museum, Jerusalem; Leicestershire Museums, Arts and Records Service

'There is the powerful position of the cathedral, but also a balance between the community (of houses), the dock and the church.' (HM, 4/12/1999 and following quotes)

643 Everton from Browside

Etching, sugar-lift aquatint, four copperplates, printed in two oranges, blue, red brown
Plate: 417 × 550 mm ($16\frac{7}{16}$ × $21\frac{5}{8}$ in), paper: 512 × 663 mm ($20\frac{3}{16}$ × $26\frac{1}{8}$ in) (ea 101)

'This is how it looked in Everton, line upon line of houses on steep hills There were some sparkling houses, and then not far away some very neglected areas Also some extraordinary sunsets, mixed with pollution of course.'

644 Pier Head

Etching, sugar-lift aquatint, four copperplates, printed in blue, orange, crimson red, green
Plate: 426 × 550 mm ($16\frac{13}{16}$ × $21\frac{5}{8}$ in), paper: 565 × 795 mm ($22\frac{1}{4}$ × $31\frac{5}{16}$ in) (ea 102)
Coll: Leeds City Art Gallery

'Walking around I got to know individual buildings, their form and particular place in the wider scheme of things. At the time I was becoming quite minimal, this project pulled me in a different direction'

645 Albert Dock

Etching, sugar-lift aquatint, two copperplates, printed in black and blue

Plate: 400 × 500 mm (15 $\frac{3}{4}$ × 19 $\frac{11}{16}$ in), paper: 571 × 800 mm (22 $\frac{1}{2}$ × 31 $\frac{1}{2}$ in) (ea 103)

'I like to isolate a certain structure and present a sense of place At the time they were threatening to pull all of this (Albert Dock) down. I remember John Betjeman getting involved'

646 The Cathedral
Etching, sugar-lift aquatint and open bite, three copperplates, printed in Indian red, yellow, purple
Plate: 429 × 548 mm (16 $\frac{5}{8}$ × 21 $\frac{9}{16}$ in), paper: 570 × 797 mm (22 $\frac{7}{16}$ × 31 $\frac{3}{8}$ in) (ea 104)

647 William Brown Street
Etching, sugar-lift aquatint, copperplate, printed in black and blue
Plate: 399 × 500 mm (15 $\frac{3}{4}$ × 19 $\frac{11}{16}$ in), paper: 570 × 799 mm (22 $\frac{7}{16}$ × 31 $\frac{7}{16}$ in) (ea 105)

'I would walk around getting to know buildings, civic and residential, and their particular features'

648 Newington Green, 1964
Etching, sugar-lift aquatint, four copperplates, printed in brown, yellow, ochre, blue
Plate: 530 × 430 mm (20 $\frac{5}{8}$ × 16 $\frac{15}{16}$ in), paper: 719 × 556 mm (28 $\frac{5}{16}$ × 21 $\frac{5}{8}$ in)
Insc bl: *Artists Proof*, bc: *Newington Green*, br: *Helena Markson* (pencil)
Edition: 50, 5 ap
Proofed by the artist, Stoke Newington studio
Pr: Atelier Georges Leblanc, Paris; pub: 1964 (ea 106)

NEW SUITE, 1968
Six colour etchings on handmade Crisbrook paper
Paper: 570 × 796 mm (22 $\frac{7}{16}$ × 31 $\frac{3}{8}$ in, with slight variation)
Insc bl: edition number, bc: title, br: signed *Helena Markson* (pencil)
Edition: 100, 10 ap
Pr: Michael Templar, Danyon Black and Maurice Payne, Alecto Studios, London; pub: 1968 (ea 543–8)

649 The Church on the Hill
Etching, sugar-lift aquatint, four copperplates, printed in black brown, two greens, blue with dabbed purple
Plate: 439 × 589 mm (17 $\frac{5}{16}$ × 23 $\frac{3}{16}$ in) (ea 543)

'This is the church in Pentonville (London) where Richard Bonnington is buried. This is now owned by a corporate firm with the gravestones moved to one side The house on the right is symbolic of houses/dwellings there.'

650 Hampstead Pond
Etching, sugar-lift aquatint, three copperplates, printed in black, orange, lighter orange
Plate: 595 × 448 mm (23 $\frac{7}{16}$ × 17 $\frac{5}{8}$ in) (ea 544)

651 Town Hall (Liverpool)
Etching, sugar-lift aquatint, four copperplates, printed in black, yellow, ochre, blue
Plate: 431 × 552 mm (17 × 21 $\frac{3}{4}$ in) (ea 545)

652 Falconer Square (Liverpool)
Etching, sugar-lift aquatint, three copperplates, printed in Naples yellow, brick red, two blues wiped onto single plate
Plate: 352 × 602 mm (13 $\frac{5}{8}$ × 23 $\frac{11}{16}$ in) (ea 546)
Coll: GAC

'I used pigment and oil not tins of paint so I could control the colour better I remember Michael Rothenstein said I worked on the plates "like a painting". Falconer Square was a residential area in Liverpool where I stayed.'

653 Entrance to Wapping Basin (Wapping)
Etching, sugar-lift aquatint, four copperplates, printed in blue, red brown, purple, black
Plate: 428 × 547 mm (16 $\frac{7}{8}$ × 21 $\frac{9}{16}$ in) (ea 547)
Coll: GAC

'The large warehouse on the right was designed by Jesse Hartley and torn down shortly after I completed this print. All the docks in Liverpool connect'

654 Stoke Newington in the Rain
Etching, sugar-lift aquatint and open bite, three zinc plates, printed in black, blue, orange
Plate: 305 × 520 mm (12 × 20 $\frac{1}{2}$ in), paper: 566 × 795 mm (22 $\frac{5}{16}$ × 31 $\frac{5}{16}$ in)
Proofed by the artist, Central School, London in 1954 or 1955 and later pr: Douglas Allsop, Digswell Arts Trust, Welwyn Garden City, 1968 (ea 548)
Coll: GAC

'A student plate which Paul Cornwall-Jones later picked out . . . a general idea of an area I knew well . . . people waiting for buses, going about a dreary day.'

Michael McKinnon (*b.*Beulah, Victoria, Australia, 1940)

Studied History of Art, University of Melbourne, 1959–62 and painting at RCA, 1965–8. Founder member of Continuum with Robert Janz and Dante Leonelli, exhibiting at Axiom Gallery, London, 1967. Showed in *Kinetic Art* and *Continuum* exhibitions, both at Hayward Gallery, London, 1970. Taught at Hornsey College of Art, 1977–9, helping to run 4-D Department dealing with video, film, performance and kinetic art. V&A touring exhibition of *Fibonacci Portfolio*, 1977. Moved into film, founding McKinnon Films to direct and produce natural history films, 1978.

FIBONACCI PORTFOLIO, 1976
Series of four images in various media exploring the structural principles found in nature and based on the work of the

→ p.184

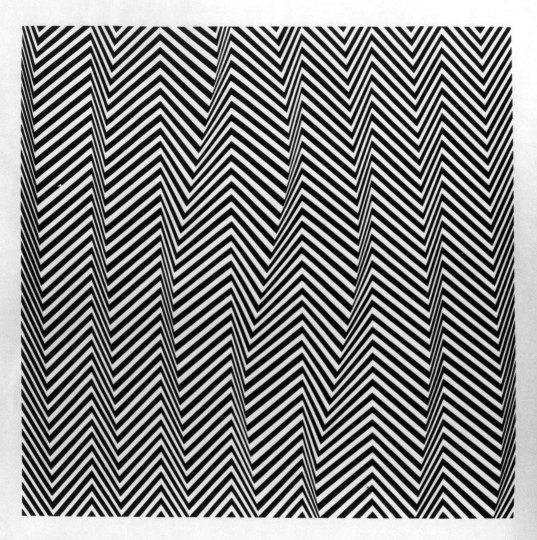

DESCENDING

Going down. How the voice
Stepwise descends. Who cries
There, behind the curtain
And says those muffled words–
Untelligible
Secrets being told?
You would like to know them
But if you heard clearly,
Would you not invoke the
Black descent of silence?

 Poster by Bridget Riley.
Poem by Edward Lucie-Smith.
Published by Editions Alecto

Plate 114 Bridget Riley and Edward Lucie-Smith, *Poster Poem: Descending*, 1968 (972)

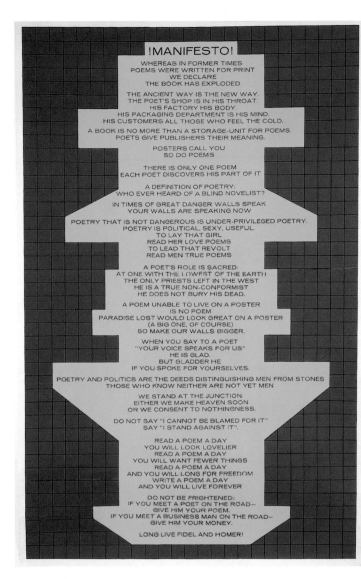

Plate 115 Christopher Logue and Derek Boshier, *Poster Poem: Manifesto*, 1968 (138)

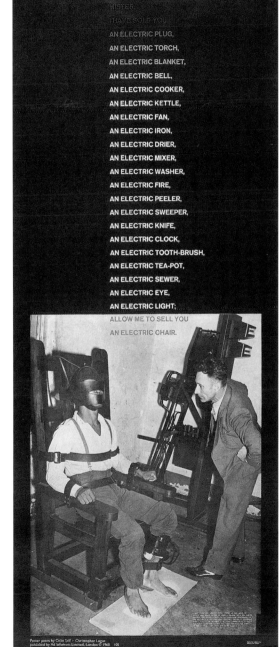

Plate 116 Christopher Logue and Colin Self, *Poster Poem: Electric Chair*, 1968 (1051)

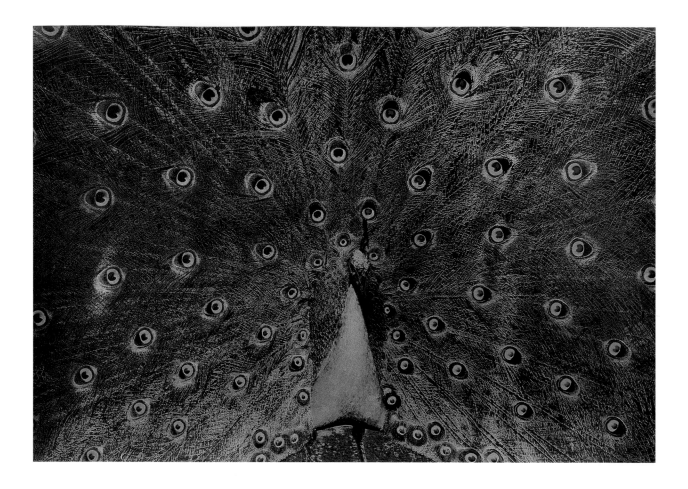

Plates 117, 118 Colin Self, *Power and Beauty* Series, Volume One: *Peacock* and *Car*, 1968–9 (1044, 1041) © Colin Self 2002. All Rights Reserved, DACS

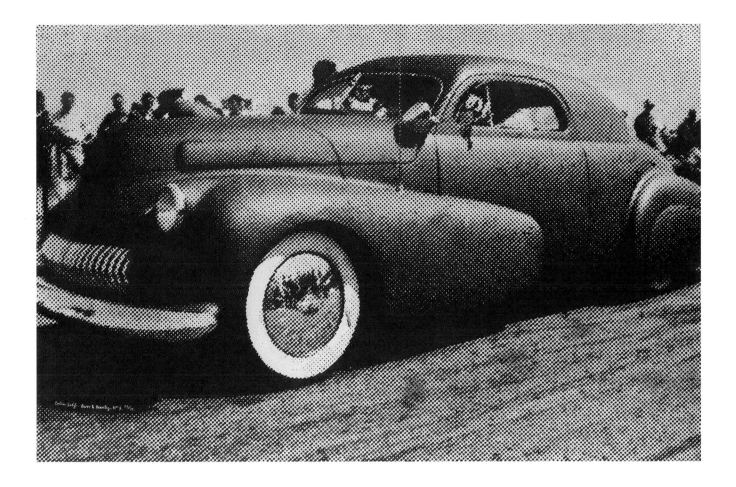

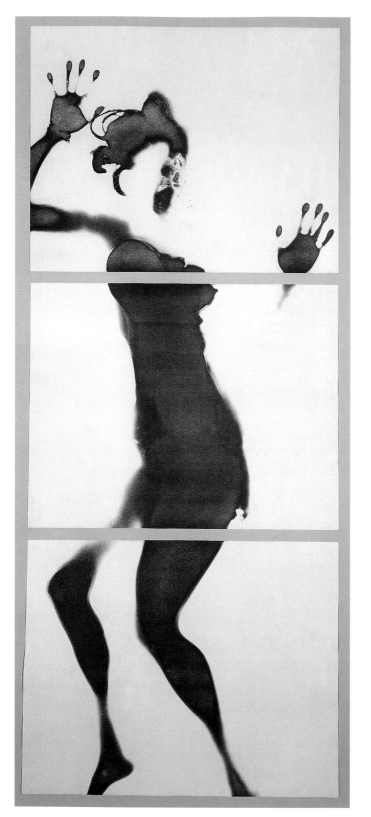

Plate 119 Colin Self, *Figure No 2: Nude Triptych* from
Prelude to 1000 Temporary Objects of our Time, 1971 (1058)
© Colin Self 2002. All Rights Reserved, DACS

OPPOSITE PAGE
Plate 120 Colin Self, *Out of Focus Object and Flowers 1*
(*Provincial Image*), 1968 (1035) © Colin Self 2002. All
Rights Reserved, DACS

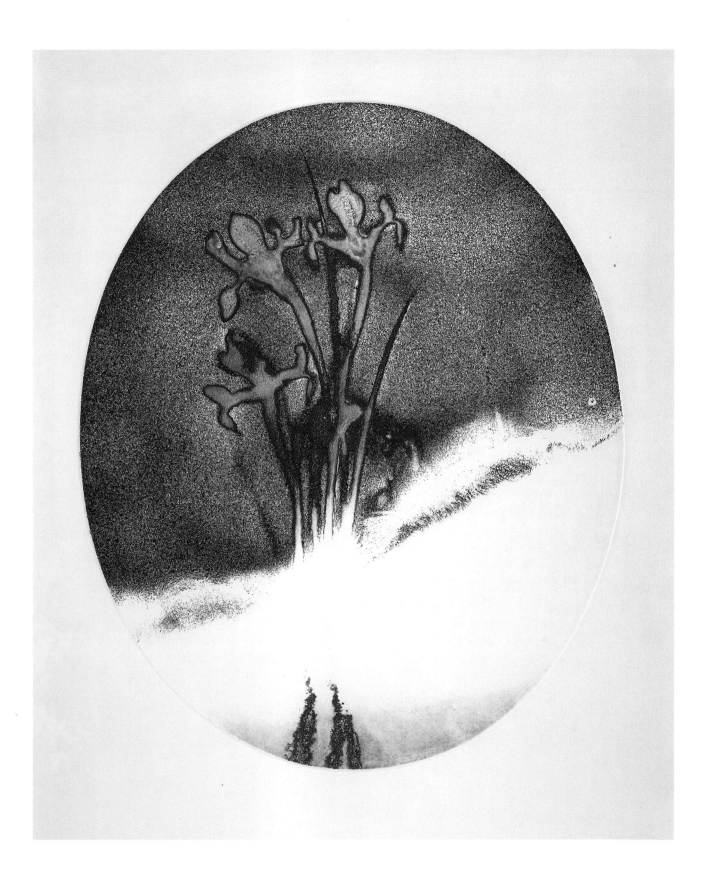

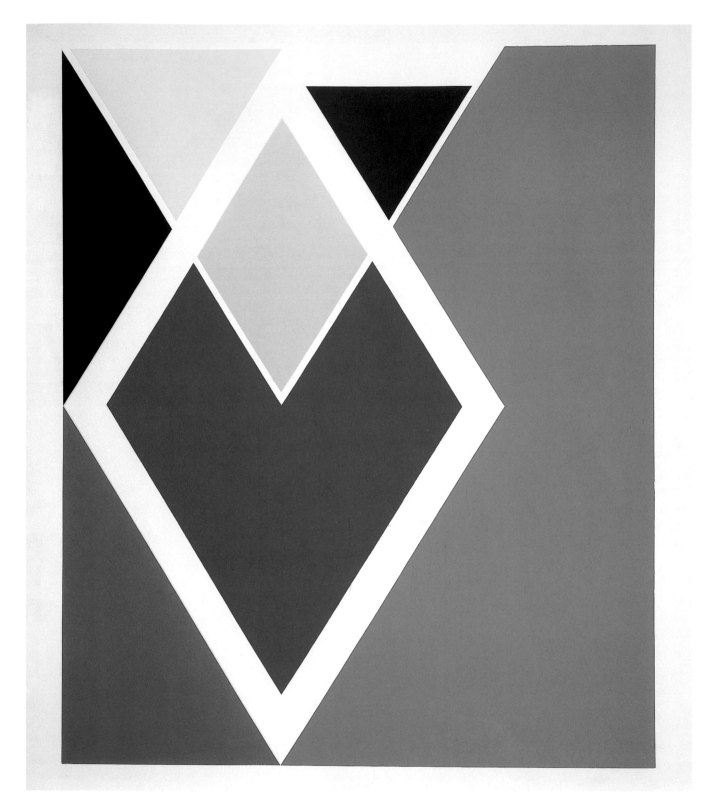

Plates 121, 122 Larry Zox, *Diamond Drill 2* and *3*, 1968 (1159–60)

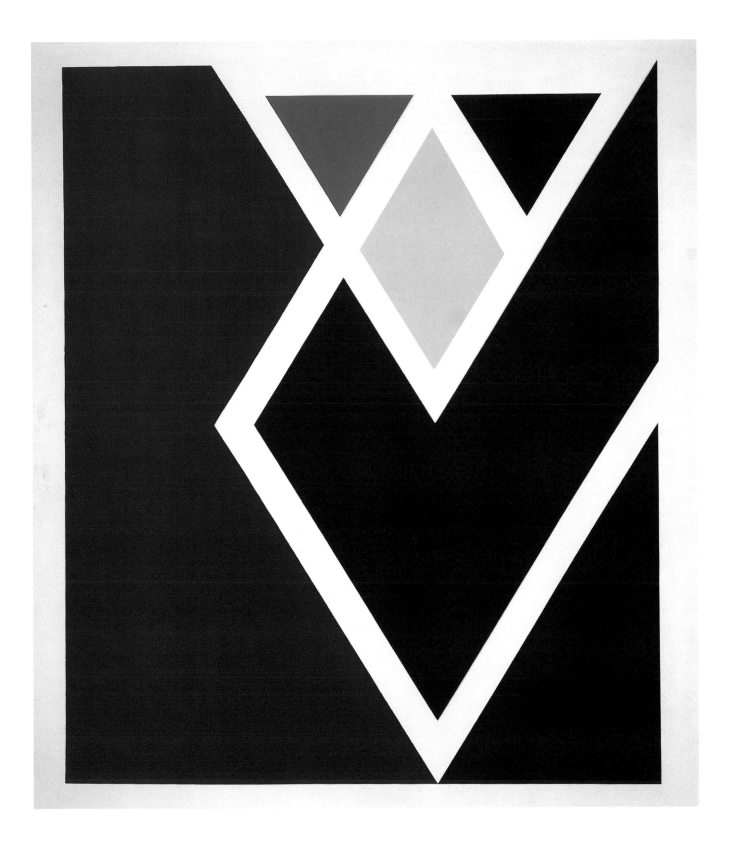

I. did you ever go for long walks
ride in a donkey cart
or on the back of a pig

II. did you ever visit a sandpit and see the sandmartins homes
play in a sandpit among hills covered in yellow gorse
or try to catch butterflies on clumps of thistles
III. did you ever pick wild strawberries at the edge of a wood
fall off a bicycle after playing in a farmyard
or see a freshly ploughed field through drizzle
IV. did you ever swim in a sandy bottomed river
catch pinkeens and eels
or eat hawberries and play in ripe corn

V. did you ever play hurling in a field surrounded by hedges
see where the tinkers had camped
or go rabbit shooting with your father
VI. did you ever dance across the kitchen floor
or see a farmer play an accordian
or have a bath in front of the kitchen fire
VII. did you ever think your father dead and cut his hair to wake him up
see a dead man
or go to a wake
VIII. did you ever draw with coloured chalks on the stone kitchen floor
get chased by a donkey
or stand chest high in a field full of dog-daisies

I DID
Anthony Deigan

Plates 123, 124 Anthony Deigan, *I Did* (*Poem* and *VII*), 1969 (284)

AP VII Deigan '69

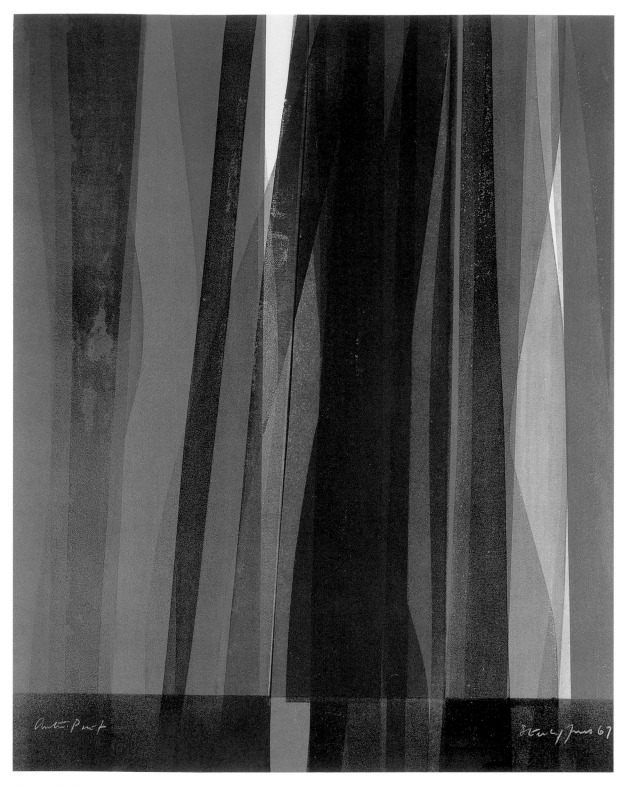

Plate 125 Stanley Jones, *Lunar Sound*, 1969 (544)

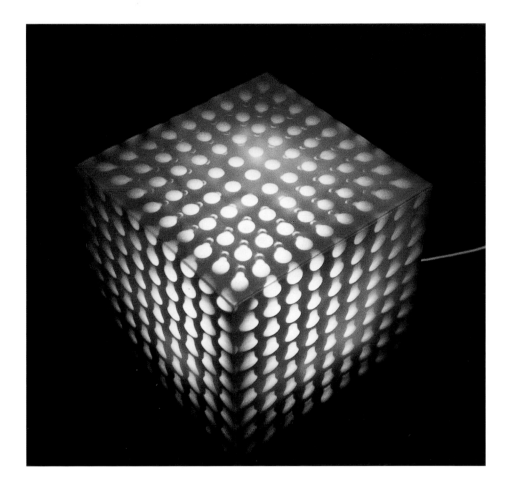

Plate 126 Bill Culbert, *Celeste*, prototype multiple, 1971 (see p.92)

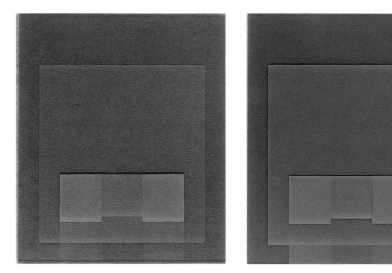

Plates 127–31 Robyn Denny, *Colour Box Series*, 1968–9 (313–17)

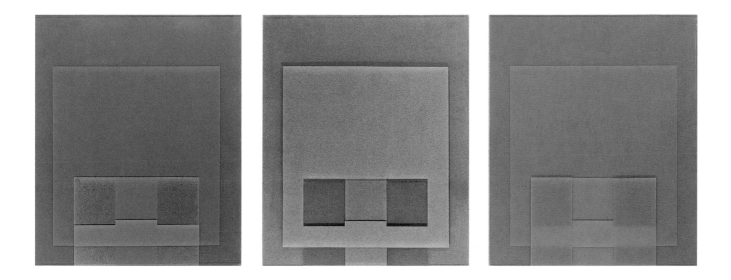

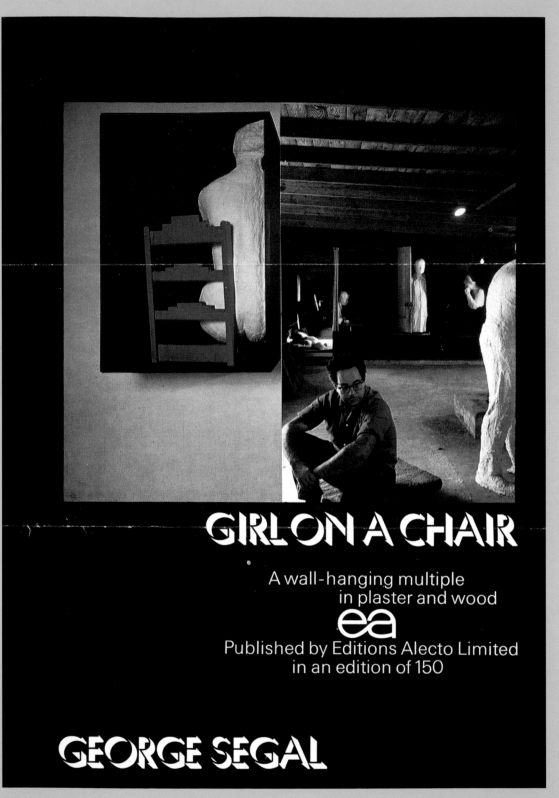

Plate 132 Promotional leaflet for George Segal's *Girl on a Chair*, 1969–70 (1025) © The George and Helen Segal Foundation / DACS, London / VAGA, New York 2002

Plate 133 Promotional leaflet for Peter Sedgley's *Video Disques*, 1969–70 (1019–24)

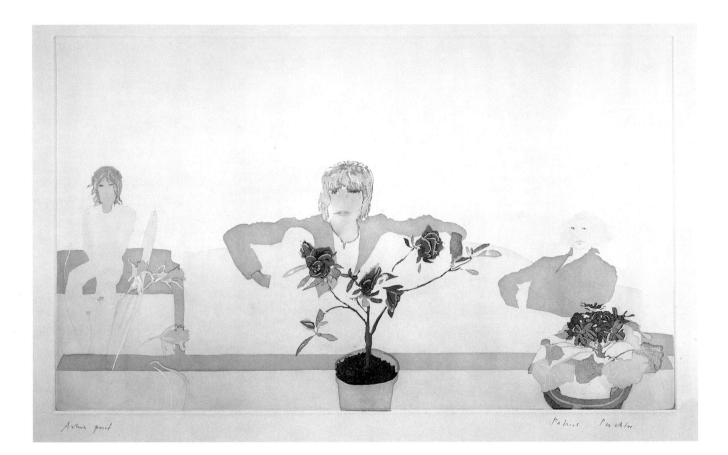

Plates 134, 135 Patrick Procktor, *Ossie, Gervase and Eric* and *Departure* from *Invitation to a Voyage*, 1969–70 (910, 908)

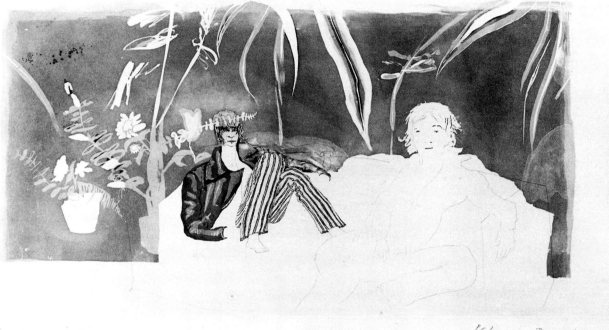

Pauline Proof Patrick Procktor

Plates 136, 137 Eduardo Paolozzi, *Cloud Atomic Laboratory*, 1971 (889–90)

Plates 138, 139 Eduardo Paolozzi, *Cloud Atomic Laboratory*, 1971 (892–3)

Ham and Enos at practice: both later flew in space.

Mobot Mk.1: mobile replacement for man in dangerous areas.

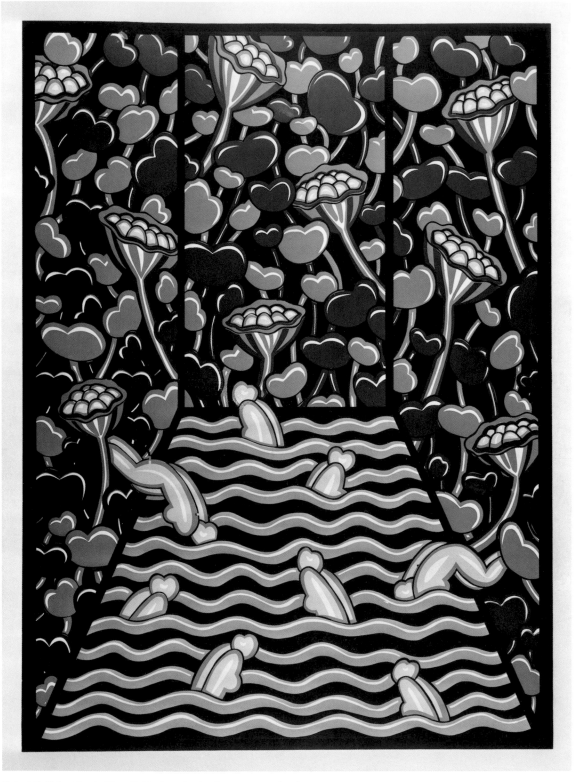

Plate 140 Robert Gordy, *Water Babies* from *Golden Days*, 1969–70 (386)

Plate 141 Michael English, *Yellow No 1*, 1979 (374)

twelfth-century mathematician Pisano Fibonacci
Edition: 125, 15 ap, icp; pub: 1976 (ea 901–4)
Coll: GAC, Tate

655 Arabian Reel, 1976
Screenprint (from hand-worked Kodatrace overlays), printed in
three blues, two greys, purple on R. K. Burt 240 lb paper
Image and paper: 636 × 826 mm (25 $\frac{1}{16}$ × 32 $\frac{1}{2}$ in)
Insc bl: *Tate*, with ea and *JO* embossed chops, bc: *Arabian
Reel*, br: *Michael McKinnon 76* (pen), vo: stamped ea *901*
Pr: Robert Jones, Megara Screenprinting Ltd, Alecto Studios,
London

Related to the mixed-media *A Bao A Qu*, 1976, in V&A.

656 Spiral Prism, 1976
Etching and aquatint, printed in yellow, orange, blue, two browns
on R. K. Burt 240 lb paper
Image and paper: 635 × 824 mm (25 × 32 $\frac{7}{16}$ in)
Insc bl: *23/125 Spiral Prism*, br: *Michael McKinnon 76* (crayon),
vo: stamped ea *902* (variously br corner: ea embossed)
Pr: Charles Newington, Tisiphone Etchings Ltd, Alecto Studios,
London

657 Phyllotaxis, 1976 (Page 251)
Photo-screenprint (with half-tone background and over-ground),
printed in dark and lighter maroon, light green, black, cream,
blue, white, red, extra blue, silver on R. K. Burt 240 lb paper
Image and paper: 637 × 824 mm (25 $\frac{1}{8}$ × 32 $\frac{7}{16}$ in)
Insc bl: *23/125 Phyllotaxis* with ea and *JO* embossed chops,
br: *Michael McKinnon 76* (pencil), vo: stamped ea *903*
Pr: Robert Jones, Megara Screenprinting Ltd, Alecto Studios,
London

658 Fibonacci's Garden, 1976
Lithograph, hand and photo-litho, printed in pale and dark green,
black, blue, pink
Image and paper: 635 × 825 mm (25 × 32 $\frac{1}{2}$ in)
Insc bl: *25/125 Fibonacci's Garden*, br: *Michael McKinnon*
(pencil), vo: stamped ea *904* (variously br corner ea embossed)
Pr: Don Bessant, Alecto Studios, London

'I am interested in the physical processes of nature In plants,
for example, as new leaves grow they spiral around the stem of a
plant. The spiral turns as it climbs and the amount of turning from
one leaf to the next is the fraction of a complete rotation around
the stem. This fraction always relates to a number series derived
from the golden mean.

The golden mean, developed in a proportional series of whole
numbers, gives the harmonic progression of 1, 1, 2, 3, 5, 8, 13,
21 . . . the sum of any two successive numbers is equal to the
number which follows.

Known as the Fibonacci scale, this series was introduced into
Europe from the Islamic world through the translation of an

Arabic text by the twelfth-century merchant and mathematician
Pisano Fibonacci.

The same ratio can be found in the cotyledons of the common
pine cone and in the arrangements of the florets of the common
daisy. The sequence of numbers can be applied equally to the
genealogical tree of bees and rabbits or to the branching
sequence of trees.

The Fibonacci principle is a wonderfully simple representation
of one of the underlying systems of nature. By placing this
system in counterpoint to other modes of structure it is possible
to link diverse areas of experience in a poetic construction in
which I have drawn heavily upon the analogies by which we
understand nature.' (MM, April 1976)

Since a change of career, McKinnon has made forty-nine
natural history films for international broadcast, which parallel the
same interest in behaviour of the natural world. 'Film allows me
to capture nature in motion – growth, change and pattern –
rather than diagrams of nature.' (MM, 25/10/2000)

Edward Meneeley (b. Wilkes-Barre, Pennsylvania, 1927)

First solo show: Donovan Gallery, Philadelphia, 1952. Founded
Portable Gallery Press (archive of American painting), 1959; and ESM
Documentations, New York, 1966. Electrostatic prints for Teuscher
Editions, New York shown at ICA and V&A in *Three Americans: Ed
Meneeley, Don Judd, Bob Graham*, 1971. Further London exhibitions:
Grabowski Gallery, 1972; Whitechapel Art Gallery, 1973.
Retrospective at Frank Marino Gallery, New York, 1978. Completed
Storms Never Last, paintings and multimedia collages, 1999.

659 Louina's Dream, 1973
Screenprint, seven colours, printed in three greens, yellow,
magenta, orange, buff on R. B. Burt mould-made HP 246 lb and
Velin Arches paper
Image: 958 × 660 mm (37 $\frac{3}{4}$ × 26 in), paper: 1035 × 740 mm
(40 $\frac{3}{4}$ × 29 $\frac{1}{8}$ in)
Insc bl: *9/150*, br: *Ed Meneeley 73* (pencil)
Edition: 150, 25 ap
Pr: Leslie Hosgood and Robert Jones, Megara Screenprinting
Ltd, Alecto Studios, London; pub: EACC, 1973 (ea 828)
Lit: *Alecto Monographs 5* (ill.)
Coll: Tate

'A print show entitled *Three Americans* was staged in the only
space in the Victoria and Albert Museum where living artists
were being shown It was not hard for Joe Studholme to find
me Most of the artists of the 1960s made a work on paper,
then had it photo-separated by colour I had no maquette.
The design for each colour was created by hand on the screen.
We proofed each screen (colour) one at a time I owned a
copy of a medical book used to test colour blindness. My goal
was to create a colour experience internally, within the viewer's
inner being. All the colour dots would conspire to reveal a colour
that was *not* printed but experienced' (EM, 19/12/2000)

The title honours the memory of the artist's mother, Louina Halter, who died in 1934 when he was seven.

Lil Michaelis (b.Nice, 1911–87)

Largely self-taught and brought up in French aristocratic family, Lil Lobuf gave up painting after Second World War to support her husband Cecil Michaelis as a painter. Career relaunched when Roland Penrose introduced her to Atelier 17, where she studied late 1960–4. Based in Paris, she successfully exhibited her etchings and collages in Italy, London, USA and Europe. The artist George Ball, and master printers Raymond Haasen and George Leblanc, proofed and editioned much of her later work.

PERSONNAGES, 1964–5

Series of twelve colour etchings, each printed simultaneously in three colours on single zinc plate using combination of hard and soft rollers. Printed on Arches paper, and presented in black cloth-covered portfolio titled: *Lil Michaelis/Personnages* with colophon details on inside lid
Plate: 260 × 200 mm (10 $\frac{1}{4}$ × 7 $\frac{7}{8}$ in), paper: 567 × 380 mm (22 $\frac{5}{16}$ × 14 $\frac{15}{16}$ in), box: 590 × 400 mm (23 $\frac{1}{4}$ × 15 $\frac{3}{4}$ in)
Insc bl: with edition numbered and signed br: *Lil Michaelis* (pencil), vo: ℮a stamp and publication number
Edition: 50 (1–10 as a portfolio), 10 ap (insc: *Ep d'artiste*)
Proofed: The artist, with George Ball, in Paris studio at Rue de la Huchette over a two year period
Pr: Raymond Haasen, Rue Vandrezanne studio near Place d'Italie, Paris; pub: 1966 (℮a 338–49)
Coll: Bibliothèque Nationale, Paris; BMAG

660 I (Yellow Green)
Etching, soft-ground and aquatint, deeply etched, printed in cadmium yellow, red with black, rolled in emerald green
Plate: 267 × 209 mm (10 $\frac{1}{2}$ × 8 $\frac{1}{4}$ in) (℮a 338)

Lil Michaelis met Paul Cornwall-Jones through her stepson Dominique, who had also studied architecture at Cambridge. *Personnages* was commissioned after seeing some of her recent etchings, including *Encore plus rose 2*. The final editioned images were intended to be untitled, Michaelis preferring to see the figurative relations without any kind of order or sequence.

661 II (Blue)
Etching, soft-ground with aquatint, deeply bitten, printed in blue, rolled in black and violet
Plate: 247 × 199 mm (9 $\frac{3}{4}$ × 7 $\frac{7}{8}$ in) (℮a 339)

'She achieved a great effect with a few colours. There is no formula or repetition, instead colour differs from plate to plate which is much more interesting.' (George Ball, 26/1/2000 and for following quote)

662 III (Yellow)
Etching, soft-ground with aquatint, deeply bitten, printed in cadmium yellow, rolled in turquoise with transparent white and black
Plate: 264 × 207 mm (10 $\frac{3}{8}$ × 8 $\frac{1}{8}$ in) (℮a 340)

'This is not a gratuitous display of yellow. Instead she aimed to achieve maximum emotional intensity through an optical layering of colour.'

663 IV (Red)
Etching, soft-ground with aquatint, deeply bitten, printed in red, rolled in transparent yellow and turquoise
Plate: 266 × 208 mm (10 $\frac{1}{2}$ × 8 $\frac{3}{16}$ in) (℮a 341)

664 V (Pink and Blue)
Etching, soft-ground with aquatint, deeply bitten and scraped, printed in Monaco blue and black, rolled in transparent yellow and turquoise blue
Plate: 247 × 198 mm (9 $\frac{3}{4}$ × 7 $\frac{13}{16}$ in) (℮a 342)

665 VI (Yellow and Blue)
Etching, soft-ground with aquatint, deeply bitten, printed in cadmium yellow, rolled in blue and black with transparent white
Plate: 267 × 208 mm (10 $\frac{1}{2}$ × 8 $\frac{3}{16}$ in) (℮a 343)

666 VII (Red and Green)
Etching, soft-ground with aquatint, deeply bitten, printed in red, rolled in transparent yellow and green
Plate: 246 × 198 mm (9 $\frac{11}{16}$ × 7 $\frac{13}{16}$ in) (℮a 344)
Coll: South London Gallery

667 VIII (Turquoise)
Etching, soft-ground with aquatint, deeply bitten, printed in turquoise, rolled in emerald green and black
Plate: 268 × 209 mm (10 $\frac{9}{16}$ × 8 $\frac{1}{4}$ in) (℮a 345)
Coll: South London Gallery

668 IX (Red and Turquoise)
Etching, soft-ground with aquatint, deeply bitten, printed in red, rolled in red and turquoise
Plate: 268 × 209 mm (10 $\frac{9}{16}$ × 8 $\frac{1}{4}$ in) (℮a 346)

669 X (Pink and Ochre)
Etching, soft-ground with aquatint, deeply bitten, printed in blue, rolled in red and yellow orange
Plate: 248 × 198 mm (9 $\frac{3}{4}$ × 7 $\frac{13}{16}$ in) (℮a 347)

670 XI (Red and Yellow) (Page 48)
Etching, soft-ground with aquatint, deeply bitten, printed in Indian yellow, rolled in violet blue and red with transparent white
Plate: 263 × 206 mm (10 $\frac{3}{8}$ × 8 $\frac{1}{8}$ in) (℮a 348)

671 XII (Blue and Black-Yellow) (Page 49)
Etching, soft-ground with aquatint, deeply bitten, printed in blue, rolled in black and transparent yellow
Plate: 267 × 207 mm (10 ½ × 8 ³⁄₁₆ in) (ea 349)

Michael Michaeledes (b.Cairo, 1927)

Studied art and architecture, Milan and London. First solo exhibition: Leicester Galleries, London, 1959. Met Annely Juda, 1962, who became principal dealer. Canvas reliefs exhibited at Hamilton Galleries, London, 1966. Mylar mirrors and paperworks exhibited at Galleria Il Giorno, Milan, 1969. Represented Greece at Venice Biennale, 1976. Regular exhibitions in London and Italy including: Ettlingen (Germany); Strasbourg, France; and Flowers East, Los Angeles, 2000.

672 Silver Reflections, 1971 (Page 217)
Mylar (metalised plastic sheet), cut, scored and folded, in clear acrylic box frame with wooden backboard
350 × 350 × 65 mm (13 ¾ × 13 ¾ × 2 ⁹⁄₁₆ in)
Insc vo: *Michael Anthony Michaeledes/ London 1971 – Bassorilievo in Plastica*
Edition: 250, signed and numbered
Produced by the artist at home/studio in Hampstead, London; framed by John Jones, London
Pub: AI, 1971
Lit: *A Decade of Printmaking*, p.95 (ill.)

Michaeledes had already used paper to work between the two- and three-dimensional, when he discovered Mylar, thin sheets of metalised plastic with the reflective qualities of a mirror, at the *Paperchase* shop in Tottenham Court Road, London around 1968.

'There are three parts to the box: perspex, a base of hardboard, and a semi-hardwood frame on which the perspex box was screwed sideways. The first task was to cover the base with Mylar, and secure it with semi-hardwood beading. I made the whole edition myself, cutting and scoring with a surgical knife and then folding backwards and forwards A material similar to Mylar was used to seal the gap between the perspex box and the base of the work. The process was meticulous and each piece took some six hours to complete.' (MM, 15/4/2000)

Keith Milow (b.London, 1945)

Camberwell School of Art, 1962–7 and RCA, 1967–8. Awarded Gregory Fellowship, University of Leeds, 1970–2. First solo exhibition: Nigel Greenwood Inc, London, 1970, who continued to show Milow throughout 1970s and 1980s. First print series *PR1NT A–PR6NT A*, 1969. Included in: *Art as Thought Process*, Serpentine Gallery, London, 1974. Moved to New York, 1980. Continues to exhibit painting and sculpture in USA, London and Europe.

673 Recollection, 1972 (Page 222)
Lithograph, tusche and crayon, six printings from three zinc plates (each plate printed twice in split fount or blended inking), printed in orange to white, white to blue and red to white on J. Green mould-made 240 lb paper
Image: 475 × 480 mm (18 ¾ × 18 ⅞ in)
Insc bl: *Recollection 42/75*, br: *Keith Milow 72* (pencil)
Edition: 75, 15 proofs
Pr: Bud Shark, Alecto Studios, London; pub: AI, 1972
Coll: Walker Art Gallery, Liverpool (National Museums and Galleries on Merseyside)

This single print is related to the painting series, *Interference*, produced at the same time. It was not considered particularly successful by the artist.

HUE NEG MIX SUITE, 1972
Proof series of (at least) three lithographs; based upon lithographic marks transferred photographically to two photo-sensitised aluminium plates, with blending in green, white and red inks on J. Green mould-made paper
Insc b: in pencil with proof number, signature and date; embossed chop of Bud Shark and *HUE/NEG/MIX* stamp; distributed but not finally editioned
Pr: Bud Shark, Alecto Studios, London, 1972
Edition: 10 ap, pp, plus proofs
Lit: *A Decade of Printmaking*, p.100

The title refers to 'my preoccupation at the time with process and the comparison between the printed mark and the painted . . . Red + Green = Black. Perhaps not the most promising premise for a print but I do however continue to be preoccupied with mixed colours, using copper & iron (red & green)' (KM, 21/9/2000)

'If you look at the prints there are two sets of three marks or bars, three thinner bars in the top grouping and three thicker bars in the lower grouping. The first plate had the top and bottom bar on both sets printed in a green to white blend. The second plate had the middle and bottom bar in both sets linked to a red to white blend. Thus the bottom bar and left side blocks in both sections become black to white when the green and red inks mix from the overprinting, and so the title: Hue = green, Neg = red, Mix = black.' (Bud Shark, 8/5/2002)

674 O
Lithograph, photo, printed in green to white and red to white blend
Image and paper: 484 × 484 mm (19 ¹⁄₁₆ × 19 ¹⁄₁₆ in)

675 6
Lithograph, photo, printed in green to white and red to white blend
Image and paper: 480 × 482 mm (18 ⅞ × 19 in)

676 63
Lithograph, photo, printed in green to white and red to white blend
Image and paper: 484 × 483 mm (19$\frac{1}{16}$ × 19 in)

Claes Oldenburg (b.Stockholm, 1929)

Yale University, 1946–50. New York in 1956, with first solo show at Judson Gallery showing figurative drawings and papier mâché sculptures, 1969. Exhibited the sculptural environment *The Street* at same gallery, 1960, also staging his first Happening. Large-scale soft sculptures, 1960s; and drawings and collages of imaginary outdoor projects, such as *Lipsticks in Piccadilly Circus, London*, 1966. Experiments with prints and multiples. Public commissions from early 1970s.

Lit: *Claes Oldenburg Multiples in Retrospect 1964–1990*, Rizzoli International Publications, New York, 1991

677 London Knees, 1966–8 (Page 121)
Cast Latex painted with coloured polyurethane, cast acrylic stand; presented in a cloth-covered travelling case with three folders containing: postcards, drawings and photos concerning the knees as a Colossal London Monument to be erected on Victoria Embankment, with two other related drawings of fag ends.
Insc on envelope in folder: edition number and signature *Oldenburg* (pencil); rubber stamped on bottom of knees: *CO 66*; three postcards: ea *537* (printed)
Knees: 381 × 152 × 140 mm (15 × 6 × 5$\frac{1}{2}$ in); stand: 250 × 406 × 267 mm (9$\frac{7}{8}$ × 16 × 10$\frac{1}{2}$ in); prints: 406 × 267 mm (16 × 10$\frac{1}{2}$); case (closed): 292 × 432 × 191 mm (11$\frac{1}{2}$ × 17 × 7$\frac{1}{2}$ in)
Pr: Lautrec Litho Ltd, Leeds and Editions Alecto Ltd, Alecto Studios, London
Knees cast: Models Ltd, London
Knees coating: Hadfields Radiation Research Ltd, Surrey (and contained in wool felt bags)
Acrylic base: J. Watson and Co. Ltd, London
Case: F. & J. Randall Ltd, London
Edition: 120, 10 ap
Pub: Editions Alecto Ltd in association with Neuendorf Verlag, Hamburg, June 1968 (ea 537)
Coll: ACE; MOMA

Chris Orr (b.Islington, London, 1943)

Beckenham (later Ravensbourne) College of Art, Hornsey College of Art, and RCA, 1964–7. First solo show: Gorner & Millard Gallery, London, 1969; and Serpentine Gallery, 1971. *The Complete Chris Orr* touring exhibition opened: Whitechapel Art Gallery, London, 1976. Regularly exhibits with Jill George Gallery, London. Elected RA in 1995 and Professor of Printmaking, RCA, 1998.

678 A Cornish Lugger Sets Sail, 1979
Lithograph, crayon, printed in black with additional hand-coloured touches of green, red and ochre watercolour on Arches crème paper
Image: 464 × 745 mm (18$\frac{1}{4}$ × 29$\frac{5}{16}$ in), paper: 755 × 1056 mm (29$\frac{3}{4}$ × 41$\frac{9}{16}$ in)
Insc bl: *25/35*, bl corner: *DE* embossed, bc: *A Cornish Lugger Sets Sail*, br: *Chris Orr 1979* (green crayon), br corner: ea embossed
Edition: 35, proofs
Pr: The artist, Dog's Ear Studio, Wapping, London, with assistance of Nick Hunter; pub: December 1979 (ea 982)

This crowded scene of a Cornish fishing village shows 'two dozen carefully characterised residents and trippers of all ages and in various stages of dress or undress The destination of the Cornish lugger is left to our imagination: so are the intentions of the lightly clad lady with a bow, a sort of aspirant Cornish cupid, whose arrow can be discovered tucked casually under the arm of a gentleman on the other side of the picture.

Meanwhile indoors, using the artist's licence both to evoke the external architecture and at the same time to penetrate behind walls to the parts which the camera cannot reach, Chris Orr's x-ray vision discloses bedroom scenes which range from realism to melodrama and from farce to tragedy' (Mark Glazebrook, *Prospectus*, 1979)

David Jowett Greaves Oxtoby (b.Horsforth, Yorkshire, 1938)

Junior and then Graphics Department, Bradford College of Art, 1950–7. Manual labourer, commercial artist and various painting jobs, 1957–60. Studied painting at Royal Academy Schools, 1960–4. First solo show: Gallery One, London, 1963. Visiting Professor of Painting, Minneapolis Institute of Arts, 1964–5. Taught painting at Maidstone College of Art, 1966–72. Stopped teaching to concentrate on painting. Continues to exhibit in solo and group shows throughout UK and abroad.

Exh: *Oxtoby's Rockers*, Editions Alecto Gallery, Kelso Place, 14 April–26 May 1977 with tour, including Redfern Gallery, London, in 1978

Lit: *Oxtoby's Rockers*, Oxford, Phaidon Press, 1978.

679 Elvis Presley 1956 'The Boy King', 1977 (Page 255)
Etching and aquatint, copperplate, printed in prussian blue and reddy brown on Arches crème paper
Plate: 688 × 542 mm (27$\frac{1}{16}$ × 21$\frac{3}{16}$ in), paper: 870 × 670 mm (34$\frac{1}{4}$ × 26$\frac{3}{8}$ in)
Insc bl: *25/77*, br: *David J G Oxtoby 1977* (pencil), vo: stamped ea *932*
Edition: 75, 5–8 ap
Pr: Tisiphone Etching Ltd, Alecto Studios, London; pub: 1977 (ea 932)

'*The Boy King* was created under bitterly cold conditions in the vast print studio of Editions Alecto. I had drawn up the plate and wanted to produce an uneven bite on the aquatint, an effect that is notoriously difficult to control even though it can happen easily when unwanted.

All doors and windows were open to the freezing elements in what proved a futile effort to dispel noxious fumes from the acid. Not suprisingly I remained alone for the entire duration of this process, cocooned in layers of thick clothing topped by fur hat, scarf and fur coat, hunched over my fuming bath of undiluted acid, peering at the submerged copperplate and continuously stroking it with a feather to achieve the desired effect.' (DO, 27/1/2000)

680 Elvis Presley 1976 'The King', 1977

Etching and aquatint, copperplate, printed in prussian blue and light cadmium red on Arches blanc paper
Plate: 690 × 544 mm (27 $\frac{3}{16}$ × 21 $\frac{7}{16}$ in), paper: 898 × 681 mm (35 $\frac{3}{8}$ × 26 $\frac{13}{16}$ in)
Insc bl: *64/75*, bc: *'The King'*, br: *David J G Oxtoby 1977* (pencil), vo: stamped *ea 933*
Edition: 75, 5–8 ap
Pr: Tisiphone Etching Ltd, Alecto Studios, London; pub: 1977 (*ea* 933)

These two etchings of Elvis were based upon a double aquatec-on-canvas painting, later burnt when exhibited in Copenhagen. Together they present 'two faces of Elvis as the wriggling rockabilly singer versus the smooth performer he became at the time of his death.' (Pat Gilmour, *Arts Review*, 28/9/1978)

681 Dylan, 1977

Etching and aquatint, copperplate, printed in brown and black on Arches blanc paper
Plate: 402 × 465 mm (15 $\frac{13}{16}$ × 18 $\frac{5}{16}$ in), paper: 620 × 674 mm (24 $\frac{3}{8}$ × 26 $\frac{9}{16}$ in)
Insc bl: *28/50*, bc: *Dylan*, br: *David J G Oxtoby 1977* (pencil) and *ea* embossed, vo: stamped *ea 984*
Edition: 50, approx. 5 ap
Pr: Tisiphone Etching Ltd, Alecto Studios, London; pub: 1977 (*ea* 934)

682 Rock Block, 1977

Etching and aquatint, two copperplates, sixteen images, twenty-seven colours, on Arches blanc paper
Individual plates: 155 × 124 mm (6 $\frac{1}{8}$ × 4 $\frac{15}{16}$ in), overall plate: 690 × 540 mm (27 $\frac{3}{16}$ × 21 $\frac{1}{4}$ in), paper: 1017 × 695 mm (40 $\frac{1}{16}$ × 27 $\frac{3}{8}$ in)
Insc bl: *11/25*, bc: *'Rock Block'*, br: *David J G Oxtoby 1977* (pencil)
Edition: 25, approx. 5 ap
Pr: Tisiphone Etching Ltd, Alecto Studios, London; pub: 1977 (*ea* 935)
Lit: *Oxtoby's Rockers*, Phaidon Press, 1978 (ill.)

Coll: Potteries Museum and Art Gallery, Stoke-on-Trent; British Museum; Glasgow Museums

This composite of some of the most celebrated figures of early rock, runs top, left to right: Gene Vincent, Elvis Presley, Roy Orbison, Eddie Cochran, Chuck Berry, Little Richard, Jape Richardson (Big Bopper), Antoine 'Fats' Domino, Buddy Holly, William Haley, Willie Mae Thornton (Big Mamma Thornton), Chester Burton Atkins, Carl Perkins, Bo Diddley, Richard Venezuela (Ricky Valence) and Jerry Lee Lewis.

DYLAN BOOK, 1977

Suite of twelve colour etchings, single copperplate, on Arches blanc paper
Plate: 251 × 200 mm (9 $\frac{7}{8}$ × 7 $\frac{7}{8}$ in), paper: 430 × 358 mm (16 $\frac{15}{16}$ × 14 $\frac{1}{8}$ in), bound version: 479 × 375 mm (18 $\frac{7}{8}$ × 14 $\frac{3}{4}$ in)
Edition: 10 ap, numbered, titled, and signed *David J G Oxtoby 77*.
Single bound dummy copy in brown leather goat skin inscribed *Dylan* on the spine, with title page and accompanying extracts from the song titles intended to be printed opposite the etchings; one set of uncoloured proofs with artist
Pr: Tisiphone Etching Ltd, Alecto Studios, London; pub: 1977 (*ea* 936–47)
Lit: *Oxtoby's Rockers*, Phaidon Press, 1978, p.64 (ill.)

683 Title Page (Minnesota State of 1000 Lakes) (1)

Etching, printed in dark blue
Insc on plate: *Bob Zimmerman May 24th 1941* (*ea* 936)

Dummy bound book is inscribed with notes by the artist, here: 'People I know in Mpls (Minneapolis) – written backwards.'

684 Song to Woody (Woody Guthrie and Bob Dylan) (2)

Etching, with partial embossing along top *Woody Gut . . .* , printed in black
(*ea* 937)

685 It's all over now Baby Blue (3)

Etching, open bite, printed in black
(*ea* 938)

'60s type image/ all before broken neck/ off black.' (DO in dummy book and for following quotations unless stated otherwise)

686 Highway 61 Revisited (4)

Etching, printed in dark brown
(*ea* 939)
Coll: Manchester City Art Galleries

'Based upon a Highway 61 sign I saw in Decalb, Minnesota.' (DO, 3/9/1999)
'Little more light? With touch more black (buff down).'

687 Blonde on Blonde (5)
Etching, printed in green grey
(ea 940)

'Dylan was staying at the Chelsea Hotel at the time he was working on the album *Blonde on Blonde*.' (DO, 3/9/1999)

688 July 1966 (6)
Etching, with blind embossing
(ea 941)

'The date when Dylan broke his neck in a motor bike accident. I wanted this print to look like a tomb stone.' (DO, 3/9/1999)

689 January 1968 (7)
Etching, printed in dark brown
Insc: *John Wesley Hardin/ killed August 19th/ 1895* (ea 942)

690 Nashville Skyline (8)
Etching, printed in apple green
(ea 943)

'The sunglasses reflect the Nashville skyline taken from the back of the *Nashville* album. Coincidentally there is a cross in there somewhere.'

691 Wigwam (9)
Etching, printed in purple
(ea 944)

The title comes from a number where Dylan just hums. 'John Wesley Hardin was shot after throwing four sixes in a saloon called Wigwam by old John Selman.'

692 Billy (10)
Etching, open bite, printed in dark brown
(ea 945)

The title refers to the *Billy the Kid* album. 'Antique brown. My motor cycle boots.'

693 Isis (11)
Etching, printed in bitter green
(ea 946)

'The Madonna-like statue is taken from the *Desire* album where there is an image of the Empress *Isis* on the back Dylan himself looks very tortured.' (DO, 3/9/1999)

694 Rolling Thunder (12)
Etching and aquatint, printed in dark blue
(ea 947)
The *Rolling Thunder Review* was a big tour marked by Dylan's reworkings of earlier songs. 'Clouds rotating. Dylan looking back into the past – in the same way as he rethinks his earlier records on *Hard Rain* (start again).'

695 August 16th (Presley), 1978
Lithograph, zinc, tusche and crayon, printed in brown on buff cartridge paper
Image: 159 × 130 mm (6 $\frac{1}{4}$ × 5 $\frac{1}{8}$ in), paper: 200 × 170 mm (7 $\frac{7}{8}$ × 6 $\frac{11}{16}$ in)
Insc on image: *Elvis/August 16th*
Edition: 6000
Pr: Alecto Studios, London; pub: Editions Alecto Ltd for *Arts Review*, 28 September 1978, where inserted as special give-away (ea 972)

Three colour lithographs of *Elvis, Jagger* and *Dylan* were also printed at Alecto Studios in 1978 for St James's House Collection in a worldwide edition of 750. This was finally realised as an edition of 200 following the ea fire.

Eduardo Paolozzi (*b.*Edinburgh, 1924)

Edinburgh College of Art, St Martin's and Slade Schools of Art, 1944–7. Paris, 1947–9. First exhibition: Mayor Gallery, 1947. Lithographs and screenprint experiments date from early 1950s. Created 'basic living unit' with Nigel Henderson and Peter and Alison Smithson for *This is Tomorrow*, Whitechapel Art Gallery, 1956. Collaborated with Chris Prater and Kelpra Studio, London from 1962. Elaborate screen-collage projects, 1964–70. Visiting Lecturer at University of California, Berkeley, 1968, when also began to teach ceramics at RCA. Tate Gallery Retrospective, 1971. *Lost Magic Kingdoms and Six Paper Mooons*, 1985.

Lit: Rosemary Miles, *The Complete Prints of Eduardo Paolozzi: prints drawings collages 1944–77*, V&A, London, 1977; Winfried Konnertz, *Eduardo Paolozzi*, Cologne, Dumont Verlag, 1984

696 Tafcl 16, 1964
Screenprint, hand and photo-stencils, printed in combinations of black, yellow, green, blue, red on Esparto Cartridge paper
Overall image size: 660 × 271 mm (26 × 10 $\frac{11}{16}$ in), paper: 843 × 584 mm (33 $\frac{3}{16}$ × 23 in, variable)
Insc on image: *Tafel 16*, bl: *50/80*, bc: *colour combination in pairs*, br: *Eduardo Paolozzi* (pencil)
Edition: 80, 15 ap; divided into pairs, each pair printed in a different colourway
Pr: Kelpra Studio, London; pub: 1964 (ea 17)
Coll: British Council; Tate; National Gallery of Australia, Canberra

AS IS WHEN, 1964–5
Portfolio of twelve screenprints, hand and photo-stencils, screen, presented in burgundy cloth-covered portfolio box with silver-screened collage of Laocöon and Minnie Mouse (988 × 685 mm, 38 $\frac{13}{16}$ × 27 in), designed by Eric Ayers. Contents: poster/title page, colophon, page of text entitled *Wild Track for Ludwig/ The Kakafon Kakkoon Laka con Elektrik Lafs*; printed on 133 lb HP J. Green paper

Insc b: with edition number, signature and date (in pencil; some variation in placement), and *ea* embossed
Edition: 65, 12 ap
Pr: Kelpra Studio, London, 1964–5; pub: 1965 (*ea* 18–29)
Coll: Tate; New Orleans Museum of Art; National Museum and Gallery of Wales, Cardiff; National Gallery of Australia, Canberra; MOMA, V&A, BMAG

'Eduardo Paolozzi assembles collages specifically to provide the first statement from which stencils are developed by a combination of photography and manual separation; he controls all aspects of the work as handled physically by the Master Printer. The image is built up by multiple/printings through a colour chart, the final statement in each case/ varying according to the programme of colour selection. This is possible/ only by the use of precision techniques and photo-mechanical aids' (colophon sheet)

697 Artifical Sun
Colour screenprint, hand-cut and photo-stencil
Image: 721 × 558 mm (28 $\frac{3}{8}$ × 22 in), paper: 960 × 656 mm (37 $\frac{13}{16}$ × 25 $\frac{13}{16}$ in)
Insc br on print: *artifical sun/ 13 May 1964*, bl: *34/65*, br: *Eduardo Paolozzi 1965* (pencil), b on print: *The world is all that is the case Tractatus Logico – Philosophicus Ludwig Wittgenstein* (*ea* 18)

698 Tortured Life (Page 38)
Colour screenprint, hand-cut and photo-stencil, English text
Image: 785 × 565 mm (30 $\frac{7}{8}$ × 22 $\frac{1}{4}$ in), paper: 958 × 657 mm (37 $\frac{3}{4}$ × 25 $\frac{7}{8}$ in)
Insc bl: *34/65*, br: *Eduardo Paolozzi 1965* (pencil), *June 1964* (printed), bl printed: *The tortured life of an influential modern philosopher: the late Ludwig Wittgenstein* (*ea* 19)
Coll: Manchester City Art Galleries

699 Experience (Page 39)
Colour screenprint, hand-cut and photo-stencil, German and English text
Image: 685 × 487 mm (25 $\frac{15}{16}$ × 19 $\frac{3}{16}$ in), paper: 959 × 657 mm (37 $\frac{3}{4}$ × 25 $\frac{7}{8}$ in)
Insc lr: *Wittgenstein/ Notebooks/ 1914–1916/ July 1964* (printed), bl: *34/65*, br: *Eduardo Paolozzi 1965* (pencil), b printed: *Is belief a kind of experience? Is thought a kind of experience? All experience is world and does not need the subject. The act of will is not an experience* (*ea* 20)
Coll: British Museum

700 Reality
Colour screenprint, hand-cut and photo-stencil, German and English text
Image: 700 × 507 mm (27 $\frac{9}{16}$ × 20 in), paper: 962 × 660 mm (37 $\frac{7}{8}$ × 26 in)
Insc bl: *34/65*, br: *Eduardo Paolozzi 1965* (pencil), *July 1964*

(printed), b printed: *The sum total of reality is the world A picture is a model of reality* (*ea* 21)
Coll: British Museum; Museum of Fine Arts, Boston

701 Wittgenstein the Soldier
Colour screenprint, hand-cut and photo-stencil, English text
Image: 773 × 553 mm (30 $\frac{7}{16}$ × 21 $\frac{13}{16}$ in), paper: 961 × 655 mm (37 $\frac{7}{8}$ × 25 $\frac{13}{16}$ in)
Insc tr: *at the outbreak of the war, Wittgenstein entered the Austrian/ army as a volunteer, although he had been exempted . . .* (printed), bl: *34/65*, br: *Eduardo Paolozzi 1965* (pencil) and *August 1964* (printed) (*ea* 22)
Coll: Manchester City Art Galleries; Museum of Fine Arts, Boston

702 Wittgenstein in New York (Page 38)
Colour screenprint, hand-cut and photo-stencil, English text
Image: 762 × 547 mm (30 × 21 $\frac{9}{16}$ in), paper: 964 × 656 mm (37 $\frac{15}{16}$ × 25 $\frac{13}{16}$ in)
Insc mr: *I went to New York/ to meet Wittgenstein/ at the ship. When I/ first saw him I was/ surprised at his/ apparent physical/ vigour. He was/ striding down the/ ramp with a pack/ on his back, a/ heavy suitcase in one/ hand, cane in the/ other* (printed); lr: *August 1964* (printed), bl: *34/65*, br: *Eduardo Paolozzi 1965* (pencil) (*ea* 23)
Coll: Whitworth Art Gallery, University of Manchester

703 Parrot
Colour screenprint, hand-cut and photo-stencil, English text
Image: 768 × 548 mm (30 $\frac{1}{4}$ × 21 $\frac{9}{16}$ in), paper: 958 × 656 mm (37 $\frac{3}{4}$ × 25 $\frac{13}{16}$ in)
Insc tr: *What I give is the morphology of the use of an expression . . . what I do is suggest, or even invent, other ways of looking at it . . .* ; tl: *November 1964* (printed), bl: *34/65*, br: *Eduardo Paolozzi 1965* (pencil) (*ea* 24)
Coll: SNGMA

704 Futurism at Lenabo
Colour screenprint, hand-cut and photo-stencil, English text
Image: 688 × 547 mm (27 $\frac{1}{8}$ × 21 $\frac{9}{16}$ in), paper: 959 × 656 mm (37 $\frac{3}{4}$ × 25 $\frac{13}{16}$ in)
Insc tr: *It is worth noting that Wittgenstein once said that a serious and good philosophical work could be written that would consist entirely of jokes (without being facetious) . . .* (printed); bl: *"Futurism" at Lenabo*, br: *November/ 1964* (printed), bl: *34/65*, br: *Eduardo Paolozzi 1965* (pencil) (*ea* 25)

705 Assembling Reminders for a Particular Purpose
Colour screenprint, hand-cut stencil, English and German text
Image: 822 × 509 mm (32 $\frac{3}{8}$ × 20 $\frac{1}{16}$ in), paper: 956 × 660 mm (37 $\frac{5}{8}$ × 26 in)
Insc tl: *Philosophical Investigations*, bl: *Ludwig Wittgenstein/ Philosophy simply puts everything before us, and neither explains nor deduces anything . . .* (printed) and *34/65* (pencil),

br: *Eduardo Paolozzi 1965* (pencil), *January 1965* (printed)
(ℯℯ 26)

706 The Spirit of the Snake
Screenprint, hand-cut and photo-stencil, English and German
text around border
Image: 765 × 510 mm (30 $\frac{1}{8}$ × 20 $\frac{1}{16}$ in), paper: 960 × 657 mm
(37 $\frac{13}{16}$ × 25 $\frac{7}{8}$ in)
Insc bl: *34/65*, br: *Eduardo Paolozzi 1965* (pencil), b: *But the
question arises whether even here, my body is not on the same
level with that of the wasp and of the snake (and surely it is
so). . .* (printed) (ℯℯ 27)

Throughout this edition, Paolozzi alters where he signs and dates
this image.

707 He Must, So to Speak, Throw away the Ladder, (Page 40)
Screenprint, hand-cut stencil, German and English text around
border
Image: 782 × 512 mm (30 $\frac{13}{16}$ × 20 $\frac{3}{16}$ in), paper: 962 × 657 mm
(37 $\frac{7}{8}$ × 25 $\frac{7}{8}$ in)
Insc left margin: *My propositions serve as elucidations in the
following way What we cannot speak about we must pass
over in silence February 1965* (printed), bl: *34/65*, br: *Eduardo
Paolozzi 1965* (pencil) (ℯℯ 28)

'The origin of this background is somewhat uncertain. It could be
a single photographic process or, more likely, achieved by
collaging two grids together.' (Douglas Corker, 3/8/2002)

708 Wittgenstein at the Cinema Admires Betty Grable
Screenprint, hand-cut and photo-stencil, English text
Image: 830 × 503 mm (32 $\frac{11}{16}$ × 19 $\frac{13}{16}$ in), paper: 962 × 657 mm
(37 $\frac{7}{8}$ × 25 $\frac{7}{8}$ in)
Insc b: *Wittgenstein was always exhausted by his lectures. He
was/ also revolted by them. He felt disgusted with what he had
said/ and with himself. Often he would rush off to a cinema
imme-/ diately after the class ended . . .* (printed); bl: *34/65*
(pencil), br: *March 65* (printed) and *Eduardo Paolozzi 1965*
(pencil) (ℯℯ 29)
Coll: British Museum

The Kelpra Studio entry books in Tate Archives record that *As is
When* was printed in the following sequence: Print 1–4 (invoiced
20/8/1964), Print 5–6 (invoiced 19/10/1964), Print 7–8
(invoiced 30/11/1964), Print 9 (invoiced 31/1/1965), Print
10–11 (invoiced 27/2/1965) and Print 12 (invoiced 31/3/1965).

In 1976 interview with Pat Gilmour, Chris Prater refers to five or
six colours being used in each image, and Paolozzi's liking at the
time of 'Woolworth's colours – really bright, brilliant.' *Artifical
Sun* was the first in the suite, which was cut up on the guillotine,
elements then being re-collaged into *Tortured Life* and
Experience. *Wittgenstein The Soldier* in turn drew from *Tortured
Life*; 'Eduardo had lots and lots of bromides done of these
patterns, which he collaged, then had photographed again, and

then re-cut them up. So it is a self-perpetuating thing'
(Research Centre, Tate, 51AB)

709 Poster/Title Page, 1965 (Page 80)
Screenprint, printed in pink, red, green, blue and yellow on J.
Green 133 lb paper
Image: 830 × 508 mm (32 $\frac{11}{16}$ × 20 in), paper: 962 × 659 mm
(37 $\frac{7}{8}$ × 25 $\frac{15}{16}$ in)
Insc in stencilled lettering: *As is When/ A series of screenprints
based on the life and writings of Ludwig Wittgenstein/ Eduardo
Paolozzi/ Editions Alecto London May 1965*, br: *Eduardo
Paolozzi 1965* (some, pencil/pen) and ℯℯ embossed
Typography: Eric Ayers; pr: Kelpra Studio, London, 1965
Edition: 190

This design for the portfolio edition was printed as an additional
poster of 140 for the 1965 Print Centre exhibition, with text:
Eduardo Paolozzi/ Editions Alecto London May 1965 (image
and paper: 772 × 510 mm, 30 $\frac{3}{8}$ × 20 $\frac{1}{16}$ in).
 Laocoön and Minnie Mouse on the cover of the porfolio box of
As is When was also printed as a black and white poster
(803 × 573 mm, 31 $\frac{5}{8}$ × 22 $\frac{9}{16}$ in).

MOONSTRIPS EMPIRE NEWS, 1967 (Page 120)
Portfolio of ninety-two screenprints with photo-screen, in
different combinations of text, pattern and imagery with title
page, colophon sheet and introductory text by Christopher
Finch; plus eight sheets insc: *Eduardo Paolozzi* with edition
number (pencil) with vo: stamped title, ℯℯ and publication
number and *K* of Kelpra Studio. Printed on various papers: All
British Cartridge, clear Acetate, Fibrex Flexicover, Kendal and
Soho coverboards, Astralux cast coated boards, Centurion,
Ferndown, and presented in coloured perspex box fabricated by
Herault Studios; typography by Gordon House
Image and paper: 380 × 254 mm (15 × 10 in), box:
400 × 278 × 50 mm (15 $\frac{3}{4}$ × 10 $\frac{15}{16}$ × 2 in)
Edition: 500, 50 ap
Pr: Kelpra Studio, London 1967 (invoices dated
31/1/1967–26/6/1967); pub: 1967 (ℯℯ 480–7, 489)
Coll: Tate; V&A; British Council; SNGMA; ACE; Art Gallery of
Ontario, Toronto; National Gallery of Canada, Ottawa; Sheffield
Galleries and Museums Trust; The Fine Art Museums of San
Francisco; Brooklyn Museum of Art; National Gallery of Australia,
Canberra; MOMA; Fitzwilliam Museum, Cambridge

710 Memory Core Units
Screenprint, printed in cyan, magenta, yellow, black, gold, green
(ℯℯ 480)

711 The Silken World of Michelangelo
Screenprint with photo-stencil, printed in gold, black, red,
orange, pink, blue, green
(ℯℯ 481)

712 **High Life**
Screenprint, printed in black, cyan, red, yellow
(ea 482)

713 **Cover for a Journal, 1967**
Screenprint, printed in gold, yellow, magenta, cyan
(ea 483)

714 **Ernie and T. T. at St Louis Airport**
Screenprint, with photo-stencil, printed in magenta, yellow,
purple, green
(ea 484)

715 **Donald Duck meets Mondrian**
Screenprint, with photo-stencil, printed in magenta, yellow,
purple, green
(ea 485)

716 **Formica-Formikel**
Screenprint, printed in gold, black, yellow, cyan and magenta
(ea 486)

717 **Secrets of the Internal Combustion Engine**
Screenprint, with photo-screen, printed in pink, green, orange,
blue, black and red brown
(ea 487)

The following sheets are stamped vo: *ea 489* or *ea No 489*
with *K* of Kelpra Studio. Titles taken by author from text on each
image.

718 **Title Page:** *moons/ trips/ empir/ e news/ eduar/ dopao/
lozzi/* with ea

719 **Colophon**

720 **Intoductory text by Christopher Finch**

721 **Untitled (black, gold and white rectangles)**

722 **All Stand In Horus, Lion's Roar Inter/mingling . . .**

723 **Comic-book tank firing**

724 **And it is not a little curious that . . .**

725 **Untitled (Creature from The Black Lagoon)**

726 **Untitled (numbered cityscape)**

727 **Colour and Graphic**

728 **Vouse trouverez ici sans doubte que . . .**

729 **Crusifix** (sic) **in a Bottle**

730 **A singular success . . .**

731 **That was when he began to go to pieces . . .**

732 **But the advance of the human intellect . . .**

733 **Cloud Communications**

734 **Alphabetical Index for Soldiers**

735 **beach. Toby told me . . .**

736 **Personal History**

737 **Scene 22. Fade in on a close-up . . .**

738 **Untitled (spiral circle and dancing figure)**

739 **Most essential assi/stance of a little bla/ck powder . . .**

740 **Ground/ Illusion and Reality**

741 **The body as a tool for grasping reality . . .**

742 **Untitled (elongated arched form)**

743 **Isamu Noguchi supplied the model . . .**

744 **Sixteen brilliant banners . . .**

745 **Envelopes, calling cards . . .**

746 **Untitled (Cup and egg-beater)**

747 **Unser Nachbar Amerika**

748 **Untitled (Girl modelling Bra)**

749 **Ruas Do Rio de Janeiro**

750 **My Pal the Gorilla Gargantua**

751 **Almost a complete circle . . .**

752 **Object decorated . . .**

753 **Untitled (S-shape: green, black and gold)**

754 **Untitled (Minnie Mouse, girl, car and birds)**

755 **Untitled (squares within squares and circle dots)**

756 **If the limits of pure colour sensualism . . .**

810 Illumination and The Eye (Suite No 1), 1967
Screenprint, three printings, printed in green, purple with red
printed text, on D. E. Saunders Special 230 lb plain mould-made
paper
Image and paper: 1000 × 661 mm (39 $\frac{3}{8}$ × 26 in)
Insc bc: *Eduardo Paolozzi March 1967*, br: *58/75* (pencil), vo:
ℯa *No 490* stamped
Edition: 75, 11 ap
Pr: Kelpra Studio, London (invoiced 16/3/1967); pub: 1967
(ℯa 490)
Coll: British Council

811 The Theory of Relativity (Suite No 2), 1967
Screenprint, printed in red, gold, blue, black, yellow, orange, pink,
dark blue, dark red, rust red with copper text on D. E. Saunders
Special 230 lb plain mould-made paper
Image: 901 × 601 mm (35 $\frac{1}{2}$ × 23 $\frac{11}{16}$ in), paper: 1000 × 682 mm
(39 $\frac{3}{8}$ × 26 $\frac{7}{8}$ in)
Insc br: *Eduardo Paolozzi 1967* (pencil), b printed: *The Theory
of relativity, may certainly be a true description of the facts
concerned, even though a theory which took such liberties fully,
with the help of what is nothing but a host of metaphors taken
from the languages of physics, of biology, + of social life, works
out/ their categorical structure, and only recasts what has
formed concentric circles, surrounded by smaller ones of the
same shape; then again a vertical band filled with horizontal
strokes; and lastly, two vertical bands of concentric circles.*
Edition: 75, 11 ap
Pr: Kelpra Studio, London (invoiced 16/3/1967); pub: 1967
(ℯa 491)
Coll: ACE; Museum of Fine Arts, Boston; Fitzwilliam Museum,
Cambridge

812 Poster: Universal Electronic Vacuum, 1967
Colour lithograph, off-set, photo, on Foxhunter Smooth white
paper
Image and paper: 903 × 565 mm (35 $\frac{9}{16}$ × 22 $\frac{1}{4}$ in)
Printed t: *Universal Electronic Vacuum 1967/ a folio of ten
screenprints by Eduardo Paolozzi*, b: *Alecto Gallery 38
Albemarle Street London W1 November 1967*
Edition: 4000, unsigned, unnumbered and unstamped
Pr: Mansell Litho
Coll: National Museum and Gallery, Cardiff

This poster for the 1967 Alecto Gallery exhibition is not to be
confused with the different design screened for the artist by
Kelpra Studio as a signed edition of seventy-five, and included in
the *Universal Electronic Vacuum* portfolio.

GENERAL DYNAMIC F.U.N., 1965–70
(Part 2 of *Moonstrips Empire News*)
Screenprint with photo, and photo-lithography; 50 sheets plus
title sheet with colophon details, text by J. G. Ballard and list of
print titles 700–49, and technical information sheet
Image and paper: 380 × 255 mm (14 $\frac{15}{16}$ × 10 $\frac{1}{16}$ in); on various

papers: Bex propylene-clearfilm, Crawley antique board,
Kromkote cast coated board, Vantage art board, Victory
heavyweight cartridge
Each print stamped vo: facsimile of artist's signature and
portfolio title, with individual title, ℯa and publication number,
printers' chops and *1965–1970*
Pr: Richard Davis, London (lithos) and Lyndon Haywood,
Geoffrey Jones and Kevin Harris, Alecto Studios, London
(screenprints), 1970
Boxed in five versions: silver metallic and transparent acrylic,
insc: *Eduardo Paolozzi/ General Dynamic F.U.N./* ℯa (on
front side), fabricated by Protoplastics, London and
screenprinted by Alecto Studios; measuring 400 × 280 × 50 mm
(15 $\frac{3}{4}$ × 11 × 2 in, with variation)
Edition: 350, identified as volume A, B, C, D, E, and limited to 70
in each boxed volume
Pub: 1970 (ℯa 700–49)
Coll: V&A; SNGMA; Glasgow Museums; National Gallery of
Australia, Canberra; MOMA

813 Transparent creatures hunting New Victims (1)
Photo-lithograph
(ℯa 700)
Coll: Wolverhampton Museum and Art Gallery

814 Ready to Sparkle Fashions (2)
Photo-lithograph
(ℯa 701)

815 Almost any suburbs (3)
Photo-lithograph
(ℯa 702)

816 Early mental traits of 300 geniuses (4)
Photo-lithograph
(ℯa 703)

817 Calling Radio Free America (5)
Photo-lithograph
(ℯa 704)

818 Synthetic Sirens in the Pink Light District (6)
Photo-lithograph
(ℯa 705)

819 Astute sizing up perfume trends (7)
Photo-lithograph
(ℯa 706)

820 Cary Grant as a male war bride (8)
Photo-lithograph
(ℯa 707)

821 **Why children commit suicide . . . read next month's issue (9)**
Photo-lithograph
(ea 708)

822 **An Empire of Silly Statistics . . . A Fake War for Public Relations (10)**
Photo-lithograph
(ea 709)

823 **Frank Lloyd Wright says . . . Tough Times (11)**
Photo-lithograph
(ea 710)
Coll: Wolverhampton Museum and Art Gallery

824 **The Impossible Dream. It's all the same (12)**
Photo-lithograph
(ea 711)
Coll: Wolverhampton Museum and Art Gallery

825 **Becoming is Meaning like Nothing is Going (13)**
Photo-lithograph
(ea 712)

826 **Sex Crime Wave Rolling High (14)**
Screenprint
(ea 713)

827 **Inside Down Under . . . What are the building blocks of structuralism? (15)**
Photo-lithograph
(ea 714)

828 **Part One, Frozen Terror . . . Part Two, Fangs of Death (16)**
Photo-lithograph
(ea 715)
Coll: Wolverhampton Museum and Art Gallery

829 **New Semesta Reward of the Oppressed? (17)**
Photo-lithograph
(ea 716)

830 **Similar remarks apply to Uranium 235 (18)**
Photo-lithograph
(ea 717)

831 **Totems and Taboos of the Nine to Five Day (19)**
Photo-lithograph
(ea 718)

832 **Animals as Aliens (20)**
Photo-lithograph
(ea 719)

833 **Mumbling and Munching to Muzak (21)**
Photo-lithograph
(ea 720)

834 **Comparative Research in Inexperienced Types (22)**
Photo-lithograph
(ea 721)

835 **Llalla Pallooza . . . Image fades but memory lingers on (23)**
Screenprint
(ea 722)

836 **Will Man desert the Dog for the Dolphin? (24)**
Photo-lithograph
(ea 723)

837 **Decency and Decorum in Production (25)**
Photo-lithograph
(ea 724)
Coll: Wolverhampton Museum and Art Gallery

838 **The A B C of Z (26)**
Photo-lithograph
(ea 725)

839 **Cucumber Night Cream (27)**
Photo-lithograph
(ea 726)

840 **Jesus colour by numbers (28)**
Photo-lithograph
(ea 727)
Coll: Wolverhampton Museum and Art Gallery

841 **Temporary Variations in Experienced Type (29)**
Photo-lithograph
(ea 728)

842 **Hermaphroditic Children from Transvestite Parents (30)**
Photo-lithograph
(ea 729)

843 **Fifty-Nine Varieties of Paradise (31)**
Photo-lithograph
(ea 730)

844 **6 miles over vacation-land (32)**
Photo-lithograph
(ea 731)

845 **Notes on the organisation of Paradise (33)**
Photo-lithograph
(ea 732)

846 Pig or Person, it's the same, Fortune plays a funny game (34)
Photo-lithograph
(ea 733)

847 Plate interpreted as a Whole (Whole Answer) (35)
Photo-lithograph
(ea 734)

848 How to spend time in Hollywood (36)
Photo-lithograph
(ea 735)

849 Careers today . . . How children fail (37)
Screenprint
(ea 736)

850 Brainiac 5 no puede ganar contra tres maquinas (38)
Screenprint
(ea 737)

851 No Heroes Developed (39)
Screenprint
(ea 738)

852 The Puzzle of Female Pleasure (40)
Screenprint
(ea 739)

853 Risk-taking as a function of the Situation (41)
Screenprint
(ea 740)

854 More power to everybody (42)
Screenprint
(ea 741)

855 The Ritual Mainspring of the Area's Culture (43)
Screenprint
(ea 742)

856 Fortune's Guide to Government Contracts (44)
Screenprint
(ea 743)

857 A single series, consisting of twenty choices (45)
Screenprint
(ea 744)

858 The accident syndrome, the Genesis of injury (46)
Screenprint
(ea 745)

859 Smash hit, Good Loving, plus like a Rolling Stone, Slow Down etc. (47)
Screenprint
(ea 746)

860 Twenty Traumatic Twinges (48)
Screenprint
(ea 747)

861 Studies in human salvage (49)
Screenprint
(ea 748)

862 Watch out for Miracles . . . New hope for better babies (50)
Screenprint
(ea 749)

863 Poster: photo-lithograph on cartridge paper (Page 80)
Insc: *General Dynamic F.U.N./ Eduardo Paolozzi/ General Dynamic F.U.N./ Eduardo Paolozzi*
Edition: unlimited, two runs, one with introduction and catalogue listing on reverse
Image and paper: 717 × 564 mm (28 $\frac{1}{4}$ × 22 $\frac{3}{16}$ in, variation)
Coll: National Museum and Gallery, Cardiff; Research Centre, Tate

THE CONDITIONAL PROBABILITY MACHINE, 1970

Series of twenty-four photogravures, single copperplates, printed in black, on Barcham Green Royal Watercolour Society not Surface Paper 140 lb measuring 572 × 397 mm (22 $\frac{1}{2}$ × 15 $\frac{5}{8}$ in, slight variations), divided into four sections each titled and with contents page
Insc vo: stamped ea with publication number and *JC* chop of James Collyer or *J* chop of John Crossley
Presented as a box made by Multiservice Ltd of London measuring 610 × 432 × 38 mm (24 × 17 × 1 $\frac{1}{2}$ in). Edition: 24, 6 ap, 2 sets of cp; with introductory text by Diane Kirkpatrick
Proofed by James Collyer with John Crossley and Danyon Black on A. J. Craig & Sons Starwheel Press, Alecto Studios
Pr: James Collyer and John Crossley, Alecto Studios, London; pub: 1970 **(**ea 760–83**)**
Source images selected by the artist from personal archives
Coll: Tate; British Council; National Gallery of Canada, Ottawa; SNGMA; MOMA

One of the twenty-four cancellation plates is set on the cover of each box and a cancellation pull of this plate is included with the portfolio.

Group 1: Secrets of Life: The Human Machine and How it Works

864 Conception through Impression (1)
Image: 143×115 and 143×135 mm ($5\frac{5}{8} \times 4\frac{1}{2}$ and $5\frac{5}{8} \times 5\frac{5}{16}$ in), plate: 192×305 mm ($7\frac{9}{16} \times 12$ in)
Insc bl: printed title (ea 760)

865 Bird (2)
Image: 164×113 mm ($6\frac{7}{16} \times 4\frac{7}{16}$ in), plate: 202×138 mm ($7\frac{15}{16} \times 5\frac{7}{16}$ in) (ea 761)

866 Hazardous Journey (3)
Image: 94×115 mm ($3\frac{11}{16} \times 4\frac{1}{2}$ in), plate: 133×140 mm ($5\frac{1}{4} \times 5\frac{1}{2}$ in)
Insc bl: printed title (ea 762)

867 Reproduction (4)
Image: 64×114 mm ($2\frac{1}{2} \times 4\frac{1}{2}$ in), plate: 102×138 mm ($4 \times 5\frac{7}{16}$ in)
Insc bl: printed title (ea 763)

868 The Moment of Conception (5)
Image: 157×114 and 173×118 mm ($6\frac{3}{16} \times 4\frac{1}{2}$ and $6\frac{13}{16} \times 4\frac{5}{8}$ in), plate: 207×284 mm ($8\frac{1}{8} \times 11\frac{3}{16}$ in)
Insc bl: printed title (ea 764)

869 Inside the Brain (6)
Image: 168×114 mm ($6\frac{5}{8} \times 4\frac{1}{2}$ in), plate: 207×140 mm ($8\frac{1}{8} \times 5\frac{1}{2}$ in)
Insc bl: printed title (ea 765)

Group 2: From Genot to Unimate

870 Sim One (1)
Image: 139×169 mm ($5\frac{1}{2} \times 6\frac{5}{8}$ in), plate: 162×194 mm ($6\frac{3}{8} \times 7\frac{5}{8}$ in)
Insc bl: printed title (ea 778)

871 Genot (2)
Image: 114×134 mm ($4\frac{1}{2} \times 5\frac{1}{4}$ in), plate: 150×170 mm ($5\frac{7}{8} \times 6\frac{11}{16}$ in) (ea 779)

872 Untitled (Walking Machine) (3)
Image: 188×152 mm ($7\frac{3}{8} \times 6$ in), plate: 227×190 mm ($8\frac{15}{16} \times 7\frac{1}{2}$ in) (ea 780)

873 Untitled (Parade Robot) (4)
Image: 127×128 mm ($5 \times 5\frac{1}{16}$ in), plate: 152×143 mm ($6 \times 5\frac{5}{8}$ in) (ea 781)

874 Untitled (Unimate and Egg) (5)
Image: 208×161 mm ($8\frac{3}{16} \times 6\frac{5}{16}$ in), plate: 234×190 mm ($9\frac{3}{16} \times 7\frac{1}{2}$ in) (ea 782)

875 Untitled (Robot Commando and boy) (6)
Image: 51×52 mm ($2 \times 2\frac{1}{16}$ in), plate: 76×67 mm ($3 \times 2\frac{5}{8}$ in) (ea 783)

Group 3: Manikins for Destruction

876 Untitled (M. I. R. A. pair) (1)
Image: 134×163 mm each ($5\frac{1}{4} \times 6\frac{7}{16}$ in), plate: 325×200 mm ($12\frac{13}{16} \times 7\frac{7}{8}$ in) (ea 766)
Lit: *Konnertz* (352) where illustrated with Iain Macnab, *Figure Drawing*, 1946

877 Untitled (Monkey No 9) (2)
Image: 102×165 mm each ($4 \times 6\frac{1}{2}$ in), plate: 131×195 mm ($5\frac{5}{32} \times 7\frac{11}{16}$ in) (ea 767)

878 Untitled (U 14322) (3)
Image: 120×164 mm ($4\frac{3}{4} \times 6\frac{7}{16}$ in), plate: 146×189 mm ($5\frac{3}{4} \times 7\frac{7}{16}$ in) (ea 768)

879 Untitled (School Bus) (4)
Image: 100×137 mm each ($3\frac{15}{16} \times 5\frac{3}{8}$ in), plate: 254×174 mm ($10 \times 6\frac{7}{8}$ in) (ea 769)

880 Untitled (Broken open dummy skeleton) (5)
Image: 170×117 mm ($6\frac{11}{16} \times 4\frac{5}{8}$ in), plate: 195×143 mm ($7\frac{11}{16} \times 5\frac{5}{8}$ in) (ea 770)

881 Untitled (Tape dummy) (6)
Image: 176×122 mm ($6\frac{15}{16} \times 4\frac{13}{16}$ in), plate: 207×156 mm ($8\frac{1}{8} \times 6\frac{1}{8}$ in) (ea 771)
Lit: *Konnertz* (349) where illustrated with Max Ernst's *Anatomie Jeune Mariée*, 1921

Group 4: Pages from the Aerospace Medical Library

882 Untitled (Baboon on sled) (1)
Image: 113×104 mm ($4\frac{7}{16} \times 4\frac{1}{8}$ in), plate: 152×143 mm ($6 \times 5\frac{5}{8}$ in) (ea 772)

883 Electrodes, etc, Arm Support, etc. (2)
Image: 115×84 each ($4\frac{1}{2} \times 3\frac{5}{16}$ in), plate: 292×121 mm ($11\frac{1}{2} \times 4\frac{3}{4}$ in) (ea 773)

884 Geometry Relations in Electron Irradiation of a Mouse (3)
Image: 90×120, 48×120, 48×120, 108×120 mm ($3\frac{9}{16} \times 4\frac{3}{4}$, $1\frac{7}{8} \times 4\frac{3}{4}$, $1\frac{7}{8} \times 4\frac{3}{4}$, $4\frac{1}{4} \times 4\frac{3}{4}$ in), plate: 375×156 mm ($14\frac{3}{4} \times 6\frac{5}{32}$ in) (ea 774)

885 Untitled (Decompression pair) (4)
Image: 95×170 mm each ($3\frac{3}{4} \times 6\frac{11}{16}$ in), plate: 131×207 mm ($5\frac{5}{32} \times 8\frac{1}{8}$ in) (ea 775)

886 Untitled (Tape Dummy) (5)
Image: 74 × 84 mm (2$\frac{15}{16}$ × 3$\frac{5}{16}$ in), plate: 112 × 120 mm
(4$\frac{13}{32}$ × 4$\frac{3}{4}$ in) (ea 776)

887 Carpenter (6)
Image: 160 × 100 mm (6$\frac{5}{16}$ × 3$\frac{15}{16}$ in), plate: 199 × 125 mm
(7$\frac{13}{16}$ × 4$\frac{15}{16}$ in)
Insc bl printed: *Carpenter* (ea 777)

CLOUD ATOMIC LABORATORY, 1971
Series of eight photogravures with title page, introductory text by
the artist and contents page, presented in mottled green covered
box insc: *Eduardo Paolozzi/ Cloud Atomic Laboratory*. Printed in
black as two images on a single sheet, each from single
copperplate on Crisbrook Hot Press waterleaf 140 lb paper
Insc br: *Eduardo Paolozzi* with date and edition number, vo:
stamped ea and publication number, and *JC* chop of James
Collyer or *J* chop of John Crossley
Pr: James Collyer and John Crossley of J. C. Editions, Alecto
Studios, London April–May 1971; pub: Editions Alecto Ltd for
British Olivetti Ltd, 1971 (ea 801–8)
Edition: 75, 10 ap, 3 cp
Coll: Tate; British Council; SNGMA

Paolozzi's introduction describes the series as, 'translations of
paintings based on/ photographs spanning a period of time from
1952 up to the present. The collection of/ material from
magazines, books and newspapers has been a continual search
for/ meaning starting from early school days Four images in/
this portfolio have reasonable historic value being originally
presented with a diverse/ amount of images at the ICA in 1952
. . . a difficulty in assessing aesthetic value in these works is
emphasised by the monolithic/ concepts concerning all the
GREAT MECHANICAL ARTS./ The schism that separates
Space Age Engineering, technical photography, film/ making and
types of street art from fine art activities is for many people/
artists unbridgeable./ Within the grand system of paradoxes, the
theme of this portfolio is the Human Predicament. Content
enlarged by precision. History shaded into the grey scale as/ in
the television tube.'

888 A
Garco Robot Nailing a Wooden Box (1957)
Little Boy on his Bed in his Room (early 1960s)
Double image: 312 × 204 mm (12$\frac{5}{16}$ × 8$\frac{1}{16}$ in), plate:
350 × 241 mm (13$\frac{3}{4}$ × 9$\frac{1}{2}$ in), paper: 531 × 352 mm
(20$\frac{15}{16}$ × 13$\frac{7}{8}$ in) (ea 801)

889 B (Page 178)
Skull of Test Dummy (Sierra Engineering)
USSR Proton – Synchron Electrophysical Laboratory
Double image: 225 × 488 mm (8$\frac{7}{8}$ × 19$\frac{1}{4}$ in), plate:
264 × 527 mm (10$\frac{3}{8}$ × 20$\frac{3}{4}$ in), paper: 360 × 530 mm
(14$\frac{3}{16}$ × 20$\frac{7}{8}$ in) (ea 807)

890 C (Page 179)
**Le Robot Robert voulait aller a New York Mais Le
Passager est Trop Lourd/ TWA Plane – Steps – Cap 14
Persons with two Stewardesses**
Wonder Toy
Double image: 203 × 315 mm (8 × 12$\frac{7}{16}$ in), plate: 241 × 351
mm (9$\frac{1}{2}$ × 13$\frac{13}{16}$ in), paper: 357 × 535 mm (14$\frac{1}{16}$ × 21$\frac{1}{16}$ in)
(ea 806)

The original Wonder Toy advertisement reads: here is an amazing
remote-controlled robot called Robert the Robot, who can move
in any direction and where hands move up and down when a
child simply cranks the controls. An on and off switch lights on
the robot's antenna and in his eyes. A record mechanism permits
him to talk. A tool chest in his body contains tools enabling
battery replacement. Made of high impact plastic, the robot is
14 in tall and manufactured by the Ideal Toy Corp. He retails for
$6.00.

891 D
**CULTURE/ Monkeys may be the next space Travellers
on/ US made satellites**
X. 15's Maiden Flight
Double image: 348 × 149 mm (13$\frac{11}{16}$ × 5$\frac{7}{8}$ in), plate:
383 × 186 mm (15$\frac{1}{8}$ × 7$\frac{5}{16}$ in), paper: 532 × 363 mm
(20$\frac{15}{16}$ × 14$\frac{5}{16}$ in) (ea 804)

892 E (Page 180)
**Public Torso on Lorry in a Manhattan Street for 'Bond
Clothes for Men'**
Varga – Billboard Girl (Winter Garden – Zanzibar)
Double image 184 × 438 mm (7$\frac{1}{4}$ × 17$\frac{1}{4}$ in), plate:
222 × 477 mm (8$\frac{3}{4}$ × 18$\frac{13}{16}$ in), paper: 353 × 535 mm
(13$\frac{7}{8}$ × 21$\frac{1}{16}$ in) (ea 808)

893 F (Page 181)
**Chimpanzee in a Test Box Designed for Space Flight
(Ham and Eros at practice: both later flew in space)**
**Mobot Mk 1: Mobile replacement for men in dangerous
areas**
Double image: 312 × 202 mm (12$\frac{5}{32}$ × 7$\frac{31}{32}$ in), plate:
351 × 240 mm (13$\frac{13}{16}$ × 9$\frac{7}{16}$ in), paper: 530 × 361 mm
(20$\frac{7}{8}$ × 14$\frac{1}{4}$ in) (ea 803)

894 G
**Space Age Archaeology (Two images from centre pages,
Time Magazine 1952):**
Fathers and Sons
Double image: 202 × 380 mm (7$\frac{31}{32}$ × 15 in), plate:
240 × 419 mm (9$\frac{11}{16}$ × 16$\frac{1}{2}$ in), paper: 358 × 535 mm
(14$\frac{1}{8}$ × 21$\frac{1}{16}$ in) (ea 805)

895 H
Television Series "Lost in Space": Robot as in "Forbidden Planet"
Soviet Dog and Man exit Space Chamber (News Magazine)
Double image: 227 × 340 mm (8 15/16 × 13 3/8 in), plate: 265 × 377 mm (10 7/16 × 14 7/8 in), paper: 355 × 531 mm (14 × 20 15/16 in) (ea 802)

896 Flikker Book No. 3, 1972 (Page 225)
Lithograph, off-set, printed in black
75 × 93 mm (2 15/16 × 3 11/16 in)
Printed front: *Flikker/ book/ Eduardo Paolozzi*, back page: *Eduardo Paolozzi*
Pr: Hillingdon Press, Uxbridge; pub: AI, 1972

Play on two suspended ovals.

897 Selasa, 1975
Coloured screenprint, printed on all British cartridge 200 gsm paper
Image: 650 × 565 mm (25 5/16 × 22 1/4 in), paper: 932 × 729 mm (36 11/16 × 28 11/16 in)
Insc br: *Selasa Eduardo Paolozzi* (pencil), b. printed: *Eduardo Paolozzi Editions Alecto/ Published for PSA Supplies, Department of the Environment by Editions Alecto © Screenprinted in London, England*
Edition: unlimited (3500)
Pr: Leslie Hosgood and Robert Jones, Megara Screenprinting Ltd, Alecto Studios, London; pub: Editions Alecto Ltd for PSA, Department of the Environment, 1975 (ea 911)
Coll: Cartwright Hall Art Gallery, Bradford; National Gallery of Australia, Canberra; GAC

Kevin Pearsh (*b.*Melbourne 1951)

Perth College of Art, 1967–9. Moved to London in 1972. Exhibited at Mercury Gallery, London, 1972 and Holdsworth Gallery, Sydney, 1977. Worked previously in etching, before being given the opportunity to work with lithography in 1979. Commissioned to paint the Château de Chaudenay in Central France, 1982, where he continues to live and work.

SIX LITHOGRAPHS of remote areas of North-West Australia, with proofs (seen by author) on Somerset and Arches paper
Insc across b: with edition number, title and signed *Pearsh* (pencil)
Image and paper: 545 × 568 mm (21 7/16 × 22 3/8 in)
Edition: 150, with proofs
Pr: Tom Piper, Alecto Studios, London; pub: 1979 (ea 976–81)

898 Millstream, Pilbara
Lithograph, crayon, printed in blue, yellow, purple brown and green
(ea 976)

Palm trees provide the structure to this millstream scene.

899 Kalamain Gorge, Hamersley Range
Lithograph, crayon, printed in yellow, orange, blue, two reds and green
(ea 977)

Steep escarpment to the left, as seen from a low vantage point.

900 Hamersley Gorge
Lithograph, crayon, printed in yellow, brown, blue and green
Insc b: *colour corrections 1 Hamersley gorge* and *Pearsh '79* (pencil) (ea 978)

Gorge which dips in the left middle ground of this image.

901 Red Gorge, Hamersley Range
Lithograph, crayon, printed in red pink, brown, yellow, green and blue
Insc bl: *AP*, br: *Pearsh '79* (pencil) (ea 979)

Hot red brown dominates the right side of this low-lying gorge.

902 Mount Nameless, Hamersley Range
Lithograph, crayon, printed in blue, two reds, green and yellow
(ea 980)

Also titled *Evening atmosphere* on an ap seen by the author, this scene is identified by the bare silhouette of the foreground trees.

903 City of Ruins, Kimberley Range*
Colour lithograph
(ea 981)

This first series of lithographs by Kevin Pearsh was based upon sketches and photographs produced during a trip to the Hamersley and Kimberley Ranges of North-West Australia.

David Pelham (*b.*Gloucestershire, 1938)

Graduated from St Martin's School of Art in late 1950s. Art editor of *Studio International*, the London-based art magazine, and Fiction Art Director for Penguin Books Ltd. In 1980 began to develop interest in paper engineering and sculptural possibilities of paper. Led to celebrated work with pop-up books. Collaborated with Jonathan Miller on the first serious pop-up book *The Human Body* (1982). Recently has worked with Anthony Caro on a wall-mounted card sculpture *Leaf Pool*, published in edition of 500.

904 The Minimum Chess Set, 1970 (Page 226)
Acrylic highly polished, with sixty-four clear and frosted squares forming a playing board and thirty-two clear and frosted chess pieces; fit into an acrylic box with sliding top and bottom, accompanied by metallic identification sheet
Measuring: 95 (h) × 175 (l) × 95 (w) mm (3 3/4 × 6 7/8 × 3 3/4 in)
Insc on top lid: *The Minimum Chess Set by David Pelham Published by Editions Alecto Limited London © 1970* ea

Edition: unlimited
Produced by Olympia Plastics, Wembley, Middlesex; pub: 1970
(ea 691)
Ref: *A Decade of Printmaking*, p.95 (ill.)

Pelham also worked with Niels Young on *Loopee*, a pipe made of injected moulded acrylic in primary colours, through which air was blown to form a moving loop of fibrous thread. This reached prototype stage, and was advertised by AI, but not finally produced.

Tom Phillips (*b.*South London, 1937)

St Catherine's College, Oxford and Camberwell School of Art. Music and African Art have been long interests. John Moores Award, 1969. Following year exhibited at Angela Flowers Gallery, London. Opera *Irma* premiered in 1973. Graphics in various media produced throughout the 1970s, and exhibited at Marlborough Graphics, 1973. Late 1977 began working in Alecto Studios on *Dante's Inferno*, book project severely interrupted by fire and finally published by Thames and Hudson (Trade Edition), 1985. Theatre design, films, curatorship of exhibitions, further books and continuing painting have figured in recent projects.

Lit: *Alecto Monographs 2*

905 After Raphael?, 1972–3 (Page 224)
Screenprint, thirty-one colours, printed on R. K. Burt mould-made 285 gsm waterleaf paper
Image: 582 × 483 mm (22$\frac{15}{16}$ × 19 in), paper: 737 × 611 mm (29 × 24$\frac{1}{16}$ in)
Edition: 150, 25 ap
Insc bl: edition number, br: *Tom Phillips LXXIII*, vo: ea *825*
Pr: Leslie Hosgood, Robert Jones and Brian Smith, Tanagra Ltd, London, 1972; pub: EACC, 1973 (ea 825)
Coll: V&A; Cartwright Hall Art Gallery, Bradford; Walker Art Gallery, Liverpool (National Museums and Galleries on Merseyside); National Gallery of Australia, Canberra; GAC

The source of this print is the Umbrian School Votive Picture in the Walker Art Gallery, Liverpool, from which Phillips produced two canvases, 'one of which contains the image and the other which contains the grid and drawing which underlies that image. The ideal solution is in fact found in the print where the two appear simultaneously; something that could only be achieved in screenprint. The colours in the print are not those you would find were you to visit the Liverpool original. Four hundred and fifty years of rubbing, restoration and bleaching from the light have left only hints of its once rich harmony. I have tried to be not over-cautious in guessing the original colours It was in fact the invitation of Editions Alecto to make a silkscreen print in which (unusually) there are no limits to the number of colours used, that led to my devising what turns out to be the definitive statement at the end of a long process.' (TP, *Alecto Monographs*)
 Technically 'it was a combined effort with Les cutting and separating stencil preparation from Tom's keyline drawing. Brian

Smith made photo stencils and I mixed, proofed and editioned.' (Robert Jones, 26/4/2000)

906 Ten Views of the Union Jack, 1975–6
Screenprint, photo, coloured, printed on all British Cartridge 200 gsm paper
Image: 804 × 477 mm (31$\frac{11}{16}$ × 18$\frac{13}{16}$ in), paper: 967 × 565 mm (38$\frac{1}{16}$ × 22$\frac{5}{16}$ in)
Insc printed: *On Postcards of Public Buildings Fly The Flags Here R/ Econstructed. Ten Union Jacks Their Proper Outlines/ Superimposed. Published for PSA Supplies Division by Edit/ions Alecto. Copyright 1976. Screenprinted in London/ England. Tom Phillips LXXV*
Edition: unlimited
Pr: Leslie Hosgood and Robert Jones, Megara Screenprinting Ltd, Alecto Studios, London, 1975; pub: Editions Alecto Ltd for PSA, Department of the Environment, 1976 (ea 913)
Coll: Cartwright Hall Art Gallery, Bradford; National Gallery of Australia, Canberra; Research Centre, Tate; GAC

907 Orpheus, 1977
Etching and aquatint, printed in brown and yellow
Plate: 312 × 227 mm (12$\frac{5}{16}$ × 8$\frac{15}{16}$ in), paper: 481 × 379 mm (18$\frac{15}{16}$ × 14$\frac{15}{16}$ in)
Insc bl: *75/125* and *Tom Phillips* (crayon), br: *w* embossed
Edition: 125, proofs
Pr: Alecto Studios; pub: Editions Alecto Ltd in support of The Yehudi Menuhin School, 1977 (no publication number)

The connection with The Yehudi Menuhin School, Stoke d'Abernon, Cobham, came through Tom Phillips's daughter, Ruth, who was a pupil at the school. This image was printed and published non-commercially by ea.

John Piper (*b.*Epsom, Surrey, 1903–92)

See Appendix

Patrick Procktor (*b.*Dublin, 1936)

Slade School of Fine Art, 1958–62. First exhibition at Redfern Gallery, London, 1963. Etched at the Slade and worked in lithography for first published edition *Seated Crowd on Grass*, printed by Ken Tyler, Gemini Studio, Los Angeles, 1965. First trip to Venice, 1962. Took up watercolour painting in summer 1967, and subsequently made colour aquatints based on watercolours. Visits to India, South Africa, Venice and China in 1970, 1974, 1977 and 1980 resulted in suites, all published by ea.

Lit: Tessa Sidey, *Patrick Procktor Prints 1959–1985*, Redfern Gallery, London and Editions Alecto Ltd, 1985

INVITATION TO A VOYAGE, 1969–70
Series of five aquatints on J. Green 246 lb handmade waterleaf paper

Insc br: signed *Patrick Procktor* (pencil), vo: stamped ℮a and publication number
Proofing begun by Maurice Payne and Danyon Black, and completed by Danyon Black, James Collyer and John Crossley at Alecto Studios, London where the edition was printed by James Collyer and John Crossley, 1969–70
Edition: 75, 15 ap including a portfolio/frame made by Design Animations, London, with quotations from Charles Baudelaire on translucent paper, and colophon sheet
Pub: 1969 (℮a 578–9, 582–4)
Exh: *Patrick Procktor*, Redfern Gallery, London, 22 April–16 May 1969
Coll: Financial Times, London

This series was based on drawings done in late 1968 in a New York apartment and subsequently worked up as watercolours. They focus variously on three friends: Gervase Griffiths, singer and model; Eric Emerson, actor; and Ossie Clarke, fashion designer.

Proofing began in early 1969, but editioning was only finished over a year later after three phases of printing.

908 Departure (Page 177)
Etching, hard-ground and aquatint, two chrome-faced zinc plates, printed in red, yellow, purple, green
Plate: 403 × 750 mm (15 $\frac{7}{8}$ × 29 $\frac{1}{2}$ in), paper: 680 × 990 mm (26 $\frac{3}{4}$ × 39 in) (℮a 578)
Coll: BMAG

With quotation from *Chant d'Automne 1*, 1859

909 Mirrors
Aquatint, two chrome-faced zinc plates, printed in blue, purple, greens, orange
Plate: 454 × 754 mm (17 $\frac{7}{8}$ × 29 $\frac{11}{16}$ in), paper: 676 × 989 mm (26 $\frac{5}{8}$ × 38 $\frac{15}{16}$ in) (℮a 579)
Coll: Glasgow Museums; MOMA

With quotation from *L'Invitation au Voyage*, 1854

910 Ossie, Gervase and Eric (Page 176)
Aquatint, two chrome-faced zinc plates, printed in blue, yellow, orange, pink, greens, brown, purple
Plate: 278 × 875 mm (10 $\frac{15}{16}$ × 34 $\frac{7}{16}$ in), paper: 681 × 988 mm (26 $\frac{13}{16}$ × 38 $\frac{7}{8}$ in) (℮a 582)

With quotation from *Chant d'Automne 11*, 1859 and *Le Poison*, 1857

911 Sadie and Prudence
Aquatint, three chrome-faced zinc plates, printed in pink, red, purple, greens, yellow, blue, grey
Plate: 254 × 451 mm (10 × 17 $\frac{3}{4}$ in), paper: 682 × 988 mm (26 $\frac{7}{8}$ × 38 $\frac{15}{16}$ in) (℮a 583)

With quotation from *Le Crepuscule du Soir*, 1857. The title comes from the two Beatles numbers on the White Album: *Sexy Sadie* and *Dear Prudence*.

912 Language of Flowers
Aquatint, three chrome-faced zinc plates, printed in purples, red, pink, yellow, grey, greens, flesh, blue
Plate: 454 × 752 mm (17 $\frac{7}{8}$ × 29 $\frac{5}{8}$ in) (℮a 584)

With quotation from *L'Invitation au Voyage*, 1854

913 Poster Poem: Lullaby for William Blake, 1968
Collaboration with Adrian Mitchell
Photo-reproduction from wash drawing, brown and blue lettering
Image and paper: 610 × 937 mm (24 × 36 $\frac{7}{8}$ in)
Printed r: *Blakehead, Babyhead,/ Your head is full of light./ You sucked the sun like a godstopper./ Blakehead.Babyhead,/ High as a satellite on sunflower seeds./ First man-powered man to fly the Atlantic,/ Inventor of the poem which kills itself./ The poem which gives birth to itself./ The human form, jazz, Jerusalem/ And other luminous, luminous galaxies./ You out-spot your enemies./ You irradiated your friends./ Always naked, you shaven, shaking tyger-lamb,/ Moon-man, moon-clown, moon-singer, moon-drinker./ You never killed anyone./ Blakehead, Babyhead,/ Accept this mug of crude red wine-/ I love you!/ Adrian Mitchell Lullaby for William Blake/ br: Poster poem by Patrick Procktor + Adrian Mitchell/ published by Ad Infinitum Limited, London © 1968 103/ poem from "Our Lord" Cape Goliard Press, London © 1968*
Edition: unlimited
Pub: Ad Infinitum, London, 1968

914 My Gardenia, 1969
Lithograph, crayon and tusche, printed in grey, greens, orange and pink on Crisbrook waterleaf handmade paper
Image: 320 × 669 mm (12 $\frac{5}{8}$ × 26 $\frac{3}{8}$ in), paper: 585 × 787 mm (23 $\frac{1}{16}$ × 31 in)
Insc tl: *My Gardenia 11/100* and tr: *Patrick Procktor* (pencil), vo: ℮a *596* stamped
Edition: 100, approx. 10 ap
Proofed: Ian Lawson at Fulham studio; pr: Ian Lawson, Alecto Studios, London 1969; pub: 1969 (℮a 596)

INDIA, MOTHER, 1970
Suite of seven aquatints on Crisbrook waterleaf handmade 140 lb paper measuring: 570 × 788 mm (22 $\frac{7}{16}$ × 31 $\frac{1}{16}$ in, slight variations)
Insc bl: with edition number and signed br: *Procktor* (pencil), vo: stamped with ℮a and publication number, and flat chops of James Collyer and John Crossley
Edition: 60, 8 ap
Proofed: Danyon Black, James Collyer and John Crossley, Alecto Studios, London where edition pr: James Collyer and John Crossley, 1970; pub: 1970 (℮a 753–9)

Derived from over eighty watercolours made by the artist while travelling in India and Nepal in 1970. The seven aquatints and one abandoned print took six months to proof and were first exhibited at Redfern Gallery, London, November 1970.

915 Mount Abu (Rowli Mountains, Rajasthan)
Aquatint, two steel-faced copperplates, printed in blue, pink, yellow
Plate: 434 × 623 mm (17 $\frac{1}{16}$ × 24 $\frac{9}{16}$ in) (ea 753)
Coll: Rochdale Art Gallery; Arthur Andersen, London

916 Rowli Mountains (Rajasthan)
Aquatint with hand-colouring, steel-faced copperplate, printed in blues and hand-coloured green
Plate: 431 × 617 mm (17 × 24 $\frac{5}{16}$ in) (ea 754)
Coll: Arthur Andersen, London

917 Queens Necklace (Bombay)
Aquatint with hand-colouring, steel-faced copperplate, printed in purple, blue, green, pink
Plate: 432 × 620 mm (17 × 24 $\frac{7}{16}$ in) (ea 755)
Coll: Leeds City Art Gallery; Brooklyn Museum of Art

918 Back Bay in Bombay
Aquatint, steel-faced copperplate, printed in blues
Plate: 434 × 617 mm (17 $\frac{1}{8}$ × 24 $\frac{5}{16}$ in) (ea 756)

919 Pie-Jaw, Jaipur
Aquatint, two steel-faced copperplates, printed in blues, greens, red, brown, yellow
Plate: 431 × 615 mm (17 × 24 $\frac{1}{4}$ in) (ea 757)

920 Illumination
Aquatint, with screenprinting, two steel-faced copperplates, printed in black, brown, blue, white, pink, greens
Plate: 433 × 619 mm (17 $\frac{1}{16}$ × 24 $\frac{3}{8}$ in) (ea 758)

The same scene as *Pie-Jaw, Jaipur*, but seen at night with additional black screenprinting.

921 Kathmandu
Aquatint, two steel-faced copperplates, printed in blues, greens, yellow, pink, brown, red, orange, purple
Plate: 470 × 657 mm (18 $\frac{1}{2}$ × 25 $\frac{7}{8}$ in) (ea 759)

An eighth aquatint *Hiding Places of my Power* was originally intended to be included in *India, Mother* series, but was finally realised as unpublished edition of five proofs.
Coll: BMAG; GAC

922 Marcus with a Pink, 1971
Aquatint, two chrome-faced plates, printed in blue, grey, turquoise, brown, green, red, pink, flesh on J. Green waterleaf mould-made 140 lb paper
Plate: 541 × 345 mm (21 $\frac{5}{16}$ × 13 $\frac{5}{8}$ in), paper: 803 × 592 mm (31 $\frac{5}{8}$ × 23 $\frac{5}{16}$ in)
Insc bl: *117/500*, br: *Procktor* (pencil), vo: ea *810* and flat chops of James Collyer and John Crossley
Edition: 500, proofs
Proofed and pr: James Collyer and John Crossley, Alecto

Studios, London; pub: Observer Art in collaboration with Editions Alecto Ltd, 1971 (ea 810)
Coll: Warwickshire Museum (School Loan Collection); GAC

The subject is Marcus Benson, step-nephew of the artist. A hundred impressions of this edition were bought by Patrick Seale Gallery, London who subsequently sold them to Christie's Contemporary Art. Proof at Redfern Gallery, London is entitled *Dirty Knees*.

923 Queen Mary's Rose Garden, Regent's Park in November, 1971
Aquatint, two steel-faced copperplates, printed in green and brown with red, purple, yellow, blue on J. Green waterleaf mould-made 246 lb paper
Plate: 549 × 694 mm (21 $\frac{5}{8}$ × 37 $\frac{5}{16}$ in), paper: 724 × 858 mm (28 $\frac{1}{2}$ × 33 $\frac{13}{16}$ in)
Insc bl: *57/75*, br: *Patrick Procktor* (pencil), vo: stamped ea *811* and flat chops of James Collyer and John Crossley
Edition: 75, 15 ap, 1 bat
Proofed and pr: James Collyer and John Crossley of J. C. Editions, Alecto Studios, London; pub: 1971 (ea 811)
Coll: Arthur Andersen, London; Sheffield Galleries and Museums Trust; MOMA; GAC

A smaller photographic version of this image (run of about 300) was produced for a hotel chain.
Published as a pair with ea 812.

924 Back of the Zoo, Regent's Park, 1971
Hard-ground etching and aquatint, two steel-faced copperplates, printed in green and black on J. Green waterleaf mould-made 246 lb paper
Plate: 545 × 690 mm (21 $\frac{7}{16}$ × 27 $\frac{3}{16}$ in), paper: 698 × 871 mm (27 $\frac{1}{2}$ × 34 $\frac{5}{16}$ in)
Insc bl: *54/75*, br: *Patrick Procktor* (pencil), vo: stamped ea *812* and flat chops of James Collyer and John Crossley
Edition: 75, 15 ap
Proofed and pr: James Collyer and John Crossley of J. C. Editions, Alecto Studios, London; pub: 1971 (ea 812)

Based on watercolour study of 1971, and published as a pair with ea 811. Third London scene *Regent's Park Lake* was never finally published.

925 Dogano (Customs House, Venice), 1972
Aquatint, two steel-faced copperplates, printed in black and Naples yellow on J. Green waterleaf mould-made paper
Plate: 274 × 690 mm (10 $\frac{3}{4}$ × 27 $\frac{3}{16}$ in)
Insc br: *Patrick Procktor* (pencil), vo: stamped ea *819* and flat chops of J. C. Editions
Edition: 75, 15 ap
Proofed and pr: James Collyer and John Crossley of J. C. Editions, Alecto Studios, London; pub: AI, 1972 (ea 819)
Coll: GAC

926 Riva, I 1972
Etching, hard-ground, copperplate, printed in black on J. Green waterleaf mould-made paper
Plate: 274 × 694 mm (10 $\frac{3}{4}$ × 27 $\frac{5}{16}$ in)
Insc br: *Patrick Procktor* (pencil) and embossed chops of J. C. Editions, vo: stamped ℮ℯ *820*
Edition: 75, 15 ap
Proofed and pr: James Collyer and John Crossley of J. C. Editions, Alecto Studios, London; pub: AI, 1972 (℮ℯ 820)
Coll: GAC

927 Riva II, 1972
Aquatint, two steel-faced copperplates, printed in blue, brown, pink, red, black on J. Green waterleaf mould-made paper
Plate: 274 × 692 mm (10 $\frac{3}{4}$ × 27 $\frac{1}{4}$ in)
Insc bl: *61/75*, br: *Patrick Procktor* (pencil) and embossed chops of J. C. Editions, vo: stamped ℮ℯ *821*
Edition: 75, 15 ap
Proofed and pr: James Collyer and John Crossley of J. C. Editions, Alecto Studios, London; pub: AI, 1972 (℮ℯ 821)
Coll: GAC; Sheffield Galleries and Museums Trust

928 Flikker Book No. 4, 1972 (Page 225)
Off-set lithograph, printed in black; 75 × 93 mm (3 × 3 $\frac{11}{16}$ in)
Printed front: *Flikker/ book/ Patrick Procktor*
Pr: Hillingdon Press, Uxbridge; pub: AI, 1972

Young man prepares to take a shower.

929 London Bridge, 1973
Etching, hard-ground and aquatint, two steel-faced copperplates, printed in black, brown, red, green on J. Green waterleaf mould-made paper
Plate: 345 × 542 mm (13 $\frac{5}{8}$ × 21 $\frac{3}{8}$ in)
Insc br: *Patrick Procktor* (pencil) and embossed chops of J. C. Editions, vo: stamped ℮ℯ *836*
Edition: 50, and 50 numbered 1–50 in Roman numerals, 15 ap
Proofed and pr: James Collyer and John Crossley of J. C. Editions, Alecto Studios, London; pub: Editions Alecto Ltd and John Mowlem Co. Ltd (Roman numerals edition) to celebrate opening of new London Bridge by HM The Queen, 1973 (℮ℯ 836)
Coll: Tate; Leicestershire Museums, Arts and Records Service; GAC

930 Roses, 1973
Screenprint, printed in red, green, pink on white cartridge paper
Image: 322 × 443 mm (12 $\frac{11}{16}$ × 17 $\frac{7}{16}$ in), paper: 384 × 561 mm (15 $\frac{1}{8}$ × 22 $\frac{1}{16}$ in)
Edition: 100, 5 ap (two series)
Proofed and pr: Robert Jones and Leslie Hosgood, Megara Screenprinting Ltd, Alecto Studios, London. The first lettered edition pub: The Salisbury Festival: the second edition without lettering: Editions Alecto Ltd (no publication number)
Coll: GAC

SOUTH AFRICA SUITE, 1974
Six coloured etchings on R. K. Burt mould-made paper
Insc bl: edition number, br: *Patrick Procktor* (pencil) with ℮ℯ embossed and embossed chops of James Collyer and John Crossley of J. C. Editions, vo: stamped ℮ℯ and publication number
Edition: 50, 5 ap
Proofed and pr: James Collyer and John Crossley, Alecto Studios, London; pub: 1974 (℮ℯ 864–9)
Exh: *Patrick Procktor: South African Exhibition*, Gallery 101, Johannesburg, 22 March–7 April 1977
Coll: Tate

Initially etched directly onto copperplates in South Africa and completed with aquatint in London.

931 Sleeping Baby, Johannesburg
Etching, hard-ground and aquatint, steel-face copperplate, printed in black
Plate: 125 × 179 mm (4 $\frac{15}{16}$ × 7 $\frac{1}{16}$ in), paper: 293 × 393 mm (11 $\frac{9}{16}$ × 15 $\frac{1}{2}$ in) (℮ℯ 864)

932 Municipal Gardens, Johannesburg
Etching, hard-ground and aquatint, steel-faced copperplate, printed in black
Plate: 178 × 125 mm (7 × 4 $\frac{15}{16}$ in), paper: 395 × 297 mm (15 $\frac{9}{16}$ × 11 $\frac{11}{16}$ in) (℮ℯ 865)

933 National Gallery, Johannesburg
Aquatint, two steel-faced copperplates, printed in black and green
Plate: 202 × 120 mm (7 $\frac{31}{32}$ × 4 $\frac{3}{4}$ in), paper: 393 × 300 mm (15 $\frac{1}{4}$ × 11 $\frac{13}{16}$ in) (℮ℯ 866)

934 Lunch Hour, Johannesburg
Aquatint, two steel-faced copperplates, printed in green, black, blue
Plate: 120 × 202 mm (4 $\frac{3}{4}$ × 7 $\frac{31}{32}$ in), paper: 293 × 392 mm (11 $\frac{9}{16}$ × 15 $\frac{7}{16}$ in) (℮ℯ 867)

935 Leaping Cataract, Victoria Falls
Aquatint, two steel-faced copperplates, printed in green, yellow green, purple, blue, black, brown
Plate: 202 × 120 mm (7 $\frac{31}{32}$ × 4 $\frac{3}{4}$ in), paper: 398 × 297 mm (15 $\frac{11}{16}$ × 11 $\frac{11}{16}$ in) (℮ℯ 868)

936 Victoria Falls
Aquatint, two steel-faced copperplates, printed in black, blue, purple, green, yellow green, brown
Plate: 120 × 202 mm (4 $\frac{3}{4}$ × 7 $\frac{31}{32}$ in), paper: 299 × 399 mm (11 $\frac{25}{32}$ × 15 $\frac{11}{16}$ in) (℮ℯ 869)

THE RIME OF THE ANCIENT MARINER, 1976

Series of twelve aquatints illustrating Samuel Taylor Coleridge's poem in various editions. Proofed and pr: Charles Newington of Tisiphone Etching Ltd, Alecto Studios, with assistance of Frank Tinsley, Cathy Chalker and Lorraine Smith; pub: 1976 (ea 916–27)

Portfolio edition: 75, 10 ap on loose sheets of B. F. K. Rives Velin Cuve mould-made paper measuring: 650 × 497 mm (25 $\frac{5}{8}$ × 19 $\frac{9}{16}$ in, with variation), each image insc bl: edition number, br: signed *Patrick Procktor* (pencil), with ea embossed and vo: stamped ea and publication number

937 Samuel Taylor Coleridge (Frontispiece)
Etching, hard-ground and aquatint, steel-faced copperplate, printed in black
Plate: 223 × 149 mm (8 $\frac{25}{32}$ × 5 $\frac{7}{8}$ in) (ea 916)

938 And ice, mast-high, came floating by, As green as emerald (Part I, lines 53–4) (Page 254)
Aquatint, steel-faced copperplate, printed in brown and cobalt green
Plate: 348 × 274 mm (13 $\frac{11}{16}$ × 10 $\frac{13}{16}$ in) (ea 917)

939 And we did speak only to break The silence of the sea! (Part II, lines 109–10)
Etching, hard-ground and aquatint, steel-faced copperplate, printed in black
Plate: 342 × 271 mm (13 $\frac{1}{2}$ × 10 $\frac{11}{16}$ in) (ea 918)

940 The very deep did rot (Part II, line 123)
Etching, hard-ground and aquatint, steel-faced copperplate, printed in black
Plate: 342 × 270 mm (13 $\frac{1}{2}$ × 10 $\frac{5}{8}$ in) (ea 919)

941 The spectre bark (Life-in-Death winneth the ancient Mariner) (Part III, line 185ff)
Etching, hard-ground and aquatint, two steel-faced copperplates, printed in black, brown and touch of red
Plate: 342 × 272 mm (13 $\frac{1}{2}$ × 10 $\frac{11}{16}$ in) (ea 920)

942 The ribbed sea-sand (Part IV, line 227) (Page 254)
Etching, hard-ground and aquatint, steel-faced copperplate, printed in black
Plate: 342 × 272 mm (13 $\frac{1}{2}$ × 10 $\frac{11}{16}$ in) (ea 921)

943 The charmed water burnt alway A still and awful red (Part IV, lines 270–1)
Aquatint, two steel-faced copperplates, printed in black and red
Plate: 221 × 150 mm (8 $\frac{11}{16}$ × 5 $\frac{15}{16}$ in) (ea 922)

944 The water-snakes (Part IV, line 273ff)
Etching, hard-ground and aquatint, two steel-faced copperplates, printed in black, blue, green, yellow and orange
Plate: 340 × 270 mm (13 $\frac{3}{8}$ × 10 $\frac{5}{8}$ in) (ea 923)

945 Two of the Polar Spirit's fellow daemons (Part VI, line 410 ff)
Etching, hard-ground and aquatint, two-steel copperplates, printed in red, orange, turquoise
Plate: 223 × 150 mm (8 $\frac{13}{16}$ × 5 $\frac{15}{16}$ in) (ea 924)

946 All fixed on me their stony eyes That in the Moon did glitter (Part VI, lines 436–7)
Etching, hard-ground and aquatint, steel-faced copperplate, printed in black
Plate: 341 × 270 mm (13 $\frac{7}{16}$ × 10 $\frac{5}{8}$ in) (ea 925)

947 I pass, like night, from land to land (Part VII, line 586)
Aquatint, two steel-faced copperplates, printed in black, green, pink
Plate: 149 × 225 mm (5 $\frac{7}{8}$ × 8 $\frac{7}{8}$ in) (ea 926)

948 Charles Newington, Printer (Endpiece)
Etching, hard-ground and aquatint, steel-faced copperplate, printed in black
Plate: 142 × 73 mm (5 $\frac{5}{8}$ × 2 $\frac{7}{8}$ in) (ea 927)

949 Standard book; edition: 100, 10 ap on Crisbrook handmade paper measuring 355 × 283 mm (14 × 11 $\frac{1}{8}$ in, variations) Bound in quarter cloth by John P. Gray and Son, Cambridge; signed and numbered in the colophon by the artist, and contained in slipcase. The cover paper printed by Megara Screenprinting Ltd at Alecto Studios, London with letterpress printed by Sebastian Carter, Rampant Lions Press, Cambridge (ea 930)
Coll: MOMA

950 Special book; edition: 25, 5 ap; bound in full leather with four loose prints: *Samuel Taylor Coleridge, The charmed water burnt always, Two of the Polar Spirit's fellow daemons*, and *I pass, like night, from land to land*, each signed and numbered by the artist: *I/XXV–XXV/XXV*. Bound by Sangorski and Sutcliffe, London; signed on the colophon paper by the artist and numbered *I–XXV* and *Artist's Proof I–V*; book and loose sheets contained in slipcase (ea 931)
Exh: *Patrick Procktor: The Rime of The Ancient Mariner*, Redfern Gallery, London, 4 May–4 June 1976

951 I fear thee, Ancient Mariner! , 1976
Etching, hard-ground and aquatint, printed in black on Crisbrook oatmeal paper
Plate: 474 × 353 mm (18 $\frac{11}{16}$ × 13 $\frac{15}{16}$ in), paper: 787 × 562 mm (31 × 22 $\frac{1}{8}$ in)
Insc bl: *32/38*, br: *Patrick Procktor* (pencil), vo: ea *929* stamped (mostly)
Edition: 38, 5 ap
Pr: Charles Newington of Tisiphone Etching Limited, Alecto Studios, London; pub: 1976 (ea 929)

This is a variation of *The ribbed sea-sand* (ea 921), the title taken from Part IV, line 224, of Coleridge's poem.
Coll: BMAG

952 Dahlias (Swastika), 1977
Aquatint, two steel-faced copperplates, printed in brown and black on B. F. K. Rives mould-made paper
Plate: 310 × 268 mm (12 $\frac{1}{4}$ × 10 $\frac{9}{16}$ in), paper: 652 × 497 mm (25 $\frac{11}{16}$ × 19 $\frac{9}{16}$ in)
Insc bl: *11/100*, br: *Patrick Procktor* (pencil) and ℮a embossed
Edition: 100, 15 ap
Proofed: The artist at Chelsea School of Art, pr: Charles Newington of Tisiphone Etching Ltd, Alecto Studios, London; pub: 1977 (℮a 948)
Coll: British Museum

THE VENICE SERIES, 1978
Seven colour aquatints, two steel-faced copperplates (unless stated otherwise), on B. F. K. Rives mould-made paper
Insc bl: edition number, br: *Patrick Procktor* (pencil), br corner: embossed snake chop of Tisiphone Etching Ltd
Edition: 35, 15 ap
Proofed and pr: Charles Newington of Tisiphone Etching Ltd, Alecto Studios, London; pub: Editions Alecto Ltd and Redfern Gallery, London, 1978 (℮a 965–71)

953 Consiglio
Aquatint, printed in indigo and red
Plate: 657 × 893 mm (25 $\frac{7}{8}$ × 35 $\frac{3}{16}$ in), paper: 880 × 1300 mm (34 $\frac{11}{16}$ × 51 $\frac{3}{16}$ in) (℮a 965)
Coll: Arthur Andersen, London

954 Bacino
Aquatint, printed in grey, blue, brown, red
Plate: 657 × 894 mm (25 $\frac{5}{8}$ × 35 $\frac{3}{16}$ in), paper: 880 × 1300 mm (34 $\frac{11}{16}$ × 51 $\frac{3}{16}$ in) (℮a 966)
Coll: Arthur Andersen, London

955 Regata Storica
Aquatint, printed in grey, orange, yellow, blue, red, green
Plate: 657 × 889 mm (25 $\frac{5}{8}$ × 35 in), paper: 880 × 1300 mm (34 $\frac{11}{16}$ × 51 $\frac{3}{16}$ in) (℮a 967)

956 Zattere
Aquatint, printed in blue and turquoise
Plate: 318 × 539 mm (12 $\frac{1}{2}$ × 21 $\frac{1}{4}$ in), paper: 630 × 800 mm (24 $\frac{13}{16}$ × 31 $\frac{1}{2}$ in) (℮a 968)

957 Ponte Lungo
Aquatint, printed in black and blue
Plates: 459 × 592 mm (18 $\frac{1}{16}$ × 23 $\frac{5}{16}$ in), paper: 660 × 880 mm (26 × 34 $\frac{11}{16}$ in) (℮a 969)

958 Palazzo Doria
Aquatint with sugar-lift, steel-faced copperplate, printed in blue, green, grey, pink, brown
Plate: 894 × 657 mm (35 $\frac{3}{16}$ × 25 $\frac{7}{8}$ in), paper: 1300 × 880 mm (51 $\frac{3}{16}$ × 34 $\frac{5}{8}$ in) (℮a 970)

959 Giudecca
Aquatint, printed in blue, turquoise, brown
Plate: 430 × 655 mm (16 $\frac{15}{16}$ × 25 $\frac{13}{16}$ in), paper: 630 × 800 mm (24 $\frac{13}{16}$ × 31 $\frac{1}{2}$ in) (℮a 971)

960 Aesthete, 1979
Etching, hard-ground and aquatint, steel-faced copperplate, printed in black on Somerset mould-made paper
Plate: 422 × 277 mm (16 $\frac{5}{8}$ × 10 $\frac{29}{32}$ in), paper: 626 × 490 mm (24 $\frac{5}{8}$ × 19 $\frac{5}{16}$ in)
Insc bl: *21/98*, br: *Patrick Procktor* with ℮a embossed
Edition: 98, 10 ap
Pr: Charles Newington, Dog Ear Studios, London; pub: 1979 (℮a 974)

Portrait of Roger Bevan, then Director of New Academy for Art Studies in London.

961 Quinta da Vargelas, 1979
Silkscreen, fourteen colours with hand-spraying on B. F. K. Rives paper
Image: 510 × 730 mm (20 $\frac{1}{16}$ × 28 $\frac{3}{4}$ in), paper: 745 × 935 mm (29 $\frac{3}{8}$ × 36 $\frac{13}{16}$ in)
Insc bl: *25/180*, br: *Patrick Procktor* (pencil), vo: ℮a 975 stamped
Edition: 180, 20 ap
Pr: Leslie Hosgood and Robert Jones, Megara Screenprinting Ltd, Alecto Studios, London; pub: Editions Alecto Ltd for Taylor, Fladgate and Yeatman, 1979 (℮a 975)

A CHINESE JOURNEY, 1980
Series of eight aquatints, selected from fifty-nine watercolours, printed on Velin Arches Blanc paper, 683 × 806 mm (26 $\frac{7}{8}$ × 31 $\frac{3}{4}$ in, slight variation)
Insc br: edition number and *Patrick Procktor* (pencil), with *JC* embossed chop of J. C. Editions
Edition: 75, 15 ap, plus at least 1 hc
Proofed: James Collyer and John Crossley of J. C. Editions, Alecto Studios, London and editioned: J. C. Editions, 180 Goswell Road, London EC1; pub: Editions Alecto Ltd and Redfern Gallery, London, 1980 (℮a 983–90)

962 Forbidden City, Peking
Aquatint, three steel-faced copperplates printed in red, brown, yellow, blue
Plate: 453 × 600 mm (17 $\frac{5}{8}$ × 23 $\frac{5}{8}$ in) (℮a 983)

963 Camels, Tomb of The First Emperor of the Ming Dynasty, Zhu Yuan Shang, Nanking
Aquatint, sugar-lift, two steel-faced copperplates, printed in dark and lighter brown, blue, purple
Plate: 453 × 600 mm (17 $\frac{7}{8}$ × 23 $\frac{5}{8}$ in) (℮a 984)

964 Lions Rocks Garden, Soochow

Aquatint, sugar-lift, two steel-faced copperplates, printed in browns, greys, orange, yellow, blue

Plate: 454 × 601 mm (17 $\frac{7}{8}$ × 23 $\frac{2}{32}$ in) (ea 985)

Reproduced as the exhibition poster for *A Chinese Journey*, Redfern Gallery, November 1980.

965 Lake Tai-Hu, Wusih

Aquatint, sugar-lift, two steel-faced copperplates, printed in black, ochre, dark brown, pink, green and lighter green

Plate: 454 × 601 mm (17 $\frac{5}{8}$ × 23 $\frac{11}{16}$ in) (ea 986)

966 Nasturtiums, Wusih

Aquatint, two steel-faced copperplates, printed in green, brown, orange, black, yellow

Plate: 599 × 454 mm (23 $\frac{5}{8}$ × 17 $\frac{7}{8}$ in) (ea 987)

967 Yellow Dragon Cave, Hangchow

Aquatint, three steel-faced copperplates, printed in brown, grey, yellow, red, green

Plate: 455 × 602 mm (17 $\frac{15}{16}$ × 23 $\frac{11}{16}$ in), paper: 685 × 810 mm (27 × 31 $\frac{7}{8}$ in) (ea 988)

968 Da Miou Mountains, Kweilin

Aquatint, two steel-faced copperplates, printed in pink, green, black, orange, yellow

Plate: 455 × 602 mm (17 $\frac{15}{16}$ × 23 $\frac{11}{16}$ in) (ea 989)

969 Flower Bridge, Kweilin

Aquatint, two steel-faced copperplates, printed in yellow, blue, green, orange, red

Plate: 602 × 447 mm (23 $\frac{11}{16}$ × 17 $\frac{5}{8}$ in) (ea 990)

Coll: Leicestershire Museums, Arts and Records Service

Three additional etchings were produced as trials for *A Chinese Journey*, but not finally published (*Sidey*, 93–5).

970 Peking Opera, 1980

Etching, hard-ground and aquatint, two steel-faced copperplates, printed in black and red on Velin Arches Blanc paper

Plate: 273 × 689 mm (10 $\frac{3}{4}$ × 27 $\frac{1}{8}$ in), paper: 470 × 857 mm (18 $\frac{1}{2}$ × 33 $\frac{3}{4}$ in)

Insc with edition number and signed br: *Patrick Procktor* (pencil) with embossed *J C* chop of James Collyer and John Crossley of J. C. Editions

Edition: 500 announced, 100 printed and distributed through *Sunday Telegraph Magazine*, 1980

Proofed and pr: James Collyer and John Crossley of J. C. Editions, Goswell Road studio, London; pub: 1980 (ea 991)

William Pye (*b.*London, 1938)

Fine Art at Wimbledon School of Art, 1958–61, and sculpture at RCA, 1961–5. First solo show at Redfern Gallery, London, 1966. Widely exhibited in UK and abroad, including *British Art*, Palazzo Strozzi, Florence, 1968 and *Middleheim 10th Biennale of Sculpture*, Antwerp, 1969. The following decade marked by highly polished geometric works in stainless steel. Water, reflection and the use of light become further important elements. Work embraces private and public, interior and exterior commissions.

Lit: *A Decade of Printmaking*, pp.98–9, ill.

971 Cancrizan Series, 1969 (Page 227)

Wall hanging chrome-plated steel base, with thirty movable magnetic units

432 × 357 × 103 mm (17 × 14 $\frac{1}{16}$ × 4 $\frac{1}{16}$ in)

Edition: 75

Exh: *William Pye New Sculpture*, Redfern Gallery, May–June 1969

Pub: 1969 (no publication number)

'A flexible magnetic sculpture in an edition of seventy-five, each signed and numbered. This sculptural object, of chrome-plated steel, consists of a base, 19 × 16 in, which can either stand or be hung. Onto this base can be placed a wide choice of small magnetised units (thirty in all) and these are reflected in the highly mirrored surface of the base.

These can be moved around, or changed simply and easily, so the spectator virtually makes his own piece of sculpture each time – offering an unusual and exciting possibility of creation within the framework determined by an established artist. The price of this object is extremely reasonable – £20 for the base, and £10 for each unit – as few or as many of each unit can be brought . . . because of its flexibility, we would suggest that it is eminently suitable for use in schools or educational establishments.' (leaflet issued by Alecto Gallery, 1969)

The title comes from musical term used to describe a phrase that is given and immediately reversed. Pye advocated that 'overcrowding of the base should be avoided', with the result that most of the edition was sold with four units.

Pye later worked for AI on maquettes for a projected motorised multiple *Koutoubia*, 1971–2, based upon the kinetic *Revolving Tower* shown in 'Kinetic Art', Hayward Gallery, 1970. The prototypes, in black, silver, crimson and cyan blue, were produced by Woodward & Barugh Ltd, Putney, under the direction of George Tooth, its title derived from an Arabic belly-dancing nightclub.

Bridget Riley (*b.*London, 1931)

Goldsmiths' School of Art, 1949–52 and RCA, 1952–5. Worked intermittently at an advertising agency, 1959–64. First solo show: Gallery One, London, 1962, with subsequent shows at Richard Feigan Gallery, New York 1965, 1967 and Robert Fraser Gallery, London, 1966. Included in: *The New Generation*, Whitechapel Art Gallery,

London, 1964; and *The Responsive Eye*, MOMA, 1965. Four screenprints entitled *Nineteen Greys* produced at Kelpra Studio, 1968.

972 Poster Poem: Descending, 1968 (Page 160)
Collaboration with Edward Lucie-Smith
Screenprint, printed in black on white mellonex 100 lb matt paper
Image: 630 × 635 mm (24$\frac{13}{16}$ × 25 in), paper: 1015 × 760 mm (40 × 29$\frac{15}{16}$ in)
Insc br printed: *Poster by Bridget Riley ©/ Poem by Edward Lucie-Smith ©/ Published by Editions Alecto/* ea, bl printed: *Descending/ Going down. How the voice/ Stepwise descends. Who cries/ There, behind the curtain/ And says those muffled words –/ Untelligible/ Secrets being told?/ You would like to know them/ But if you heard clearly,/ Would you not invoke the/ Black descent of silence?*
Edition: unlimited
Pr: Lyndon Haywood, Alecto Studios, London; pub: 1968 (ea 539)
Coll: Walker Art Gallery, Liverpool (National Museums and Galleries on Merseyside)

An unlimited edition without the poem was also produced measuring: 793 × 762 mm (31$\frac{1}{4}$ × 30 in) (paper).
Coll: Art Gallery of Ontario, Toronto

Michael Rothenstein (b.London, 1908–93)

Central School of Art and Crafts, 1924–7. Solo show of landscape watercolours, Matthiesen Gallery, London, 1938. Moved to Great Bardfield, Essex, 1941, establishing print studio, 1954. Lithographs, monotypes and etchings, 1946–56. Encouraged by Edward Bawden began to make linocuts, 1954. Relief printmaking became a central form of expression, combining wood and lino on expansive scale from late 1950s. The 1960s marked by increasing international reputation as exhibitor, writer and lecturer on graphics.

Lit: Michael Rothenstein, *Frontiers of Printmaking: New Aspects of Relief Printing*, London, Studio Vista, 1966; Tessa Sidey, *The Prints of Michael Rothenstein*, Scolar Press, 1993

973 Spider Jazz, 1965–6
Linocut, metal relief plates, printed in cream, black, white, dark and light blue, red, pink on filter paper
Image: 490 × 861 mm (19$\frac{5}{16}$ × 33$\frac{7}{8}$ in), paper: 571 × 895 mm (22$\frac{1}{2}$ × 35$\frac{1}{4}$ in)
Insc bl: *artists proof*, br: *Michael Rothenstein* (pencil)
Edition: 30, aps and proofs
Pr: The artist, with assistance of Trevor Allen, Great Bardfield studio, 1965; pub: 1966 (ea 353)
Coll: BMAG; British Council; GAC

974 Inset Wheels, 1965–6
Linocut, metal relief plates, photo-lithograph, half-tone blocks printed in black, white, cream, red on filter paper

Image: 446 × 728 mm (17$\frac{9}{16}$ × 28$\frac{11}{16}$ in), paper: 570 × 884 mm (22$\frac{7}{8}$ × 34$\frac{13}{16}$ in)
Insc bl: *2/30*, br: *Michael Rothenstein* (pencil)
Edition: 30, aps and proofs
Pr: The artist, Great Bardfield studio; the litho inset printed at Curwen Press, London; pub: 1966 (ea 354)
Coll: GAC; Drumcroon Education Art Centre, Wigan

975 Circles and Waving Lines, 1966
Linocut and stencil, printed in cream, dark and light green, red, black, pink, dark and light blue on filter paper
Image: 448 × 731 mm (17$\frac{5}{8}$ × 28$\frac{13}{16}$ in), paper: 570 × 883 mm (22$\frac{7}{16}$ × 34$\frac{3}{4}$ in)
Insc bl: *9/30*, br: *Michael Rothenstein* (pencil)
Edition: 30, aps and proofs
Pr: The artist, Great Bardfield studio; pub: 1966 (ea 356)
Coll: Drumcroon Education Art Centre, Wigan

976 Red, Blue and Brown, 1965–6
Linocut, metal relief plates and half-tone blocks, printed in cream, brown, white, red, blue ink on filter paper
Image: 445 × 727 mm (17$\frac{1}{2}$ × 28$\frac{5}{8}$ in), paper: 570 × 884 mm (22$\frac{7}{16}$ × 34$\frac{13}{16}$ in)
Insc bl: *artists proof*, br: *Michael Rothenstein* (pencil)
Edition: 30, aps and proofs
Pr: The artist, with assistance of Trevor Allen, Great Bardfield studio, 1965; pub: 1966 (ea 357)
Coll: BMAG

977 Bronze and Black, 1965–6
Linocut, metal relief plates, half-tone block, printed in white, black, brown, blue on filter paper
Image: 445 × 727 mm (17$\frac{1}{2}$ × 28$\frac{5}{8}$ in), paper: 567 × 901 mm (22$\frac{5}{8}$ × 35$\frac{1}{2}$ in)
Insc bl: *artists proof*, br: *Michael Rothenstein* (pencil)
Edition: 30, aps and proofs
Pr: The artist, Great Bardfield studio, 1965; pub: 1966 (ea 358)
Coll: BMAG

978 Diamond, 1966
Linocut and woodcut, printed in red, blue, black, yellow brown, dark grey on filter paper
Image: 683 × 446 mm (26$\frac{7}{8}$ × 17$\frac{9}{16}$ in), paper: 765 × 558 mm (30$\frac{1}{8}$ × 22 in)
Insc bl: *22/30*, br: *Michael Rothenstein* (pencil)
Edition: 30, proofs (numbered and signed working proofs)
Pr: The artist, Great Bardfield studio; pub: 1966 (ea 359)
Coll: British Council; Drumcroon Education Art Centre, Wigan; GAC

979 Round, Round, Round, 1966
Woodcut, linocut, metal relief plates, half-tone blocks printed in white, brown, red, pink, blue, dull yellow on filter paper

Image: 721 × 640 mm (28 $\frac{3}{8}$ × 25 $\frac{3}{16}$ in), paper: 795 × 693 mm (32 $\frac{5}{16}$ × 27 $\frac{5}{16}$ in)
Insc bl: *17/30*, br: *Michael Rothenstein* (pencil)
Edition: 30, proofs numbered with alphabet letters, numbered and signed
Pr: The artist, Great Bardfield studio; pub: 1966 (ea 360)
Coll: Drumcroon Education Art Centre, Wigan; GAC

980 Black, Blue and White, 1965–6 (Page 69)
Woodcut, linocut and metal relief plates printed in black, white, blue on filter paper
Image: 805 × 590 mm (31 $\frac{11}{16}$ × 23 $\frac{1}{4}$ in), paper: 914 × 650 mm (36 × 25 $\frac{5}{8}$ in)
Insc bl: *2/30*, br: *Michael Rothenstein* (pencil)
Edition: 30, proofs
Pr: The artist, Great Bardfield studio, 1965; pub: 1966 (ea 361)
Coll: BMAG

981 Radial Shakes, 1965–6
Woodcut, linocut and metal relief plates printed in pink, blue, black, dark red, brown on 3 mm filter paper
Image: 805 × 590 mm (31 $\frac{11}{16}$ × 23 $\frac{1}{4}$ in), paper: 914 × 653 mm (36 × 25 $\frac{11}{16}$ in)
Insc bl: *23/30*, br: *Michael Rothenstein* (pencil)
Edition: 30, proofs mostly numbered and signed
Pr: The artist, Great Bardfield studio, 1965; pub: 1966 (ea 355)
Coll: British Council; GAC; V&A

Ed Ruscha (b.Omaha, Nebraska, 1937)

Chouinard Art Institute, Los Angeles studying Fine and Commercial Art, 1956–60. Graphic designer, before travelling in Europe. Earliest paintings incorporated interests in typography and popular imagery. Solo exhibitions: Ferus Gallery, Los Angeles, 1963–5; Robert Fraser Gallery, London, 1966. Produced series of influential books as well as word drawings using gunpowder. Turned to unorthodox organic materials during the 1970s to stain canvases and print editions.

Lit: Siri Engberg and Clive Phillpot, *Edward Ruscha Editions 1959–1999 Catalogue Raisonné*, Walker Art Center, Minneapolis, 1999

NEWS, MEWS, PEWS, BREWS, STEWS AND DUES, 1970

Series of six organic screenprints proofed and printed by Lyndon Haywood from positives hand-cut by the artist, 1970; assisted on editioning by Kevin Harris, at Alecto Studios, London on Silverbrook Snow White Antique Finish 250 gsm paper
Image and paper: 583 × 808 mm (23 × 31 $\frac{13}{16}$ in), portfolio: 627 × 840 mm (24 $\frac{3}{4}$ × 33 $\frac{1}{16}$ in)
Inscribed bl: edition number and *E Ruscha 1970* (pencil); vo: stamped ea and publication number, and chop of Lyndon Haywood
Edition: 125, 25 ap, 1 pp

Accompanying leaflet with photos by Tony Evans of Ed Ruscha shopping in Covent Garden and series of contact sheets showing Ed Ruscha and Lyndon Haywood at work on printing this series
Presented in deep red velvet portfolio made by Multiservice Limited, London; pub: June 1970 (ea 685–90)
Coll: British Museum; Bibliothèque Nationale, Paris; New Orleans Museum of Art; Brooklyn Museum of Art

Printed shortly after Ruscha had produced a series of word lithographs at Tamarind Institute, *eg City, Air, Hey*, 1969.
'Lyn (Haywood) and Ed Ruscha would go out to buy products. Ruscha was interested in the colours from unorthodox materials We had the problem that egg salmon roe for example might change over a month from when it was first proofed. Some of the images with time have got darker, others lighter, as the cellulose in the good cartridge paper that was used reacts with the organic stains and changes the colour Baked beans and crushed daffodils, for example, gave you little colour, others like salmon roe printed darker than one might think.' (Kevin Harris, 12/6/2000)

Title Page
Inscribed: *News, Mews, Pews, Brews, Stews and Dues/ Six Organic Screenprints By/ Edward Ruscha/ Editions Alecto London/ 1970*

Second Page
Inscribed: *Important* and describing conservation concerns

Colophon Sheet
With list of ingredients used for individual prints

982 News
Screenprint, organic, split fount for background, printed with blackcurrant pie filling (Morton Beacham Products, Brentford, Middlesex), over red salmon roe (Salmonroe Products, Vancouver)
(ea 685)

983 Mews
Screenprint, organic, background printed with Bolognese sauce (Pasta Products, Croydon, Surrey) and split fount for lettering printed in blackcurrant pie filling (Morton Beacham Products, Brentford, Middlesex), over cherry pie filling (James Robertson Limited, Regent Street, London), over mixed raw egg (Valley Farm Eggs Limited, Pembroke Road, Walthamstow, London E17)
(ea 686)

984 Pews
Screenprint, organic, background printed with Hershey's chocolate flavour syrup (Hershey Foods Corporation, Pennsylvania) and Camp coffee and chicory essence (R. Patterson & Sons, Glasgow) mixed 6/4; and squid in ink (Valentin Puga, Vigo) for lettering
(ea 687)

985 Brews (Page 218)

Screenprint, organic, split fount lettering printed with axle grease (Total Limited, Hanwell, London) over caviar (Odden Caviar Limited, Sjaellands Odde, Denmark)

(*ea* 688)

986 Stews

Screenprint, organic, split fount lettering printed with crushed baked beans (H. J. Heinz & Company Ltd, Hayes, Middlesex), caviar (Odden Caviar Limited, Sjaellands Odde, Denmark), fresh strawberries (Agrexco Limited, Israel), cherry pie filling (James Robertson Limited, Regent Street, London), mango chutney (Wilkins & Sons Limited, Tiptree, Essex), tomato paste (Rebaudengo S.A.S. Turin), daffodils (Springfield, Spalding), tulips (Pick Limited, Spalding) and leaves

(*ea* 689)

987 Dues (Page 219)

Screenprint, organic, background and lettering printed with Branston Pickle (Crosse & Blackwell Limited, Croydon, Surrey)

(*ea* 690)

988 Brews, 1970

Screenprint, printed in five colours in three runs from three screens (1. brown, orange, yellow–split fount screen; 2. tan; 3. white) on snow-white antique finish paper

Image: 457 × 687 mm (18 × 27$\frac{1}{16}$ in), paper: 582 × 807 mm (22$\frac{15}{16}$ × 31$\frac{3}{4}$ in)

Insc bl : 73/75 E Ruscha 1970 (pencil), vo: stamped *ea* 750 (mostly)

Edition: 75, 15 aps, proofs

Pr: Lyndon Haywood and Kevin Harris, Alecto Studios, London; pub: 1970 (*ea* 750)

Coll: GAC; Whitworth Art Gallery, University of Manchester; Cleveland Museum of Art

'We used oil-based inks which was basically a commercial decision, as they were much less troublesome than organic materials First there was the blend of colours from the cream through to a tan, and then a film positive of a line drawing for the bubble-part of the image' (Kevin Harris, 12/6/2000)

Peter Schmidt (*b.*Berlin, 1931–80)

Emigrated to England, 1938. Goldsmiths' College, 1951–3 and Slade School of Fine Art, 1953–7 (both London). Taught at Watford School of Art from 1959. Solo shows: Beaux Arts Gallery, 1961; paintings and prints at Curwen Gallery, 1966. Live electronic improvisation and film work. *Monoprints*, Alecto Gallery, 1968; *Autobiographical Monoprints*, Lisson Gallery, 1970; and Whitechapel Art Gallery, 1975 (all London). Collaborations with Brian Eno, included the deck of cards *Oblique Strategies*, 1975 (first edition). Turned to watercolour painting. *Remembered Images*, Watford Museum, 1987.

989 Monoprints, 1968*

Screenprint, circular theme, three screens, individually printed in different combinations

Image and paper: 1016 × 762 mm (40 × 30 in)

Edition: 200

Pr: Lyndon Haywood, Alecto Studios, London; pub: 1968

(*ea* 580)

Coll: GAC

990 Flikker Book No. 7, 1972 (Page 225)

Lithograph, off-set, printed in black

75 × 93 mm (29$\frac{1}{2}$ × 36$\frac{5}{8}$ in)

Pr front: *Flikker/ book/ Peter Schmidt*, back page: *Peter Schmidt*

Pr: Hillingdon Press, Uxbridge; pub: AI, 1972

Bare stem acquires leaves and is transformed into flying bird and sun.

William Scott (*b.*Greenock, 1913–89)

Belfast School of Art, and Royal Academy Schools, London, to study painting, 1931. Learnt lithography alongside Henry Cliffe during Second World War, when both worked as cartographers for Royal Engineers. Head of Fine Art, Bath Academy of Art, 1946–56. Prominent international exhibitor during 1950s and 1960s, showing at Venice Biennale, 1958. Met Anthony Mathews, later to join *ea*, through Design Research Unit. Awarded prize for *Odeon Suite* at International Print Biennale, Tokyo, 1966.

ODEON SERIES, 1966

Six colour lithographs, crayon and tusche, printed on B. F. K. Rives paper

Image: 505 × 625 mm (19$\frac{7}{8}$ × 24$\frac{5}{8}$ in), paper: 633 × 763 mm (24$\frac{15}{16}$ × 30$\frac{1}{16}$ in, slight variations)

Insc bl: with edition number, br: signed *W Scott 66* (pencil)

Edition: 75, 15 ap

Pr: Matthieu AG, Zürich; pub: 1967 (*ea* 458–63)

Exh: Fifth International Print Biennale, Tokyo, 1966 as *Untitled, Zurich Series*

Coll: V&A; Financial Times; GAC

William Scott had a long association with Zürich and the Galerie Lienhard, where he exhibited alongside Wols, Hartung, Soulages, Ben Nicholson and Peter Lanyon amongst others in 1959. The title of this series refers to *Café Odéon*, made famous by the Dadaists before the First World War, and which Scott liked to visit on trips to Zürich.

991 I (Page 119)

Lithograph, printed in fawn, stone grey, black, maroon

(*ea* 458)

992 II
Lithograph, printed in stone grey, green, dark blue, grey black
(*ea* 459)
Coll: Art Gallery of Ontario, Toronto

993 III
Lithograph, printed in stone grey, orange, light and darker brown
(*ea* 460)

William Scott produced sixty-two prints between 1948 and 1979. His themes are usually related to gouaches, which are then developed graphically by direct drawing on the plate or stone. The related gouache, *Orange and Brown Composition*, for this particular lithograph was exhibited at The Dawson Gallery, Dublin in 1972.

994 IV
Lithograph, printed in stone grey, dark and lighter brown
(*ea* 461)
Coll: Fitzwilliam Museum, Cambridge

995 V
Lithograph, printed in dark grey, black, dark blue, orange, blue-grey
(*ea* 462)

996 VI (Page 119)
Lithograph, printed in stone grey, dark grey, buff, black, dark blue
(*ea* 463)

997 Blue Still-Life, 1975
Lithograph, off-set, tusche and crayon, printed in blue, on all British cartridge 200 gsm paper
Image: 565 × 760 mm (22 $\frac{1}{4}$ × 29 $\frac{5}{16}$ in), paper: 759 × 965 mm (29 $\frac{7}{8}$ × 38 in)
Insc b: *Blue Still Life by William Scott Published for P.S.A. Supplies Division by Editions Alecto Ltd © 1975 Printed in London England*
Edition: unlimited
Proofed by Don Bessant, Alecto Studios, London, 1975
Pr: Curwen Studio, Midford Place, London, 1975–6 under the supervision of Stanley Jones; pub: PSA, Department of the Environment, through Editions Alecto Ltd, 1975 (*ea* 912)
Coll: Cartwright Hall Art Gallery, Bradford; GAC

Robert Scott recalls that his father printed in one colour, 'as he wanted to distinguish between the editioned and unlimited image' by making the latter 'less special My father worried that people would buy his prints rather than his paintings, and so never showed paintings and prints together' (27/3/2001)

SUMMER SUITE, 1975–6
Set of three lithographs, tusche and crayon, four zinc plates, on Aquarelle Arches Satine paper

Edition: 40, 15 ap (6 ap for *Brown Predominating*) and unsigned proofs
Proofed by the artist and Don Bessant, Alecto Studios, London, summer 1975 and editioned by Curwen Studio, Midford Place, London under the supervision of Stanley Jones 1975; pub: January 1976 (*ea* 898–900)
Coll: Tate; GAC; British Council (incomplete)

The Curwen Studio records refer to edition of 50 plus 10 ap.

998 With Blue
Lithograph, printed in pinky grey, buff brown, black, blue
Image and paper: 566 × 770 mm (22 $\frac{5}{16}$ × 30 $\frac{5}{16}$ in)
Insc br: *W Scott 76 Curwen* (pencil), bl: *ea* embossed, vo: stamped *ea* 898

999 Brown Predominating
Lithograph, printed in sand, buff grey, grey, black
Image and paper: 560 × 758 mm (22 $\frac{1}{16}$ × 29 $\frac{7}{8}$ in)
Insc br: *W Scott 76 36/40* (pencil), bl: *ea* embossed, vo: stamped *ea* 899
Coll: Arthur Andersen, London

A related wash drawing is owned by Joe Studholme.

1000 Green Predominating, 1976
Lithograph, printed in green, black, blue, light green, white
Image and paper: 568 × 772 mm (22 $\frac{3}{8}$ × 30 $\frac{3}{8}$ in)
Insc br: *W Scott 76 36/40* (pencil), bl: *ea* embossed, vo: stamped *ea* 900
Coll: Glasgow Museums

Peter Sedgley (*b.*London, 1930)

Studied architecture before turning to painting. First solo show: McRoberts and Tunnard, London, 1965 included *Blue Scale* screenprint. *Looking Glass Suite* published in 1966 provided crucial regular income. Exhibitions in London, USA and Germany, 1965–72, including *The Responsive Eye*, MOMA, 1965. *Video Disques*, Alecto Gallery, London, 1969, and two *Firebird Suite* reliefs at Ikon Gallery, Birmingham, 1973. Prime interest in colour now embraced the effects of light on colour and intergration of light and sound.

1001 Blue Scale, 1965
Screenprint, printed in three blues and two greens on ivoretta board
Image and board: 483 × 484 mm (19 × 19 $\frac{1}{16}$ in)
Insc br: *Peter Sedgley '65* (pencil), vo: *K6570* stamped
Edition: 40, 9 ap
Pr: Kelpra Studio, London (invoiced 7/10/1965); pub: 1965 (*ea* 297)
Coll: Tate; Art Gallery of Ontario, Toronto; GAC

This is Sedgley's first editioned print, based upon a painting of the same title shown at the *Seven 64* group show at McRoberts and Tunnard, London, 1964. 'The circle became the dominant

form in my work . . . allowing the colours to interact with each other or, as in this case, an anonymous field of colour interacting with a simultaneous contrast of colour' (PS 26/11/1999)

LOOKING GLASS SUITE, I–IX, 1966
Nine screenprints, airbrush, with transparent title sheet, printed on M.T. white matt board
Image and board: 495 × 495 mm (19 ½ × 19 ½ in)
Insc bc: signed *Peter Sedgley* with edition number (crayon), vo: stamped ℮a with publication number and *K* with number
Edition: 75, 15 ap, 5 pp
Pr: Kelpra Studio, London, March–June 1966; pub: 1966
(℮a 310–18)
Coll: Tate; Arthur Andersen, London; GAC; British Council

Kelpra Studio entry book records 10 ap.

1002 I
Screenprint, printed in turquoise, green, two oranges
(℮a 313)

1003 II (Page 115)
Screenprint, printed in dark blue, purple, two reds
(℮a 316)

1004 III
Screenprint, printed in two blues, mauve, red
(℮a 310)

1005 IV (Page 115)
Screenprint, printed in green, three ochres, yellow
(℮a 312)

1006 V
Screenprint, printed in light yellow, pink, two blues
(℮a 317)

1007 VI
Screenprint, printed in black and three reds
(℮a 318)

1008 VII
Screenprint, printed in red, two blues, green
(℮a 311)

1009 VIII
Screenprint, printed in yellow, orange, deeper orange, brown, green, dark orange
(℮a 315)

1010 IX
Screenprint, printed in two pinks, blue, yellow
(℮a 314)

Based upon nine acrylic paintings of similar size, 'I am not a great printmaker. It is almost impossible to translate painterly texture into print There is always a graininess from one colour to another whereas I wanted to fine-tune the soft edges, to create an unstable image so that it becomes kinetic. I also wanted to lose the surface of the picture, so you were looking at an image rather than a flat object. With this in mind, I had to rethink the limitations of the print technique with the printer' (PS 26/11/1999)

FIREBIRD SUITE I–VI, 1966–7
Six ceramic tiles, low-fired porcelain, moulded and hand-coloured
Overall size: 330 × 330 mm (13 × 13 in)
Insc along side: *Sedgley 1967* with edition number (white paint); and vo stamped: *Pemberton/ Pottery/ London W6* with date
Edition: 50 (up to 12 finally made), plus ap
Produced at Pemberton Potteries, Fulham, London; pub: 1967
(℮a 494–9)
Coll: Neuberger Museum of Art, New York (4, 5 and 6)

1011 I
Porcelain, moulded, hand-painted in black, crimson and yellow outer rings, with white, yellow, green, blue, black centre rings (projects out)
(℮a 494)

1012 II
Porcelain, moulded, hand-painted in blue, green, yellow, white, orange, crimson, black
(℮a 495)

1013 III
Porcelain, moulded, hand-painted in blue, green and yellow outer rings, with white centre
(℮a 496)

1014 IV
Porcelain, moulded, hand-painted in black, crimson and yellow outer rings, with white, yellow, green, blue and black centre rings (projects inwards)
(℮a 497)

1015 V
Porcelain, moulded, hand-painted, in black, red crimson, red orange and yellow outer rings, with white centre
(℮a 498)

1016 VI
Porcelain, moulded, hand-painted in white and yellow circles
(℮a 499)

'The potter Joseph Pemberton used to drink in the Queen's Elm, Fulham Road. Over a pint we decided to make a multiple

together I was interested in the idea of the ambiguity of the circle being accentuated by laying a circular form on top of a moulded form; the ambiguity between what was painted and what was sculptured I wanted a matt rather than a glossy surface as I wanted to lose the surface as a reflective surface I went through the spectrum of cold and warm colours: blue-violet, dark green, middle green, light green, yellow and on the other side: yellow, yellow orange, orange, red, purple, red and violet I like them to be shown on their own on the wall, screwed from the back. Glass always distracts as there is reflection' (PS 26/11/1999)

1017 Poster: Probe, 1968
Screenprint, printed in red, orange, blue on cartridge paper
Image and paper: 885 × 659 mm (34 $\frac{7}{8}$ × 25 $\frac{15}{16}$ in)
Text: *Probe/ Environmental Events/ Middle Earth/ 43 King Street WC2/ Admission by Purchase of Poster 8.00pm Jan 21 theatre of conflict; the mind; psychological powers are/ mobilizing/ A.I.R. The agency, enlists minds for guerilla training &/ present an environment to support stance/ probe the occult region zeitgeist at/ Middle Earth on Sunday 21 January 8pm/ The purchase of probe poster is admission*
Edition: unlimited
Pr: Alecto Studios, London

'I made it up to promote happenings and multimedia events a group of us were presenting at the Middle Earth venue in Covent Garden. Artists taking part included Stuart Brisley, John Latham, Cornelius Cardew, Bruce Lacey, Yoko Ono, Peter Dockley, myself and others.' (PS, 26/11/1999)

1018 Poster: Floodlight, 1968
Screenprint, printed in black, yellow, blue, green on mellonex paper
Image and paper: 444 × 442 mm (17 $\frac{1}{2}$ × 17 $\frac{7}{16}$ in)
Insc printed: ea/ new graphics/ from/ Editions Alecto/ continuously on show at/ The Alecto Gallery/ 30 Albemarle Street/ London W1/ tel 01–493–4226, vo: 'Floodlight' by Peter Sedgley 1968/ Published by Editions Alecto Limited/ Printed in England
Pr: Lyndon Haywood, Alecto Studios, London
Edition: unlimited (ea 540)

VIDEO DISQUES, 1969–70 (Page 175)
Boxed portfolio of six kinetic screenprints on spun aluminium discs, painted in fluorescent colours, with motor and ultraviolet light unit
Diam: 760 mm (29 $\frac{15}{16}$ in)
Insc vo: signed, dated, titled (abbreviated letters) and editioned by the artist
Edition: 100, 20 ap (only half of the edition is thought to have been finally produced)
Pr: Lyndon Haywood and Michael O'Connor, Alecto Studios, London, 1969–70
Motor/Lamp unit by George Robbins of Design Animations,

Wandsworth, London
Black box for motor and light unit and spun aluminium discs inscribed: *Video Disques/ Peter Sedgley/ 1969/ Editions Alecto Ltd.*; and made by Harris Display Ltd; 790(h) × 830(w) × 245(d) mm (31 $\frac{1}{8}$ × 32 $\frac{11}{16}$ × 9 $\frac{21}{32}$ in)
Pub: December 1969 (ea 597–602)
Lit: *A Decade of Printmaking*, 1973, p.97 (ill.)
Coll: Walker Art Gallery, Liverpool (National Museums and Galleries on Merseyside; 5 and 6)

Sold as set and individually at respectively £200 and £40, the manufacture of *Video Discs* continued into 1970.

In a letter accompanying publication, Joe Studholme writes: 'If you display or sell individually *Video Disques* without motor unit, use a black ultraviolet light. They work marvellously statically as well as kinetically.'

1019 Disque 1: Red, Orange, White
(ea 597)

1020 Disque 2: Yellow, Orange, Blue
(ea 598)

1021 Disque 3: Yellow, Orange, Red
(ea 599)

1022 Disque 4: Blue, Orange, Yellow
(ea 600)

1023 Disque 5: Blue, Yellow, Blue
(ea 601)

1024 Disque 6: Yellow, White, Orange
(ea 602)

'I painted a large five foot in diameter painting *Cosmos* shown at the Redfern Gallery in 1968, a moving kinetic painting, the first of its kind. At the same time, I showed my initial proof ideas on card for *Video Disques*. I was interested in the properties of ultraviolet light and fluorescent colour and how they responded to each other. The original idea for a spun disc came from a record player and I tested the speeds for the aluminium discs on a 33 $\frac{1}{3}$ speed turntable' (PS, 26/11/1999)

George Segal (b.New York, 1924–2000)

New York University and Rutgers University, New Jersey. First solo show: Hansa Gallery, New York, 1956. Turned to sculpture. First work cast in white plaster from a living body, *Man at a Table*, 1961. Characteristic setting for these figures was an environmental assemblage of real objects. Regular exhibitions with Sidney Janis Gallery, New York, 1965–80s. Associated with *American Pop* exhibitions in the 1960s. In 1969 developed series of variations around the idea of a 'box' framing partial views of figures.

Lit: *A Decade of Printmaking*, 1973

1025 Girl on a Chair, 1969–70 (Page 174)
Wall hanging multiple in white plaster, wooden-backed chair painted red contained within black painted lumber-wood box, with crate stamped: *George Segal/ Girl on a Chair/ Editions Alecto Ltd/ 1970*
Box: 916 (h) × 610 (w) × 299 (d) mm (36$\frac{1}{16}$ × 24 × 11$\frac{25}{32}$ in); crate: 1045 (h) × 690 (w) × 436 (d) mm (41$\frac{1}{8}$ × 27$\frac{3}{16}$ × 17$\frac{3}{16}$ in)
Edition: 150, 30 proofs
Manufacturer: Norman and Raymond Harris Displays, 1969; pub: Editions Alecto Ltd and Hans Neuendorf, 1970 (*ea* 650)
Coll: Wolverhampton Museum and Art Gallery; Brooklyn Museum of Art, New York

'That same chair has been knocking around in my studio for years with the funny steps cut into the back of it. After having been drawn so often, it's finally been incorporated into a sculpture. The chair is like a ladder with steps, the box is like a house, the girl is like a Greek caryatid holding up the roof I've always liked the hardness and softness combined, this wedding of organic and geometric' (GS in conversation with Richard Bellamy, 13/9/1969)

Doris Seidler (*b.*London, 1912)

Resident in USA since 1940. Studied at Atelier 17, New York, 1940–5. Fellowship at Tamarind Lithographic Workshop, 1964. Member and past Vice President of The Society of American Graphic Artists. Represented in: Library of Congress, Washington; Whitney Museum, New York and British Museum. Exhibitions include: The Print Centre, London, 1964; *Atelier 17* exhibition, Elvehjem Art Center, Wisconsin, 1977; and solo exhibition of collages on handmade paper at Pallant House, Chichester, 1991.

ARKHAIOS SERIES – VARIATIONS ON A THEME OF ANTIQUITY 1963–4
Eight relief prints, plus one lithograph, from the series of eighteen numbered in Roman numerals indicating the order in which they were done
Proofed by the artist in Great Neck studio, New York and pr: Sergio Gonzalez-Tornero, New York (unless stated otherwise); pub: 1964 (*ea* 157–65)
Coll: BMAG; GAC (incomplete)

The artist describes the theme as being, 'prompted by my love of ancient wall surfaces, steles, ruins, all the marvellous textural things that one finds on ones travels – mine from Mexico to Greece, and points inbetween Mr Cornwall-Jones selected the pieces – no doubt with thoughts of saleability in mind. They had previously put on an exhibition in their London gallery of the complete series' (DS, 3/12/1998)

1026 Arkhaios (No V), 1963
Relief etching, zinc plate, printed in yellow ochre toned white ink on Van Gelder paper
Image: 175 × 254 mm (6$\frac{7}{8}$ × 10 in), paper 329 × 414 mm (12$\frac{15}{16}$ × 16$\frac{5}{16}$ in, some variation)
Insc bl: *12/25 Arkhaios V*, br: *D Seidler 63* (pencil)
Edition: 25, 6 ap, bat (*ea* 157)

1027 Arkhaios (No XVI), 1964 (Page 31)
Relief etching, copperplate, printed in yellow ochre toned white ink on Van Gelder paper
Image: 226 × 302 mm (8$\frac{7}{8}$ × 11$\frac{7}{8}$ in), paper 410 × 489 mm (16$\frac{1}{8}$ × 19$\frac{1}{4}$ in)
Insc bl: *12/25 Arkhaios XVI* and *Doris Seidler 64* (pencil)
Edition: 25, 4–6 ap, bat (*ea* 158)

1028 Cento (No VI), 1963–4
Relief etching, copperplate, printed in yellow ochre toned white on Van Gelder paper
Plate: 151 × 224 mm (5$\frac{15}{16}$ × 8$\frac{13}{16}$ in), paper: 487 × 445 mm (19$\frac{3}{16}$ × 17$\frac{1}{2}$ in)
Insc bl: *proof Cento/ Arkhaios VI*, br: *D Seidler 63*, b: *Ed 25 20 prints sold to Editions Alecto London* (pencil)
Edition: 25, 4 ap, bat
Proofed and half-editioned by the artist at Seong Moy's workshop, Provincetown, Cape Cod; printing completed by Sergio Gonzales, New York (*ea* 159)
Coll: Manchester City Art Galleries

1029 Façade I, (No III) 1963–4
Relief etching, copperplate, printed in toned white on Van Gelder paper
Image: 193 × 108 mm (7$\frac{5}{8}$ × 4$\frac{1}{4}$ in), paper: 249 × 156 mm (9$\frac{13}{16}$ × 6$\frac{1}{4}$ in)
Insc bl: *proof Façade*, br: *D Seidler/ 64*, b: *Ark 111/ ed. sold to Editions Alecto London* (pencil)
Edition: 25, 6 ap, bat (*ea* 160)

1030 Moongarden I (No I), 1963–4 (Page 31)
Relief etching, two copperplates including 'the collaged moon', printed in darker and lighter ochre toned white on Van Gelder paper
Plate: 185 × 107 mm (7$\frac{5}{16}$ × 4$\frac{7}{32}$ in), paper 293 × 212 mm (11$\frac{9}{16}$ × 8$\frac{3}{8}$ in)
Insc bl: *Bon a tirer/ Moongarden 1*, br: *D Seidler 63*, bl corner: *Arkh 1/ Ed 25 5/25–25/25 sold to Editions Alecto London* (pencil)
Edition: 25, 4 ap (*ea* 161)

1031 Moonworld II (No II), 1963–4
Relief etching, two zinc plates, printed in grey toned white on Van Gelder paper
Overall plate size: 153 × 100 mm (6$\frac{1}{32}$ × 3$\frac{15}{16}$ in), paper: 278 × 223 mm (10$\frac{15}{16}$ × 8$\frac{13}{16}$ in)

Insc bl: *P6*, br: *D Seidler 63*, b: *Edition sold to Editions Alecto London Moonworld 11* (pencil)
Edition: 25, 6 ap and 3 on Doug Howell paper (ea 162)

1032 Tamarind (No XX), 1963–4

Lithograph, tusche, printed in beige on B. F. K. Rives paper
Image and paper: 380 × 512 mm (15 × 20$\frac{3}{16}$ in)
Insc bl: *Ed/20 PVI/X*, br: *D Seidler 63* (pencil), with embossed chops of Ken Tyler and Tamarind Lithography Workshop
Edition: 20, 9 Tamarind impressions, 3 ap, pp, presentation proof, tp, 2 paper trial proofs, cp
Pr: Ken Tyler, Tamarind Lithographic Workshop, Los Angeles, 21 January 1964 (ea 163)
Lit: *Tamarind*, p.221
Coll: University of New Mexico Art Museum, Albuquerque; BMAG; National Gallery of Art, Washington; Chicago Art Institute; Los Angeles County Museum; MOMA

Titled *Arkhaios* by Tamarind Lithography Workshop and *Tamarind* by the artist.

1033 Temple (No XIII), 1964

Relief etching, zinc plate, printed in faint-ochre toned white on J. Green paper
Plate: 150 × 228 mm (5$\frac{15}{16}$ × 9 in), paper: 325 × 458 mm (12$\frac{13}{16}$ × 18$\frac{1}{16}$ in)
Insc bl: *P2/VI Temple–Arkhaios XIII*, br: *D Seidler 64*, b: *Edition sold to Editions Alecto London* (pencil)
Edition: 25, 6 ap, bat (ea 164)

1034 Triad, 1964

Relief etching, two zinc plates printed in ochre toned white on Van Gelder paper
Overall plate size: 125 × 130 mm (4$\frac{15}{16}$ × 5$\frac{1}{8}$ in), paper: 202 × 204 mm (7$\frac{31}{32}$ × 8$\frac{3}{32}$ in)
Insc bl: *A P/ Edition 25. Sold to Editions Alecto London*, br: *D Seidler* (pencil), vo: *Triad* (pencil)
Edition: 25, 3 ap, bat (ea 165)

'All of these prints were essentially white on white in high relief. The white ink was toned either with yellow ochre giving a warm tone or with grey for a cooler white.

Where Gonzales printed the edition, I had first done the proofing. In the case of *Centro*, I printed the first half of the edition and Gonzales did the second half. My studio at the time was 215 Middle Neck Road, Great Neck.' (DS, 11/11/1998)

Colin Self *(b.Norwich, 1941)*

Norwich School of Art, and Slade School of Art 1961–3 where began to produce multiple-plate *Nuclear Bomber* etchings. USA and Canada, 1962 and 1965, working in pencil and pen as well as producing sculptures on theme of nuclear destruction. First solo exhibition: Piccadilly Gallery, London, 1965 which included dye-line prints. ea became main outlet for prints, 1968–71. More recent London

exhibitions: ICA, 1986; and Tate Gallery, 1995–6.

Lit: *Tate Gallery Catalogue of Acquisitions 1982–84*; *Colin Self One Man Exhibition*, Tate Gallery, 1995–6

1035 Out of Focus Object and Flowers 1 (Provincial Image), 1968 (Page 165)

Etching and aquatint, zinc plate, printed in pink and brown on Crisbrook waterleaf paper
Plate: 543 × 447 mm (21$\frac{3}{8}$ × 17$\frac{5}{8}$ in), 788 × 571 mm (31$\frac{1}{8}$ × 22$\frac{1}{2}$ in)
Insc b: *Artists proof 1/10/ Out of focus object & flowers 1 (provincial image) Colin Self '68* (pencil)
Edition: 75, 10 ap
Pr: Maurice Payne and Danyon Black, Alecto Studios, London, May 1968; pub: 1968 (ea 534)
Coll: British Council

1036 Out of Focus Object and Flowers 2 (the 1940s), 1968

Aquatint, copperplate, printed in purple pink on Crisbrook waterleaf paper
Plate: 540 × 443 mm (21$\frac{1}{4}$ × 17$\frac{7}{16}$ in), paper: 775 × 565 mm (30$\frac{1}{8}$ × 22$\frac{1}{4}$ in)
Insc b: *Artists Proof Out of Focus Object & Flowers 2 (The 1940s) Colin Self 1968* (pencil)
Edition: 75, 10 ap
Pr: Maurice Payne, Alecto Studios, London, May 1968; pub: 1968 (ea 535)
Coll: GAC; Castle Museum, Norwich; British Council; Art Gallery of Ontario, Toronto

1037 Out of Focus Object and Flowers 3 (the 1940s), 1968

Etching, hard-ground, copperplate, with photographic sources screened onto second copperplate print; printed in black, rolled pure oil onto which raw silver pigment was sprinkled through a sieve, and violet on Crisbrook waterleaf paper
Plate: 700 × 551 mm (27$\frac{9}{16}$ × 21$\frac{11}{16}$ in), paper: 1049 × 695 mm (41$\frac{5}{16}$ × 27$\frac{3}{8}$ in)
Insc b: *20/75 Out of Focus Object & Flowers 3 (the 1940s) Colin Self 1968* (pencil), vo: ea *536*
Edition: 75, 10 ap, at least 9 stage proofs, trial proof (Tate)
Pr: Maurice Payne and Danyon Black, Alecto Studios, London, May 1968; pub: 1968 (ea 536)
Prizewinner at Bradford International Print Biennale, 1968
Coll: GAC; Cartwright Hall, Bradford; British Council

Tate has a unique trial proof whose surface has broken down in the acid, while a stage proof with collage of earth/moon has been seen at the Alan Cristea Gallery, as well as working proof insc: *6/ gold, crimson gold and crimson/ Dear Maurice, screen of glitter objects to cover this/ Colin*

Self writes: 'this one took *ages* to get "there" . . . a lovely time creating this etching with Maurice Payne and Danyon Black at Alecto. It's about "turning the clock back". Memory. An inner yearning almost back to an age of my early childhood before the

bomb on Hiroshima. And before one was ever confronted and assaulted by all those arrogant, prattish "isms" of Art and behaviour. It's about time, oracles' (Notes, Alan Cristea Gallery)

1038 Picasso's Guernica and the Nazis, 1968
Lithograph, red biro and black Indian ink
Image: 180 × 311 mm ($7\frac{3}{32}$ × $12\frac{1}{4}$ in)
Insc bl: *Lithotrial 2 1/3 CS 1968/ Picasso's Guernica and the Nazis*
Pr: Ian Lawson, Alecto Studios, London
Proofs: 3 – from 'two or three works on this theme, each with a different *Picasso Forgery* drawn in ink to bring out one of the "whys" of his art.' (*Tate Gallery 1982–84*)
Coll: Tate

From an intended series *Ritual in our Times*, 'a litho series to have included the funeral of President Kennedy (his horse with boots reversed in stirrups) The only trial print created was of a 1930s Nazi rally. Suite abandoned in order to concentrate energies on (sic) the Alecto etchings series.' (*Notes,* Castle Museum, Norwich)
　This remains a rare lithograph by Self, 'I didn't like litho and thought it too flowery. I like the 25 tons per inch pressure of etching and if I screenprinted – wanted it like that too – R E A L.' (CS, 27/11/2001)

POWER AND BEAUTY SERIES, VOLUME ONE, 1968–9
Five photo-screenprints and one photo-etching. Edition: 75, 15 ap; plus three smaller editions and related proofs. Unless stated otherwise, screenprinted by Lyndon Haywood, Alecto Studios, London, 1968–9; pub: 1968 (ea 549–55, 563–5).
Coll: V&A; Tate; MOMA; British Council (incomplete set)

1039 Cat, 1968 (1)
Photo-screenprint, printed in white on black on Saunders rag paper
Image and paper: 678 × 1040 mm ($26\frac{11}{16}$ × $40\frac{15}{16}$ in)
Insc bl: *Power & Beauty No 1*, br: *64/75 Colin Self* (white ink)
Edition: 75, 15 ap, pp (ea 549)
Coll: Manchester City Art Gallery; Art Gallery of Ontario, Toronto

A date is included in most of the impressions in this edition: *15–10–68*. The source for nos 1, 2, 4, 5 and possibly 6 was *Hutchinson's Animals of all Countries*, Hutchinson and Co, London, 1923–5, which Self's first wife's grandmother had given him in the 1950s.

1040 Whale, 1968 (2)
Photo-screenprint, printed in steely-blue and black on Saunders rag paper
Image and paper: 675 × 1046 mm ($26\frac{9}{16}$ × $41\frac{3}{16}$ in)
Insc bl: *Power & Beauty No 2*, br: *64/75 Colin Self* (white ink)
Edition: 75, 15 ap, 8 pp (ea 550)

Coll: BMAG

1041 Car, 1968–9 (3) (Page 163)
Photo-screen etching, zinc plate, printed in black intaglio and silver grey surface roll on Saunders rag paper
Image and paper: 675 × 1027 mm ($26\frac{9}{16}$ × $40\frac{7}{16}$ in)
Insc bl: *Power & Beauty No 3*, br: *64/75 Colin Self* (pencil)
Edition: 75, 15 ap and pp
Proofing begun by Maurice Payne and Danyon Black, 1968; re-proofed and editioned by James Collyer and John Crossley, Alecto Studios, London, 1969; pub: 1968 (ea 551)

Self also produced a screened version of this image (ea 563).

1042 Cockerel, 1968 (4)
Photo-screenprint, printed in red, lime yellow, black on Saunders rag paper
Image and paper: 1046 × 675 mm ($41\frac{3}{16}$ × $26\frac{9}{16}$ in)
Insc b: *Artists Proof 11 Colin Self Power + Beauty No 4* (white ink)
Edition: 75, 15 ap, 11 pp (ea 552)
Coll: National Gallery of Canada, Ottawa

1043 Elephant, 1968 (5)
Photo-screenprint, printed in black and terracotta red on Saunders rag paper
Image and paper: 680 × 1047 mm (27 × $41\frac{1}{4}$ in)
Insc b: *Power + Beauty No 5 67/75 Colin Self* (white ink)
Edition: 75, 15 ap, 17 pp (ea 553)
Coll: Brooklyn Museum of Art

1044 Peacock, 1968–9 (6) (Page 162)
Photo-screenprint, printed in white onto black screen, with cyan, yellow, magenta printed on top on Saunders rag paper
Image and paper: 700 × 991 mm ($27\frac{9}{16}$ × 39 in)
Insc b: *Power + Beauty No 6 Artists Proof 3 Colin Self* (white ink)
Edition: 75, 15 ap, 8 pp (ea 554)

The *Power and Beauty* prints are 'about images which have haunted me . . . (and) have seemed complete and impregnable. All I have wanted to do with them so far is to foster them (a valid act) and to try to recreate those images and what they have made me feel. By using a standard size for all the prints (and other devices) the subjects are transformed, can be seen for appearance, aggressive or passive looks. This upsets the objects's real physical size to a certain extent so that eg the cockerel looks deadlier and more massive than the charging elephant and Joe Baillon's classic customised car becomes elephantine, sinister and oppressive, more menacing than nuclear warheads.' (Colin Self, *Notes – Alecto Gallery,* 1968)
　The final *Peacock* edition was intentionally 'dark', though contains lighter impressions simply printed in cyan directly onto white paper. Self states that 'a third to a half of the edition' was printed this way.
→ p.231

Plate 142 Les Levine, *Masterprint* (*Front Cover*), 1970 (633)

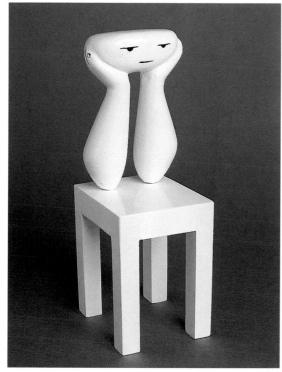

143

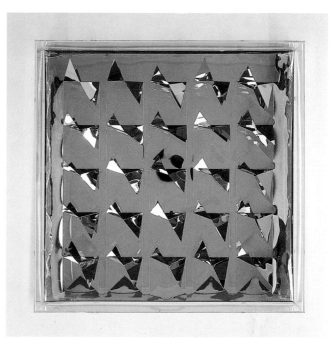

145

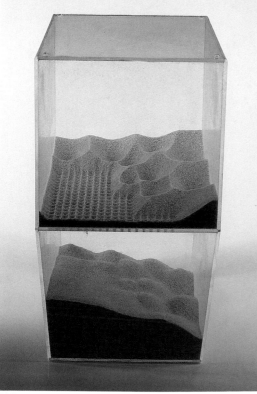

144

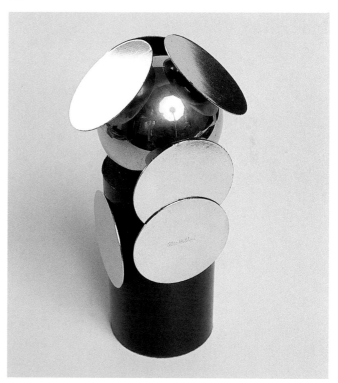

146

Plates 143–6 Kenneth Armitage, *Daydream*, 1973 (9); Chic Taylor, *Sandbox II*, 1971(1092); Michael Michaeledes, *Silver Reflections*, 1971 (672); Alice Hutchins, *Sound Piece*, 1971 (498)

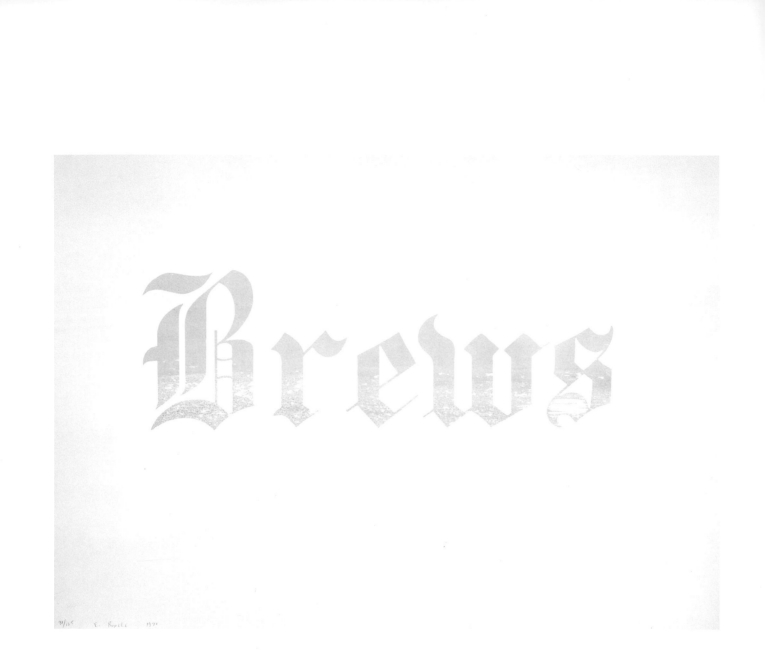

Plates 147, 148 Ed Ruscha, *Brews* and *Dues* from *News, Mews, Pews, Brews, Stews and Dues*, 1970 (985, 987)

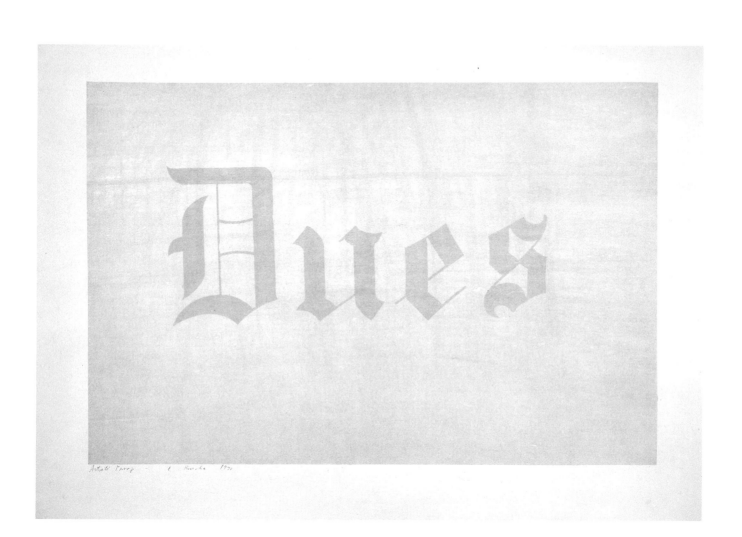

Artist's Proof — / Ruscha 1970

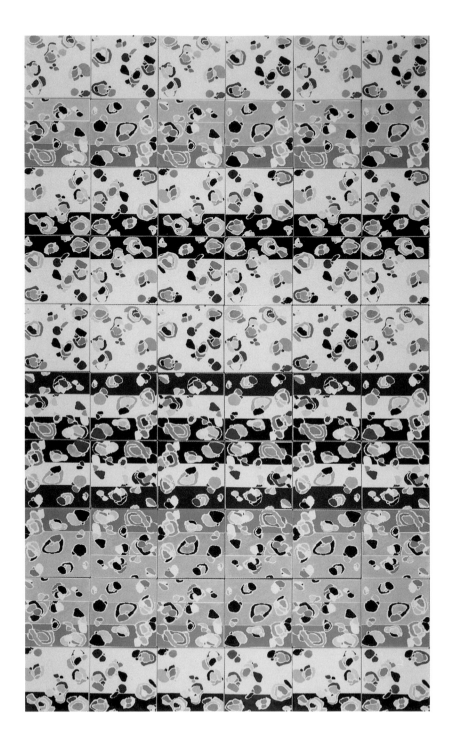

Plate 149 Gillian Ayres, *Variants*, a wall arrangement, 1970 (17–24)

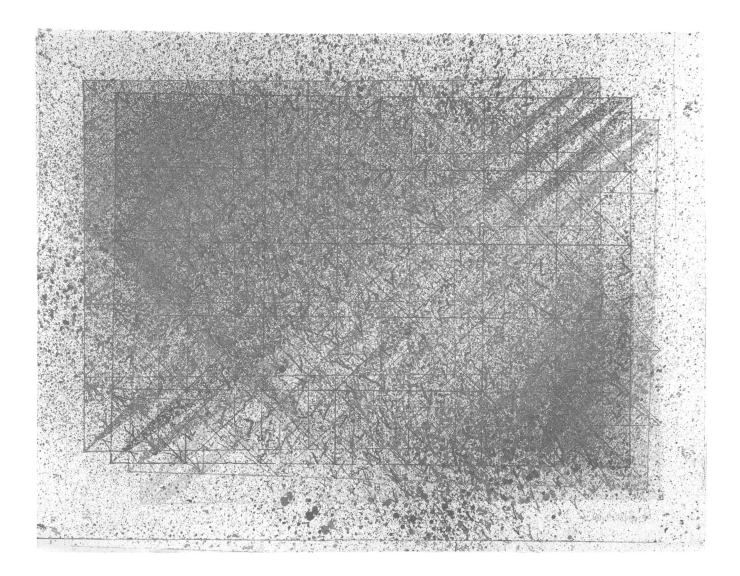

Plate 150 David Leverett, *State of Change*, 1973 (629)

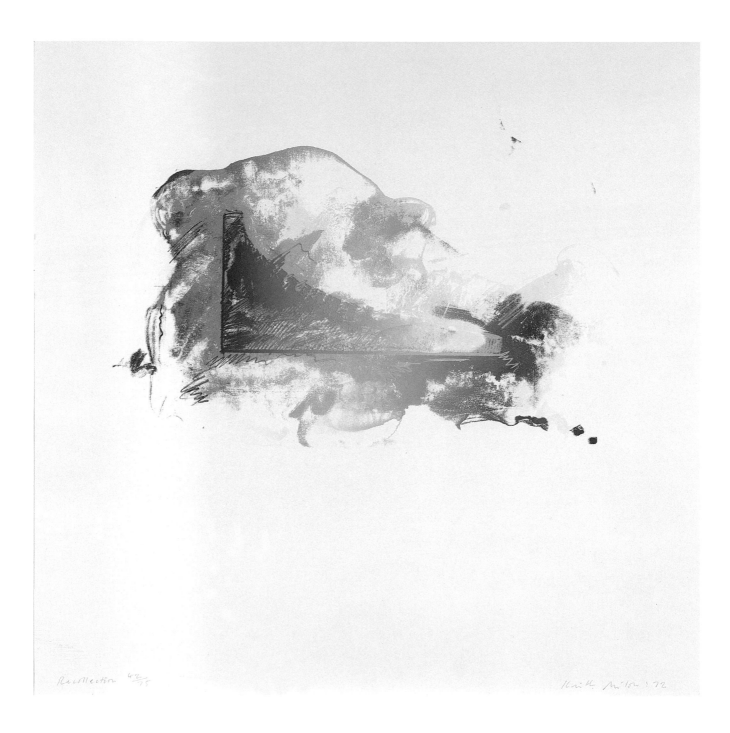

Recollection 42/75 Keith Milow 72

Plate 151 Keith Milow, *Recollection*, 1972 (673)

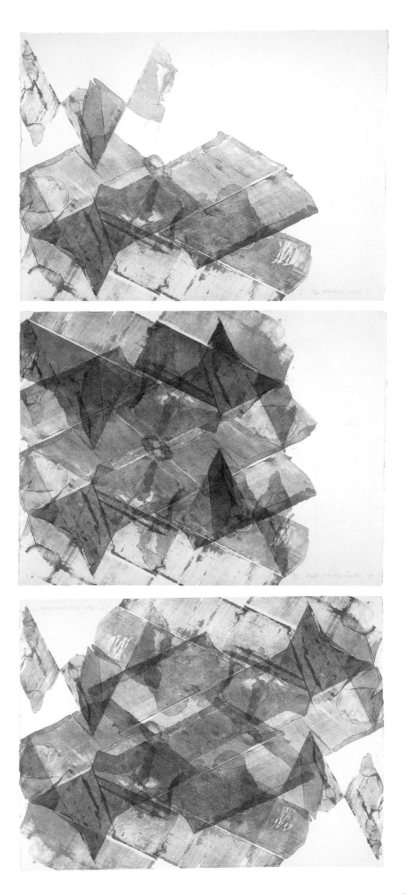

Plates 152–4 Mark Lancaster, *Henry VI*
(*Monochrome*), 1972 (607–9)

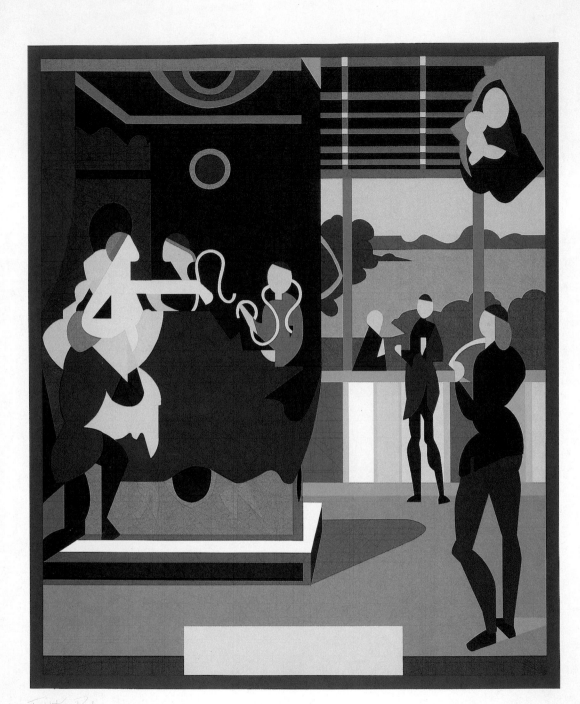

Plate 155 Tom Phillips, *After Raphael?*, 1972–3 (905)

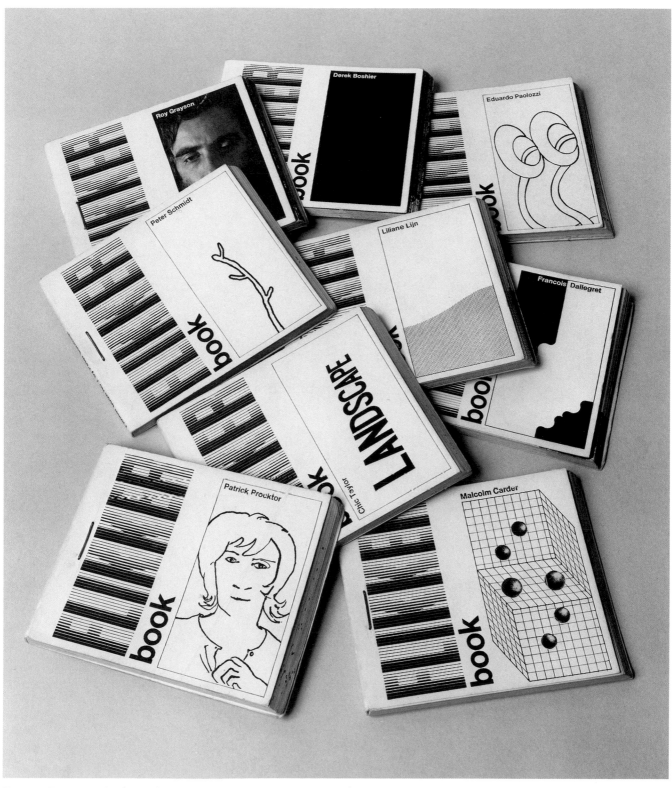

Plate 156 *Flikker Books* (1–9), 1971 (139, 154, 242, 405, 640, 896, 928, 990, 1093)

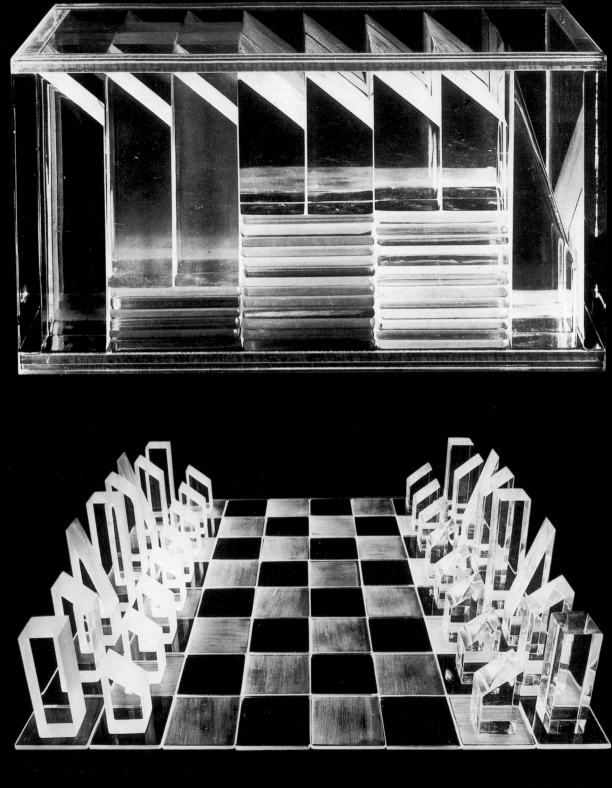

Plate 157 David Pelham, *The Minimum Chess Set*, 1970, closed and open (904)

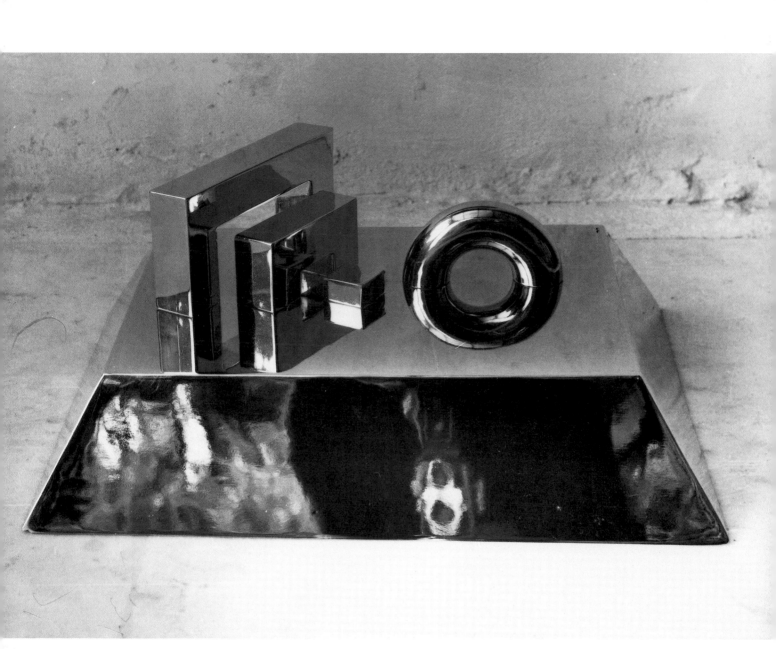

Plate 158 William Pye, *Cancrizan Series*, 1961 (971)

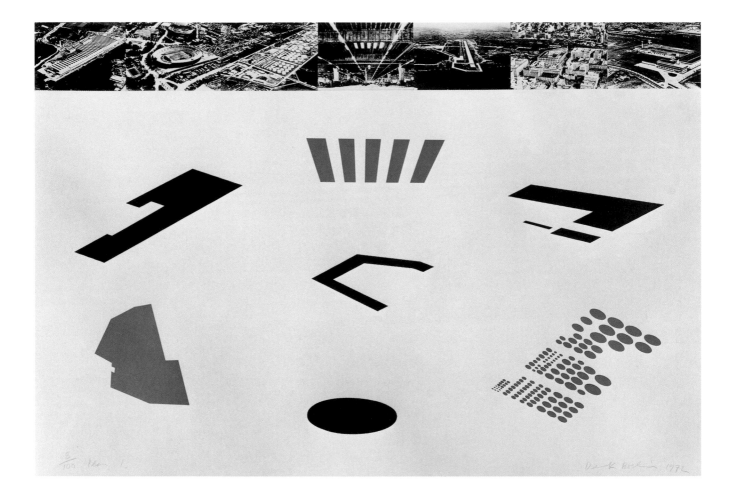

Plates 159, 160 Derek Boshier, *Plan I* and *II*, 1972 (135–6)

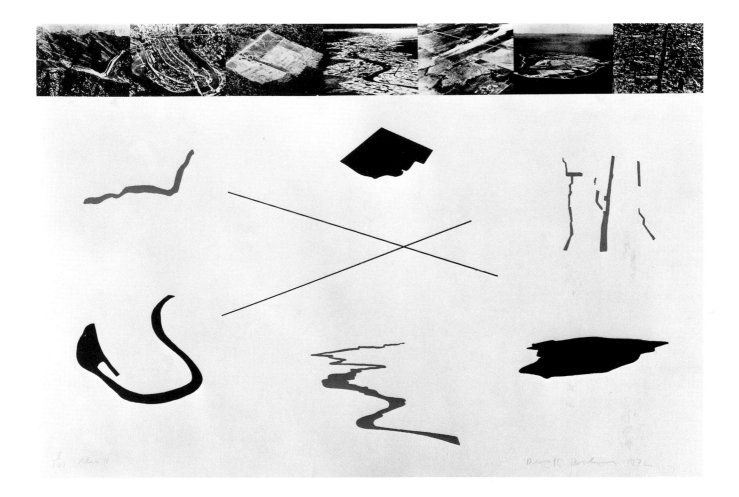

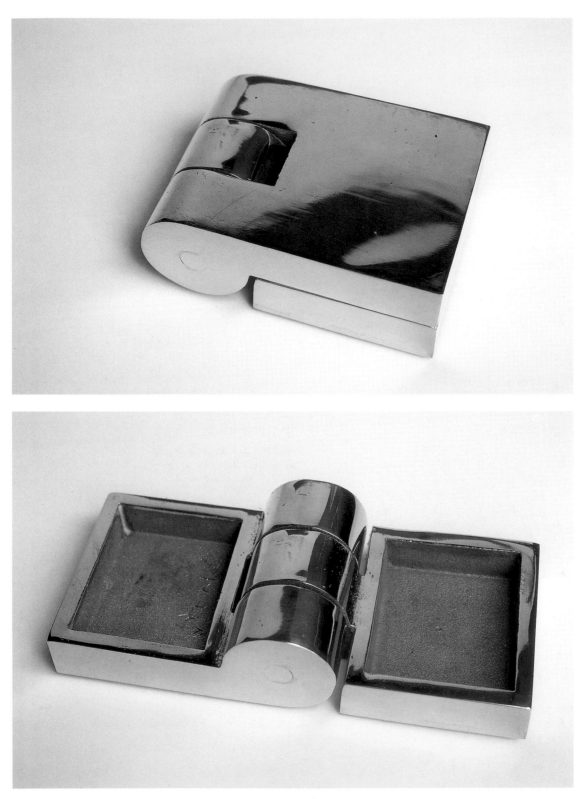

Plate 161 Tony Stubbing, *The Windsor Box*, 1971, closed and open (1090)

1045 White Peacock (7), 1968
Photo-screenprint, printed in white on black screened paper
Image and paper: 728 × 993 mm (28$\frac{11}{16}$ × 39$\frac{1}{8}$ in)
Insc bc: *Colin Self Power & Beauty no 7 2/2*
Proofs: 2
Coll: Tate

1046 Portfolio Print: Unique Airship (8), 1968
Photo-screenprint, printed in black over grey on stiff cartridge paper
Image and paper: 675 × 1048 mm (26$\frac{9}{16}$ × 41$\frac{1}{4}$ in)
Insc bl: *Power and Beauty Unique Print No 2 Colin Self*, br: *27/30*, vo: ℮ 564
Edition: 30 (15), 3 (12) ap, 5 pp? (℮ 564)

Artist's proofs of this R100 airship, designed by Barnes Wallace, include a brown printing. Another blue variant is inscribed: *Power & Beauty No 8 1/1 Colin Self/ Unique.*

1047 Howitzer "Supply" (9), 1969
Photo-screenprint, printed in white on black sugar paper
Image and paper: 613 × 1021 mm (24$\frac{1}{8}$ × 40$\frac{3}{16}$ in)
Insc: *Power & Beauty No 9 1/2 Colin Self* (ink)
Edition: 2, plus one gift

1048 Howitzer "Supply": Second Stage (9a), 1969
Photo-screen etching, copperplate, bitten and open etched, printed in black and heavily annotated in pencil
Image and paper: 665 × 997 mm (26$\frac{3}{16}$ × 39$\frac{5}{16}$ in)
Unique proof
Proofed: Danyon Black, Alecto Studios, London
Coll: The artist

'Howitzer "Supply" was to become a two plate black and colour etching. The three screenprints were trials on black sugar paper. We etched it. One print was made, very interesting Work interrupted by "home domestics" and the plate regretfully got destroyed in (sic) the Alecto fire.' (catalogue notes by Colin Self in Castle Museum, Norwich)

1049 Portfolio Print: Unique Car, 1968
Photo-screenprint, printed in orange and black
Image and paper: 678 × 1058 mm (26$\frac{11}{16}$ × 41$\frac{11}{16}$ in)
Insc bl: *Power and Beauty Colin Self* (white ink)
Edition: 15, 12 ap, 3 pp (℮ 563)
Coll: British Council; MOMA

This is a reversed screen version of *Car* in the *Power and Beauty* Series; other colour variants also exist.

1050 Prelude to Power and Beauty (Marauder), 1968
Photo-screen etching, copperplate, printed in black and white; plate marks then cropped, laid onto screened red sheet
Image: 234 × 354 mm (9$\frac{7}{32}$ × 13$\frac{15}{16}$ in), paper: 572 × 790 mm (22$\frac{1}{2}$ × 31$\frac{1}{8}$ in)

Insc b: *Prelude to the Series 'Power & Beauty' 11/15 Colin Self 14-10-68* (white ink), vo: ℮ *565* stamped
Edition: 15, 10 ap
Pr: Lyndon Haywood, Maurice Payne and Danyon Black, Alecto Studios, London; pub: 1968 (℮ 565)
Coll: British Museum

'Marauder bomber against a Tibetan sky, guillotined like a photo, and then glued onto red-screened sheets of paper I didn't want the effects of plate marks' (CS, 23/11/2001)

The ℮ Register records that ℮ 563–5 were 'printed for inclusion in the first fifteen sets of The *Power and Beauty* Series'. Self also recalls that he suggested copies be given to critics.

1051 Poster Poem: Electric Chair, 1968 (Page 161)
Collaboration with Christopher Logue
Off-set lithograph, printed in black with red pink for text
Image and paper: 976 × 402 mm (38$\frac{7}{16}$ × 15$\frac{13}{16}$ in)
Edition: unlimited, printed both sides; 11 or 12 numbered and signed by the author
The poster shows a photograph of Jimmy Thompson, executioner, and Willie Mae Bragg after 2300 volts had been sent through Bragg's body
Lit: George Ramsden, *Christopher Logue A Bibliography 1952–97*, Stone Trough Books, 1997 (D15)
Pub: Ad Infinitum Ltd, London, 1968
Coll: National Museum and Gallery, Cardiff; Whitworth Art Gallery, University of Manchester

Text: *Mister,/ I have Sold You/ An Electric Plug,/ An Electric Torch,/ An Electric Blanket,/ An Electric Bell,/ An Electric Cooker,/ An Electric Kettle,/ An Electric Fan,/ An Electric Iron,/ An Electric Drier,/ An Electric Mixer,/ An Electric Washer,/ An Electric Fire,/ An Electric Peeler,/ An Electric Sweeper,/ An Electric Knife,/ An Electric Clock,/ An Electric Tooth-Brush,/ An Electric Tea-pot,/ An Electric Sewer,/ An Electric Fye,/ An Electric Light; Allow me To Sell You/ An Electric Chair*
Insc b: *Poster Poem by Colin Self + Christopher Logue/ Published by Ad Infinitum Limited, London © 1968 105*

This image is printed on both sides: a white executioner and black victim, and verso in negative (reversed): a black executioner and white victim. A large number of these posters were donated to support the Occupation of Glasgow Shipyard.

PRELUDE TO 1000 TEMPORARY OBJECTS OF OUR TIME, (VOLUME 1), 1971
Series of nine etchings, eleven copperplates, on Crisbrook paper
Insc vo: with title, edition number, signature and date in pencil (*Colin Self 25–27 Aug 71*), with ℮ stamp and number, and respective *JC* and *J* stamps of James Collyer and John Crossley
Edition: 60, at least 5 ap
Pr: James Collyer and John Crossley of J. C. Editions, Alecto Studios, London; pub: 1971 (℮ 791–9)
Coll: Castle Museum, Norwich; British Council; Tate

1052 Single Blackbird 2 (1)
Etching, open bite, printed in black
Plate and paper: 687 × 540 mm (27$\frac{1}{16}$ × 21$\frac{1}{4}$ in) (ea 792)

'Colin found a dead bird and brought it in . . . all that is white was
sprayed with acid resist, so when we took the bird off and
etched with aquatint this is how we got the black The paler
bird had no aquatint, it was open bite The acid just ate the
copper away. That is why when you then clean the centre area
and ink up, the ink catches on the edge and leaves a dark line
around it' (James Collyer, 3/5/2000)

1053 Single Blackbird 1 (2)
Aquatint, printed in black
Plate and paper: 687 × 539 mm (27$\frac{1}{16}$ × 21$\frac{1}{4}$ in) (ea 791)
Coll: Financial Times

1054 Shoe Trees (3)
Etching, open bite, printed in black
Plate and paper: 687 × 539 mm (27$\frac{1}{16}$ × 21$\frac{1}{4}$ in) (ea 793)

1055 Spaghetti (4)
Etching, open bite, printed in red oxide (mixed to the colour of
spaghetti/ tomato sauce)
Plate and paper: 687 × 540 mm (27$\frac{1}{16}$ × 21$\frac{1}{4}$ in) (ea 794)
Coll: BMAG

1056 Willow (5)
Etching, open bite, printed in black
Plate and paper: 687 × 540 mm (27$\frac{1}{16}$ × 21$\frac{1}{4}$ in) (ea 795)

1057 Grain (6)
Etching, open bite, printed in black
Image and paper: 692 × 543 mm (27$\frac{1}{4}$ × 21$\frac{3}{8}$ in) (ea 796)

1058 Figure No 2: Nude Triptych (7a–c) (Page 164)
Aquatint, three copperplates, printed in black
Plate and paper: 540 × 688 mm (21$\frac{1}{4}$ × 27$\frac{1}{8}$ in, each sheet)
Edition: 60, at least 5 ap, 1 pp (ea 797)
Coll: Whitworth Art Gallery, University of Manchester; Santa
Barbara Museum of Modern Art, California

Isabel Rice, a model from Norwich School of Art, was asked to
lie outstretched and face down on three closely set
copperplates. The area around her contour was sprayed with
acid resist, and the plates subsequently etched with aquatint,
bitten and inked. *Figure 1* shows the same model, only now
curled up on a single plate and etched with open bite.

1059 Figure 1 (8)
Etching, open bite, printed in black
Plate and paper: 686 × 540 mm (27 × 21$\frac{1}{4}$ in) (ea 798)
Coll: Brooklyn Museum of Art

1060 Sand (9)
Etching, open bite, printed in black
Plate and paper: 690 × 541 mm (27$\frac{3}{16}$ × 21$\frac{5}{16}$ in) (ea 799)
Coll: BMAG

'I made a series of spray paintings between 1965–74 on the
theme of *1000 Temporary Objects*, fascinated with the marks left
by ordinary shapes I got a bit worried that some other artist
might get wind of it and made a series of etchings to make my
project *public* I took bags of sand to Alecto and got a big
plastic etching tray which we filled with water and the etching
plate, and then floated the sand. Nothing happened, so we did it
again creating movement with mallets banged against the tray,
and the sand moved into all these shapes . . . then sprayed with
resist and etched.' (CS, 27/11/2001 and 15/2/2002)

Birgit Skiöld (*b*.Stockholm, 1923–82)

Studied lithography and etching at Regent Street Polytechnic. In Paris,
encountered lithographs of Antoni Clavé. Exhibited in *Swedish
Graphic Art*, St George's Gallery, London, 1957. Set up Print
Workshop in basement of 28 Charlotte Street, London, 1958. *The
Graven Image*, Whitechapel Art Gallery, London, 1959. Solo shows:
Curwen Gallery, 1968. Japan 1970, publishing *Zen Gardens* (photo-
etchings and linocuts to accompany poems by James Kirkup) with
Circle Press, 1973.

Lit: *Alecto Monographs 9*; *Birgit Skiöld: Paintings Drawings Prints
Photographs and Artist's Books 1958–1982*, Birgit Skiöld Memorial
Trust, 1984

1061 Moruroa, 1973 (Page 249)
Etching, embossed with aquatint, printed from five shaped plates
in silver grey and green on Saunders HP mould-made 200 lb
paper
Image and paper: 591 × 541 mm (23$\frac{1}{4}$ × 21$\frac{5}{16}$ mm)
Insc bl: 7/150 Moruroa, br: *Birgit Skiold* (pencil)
Edition: 150, 25 ap
Pr: Marie Walker, Print Workshop, Charlotte Street, London;
pub: EACC, November 1973 (ea 833)
Coll: V&A

'Birgit had a close New Zealand friend Kate Kulafan, and was
very upset to hear about Moruroa Atol, the island where the
French undertook nuclear explosions.' (Marc Balakjian)
 'I have used (in *Moruroa*) as a starting point part of one of my
photographs of a Japanese raked garden transferred to the
copperplate in image and mirror image and etched through fine
aquatint. This suggested to me the mushroom cloud of the
hydrogen bomb and the fears of the Japanese and the rest of the
world of the tests being carried out by the French.' (BS, *Alecto
Monographs 9*)

1062 Shisen-do, 1974 (Page 248)
Etching, embossed with aquatint and lithograph, from small
metal pieces and zinc plate, printed in cream, blue, black

Image and paper: 525 × 612 mm (20$\frac{11}{16}$ × 24$\frac{1}{8}$ in)
Insc bl: *pp Shisen–do*, br: *Birgit Skiold* (pencil)
Edition: 30, 6 ap
Pr: Marie Walker, Print Workshop, Charlotte Street, London, 1974; pub: EACC, 1974 (ea 839)
Coll: BMAG; Leicestershire Museums, Arts and Records Service

Based on clipped azalea clusters of Shisendo Retreat, Kyoto, which Skiöld first visited 1970.

Richard Smith (*b.*Letchworth, 1931)

Luton School of Art, St Albans School of Art, and RCA, 1954–7. Harkness Fellowship for travel in USA, 1959–61. Early solo exhibitions: Green Gallery, New York, 1961; Kasmin Gallery, London, 1967 and 1969. *Richard Smith retrospective exhibition of graphics + multiples*, Arnolfini Art Gallery, Bristol, 1970. Retrospective at Tate Gallery, 1975. First prize at Bradford International Print Biennale 1976. More recently making prints with Hugh Stoneham.

SPHINX SERIES, 1966 (Page 79)
Five three-dimensional screenprints, printed on paper applied to white fabricated metal; with attached label at back printed: *1–5* and *Sphinx Series/ Richard Smith 1966/* ea *Editions Alecto* and respective ea number; insc: *R Smith* with edition number (ink, variously)
Each contained in black slip box, 454 × 288 mm (17$\frac{5}{8}$ × 11$\frac{5}{16}$ in)
Edition: 50, 10 ap
Screenprinted at Kelpra Studio, London; pub: 1966 (ea 303–7)
Coll: British Council; National Museum and Gallery, Cardiff

1063 I
Screenprinted in magenta, orange, yellow ochre, green, sky blue, dark blue, purple, silver
408 (h) × 280 (l) × 129 mm (w) (16$\frac{1}{16}$ × 11$\frac{1}{32}$ × 5$\frac{3}{32}$ in) (ea 303)

1064 II
Screenprinted in orange, light ochre, light pink, darker ochre, magenta, red, light magenta
434 (h) × 234 (l) × 69 mm (w) (17$\frac{1}{8}$ × 9$\frac{7}{32}$ × 2$\frac{22}{32}$ in) (ea 304)

1065 III
Screenprinted in white, yellow, orange, blue and light blue, magenta and pink, mauve and pale mauve, light orange, silver, grey
415 (h) × 205 (l) × 207 mm (w) (16$\frac{3}{8}$ × 8$\frac{1}{16}$ × 8$\frac{5}{32}$ in) (ea 305)

1066 IV
Screenprinted in cream, pink, orange, red, pale and dark green, yellow
383 (h) × 282 (l) × 180 mm (w) (15$\frac{1}{8}$ × 11$\frac{1}{8}$ × 7$\frac{3}{16}$ in) (ea 306)

1067 V
Screenprinted in shades of cream, salmon pink, turquoise, pale blue, mid and dark blue
359 (h) × 178 (l) × 192 mm (w) (14$\frac{1}{8}$ × 7 × 7$\frac{9}{16}$ in) (ea 307)

TRIPTYCH, 1968 (Page 112)
Three embossed lithographs, tusche, two copperplates
Paper: 455 × 455 mm (17$\frac{15}{16}$ × 17$\frac{15}{16}$ in)
Insc bl: with title, br: edition number and *R Smith* (pencil)
Edition: 75, 15 ap
Pr: Ian Lawson and Ernest Donagh, Alecto Studios, London, 1968; pub: 1969 (all three ea 577)
Coll: ACE; Art Gallery of Ontario, Toronto; Fitzwilliam Museum, Cambridge

1068 Thirty Degrees
Lithograph, embossed, printed in pink purple and blue
Two plates: 98 × 168 and 96 × 165 mm (3$\frac{7}{8}$ × 6$\frac{5}{8}$ and 3$\frac{22}{32}$ × 6$\frac{1}{2}$ in)

1069 Forty-Five Degrees
Lithograph, embossed, printed in two blues
Two plates: 165 × 168 and 162 × 157 mm (6$\frac{1}{2}$ × 6$\frac{5}{8}$ and 6$\frac{3}{8}$ × 6$\frac{3}{16}$ in)

1070 Sixty Degrees
Lithograph, embossed, printed in blue and green
Two plates: 285 × 170 and 162 × 157 mm (11$\frac{7}{32}$ × 6$\frac{11}{16}$ and 6$\frac{3}{8}$ × 6$\frac{3}{16}$ in)

ea's promotional brochure for 1969 illustrates *Triptych* as a single horizontal frame.

Norman Stevens (*b.*Yorkshire, 1937–88)

Bradford College of Art, 1952–7; RCA, 1957–60. USA in 1965 and 1969. Solo shows. Bradford City Art Gallery, 1966 and Hanover Gallery, London, 1969 and 1971. Prints published by Christie's Contemporary Art and ea. Working in etching, lithography and mezzotint. Topiary, gardens and countryside of England, became favourite subjects. Paintings, drawings and prints in *Norman Stevens An English Landscape*, Redfern Gallery, London, 1989.

Lit: *Alecto Monographs 8*

1071 Louvered Shutter (Evening), 1971
Lithograph, three printings from three zinc plates, with gum arabic stop-out and tusche applied with airbrush, and split-fount or blended inking, printed in narrow bands of colour progressing from orange and pink to lilac through to blue and grey, on white B. F. K. Rives paper
Image: 527 × 463 mm (20$\frac{3}{4}$ × 18$\frac{1}{4}$ in), paper: 674 × 558 mm (26$\frac{9}{16}$ × 22 in)

Insc bl: *Louvered Shutter, Evening AP 3/12*, br: *Norman Stevens 71* (pencil) and embossed Bud Shark chop (mostly), vo: stamped ea *784*
Edition: 65, 12 ap
Pr: Bud Shark, Alecto Studios, London, Jan/Feb 1971; pub: 1971 (ea *784*)
Coll: Sheffield Galleries and Museums Trust; Fitzwilliam Museum, Cambridge; GAC

Second USA trip in 1969 produced series of American-influenced subjects, of which Louvered Shutters or Venetian Blinds became one of the most obsessional; 'a device for fixing the space; a screen for closing off a shallow space close to the picture plane, yet leaving him free to exploit the ambiguous space.' (*Alecto Monographs 8*)

 'This is the first print that I did at ea after arriving from the USA. Norman had to redraw the air-brush plate several times because I was having difficulties adjusting to a new press, plates, inks and chemistry and the plate kept "filling-in" (*ie* losing detail and subtlety) The split-fount inking on the second plate was a very difficult one to accomplish with fifteen different colours in very narrow bands.' (Bud Shark, 17/1/2000)

1072 Clapboard House with Fronds, 1972
Etching with aquatint, copperplate, printed in sepia on J. Green paper
Plate: 249 × 315 mm (9 $\frac{13}{16}$ × 12 $\frac{7}{16}$ in), paper: 395 × 504 mm (15 $\frac{9}{16}$ × 19 $\frac{5}{8}$ in)
Insc bl: *Colour Proof – Clapboard House with Fronds*, br: *Norman Stevens 72-* (pencil)
Edition: 50, proofs
Pr: James Collyer and John Crossley of J. C. Editions, Alecto Studios, London; pub: AI, 1972
Coll: ACE

1073 Garden, 1972
Lithograph, tusche and crayon, three zinc plates, printed in pale blue, cream brown, grey on B. F. K. Rives paper
Image: 436 × 603 mm (17 $\frac{3}{16}$ × 23 $\frac{3}{4}$ in), paper: 585 × 747 mm (23 $\frac{1}{16}$ × 29 $\frac{7}{16}$ in)
Insc bl: *Garden 39/46*, br: *Norman Stevens 72–* (pencil), br corner: embossed chop of Bud Shark
Edition: 46, pp and proofs
Pr: Bud Shark, Alecto Studios, London; pub: AI, 1972

1074 Rain, 1973
Etching and aquatint, copperplate, printed in black with prussian blue on J. Green waterleaf paper
Plate: 268 × 345 mm (10 $\frac{9}{16}$ × 13 $\frac{5}{8}$ in), paper: 395 × 467 mm (15 $\frac{9}{16}$ × 18 $\frac{3}{8}$ in)
Insc bl: *2/15 – AP – Rain –*, br: *Norman Stevens 73 -* (pencil) and embossed chops of James Collyer and John Crossley of J. C. Editions
Edition: 100, 15 ap
Pr: James Collyer and John Crossley of J. C. Editions, Tysoe

Street, London EC1; pub: AI, 1973
Coll: GAC

1075 Dusk, 1973
Mezzotint, two copperplates, printed in pink, black with prussian blue on J. Green waterleaf HP 146 lb paper
Plate: 400 × 300 mm (15 $\frac{3}{4}$ × 11 $\frac{13}{16}$ in), paper: 658 × 508 mm (25 $\frac{15}{16}$ × 20 in, some variation)
Insc bl: *To Norman*, bc: *Dusk-from Jim, John, David/ or 'Pink Border"*, br: *- 73* (pencil) and embossed chops of James Collyer and John Crossley of J. C. Editions with embossed ea
Edition: 150, 25 ap
Pr: James Collyer and John Crossley of J. C. Editions with David Green, Alecto Studios, London, 1973; pub: EACC, November 1973 (ea *832*)
Coll: British Museum; School of Art Collection, University of Wales, Aberystwyth; Leicestershire Museums, Arts and Records Service; Tate
Lit: *Alecto Monographs 8* (ill.)

The source for this scene was Holland Park, close to where Stevens lived in London, and which became a regular place to visit with his family. The appeal of mezzotint lay in its 'directness and flexibility – any part of the surface removed can be replaced easily. I also wanted the overall texture that it has, the soft quality peculiar to it and its richly varied tonal range.' *Dusk* was about achieving 'a mood/atmosphere that occurs at a certain time of day, in a particular kind of light.' (NS, *Alecto Monographs 8*)
A proof impression seen by the author is inscribed: *final 5th state*.

1076 Clapboard House with Fronds and Architectural French Curve, 1974 (Page 252)
Etching, hard-ground and aquatint, copperplate, printed in black with prussian blue on J. Green HP waterleaf paper
Plate: 269 × 343 mm (10 $\frac{19}{32}$ × 13 $\frac{1}{2}$ in), paper: 479 × 545 mm (18 $\frac{7}{8}$ × 21 $\frac{1}{2}$ in)
Insc b: *2/3 Exhibition proof – Clapboard House with Fronds and Architectural French Curve – Norman Stevens –74-* (pencil)
Edition: 83, 15 ap, 3 ep
Pr: James Collyer and John Crossley of J. C. Editions at Alecto Studios, London, 1974; pub: 1974 (ea *840*)
Coll: Leeds City Art Gallery; Arthur Andersen, London; Leicester City Museums Service; Cartwright Hall Art Gallery, Bradford; GAC; Tate

Stevens's father, a commercial graphic designer, owned a set of plastic stencils. One of these abstracted shapes is used here as a faint silhouette against the house front.

 'This is etched with acid-resist ground on the copperplate and all the darker bits cross-hatched. It took ages to do.' (James Collyer, 13/5/2000)

1077 Flight of Steps, 1973–4
Aquatint, scraped and burnished, copperplate, printed in red, brown, a small amount of black on J. Green HP waterleaf paper

Plate: 302 × 270 mm (11⅞ × 10⅝ in), paper: 560 × 475 mm (22 1/16 × 18 ¾ in)
Insc bl: *3/9 Flight of Steps*, br: *Norman Stevens 74-* (pencil), br corner: J. C. Editions and ℮ℬ embossed stamps
Edition: 83, 15 ap, 9 pp
Pr: James Collyer and John Crossley of J. C. Editions, Alecto Studios, London, 1973–4; pub: 1974 (℮ℬ 841)
Coll: British Council; School of Art, University of Wales, Aberystwyth; GAC; Tate

Flight of Steps and the rest of the Alecto series from late 1973 show Stevens' continuing interest in simplified subject matter, 'in an attempt to get some of the qualities of stone with soft lights on its surface, a very coarse aquatint was put on the plate. This was then scraped, using a sharp-edged tool to remove the rough surface, and burnished, with a rounded polished steel tool which smoothes the copper flat, to get the lightest areas of the image on the plate' (NS, *Alecto Monographs 8*)

1078 Morning, 1973–4
Etching and aquatint with roulette, copperplate, printed in black with Prussian blue on J. Green HP waterleaf paper
Plate: 539 × 389 mm (21 ¼ × 15 5/16 in), paper: 792 × 570 mm (31 3/16 × 22 7/16 in)
Insc bl: *B A T (Final Proof for plating) -Morning -*, br: *Norman Stevens – November 6th 1973* (pencil)
Edition: 83, 15 ap, plus additional proofs
Pr: James Collyer and John Crossley of J. C. Editions, Alecto Studios, London, 1973; pub: 1974 (℮ℬ 842)
Coll: British Council; Leeds City Art Gallery; Glasgow Museums; Fitzwilliam Museum, Cambridge

1079 Covered Walk, 1974
Etching and aquatint, two copperplates, printed in green and yellow on J. Green HP waterleaf paper
Plate: 252 × 364 mm (9 15/16 × 14 5/16 in), paper: 516 × 699 mm (20 5/16 × 27 17/32 in)
Insc bl: *Proof*, bc: *Covered Walk -*, br: *Norman Stevens - 74* (pencil)
Edition: 83, 15 ap, plus additional proofs
Pr: James Collyer and John Crossley of J. C. Editions, Alecto Studios, London, 1974; pub: 1974 (℮ℬ 843)
Coll: British Council; Arthur Andersen, London

Stevens had initially considered the title *Alley* for this print of Kew Gardens.

1080 Stonehenge, 1974
Aquatint, scraped and burnished, with roulette, two copperplates, printed in pink and black with prussian blue on J. Green HP waterleaf paper
Plate: 440 × 465 mm (17 5/16 × 18 5/16 in), paper: 665 × 665 mm (26 3/16 × 26 3/16 in)
Insc bl: *A. P./ Stonehenge*, br: *Norman Stevens/ 74* (pencil), br corner: embossed stamps of J. C. Editions and ℮ℬ embossed

Edition: 83, 15 ap, plus proofs
Pr: James Collyer and John Crossley of J. C. Editions, Alecto Studios, London; pub: 1974 (℮ℬ 844)
Coll: British Council; Leeds City Art Gallery; Cartwright Hall Art Gallery, Bradford; National Museum and Gallery, Cardiff; GAC; Tate

'This was the first Stonehenge image. We used to see it on the way to Devon. In another life, Norman would have been an archaeologist.' (Jean Stevens, 7/2/1999)

1081 Stone Circle, 1974
Aquatint, burnished, two copperplates, printed in prussian blue and pink on J. Green HP waterleaf paper
Plate: 248 × 433 mm (9 ¾ × 17 1/16 in), paper: 500 × 665 mm (19 11/16 × 26 3/16 in)
Insc bl: *6/15 AP Stone Circle*, br: *Norman Stevens 74 -* (pencil), br corner: embossed stamps of J. C. Editions and ℮ℬ embossed
Edition: 83, 15 ap, plus proofs
Pr: James Collyer and John Crossley of J. C. Editions, Alecto Studios, London 1974; pub: 1974 (℮ℬ 845)
Coll: Cartwright Hall Art Gallery, Bradford; GAC; Tate

1082 Courtyard, 1974
Photo-screen etching with coarse aquatint, copperplate, inked in pink and rolled over with black with prussian blue on J. Green HP waterleaf paper
Plate: 322 × 629 mm (12 11/16 × 24 ¾ in), paper: 565 × 834 mm (22 ¼ × 32 22/... in)
Insc bl: *4/15 AP Courtyard*, br: *Norman Stevens 74 -* (pencil), br corner: embossed stamps of James Collyer and John Crossley of J. C. Editions, and ℮ℬ embossed
Edition: 83, 15 ap, plus proofs
Pr: James Collyer and John Crossley of J. C. Editions, Alecto Studios, London; pub: 1974 (℮ℬ 846)
Coll: British Council; Cartwright Hall Art Gallery, Bradford; Tate

'The heart of the Old Courtyard at Hampton Court, with rain between the cobbles.' (Jean Stevens, 7/2/1999)

1083 Path, 1974
Photo-screen etching with coarse aquatint, single copperplate, printed in pink brown on J. Green HP waterleaf paper
Plate: 326 × 629 mm (12⅞ × 24 ¾ in), paper: 558 × 834 mm (22 × 32 ⅞ in)
Insc bl: *AP/ Path/ Norman Stevens*, br: *74 -* (pencil), br corner: embossed stamps of James Collyer and John Crossley of J. C. Editions, and ℮ℬ embossed
Edition: 83, 15 ap, plus proofs
Pr: James Collyer and John Crossley of J. C. Editions, Alecto Studios, London; pub: 1974 (℮ℬ 847)
Coll: British Council; Cartwright Hall Art Gallery, Bradford; GAC; Tate

LOWER WESSEX LANE, 1975–6
Series of four lithographs, tusche and crayon, on T. H. Saunders
paper
Image: 445 × 507 mm (17 $\frac{1}{2}$ × 19 $\frac{31}{32}$ in); paper: 610 × 660 mm
(24 × 26 in, slight variation)
Insc b: with edition number, title; br: *Norman Stevens 75 / 76*
(pencil) with variously *ea* embossed (corner)
Edition: 75, 60, 25 and 45, with 15 (10) ap
Pr: Curwen Studio, London; pub: 1976 (*ea* 894–7)
Coll: GAC; Tate

1084 Lower Wessex Lane – Spring, 1975–6
Lithograph, printed in green, yellow, olive, blue
(*ea* 894)

1085 Lower Wessex Lane – Summer, 1975–6
Lithograph, printed in red, yellow, two blues
(*ea* 895)

1086 Lower Wessex Lane – Autumn, 1975
Lithograph, printed in green, brown red, yellow, brown purple
(*ea* 896)

1087 Lower Wessex Lane – Winter, 1975
Lithograph, printed in blue, green, purple
(*ea* 897)

Lower Wessex Lane was produced as a joint venture with PSA,
Department of the Environment, who acquired thirty, twenty-five,
ten and ten impressions respectively (plus proofs) from the four
editions.

Michael Stokoe (*b*.London, 1933)

St Martin's School of Art, 1953–7. Worked for advertising agency
Charles Hobson and Associates and then in marketing department of
Iliffe Press. Lecturer at Ravensbourne College of Art, 1966–96.
Produced 'hard edge' colour field painting and printmaking, op art,
wall-based constructions and, more recently, 'fauvist' approach to
colour, subject and technique. First screenprint dated to 1967, also
black and white etchings. Largely prints own work which have been
published by Collectors Guild, USA; and Annely Juda, London.

1088 Wave under nine, 1969
Screenprint, printed in brown, blue, turquoise, red
Image: 484 × 434 mm (19 $\frac{1}{16}$ × 17 $\frac{1}{8}$ in)
Insc bl: *55/60*, bc: *Wave under nine*, br: *Michael Stokoe 69*
(pencil)
Edition: 60, proofs
Pr: The artist, Fulham studio; pub: 1969 (*ea* 640)
Coll: GAC

'This is closely related to another screenprint *Movements on a
green field*. I made *Wave* first and then turned it around and
changed the wave at the bottom to a straight edge at the top.

The same stencils were used with colour variation' (MS,
17/6/2000)

1089 Weights on a brown field, 1969
Screenprint, printed in orange brown, orange, khaki, magenta,
peacock blue on thin card
Image: 505 × 510 mm (19 $\frac{7}{8}$ × 20 $\frac{1}{16}$ in), card: 708 × 572 mm
(19 $\frac{7}{8}$ × 22 $\frac{17}{32}$ in)
Insc bl: *56/60*, bc: *Weights on a brown field*, br: *Michael Stokoe
69* (pencil)
Edition: 60, aps
Pr: The artist, Fulham studio; pub: 1969 (*ea* 641)
Coll: GAC

'At the time I was using stemplex film, which came in a roll, to
play around with basic shapes on a flat field, and in particular
with the idea of circles in a square. Here you feel the difference
between forms that appear to float and those that are weighed
down . . . physical weight at the bottom and spiritual escape at
the top if you like. There is the importance of the brown spacing
at the bottom which stops the forms falling off' (MS,
17/6/2000)

N. H. (Tony) Stubbing (*b*.London, 1921–83)

Self-taught, painted in spare time when serving in Iceland, 1941–3.
First solo exhibition at British Institute, Famagusta, Cyprus, 1944.
Evening classes at Camberwell School of Art, 1946–7. Lived in Spain,
1947–8. Period of producing sculpture and ceramics, 1949.
Developed hand-painting style inspired by cave drawings and
paintings, 1951–4. New York, 1961–3. Mural commissions, 1964–8,
completing *Manannins Heritage* for the Isle of Man Casino, 1967.
Returned to sculpture, 1968–72.

Lit: *Tony Stubbing and the Box–Hinge–Tome–Volume*, New Art-
Liaison Ltd, London, 1974 (brochure).

1090 The Windsor Box, 1971 (Page 230)
Two-sided gun metal box, polished with large hinge
Closed size: 140 × 125 × 50 mm (5 $\frac{1}{2}$ × 4 $\frac{15}{16}$ × 2 in)
Edition: 250
Pub: Al, 1971

'The existence of Tony Stubbing's hinges began with the thought
of a large book – tome – containing secrets For this
purpose, Stubbing drew a lectern upon which sat a large book-
volume. He then made models in plaster . . . carved out a hollow
on both sides which also made it a box.
 This was the first work that was produced by New Art-Liaison,
to be a fifty example edition in brass, later reduced to twenty-five
when the edition was bought by Alecto, a larger firm who
changed the title to *The Windsor Box* and made it into a gun-
metal edition of 250. Stubbing wanted to make a mould of an ear
and put it inside the box in perspex to symbolise the oracle, or
listener of silent wisdom; but he thought better of this and finally
left its contents up to each collector.' (New Art-Liaison, 1974)

Chic Taylor (*b*.Lennoxtown, Scotland, 1947)

Studied at Carlisle and Hull Colleges of Art. Moved to London in early 1970s, living in Notting Hill Gate. Work at this time involved with 'the properties of change, in particular change within a defined set of circumstances; the change occuring either by natural causes or by the direct decision-making of the observer on the circumstances offered.' Dice would be thrown, for example, each number corresponding to a different colour. This result, in print form, was the screenprint *Random*. Selected for *A Concept of Multiples*, Bluecoat Gallery, Liverpool, 1972.

Lit: *A Decade of Printmaking*, p.97

1091–2 Sandbox I and II, 1971* (Page 217)
Moulded acrylic box with a choice of fine washed and sieved natural or red sand
Size: 200 × 100 × 100 mm (7 $\frac{7}{8}$ × 3 $\frac{15}{16}$ × 3 $\frac{15}{16}$ in); and 300 × 150 × 150 mm (11 $\frac{13}{16}$ × 6 × 6 in)
Edition: unlimited, two versions
Pub: AI, 1971

This sandbox, produced in a smaller and larger version, selling respectively for £12.50 and £25, was '. . . like an egg timer, with a grid dividing an acrylic box into compartments. When the box is turned, the sand, red or natural, filters from one compartment to another, never completely emptying either and always forming different patterns of hollows above the grid and mounds on the base section.' (Pat Gilmour, *Arts Review*, 20/11/1971)

1093 Landscape: Flikker Book No. 2, 1972 (Page 225)
Off-set lithograph, printed in black, 75 × 92 mm (2 $\frac{31}{32}$ × 3 $\frac{5}{8}$ in)
Printed front: *Flikker/ book/ Chic Taylor/ Landscape* and last page: *Chic Taylor*
Pr: Hillingdon Press, Uxbridge; pub: AI, 1972

Valerie Thornton (*b*.London, 1931–91)

Byam Shaw School of Drawing and Painting, 1949–50; Regent Street Polytechnic, 1950–3. Architectural drawings. Studied at Atelier 17, Paris, 1954. Set up workshop in Shackleford, near Guildford. Exhibitions include: The Minories, Colchester, 1960; Philadelphia Print Club, 1961; Zwemmer Gallery, London, 1965. In 1966 moved to The Minories, Colchester, and in 1969 began twenty-year association with agent Anthony Dawson. Elected Fellow of Royal Society of Painter-Etchers and Engravers, 1970.

Lit: *Valerie Thornton*, Zwemmer Gallery, London, 14 October–6 November 1965; *Valerie Thornton RE (1931–1991)*, Ipswich Museums and Galleries, 1994

1094 Eton College Chapel, c.1964 (Page 30)
Etching and aquatint, deep bite and burnished, copperplate, printed in green and black
Plate: 378 × 522 mm (15 $\frac{5}{16}$ × 20 $\frac{9}{16}$ in), paper: 510 × 692 mm (20 $\frac{1}{16}$ × 27 $\frac{1}{4}$ in, cut edge)
Insc bl: *5/100*, br: *Eton College Chapel*, br: *Valerie Thornton* (pencil)
Edition: 100, 10 ap
Pr: The artist at her Shackleford Studio, Surrey; pub: Editions Alecto Ltd as part of the *Public Schools Series*, 1964 (ea 94)
Coll: Ashmolean Museum, Oxford; GAC

Valerie Thornton produced a second abstracted version of *Eton College Chapel* in an edition of fifty (GAC).

1095 Winchester, c.1964*
Colour etching with aquatint
Edition: 100, 10 ap (ea 95)

1096 Harrow, c.1964*
Colour etching with aquatint
Edition: 50, 5 ap (ea 96)

1097 Grand Canal, 1964
Etching with aquatint, deep bite, with varnish, roulette wheels and scraper, two copperplates, printed in grey, brown, green
Image: 402 × 522 mm (15 $\frac{13}{16}$ × 20 $\frac{9}{16}$ in), paper: 525 × 636 mm (20 $\frac{11}{16}$ × 25 $\frac{1}{16}$ in, left edge folded back)
Insc bl: *15/50*, br: *Valerie Thornton,* br corner: ea embossed
Edition: 50, 5 ap
Pr: The artist at Shackleford Studio, Surrey; pub: 1964 (ea 97)
Lit: *Brunsdon*, ill.27
Coll: New York Public Library; Ipswich Borough Museums and Arts; Leeds City Art Gallery

1098 Breakwater, 1964
Etching and aquatint, deep bite with varnish, copperplate, printed in brown on Crisbrook 140 lb paper
Image overall size: 285 × 535 (11 $\frac{7}{16}$ × 21 $\frac{1}{16}$ mm), paper: 507 × 697 mm (19 $\frac{31}{32}$ × 27 $\frac{7}{16}$ in, variable)
Insc bl below image: *41/50*, br: *Valerie Thornton*, bl corner: ea embossed
Edition: 50, 5 ap
Pr: The artist at Shackleford Studio, Surrey; pub: 1964 (ea 98)
Coll: New York Public Library; Ashmolean Museum, Oxford; Leeds City Art Gallery

1099 Queen's College, Oxford, 1965*
Colour etching on Crisbrook 140 lb paper
Image: 399 × 524 mm (15 $\frac{23}{32}$ × 20 $\frac{5}{8}$ in)
Edition: 50, 7 ap (ea 233)
Exh: *Zwemmer Gallery* (7)

1100 Queen's College Façade, 1965
Etching and aquatint, deep bite, printed in brown and ochre on Crisbrook 140 lb paper
Plate: 399 × 524 mm (15 $\frac{23}{32}$ × 20 $\frac{5}{8}$ in), paper: 572 × 788 mm (22 $\frac{17}{32}$ × 31 $\frac{1}{32}$ in)
Insc bl: *Artists Proof*, br: *Valerie Thornton* (pencil)
Edition: 50, 7 ap

Pr: The artist, Fulham studio, London; pub: 1965 (ea 234)
Exh: *Zwemmer Gallery* (8), *Ipswich* (58)
Coll: Arthur Andersen, London; Ipswich Borough Museums and Arts

1101 Farm Buildings, 1965*
Colour etching and aquatint on Crisbrook 140 lb paper
Image: 368 × 470 mm (14 $\frac{1}{2}$ × 18 $\frac{1}{2}$ in)
Edition: 30, 5 ap
Exh: *Zwemmer Gallery* (10) (ea 235)

1102 Suffolk Barns, 1965
Etching and aquatint, deep bite, printed in brown green, pink on Crisbrook 140 lb paper
Plate: 345 × 468 mm (13 $\frac{5}{8}$ × 18 $\frac{7}{16}$ in), paper: 565 × 778 mm (22 $\frac{1}{4}$ × 30 $\frac{5}{8}$ in)
Insc bl: *Artist's Proof*, br: *Valerie Thornton/ Artist's Collection* (pencil)
Edition: 30, 5 ap
Pr: The artist, Fulham studio, London; pub: 1965 (ea 236)
Exh: *Zwemmer Gallery* (9)
Coll: Ipswich Borough Museums and Arts

Valerie Thornton worked from Molesford Road, Fulham, close to where Agathe Sorel and Michael Rothenstein lived in London.

1103 Navajo Canyon, 1965
Etching and aquatint, deep bite, printed in brown ochre and green on Crisbrook 140 lb paper
Plate: 393 × 488 mm (15 $\frac{1}{2}$ × 19 $\frac{1}{4}$ in), paper: 557 × 777 mm (21 $\frac{15}{16}$ × 30 $\frac{5}{8}$ in, some variation)
Insc bl: *40/50*, br: *Valerie Thornton* (pencil), vo: ea *No237*
Edition: 50, 7 ap
Pr: The artist, Fulham studio, London; pub: 1965 (ea 237)
Exh: *Ipswich* (61)
Coll: Ipswich Borough Museums and Arts

1104 Mese Verde, 1965
Etching and aquatint, deep bite, printed in brown, ochre, green on Crisbrook 140 lb paper
Plate: 402 × 526 mm (15 $\frac{13}{16}$ × 20 $\frac{11}{16}$ in), paper: 571 × 790 mm (22 $\frac{1}{2}$ × 31 $\frac{1}{8}$ in)
Insc bl: *Artist's proof*, br: *Valerie Thornton* (pencil)
Pr: The artist, Fulham studio, London; pub: 1965 (ea 238)
Edition: 30, 5 ap
Exh: *Zwemmer Gallery* (4), *Ipswich* (64)
Coll: Ipswich Borough Museums and Arts; GAC

Hayle Mill linen 77 paper was used at the proofing stage.

1105 Arizona, 1965
Etching and aquatint, deep bite, printed in green ochre on Crisbrook 140 lb paper
Plate: 385 × 495 mm (15 $\frac{3}{16}$ × 19 $\frac{1}{2}$ in, irregular plate edge), paper: 567 × 784 mm (22 $\frac{5}{16}$ × 30 $\frac{7}{8}$ in)
Insc bl: *Artist's proof*, br: *Valerie Thornton* (pencil)

Pr: The artist, Fulham studio, London; pub: 1965 (ea 239)
Exh: *Zwemmer Gallery* (3)
Coll: Ipswich Borough Museums and Arts (vo: title and price £40 in pencil)

1106 Golden Canyon, 1964–5
Etching and aquatint, deep bite, printed in dark brown, ochre, green on Crisbrook 140 lb paper
Plate: 374 × 497 mm (14 $\frac{3}{4}$ × 19 $\frac{9}{16}$ in), paper: 573 × 800 mm (22 $\frac{9}{16}$ × 31 $\frac{1}{2}$ in)
Insc bl: *Valerie Thornton* (ink)
Edition: 30, 5 ap
Pr: The artist, Fulham studio, London; pub: 1965 (ea 240)
Exh: *Zwemmer Gallery* (1); *Ipswich* (59)
Coll: Ipswich Borough Museums and Arts

Thornton lived in New York for ten months 1963–4, and worked at the Pratt Graphic Art Center workshop. Sales of work supported her and funded a trip to Mexico.

1107 Vézelay (France), 1965
Etching and aquatint, copperplate, printed in brown on Crisbrook 140 lb paper
Plate: 400 × 525 mm, paper: 460 × 620 mm (18 $\frac{1}{8}$ × 24 $\frac{7}{16}$ in)
Insc bl: *Artist's Proof*, bc: *Vezelay*, br: *Valerie Thornton* (pencil)
Edition: 50, 7 ap
Pr: The artist, Fulham studio, London; pub: 1965 (ea 241)
Coll: Ashmolean Museum, Oxford

One of a series associated with Romanesque architecture of Vézelay. BMAG has an abstract stone composition entitled *Vezelay Romaine*.

1108 Lady Chapel, Ely Cathedral, 1967
Etching, copperplate, printed in brown and black
Plate: 403 × 523 mm (15 $\frac{7}{8}$ × 20 $\frac{5}{8}$ in)
Insc bl: *25/50*, br: *Valerie Thornton* (pencil)
Edition: 50, aps
Pr: The artist, her studio at The Minories, Colchester; pub: 1967 (ea 500)
Coll: GAC

The following woodcuts were bought and sold but not officially published by Editions Alecto:

San Domingo, 1964–5; Three Venetian Palaces 1964–5; Mexican Façade, 1964–5; Yellow Palace, 1964–5; St Mark's Library, 1964–5; Mexican Cathedral 1964–5; Baptistry, Florence, 1967; San Francisco, 1967; Utah Rocks, 1967.

Carl Toms (*b.*Nottinghamshire, 1927–99)

Mansfield College of Arts and RCA. After national service, joined Old Vic School, followed by apprenticeship with Oliver Messel. Became a leading stage designer, working for RSC, Old Vic and National Theatre, as well as for opera and ballet in London and New York.

1109 Covent Garden, _c._1974
Lithograph, tusche, printed in red, brown, black, yellow
Image: 585 × 425 mm (23$\frac{1}{16}$ × 16$\frac{3}{4}$ in), paper: 647 × 483 mm
(25$\frac{1}{2}$ × 19$\frac{1}{32}$ in)
Insc bl: _49/100_, br: _Carl Toms_ (pencil)
Edition: 100, proofs
Pub: EACC, 1974 (℮a 855)
Coll: GAC

A view, from one of the side boxes, of a performance on the
proscenium stage of Covent Garden, London.

Julian Trevelyan (_b._Dorking, 1910–88)

Trinity College, Cambridge, 1928–30. Atelier 17, Paris studying intaglio
printing, 1931. First joint exhibition: Bloomsbury Gallery, 1932. Joined
Mass Observation Team and English Surrealist Group, 1937. Taught
etching at Chelsea School of Art, 1950–5, and RCA, 1955–63. His
book _Etching, Modern Methods of Intaglio Printmaking_, Studio Books,
published in 1963. Extensive travelling, including: Gozo (1963), Italy
(1965 and 1969) and Uganda (1966). Published by Waddington
Prints Ltd, 1971–5.

Lit: Silvie Turner, _Julian Trevelyan: Catalogue raisonné of prints_, Scolar
Press with Bohun Gallery, Henley-on-Thames, 1998

CAMBRIDGE SUITE, 1959–62
Set of ten colour lithographs on handmade J. Whatman paper,
printed by George Devenish, RCA, London, 1960–2
Insc with edition number and br: _Julian Trevelyan_ (pencil)
Edition: 70, 30 ap (unless stated otherwise)
Pub: Paul Cornwall-Jones and Michael Deakin, 1960–2 (no
publication number)
Coll: GAC

1110 Emmanuel College (Page 33)
Lithograph, printed in three colour versions in four colours
1. black, brown, mauve, orange
2. black, brown, turquoise, yellow
3. black, brown, green, grey
Image: 532 × 382 mm (20$\frac{15}{16}$ × 15$\frac{1}{16}$ in), paper: 790 × 573 mm
(31$\frac{1}{8}$ × 22$\frac{9}{16}$ in)
Edition: 70 (75), 25 ap?

1111 Jesus College
Lithograph, printed in blue, brown, ochre
Image: 385 × 530 mm (15$\frac{5}{32}$ × 20$\frac{7}{8}$ in), paper: 582 × 740 mm
(22$\frac{15}{16}$ × 29$\frac{1}{8}$ in)
Coll: GAC

Emmanuel and Jesus, the respective colleges of Michael Deakin
and Paul Cornwall-Jones, were the first images in the _Cambridge
Series_ (otherwise listed alphabetically).

1112 Caius College
Lithograph, printed in brown, green, grey, yellow
Image: 487 × 389 mm (19$\frac{3}{16}$ × 15$\frac{5}{16}$ in), paper: 730 × 580 mm
(28$\frac{3}{4}$ × 22$\frac{27}{32}$ in)

1113 Caius College 2
Lithograph, printed in beige, brown, purple
Image: 385 × 515 mm (15$\frac{3}{16}$ × 20$\frac{9}{32}$ in), paper:
580 × 695 mm (22$\frac{27}{32}$ × 27$\frac{3}{8}$ in)

1114 Christ's College
Lithograph, printed in black, blue, red, yellow
Image: 382 × 422 mm (15$\frac{1}{16}$ × 16$\frac{5}{8}$ in), paper: 582 × 760 mm
(22$\frac{15}{16}$ × 29$\frac{15}{16}$ in)
Edition: 70, 34 ap
Coll: GAC; Sheffield Galleries and Museums Trust

1115 Corpus College
Lithograph printed in two colour versions:
1. beige, black, blue, yellow
2. black, brown, green, ochre
Image: 387 × 535 mm (15$\frac{1}{4}$ × 21$\frac{1}{16}$ in), paper: 582 × 790 mm
(22$\frac{15}{16}$ × 31$\frac{1}{8}$ in)
Edition: 70, 25 ap

1116 Downing College
Lithograph printed in blue, green, ochre, purple
Image: 395 × 448 mm (15$\frac{9}{16}$ × 17$\frac{5}{8}$ in), paper: 582 × 790 mm
(22$\frac{15}{16}$ × 31$\frac{1}{8}$ in)

1117 Peterhouse College
Lithograph, printed in brown, green, grey, yellow
Image: 382 × 437 mm (15$\frac{1}{16}$ × 17$\frac{3}{16}$ in), paper: 582 × 790 mm
(22$\frac{15}{16}$ × 31$\frac{1}{8}$ in)
Coll: Leicester City Museums

1118 St Catherine's College
Lithograph, printed in brown, green, grey purple, orange
Image: 390 × 460 mm (15$\frac{3}{8}$ × 18$\frac{1}{8}$ in), paper: 582 × 788 mm
(22$\frac{15}{16}$ × 31$\frac{1}{32}$ in)

1119 Sidney Sussex College
Lithograph, printed in beige pink, brown, green, grey
Image: 390 × 460 mm (15$\frac{3}{8}$ × 18$\frac{1}{8}$ in), paper: 582 × 790 mm
(22$\frac{15}{16}$ × 31$\frac{1}{8}$ in, variable)

LONDON SUITE, 1964
Six colour etchings, two steel-faced copperplates (unless stated
otherwise), on handmade Crisbrook waterleaf 140 lb paper,
measuring 571 × 800 mm (22$\frac{1}{2}$ × 31$\frac{1}{2}$ in, with variation)
Insc: with edition number, title and br: _Julian Trevelyan/ 1964_
(pencil); vo: stamped with ℮a and publication number
Edition: 75, 10 ap

Pr: Michael Rand, The Studio, Bushey, 1964; pub: 1964 (ℯα 107–12)
Coll: Leicester City Museums; GAC

1120 Trafalgar Square
Etching, soft-ground (comb effect) and aquatint, three steel-faced copperplates, printed in yellow, orange, blue, brown, black
Image: 351 × 471 mm (13$\frac{13}{16}$ × 18$\frac{9}{16}$ in) (ℯα 107)
Coll: Sheffield Galleries and Museums Trust

1121 Piccadilly Circus
Etching and aquatint, printed in black, purple
Image: 350 × 475 mm (13$\frac{13}{16}$ × 18$\frac{11}{16}$ in) (ℯα 108)

1122 St Pauls
Etching, soft-ground and aquatint, printed in purple, orange, black
Image: 475 × 350 mm (18$\frac{11}{16}$ × 13$\frac{13}{16}$ in) (ℯα 109)

1123 The Thames
Etching, soft-ground (impressed card), printed in black and blue
Image: 350 × 475 mm (13$\frac{13}{16}$ × 18$\frac{11}{16}$ in) (ℯα 110)

1124 Tower Bridge
Etching, soft-ground and aquatint, printed in black, yellow, blue, orange, brown
Image: 475 × 350 mm (18$\frac{11}{16}$ × 13$\frac{13}{16}$ in) (ℯα 111)
Coll: Sheffield Galleries and Museums Trust

'The black plate includes line, aquatint, steel wool (sky) and the impression of newspaper matrices all in soft-ground. The colour plate includes areas of impressions of lace in soft-ground and aquatint following the pattern of an offset from the black plate.' (*Brunsdon*, ill.19)

1125 Westminster Abbey
Etching, soft-ground and aquatint, scrim wipe, printed in blue, red, black
Image: 350 × 475 mm (13$\frac{13}{16}$ × 18$\frac{11}{16}$ in) (ℯα 112)
Coll: Leeds City Art Gallery

FLORENTINE SUITE, 1965–6
Suite of twelve colour etchings, two steel-faced copperplates, printed on handmade Crisbrook waterleaf 140 lb paper, measuring: 565 × 800 mm (22$\frac{1}{4}$ × 31$\frac{1}{2}$ in, with variation)
Insc: with edition number and title, br: *Julian Trevelyan* and dated *1965* occasionally (pencil); vo: stamped ℯα and publication number
Edition: 100, 12 ap
Pr: Michael Rand, Alecto Studios, London; pub: 1966
(ℯα 242–53)
Coll: GAC

1126 Ponte Vecchio
Etching and aquatint, printed in black and brown
Image: 350 × 476 mm (13$\frac{2}{8}$ × 18$\frac{3}{4}$ in) (ℯα 242)

1127 Duomo
Etching and aquatint, printed in red and orange
Image: 350 × 475 mm (13$\frac{2}{8}$ × 18$\frac{11}{16}$ in) (ℯα 243)

1128 Florence at Night
Etching and aquatint with soft-ground (scrim wipe) from steel-faced plate, printed in black green
Image: 352 × 476 mm (13$\frac{7}{8}$ × 18$\frac{3}{4}$ in) (ℯα 244)
Coll: Sheffield Galleries and Museums Trust

Entered in ℯα Register as *Florence by Night*.

1129 Santa Maria Novella
Etching and aquatint from steel-faced copperplate, printed in red, brown, green
Image: 350 × 476 mm (13$\frac{2}{8}$ × 18$\frac{3}{4}$ in) (ℯα 245)
Coll: GAC

1130 Easter Festival
Etching and aquatint, printed in blue and purple
Image: 351 × 475 mm (13$\frac{13}{16}$ × 18$\frac{11}{16}$ in) (ℯα 246)

1131 Piazza Signoria
Etching and aquatint with soft-ground (scrim wipe), printed in black and yellow
Image: 478 × 350 mm (18$\frac{13}{16}$ × 13$\frac{3}{4}$ in) (ℯα 247)

1132 Uffizi Gallery
Etching and aquatint, printed in red and yellow
Image: 475 × 352 mm (18$\frac{11}{16}$ × 13$\frac{7}{8}$ in) (ℯα 248)

1133 Palazzo Pitti
Etching, soft-ground (comb effect) and aquatint, printed in blue and green
Image: 352 × 475 mm (13$\frac{7}{8}$ × 18$\frac{11}{16}$ in) (ℯα 249)

1134 Florence Panorama
Etching, soft-ground and aquatint, scrim wipe, printed in blue and brown
Image: 350 × 475 mm (13$\frac{3}{4}$ × 18$\frac{11}{16}$ in) (ℯα 250)

1135 Self-Portrait
Etching and aquatint, printed in brown and grey
Image: 350 × 476 mm (13$\frac{3}{4}$ × 18$\frac{3}{4}$ in) (ℯα 251)
Coll: Castle Museum, Norwich

1136 Villa Gamberia
Etching, soft-ground (comb effect) and aquatint, printed in brown and pink
Image: 477 × 351 mm (18$\frac{2}{8}$ × 13$\frac{13}{16}$ in) (ℯα 252)
Coll: GAC

1137 Near Fiesole
Etching, soft-ground and aquatint, scrim wipe, printed in blue, green and brown
Image: 351 × 476 mm (13$\frac{13}{16}$ × 18$\frac{3}{4}$ in) (ea 253)
Coll: Hunterian Museum and Art Gallery, University of Glasgow

AFRICA SUITE, 1966–7
Series of twelve colour etchings, two steel plates (unless stated otherwise), printed on white handmade Crisbrook 140 lb paper, measuring 565 × 790 mm (22$\frac{1}{4}$ × 31$\frac{1}{8}$ in, with variation)
Insc: with edition number and title, br: *Julian Trevelyan* (pencil) and dated *1966* (occasionally), vo: stamped ea and publication number
Edition: 125, 14–19 ap
Pr: Michael Templar and Harry Snook, Alecto Studios, London, 1966–7; pub: 1967 (ea 419–30)

1138 Hippos
Etching, soft-ground and aquatint, scrim wipe, printed in brown, yellow, orange
Image: 475 × 350 mm (18$\frac{11}{16}$ × 13$\frac{13}{16}$ in) (ea 419)

1139 Ankole Cattle
Etching, soft-ground (comb effect) and aquatint, printed in blue and brown
Image: 350 × 473 mm (13$\frac{13}{16}$ × 18$\frac{5}{8}$ in) (ea 420)

1140 The White Nile
Etching and aquatint, steel and zinc (relief) plates, printed in green, pink, blue, yellow, brown, black
Image: 350 × 475 mm (13$\frac{2}{8}$ × 18$\frac{11}{16}$ in) (ea 421)

1141 Outside Kampala
Etching, soft-ground and aquatint, scrim wipe, printed in maroon, orange, blue
Image: 350 × 474 mm (13$\frac{2}{8}$ × 18$\frac{21}{8}$ in), paper: 565 × 790 mm (22$\frac{1}{4}$ × 31$\frac{1}{8}$ in) (ea 422)

1142 Banana Girl
Etching, soft-ground and aquatint, printed in pink, brown, black
Image: 473 × 350 mm (18$\frac{5}{8}$ × 13$\frac{2}{8}$ in) (ea 423)

1143 Crocodiles
Etching and aquatint, printed in yellow, black, pink, grey
Image: 350 × 475 mm (13$\frac{2}{8}$ × 18$\frac{11}{16}$ in) (ea 424)

1144 Rain Forest
Etching, soft-ground and aquatint, scrim wipe, printed in black, blue, grey, pink, yellow
Image: 475 × 350 mm (18$\frac{11}{16}$ × 13$\frac{2}{8}$ in) (ea 425)

1145 Game Park
Etching, soft-ground (comb effect) and aquatint, scrim wipe, printed in green, red, brown
Image: 350 × 473 mm (13$\frac{2}{8}$ × 18$\frac{5}{8}$ in) (ea 426)

1146 Elephants
Etching, soft-ground (impressed folded cloth) and aquatint, steel plate, printed in black, grey, red
Image: 473 × 350 mm (18$\frac{5}{8}$ × 13$\frac{2}{8}$ in) (ea 427)

1147 Lions
Etching, soft-ground and aquatint, printed in orange brown, black, magenta
Image: 350 × 470 mm (13$\frac{2}{8}$ × 18$\frac{1}{2}$ in) (ea 428)

1148 Fruit Bats
Etching, soft-ground (lace impression, scrim wipe) and aquatint, printed in brown, orange, grey
Image: 351 × 473 mm (13$\frac{13}{16}$ × 18$\frac{5}{8}$ in) (ea 429)

1149 Rhinos
Etching, soft-ground (scrim wipe) and aquatint, steel plate, printed in brown
Image: 350 × 475 mm (13$\frac{25}{32}$ × 18$\frac{11}{16}$ in) (ea 430)

Ian Tyson (*b.*Wallasey, Cheshire, 1933)

Birkenhead School of Art and Royal Academy Schools, London. Taught lithography at Farnham School of Art, where met Ron King. Screenprints for *Sightings I–IX & Red Easy A Color*, with poetry by Jerome Rothenberg; and for *A Line That May Be Cut* with poems by Larry Eigner, both pub: Circle Press, 1968. Founded Tetrad Press, 1970, publishing own work and work by Tom Phillips, Derek Greaves, Ian Breakwell and others. Exhibitions include: Tate Gallery, 1973; Galerie Hoffmann, Friedberg, 1980; Galerie Vega, Liege, 1991; Flowers East, London, 1994; UC San Diego Library, 1996; Aviuson Gallery, Paris, 1998.

MID WEST I–III, 1970
Three colour screenprints printed on white 300 gsm paper
Image: 865 × 153 mm (34$\frac{1}{16}$ × 6$\frac{1}{32}$ in), paper: 927 × 204 mm (36$\frac{1}{2}$ × 8$\frac{1}{32}$ in)
Insc bl: with edition number, br: *Ian Tyson 70* (pencil), vo: stamped with *K* of Kelpa Studio and work number
Edition: 70, approx. 7 ap
Pr: Kelpra Studio, London; pub: 1970 (ea 682–4)
Coll: Tate

1150 I
Screenprint, printed in grey, black, two blues
(ea 682)

1151 II
Screenprint, printed in green, blue, red, black
(ea 683)

1152 III
Screenprint, printed in blue, two greens, black
(ea 684)

Related to five long paintings that grew out of a USA visit to the Midwest in 1969. Tyson was particularly struck by the architecture: 'a lot of the farmhouses have stained glass, in the kitchen for example, simple not ornate. The prints are extensions of the paintings completely geometric and abstract, a kind of counter-action to the landscape' (Ian Tyson, 1998)

John Ward (b.Hereford, 1917)

Hereford School of Arts and Crafts, 1932–6; RCA, 1936–9 and 1946–7. Worked for *Vogue* magazine, 1948–53. Portrait painter and illustrator of such books as Laurie Lee's *Cider with Rosie*, 1959. Showed in London with Arthur Jeffries and Maas Gallery, with retrospectives at: Agnew's, 1990 and Royal Museum, Canterbury, 1997. Millennium mural for Church of Saints Cosmos and Damian, Challock in Kent.

1153 Sutton Valence School, Kent, 1963
(ea 856)

The King's School, Canterbury, 1963
See Appendix

1154 Grays Inn Hall, c.1965
Lithograph, tusche, printed in grey, brown, blue on handmade paper
Image: 470 × 637 mm (18 $\frac{1}{2}$ × 25 $\frac{1}{8}$ in), paper: 568 × 802 mm (22 $\frac{3}{8}$ × 31 $\frac{5}{8}$ in)
Insc br: *John Ward 98/100* (pencil), br corner: ea embossed
Edition: 100, approx. 10 ap
Pr: Richard Bawden at Essex studio, c.1965; redistributed: 1974
(ea 857)
Lit: *Law Guardian*, April 1969 (ill.)
Coll: South London Gallery; GAC

Looking towards the celebrated Armada Screen at the back, so called because it is made of wood taken from that fleet. In the foreground is a griffin on one of the chairs, the symbol of this particular inn.

1155 The Law Society Library, c.1965
Lithograph, tusche, printed in pink, yellow, brown, grey green, blue
Image: 500 × 675 mm (19 $\frac{11}{16}$ × 26 $\frac{9}{16}$ in), 570 × 800 mm (22 $\frac{7}{16}$ × 31 $\frac{1}{2}$ in, approx.)
Insc br: *17/100 John Ward* (pencil), br: ea embossed
Edition: 100, approx. 10 ap
Pr: Richard Bawden at Essex studio, c.1965; redistributed: 1974
(ea 858)
Coll: GAC

1156 Inner Temple Hall, c.1965
Lithograph, tusche, printed in grey, yellow, blue, brown on handmade paper
Image: 435 × 590 mm (17 $\frac{1}{8}$ × 23 $\frac{1}{4}$ in), paper: 576 × 806 mm (22 $\frac{11}{16}$ × 31 $\frac{3}{4}$ in)
Insc br: *John Ward 32/100* (pencil), br corner: ea embossed (variously inscribed with title)
Edition: 100, approx. 10 ap
Pr: Richard Bawden at Essex studio, c.1965; redistributed: 1974
(ea 859)
Coll: South London Gallery; GAC

The commission to draw historic sites associated with Lincoln's Inn produced John Ward's first set of lithographs. He also produced *Lincoln's Inn* and *Middle Temple Hall* in the same series, which were distributed but not published by ea. Here a high viewpoint looks down on the lines of dining tables filling the Inner Temple Hall.

John Watson (1923–92)
1157 Eastbourne College, Sussex
(ea 860)

Ardingley School*

Rossall School, Lancashire
See Appendix

Gerald Woods (b.Donnington, 1942)

See Appendix

Larry Zox (b.Des Moines, Iowa, 1936)

Oklahoma University and Des Moines Art Center studying with George Grosz. Associated with post-painterly school of abstract painting. Series of exhibitions at Kornblee Gallery, New York, 1964–9. Annual exhibition at Whitney Museum of American Art, New York, 1967 and *American Art Now*, USA Pavilion at Expo '67, Montreal. Both the *Diamond Drill* and *Gemini Series* of large acrylic paintings were produced from 1968, and became the basis for portfolio of same title.

DIAMOND DRILL, 1968
Portfolio of six colour screenprints with underlaid varnish, plus title page, presented with Kulicke frameless frame (wooden back frame and perspex cover), overall size: 660 × 580 mm (26 × 22 $\frac{27}{32}$ in)
Image: 610 × 507 mm (24 × 19 $\frac{31}{32}$ in) (*Diamond Drill 1–4*); image: 610 × 557 mm (24 × 21 $\frac{15}{16}$ in) (*Gemini 1–2*); paper: 656 × 584 mm (25 $\frac{27}{32}$ × 23 in, with variation)
Insc bl: edition number, br: *Zox*, br corner: *Chiron Press/New York* blind embossed stamp
Edition: 75, 15 ap

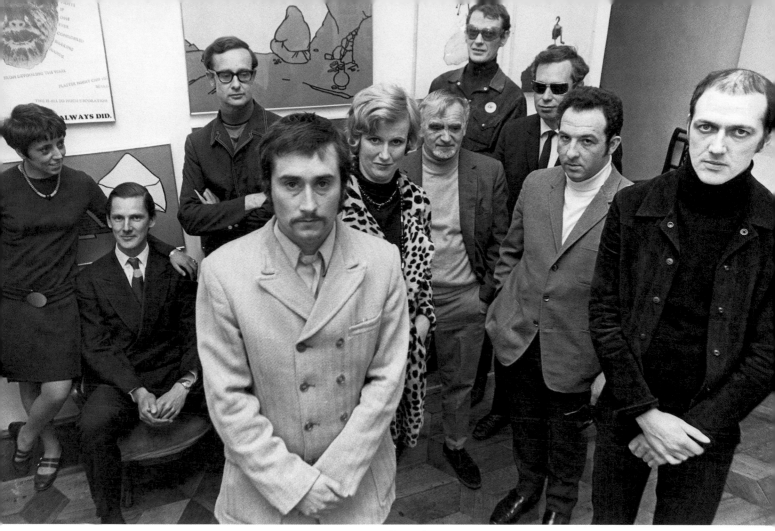

Fig.24 Opening of the Editions Alecto exhibition at La Galleria, Milan, 1968, with left to right: Carla Pellegrini, Joe Studholme, Robyn Denny, Colin Self, Gillian Ayres, William Scott, Peter Sedgley, Howard Hodgkin, Bernard Cohen and Allen Jones

Pr: Chiron Press, New York, 1968; pub: Kornblee Gallery, New York and Editions Alecto Ltd, 1968 (ℯɑ 566–71)
Coll: Metropolitan Museum of Art, New York

Diamond Drill, 1–4

1158 1
Screenprint, printed in pink, orange, grey, brown
(ℯɑ 566)

1159 2 (Page 166)
Screenprint, printed in green, orange, yellow, blue
(ℯɑ 567)

1160 3 (Page 167)
Screenprint, printed in red, yellow, black, green
(ℯɑ 568)

1161 4
Screenprint, printed in grey, purple, black, orange, brown, yellow
(ℯɑ 569)

Gemini, 1–2

1162 1
Screenprint, printed in purple, yellow, orange, green, red
(ℯɑ 570)

1163 2
Screenprint, printed in yellow, green, orange, black, red
(ℯɑ 571)

Appendix: Public Schools Series, 1961–4

Series which began in 1961 with commissioning of John Piper's lithographs of *Westminster School*, and continued with selection of further artists depicting public boys' schools throughout England and Scotland.

Insc with edition number, variously titled, and artist's signature. Edition: 100, 10 ap (mostly). Predominantly without publication numbers.

This is not a complete list but records those images that have been located to date.

Edward Ardizzone (1900–79)

Lit: Nicholas Ardizzone, *Edward Ardizzone's World: The Lithographs and Etchings, an introduction and catalogue raisonné*, London, Unicorn Press and Wolseley Fine Arts, 2000

Charterhouse: The Courtyard
Lithograph, image: 381 × 532 mm (15 × 20$\frac{15}{16}$ in)
Pr: Desjoubert, Paris, *c.*1964; redistributed: 1973–4 (ea 851)
Lit: *Lithographs*, NAP 38
Coll: GAC

Charterhouse: The Mulberry Tree
Lithograph, image: 381 × 538 mm (15 × 21$\frac{3}{16}$ in)
Pr: Desjoubert, Paris, *c.*1964; redistributed: 1973–4 (ea 848)
Lit: *Lithographs*, NAP 39

Downside Abbey: The Tower
Lithograph on B. F. K. Rives paper; image: 370 × 530 mm
(14$\frac{9}{16}$ × 20$\frac{7}{8}$ in)
Pr: Desjoubert, Paris, *c.*1964
Lit: *Lithographs*, NAP 40
Coll: GAC

Downside Abbey: The Courtyard, c.1964
Lithograph on B. F. K. Rives paper; image: 345 × 536 mm
(13$\frac{9}{16}$ × 21$\frac{1}{8}$ in)
Pr: Desjoubert, Paris, *c.*1964; redistributed: 1973–4 (ea 849)
Lit: *Lithographs*, NAP 41
Coll: GAC

St Paul's School, Hammersmith: The Front, c. 1964
Lithograph on B. F. K. Rives paper; image: 345 × 536 mm
(13$\frac{9}{16}$ × 21$\frac{1}{8}$ in)
Pr: Desjoubert, Paris, *c.*1964

Lit: *Lithographs*, NAP 42
Coll: GAC

St Paul's School, Hammersmith: The Nets
Lithograph on B. F. K. Rives paper; image: 382 × 532 mm
(15$\frac{1}{16}$ × 20$\frac{15}{16}$ in)
Pr: Desjoubert, Paris, *c.*1964; redistributed 1973–4 (ea 850)
Lit: *Lithographs*, NAP 43
Coll: GAC

'The initial drawings for these school prints are about a third the size of the finished image, which Ardizzone then squared up for transfer My guess is that they are probably plate rather than stone.' (Nicholas Ardizzone, 17/4/2000)

Elizabeth Aslin (1923–89)

Oundle School, Northamptonshire
Colour etching, aquatint; plate: 412 × 437 mm (16$\frac{1}{4}$ × 17$\frac{3}{16}$ in)
Coll: GAC

Stowe School, Buckinghamshire
Colour etching, aquatint; plate: 300 × 503 mm (11$\frac{13}{16}$ × 19$\frac{13}{16}$ in)
Coll: GAC

Chigwell School, Essex*
Colour etching, aquatint
Coll: GAC

Richard Bawden (*b.*1936)

Shrewsbury School, Shropshire
Colour lithograph; plate: 402 × 610 mm (15$\frac{13}{16}$ × 24 in)
Pr: The artist, studio at Coggeshall, Essex
Coll: GAC

Uppingham School, Rutland*
Colour lithograph

André Bicât (1909–96)

Cheltenham College, Gloucestershire
Colour etching, aquatint; plate: 340 × 454 mm (13$\frac{3}{8}$ × 17$\frac{7}{8}$ in)
Pr: Michael Rand, The Studio, Bushey
Coll: GAC

Editioning of *Cheltenham* took place in summer 1964, though the signing of the prints went into January 1965. In a letter to Bicât, Elizabeth Fenwick, Administrator at ea, writes, 'I should be most grateful if you could sign these Cheltenham prints as people are screaming for them and we are sold out. Number 77 onwards.' (16/12/1964)

Tonbridge School, Kent
Colour etching, aquatint; plate: 341 × 454 mm (13 $\frac{7}{16}$ × 17 $\frac{7}{8}$ in)
Pr: Michael Rand, The Studio, Bushey

Royal Air Force College, Cranwell
Colour etching, aquatint; plate: 455 × 340 mm (17 $\frac{15}{16}$ × 13 $\frac{3}{8}$ in)
Coll: RAF Cranwell

View of middle part of College Hall and Tower, built *c.*1932.

Wellington College, Berkshire, 1964
Colour etching with aquatint; plate: 450 × 338 mm (17 $\frac{23}{32}$ × 13 $\frac{5}{16}$ in)
Lit: *Wellington Year Book*, 1964 (p.3); *A Decade of Printmaking*, p.19 (ill.)

View from Front Quad looking towards the Great Gate, the main entrance to Wellington College whose foundation stone was laid in 1856.

George Chapman (1908–93)

Repton School, Derbyshire
Colour etching, aquatint; plate: 600 × 390 mm (23 $\frac{5}{8}$ × 15 $\frac{5}{16}$ in)
Pr: Peter Matthews, RCA, 1962

View, from inside the Arch, of Old Priory Building and Causeway on the right, with The Hall in background. 'George was not that happy with the *Public School Series* and with what he produced. Basically because the plate was so deeply etched it held too much ink for the paper to absorb and the ink began to bleed out' (Peter Matthews, 8/7/2000)

Uppingham School, Rutland
Etching; plate: 467 × 558 mm (18 $\frac{3}{8}$ × 21 $\frac{15}{16}$ in)
Edition: a few proofs
Proofed: The artist, Moat House Studio, Hethel, near Norwich, *c.*1962 but not considered successful enough to edition; three proofs re-pr: Robert Meyrick, Visual Art Department, University of Wales, Llanbadarn Road, Aberystwyth, 1992
Coll: School of Art Collection, University of Wales, Aberystwyth

Letter from Paul Cornwall-Jones to George Chapman, dated 12/7/1962, refers to Peter Matthews and the printing of Repton, and goes on to mention the arrangements for prints of Stowe and Oundle Schools 'to make up the set of six (with Bryanston)'. These were unrealised by Chapman.

Bernard Cheese (*b.*1925)

Radley College (near Oxford)
Colour lithograph on J. Green waterleaf paper; image: 530 × 698 mm (20 $\frac{7}{8}$ × 27 $\frac{1}{2}$ in)
Pr: The artist, Stisted studio, Essex
Coll: School of Art Collection, University of Wales, Aberystwyth

Godfrey Paul Eagleton (*b.*1935)

Sherborne School, Dorset*
Etching

Gertrude Hermes (1901–83)

Framlingham College, Suffolk
Colour linocut on handmade Japanese paper; image: 330 × 508 mm (13 × 20 in)
Pr: The artist, 1964
Coll: GAC

Walter Hoyle (1922–2000)

Rugby School (Page 31)
Colour linocut on handmade Japanese paper; image: 610 × 460 mm (24 × 18 $\frac{1}{8}$ in)
Pr: The artist, Rosemary House, Great Saling, Essex, 1964

Bernard Kay (*b.*1927)

Malvern College
Colour etching, sugar-lift aquatint; plate: 303 × 603 mm (11 $\frac{15}{16}$ × 23 $\frac{3}{4}$ in)

Hereford Cathedral School
Etching, sugar-lift aquatint; plate: 352 × 503 mm (13 $\frac{7}{8}$ × 19 $\frac{13}{16}$ in)

Both printed by C. H. Welch, London, 1964.

Edwin La Dell (1914–70)

The following were printed at RCA, almost certainly by George Devenish, on T. H. Saunders and handmade Crisbrook papers, *c.*1964.

Ampleforth, Yorkshire
Colour lithograph, image: 370 × 565 mm (14 $\frac{9}{16}$ × 22 $\frac{1}{4}$ in)
Coll: GAC

Wrekin College, Wellington, Telford
Colour lithograph; image: 332 × 567 mm (13 $\frac{1}{16}$ × 22 $\frac{5}{16}$ in)

Merchiston Castle School, Edinburgh
Colour lithograph; image: 351 × 565 mm (13$\frac{13}{16}$ × 22$\frac{1}{4}$ in)

Glenalmond College, Perth
Colour lithograph; image: 360 × 565 mm (14$\frac{3}{16}$ × 22$\frac{1}{4}$ in)

Gordonstoun School, Elgin, Morayshire
Colour lithograph; image: 390 × 587 mm (15$\frac{3}{8}$ × 23$\frac{1}{8}$ in)

Canford School, Wimborne, Dorset
Colour lithograph; image: 410 × 536 mm (16$\frac{1}{8}$ × 21$\frac{1}{8}$ in)

Fettes, Edinburgh
Colour lithograph; image: 384 × 568 mm (15$\frac{1}{8}$ × 22$\frac{3}{8}$ in)

Glasgow Academy
Colour lithograph; image: 403 × 566 mm (15$\frac{7}{8}$ × 22$\frac{1}{4}$ in)

Brighton College, Sussex
Colour lithograph; image: 363 × 605 mm (14$\frac{5}{16}$ × 23$\frac{13}{16}$ in)

Clifton College, Bristol
Colour lithograph; image: 410 × 518 mm (16$\frac{1}{8}$ × 20$\frac{3}{8}$ in)

Unidentified School (Cricketing Scene)
Colour lithograph; image: 394 × 558 mm (15$\frac{1}{2}$ × 22$\frac{1}{32}$ in)
Proof insc: *grass & cricketers out*

These images are part of the artist's estate.

Helena Markson (*b.*1934)

Beaumont School, near Windsor, Berkshire
Colour etching, sugar-lift aquatint on Crisbrook paper
Plate: 422 × 554 mm (16$\frac{5}{8}$ × 21$\frac{13}{16}$ in)
Proofed: The artist, Stoke Newington studio, pr: Leblanc, Paris, 1964
(ea 99)
Coll: GAC

Haileybury College, Hertfordshire*
Colour etching, sugar-lift aquatint, plate: 555 × 410 mm
(21$\frac{7}{8}$ × 16$\frac{1}{8}$ in), paper: 755 × 560 mm (29$\frac{3}{4}$ × 22$\frac{1}{16}$ in)
Proofed: The artist, Stoke Newington studio; pr: Leblanc, Paris, 1964
Coll: GAC

Dover College, Kent
Colour etching, sugar-lift aquatint, open bite
Plate: 428 × 602 mm (16$\frac{7}{8}$ × 23$\frac{11}{16}$ in)
Proofed: The artist, Stoke Newington studio; pr: Leblanc, Paris, 1964

John Piper (1903–92)

Lit: Orde Levinson, *John Piper The Complete Graphic Works: A Catalogue Raisonné 1923–1983*, London, Faber and Faber, 1987 (reprinted London, Lund Humphries, 1996)

Westminster School I
Colour lithograph on Barcham Green 300 gsm paper
Image: 449 × 582 mm (17$\frac{11}{16}$ × 22$\frac{15}{16}$ in), paper: 577 × 808 mm
(22$\frac{11}{16}$ × 31$\frac{13}{16}$ in)
Pr: Curwen Studio, London under supervision of Stanley Jones, April–June 1961
Coll: Tate

Piper focuses on Arch entrance to the school, attributed to Lord Burlington, with to the east across Little Dean's Yard, Victoria Tower of The Houses of Parliament.
 Orde Levinson refers to a pink and grey trial proof, pink possibly quite coincidentally being the Westminster School colour.

Westminster School II (Page 33)
Colour lithograph on Barcham Green 300 gsm paper
Image: 430 × 582 mm (16$\frac{15}{16}$ × 22$\frac{15}{16}$ in), paper: 576 × 805 mm
(22$\frac{11}{16}$ × 31$\frac{11}{16}$ in)
Pr: Curwen Studio, London under supervision of Stanley Jones, April–June 1961
Coll: Tate

This is a view of the south side of Little Dean's Yard, the three buildings left to right being: the house of the Master of The Queen's Scholars, Grant's House and Rigaud's House.

Sheila Robinson (1925–87)

Monkton Combe, near Bath, Somerset
Colour linocut and card with pva surface on laid Hosho paper
Image: 397 × 509 mm (15$\frac{5}{8}$ × 20 in)
Hand-printed: The artist, studio–front room, Cage Cottage, Great Bardfield, 1964
Coll: GAC

Felsted School, Essex
Colour linocut and card with pva surface on laid Hosho paper
Image: 384 × 582 mm (15$\frac{1}{8}$ × 22$\frac{29}{32}$ in)
Hand-printed: The artist, studio–front room, Cage Cottage, Great Bardfield, 1964
Coll: GAC

'Though the carved nude figure on the right was not well received, it was a characteristic bold, strong statement by my mother She used oil-based colours with quite a bit of overprinting for the hills'
(Chloë Cheese, 2/4/2000)

Valerie Thornton (1931–91)

See catalogue

John Ward (b.1917)

The King's School, Canterbury (Vignettes in the Precincts)
Colour lithograph; image: 515 × 595 mm (20 $\frac{1}{4}$ × 23 $\frac{7}{16}$ in)
Pr: Richard Bawden, Coggeshall studio, 1963
Coll: GAC

ea approached the Old King's Scholars Association to publicise this particular commission. Alan Wilson, then Secretary of OKSA, recalls seeing *Public School Prints* at The Print Centre at the same time as Hockney's *A Rake's Progress*, December 1963.

Sutton Valence School (Kent)
Colour lithograph
Image: 450 × 635 mm (17 $\frac{11}{16}$ × 25 in), paper: 573 × 800 mm
(22 $\frac{9}{16}$ × 31 $\frac{1}{2}$ in)
Pr: Richard Bawden, Coggeshall studio, 1963; redistributed: 1974
(ea 856)
Coll: GAC

The Centre Block of the school looking towards four chestnut trees, alongside a view of the school in relation to the village of Sutton Valence.

John Watson (1923–92)

Ardingley College, Sussex*
Colour lithograph
Coll: GAC

Eastbourne College, Sussex
Colour lithograph, image: 460 × 482 mm (18 $\frac{1}{8}$ × 19 in)
Pr: The artist, Wavendon studio, Milton Keynes, 1964; redistributed:
1974 (ea 860)
Coll: GAC

Rossall School, Lancashire, 1964
Colour lithograph; image: 423 × 538 mm (16 $\frac{5}{8}$ × 21 $\frac{3}{16}$ in)
Pr: The artist, Wavendon studio, Milton Keynes
Coll: GAC

Gerald Woods (b.1942)

Dulwich College
Colour lithograph, off-set, on Crisbrook handmade paper
Image: 480 × 575 mm (18 $\frac{7}{8}$ × 22 $\frac{5}{8}$ in)
Proofed: The artist, Ipswich School of Art; pr: Cowells of Ipswich,
1964
Coll: South London Gallery, GAC

Gerald Woods began by printing an edition of hundred on direct litho press, but 'Alecto said the registration marks in the margins were unacceptable'. He was asked to redraw the image 'using the Plastocowell process. This involved drawing each separate colour with tusche and crayon on grained sheets of plastic, which were then transferred to plates and editioned on an offset press.' (GW, 2/2/2001)

Taunton School, Somerset
Colour woodcut, linocut on Japanese paper
Image: 330 × 475 mm (13 × 18 $\frac{11}{16}$ in)
Pr: The artist, Ipswich School of Art, 1964

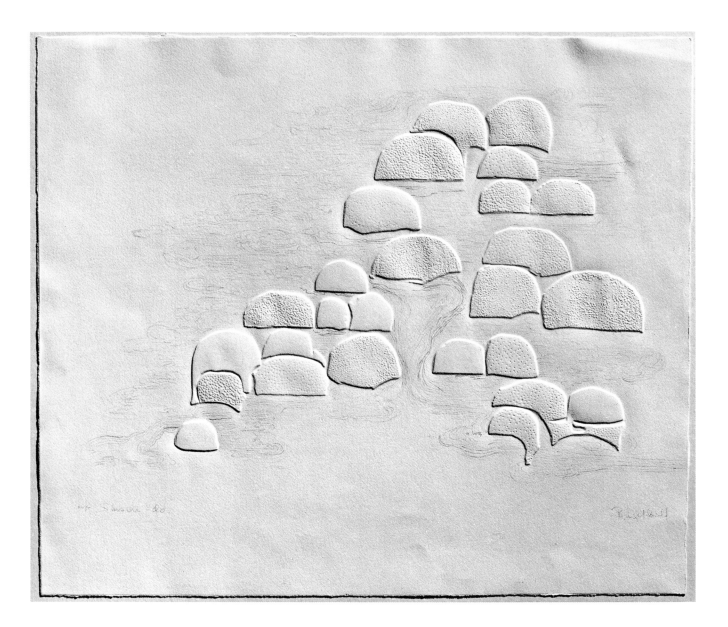

Plate 162 Birgit Skiöld, *Shisen-do*, 1974 (1062)

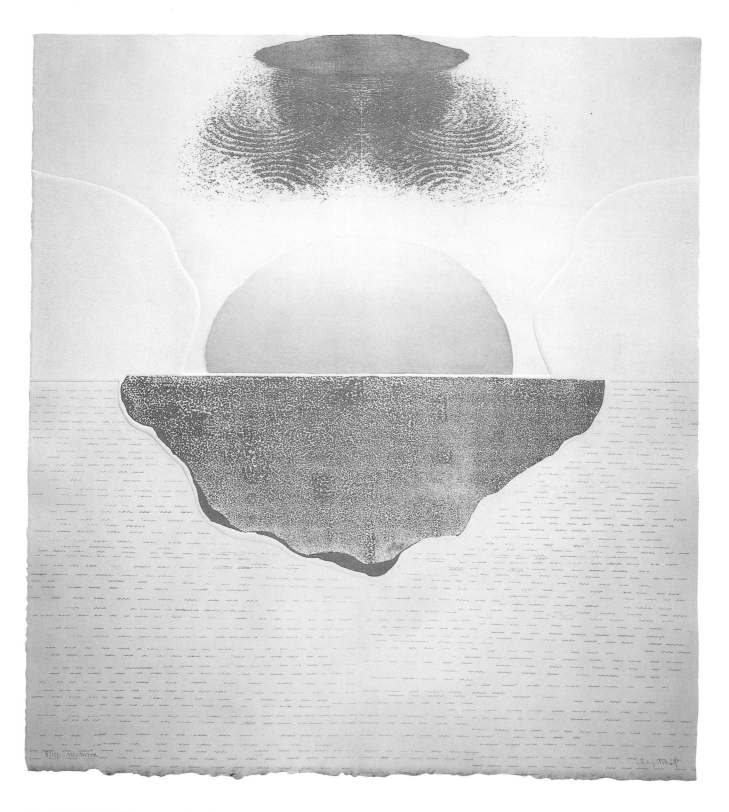

Plate 163 Birgit Skiöld, *Moruroa*, 1973 (1061)

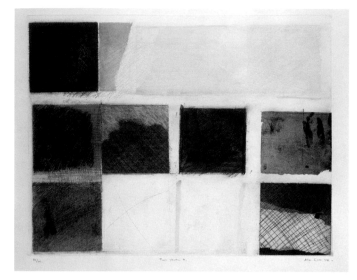

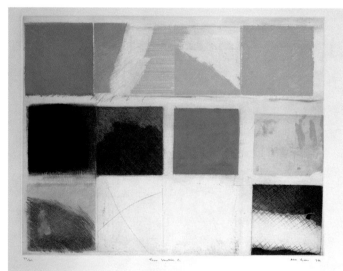

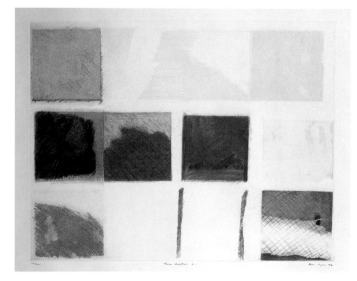

Plates 164–6 Alan Green, *Three Variations A–C*, 1974 (406–8)

Plate 167 Michael McKinnon, *Phyllotaxis*, 1976 (657)

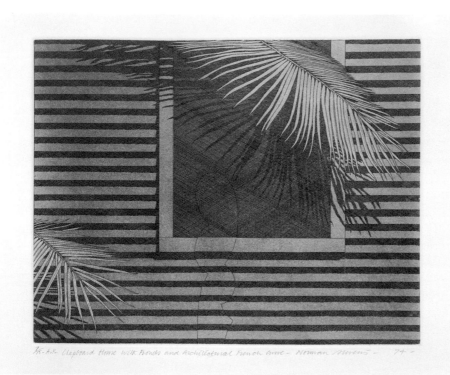

Plate168 Norman Stevens, *Clapboard House with Fronds and Architectural Curve*, 1974 (1076)

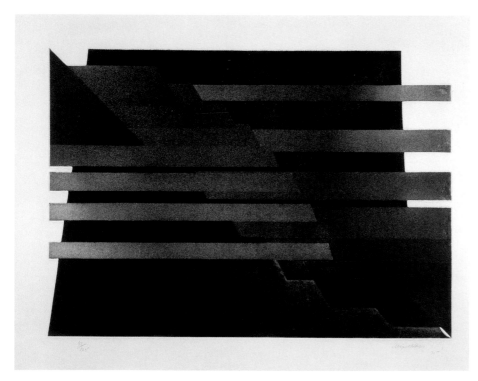

Plate 169 Nigel Hall, *Dialogue*, 1975 (409)

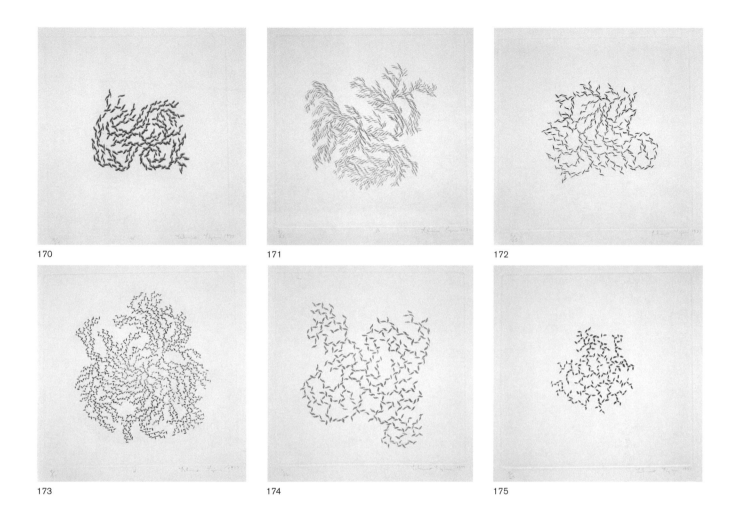

170

171

172

173

174

175

Plates 170–5 Liliane Lijn, *Biting Through 1–6*, 1976–7 (634–9)

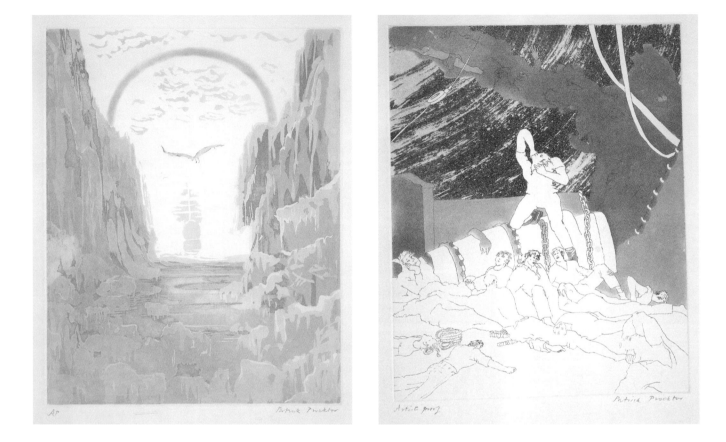

Plates 176, 177 Patrick Procktor, *And ice, mast-high, came floating by, As green as emerald*
and *The ribbed sea-sand*, from *The Rime of The Ancient Mariner*, 1976 (938, 942)

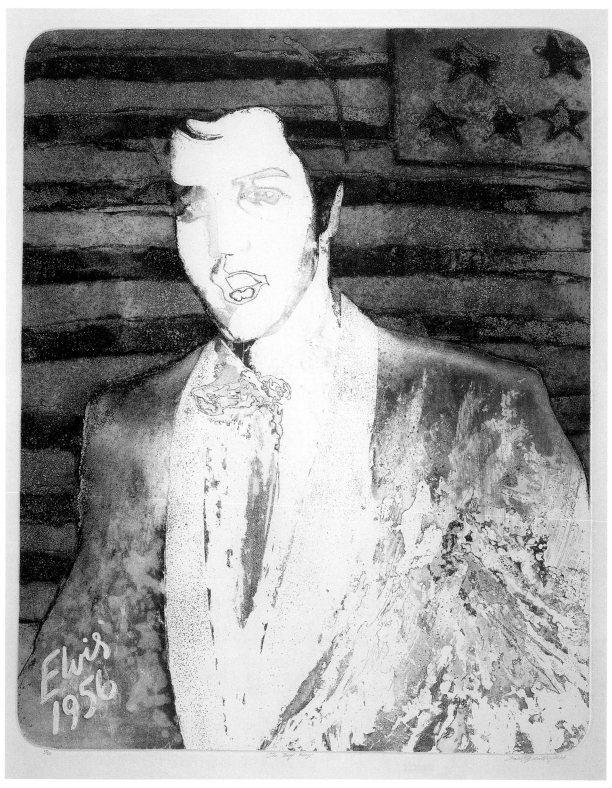

Plate 178 David Oxtoby, *Elvis Presley 1956 'The Boy King'*, 1977 (679)

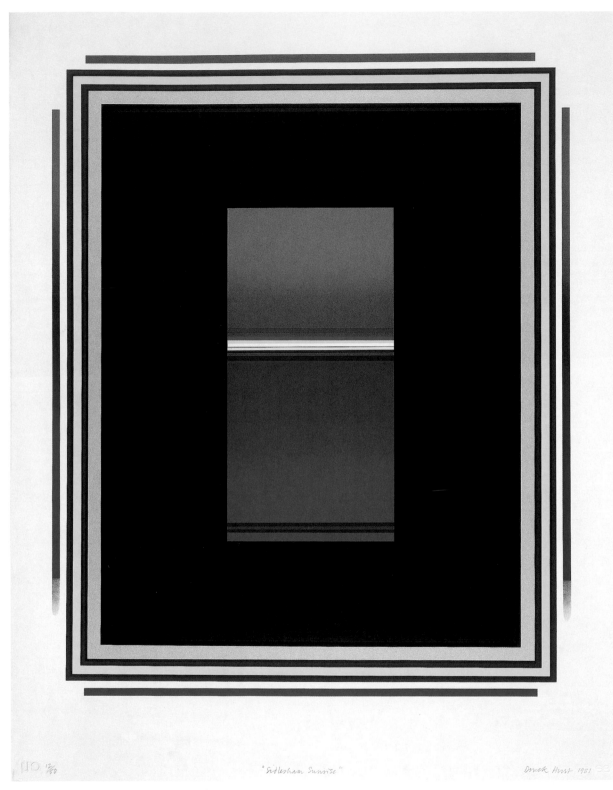

"Sidlesham Sunrise" Derek Hirst 1981

Plate 179 Derek Hirst, *Sidlesham Sunset*, 1981 (428)

BILL CULBERT

III IV

WINDOW 84490

10 photographs taken between
sunrise and moonrise on one day in winter 1975
Photographic prints 30 x 30 in.

Published by
Editions Alecto Limited
in an edition of 25
with 5 Artist's Proofs
and first exhibited
at the Editions Alecto Gallery
27 Kelso Place London W8
from 20 January to 25 February 1977

'The lens is the camera, the window the house.'

Editions Alecto

27 Kelso Place London W8 5QG Telephone 01-937 6611 **ea** 200 East 58 Street New York NY 10022 Telephone 212 421 3272

Plate 180 Bill Culbert, *Window 84490*, 1977 (220–9)

Biographies

The following brings together documentation on associates of ea who have been interviewed or who have regularly appeared during the course of research and/or conversations. Inevitable omissions have mostly been the result of being unable to locate or make contact with certain individuals.

Brooke Alexander (*b.*Los Angeles, 1937**)**
Studied classics at Yale University. After period in Los Angeles, joined Marlborough Fine Art, New York, with responsibility for modern and contemporary prints. Moved to work for ea, New York in 1967, later running their office at 165 East 61st Street and coordinating first publishing project, Larry Zox's *Diamond Drill*. Founded Brooke Alexander Inc in November 1968 with wife Carolyn, in storefront on East 68th Street, and began to publish prints and multiples, including Richard Artschwager's multiple *Locations*, 1969. MOMA celebrated over twenty-five years of publishing prints as Brooke Alexander Editions in 1994.

Douglas Allsop (*b.*London, 1943)
Introduced to ea through John Brunsdon, a lecturer at St Albans School of Art, where Allsop was a student. Began to assist Brunsdon with intaglio printing at Digswell Arts Trust, 1962. ea became a client, and on taking over the studio in 1964, continued to run and print for such artists as Richard Beer, Helena Markson, Anthony Currell and Alistair Grant. Expanded to include screen and lithography, continuing until 1973. From 1965 began to exhibit own artwork. Represented by Lucy Milton Gallery, London, 1968–75, and widely exhibited in Germany. Thirty-year retrospective shown simultaneously at Städtisches Museum, Gelsenkirchen and Emschertal Museum, Herne, 2001.

Eric Ayers (*b.*Dulwich Village, London, 1921–2001)
On leaving school, messenger for advertising agency Associated Publicity Services in Fleet Street. Took evening classes in lettering, drawing, design and graphic reproduction at L.C.C. School of Photoengraving and Lithography in nearby Bolt Court. Beckenham School of Art from January 1940, meeting Walter Hoyle; and RCA, September 1940, before being called up to join 30th Armoured Assault Brigade. Returned to RCA to study graphic design, 1945. Art Director of advertising agency C. R. Casson; mural painter in Dome of Discovery, Festival of Britain; and from 1958 Design Director for publishers Weidenfeld and Nicholson. Freelance design work for ea from 1963, joining board of directors until 1967. Played major role in

realising company's early image, designing the ea symbol and responsible for the design and typography associated with posters, portfolio boxes, catalogues and invitation cards. Continued as consultant designer/typographer, notably working for Petersburg Press. Lectured at London College of Printing, and Senior Lecturer in Graphic Arts at Camberwell School of Art, 1962–83. Lived and worked in Bloomsbury, London since 1958, with wife Duffy Ayers, the painter.

Terence Benton (*b.*Kansas City, 1933)
After studying at Kansas Art Institute and national service in USA, came to England in 1957. Opened fine art business in Knightsbridge, before meeting Paul Cornwall-Jones through André Bicât. Joined ea in 1963 to help administer projects, later joining board of directors. Left in 1969, to work at Royal Opera House, Covent Garden, where established Archive Department. Subsequently, began working as an unofficial cultural envoy, mainly concerned with Russian opera and ballet. This continued into 1980s.

Don Bessant (*b.*Gillingham, Kent, 1941–93**)**
Rochester School of Art, before studying printmaking at RCA, 1961–4, gaining first class honours and gold medal. Part-time lecturer in printmaking at Maidstone College of Art, before moving to Wolverhampton College of Art, 1972–93. Taught Tim Mara and Chris Plowman. Printing lithographs for ea at Alecto Studios, 1973–5. Assisted Alan Cox at Sky Editions, initially at studio in Butlers Wharf and later in Shoreditch, 1978–93. There worked with lithography and monoprint techniques for such artists as Martin Naylor, Prunella Clough, Jim Dine, Howard Hodgkin, Robyn Denny, Dieter Roth and Bruce McLean. In 1984 editioned own lithographs and visiting printer at new print workshop in Athens set up by Stavros Mihalarias and Alan Cox. Work includes scenes of the landscape around Slad in Gloucestershire, the home of friend Laurie Lee. *Retrospective Exhibition of the late Don Bessant*, Wolverhampton College of Art, 1994.

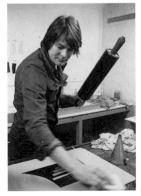

Fig.25 Don Bessant printing for Nigel Hall in the lithography studio, Kelso Place, 1974 © Nigel Hall

Fig.26 Steve Poleskie of Chiron Press (second left) and Larry Zox (third left) in Union Square, New York for a publicity shot (with Larry Rivers on right and Nicholas Krushenick on left), 1968

Chiron Press, New York

Pioneering New York screen studio founded by **Steve Poleskie** (*b.*Pringle, Pennsylvania 1938) 1962, initially producing four prints entitled *Unity 72* by Alfred Jensen in storefront studio at 614 East 11th Street. Followed by work for Roslyn Drexler, Nicholas Krushenick and Malcolm Morley, before studio moved to 76 Jefferson Street, New York. Printed for: Andy Warhol, Louise Nevelson, Robert Motherwell, Roy Lichtenstein, Claes Oldenburg, Larry Rivers, Jim Dine, Helen Frankenthaler, Arman, Larry Zox, Peter Phillips, Allen Jones. Co-purchased by **Michael Knigin** and **Roger Loft** in 1969, the press moved to 58 East 11th Street, printing screen and litho. Sold to run as Chiron Art, 1971, in Mexico City. Steve Poleskie became Professor of Art, Cornell University, and had graphics retrospective at State Museum of Poland, Lodz, 1987; and John Hansard Gallery, Southampton, 1989. International reputation for Aerial Theatre activities, 1972–92 and, more recently, has devoted time to writing. Michael Knigin works from East Hampton, exhibiting widely, while teaching part time at Pratt Institute, Brooklyn.

James Collyer (*b.*London, 1948)

Studied painting and printmaking at Bournemouth and Poole College of Art, 1964–8. Gained experience of intaglio process from tutor Peter Olley. Kingston-upon-Thames College of Art, 1968–9. Worked on building site in Battersea. Master etcher at ea, 1969–71. Joint founder of new intaglio studio, J. C. Editions, London, with John Crossley, 1971–87. Continued to print for ea on a project basis. Travelled to Canada, USA, Mexico and North Africa. Etcher to Henry Moore, 1979–86; various lecturing posts. Following dissolving of J. C. Editions, concentrated on own work, experimenting with monoprint and, from 1994, with mixed-media painting on paper.

John Crossley (*b.*Bradford, 1946)

Studied fine art at Bradford College of Art, 1963–4 and Hornsey College of Art, London, 1964–8. Master etcher at ea, 1969–71. Joint principal etcher with James Collyer of new intaglio studio J. C. Editions, based at Tysoe Street, London EC1, 1971–5 (during which time continued to work for Editions Alecto), and then at Goswell Road, 1978–88. Etcher to Henry Moore, 1979–86. From 1988 working as Crossley Intaglio, based at studio in Islington.

Michael Deakin (*b.*Oxford, 1939)

Emmanuel College, Cambridge where met Paul Cornwall-Jones and Mark Glazebrook. Founding Director of ea, 1960–4. Producer BBC Radio Current Affairs Department, 1964–8. Producer, then Editor, of Yorkshire Television Documentary Unit, 1968–81. Director of Gryphon Productions Ltd since 1985. Documentary film productions include:

Johnny Go Home (British Academy Award), 1976; *David Frost's Global Village*; *The Frost Interview – The Shah*; *Not a Penny More, Not a Penny Less*, 1990 (TV mini series), and many others. Founding Member, TV am Breakfast Television Consortium, 1980. Author of various political publications and for children, *Tom Grattan's War*, 1970 and 1971.

Ernest (Ernie) Donagh (*b.*Wednesbury, Staffordshire, 1941)
Studied lithography and painting, Stafford Art School, 1958–62 where met Ian Lawson, and then art education at Goldsmiths' College, London, 1962–3. Worked as commercial artist putting together exhibition stands at Olympia, before joining Ian Lawson as Fine Art Lithographer at ea, 1968–9. Left to work for Petersburg Press, 1969–77, during which time used the Charlotte Street printing facilities run by Birgit Skiöld to proof work. Worked as general production assistant on numerous projects during this period. Part-time Tutor of Life Drawing, Putney College of Art, 1977–86. Continues to teach and exhibit own work.

Robert Erskine (*b.*London, 1930)
Studying archaeology at King's College, Cambridge 1950–3, began to sell and organise exhibitions of prints published by Zürich-based Guilde de la Gravure at Heffer's Art Gallery. Visits to Paris, and Atelier Lacourière, inspired the founding of St George's Gallery, Cork Street, London, 1955. This pioneered idea of a dedicated print space, selling and commissioning contemporary British as well as modern European prints. *Contemporary British Printmakers* and *The Graven Image* were two of the series of exhibitions organised by St George's. In 1958 Erskine invited Stanley Jones to establish print studio in St Ives, the forerunner of Curwen Studio. Produced influential documentary film *Artist's Proof*, 1957. Interest in ancient history and working with film contributed to closure of the gallery in 1963, with the taking over of the print stock by newly formed Editions Alecto Ltd. Began producing films for ITV and BBC 2 from the late 1950s into 1970s. This included series on coins *Heads and Tails*, *The Roman Way* and educational programmes for schools. Remained a 'sleeping' director of ea, and in 1980s worked with Alecto Historical Editions on commentary for John James Audubon's *Birds of America* and on facsimile *Domesday Book* as general editior.

Galerie Der Spiegel, Cologne
Founded by Eva (1913–88) and Hein Stünke (1913–94) in 1945. Subsequently expanded to include workshop which became celebrated for production of portfolio boxes, limited edition catalogues and books. The gallery organised pioneering exhibitions of international and German artists, and produced artists' books and portfolios with Max Ernst, Karl Gerstner, Victor Vasarely, Anni and Josef Albers, Horst Antes, Richard Anuszkiewicz, Christo, Dieter Roth, George Segal amongst others, and multiple objects through MAT Edition, which was purchased in 1964. Became the representative for ea in Germany and, through design interests of Hein Stünke in collaboration with workshop bookbinder, Peter Swoboda, major source for the ea portfolio boxes. Located at Richartzstrasse 10, in centre of Cologne, their collaboration with ea, and Paul Cornwall-Jones in particular,

included: the staging of the *Englische Graphik* and *Allen Jones* exhibitions in 1966 and 1967; the production of portfolio boxes for *The Cavafy Series*, 1966–7, Dubuffet's *Banque de L'Hourloupe* in 1967, and Allen Jones' *Life Class*, 1968. The gallery moved back to Richartzstrasse 10, in January 1997, under directorship of Werner Hillman.

Mark Glazebrook (*b.*Burton, Cheshire, 1936)
Pembroke College, Cambridge where met Paul Cornwall-Jones, and Slade School of Fine Art. Exhibition organiser at Arts Council of Great Britain, 1961–4. Founding Director of Editions Alecto Ltd, 1960–4. Lecturer at Maidstone College of Art, 1965–7, and art critic *London Magazine*, 1967–8. Director, Whitechapel Art Gallery, 1969–71. Head of Modern English Paintings and Drawings, P. and D. Colnaghi and Co Ltd, 1973–5. Gallery Director and lecturer, San José State University, 1977–9. Director, Albemarle Gallery Ltd, London, 1986–93. Author of various catalogues on artists such as David Hockney, Edward Wadsworth and Sean Scully. Written for numerous newspapers and magazines – currently *The Spectator*. First solo show as a painter at The Mayor Gallery, London, December 2000.

Raymond Haasen (*b.*1911–82)
Son of Paul Haasen who had worked as contre-maître with Eugène Delâtre. Raymond took over father's etching studio at 23 Rue Vandrezanne in Paris after his death in 1944. Printed for Chagall, including the great *Bible* series, and became one of the few masters of 'interpretative colour aquatint' and of 'reproductions made by most unorthodox methods in collaboration with Fernand Léger and applications of orthodox plate methods in incredible reproductions; and even some plates of mine' (S. W. Hayter). Painter in his own right, Haasen was awarded the diploma of Meilleur Ouvrier de France. Established workshops for screenprinting and lithography alongside etching, the former in particular used to make 'covers for chocolate boxes, labels for expensive perfumes, book jackets and so on' As also mentioned by Hayter, Haasen reduced overhead costs by mostly working on his own. Left Paris and established workshop in Grenoble, a few years before his death.

Kevin Harris (*b.*North London, 1948)
Both father and grandfather in commercial printing trade, and associated with Vail and Company in Kings Cross. Apprenticed at sixteen to Renart Studio run by Leslie Willeson R A, specialist in 'quality graphic work'. Day-release and evening course at Ealing School of Art. Screenprinter at ea, 1970–2. Left to refurbish Print Department, Slade School of Fine Arts in collaboration with David Leverett. Established own printing studio *Calver Studio*, and then *Print Works*, 1979–85, a new studio off the Finchley Road for editing fine art prints. Began prototype work for designers, which continued with move to *Cowper Studios* in Cowper Street, EC2.

Lyndon Haywood (*b.*Eyam, Derbyshire, 1936–2001)
Served in Algerian and Korean wars when badly wounded. Established the screen facilities at Alecto Studios in 1968, working closely with Eduardo Paolozzi, Ed Ruscha and Colin Self on notable projects. Took

on role of production manager at Alecto Studios. A founder director of Megara Screenprinting Ltd, June 1973. Resigned in June 1974. Joined Studio International to work as production manager. Later career in security industry included illustrating military mines and weaponry and advising on military training aids.

John Henn (b.London, 1942)
Studied graphic design at Camberwell School of Arts and Crafts, 1955–63, becoming assistant lecturer in printmaking, September 1963. Assisted Tisiphone Etching Ltd two days a week, between 1976–8.

Irwin Hollander and Hollander Workshop, New York
Irwin Hollander (b.New York, 1927) studied at Brooklyn Museum and Art Students League in New York, as well as in Mexico. Two years on trainee programme at Tamarind Lithography Workshop, before becoming the Workshop's Technical Director, 1963–4. Moved to New York in 1964 to set up Hollander Workshop at 90 East 10th Street, specialising in lithography as well as publishing and selling through its gallery. Purchased presses included a Brand Brother, the first of the new steel presses. List of artists included: William de Kooning, John Cage, Sam Francis, Louise Nevelson, Allen Jones, Helen Frankenthaler, Robert Motherwell, Jasper Johns, Josef Albers, Robert Rauschenburg, James Rosenquist and many others. Joined by lithographer Fred Genis, 1969, to form Hollanders Workshop, newly located on Lower East Side at 195 Christie Street. Moved from New York in 1984 to live in New York State and concentrate on painting.

Leslie Hosgood (b.Bermondsey, London, 1922–90)
Left school at fourteen and attended Lime Grove School of Arts and Crafts for a year. Apprenticeship in carpentry. Joined Regular Army Tank Corps from which was invalided out in 1942. After spell working for Gas Board, began career in commercial screenprinting joining A. H. Clarke & Sons around 1948. Head-hunted by Tanagra Ltd, new firm based at Prince Dale Road, Holland Park, specialising in manufacture of children's toys. Joined the company as foreman, 1949. In 1954 started own business Mor-goods, printing for Tanagra as well as other customers. Closed in 1967. Returned to Tanagra, whose clients now included Marks and Spencer and Platex. Began to screenprint for Fine Art world. Approached by Joe Studholme to work as printer at Megara Screenprinting Ltd, 1973–8. After fire moved with Megara to Freston Road in West London until 1981. Returned to Tanagra. Suffered a stroke in 1986.

Gordon House (b.Pontardawe, South Wales, 1932)
Luton and St Albans Schools of Art, 1947–50. Worked in advertising agency, also assistant to ecclesiastic sculptor, 1950–2. Designer for Plastics Division of ICI and graphic designer for Kynoch Press, Birmingham (ICI London office), 1952–61. *Situation*, RBA Galleries, London, 1960. First artist to work with Chris Prater at Kelpra Studio, 1961, continuing until 1991. *Eight Red Arcs* for ICA Screenprint Project, 1964. Painter, designer and typographer from 1960s; clients included: ℮a, The Beatles, Rolling Stones, Arts Council etc. Worked in most print media. Boxed edition of vacuum-formed vinyl sheets

produced for ℮a, and subsequently withdrawn from publication in 1967 because of ℮a financial crises. Founder director of the print studio *White Ink* in North London. *Gordon House: A Print Retrospective*, Museum of Art, Carnegie Institute, Pittsburgh and Brooklyn Museum, New York, 1981–2.

Paul Cornwall-Jones (b.Peshawar (then India), Pakistan, 1936)
After national service, where he met Joe Studholme, studied architecture at Jesus College, Cambridge, 1956–61. Formed Editions Alecto Ltd with Michael Deakin in 1960 to publish a series of prints of Cambridge Colleges. In 1962, the partnership was incorporated into a limited company. Moved to 8 Holland Street in 1963 to run as The Print Centre and, in 1965, to 27 Kelso Place, Kensington. Resigned in 1967, and established Petersburg Press Ltd at 36 St Petersburg Place, London, in 1968. Continued to publish portfolios, books and multiples by such artists as David Hockney, Richard Hamilton, Dieter Roth, Marcel Broodthaers, Duchamp as well as Jasper Johns, Roy Lichtenstein, Jim Dine, Mark Tobey, Frank Stella, Claes Oldenburg, Francisco Clemente, Patrick Caulfield, Eduardo Paolozzi and others. This produced such celebrated works as: Dine's *The Picture of Dorian Gray* (1968–9), Hockney's *Six Fairy Tales from the Brothers Grimm* (1969/70) and Caulfield's *Some Poems of Jules Laforgue* (1973). Opened New York office in 1972, continuing to publish until 1990, and to deal in paintings, drawings and prints through to 2000 and thereafter.

Robert Jones (b.Hanwell, London, 1943)
Joined Tanagra Ltd, 1961, after persuading his brother-in-law Brian Yorke, general foreman in the company and former printer at Kelpra Studio, to give him a printing job. Printed posters and showcards for such companies as Elizabeth Arden, Playtex, Helena Rubenstein and Marks and Spencer. Left Tanagra in 1973 to work with Leslie Hosgood at Megara Screenprinting Ltd. Worked at Alecto Studios until 1978, when fire forced Megara to relocate to The Peoples' Hall in Freston Road. Remained with Megara until 1981, when started a small commercial print shop for Celsur Plastics, Staines, Middlesex. Left screenprinting trade 1987, and moved to Lincolnshire.

Stanley Jones (b.Wigan, 1933)
Artist and lithographic printer. Studied at Slade School of Fine Art, London 1954–6, where taught by Ceri Richards. Scholarship to Beaux Arts in Paris, specialising in stone and plate lithography. Worked at Atelier Patris, 1956–8. Returned to England to set up Curwen Studio in 1958, beginning with a pilot scheme in St Ives and opening in London, 1959, at St Mary's Studio, Plaistow. Prizewinner at *The Graven Image,* exhibition, 1963. Curwen Studio celebrated in *Artists at Curwen*, Tate Gallery, 1977. Lecturer in lithography at Slade School of Fine Art, 1958–98. Continues to exhibit own work while running the print centre at Curwen Chilford in Cambridgeshire, where recently has been printing for Paula Rego.

Ian Lawson (b.Leek, North Staffordshire, 1942)
Leek School of Art and Stafford School of Art, before taking an ATD year at Goldsmiths' College, London. In 1966 emigrated to America.

Printed at Hollander Workshop, New York, with Irwin Hollander, before joining Tamarind Lithographic Workshop, Los Angeles under Ford Foundation Scheme. Returned to London, 1967, and established lithography studio for ℯ𝒶 at Kelso Place, assisted by Ernest Donagh. By the end of 1968, working from own studio in Putney Bridge (an old Baptist Church Hall). Regular work for Bernard Jacobson during this period, including printing lithographs for a number of Californian artists, as well as Jim Dine for Petersburg Press. Established water-powered lithographic studio *Aymestrey Mill* in Herefordshire, 1975. Artists printed by Lawson include: Frank Stella, Robert Motherwell, William de Kooning, Roy Lichtenstein, Philip Guston, Robert Graham, Ed Ruscha, Howard Hodgkin, Ivor Abrahams, Allen Jones and William Turnbull.

Georges Leblanc (*b.*Paris, 1904–73) and **Atelier Georges Leblanc**
One of the oldest intaglio workshops in Paris dating back to 1793, Georges Leblanc was the son of a master printer trained in the atelier of Delâtre. He took over the printing house at 187 Rue Saint-Jacques from Alfred Porcabeuf in 1946, and began to work with a new generation of artists that included: Vieira da Silva, Nicholas de Staël, Bissière as well as Jacques Villon. Became the principal printer for ℯ𝒶 in Paris. Johnny Friedlaender established his own etching studio at the same address. Georges Leblanc retired in 1968. The atelier was bought by Maurice Lallier, whose son Pierre had begun his training as apprentice under Leblanc at age of fifteen in 1962. He runs the studio today.

Christopher Logue (*b.*Southsea, Hampshire, 1926)
For more than forty years engaged intermittently on *War Music*, an account of Homer's *Iliad*, first part published, 1962. After a period living and teaching in Paris, became part of team running the magazine *Merlin*. Their book imprint *Collection Merlin* published debut in poetry, *Wand and Quadrant*, 1953. First poster poem *To My Fellow Artists* published, 1958, in edition of 1000. Compiled *Christopher Logue's True Stories* and selected prose for *Pseuds' Corner*, both for *Private Eye*.

Anthony Mathews (*b.*Surrey, 1930–2003**)**
Studied painting and illustration at Kingston Art School, followed by four years as assistant in Drayton Printing Group. Ten years at Design Research Unit involved production control and materials research, working in creative environment with designers and artists. Projects included interior design of the ship *Oreana*. Production director at ℯ𝒶, 1966–8, working notably with Jim Dine, Claes Oldenburg and Eduardo Paolozzi. Founded Edizione O in London, 1968, publishing books and graphics by Derek Boshier, Pistoletto, Dan Flavin and West Coast artists. Founded the publishing company Mathews, Millar, Dunbar in London, 1970, which published fine and applied art books at affordable prices. This was followed a year later by Idea Books and its various offprints, which established a worldwide distribution network.

Peter Matthews (*b.*Islington, London, 1942)
Studied fine art including etching and lithography at Ealing School of Art, 1957–62, a year above Michael Rand and Maurice Payne. Began printing editions for Robert Erskine and St George's Gallery, 1961.

This included printing the earliest etchings by Hockney at RCA in 1961 (with Ron Fuller). Senior etching instructor at RCA, 1962–6. During this time met Paul Cornwall-Jones who asked him to edition for ℯ𝒶, including *Public School Prints*. Continued to print Hockney etchings, 1962–3. Joined Brian Perrin at Wimbledon School of Art as Senior Lecturer in Printmaking, 1966–98. Solo exhibitions of own work: Amalgam Gallery, London 1977; Galerie Unicorn, Copenhagen, 1978; and Foreign Press Association, London 1996.

Emil Matthieu and **Matthieu AG, Zürich**
The publisher and lithographer Emil Matthieu (1919–80) trained as a commercial printer with Frey & Kratz, the Zürich-based publishing house. After 1949, now working for H. Kratz, he began to print limited edition lithographs for the artists association Arta, founded by the gallery owner Armin Grossenblacher. It was probably Grossenblacher who encouraged Matthieu to purchase Kratz in 1959, a merger which embraced the rights of the former print publishers Ruff and Hofer, Johannes Frey, and Hofer and Burger. As Emil Matthieu, the company continued the tradition of lithographic-stone printing of historic maps and views of Zürich, after such artists as Hans Conrad Gyger and Johann Caspar Uhlinger, as well as the printing of daily weather charts.

Reputation for printing contemporary artwork and artists' books was secured during the 1960s, when all the printing under the Matthieu AG imprint was based at Bleicherweg 14 in Zürich. Some hundred artists printed at Matthieu including: Alberto Giacometti, Otto Dix, Hans Hartung, Erich Heckel, Sam Francis, Gail Singier, Marino Marini, Hans Falk, Hans Erni and, for ℯ𝒶, portfolio series by Bernard Cohen, Alan Davie, Allen Jones and William Scott. At its height, Matthieu AG had some twenty employees, with four or five master printers including Walter Scherer and Ernst Luthy. The historic publishing house of Verlag Emil Matthieu moved to Rieterstrasse 60 in 1969, and the stone printing firm and equipment of Matthieu AG was sold to Wolfgang Müller of Lichtdruck AG in 1971. Following death of Emil Matthieu, Verlag Matthieu was taken over by Zürcher Heimatschutz in 1986, a trust for the preservation of historic buildings and tradition.

Hans Neuendorf (*b.*Hamburg, 1937)
Leading gallery owner in 1960s, running under the name Gallery Neuendorf in Frankfurt and Hamburg and publishing as Neuendorf Verlag. Represented American, British, Italian and German artists including Andy Warhol and Cy Twombly, Robert Graham, Georg Baselitz, David Hockney and Richard Hamilton. One of the founders of the Cologne Art Fair in 1967. Founder of artnet.com, the first web site devoted to the art world and an international online network for buying and selling art, becoming Chief Executive in 1995.

Charles Newington (*b.*Kent, 1950)
Foundation studies at Byam Shaw School of Art, 1967–9, and printmaking at Central School of Art and Design, 1972–3. Etching technician at Central, 1973–6; and visiting lecturer at various colleges from 1975. Also produced artwork for rock bands Emerson, Lake and Palmer, Led Zeppelin and others. Director of Tisiphone Etching Limited, the etching studio of ℯ𝒶, 1976–9. Left to work with Chris Orr and Tom Piper at Dog's Ear Studio, New Crane Wharf, London. Moved to Kent

to work as painter-etcher, 1982. Exhibitions include: Rebecca Hossack Gallery, London in 1993, 1994 and 1998.

Maurice Payne (*b*.London)
Contemporary of Michael Rand at Ealing School of Art, who introduced him to etching at newly opened Alecto Studios in 1965. After Rand's departure, joined Danyon Black to run etching studio at Kelso Place, 1966–9. Worked for Petersburg Press, London, 1969–76, continuing to print for David Hockney and Jim Dine amongst others, from a studio in Pembroke Studios. Set up own studio in New York, 1979. Taught at Chelsea School of Art, London, and RCA, and more recently used facilities at Columbia University to print for artists. In 1998 exhibition of new etchings by David Hockney – of portraits, plants, chairs and dogs, proofed and editioned by Payne – in Los Angeles. These etchings were exhibited in London at Alan Cristea Gallery, 1999. Has been printing the work of William Kentridge, following visits to South Africa, 2001 and 2002.

Tom Piper (*b*.North Dakota, 1942)
Studied at Northern State College, South Dakota and Eastern Michigan University, USA. Moved to England, 1972, to become Head of Printmaking, Ruskin School of Drawing, Oxford, 1973–7. Co-founder with Chris Orr of Dog's Ear Studio, 1973, initially based in Wooton, near Oxford, and then in Wapping, London. Began to work with Charles Newington of Tisiphone Etching Ltd, 1978, helping to print William Daniell's *A Voyage Round Great Britain*. Revival of Lithography Studio at Alecto Studios interrupted by fire of 1978. Moved surviving equipment to studio in Wapping, where worked as Tom Piper Lithography but also printed for ea, 1979–80. Lithography Director, Jerusalem Print Workshop, 1980–2. Head of Printmaking, University of Wales Institute, Cardiff, from 1984.

Chris Prater (*b*.London, 1924–96) and the **Kelpra Studio**
At Working Men's College, London was taught etching and screenprinting by John Vince. Three-month government trainee scheme in 1951, and subsequently worked as a commercial screenprinter. In 1957 founded Kelpra Studio with wife Rose in a single room in Kentish Town, London. Printed posters for ICA, Arts Council, St George's Gallery amongst others; first artist's screenprint for Gordon House in 1961. In 1962 began to print for Eduardo Paolozzi. Worked with Richard Hamilton in 1964 to realise twenty-four screenprints for the *ICA Screenprint Project*. In the same year began to work for ea on Paolozzi's *As is When* Series. Staff expanded to include such skilled printers as Chris Betambeau, Douglas Corker and process photographer Dennis Francis. Close association with ea until spring 1967. Continued to produce outstanding work for Marlborough and Waddington Graphics. Kelpra Studio closed in 1992.

Michael Rand (*b*.London, 1942)
After studying fine art at Ealing School of Art, joined Editions Alecto in 1963 in Holland Street to run the stock room. Joined by Danyon Black as his assistant. In 1964 moved to former studio of Sir Herbert Herkomer in Bushey, Hertfordshire, owned by mezzotint printer Norman Cox, to work as first intaglio printer for ea. Used press owned by Jennifer Dickson, which later transferred to Kelso Place where, in summer of 1965, Rand became the first person to run etching studio. Assisted for few months by Trevor Allen before being joined by Danyon Black, who Rand trained in printing skills, as well as introducing Maurice Payne to the workings of an intaglio studio. Left to replace Peter Matthews as technical instructor (later Senior Technical Instructor) in the etching department of RCA, 1966–84. Position at ea taken over by Payne who in turn printed with Black. Moved to Strathy-by-Thurso in Sutherland in 1984 to pursue own work, as well as teach

Fig.27 One of the offset litho presses used by Matthieu AG, Zürich. © Alan Green

and conduct print workshops. Collaborated with Barbara Rae from 1995 to print a suite of etchings at his Strathy studio.

Brian Rushton (*b.*Bristol, 1932)
Royal West of England College of Art, and School of Printing at Bristol College of Technology. Head of Publications at Tate Gallery, 1965–71, designing and publishing a whole range of catalogues, books and 2-D material, as well as first multiple for the Tate: Ben Nicholson's *White Relief*. Established vital museum contacts in USA as a board member of The Museum Stores Association of America. Managing Director of Alecto International Ltd, 1971–4, overseeing the production of graphics and multiple objects and, later, also becoming Managing Director of Studio International Publications Ltd. Moved to New York to take up post as Director of Publications and Marketing Services, Brooklyn Museum, 1975–84. Now works as a consultant designer in New York.

Bud Shark (*b.*Devils Lake, North Dakota, 1942)
Studio manager of lithography studio at ea, 1970–3. Fellow at Tamarind Lithography Workshop, 1969. Part-time lecturer at Slade School of Fine Art, 1972–3, before spending a year printing for Petersburg Press, London. Visiting master printer at University of Colorado, 1975, and in 1976 opened Shark's Lithography Ltd, in Boulder, Colorado. Reorganised business and changed name to Shark's Ink in 1985, moving to Blue Mountain Road, Lyons, Colorado, in 1998.

Harry Snook (*b.*South Wales, 1944)
Studied painting with etching at Hornsey College of Art. Informed of a job vacancy at Alecto Studios by one of his lecturers, Richard (Dick) Fozzard. Joined Maurice Payne and Danyon Black in the etching studio, 1966–7. Left to teach lithography and afterwards foundation studies at Bradford Regional College of Art.

Charles Spencer (*b.*London, 1920)
Art historian, lecturer, writer on theatre design and ballet, and exhibition organiser. Editor of *Art and Artists*, and art critic for *The New York Times European Edition* and the *London Daily Mail*. Contributor to *Studio International* and senior lecturer at Croydon College. Joined ea in 1971 as advisor and promotor of Alecto International, also choosing artists for Editions Alecto Collectors Club. Publications include: *Erté*, Studio Vista, London, 1970; *Alecto Monograph* Series and *A Decade of Printmaking*, London, Academy Editions (both 1973); *Leon Bakst*, London, Academy Editions, 1978.

Joe Studholme (*b.*Paddington, London, 1936)
Met Paul Cornwall-Jones in 1954 during national service. Studied history at Magdalen College, Oxford, 1956–9. Worked for Lazards Bros in the City before becoming a director of King & Shaxson (bill-brokers). One of the founding shareholders of Editions Alecto Ltd on its incorporation, 1962. Joined the company full time in 1963 as executive director. With resignation of Paul Cornwall-Jones in 1967, took over as Managing Director. Initiatives that followed included establishment of Editions Alecto Collectors Club, Alecto International

(publishing editions of artists' 3-D products) and Ad Infinitum (unlimited posters). In 1981 established Alecto Historical Editions as publishing imprint for important historical material, printed from original copper plates or in facsimile. Notable AHE publications included: Banks' *Florilegium* (with the British Museum (Natural History)), portfolio of John James Audubon's *Birds of America* (with the American Museum of Natural History), and a facsimile edition of *Domesday Book* (with the Public Record Office).

John Taylor (*b.*Ayrshire, 1936)
Studied at Glasgow School of Art, and then began a long association as Senior Technician at the Glasgow Print Studio. Recommended by Scottish Arts Council in 1977 to be one of two Scottish artists (with Ainslie Yule) to take up a short residency at ea to work on a screenprint. Proofs never finally editioned. 'It was the full professional attitude at Megara that made an impression on me'

Frank Tinsley (*b.*Liverpool, 1947)
Studied graphic design at Camberwell School of Arts and Crafts, 1967–70 and later printmaking at Chelsea School of Art, 1970–1. Met Charles Newington, who invited him to become co-director of Tisiphone Etching Ltd, 1976–8. Later returned to Camberwell to lecture in printmaking.

Kenneth Tyler (*b.*East Chicago, Indiana 1931) and **Gemini Ltd/G.E.L.**
Studied art education at Art Institute of Chicago, 1950–1, where first introduced to lithography. Taught lithography by Garo Antreasian at John Herron Schol of Art, Indianapolis, 1962–3. Ford Foundation Grant to study printing at Tamarind Lithography Workshop, Los Angeles, becoming Technical Director, 1964–5. Formed Gemini Ltd (later Gemini G.E.L.), Los Angeles, 1965. Major exhibition of Gemini editions at MOMA, New York, 1971. Formed Tyler Workshop Ltd, Bedford Village, New York, 1974, which became Tyler Graphics in 1975. Artists have included: Frank Stella, Robert Rauschenberg, Roy Lichtenstein, Jasper Johns and David Hockney, printing *A Hollywood Collection* for ea, 1965.

C. H. Welch
Introduced to Robert Erskine by Anthony Gross, making the connection with ea a few years before he retired. Distant relation of Peter Matthews (Welch's stepmother Alice Matthews, was P.M.'s aunt), who printed some of Hockney's earliest etchings, Welch himself came from a family of commercial printers. His father was considered by Anthony Gross 'to be the finest in England', running a workshop and club from Oldfield House, Brook Green, Hammersmith. The Brooklyn Club, as it was called, became a centre for artists making and printing their etchings in 1920s and 1930s. S. W. Hayter refers to C. H. Welch's brother as 'a commercial colour printer in St Albans'. Inherited his father's large basement workshop 'with magnificent equipment', before Rent Act forced him to move to smaller workshop premises in Dorset Street, while living nearby in Gloucester Place. Printed Gross's *Le Boulvé Suite* and Merlyn Evans's *Vertical Suite in Black*, before editioning *A Rake's Progress* for Hockney, 1963.

Concordance of Editions Alecto (numbered) publications

ea no	artist	title	pub date	cat no
ea 1	David Hockney	A Rake's Progress	1963	430–45
ea 2	David Hockney	Gretchen and the Snurl	1963	429
ea 3–10	Allen Jones	Concerning Marriages	1964	500–7
ea 11	Allen Jones	Hermaphrodite Head	1964	509
ea 12	Mistaken entry: David Hockney	Still Life	1964	
ea 13	David Hockney	A Hollywood Collection	1965	451–6
ea 14	David Hockney	Pacific Mutual Life	1964	448
ea 15	David Hockney	Water pouring into swimming pool, Santa Monica	1964	449
ea 16	David Hockney	Portrait of Kasmin, (Figure by a Curtain)	1964	450
ea 17	Eduardo Paolozzi	Tafel 16	1964	696
ea 18–29	Eduardo Paolozzi	As is When	1965	697–708
ea 30	Richard Hamilton	The Solomon R. Guggenheim	1965	411
ea 31	Richard Hamilton	Interior	1965	410
ea 32	Bernard Cohen	Silver	1965	203
ea 33–41	Bernard Cohen	Lithographs (I–IX)	1965	204–12
ea 42–75	Alan Davie	Zurich Improvisations	1965	243–76
ea 76	Allen Jones	Woman	1965	510
ea 77	Allen Jones	Polka	1965	511
ea 78	Allen Jones	Man Woman	1965	513
ea 79	Allen Jones	Daisy Daisy	1965	512
ea 80–8	Richard Beer	Oxford Series	1964	42–50
ea 89	Richard Beer	Venetian Church	1964	51
ea 90	Richard Beer	Palazzo	1964	52
ea 91	Richard Beer	Spanish Hillside	1964	53
ea 92	Richard Beer	Red Valley	1964	54
ea 93	Richard Beer	Covent Garden	1964	55
ea 94	Valerie Thornton	Eton College Chapel	1964	1094
ea 95	Valerie Thornton	Winchester	1964	1095
ea 96	Valerie Thornton	Harrow	1964	1096
ea 97	Valerie Thornton	Grand Canal	1964	1097
ea 98	Valerie Thornton	Breakwater	1964	1098
ea 99	Helena Markson	Beaumont School	1964	641
ea 100–5	Helena Markson	Liverpool Suite	1964	642–7
ea 106	Helena Markson	Newington Green	1964	648
ea 107–12	Julian Trevelyan	London Suite	1964	1120–5
ea 113–20	Alistair Grant	Azincourt Suite (I–VIII)	1964	397–404
ea 121	Jack Coutu	Ichthyology	1964	215
ea 122	Jack Coutu	Dancer	1964	216
ea 123	Jack Coutu	Witches' Moon	1964	217
ea 124	Jack Coutu	Jungle	1964	218
ea 125	Jack Coutu	Red Monolith	1964	219
ea 126	Lewin Bassingthwaighte	Untitled (Orange)	1964	25
ea 127	Lewin Bassingthwaighte	Untitled (Blue)	1964	26

ea no	artist	title	pub date	cat no
ea 128	Lewin Bassingthwaighte	*Wall and Gate*	1964	27
ea 129	Lewin Bassingthwaighte	*Wall (Brick Structure)*	1964	28
ea 130	Radovan Kraguly	*Corn*	1964	592
ea 131	Radovan Kraguly	*Leaf and Coral*	1964	593
ea 132–44	Jennifer Dickson	*Alecto Keys*	1964	324–36
ea 145–56	Anthony Currell	*Wales Series*	1964	230–41
ea 157–65	Doris Seidler	*Arkhaios Series*	1964	1026–34
ea 166–8	Anthony Harrison	*Engraving I–III*	1964	413–15
ea 169–71	Anthony Harrison	*Red and Black I–III*	1964	416–18
ea 172–4	Anthony Harrison	*Requiem I–III*	1964	419–21
ea 175	Tadek Beutlich	*The Lake*	1964	97
ea 176	Tadek Beutlich	*The Earth*	1964	98
ea 177	Tadek Beutlich	*Burning Desert*	1964	99
ea 178	Tadek Beutlich	*Two Islands Meet*	1964	100
ea 179	Tadek Beutlich	*River*	1964	101
ea 180	Tadek Beutlich	*Fritillary (Growth II)*	1964	102
ea 181	Tadek Beutlich	*Red River*	1964	103
ea 182	Tadek Beutlich	*Heatwave in Antarctic*	1964	104
ea 183	Tadek Beutlich	*Magic Pool*	1964	105
ea 184	Tadek Beutlich	*Sunset II*	1964	106
ea 185	John Brunsdon	*Studio Panoramic*	1963	140
ea 186	John Brunsdon	*Landscape II*	1963	141
ea 187	John Brunsdon	*Studio Rhythms*	1963	142
ea 188	John Brunsdon	*Welsh Valley II*	1964	143
ea 189	John Brunsdon	*King and Queen*	1964	144
ea 190	John Brunsdon	*Blue Water*	1964	145
ea 191	John Brunsdon	*Dawn*	1964	146
ea 192	John Brunsdon	*Blue Room (Woburn)*	1964	147
ea 193	John Brunsdon	*Night Dreams*	1964	148
ea 194–203	André Bicât	*Tuscan Suite*	1966	124–33
ea 204	Mistaken entry: Allen Jones	*Miss*	1966	(See ea 308)
ea 205–14	Jennifer Dickson	*La Genèse*	1965	338–47
ea 215–16	Ronald King	*Slate Lichen I–II*	1966	567–8
ea 217–18	Ronald King	*Lichen I–II*	1966	569–70
ea 219	Ronald King	*Moonstream*	1966	571
ea 220–3	Ronald King	*Sea Anemone I–IV*	1966	572–5
ea 224–32	Bernard Kay	*Cathedral Suite*	1966	545–53
ea 233	Valerie Thornton	*Queen's College, Oxford*	1965	1099
ea 234	Valerie Thornton	*Queen's College Façade*	1965	1100
ea 235	Valerie Thornton	*Farm Buildings*	1965	1101
ea 236	Valerie Thornton	*Suffolk Barns*	1965	1102
ea 237	Valerie Thornton	*Navajo Canyon*	1965	1103
ea 238	Valerie Thornton	*Mesa Verda*	1965	1104
ea 239	Valerie Thornton	*Arizona*	1965	1105
ea 240	Valerie Thornton	*Golden Canyon*	1965	1106
ea 241	Valerie Thornton	*Vézelay*	1965	1107
ea 242–53	Julian Trevelyan	*Florentine Suite*	1966	1126–37
ea 254–65	Richard Beer	*Mediterranean Suite*	1966	56–67
ea 266–75	Walter Hoyle	*Cambridge Series*	1966	482–91
ea 276–7	No entry			
ea 278–86	Edward Bawden	*Nine London Monuments*	1966	32–40

ea no	artist	title	pub date	cat no
ea 287	Margaret Kroch-Frishman	*Belgravia*	1966	375
ea 288–90	Margaret Kroch-Frishman	*Gondola I–III*	1966	376–8
ea 291	Margaret Kroch-Frishman	*Orchid*	1966	379
ea 292	Margaret Kroch-Frishman	*Flowers*	1966	380
ea 293	Margaret Kroch-Frishman	*Tulips*	1966	381
ea 294	Margaret Kroch-Frishman	*Venice*	1966	382
ea 295	Margaret Kroch-Frishman	*Carnations*	1966	383
ea 296	Richard Hamilton	*My Marilyn*	1966	412
ea 297	Peter Sedgley	*Blue Scale*	1965	1001
ea 298	Bernard Cohen	*Taper*	1966	214
ea 299	S. W. Hayter	*Onde Verte*	1965	422
ea 300	Howard Hodgkin	*Interior with Figure*	1966	476
ea 301	Howard Hodgkin	*Girl at Night*	1966	477
ea 302	No entry			
ea 303–7	Richard Smith	*Sphinx Series I–V*	1966	1063–7
ea 308	Allen Jones	*Miss*	1966	529
ea 309	No entry			
ea 310–18	Peter Sedgley	*Looking Glass Suite I–IX*	1966	1002–10
ea 318*–27	Robyn Denny	*Suite 66*	1966	303–12
ea 328–37	Jim Dine	*A Tool Box*	1966	357–66
ea 338–49	Lil Michaelis	*Personnages I–XII*	1966	660–71
ea 350–1	Jacques Charoux	*Message III–IV*	1966	171–2
ea 352	Jacques Charoux	*Diptych II*	1966	173
ea 353	Michael Rothenstein	*Spider Jazz*	1966	973
ea 354	Michael Rothenstein	*Inset Wheels*	1966	974
ea 355	Michael Rothenstein	*Radial Shakes*	1966	981
ea 356	Michael Rothenstein	*Circles and Waving Lines*	1966	975
ea 357	Michael Rothenstein	*Red, Blue and Brown*	1966	976
ea 358	Michael Rothenstein	*Bronze and Black*	1966	977
ea 359	Michael Rothenstein	*Diamond*	1966	978
ea 360	Michael Rothenstein	*Round, Round, Round*	1966	979
ea 361	Michael Rothenstein	*Black, Blue and White*	1966	980
ea 362–73	David Hockney	*The Cavafy Series*	1967	458–69
ea 374	Derek Boshier	*Output*	1966	134
ea 375	Richard Beer	*All Souls, Oxford*	1966	68
ea 376–87	Graham Clarke	*Kent Series*	1967	175–86
ea 388–92	Allen Jones	*A Fleet of Buses*	1966	514–18
ea 393–8	Allen Jones	*A New Perspective on Floors*	1966	520–5
ea 399	Allen Jones	*Large Bus*	1966	527
ea 400	Allen Jones	*Subtle Siren*	1966	528
ea 401	Tadek Beutlich	*Dyad*	1967	107
ea 402	Tadek Beutlich	*Embryo*	1967	108
ea 403	Tadek Beutlich	*Eye*	1967	109
ea 404	Tadek Beutlich	*Idol*	1967	110
ea 405	Tadek Beutlich	*Purple Coral*	1967	111
ea 406	Tadek Beutlich	*Landscape III*	1967	112
ea 407	Tadek Beutlich	*Meteors*	1967	113
ea 408	Tadek Beutlich	*Moth*	1967	114
ea 409	Tadek Beutlich	*River III*	1967	115
ea 410	Tadek Beutlich	*Seeds*	1967	116
ea 411	Tadek Beutlich	*Twin Constellation*	1967	117

ea no	artist	title	pub date	cat no
ea 412	Tadek Beutlich	Sea Shore	1967	118
ea 413	Patrick Caulfield	The Hermit (I)	1967	165
ea 414	Patrick Caulfield	Earthenware (II)	1967	166
ea 415	Patrick Caulfield	Coloured Still Life (III)	1967	167
ea 416	Patrick Caulfield	The Letter (IV)	1967	168
ea 417	Patrick Caulfield	Sweet Bowl (V)	1967	169
ea 418	Patrick Caulfield	Weekend Cabin (VI)	1967	170
ea 419–30	Julian Trevelyan	Africa Suite	1967	1138–49
ea 431	David Hockney	Portrait of Cavafy II	1967	472
ea 432–43	Edwin La Dell	Garden Series	1967	595–606
ea 444–57	Ronald King	The Prologue**	1967	577–90
ea 458–63	William Scott	Odeon Series	1967	991–6
ea 464–75	Richard Beer	Second Mediterranean Suite	1967	69–80
ea 476	Allen Jones	Poster: A New Perspective on Floors	1967	526
ea 477	Allen Jones	Poster: A New Fleet of Buses	1967	519
ea 478	Allen Jones	Head	1967	530
ea 479	Allen Jones	Lesson	1967	531
ea 480–7, 489***	Eduardo Paolozzi	Moonstrips Empire News	1967	710–809
ea 490	Eduardo Paolozzi	Illumination and the Eye	1967	810
ea 491	Eduardo Paolozzi	The Theory of Relativity (Suite No 2)	1967	811
ea 492	John Brunsdon	Breeze I	1967	149
ea 493	John Brunsdon	The Twelfth Day	1967	150
ea 494–9	Peter Sedgley	Firebird Suite I–VI	1967	1011–16
ea 500	Valerie Thornton	Lady Chapel, Ely Cathedral	1967	1108
ea 501	Ian Lawson	LA1	1967	615
ea 502	Gillian Ayres	Damask	1967	10
ea 503–4	Gillian Ayres	Crivelli's Room I–II	1967	11–12
ea 505	Gillian Ayres	Khuds	1967	13
ea 506	Gillian Ayres	Lorenzo the Magnificent and Niccolo the Gear	1967	14
ea 507	Jim Dine	Drag: Johnson and Mao	1967	367
ea 508	Jean Dubuffet	Banque de L'Hourloupe	1967	371
ea 509	Jim Dine	Wall	1967	368
ea 510–17	Graham Clarke	Fishing Boats at Rye and Hastings (1)	1967	187–94
ea 518	David Hockney	Cushions	1968	473
ea 519	Howard Hodgkin	Indian Room	1968	478
ea 520	Richard Beer	Gordes (France)	1968	81
ea 521	Richard Beer	San Marco II	1968	82
ea 522	Richard Beer	Santa Maria Della Formosa	1968	83
ea 523	Richard Beer	Broadstairs	1968	84
ea 524	Richard Beer	Mercato	1968	85
ea 525	Richard Beer	Port Lligat	1968	86
ea 526–33	Allen Jones	Life Class	1968	533–40
ea 534–6	Colin Self	Out of Focus Object and Flowers 1–3	1968	1035–7
ea 537	Claes Oldenburg	London Knees	1968	677
ea 538	Allen Jones	Icarus (nos 24–75)	1968	532
ea 539	Bridget Riley	Poster Poem: Descending	1968	972
ea 540	Peter Sedgley	Poster: Floodlight	1968	1018
ea 541	Howard Hodgkin	Bedroom	1968	479
ea 542	Howard Hodgkin	Girl on a Sofa	1968	480
ea 543–8	Helena Markson	New Suite	1968	649–54
ea 549–54	Colin Self	Power and Beauty Series, Volume One	1968	1039–45

ea no	artist	title	pub date	cat no
ea 555	Allen Jones	*Icarus* (nos 1–23)	1968	532
ea 556	Robert Graham	*Top View*	1968	390
ea 557–62	Robert Graham	*Room Series I–VI*	1968	391–6
ea 563	Colin Self	*Portfolio Print: Unique Car*	1968	1049
ea 564	Colin Self	*Portfolio Print: Unique Airship*	1968	1046
ea 565	Colin Self	*Prelude to Power and Beauty (Marauder)*	1968	1050
ea 566–71	Larry Zox	*Diamond Drill*	1968	1158–63
ea 572–6	Robyn Denny	*Colour Box Series*	1968	313–17
ea 577	Richard Smith	*Triptych*	1968	1068–70
ea 578–9, 582–4	Patrick Procktor	*Invitation to a Voyage*	1969	908–12
ea 580	Peter Schmidt	*Monoprints*	1968	989
ea 581	Anthony Deigan	*Somebodies Old Pot*	1968	277
ea 585	Allen Jones/James Wedge	*Thrill Me*	1969	541
ea 586–95	Peter Carr/Terence Millington	*The Tassili Prints*	1969	155–64
ea 596	Patrick Procktor	*My Gardenia*	1969	914
ea 597–602	Peter Sedgley	*Video Disques*	1969	1019–24
ea 603–7	No entry			
ea 608–15	Anthony Deigan	*I Did*	1969	278–85
ea 616–23	Graham Clarke	*Fishing Boats at Rye and Hastings* (2)	1969	195–202
ea 624–7	Anthony Deigan	*Four Thoughts in a Room*	1969	286–9
ea 628–33	Robert Gordy	*Golden Days*	1970	384–9
ea 634	Anthony Deigan	*Sing to the Mirror*	1969	290
ea 635	Anthony Deigan	*Blowing Bubbles*	1969	291
ea 636	Pauline Aitken	*On no work of words . . .*	1969	1
ea 637	Pauline Aitken	*Skein*	1969	2
ea 638	No entry			
ea 639	Bernard Cheese	*Movement in a Hedgerow*	1969	174
ea 640	Michael Stokoe	*Wave under nine*	1969	1088
ea 641	Michael Stokoe	*Weights on a brown field*	1969	1089
ea 642	Stanley Jones	*Lunar Sound*	1969	544
ea 643	John Brunsdon	*Orbicular*	1969	151
ea 644	John Brunsdon	*Mud Flats*	1969	152
ea 645	John Brunsdon	*Pembroke I*	1969	153
ea 646	Walter Hoyle	*Planets*	1969	492
ea 647	Walter Hoyle	*Saturn*	1969	493
ea 648	Walter Hoyle	*Mars*	1969	494
ea 649	Walter Hoyle	*Sun*	1969	495
ea 650	George Segal	*Girl on a Chair*	1970	1025
ea 651–2	Gillian Ayres	*Aquatint 1–2*	1970	15–16
ea 653–7	Richard Demarco	*Malta Suite*	1970	292–6
ea 658–63	David Leverett	*Diagonal Inclinations*	1970	618–23
ea 664–73	Richard Beer/John Betjeman	*Ten Wren Churches*	1970	87–96
ea 674–81	Gillian Ayres	*Variants*	1970	17–24
ea 682–4	Ian Tyson	*Mid West I–III*	1970	1150–2
ea 685–90	Ed Ruscha	*News, Mews, Pews, Brews, Stews and Dues*	1970	982–7
ea 691	David Pelham	*The Minimum Chess Set*	1970	904
ea 692	Tadek Beutlich	*Radiation II*	1970	119
ea 693	Tadek Beutlich	*Waves II*	1970	120
ea 694–9	Cecil King	*Berlin Suite*	1970	554–9
ea 700–49	Eduardo Paolozzi	*General Dynamic F.U.N.*	1970	813–62
ea 750	Ed Ruscha	*Brews*	1970	988

ea no	artist	title	pub date	cat no
ea 751	No entry			
ea 752	David Leverett	*Retained Image*	1970	624
ea 753–9	Patrick Procktor	*India, Mother*	1970	915–21
ea 760–83	Eduardo Paolozzi	*The Conditional Probability Machine*	1970	864–87
ea 784	Norman Stevens	*Louvered Shutter (Evening)*	1971	1071
ea 785–7	Mark Lancaster	*Henry VI Monochrome I–III*	1971	607–9
ea 788–90	Mark Lancaster	*Henry VI Eight Colours I–III*	1971	610–12
ea 791–9	Colin Self	*Prelude to 1000 Temporary Objects of Our Time*	1971	1052–60
ea 800	No entry			
ea 801–8	Eduardo Paolozzi	*Cloud Atomic Laboratory*	1971	888–95
ea 809	Mark Lancaster	*Henry VI Series (Grey and Red)*	1971	613
ea 810	Patrick Procktor	*Marcus with a Pink*	1971	922
ea 811	Patrick Procktor	*Queen Mary's Rose Garden, Regent's Park*	1971	923
ea 812	Patrick Procktor	*Back of the Zoo, Regent's Park*	1971	924
ea 813–16	David Leverett	*Equinox, I–IV*	1972	625–8
ea 817–18	Derek Boshier	*Plan I–II*	1972	135–6
ea 819	Patrick Procktor	*Dogano (Customs House, Venice)*	1972	925
ea 820–1	Patrick Procktor	*Riva I–II*	1972	926–7
ea 822–4	No entry			
ea 825	Tom Phillips	*After Raphael?*	1973	905
ea 826	Achilles Droungas	*A fig, a plum, a quince, an apple, a pear*	1973	369
ea 827	Colin Lanceley	*Morning and Melancholia*	1973	614
ea 828	Ed Meneeley	*Louina's Dream*	1973	659
ea 829	David Hockney	*An Etching and a Lithograph for Editions Alecto*	1973	474
ea 830	Harald Becker	*Man and German Dog*	1973	41
ea 831	Igino Legnaghi	*Sculptural Image*	1973	616
ea 832	Norman Stevens	*Dusk*	1973	1075
ea 833	Birgit Skiöld	*Moruroa*	1973	1061
ea 834	Kenneth Armitage	*Daydream*	1973	9
ea 835	Paolo Legnaghi	*Perception 1*	1973	617
ea 836	Patrick Procktor	*London Bridge*	1973	929
ea 837	Achilles Droungas	*City under Siege*	1973	370
ea 838	David Leverett	*State of Change*	1973	629
ea 839	Birgit Skiöld	*Shisen-do*	1974	1062
ea 840	Norman Stevens	*Clapboard House with Fronds and Architectural French Curve*	1974	1076
ea 841	Norman Stevens	*Flight of Steps*	1974	1077
ea 842	Norman Stevens	*Morning*	1974	1078
ea 843	Norman Stevens	*Covered Walk*	1974	1079
ea 844	Norman Stevens	*Stonehenge*	1974	1080
ea 845	Norman Stevens	*Stone Circle*	1974	1081
ea 846	Norman Stevens	*Courtyard*	1974	1082
ea 847	Norman Stevens	*Path*	1974	1083
ea 848	Edward Ardizzone	*Charterhouse: The Mulberry Tree*	1974****	4
ea 849	Edward Ardizzone	*Downside Abbey: The Courtyard*	1974****	6
ea 850	Edward Ardizzone	*St Paul's School, Hammersmith: The Nets*	1974****	8
ea 851	Edward Ardizzone	*Charterhouse: The Courtyard*	1974****	3
ea 852	Tadek Beutlich	*Bios*	1974	121
ea 853–4	Tadek Beutlich	*Pollination I–II*	1974	122–3
ea 855	Carl Toms	*Covent Garden*	1974	1109
ea 856	John Ward	*Sutton Valence School, Kent*	1974****	1153

ea no	artist	title	pub date	cat no
ea 857	John Ward	*Grays Inn Hall*	1974****	1154
ea 858	John Ward	*The Law Society Library*	1974****	1155
ea 859	John Ward	*Inner Temple Hall*	1974****	1156
ea 860	John Watson	*Eastbourne College, Sussex*	1974****	1157
ea 861–3	Alan Green	*Three Variations A–C*	1974	406–8
ea 864–9	Patrick Procktor	*South Africa Suite*	1974	931–6
ea 870–5	Richard Demarco	*London Scenes*	1974	297–302
ea 876–7	Cecil King	*Threshold*	1974	560–1
ea 878–9	Cecil King	*Intrusion*	1974	562–3
ea 880–2	Cecil King	*The Dubai Suite*	1975	564–6
ea 883–5	David Leverett	*3 x 3 Shift*	1975	630–2
ea 886	Nigel Hall	*Dialogue*	1975	409
ea 887	Bert Kitchen	*Cobalt Towers*	1975	591
ea 888	Ben Johnson	*Escalator*	1975	499
ea 889–93	Derek Hirst	*Paradox Suite I–V*	1975	423–7
ea 894–7	Norman Stevens	*Lower Wessex Lane*	1976	1084–7
ea 898–900	William Scott	*Summer Suite*	1976	998–1000
ea 901–4	Michael McKinnon	*Fibonacci Portfolio*	1976	655–8
ea 905–10	Robyn Denny	*Six Miniatures*	1975	318–23
ea 911	Eduardo Paolozzi	*Selasa*	1975	897
ea 912	William Scott	*Blue Still Life*	1975	997
ea 913	Tom Phillips	*Ten Views of the Union Jack*	1975	906
ea 914	Patrick Caulfield	*Sweetbowl (Unlimited)*	1975	169a
ea 915	David Hockney	*Picture of a Still Life*	1975	475
ea 916–27	Patrick Procktor	*The Rime of The Ancient Mariner*	1976	937–48
ea 928	No entry			
ea 929	Patrick Procktor	*I fear thee, Ancient Mariner!*	1976	951
ea 930	Patrick Procktor	*The Rime of The Ancient Mariner: Standard Edition*	1976	949
ea 931	Patrick Procktor	*The Rime of The Ancient Mariner: Special Edition*	1976	950
ea 932	David Oxtoby	*Elvis Presley 1956 'The Boy King'*	1977	679
ea 933	David Oxtoby	*Elvis Presley 1976 'The King'*	1977	680
ea 934	David Oxtoby	*Dylan*	1977	681
ea 935	David Oxtoby	*Rock Block*	1977	682
ea 936–47	David Oxtoby	*Dylan Book*	1977	683–94
ea 948	Patrick Procktor	*Dahlias (Swastika)*	1977	952
ea 949–58	Bill Culbert	*Window 84490*	1977	220–9
ea 959–64	Liliane Lijn	*Biting Through*	1977	634–9
ea 965–71	Patrick Procktor	*The Venice Series*	1978	953–9
ea 972	David Oxtoby	*August 16th (Presley)*	1978	695
ea 973	Michael English	*Yellow No I*	1979	374
ea 974	Patrick Procktor	*Aesthete*	1979	960
ea 975	Patrick Procktor	*Quinta da Vargelas*	1979	961
ea 976–81	Kevin Pearsh	*North-West Australia Series*	1979	898–903
ea 982	Chris Orr	*A Cornish Lugger Sets Sail*	1979	678
ea 983–90	Patrick Procktor	*A Chinese Journey*	1980	962–9
ea 991	Patrick Procktor	*Peking Opera*	1980	970
ea 992	Derek Hirst	*Sidlesham Sunrise*	1981	428

* repeated number

** finally published by Circle Press, see catalogue entry

*** no entry for ea 488

**** refers to redistribution rather than publication date

Photography Acknowledgements

Photography for this book has been taken by Miki Slingsby, with the exception of the following plate numbers:

44, 54–5, 104, 108. Arts Council Collection, Hayward Gallery, London; 105–7. © Gillian Ayres; 4, 5, 39, 41–2, 53, 68–71, 83–5, 135, 162. Birmingham Museums and Art Gallery; 11–26, 36–7, 56, 86–7. The British Council Collection; 118, 109. Alan Cristea Gallery, London; 126. © Bill Culbert; 1, 2, 3, 6, 33, 35, 38, 40, 43, 82, 89, 136–9, 149, 159–60. © Deste; 127–31, 157–8, 161. © Editions Alecto Ltd.; Front cover, 143–6. © Tony Evans; 9–10, 52, 65, 101–2. © Crown copyright in photograph: UK Government Art Collection; 27–9, 31–2. National Museum and Gallery of Wales; 45–7. New Orleans Museum of Art; 48–51. Scottish National Gallery of Art; 8, 72, 92–3, 110. © Tate, London, 2002; 57–64. Tyler Graphics Ltd.; 151. Board of Trustees of the National Museums and Galleries on Merseyside (Walker Art Gallery, Liverpool); 30, 116, 119. The Whitworth Art Gallery, University of Manchester.